F. V.

Romanesque
and Gothic
France

Romanesque and Gothic France

Architecture and Sculpture

Viviane Minne-Sève
and Hervé Kergall

Translated from the French by
Jack Hawkes and Lory Frankel

Harry N. Abrams, Inc., Publishers

Editor, English-language edition: Lory Frankel
Design Coordinator, English-language edition: Tina Thompson

Library of Congress Cataloging-in-Publication Data

Minne-Sève, Viviane.
 [France romane et gothique. English]
 Romanesque and gothic France : architecture and sculpture / Viviane Minne-Sève,
 Hervé Kergall ; translated from the French by Jack Hawkes.
 p. cm.
 Includes bibliographical references and index.
 ISBN 0–8109–4436–7
 1. Art, French. 2. Art, Romanesque—France. 3. Art, Gothic—France. I. Kergall, Hervé.
 II. Title.

N6843 .M5613 2000
709'.44'0902—dc21 00–38974

Printed and bound in France

Harry N. Abrams, Inc.
100 Fifth Avenue
New York, N.Y. 10011
www.abramsbooks.com

Contents

Romanesque France

The Birth of Romanesque Art 10

The Challenge of Toulouse 32

The Realm of the Monks 48

Western France: A Mosaic 72

The Land of Faith 100

The Road to Puy 124

The Gates of the Empire 146

Italian Memories 164

In the Land of the Conquerors 186

Toward New Times 200

Gothic France

The Birth of the Gothic Style 214

The Acropolis of France 228

The Greatest King in the West 240

Anointment and Coronation at Reims 256

Amiens, Book of Stones 270

Threatened by the Sea 280

The Glory of Languedoc 290

The Popes in Avignon 304

The Great Dukes of the West 316

Sweet and Violent Anjou 326

Berry and Bourbon 336

Rouen of the Hundred Steeples 348

Ducal Brittany 358

Paris from Charles V to François Villon 370

Strasbourg, the Tallest Spire in Europe 386

Glossary 401

Index 406

Introduction

At the start of the third millennium, the ten centuries that form the Middle Ages in the West seem at once far removed in time and yet close to us by virtue of the keen interest our period has displayed in them as we search for the roots of our experience. Architecture, in addition to its aesthetic value, is the expression of a society, of its richness, its structures, and its choices. The buildings constructed throughout the Middle Ages, almost exclusively dedicated to the sacred, reveal the power of the Church and the faith of the people of that period. For a Christian, building meant raising souls toward God, and to this end nothing was too beautiful or too grand.

Romanesque art is the most important manifestation of the awakening and subsequent rise of the West. It had its greatest flowering in France, where no province lacks a Romanesque legacy. The transformations experienced by France of the eleventh and twelfth centuries proved among the most profoundly influential in its history. Not yet a nation, Romanesque France was a "kingless land" in which the weakness of central authority encouraged the overwhelming supremacy of an aristocracy that imposed itself by right or by force on the regional states, whose borders changed constantly. Monarchs ruled over a modest royal domain extending irregularly from Compiègne to Orléans, and defending and consolidating this area absorbed most of their efforts. Competition surrounded them, pressure was omnipresent. By the year 1000, the land of the Franks began to be militarized with mounded and fenced redoubts, quickly replaced by fortified strongholds. These constructions reveal the violence, overt or latent, that reigned in the countryside, and it did not always come from outside. In spite of the fact that the village had been established at the base of the château as a measure of protection, the village was subjected to raids and pillage by the lords of the château, motivated less by a search for subsistence than by a desire to constrain the peasant population and stifle any movement toward freedom. Keeps grew in number, since a guerrilla war was also carried on between noble families, which sought to maintain their privileges and to enlarge their estates. Violence also reigned in the cities, where a communal spirit aroused a desire for freedom early on.

In this troubled climate, the Church appeared as the only recourse. The monasteries, whose civilizing influence peaked in the Romanesque period, spearheaded a social, political, and economic renewal. To the people of towns and villages, to whom they were closer than the secular clergy, they presented a paradigm of stability and organization. The black monks of the order of Cluny held center stage in the western part of France. Their immense abbey exerted its power on a vast domain and over ten thousand members of the order, whose practical and pastoral assistance integrated them into rural society. The rival order of the Cistercian white monks stimulated the rise of military orders and departures to the Holy Lands in defense of the faith, using the lure of distant lands to promote the Crusades. These, in the service of God, diminished political rivalries and social divisions, at least for a time. Pilgrimage, another facet of the spiritual rise of the Romanesque period, enjoyed a success between the tenth and the twelfth centuries that has never since been equaled.

Although it is true that economic expansion fed local and regional conflicts by kindling greed among the powerful, it also gave the people of the Middle Ages the means to work for the future—which meant, in a time of faith, to work for their salvation. The great builders of the period—William of Volpiano, Odilon and Hugues de Cluny, Gerbert d'Aurillac, who became pope, Bruno, founder of the Carthusian monks, Bernard of Clairvaux, and Abbot Suger of Saint-Denis—are also its great charismatic figures, who used their leverage with the ruling powers to compensate for the public officials' lack of prestige and abdication of responsibility.

Romanesque art, which evolved from many sources, developed in a multifaceted fashion. Taking inspiration from the pagan heritage of barbarian tribes as well as from Gallo-Roman antiquity, which had never been completely forgotten, drawing on Early Christian beginnings, Carolingian experimentation, and Byzantine splendor, it also borrowed time-honored forms from the East, and, dazzled, turned toward the Islamic repertory. Thus, we see the appearance of the vault in Roussillon, the rise of the chevet in Burgundy, the elaboration of the decorated facade in Poitiers, and the origin of the Gothic in the Île-de-France.

With the gradual submission of the great feudal lords at the end of the twelfth and throughout the thirteenth century, the kings once again gained ascendancy, and the Gothic style, born during the Capetian realm, followed the territorial conquests of the monarchy step by step. With the economy, trade, and urban life in full expansion, the Christian kings sought to encourage the faith by founding cities in the name of God. The cathedral, taking over from the monastic art of the Romanesque period, became the principal task of architects. Places of coronation and the sepulchers of kings, they rose to great heights, ever higher at the heart of the city, symbolizing the power of the new monarchy.

Very hardy, Gothic art blossomed for four centuries. In the fourteenth century, first with the popes in Avignon, then with the dukes of Berry and Bourbon in Burgundy and Anjou, it took on the style known as *rayonnant.* In the fifteenth century it evolved into Flamboyant Gothic, whose most remarkable successes may be admired at Rouen and

Paris. The cathedral of Strasbourg, which forms part of another universe, marks the crowning achievement of the style and the end of a world.

Little appreciated or understood in the following centuries, Gothic art did not regain favor until the Romantic period. Architect and architectural historian Eugène Viollet-le-Duc (1814–1879) then oversaw vast restoration campaigns. However, many still hesitated to acknowledge in Gothic art, which they understood as a rational and functional art, the rich symbolic and mystical signification they perceived in Romanesque art. Yet, for the artist of the Gothic Middle Ages, what is rational and functional may also have a mystical and symbolic meaning. Far from being contradictory, science and faith complemented each other. Gothic art invites us to encounter this "great clarity of the Middle Ages" in this time of intellectual ferment and intense experimentation. The people of the Romantic era also had to learn how to rediscover an astonishing mixture of genres, which had disappeared in the art of the seventeenth century. Sculpture, stained glass, manuscript illumination, and tapestry reflect all the aspects of life, and the evocation of exalted spiritual experiences appear next to picturesque or bawdy details. The Gothic building had to offer a summary of the history of the world according to Christian vision, and it does so, presenting simultaneously great and sublime narratives and minor anecdotes. Created to instruct and edify, it does not forget that as a complete work of art it also must please and entertain.

We evoke all these aspects by means of a journey through the provinces of Romanesque and Gothic France in an order that attempts, insofar as possible, to correspond to a development that was as much geographic as historical. The chapters also seek to give voice to a lively history of the provinces and, by concentrating on those works that have been maintained in their original site, to observe the everyday life of the people of the times and the memory of the place.

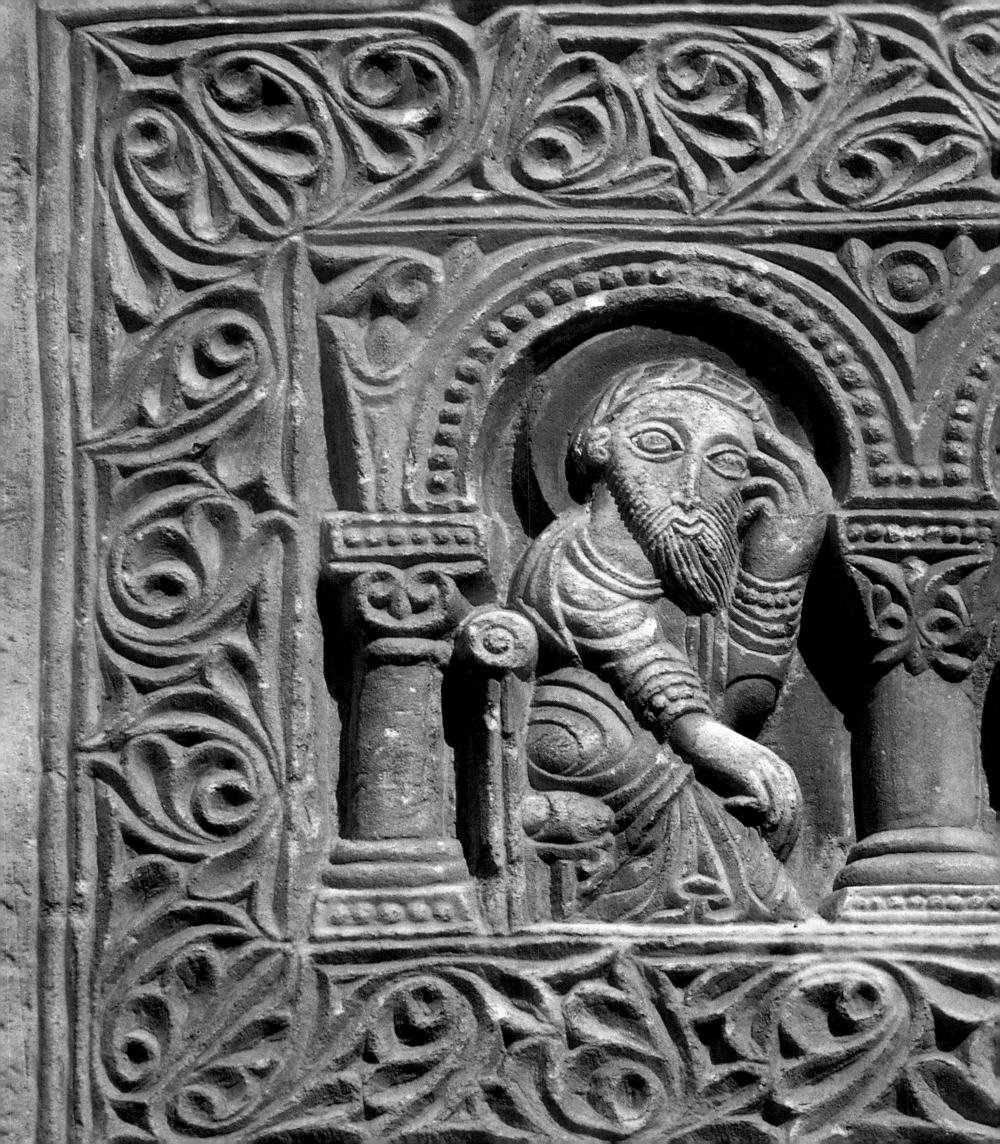

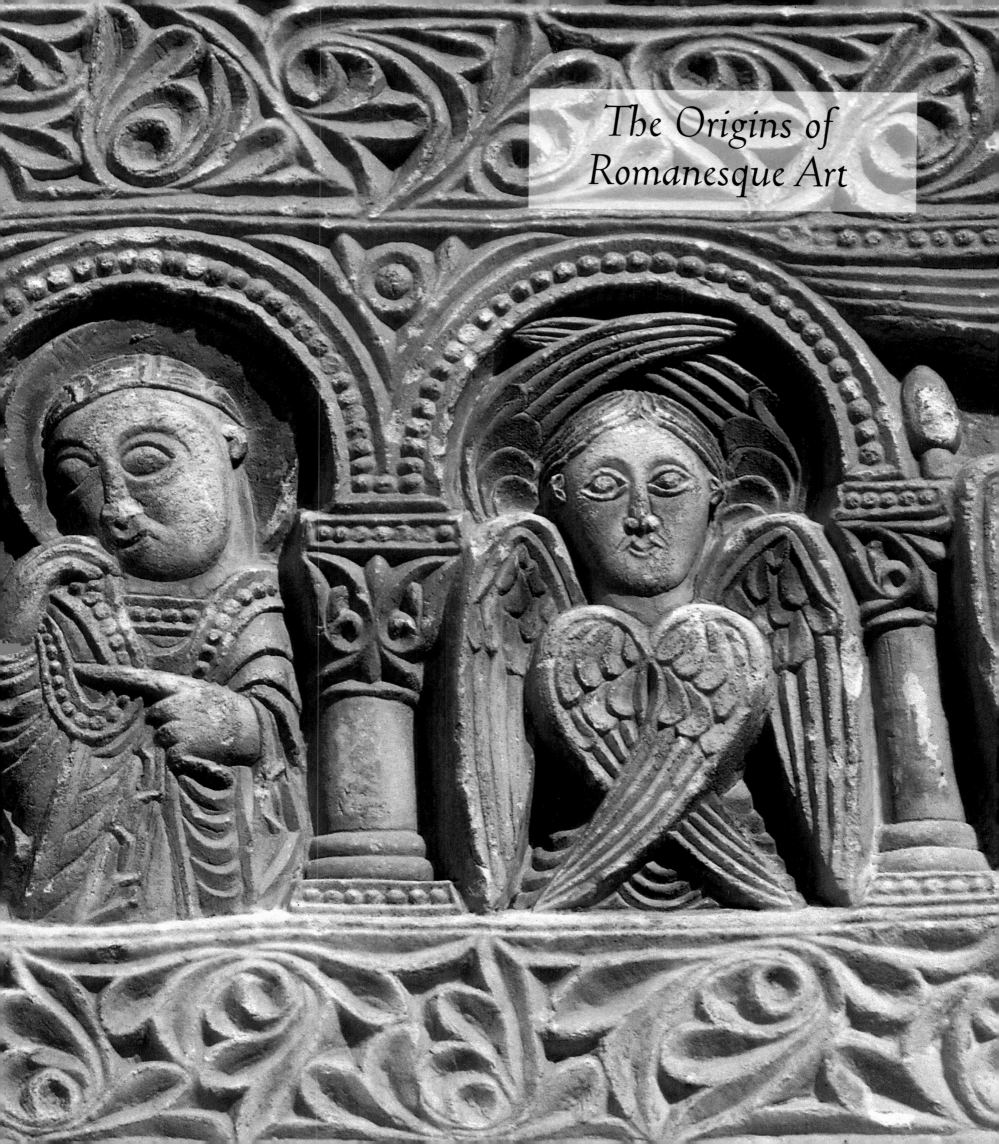

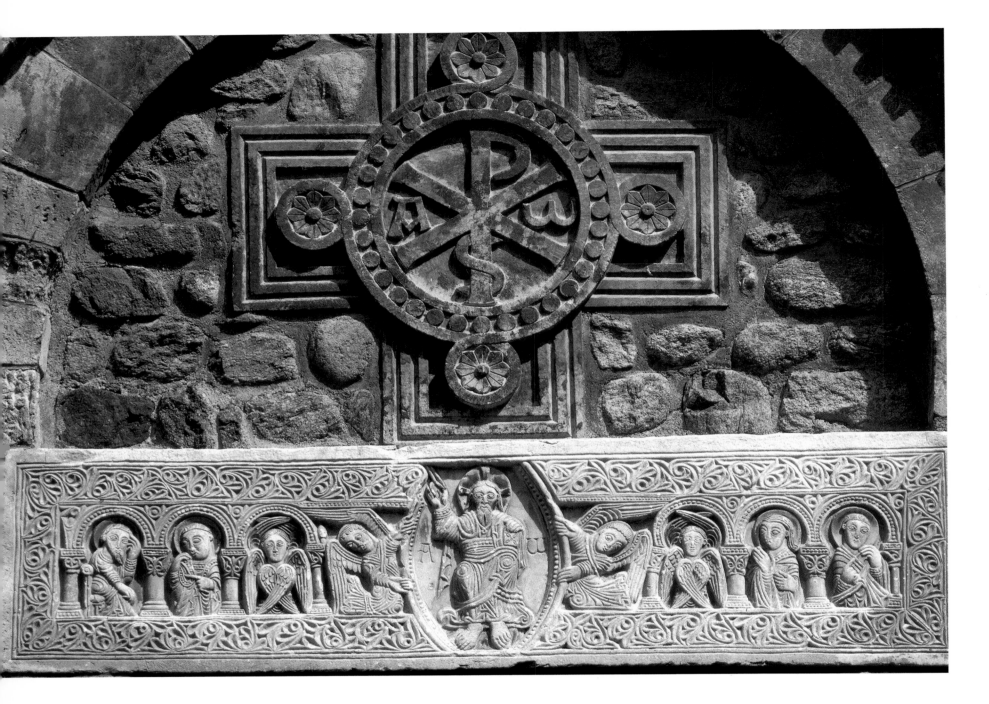

CATALONIA, around the year 1000, following a period of turmoil and insecurity: here, in the arid and wild or green and fertile valleys tucked among its mountains, far from the cities, which were slowly repopulating themselves, far from the counts of Toulouse, far from the king, appeared the first signs of a rebirth—the dawn of Romanesque art.

Catalonia owes its individuality to a strange amalgam of its various pasts: former province of Roman Gallia Narbonensis and ideal link between the Iberian and Italian peninsulas, it then for two centuries formed part of the Visigothic kingdom. It next became part of the territory of Septimania, along with Languedoc; invaded by the Arabs in 720, then freed, it was thereafter the Spanish March of the Carolingian Empire. Inexorably besieged during the tenth and eleventh centuries by the tenacious counts of Barcelona, who in the twelfth century awarded themselves the title of princes of Aragon, it then belonged to the Spanish enclave of Occitania, which extended its power from Provence to Béarn by way of Millau and Foix. This expansion, which the Capetians found so troubling, was finally contained and limited to the north by the Corbières massif. In the thirteenth century, while Languedoc again became French, the region of Roussillon just below it was integrated into Catalonia. In the succeeding centuries, the region's true geographic cement remained its distinct language and culture, which live still, the fruit of multiple vines.

BETWEEN TWO MILLENNIA

The astonishing architectural awakening that took place in Roussillon just before the end of the first millennium is related to an economic and demographic flowering tied to the political context of the time, as well as to a feudal system that was codified early and well established in the region. The true sources of this renewal, however, must be sought in the great spiritual surge that drove the southern part of France.

After the invasions of the ninth century and the decline of the Carolingian Empire, which, while it lasted, had set up new institutions, the tenth century began the slow reawakening of the medieval West. The years surrounding the year 1,000 should not be painted exclusively in the colors of anarchy and drama. In fact, it can be demonstrated that a rich dynamic of changes—agricultural, dietary, and commercial—stimulated the birth of Romanesque culture and hastened its blossoming. Even so, the four generations that saw the end of the first millennium and the beginning of the second lived through singularly dreadful times. Almost everywhere we witness a succession of disastrous weather, barren years, famines, and epidemics that seemed as though they would never end. Under this avalanche of misfortune the people suffered uncomprehendingly or brought old superstitions back to life. The priests preached penitence before what they interpreted as a clear expression of God's wrath.

If these misfortunes were felt so keenly, it was because most of the people led an extremely precarious existence and had no cushion for bad times. As for the so-called terrors of the millennium, we should not picture these as mass panics at the imagined end of the world but rather as a latent dread, an anxiety in the face of the spread of evil "to the four corners of the Earth"—an anxiety whose justification could be found in the holy Bible, in particular, in the book of the Apocalypse, where the arrival of the Antichrist and the end of time are foretold. Although it was written that mankind was living in the last phase of its history since the coming of Christ, no one knew when the end would come; in the meantime, it seemed advisable to work for the greater glory of God.

If infidels were yet to be driven from nearby Spain, where they flourished, the struggle against paganism was also local, for conversion had not yet been achieved in some parts of the countryside, where pagan rites and superstitions prevailed. In this setting, in the face of the adversity of the period the Church became the sole refuge, its saints the protectors who were invoked and whom the faithful were invited to come worship in the place where their remains lay.

THE PEACE OF GOD

Within the security of the bosom of the Church, the monasteries played an essential role. More than the clergy of the towns, the monks who had chosen to live in the countryside were understood by the peasants, from whom they had adopted their difficult life. Isolating themselves in inaccessible sites, they won the admiration of the peasants through their courage, their perseverance, and their inventiveness. By cutting down the trees, clearing, and planting, they made an important contribution to the real change that took place in the rural countryside between the tenth and the twelfth centuries.

Not all monasteries were built far from towns. In the same way that rural monasteries often gave birth to villages, those established outside the town walls often were accompanied by the spontaneous development of prosperous new towns that sometimes overshadowed the original town or, specifically, the original urban nucleus (the town of Saint-Martin at Tours, Saint-Martial at Limoges).

The abbots wielded increasing authority and prestige. Directing with equal ability the temporal and the spiritual, they expanded the original holdings of the abbeys, buying and reselling manors and woods, increasing agricultural production, and ruling a lay workforce, while overseeing the instruction of the monks and the intellectual and religious influence of the monastery as well as a strict respect for the rule.

Southern Catalonia was still, in the tenth century, composed of a checkerboard of small territories. The former officials of the Carolingian Empire—the counts—had appropriated them, first by force, then through inheritance. Although feudalism had existed here since the ninth century, during this period the authority of the lords often came into conflict with the "communities of residents," who vigorously defended their rights, their goods, and especially their lands. When legal disputes began to wane, it was at the expense of the peasants' inheritance, which was being inexorably reduced. The warrior aristocracy, withdrawn into fortresses overlooking their fragmented territories, complicated the establishment of the feudal system, as they were quick to undertake armed raids with savage violence against noble rivals or against the peasantry.

In the face of this danger the movement called the Peace of God, originating in the lower strata of society, found an ally in the Church, itself a victim of the same threat. In Catalonia in the eleventh century, this pacifist movement took the name the Truce of God at the first Synod of Elne, in 1027. It led to the creation in the countryside of "associations of peace," which rapidly came under the control of the high clergy. While order was gradually reestablished, the counts of Barcelona, who had gained control of Catalonia, wrote the first legal code known: the Usatges de Barcelona.

Meanwhile, it had become the custom in Catalonia for those on their deathbed to leave a third of the coming harvest either to a church or to a monastery. Often, a plot of land was left "to God and his saints." This act, which could endanger the very subsistence of the family, led to the erosion of the peasants' small properties while reaping a fortune in chattels and land for the Church. Alms, it was understood, were bequeathed to aid in the salvation of the deceased's soul, but in the tenth century their use was left to the discretion of the monks or the bishop—to go for charity, for the upkeep of the clergy, and especially for the restoration or the construction of religious buildings.

SAINT-MICHEL-DE-CUXA, CLOISTER, C. 1040
The original abbey had little sculpted decor. In the eleventh century the artist who created the largest of all the Romanesque cloisters in Roussillon reworked some of its capitals with plant and zoomorphic designs exclusively.

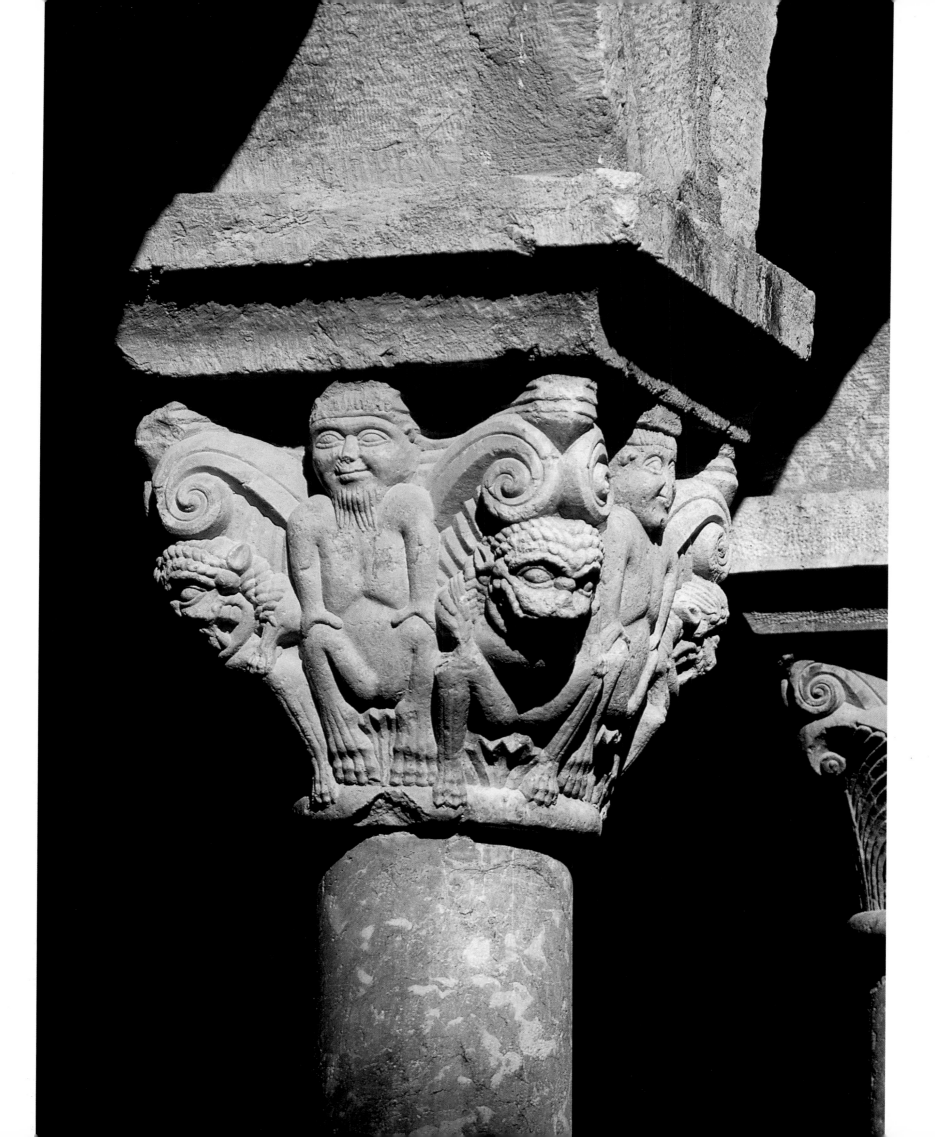

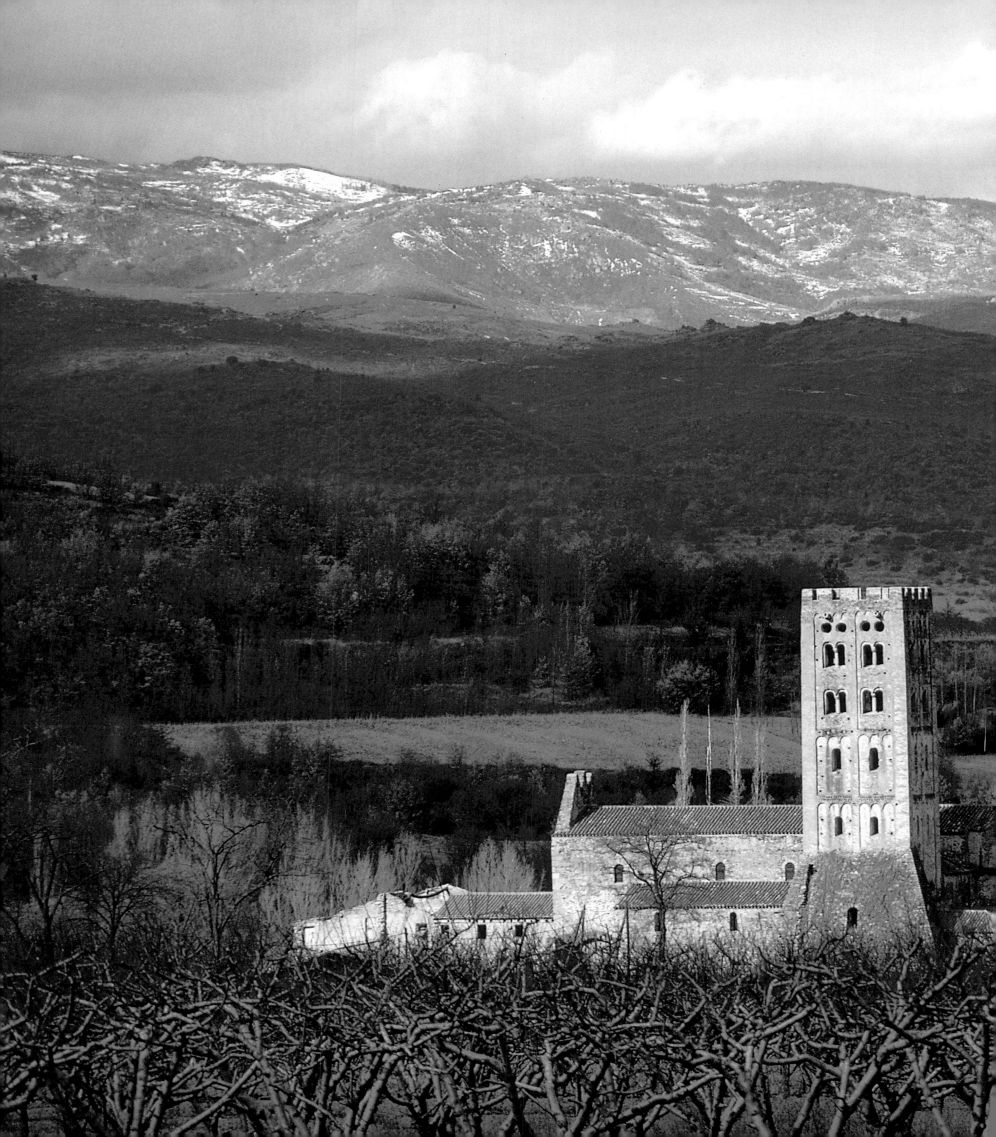

Thus, the churches of the Romanesque Middle Ages sprang up.

IN SEARCH OF A NEW LANGUAGE

In the Mediterranean regions of Europe in the tenth century, two very different centers stood out: northern Italy and Catalonia. These two radically different areas had in common the sea, the legacy of Roman antiquity, and the fact that they had both had contact with or been on the frontiers of influential civilizations: for Italy, Byzantine art; for Catalonia, the traces of the Visigoths, the Carolingians, and Islam. Having benefited from this exceptional conjunction of influences, the latter region became the catalyst through which the evolution of new architectural forms became inventive earlier than elsewhere. Curiously, while the influence of Lombardy also reached as far as Catalonia, as well as Burgundy and the middle Rhine, two regions in the natural paths of communication proved resistant: Provence and the Rhone valley. Poor in examples of early Romanesque art, they blossomed in a later style.

The buildings of the Catalan High Romanesque offer a charming contrast between rustic walls and majestic church towers, set off by isolated, wild, and stirring sites like the valley of Saint-Michel-de-Cuxa or dramatic sites like the aerie of Saint-Martin-du-Canigou. These abbeys of Roussillon, formerly very powerful, were built far from the cities, in the heart of a natural environment still unsullied by human establishments, well suited to meditation. The mystical atmosphere of these places remains affecting for the visitor despite the vicissitudes suffered by these monuments. The abbey of Saint-Michel-de-Cuxa—like the other buildings of Roussillon, with the exception of the cathedral of Elne—saw its cloister dismantled and its capitals dispersed, only to be reconstituted, in the first quarter of the century, in glorious and distant exile in the Cloisters Collection of the Metropolitan Museum of Art in New York, which also possesses the cloistral remains of Saint-Guilhem-le-Désert, Bonne-font-en-Comminges, Trie-en-Bigorre, and Froville. Since then, this great family of churches has been the object of attentive care and patient restoration, for it recounts, in its simplicity, an important page in the history of architecture, where we see the first stirring experiments by their builders in search of a new language.

ROUSSILLON, OR THE REDISCOVERY OF THE VAULT

An exponent of Romanesque art until the thirteenth century, the region of Roussillon experienced an evolution of its architectural forms in three stages. The first, and the most authentically original, centers around Catalonia and its oldest buildings, going back to the first half of the tenth century. Marked by Visigothic, Carolingian, and Iberian Islamic influences, this pre-Romanesque period, rich in innovations, saw its creative vigor supplanted by the arrival of an Italian style from Lombardy in 950. In the course of this second phase, buildings took on the forms, and especially the decoration, of the First Romanesque style from the south, which continued to develop throughout the eleventh century. These elements disappeared with the introduction, before 1100, of the Cluniac style, which characterized the mature Romanesque. As for Mediterranean Languedoc, which had previously resisted Catalan influence, in the twelfth century

SAINT-MARTIN-DU-CANIGOU, CHEVET OF THE UPPER CHURCH OF THE ABBEY CHURCH, 11TH CENTURY
Composed of three clustered apses, the chevet is dominated at the north by an imposing tower—originally higher—articulated by Lombard bands and two levels of bays. This square tower harbors a chapel dedicated to Saint Michael. The entry to the monastery, which opened at its base, was thus symbolically under the protection of the archangel.

Preceding pages
SAINT-MICHEL-DE-CUXA, ABBEY, 10TH–11TH CENTURIES
The elegant crenellated bell tower at the southern end of the transept and the loss of its twin on the northern end symbolize the vicissitudes suffered by the great institution governed by the abbots Garin and Oliba—and, indeed, the other High Romanesque buildings in Roussillon.

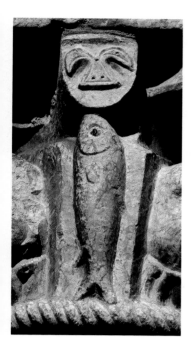

SAINT-MARTIN-DU-CANIGOU, DETAIL OF A CAPITAL IN THE ABBEY, C. 1150
The fish is one of the most ancient Christological symbols, going back to the Early Christian era. The letters of the Greek word for fish, ichthus, *form a rebus of the phrase "Jesus Christ, son of God, savior." In spite of the disappearance of Greek from the Roman church this sign lived on, representing the sacrament of baptism or Christ, the mainstay of the Church. The symbols of Early Christianity are numerous in the Pyrenees.*

THE REDISCOVERY OF THE VAULT

Abandoned by the first Christian architects in the desire to repudiate the pagan architecture of the Romans, who used it for certain temples and in the construction of baths, the vault was long rejected in favor of timber-roofed basilicas, with the exception of central-plan buildings. It returned to use in the West during the Carolingian period, when some of its techniques were mastered, as illustrated by the group of vaults built for the Palatine Chapel of Charlemagne at Aix (Aachen) about the year 800. In the main, however, the rediscovery of the vault proceeded cautiously during the ninth, tenth, and eleventh centuries. The transition from wood to stone was accomplished by stages: first the crypt, then the apse, the porch, and the aisles, until the architects dared to span the nave.

it belatedly embraced a return to the influence of Lombard forms by way of Catalonia.

While it is important not to overestimate the innovative importance of proto-Romanesque Catalan architecture, it must nonetheless be admitted that it inspired a fresh understanding among the original builders that has turned out to be critical for the renaissance of European architecture. Their experiments led, with a surprising rapidity, to a new way of thinking about ecclesiastical volumes, clearly distinct from the traditional paleo-Christian basilica—the hall church. This new design looks like a "simplified" basilica, retaining only the principle of nave and two aisles separated by two rows of arcades. The many churches of this type in Roussillon have a stocky and very simple appearance: made of four walls of medium-size rubble masonry, originally whitewashed, they are covered with a saddle roof. Unlike traditional basilicas, whose elevation presents a central space that is higher than the aisles, hall churches emphasize their essential difference by the equal height of the nave and aisles (or by its illusion when they are not exactly the same height). Light penetrates these structures only indirectly, through small arched windows that pierce the aisles, leaving them in relative darkness. Generally lacking a transept, they open to the west through a single entrance and are closed to the east with a chevet with three parallel apses.

The arches of the apses often have a horseshoe-shaped profile, which reveals a borrowing from Visigothic art. The *arco ferrada*, or horseshoe arch, drawn from the architectural vocabulary of Asturia, is often found in southern Catalonia; it gives the arches of the nave and aisles an individuality that persists rather late into the tenth century, without, however, extending beyond local limits (Saint-Martin-de-Fenollar, Saint-Michel-de-Cuxa).

In Catalonia the builders concentrated on vaulting early on. The most obvious reason for this lay in the pressing need to reduce the danger of fire, which could ravage a building's wooden frame. Starting in the second third of the tenth century, Catalonia produced entirely vaulted structures. The nave and the aisles were covered with three parallel and continuous barrel vaults, which, in supporting one another, exerted a considerable thrust that was absorbed by the thickness of the exterior walls (Santa Maria d'Amer in Spanish Catalonia and Saint-Martin-du-Canigou in French Catalonia). The continuous barrel vault, inspired by Roman models, was also used for aisleless churches. Improvements in the masonry fabric tended to lighten it, thereby reducing the danger of collapse. Toward the end of the century banded barrel vaults were introduced; the transverse arches crossing the vault constituted a real skeleton of stone that consolidated the whole and divided the space of the nave into bays (Saint-André-de-Sorède). This advance would not have been possible without modification to the supports of the nave; the simple pillars or columns were henceforth accompanied by piers and lost their square or round profile to become cross-shaped in order to receive the springing of the ribs; divided piers of engaged columns became especially widespread in the eleventh century.

Important because of their later popularity was the introduction of square towers to the west facade just before the year 1000, followed by their spread the following century (Arles-sur-Tech). For those eleventh-century churches that had a transept—in Catalonia, usually a low transept of the Carolingian type—square towers were built at the ends of the transept arms (Saint-Michel-de-Cuxa). Octagonal towers, on the other hand, arose from the transept crossing and spread on the Iberian side of the Pyrenees (San

Sadurní de Tabérnoles; San Vincenzo de Cardona). Stocky in appearance, surmounting a cupola set on squinches, they are doubtless descended from the first chevet towers of Merovingian basilicas and prefigure the great achievements of the French Romanesque in its maturity. The octagonal tower of the transept crossing crowns the success of the most important principle developed by Romanesque architecture: that of the church divided into distinct volumes, according to a pyramidal progression. This idea had been explored earlier in the east, as in Armenia; it would refine the chevet developed by Cluny.

THE GREAT MONUMENTS

At Saint-Michel-de-Cuxa, the most prestigious of the Benedictine monasteries in Catalonia, founded in 878, enlargements and modifications were undertaken at the beginning of the eleventh century on the old edifice, which had been built between 955 and 974 under Abbot Garin, who came from Cluny. The church was already large by the beginning of the tenth century; the nave measured 30 by 100 feet (9 by 30 meters). Covered by a wooden roof, it led to a rectangular apse of the Carolingian type. Most of the arches were horseshoe-shaped, notably those in the nave that opened onto the aisles, revealing an Islamic influence also seen in the famous contemporary abbey of Ripoll in Spanish Catalonia. The transept, which is very long, has four absidioles; when towers were added in the eleventh century, the arms were truncated. The abbey experienced its apogee in the first half of the eleventh century under Abbot Oliba, bishop of Vich, a founder of the Truce of God and a great builder who enriched the Catalan style while giving free rein to Lombard and French influences. At Cuxa the horseshoe arches, while no doubt slightly modified, still exist. But the gradual stylistic development is discernible: innovations only affect the ends of the building. The quadrilateral apse is surrounded by an ambulatory of the same shape, which ends in three parallel semicircular apses, although only the north apse was built at the time, the others being later. The most remarkable addition is in the western part of the church, where a sanctuary in the form of a rotunda is set out on two levels. The underground hall, consecrated to the Virgin, is accessible by means of two lateral corridors and extended by an apse on the axis of the abbey. The

audacious circular barrel vault rests on a single large, central stone pillar). This arrangement, conceived in the Carolingian spirit, is strikingly similar to the circular chapel of Sankt Michael of Fulda, Germany, built in 822 in imitation of the Holy Sepulchre in Jerusalem, or again to the rotunda of Saint-Bénigne of Dijon, designed several years before that of Cuxa by the Lombard Abbot William of Volpiano. Of the two rugged square towers of the transept only one still stands today, contrasting in its bold proportions with the simplicity of the abbey. Probably built by Abbot Oliba, it was nonetheless part of a later building campaign, indebted to Lombard influence in its ornamentation. Subtle in its effect, the ornamentation articulates the tower with lesenes (projecting vertical strips resembling pilasters without base or capital), lending it a continuous vertical thrust, while the different stories are marked by triple blind arcades and openings that become gradually larger as the tower rises higher.

The abbey of Saint-Martin near Cuxa, set not at the foot of the 9,135-foot Canigou peak but suspended from its slopes, is the creation of Abbot Oliba, who sent some of his monks to live there, at an elevation of 3,500 feet (1,094 meters), far from the outside world. Although many famous sites have been disfigured by the march of modernity, at Saint-Martin time has stood still, and the ascent of the rock is as laborious as it was nine centuries ago. We must toil up the slope with the same humility that filled Count Guifred, brother of Oliba, when he dug his own tomb in this place.

After Saint-Michel-de-Cuxa, which constitutes a link between the Carolingian past and the infancy of the Romanesque period, Saint-Martin-du-Canigou, as the oldest example of the First Romanesque in Catalonia, represents the next link in the architectural chain. Here, for the first time in the region, split-face stone masonry with a Lombard articulation makes its appearance.

The upper basilica presents a nave twice as high as its flanking aisles; nonetheless, on entering the building the visitor has the illusion of a hall church, as the blind walls of the nave seem to contain the interior volume in a single axis. Light enters through the ends only, so that openings would not weaken the walls of the nave, and also because the darkness that reigns here was appropriate to the monastic liturgy. The harmonious whole is simultaneously archaic and auda-

CORNEILLA-DE-
CONFLENT, APSE,
12TH CENTURY
Built from large blocks of granite, the transept and apse play off the contrast between the simplicity of the walls and the mature Lombard decoration that covers the embrasures of the windows and the arcades under the cornice, interspersed with sculpted modillions, monsters, and masks.

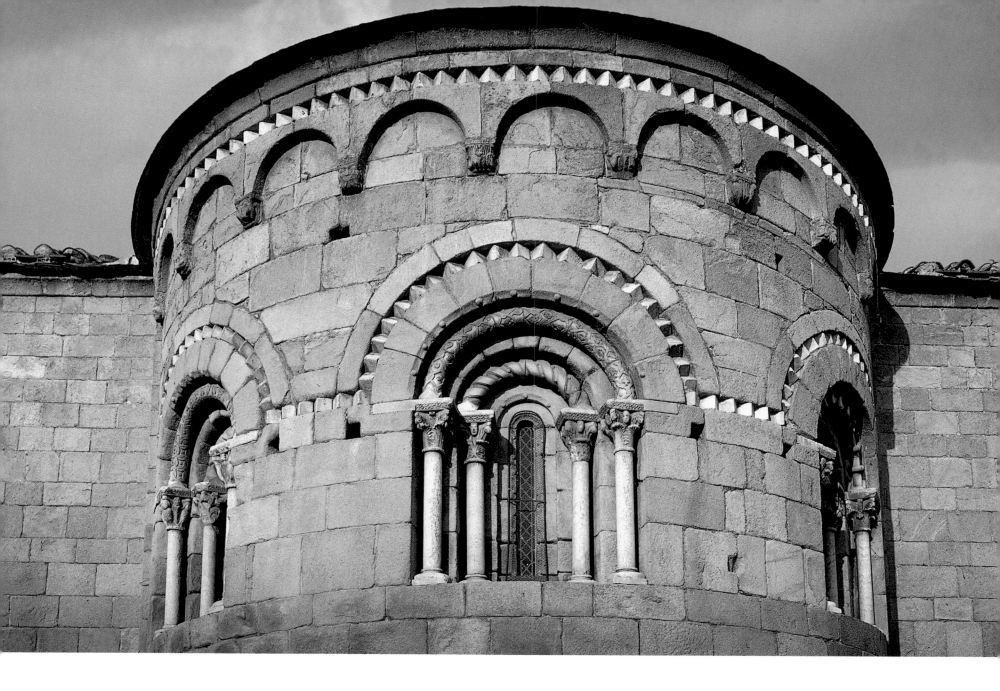

THE LOMBARDS IN CATALONIA

— ● —

After the decline of the Roman Empire, northern Europe suffered a severe shortage of capable stone workers. This led to the employment of Lombard workers in the ninth and tenth centuries, who came from a country with an ancestral heritage still intact. About the year 1000, at the moment of the architectural awakening, demand for their services increased. The establishment of a Lombard workshop in a region often led to the training of a local workforce, which ensured the subsequent spread of the style. Working for the counts of Barcelona and the powerful abbeys, Lombard masters left the imprint of their style at the heart of the local architectural traditions of Catalonia, which became a remarkable open-air museum of the First Romanesque in southern Europe. Extending a building technique that appeared at the beginning of the ninth century, they were quickly welcomed into the masons' trade through their distinctive talent for shaping stone.

The Lombards notably replaced rubble masonry and the pre-Roman herringbone-pattern courses (opus spicatum) with a technique of split stone, rough-hewn with a hammer (opus gallicum), a finished look of great solidity that sought to imitate the appearance of oblong Byzantine bricks, laid regularly in a horizontal plane. Stones that were too irregularly shaped were laid in horizontal courses inclining first in one direction, then the other, with several courses intervening, breaking the monotony of the whole.

Architectural decoration became a hallmark of the Lombard style. Projecting vertical strips known as lesenes, first used alone, were then linked by thin arched double or triple arcades, thus forming the famous Lombard bands, which covered the perimeter of the building. The repetition of this design gives life to the slightly rough walls, endowing it with a sense of verticality and balance.

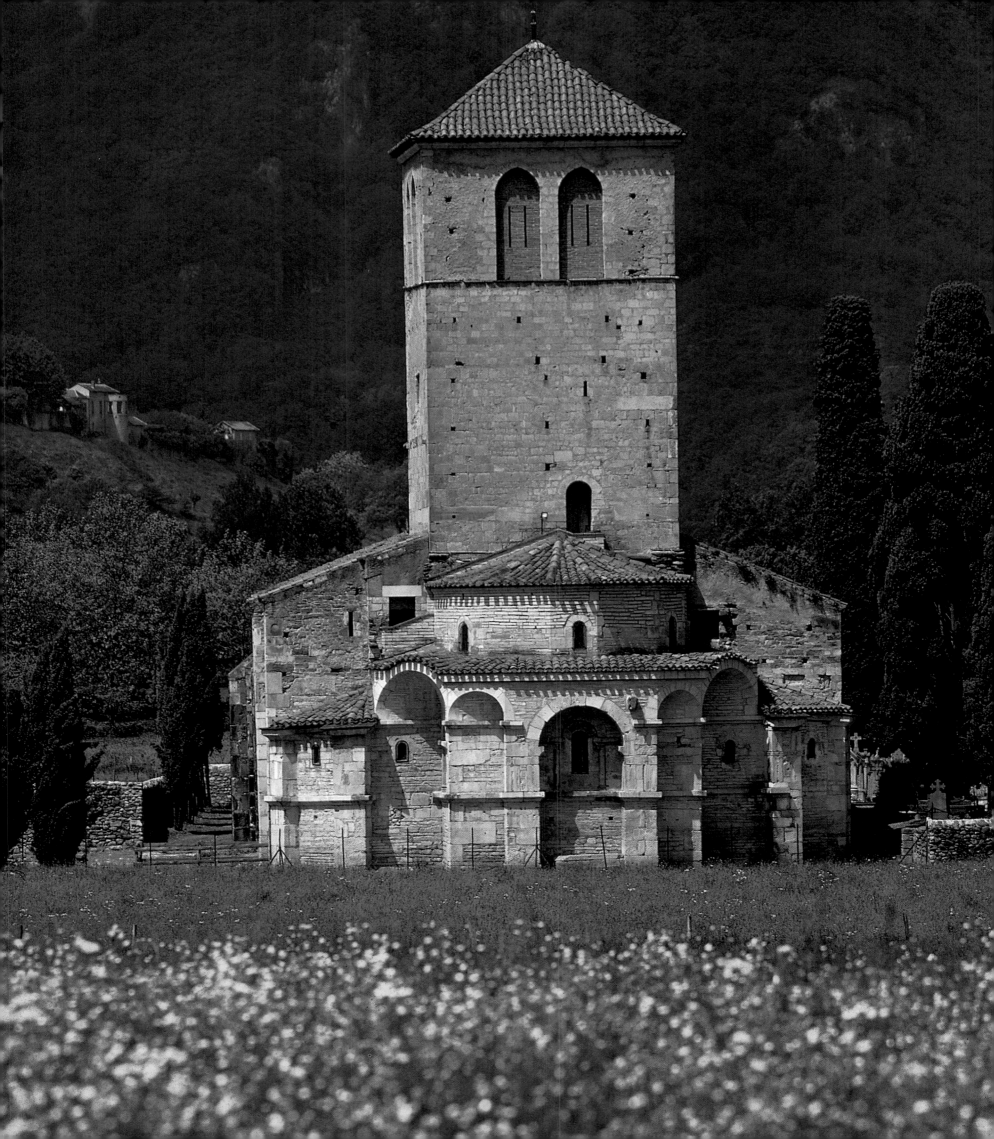

THE CRYPT

———•———

The crypt, which appeared early on in Christian architecture, was especially important in Carolingian basilicas, where it sometimes took on considerable proportions. Directly linked to the cult of relics, which intensified in the eleventh century, it was first conceived as a confessio, *with a passage that allowed the pilgrims to circulate around the sarcophagus and, later, around the reliquary. Often built at the two ends of the church—one at the east, the other at the west—in the ninth century, the crypt ended up under the eastern chevet and, as it communicated directly with the chevet, greatly contributed to the decision made in the tenth century to concentrate liturgical life at the eastern end of the church. Sometimes it even took on the outlines of the choir to give its foundation a better footing.*

SAINT-JUST-DE-VAL-
CABRÈRE, CHEVET,
11TH–12TH CENTURIES
In the shadow of the imposing cathedral of Saint-Bertrand-de-Comminges, the delightful church of Saint-Just-de-Valcabrère, surrounded by fields and cypresses, presents an unforgettable image. Built in part of materials salvaged from Gallo-Roman ruins, the monument displays its originality in its chevet, pierced with hollow niches that powerfully articulate its form.

Overleaf
SAINT-GUILHEM-LE-
DÉSERT, ABBEY
CHURCH, CHEVET,
LATE 11TH CENTURY
Although the "Desert" (wilderness) of Gellone no longer exists, the site is still dramatic, and Saint-Guilhem is the most beautiful example of the First Romanesque in Languedoc. The large chevet was built to accommodate the popular pilgrimage to the confessio *of Guillaume d'Orange, warrior hero of an epic poem. Judging from its unusual diameter (40 feet, or 12 meters), the apse was no doubt intended to receive an ambulatory, which was never built.*

cious: the three continuous barrel vaults merge into the walls following an old Byzantine formula, yet they present a good early example of the vaulting of an entire church, unlike Saint-Michel-de-Cuxa, which was originally roofed in wood. The great arcade of the nave rests on ten monolithic columns designed for wood-framed basilicas—not very suitable for this kind of very heavy vaulting, which calls for more elaborate supports. This makeshift construction reveals the first experiments of architects in search of new formulas.

The vast semisubterranean basilica of nave and flanking aisles, which serves as a crypt, is the most interesting structure in the abbey, for it clearly demonstrates a rapid evolution and the appearance of Romanesque principles: the groin vault of the eastern part of the structure cohabits with barrel vaults used in the western part, here provided with transverse ribs carried by pillars on piers. Like many "underground" sanctuaries, this crypt is dedicated to the Virgin Mary, long venerated here in the form of a statue (stolen in 1976). Other regions, including Auvergne, furthered the cult of Mary in these dark places.

With the improvement in architectural techniques came the enrichment of the articulation of the walls. At Corneilla-de-Conflent, the last residence of the counts of Cerdagne, the square-towered church was decorated in the twelfth century with a portal of six marble columns, while the chevet was emphasized by a sawtooth decoration, colonnettes, capitals, and arches framing the windows of the apse. Some of the pink marble so often seen in Roussillon was quarried near Villefranche-de-Conflent. Marble, whose use accompanied a return to monumental sculpture, was above all the preferred material for liturgical furniture, employed for many alter slabs and baptismal fonts (such as a large font at Villefranche).

Roussillon's large and small monuments vie with each other in idiosyncracies and new designs. Thus, novel designs were undertaken in the realm of building plans: the abbey at Saint-Jacques de Villefranche has two naves, while at Vals they are superimposed; at Planès, the oddest of churches, the architects compromised between a plan based on the equilateral triangle and a trefoil to symbolize the Trinity. The vaulting of Roussillon's monuments also shows diversity: at Corneilla-de-Conflent and at Elne the aisles are semicircular barrel vaults; at Saint-Pierre-de-Ruiferrer, the nave is covered by a pointed barrel vault, as at Arles-sur-Tech (1046), the only example in Roussillon of a church that faces west. Here, a second building campaign removed the wood framing to install soaring barrel vaults 55 feet (17 meters) high, oddly pierced with windows and held up by supports with joined buttresses. As at Coustouges, the side chapels of the apse are vaulted with clumsily constructed ribs and roll moldings.

On the whole, the master builders of the eleventh century adopted a composite roofing system. For example, at Saint-Eulalie in Fuilla, the barrel vaults of the nave coexist with the groin vaults of the aisles.

MEDITERRANEAN LANGUEDOC

Closer to the sphere of influence cast by Toulouse, Lower Languedoc experienced a much less stable political situation. The ancient Roman road of Domitian runs through the region, and in the eleventh and twelfth centuries the lands around each road crossing ended up in a tug-of-war for possession among the French, the Aragonese, the powerful Trencavel family, which served the count of Toulouse, and the small local potentates who jealously guarded their rights.

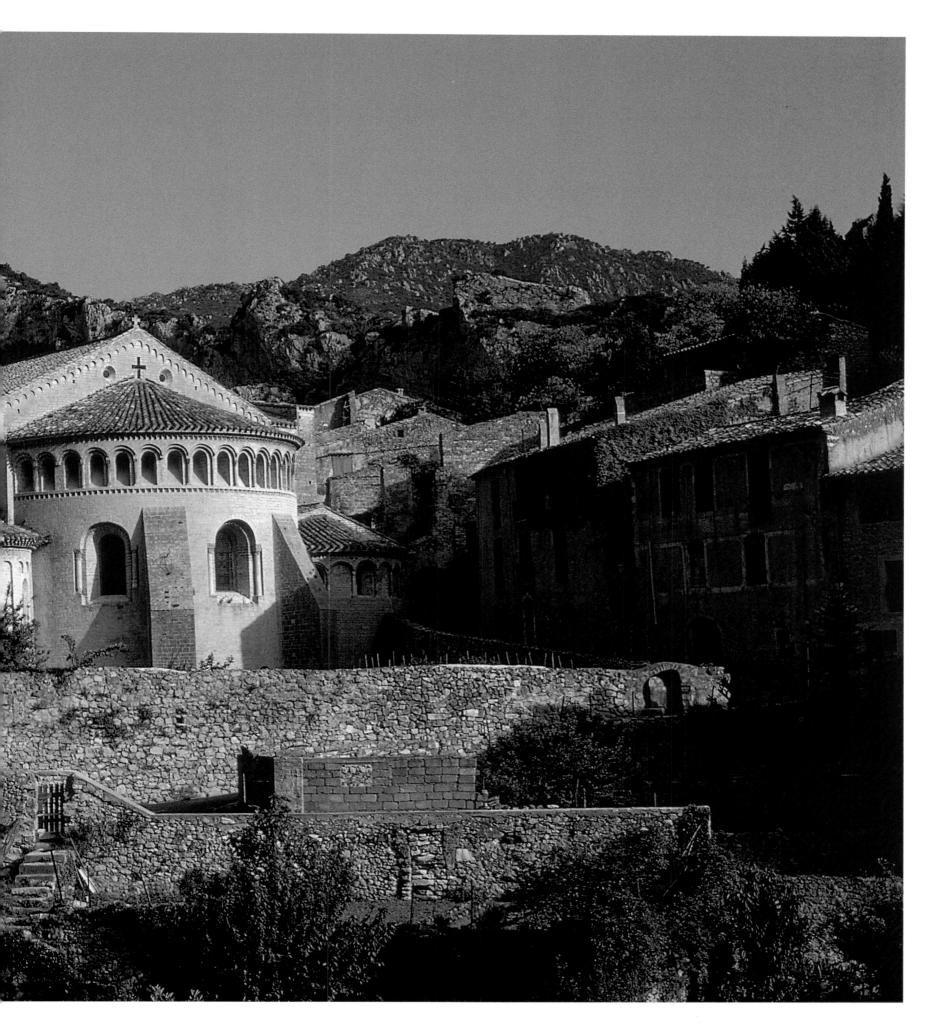

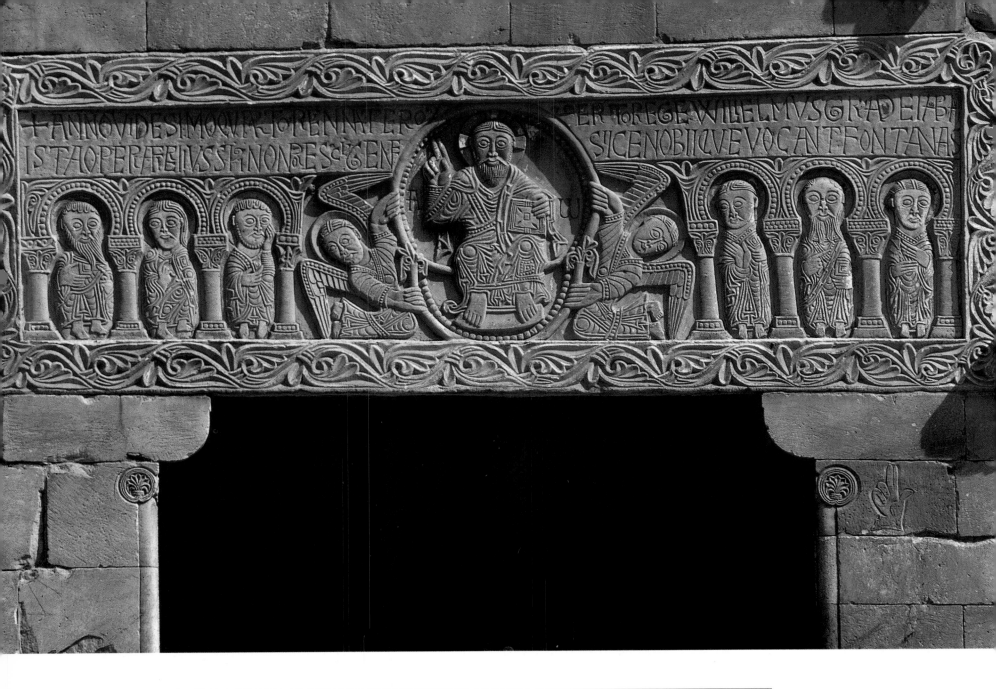

MONUMENTAL SCULPTURE

———•———

Monumental sculpture was not an original feature of Romanesque architecture. It came into play when a new conception of the church was established, that of a unitary whole in which the act of construction and the act of sculpture went together. At the beginning of the eleventh century, monumental sculpture made its appearance in order to emphasize, in an initial phase, the structural lines of buildings, through the use of repeating geometric motifs or the articulation of walls with a stylized vegetation, whose aesthetic effectiveness is amply demonstrated in the First Romanesque buildings in Roussillon, where it was introduced.

The attitude toward decoration changed suddenly when its purpose shifted from the ornamental to the didactic, becoming the bearer of a theological message. It was then necessary to find a space to illustrate the Scriptures and the great concepts of faith and morality. In Roussillon the lintel of the entrance portal became the most important artistic medium. Throughout the Romanesque period, sculpture gained in importance as it remained linked to architectural forms that it followed, the better to embellish them, and, however didactic it became, never forgot its ornamental power. This explains how Romanesque sculpture escaped the impulse toward realistic images, the better to retain the mystery proper to its sacred message. Its anthropomorphic, zoomorphic, and plant shapes became the object of metamorphoses that shrouded them in ambiguity and gave the viewer the illusion of reading a double image—a figurative image of obvious symbolic significance and a plastic image with an independent and no less important role.

Stylistically, Lower Languedoc is related to Catalonia, and it welcomed, although belatedly, the forms of the First Romanesque.

The former abbey of Gellone, Saint-Guilhem-le-Désert is the first eloquent illustration of this artistic propagation. Built in several stages, in an unforgettable site among rocks that lives up to its name, this superb monastery reveals the full repertory of the Italian masons who came for the first stage of construction (about 1030?): masonry of small, split-face stone and Lombard bands distributed irregularly. The interior shows that the techniques of the First Romanesque had had time to become more refined: three series of banded barrel vaults, made from lighter material (tufa), are supported by compound piers; the elegantly proportioned nave, soaring and luminous, designed to be taller than the aisles, following the traditional basilical elevation, is lit by a play of small openings pierced east and west.

The broad chevet, constructed in the second building campaign, is composed of a large apse communicating with two smaller parallel absidioles linked to the transept; the crypt is housed under the apse. The design that articulates the chevet is a product of the First Romanesque brought to maturity: the Lombard bands of the southern apse change into molded arches on colonnettes in the northern apse, then, in the center, into niches below cornices with reused ancient columns and delicately sculpted flat capitals carved with the stylized vegetation that characterizes Lombard ornamentation.

A mighty bastion of Christianity facing Islamic territory, Saint-Guilhem illustrates, along with its fellow monasteries in Lower Languedoc, the First Romanesque in the service of Benedictine monasticism, which had extended its domains, notably to Corbières. The abbey of Legrasse and the apses of Saint-Polycarpe and Saint-Pierre-de-Rhèdes were clearly influenced by the Lombard style, as were the churches of Quarante and Saint-Martin-de-Londres (Loudro) farther east. The latter, with a trefoil plan, is surmounted by an octagonal drum of the Catalan type, containing a cupola recalling that at Frontanvà in Spanish Catalonia. Unique in Languedoc is the church of Rieux-Minervois, with a plan based on a fourteen-sided polygon—circular on the interior—and a heptagonal bell tower.

Simultaneously, another local style developed that revived a classical vocabulary and demonstrated familiarity with Provençal elements. The ruins of the abbey d'Alet offer a different kind of scene: the broad semicircular apse, neatly built in freestone, in the rhythm of its narrow niches recalls the buildings of antiquity. The carved decoration is also distinct; the vocabulary used here comes from Roman monuments, whose remains were numerous in the south of France. Similarly, beading, ovolo moldings, and acanthus leaves adorned the thick cornice of the apse of Saint-Jacques of Béziers, whose canted shape comes from Provence. This style is an example of the last phase of Romanesque architecture in Languedoc; it assured the transition to the late arrival of Gothic forms, in the thirteenth century. The churches of Saint-Pons-de-Thomières, Saint-Étienne of Agde, Saint-Pierre of Maguelone, and Saint-Nazaire of Carcassonne are all examples of the aisleless church with a pointed barrel vault built at the end of the twelfth century.

DISTANT VALLEYS

In the churches of La Bigorre, Comminges, and Couserans in the central Pyrenees, no architectural unity can be found. Some of the stones used in the masonry of these buildings come from ancient sites, as at Saint-Lizier, Saint-Aventin, or Chapelle-Saint-Pé, in whose walls are included fragments of pilasters and small Gallo-Roman funerary monuments. The paleo-Christian tradition persisted in these remote valleys, where we see sculptural representations of lambs, doves, and fish, which date back to the beginnings of Christian iconography.

Whereas the apse of Saint-Lizier changes from the pentagonal plan to the circular plan, the chevet of the basilica of Saint-Just de Valcabrère is unusual in that it is hollowed out by niches that create a rhythm of voids. Nearby stands the cathedral of Saint-Bertrand-de-Comminges. Its cloister, through whose arcade the mountains are visible, opens to the exterior through an unprecedented design. The beautiful capitals and the pillars sculpted with the four Evangelists lend the spot a rare poetry.

THE RETURN OF THE RELIEF

Although it is useless to try to fix a chronology for the establishment of the first Romanesque sculpture in

SAINT-GENIS-DES-FONTAINES, LINTEL OF THE ENTRY PORTAL, MARBLE, 1019–20
The Latin inscription precisely dates the execution of this work to the twenty-fourth year of the reign of Robert the Pious. The lintel slightly predates that of Saint-André-de-Sorède. Unlike the latter, its disposition in the facade does not correspond to its original placement; it is perhaps a piece taken from an altar. The frieze-like composition, still with very shallow engraving, subjects its figures to the law of the frame more than does the one at Saint-André. The Apostles become human arches, while the angels spread their wings to the extent of the space available.

France, we know that several centers simultaneously opened the way to distinct styles that were nourished by various cultural traditions. Roussillon was a melting pot where Visigothic, Mozarabic, and Byzantine influences met and created, by the tenth century, a decoration of repeated plant themes and interlacing geometric forms. A noticeable change developed in this region during the first third of the eleventh century, visible in the marble sculptures on the lintel, tympanum, or framing of the windows of several churches. At Saint-Genis-des-Fontaines we find the oldest piece of Romanesque sculpture (1019–20), which integrates an iconographic program into the architecture. The oblong marble lintel, dated by its long inscription, shows Christ in Glory in the center, surrounded by a mandorla borne by two angels, and flanked by apostles linked together beneath horseshoe arches.

The relief is still very shallow, hardly more than engraving, and is related to flat Visigothic sculpture. The highly compartmentalized nature of the composition—the outline of the apostles is married to the arches—and the care accorded to the decorative frieze that frames it recall the lesser arts, such as ivories or repoussé gold objects, as a possible stylistic source. An eschatological vision is also represented on the lintel of Saint-André-de-Sorède, created by the same artisan who worked at Saint-Genis shortly before. The composition is similar, almost to the detail: Christ in Majesty appears enthroned in eternity, symbolized by the alpha and the omega. In both cases, the formal and thematic evolution is apparent. At Saint-André-de-Sorède, the design is already better rendered. At Arles-sur-Tech (1046) we find a saddleback tympanum with more ambitious iconography: the theophany appears within the framework with a Greek cross, linked to four medallions enclosing the tetramorph—the four symbols of the Evangelists—a theme long familiar in illumination and which we see here, at Roussillon, in a first rough version as a sculpture.

The ravishing gallery of pink marble of the priory of Serrabone, doubtless created in the twelfth century, displays capitals of Lombard influence like those of Saint-Michel-de-Cuxa. At this time cloisters grew more common. The first victims of the mutilations that took place in the nineteenth century, their beautiful capitals have most often been scattered. Although the former cathedral of Elne did not lose many of its capitals, its upper story was sold at auction. It still has a south gallery, sculpted in the twelfth century by local artists. They had a preference for plant motifs and animal forms, which from this point became prominent in decoration.

Romanesque sculpture long persisted in Roussillon and Languedoc. It achieved its prime between 1150 and the beginning of the thirteenth century. Roussillon, which developed influential workshops, in its turn absorbed elements disseminated by the abbey of Ripoll (which still bears one of the most beautiful sculpted facades produced by Romanesque art) and turned to its use currents from Italy and Toulouse. The last Romanesque productions are marked by a strong classical influence. The beautiful tomb of F. du Soler in the cloister of Elne created by Raymond de Bianya about 1200 presents drapery with small parallel folds, in the spirit of the works of the late Roman Empire. Provence, as well as the Cluniac expansion in Languedoc, played a role in the introduction of an ornamental vocabulary that imitated Roman art; fine Corinthian capitals, which may be seen in the apse of Alet, demonstrate the refinement offered by late Romanesque sculpture in the region.

From Illumination to Wall Painting

Catalonia is rich in churches with painted decoration. For the most part, they are concentrated in the northwest. The greatest part of this heritage today lies in Spanish territory; it includes the well-known paintings of San Clemente de Tahúll, Santa Maria de Ginestarre, and La Seo de Urgel. The French side of the Pyrenees boasts those of Saint-Martin-de-Fenollar and of L'Écluse. This painted decoration discloses a tendency toward stylization of form in its use of dark out-

CABESTANY, TYMPANUM (REMOVED) SHOWING THE DORMITION AND THE ASSUMPTION OF THE VIRGIN, C. 1170
The very particular style of this anonymous master fully illustrates the stylistic interaction between Tuscany and Christian Spain that Catalonia, cradle of the artist, crystallizes.

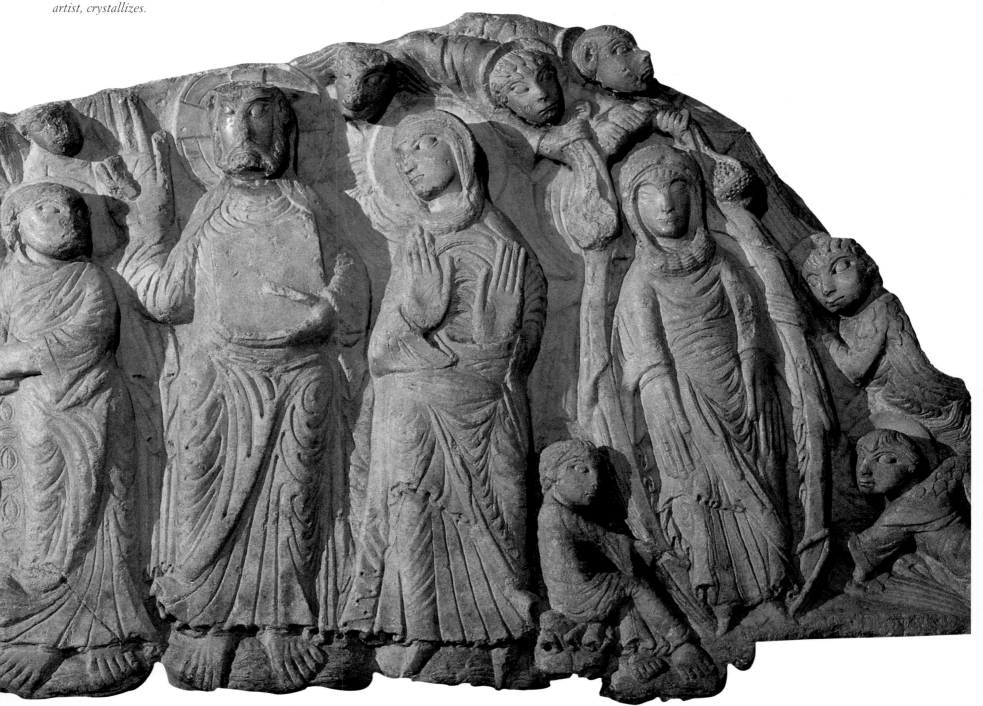

30 •

lines, oval faces, and hieratic, even rigid, postures; on the other hand, the colors are warm and lively. The church was not considered finished until it was covered with wall decoration. That it cost less than sculpture and could be easily changed explains its preponderance in the modest churches of the remote lands of Catalonia. Its execution did not necessarily accompany the construction of the building, which makes dating such work difficult.

The models for this wall painting may be found in manuscript illumination; we see common elements between the paintings of Saint-Martin-de-Fenollar and the vigorous images in the Commentaries of Beatus (a monk of the eighth century from northern Spain) illuminated at Saint-Sever. On the vault of the little chapel is depicted an apocalyptic vision of Christ in Majesty, surrounded by the twenty-four Elders of the Apocalypse in adoration, who carry flasks of perfume and viols. This theme is often represented in the southwest, the most famous example being found on the portal of Moissac. It is accompanied, at Saint-Martin, by the beginning of a Christological cycle (the

SAINT-MARTIN-DE-FENOLLAR, DETAIL OF WALL PAINTINGS, FRESCO AND DISTEMPER, AFTER 1157 *Accompanying an eschatological vision, a concise cycle of the childhood of Christ includes this Nativity, which shows the Virgin lying under a valance. Its style is related to the figures of Spanish*

Catalonia derived from Byzantine designs. The face has an expressive linearity.

Annunciation, Nativity, Annunciation to the Shepherds). These representations, painted in fresco (that is, on wet plaster) by the same painter who carried out the decoration of L'Écluse, unhappily offer a good example of the problem of the degradation of wall decoration that confronts historians and restoration workers. Many such paintings have been lost, yet others in Spain have been preserved after being detached from their original surface—a radical procedure, certainly, but one that has allowed their restoration and display in optimal conditions.

If Mozarabic influence is strong in the paintings at Cazenoves in Elne and Marvecol, the delicate paintings of Vals, Saint-Plancard, and Saint-Lizier in the central Pyrenees may be associated with a Catalan production, which emphasized an Oriental richness of detail.

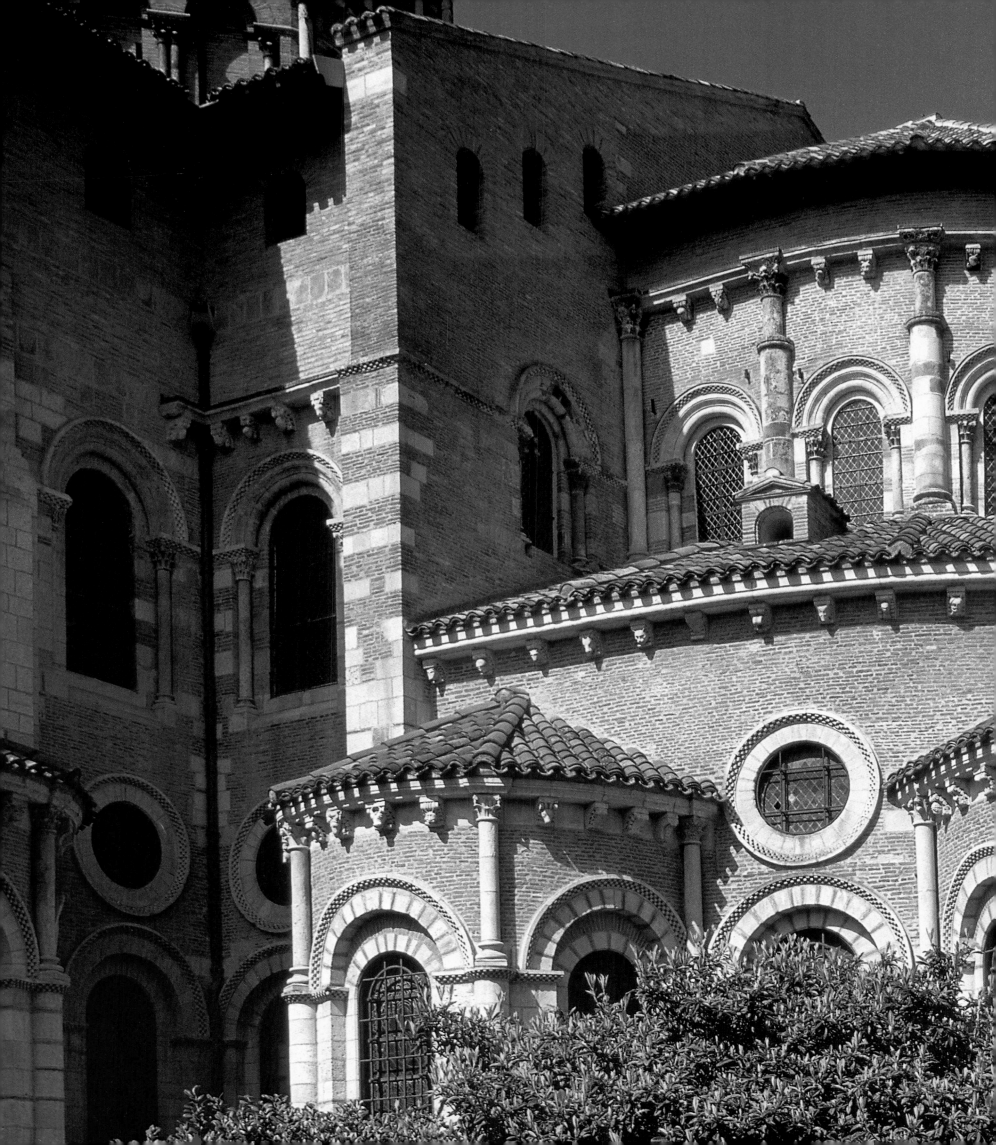

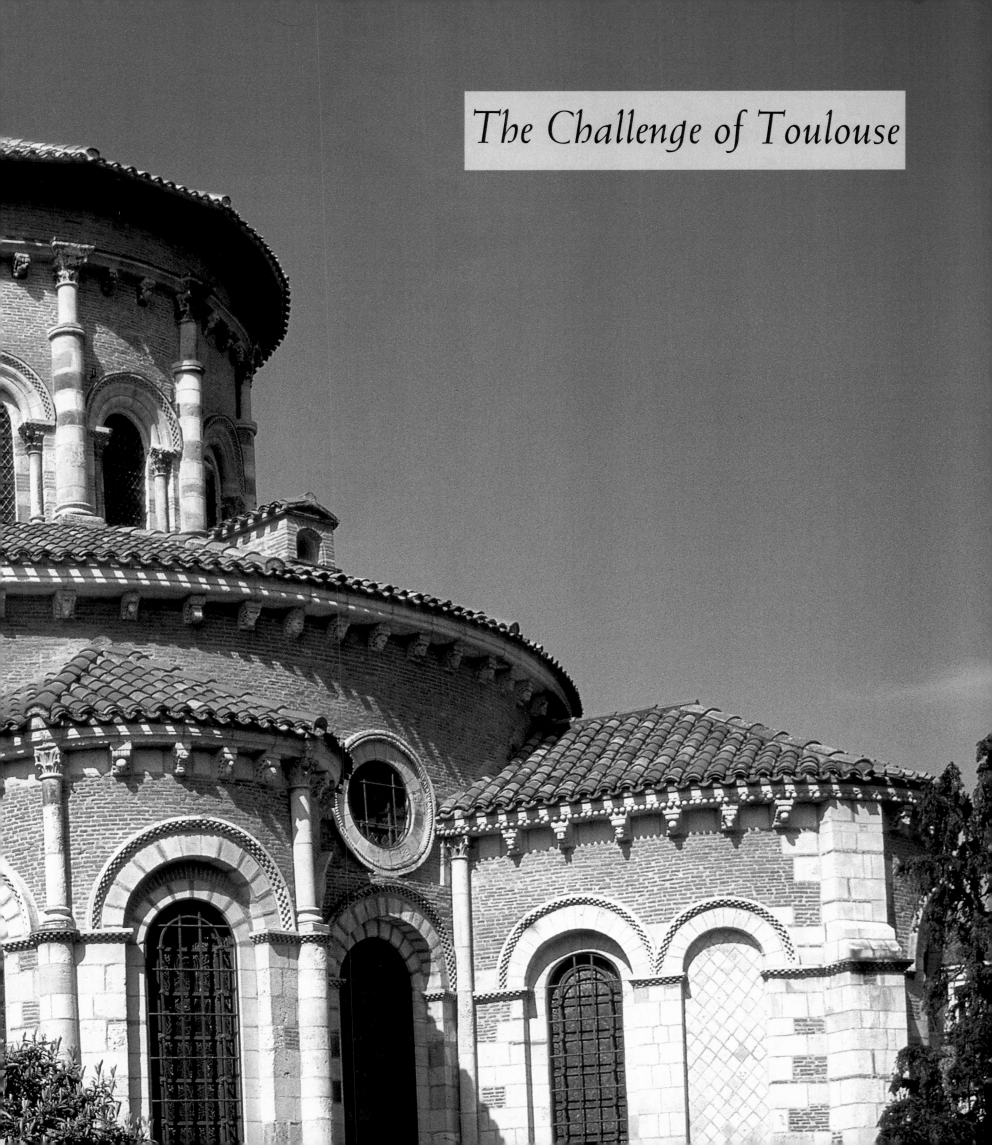

The Challenge of Toulouse

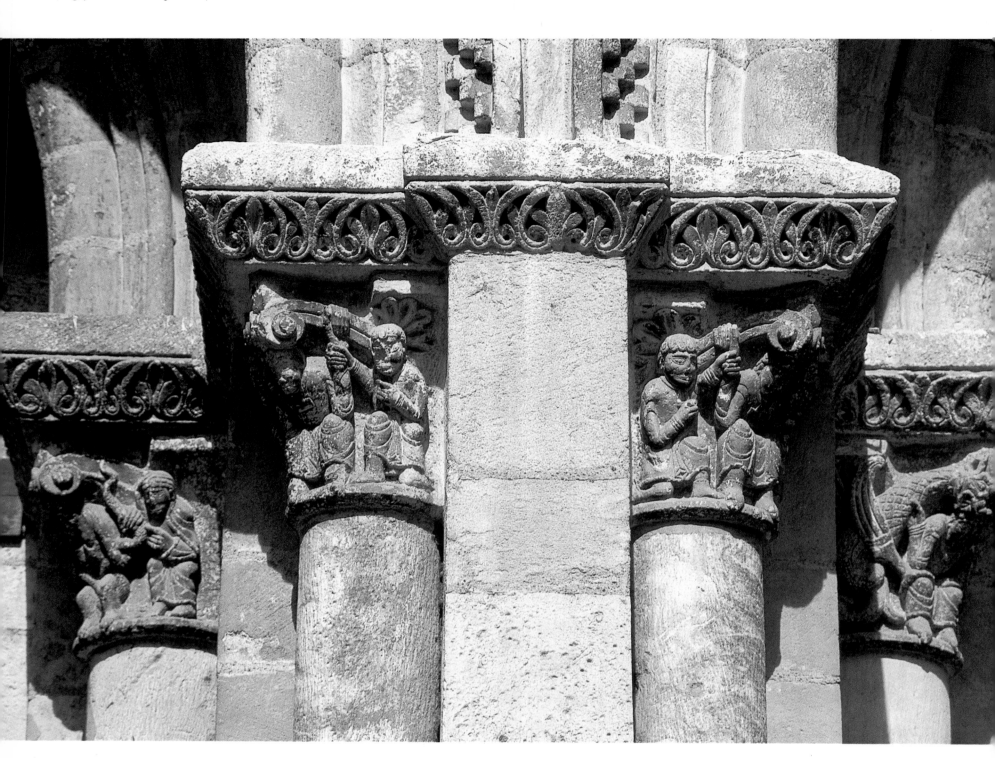

TOULOUSE: the music of its name evokes the rise of Romanesque civilization through the most refined of its productions. We will not delve into the county of Toulouse, with its ever-changing borders, or the dynasty of the Raimonds, who fought to keep its independence. The landscapes of hills, valleys, and meadows depend on the water that flows from the Massif Central and the Pyrenees. The unusual convergence of the often unpredictable rivers (Garonne, Ariège, Hers, Tarn, Agout, Aveyron), while bringing fertility, encouraged the fragmentation of the region, concentrated to the west around Toulouse and separated from its lands in Provence, controlled by the house of Saint-Gilles, by 180 miles. While its political influence was limited for the most part to Lauragais, Quercy, parts of Rouergues and Albigeois, the county of Foix, Bigorre, Comminges, Vivarais, and the entire area south of the Massif Central as far as Provence were simply in its realm. Its power was such that it was vain for the subject lands and the *castelnaus* (new towns around a château) even to try to compete. However, the county had to defend itself against the designs of the duchy of Aquitaine, its immediate neighbor,

and of the kings of Aragon, who dreamed of ruling southern France.

FACETS OF AN URBAN SOCIETY

The brick that today lends its charm and consonance to Toulouse in Romanesque times was used only for churches and aristocratic, and sometimes bourgeois, residences. Houses were plainly built of mud brick or cob (*paillebard*) strengthened with the wood that was so abundant around the city. By the end of the eleventh century the Occitan capital had been restored to a prosperity not experienced since Roman times, exemplified by the construction of the bridge over the Daurade, which at last stood beside the ancient bridge-aqueduct, allowing access to the sixty or so mills on the river.

Technical progress led to an economic and demographic expansion in the countryside; it also amplified the importance of a previously unutilized

workforce, which now turned to the city. The peasants of Lauragais rushed by the hundreds to set themselves up as artisans in the Cité, the ancient urban center of the city formerly called Tolosa. A city of landowners who controlled property beyond its limits, it lived in complete symbiosis with its rural environment, which fed it and expanded its commerce.

The medieval process of urbanization of former Gallo-Roman towns almost always followed the same formula: around the Cité—the original center of the town—which was enclosed by a wall, there spontaneously multiplied, outside the walls (*extra muros*), monastic and merchant neighborhoods, known as faubourgs. In Toulouse the division of the population took place differently, and the town of twenty thousand observed an unusual social division. With the artisans and merchants quickly occupying the great uninhabited spaces situated *intra muros*, the Cité was not the privileged domain of the notables. The street names show how they gathered by trade corporation (knife makers, spinners, and so on). The less salubrious occupations were kept away from the center of town. Thus, the *pargaminiers* (parchment-makers) gathered near the water along the Garonne, while the tanners found themselves isolated on the other side of a wasteland. Near the river (*juxta aquas*) also lived the Jews, grouped around their synagogue. They were not persecuted, for the counts held them to be essential to the financial expansion of the town; money lending, forbidden to Christians by the Church, was openly protected.

GROWTH OF A CITY

Simultaneously with this spontaneous urban growth we see the appearance, in the southwest, of the first cities or neighborhoods created ex nihilo. With the lay *castelnaus*, the *sauvetés*, or *salvitiates* (rural townships), founded by the church as sanctuaries for fugitives, foreshadowed the walled towns of the following century. They multiplied in Gascony and around Toulouse, where their number reached its peak about 1120. Born from the Peace of God movement, which tried to declare the holy perimeter of a church inviolable, this phenomenon spread, in a pacifying spirit, to villages, forests, and fallow countryside, such as Bouconne, which were settled and cultivated. Monasteries (Moissac), chapter houses, and, especially, the Hospitallers of Saint-Jean-de-Jérusalem thus founded

small villages, often round and huddled around a church, enclosed with a wall. They brought revenue to the religious communities and a beneficial stimulation to the countryside. Spanning both sides of the ramparts (still Roman) of Toulouse, a *sauveté* was born between 1120 and 1140, marked off with crosses, created by Alphonse Jourdain. As was customary, the settlers each received a *casal* (a building plot with a garden) and were granted some privileges or exemptions. This formula attracted many immigrants.

Few residences boast a sizable facade. That of Saint-Antonin-Noble-Val (1120), near Montaubin, was perhaps built by the counts or by the wealthy Granolhet family. The large arcades of the ground floor are surmounted by a gallery with small columns. On its two pillars are represented Adam and Eve and the Byzantine emperor Justinian, his code in hand, the symbol of justice.

Toulouse is a double city. Facing the Cité, the town has extended to the north since the beginning of the eleventh century. There, clerics and bourgeois lived in the shadow of the immense basilica of Saint-Sernin and its monastery. In spite of the traffic from pilgrims at the time, it was a residential quarter, far from the commercial hustle and bustle that filled the Cité and the narrow streets of the many faubourgs: Saint-Cyprien, Château Narbonnais, Saint-Michel, and Saint-Pierre-des-Cuisines, where the leather workers and cobblers worked, joined together in a powerful corporation.

Gradually, the outlines of a republic of Toulouse was established. While making their fortunes artisans, merchants, and the minor rural nobility managed their communities interdependently, with the help of elected tribunals. They acquired sufficient importance to win recognition by the count and obtain the erection of walls. Although these were composed of mud brick and bore no comparison to the Gallo-Roman enclosure, they nonetheless conferred a sense of security. Following a logical evolution of medieval urbanism, Cité, town, and faubourgs were enclosed in a single unifying wall in 1140.

In 1152 a council of six *capitulaires* sat for the municipality. Finally, on 6 January 1189, in the church of Saint-Pierre-des-Cuisines, the local petty nobility and notables obtained from Count Raymond V autonomy for the city, the right to justice, and the title of consul for the city's representatives.

At the same time a new means of expression emerged in Toulouse, which spread to northern France

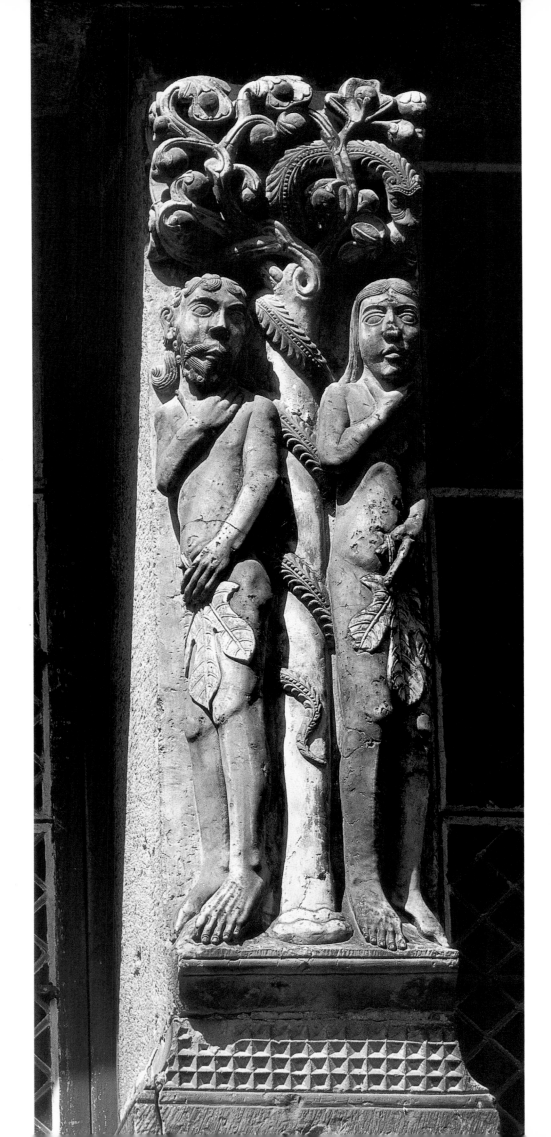

Opposite
SAINT-ANTONIN-
NOBLE-VAL, DETAIL OF
THE FACADE, C. 1120
*This representation of
the shame of Adam and
Eve after committing
the original sin, treated
in an expressive style, is
accompanied on another
pillar by the figure of
Emperor Justinian, the
great Byzantine law-
maker, who in the
sixth century held both
temporal and spiritual
power.*

SAINT-ANTONIN-
NOBLE-VAL, URBAN
RESIDENCE, MID-12TH
CENTURY
*The most beautiful
facade of a Romanesque
civil structure demon-
strates the absence of
any iconography specific
to domestic architecture.
The marriage of sacred
and profane themes was
already current in the
religious realm.*

after having been subjected to its ridicule. Courtly poetry flowered in a remarkable fashion in the lands of Occitan beginning in 1100. Behind the delicacy of the complex rhymed verses, accompanied by the lute, is concealed a weariness toward life in feudal society.

ROMANESQUE SYNTHESIS: SAINT-SERNIN

The grandiose collegiate church of Saint-Sernin in Toulouse, whose unforgettable tower dominates the town, is in itself a lesson in Romanesque art. By making light of limitations, it discovered the basic Romanesque language before 1100, which the twelfth century would only exploit.

The largest Romanesque church in France is a vast synthesis of the architectural investigations of its time. Its size (380 by 105 feet, 115 by 32.5 meters) is a reflection of the functions that it then fulfilled, as one of the most important pilgrimage churches in the west, a parish church for its suburban neighborhood, and finally a collegiate church, at the heart of a genuine small town within the city, formed by its cloistral, hospital, and civil buildings, defended by a wall.

The edifice is striking less for its innovations than for the coherence of its structures. It is the most perfect of the major pilgrimage churches, even though the latter do not have a common prototype. Saint Martin of Tours, Saint-Martiale of Limoges (no longer standing), Saint-Remi in Reims, and Santiago de Compostela share with Toulouse identical preoccupations, the result of their role as sanctuaries for relics and the necessity to develop space to accommodate their visitors, given the growing number of pilgrims and a liturgy tied to the cult of the saints. All chose a longitudinal cruciform basilica with a projecting transept, a spacious nave flanked by aisles, and, finally, an apsidal choir surrounded by an ambulatory with radiating chapels. Toulouse does not stand out from its colleagues; its architectural plan owes much to the abbey of Sainte-Foy of Conques, in Rouergues, which inspired its design before, in its turn, having its upper parts rebuilt according to the formula of Saint-Sernin. It owes its originality not to its double aisles, copied at Saint-Martin de Tours, but more generally to the unity of its construction, which prefigures a Gothic ordering of space. This can be found in the galleries that run through the interior to the apse, where a circulation corridor links them. In the same vein, we find

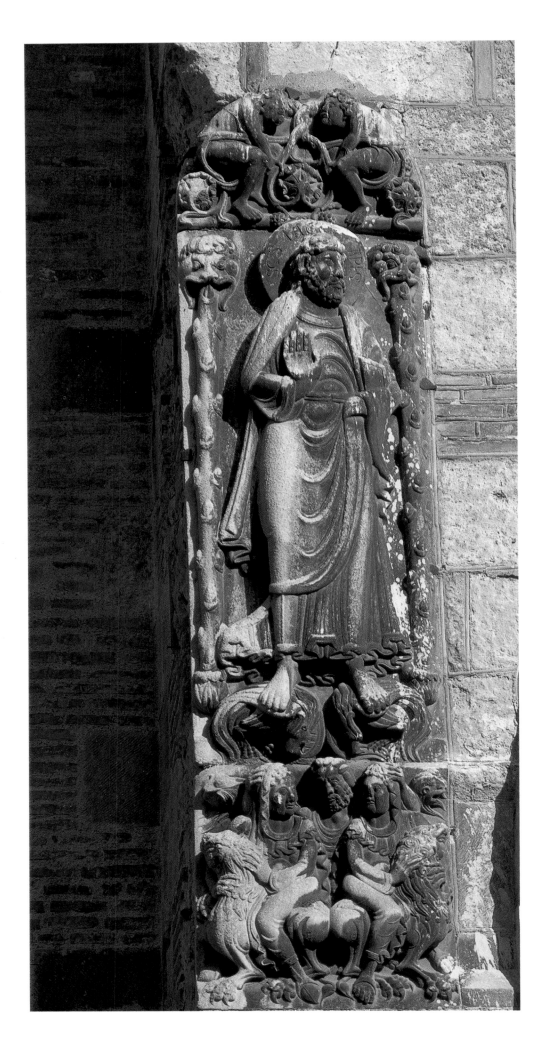

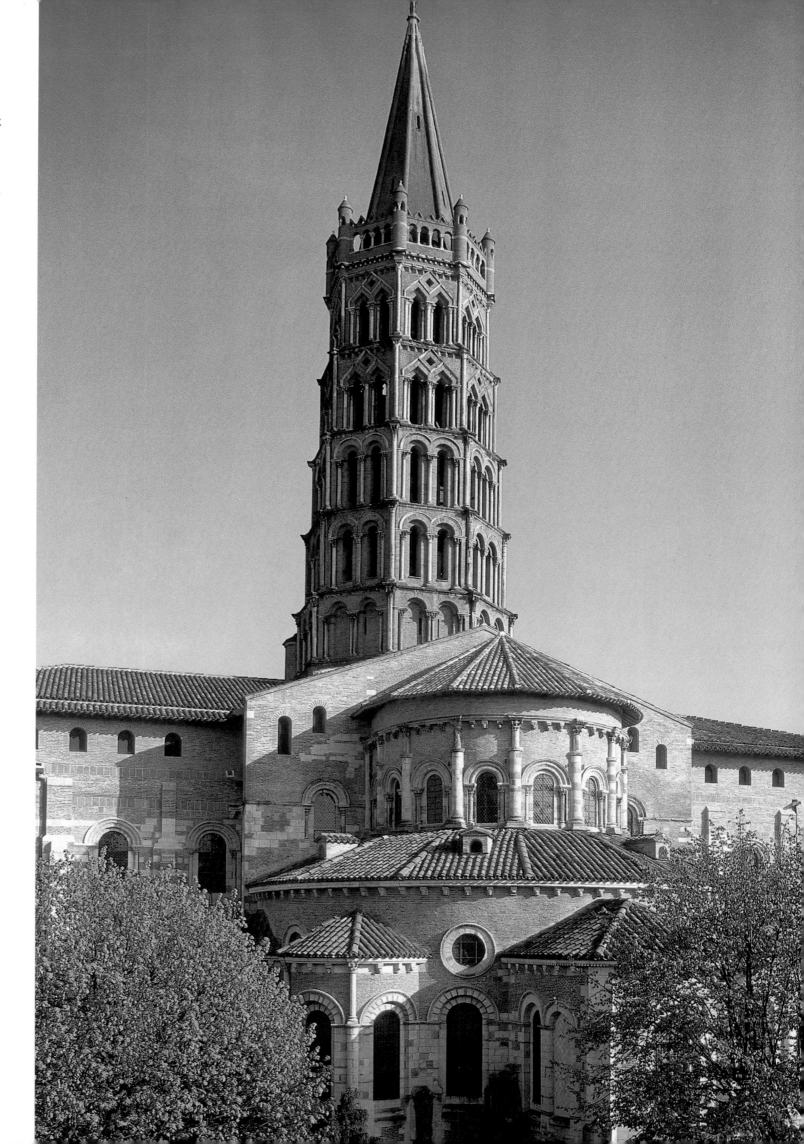

Opposite
TOULOUSE, SAINT-SERNIN, RELIEF ON THE MIÉGEVILLE PORTAL, C. 1115
Saint James and Saint Peter stand on either side of the tympanum of the first Romanesque historiated portal. Saint James, whose name is engraved on his halo, stands erect between two cut branches, as he appeared on the gold-smith's gate at Compostela. These branches, along with the two naked figures above and the two women astride a lion below, form a group whose interpretation remains enigmatic. The reliefs of the Miégeville portal were produced by the Saint-Sernin work-shop, not by a single master. While they represent a classicizing ideal—incurved folds, smooth and inscrutable faces—above all they reveal the close stylistic ties with Spain, and especially Compostela, which existed at the dawn of the twelfth century. They also prefigure the generation of the great monumental Romanesque portals of the years 1120–40.

TOULOUSE, BASILICA OF SAINT-SERNIN, CHEVET, C. 1080
Saint-Sernin, the largest Romanesque church in France, spreads a majes-tic halo of five radiating chapels. These open onto an ambulatory linked to four absidioles facing a transept that projects beyond the aisles.

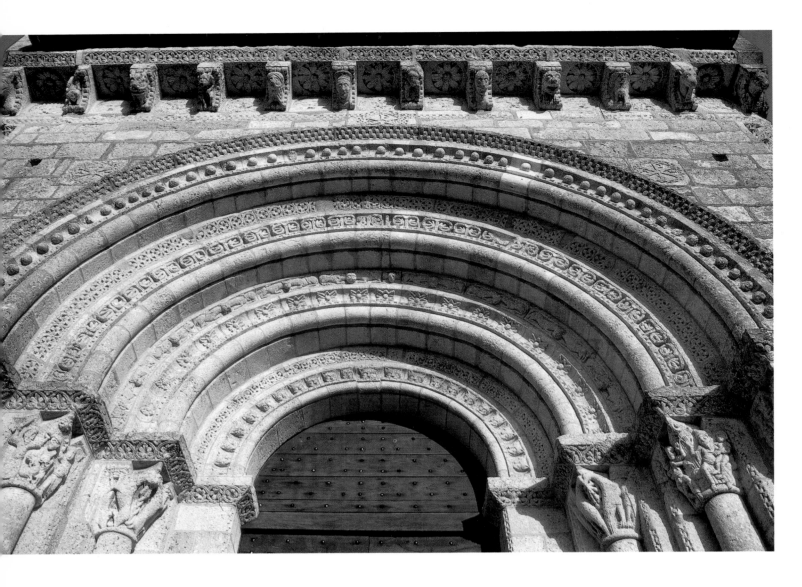

LESCURE, CHURCH OF
SAINT-MICHEL, WEST
PORTAL, EARLY 12TH
CENTURY
*This Albigensian
building was influenced
by Saint-Sernin of
Toulouse. Its portal fol-
lowed the style of the
portal at Comtes,
reduced to a single bay.
The decor, inspired by
the nearby region of
Guienne, is richer, con-
centrating designs of
beads, checkerboards,
or cats' heads on the
single archivolt. The
beautiful chip-carved
modillions under the
cornice are sculpted in a
refined style that owes
much to the cloister of
Moissac.*

Overleaf, left
CONQUES, ABBEY
CHURCH OF SAINTE-
FOY, NAVE, EARLY
12TH CENTURY
*In the eleventh and
twelfth centuries the
monks of Conques, a
small village in the
Rouergue within the
sphere of influence of
Toulouse, built an abbey
dedicated to Saint Foy
that rapidly became an
important pilgrimage
site for Western Chris-
tianity. The church was
designed to accommo-
date crowds, allowing
them to circulate in the
nave, the side aisles, the
galleries, the transept,
and the ambulatory,
and let the Benedictine
monks gather in the
choir for services at
the same time. It thus
displays a functional
architecture with the
double aim of serving
as pilgrims' sanctuary
and monastic church.*

here, for the first time, the principle of the modular bay used as a unit of measurement to rationalize plan and elevation. Finally, a similar desire for harmony is applied to the exterior volumes (today sharply distinct from one other since Eugène Viollet-le-Duc's restoration in the nineteenth century). Despite the controversy that surrounds the decision, the nave and the aisles will soon be enclosed, as they were originally, under a single double-sided roof, which should return Saint-Sernin to its original profile.

A new conception of the church entrance signaled progress in the area of access to the building: the Porte des Comtes, or door of the counts (1082, facade of the south transept), opened the way for the solution of the western portals of the twelfth century; its twin bays were designed for better circulation of the faithful and processions. All the same, it represents only an intermediate stage, since it is built up—as would be common around Toulouse—of molded voussoirs, resting on historiated capitals. This principle of the arched bay without tympanum represents an influ-

ence from antiquity, which also prevailed in the choice of the ambulatory windows, surmounted by an oculus. The Miégeville portal, finished about 1115, displays a historiated tympanum. In spite of its modest dimensions, it set the stage for the series of monumental portals of Moissac, Vézelay, and Conques several years later, culminating in those of Saint-Denis and Chartres.

It often happened that a church would be constructed as a result of improvements made to a burial chamber. For Saint Saturnin (shortened to Sernin), apostle and first bishop of Toulouse, executed in 250 and whose martyrdom—he was tied to a bull by the feet—is remembered in the name of the rue de Taur, there was first an oratory built on the tomb, outside the walls, watched over by a religious community. At the end of the fourth century the cult of the saint spread rapidly, and the bishop decided to have a basilica with transept built, barely a few hundred meters from the remains, which he had solemnly transferred. About 1080, when work was begun on the Romanesque church—as is almost always the case, beginning in the

east, where the most important liturgical space is located—a *confessio* (a section of a crypt), surrounded by a semicircular wall, was constructed under the new apse, whose shape it faithfully follows. Romanesque architecture found real solutions to make the eastern part of the church more functional, both for the cult of the saints and for everyday liturgy.

The ambulatory that surrounds the apse of the choir has the advantage of allowing free circulation by the faithful above the sacred space of the crypt, while isolating them from the sanctuary where services are held. The radiating chapels, along with those extending from the transept, complete the design of the Romanesque chevet at its height.

The most notable improvement effected to the primitive system of the timber-roofed basilica remains the advent and slow refinement of the vaulting, crucial for the stability of such large buildings. Saint-Sernin made use of it at the turn of the twelfth century, while the nave and the aisles progressed to the west. The goal of increased stability also brought about the modification of the most recently constructed supports for the nave, near the entrance. The load exerted by the fully arched barrel vault braced by transverse ribs (the most widespread Romanesque type) is resisted by a buttress of the stepped vaults of the aisles and of their galleries in groin vaults, half-barrel vaults, and half-groin vaults.

By 1115 Saint-Sernin, although unfinished because of a lack of funds, had found its stylistic fulfillment.

OTHER MONUMENTS OF TOULOUSE AND THE REGION

Reconstruction of the church of Saint-Pierre-des-Cuisines to the northwest of the Cité, begun in 1100, illustrates the expansion of the town, following the example of Saint-Sernin, but this time toward the Garonne. The parish church of a working-class quarter and *allodium* (freehold) of the abbey of Moissac, Toulouse's other Romanesque church wraps an earlier modest priory chapel, traces of which it retains, in brick and stone. What is interesting here is the aisleless nave, already very popular in Languedoc and Provence and destined to become the most important feature of southern Gothic. Formerly it opened from the side onto a western gallery, following a pattern fre-

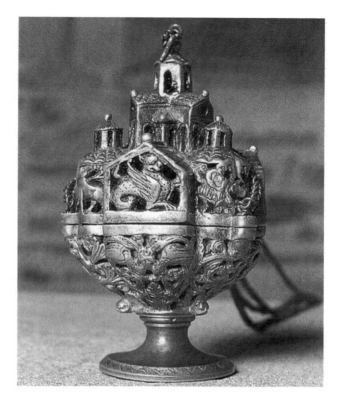

quently employed in the southwest. The pursuit of harmony, already mentioned for Saint-Sernin, is accentuated at Saint-Pierre, where the highly skilled master builders applied a ratio of 1:2 between plan and elevation, which is found in all the parts of the church. Beside a portal framed by brick arches modeled after that of Saint-Sernin stands a high monumental niche enclosing a tomb behind three arches of stone. This intriguing unit, which undoubtedly has undergone restoration, still has not revealed the mystery of its origins and date, since it is decorated with both primitive and late capitals. The sarcophagus, closed by a peaked cover, rests on five columns; it is perhaps that of a count—the donor of the church?

Regrettably, Albi has lost almost all of its Romanesque past. The great church of Saint-Salvy, besides a square tower, has retained the lower portion of its west tower-porch (end of the eleventh century), punctuated with sawtooth molding and Lombard bands, like the tower of Saint-Benoît of Castres. The priory church of Ambialet, built on a rocky overhang above a tributary of the Tarn that belonged to the Trencavels, a family of viscounts in the Toulouse area, was founded by the abbey of Saint-Victor of Marseilles, which sought to expand its holdings to the west. Composed of schist ashlar, it is the oldest example of the spread of the First Romanesque to Albigeois, from the second half of the eleventh century. The Ambialet's censer, an example of the rich trea-

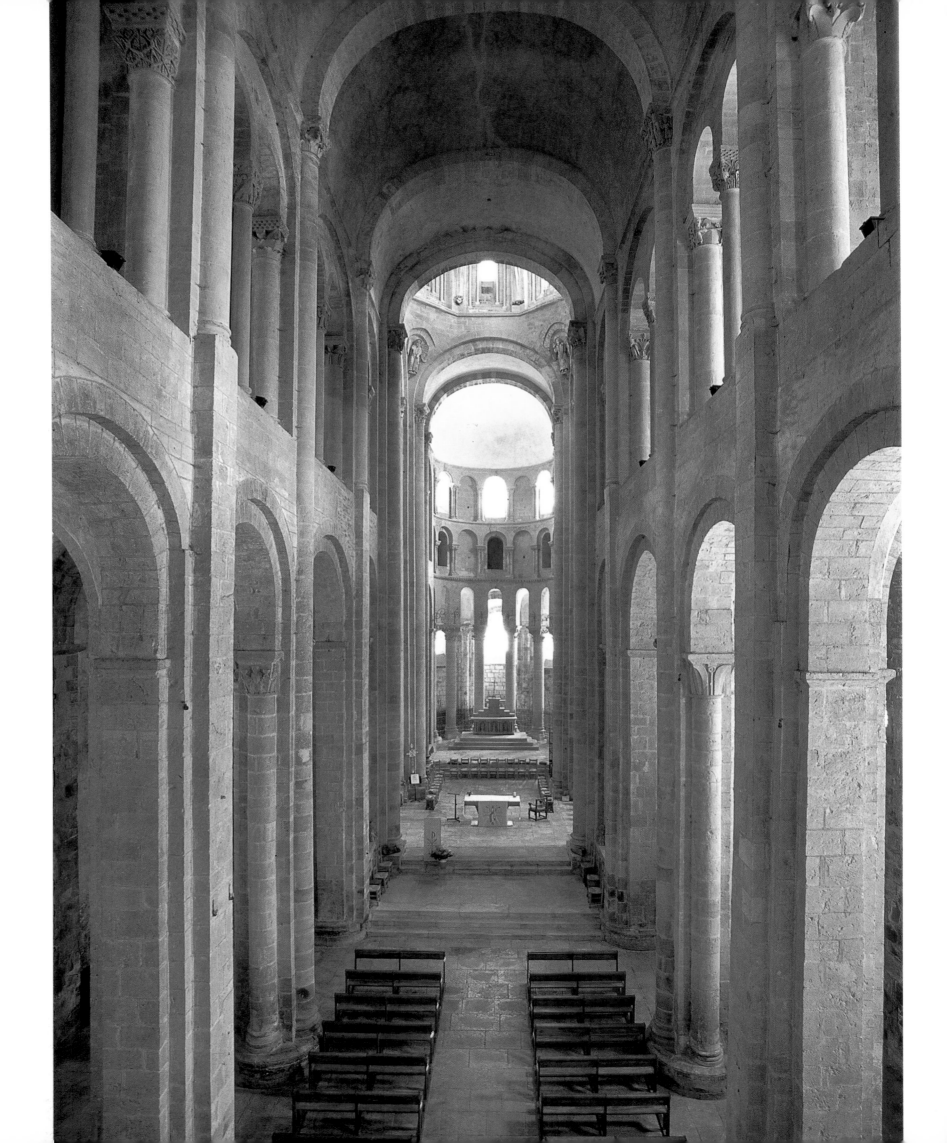

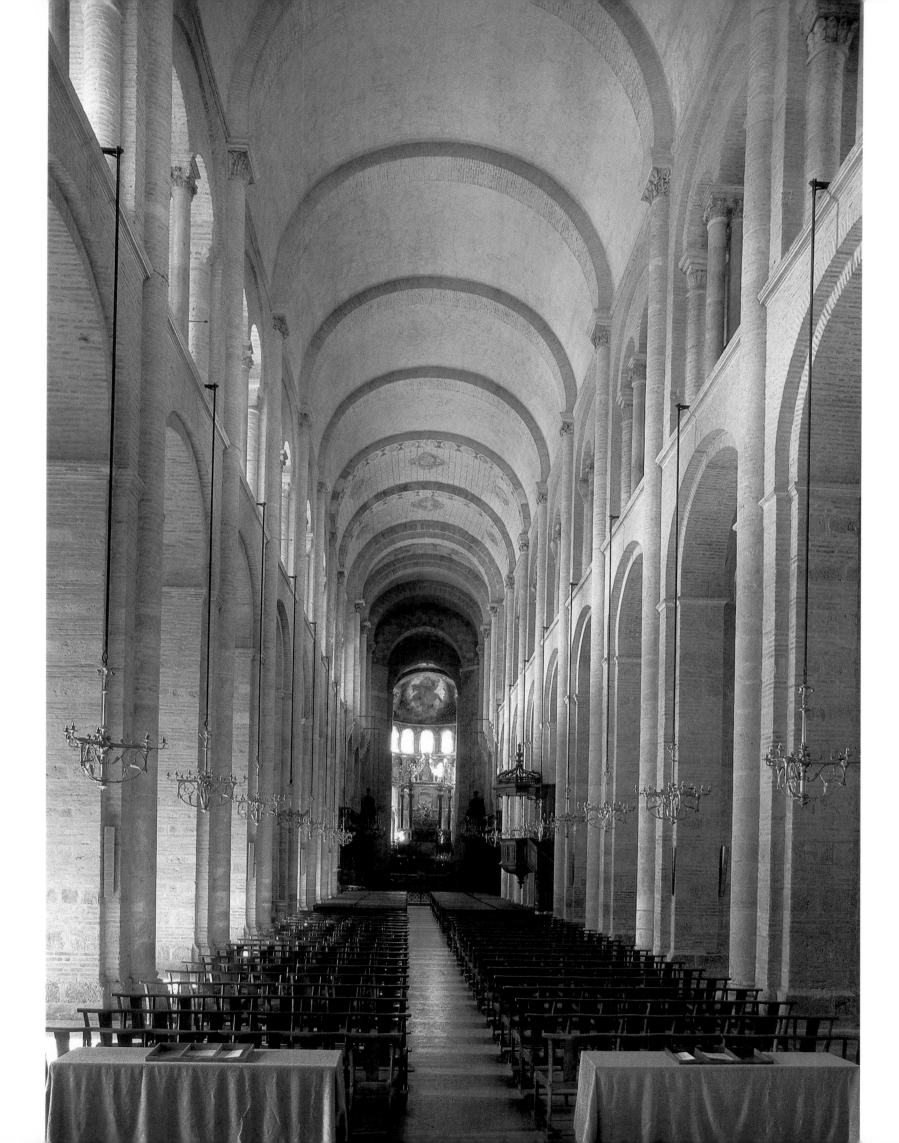

sures preserved in the great sanctuaries, visible on site, is one of the rare Romanesque specimens in copper that has come down to us. Architectural in form, it superimposes two central-plan churches, surmounted with a pentagonal tower. Its openwork design of plants and fantastic animals has an Oriental flavor.

TRANSFORMATIONS OF IMAGE AND STYLE

At Saint-Sernin ornamentation was already mastered; abundant but precise, it is read against a flat background obtained by a technique of stonecutting called hollow or sunk relief, which consists of bringing forward forms and disengaging them from their background. And here, among its earliest efforts, we find some historiated compositions, their organization developed by the workshop for the Porte des Comtes. Probably finished in 1082, the double southern entrance to the transept forms an avant-corps divided by a central pillar. There, for the first time, a coherent historiated series is laid out, designed in terms of its placement at the heart of the building and supported by four capitals whose proportions are well suited to the architecture. The theme of Salvation and Damnation is represented by the parable of the rich man and Lazarus (Luke 16: 19–31), which recurs on the portals of Moissac and Burlats to illustrate Sin. At the angle of the capital (where it would be seen most easily), we find the rounded silhouette of the scornful rich man, seated before a meal, briefly sketched. His dour air and his hunched shoulders isolate him from the two rejected characters on the side, the servant and poor Lazarus, who begs in vain for food. What the moral code here condemns in the rich man is not so much his fortune as the fact that he uses it without regard for those in need (evoked by the pilgrim's staff that Lazarus holds and the dogs that lick his sores). We may better understand the placement of this subject above the church door when we think of the beggars who stood just below on the parvis. His lack of charity leads the rich man to Hell, symbolized by two dragons devouring his head, while the naked soul of Lazarus is carried to Heaven by angels. This eschatological vision, treated with great economy of means on three capitals, serves as a warning against wealth that enslaves.

The workshop at Moissac finished the first historiated Romanesque cloister in 1100. Destined to be seen only by the monks, the iconographic program that unfolds on its seventy-six capitals elaborates a much broader moralistic discourse that more subtly establishes typological relationships between scenes from the Old and New Testaments. This didactic procedure was already well known in illuminated southern Bibles, which may have served as models. Former stonecutters who had turned to bas-relief work tackled the material with an accomplished precision, articulating forms more than previously, accentuating the contrasts between form and its absence, imparting expressivity and movement as much to the ornamental elements—treated with virtuosity—as to the figures, which are supple and dynamic. Illuminated manuscripts again seem to have inspired the forms of the apostles and of Abbot Durand, sculpted on the pillars that support the cloister, covered in slabs of white marble. Worked in low relief, their modeling is perfunctory, their appearance rigid, their drapery stylized.

Returning to Toulouse, similar slabs of marble, today displayed in the ambulatory of Saint-Sernin, were fashioned by a new workshop, that of Bernard Gilduin, who established a new aesthetic at the close of the eleventh century. A Christ in Majesty giving benediction is accompanied by a cherub, a seraphim, angels, and apostles. They are the result of a personal interpretation of the legacy of classical antiquity assimilated through Provençal ivory bas-reliefs. The first figures, executed in a severe frontality, give way, among the last, to greater suppleness of drapery, a more tangible plasticity, and an astonishing facial expressivity, due especially to their pierced pupils, all marks bearing the strong influence of Moissac. An imposing presence emanates from these full-size standing figures, which Gilduin set off on a very pure field, devoid of decoration. The artist continued his work with the beautiful slab of the main altar, hollowed out of marble from the Pyrenees. Its strokes are vigorously worked in the Moissac style. On an abacus in the gallery, the sculptor depicts himself with a helper holding this same altar, which was consecrated in 1096.

ROMANESQUE HUMANISM

The humanistic inspiration of Gilduin's sculpture endures beyond his generation in the Porte Miégeville, finished just before 1118. This door also contains antique elements imported from northern Spain, in particular, Jaca and Santiago de Compostela, where we find capitals with "split leaves" in the aisles. Here we witness the birth of the fully formed historiated

MOISSAC, ABBEY CHURCH OF SAINT-PIERRE, SOUTH PORTAL, C. 1125–30 *This portal, along with that of Vézelay in Burgundy, ushers in the generation of great Romanesque portals. Christ in Majesty sits enthroned in the center of the tympanum, surrounded with the tetramorph (the symbols of the Evangelists), seraphim, and the twenty-four adoring Elders of the Apocalypse, in a complex eschatological vision.*

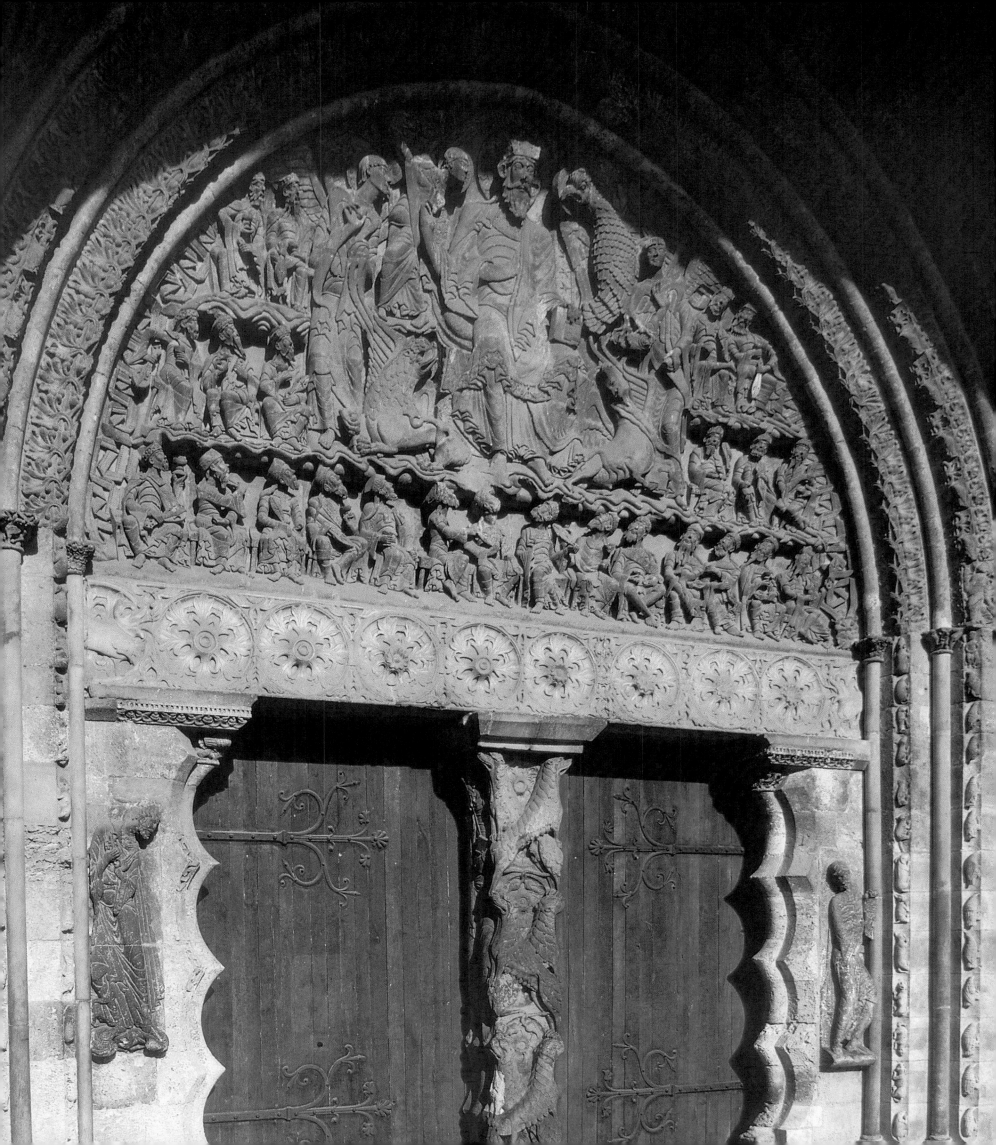

THE LAW OF THE FRAME

⏤⬤⏤

The 260 or so capitals that decorate the interior of Saint-Sernin illustrate the evolution of Romanesque deco-ration: first simply vegetative, interpreting the classical Corinthian style, or covering the capitals (with pal-mettos, stalks, and stylized foliage), it then takes on animal themes and introduces zoomorphic figures, artfully executed.

At this stage in its evolution the capital, which assumed before all else an architectonic function (sup-porting the springing of semicircular arches), was still the primary element in the ornamental repertory of the church. This repertory followed standards of composition that are ruled by what art historian Henri Focillon has called the law of the frame. The harmony sought by the Romanesque artist was obtained through the sub-ordination of sculpted form to the confines of its support. Thus, vegetative elements, animal, and often human figures were designed as a function of the trapezoidal geometry of the capitals, obeying a distribution—some-times centrifugal, sometimes centripetal—on both sides of an invisible axis, situated, depending on the case, in the middle of one of its faces or on its edges. This adaptation to the frame is obtained through organizing schemas proceeding from the palmetto, the rinceau, interlacing, and, more readily, the acanthus leaf, drawn from Corinthian foliage. This basic grammar, widespread in the Romanesque world, engendered new "living" figures whose distortions and strange postures demonstrate how much Romanesque aesthetics distanced itself from the goal of objective reality.

MOISSAC, CLOISTER OF SAINT-PIERRE, CAPITALS, LIMESTONE, BEFORE 1100
This group of historiated capitals contains within it an ornamental cycle. The bodies and their integral abacus display a plant decoration of palmettos and rinceaux from the East, inspired by Sassanid or Spanish Islamic models. The technique of shallow relief, which promotes an abstract decoration, reflects an aesthetic of the surface characteristic of First Romanesque sculp-ture. In the foreground is a pillar bearing two carved marble plaques.

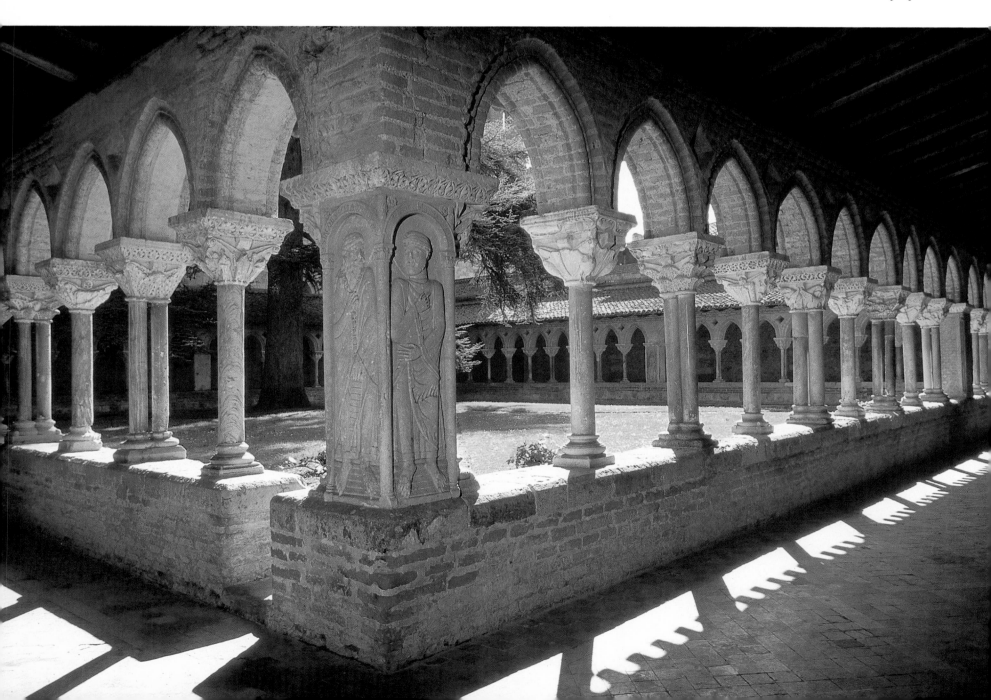

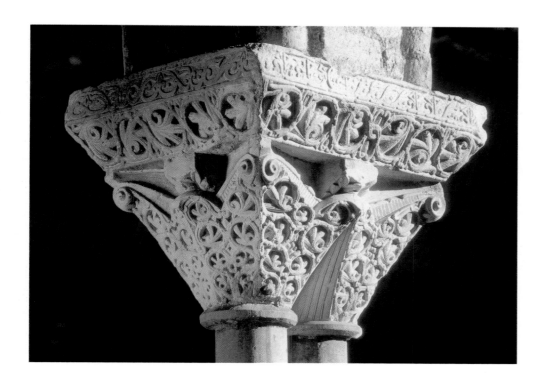

MOISSAC, CLOISTER, GALLERY, BEFORE 1100
The first historiated cloister in France, like many others, made use of an arrangement of twin columns resting on a low wall. The semicircular arches, a veritable architectural litany, bring peace and serenity to the place.

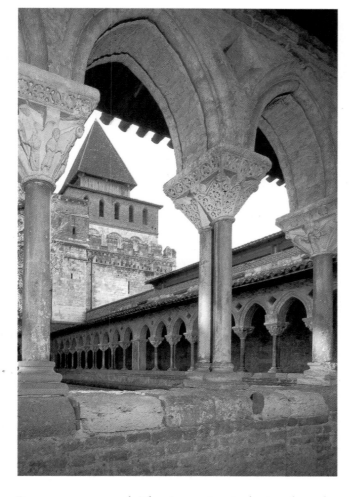

Romanesque portal. The Ascension is depicted on the tympanum, with a haloed Christ who rises into the clouds, supported by angels, in an Early Christian style. On the lintel the apostles follow him with their eyes.

Of the two centers of creativity, Saint-Sernin and Moissac, the latter had the more fruitful lineage. Its influence, direct or indirect, can be seen from Quercy as far as Rouergues and from the lower valley of the Tarn to the Garonne. Until 1125 its contributions proved decisive for the production of the second workshop of La Daurade, a Toulousan priory connected to the abbey of Quercy. Santa Maria, called Deaurata because of its golden mosaics, was destroyed along with its cloister in 1811, although some admirable lapidary elements were saved, today preserved in the Musée des Augustins. The twelve capitals devoted to the Passion of Christ and to his appearances after the Resurrection maintain a true iconographic unity while emphasizing the human aspect of God Incarnate and his triumph over death.

For the Toulousan works of the last generation, the art of composition goes hand in hand with a remarkable virtuosic execution. The modeling of the subjects leans toward a plasticity that is obtained by a technique that literally draws the figures from the surface. The same sensuality emerges from the fantastic ornamental decorations, animated by a perpetual movement developed at Moissac. As for its iconography, the anecdotal dimension becomes more common, as do profane representations, which invade the capitals in the form of vignettes drawn from everyday life. The interest focused on the human is confirmed in one of the most beautiful capitals of La Daurade; it unfolds the story of the trials of Job on four faces, geometrically broken down into medallions formed by rinceaux. The patience of the biblical character, subject to divine will, prefigures that of Christ of the Passion.

The humanism of Toulousan sculpture, which did not hesitate to marry the solemn and the frivolous, resisted the dualist heresies that rejected human nature, and thus its representation, as expressions of evil. Religious art championed the exaltation of humankind at the very moment that the stature of the individual was being asserted in society. The result was naturalism, as displayed in the eight figures of the apostles in the former chapter hall of the cathedral of Saint-Étienne, the last major achievement of the workshops of Toulouse. Romanesque statuary, pioneered by Gilduin, became monumental with this group, perhaps executed by the great Gilabertus about 1140, contemporary with the first Gothic portals at Saint-Denis. The apostles free themselves from their pedestals and become more lifelike in the henceforth widespread posture of crossed legs, suggesting movement. The entire work is stamped with an elegance devoid of preciosity.

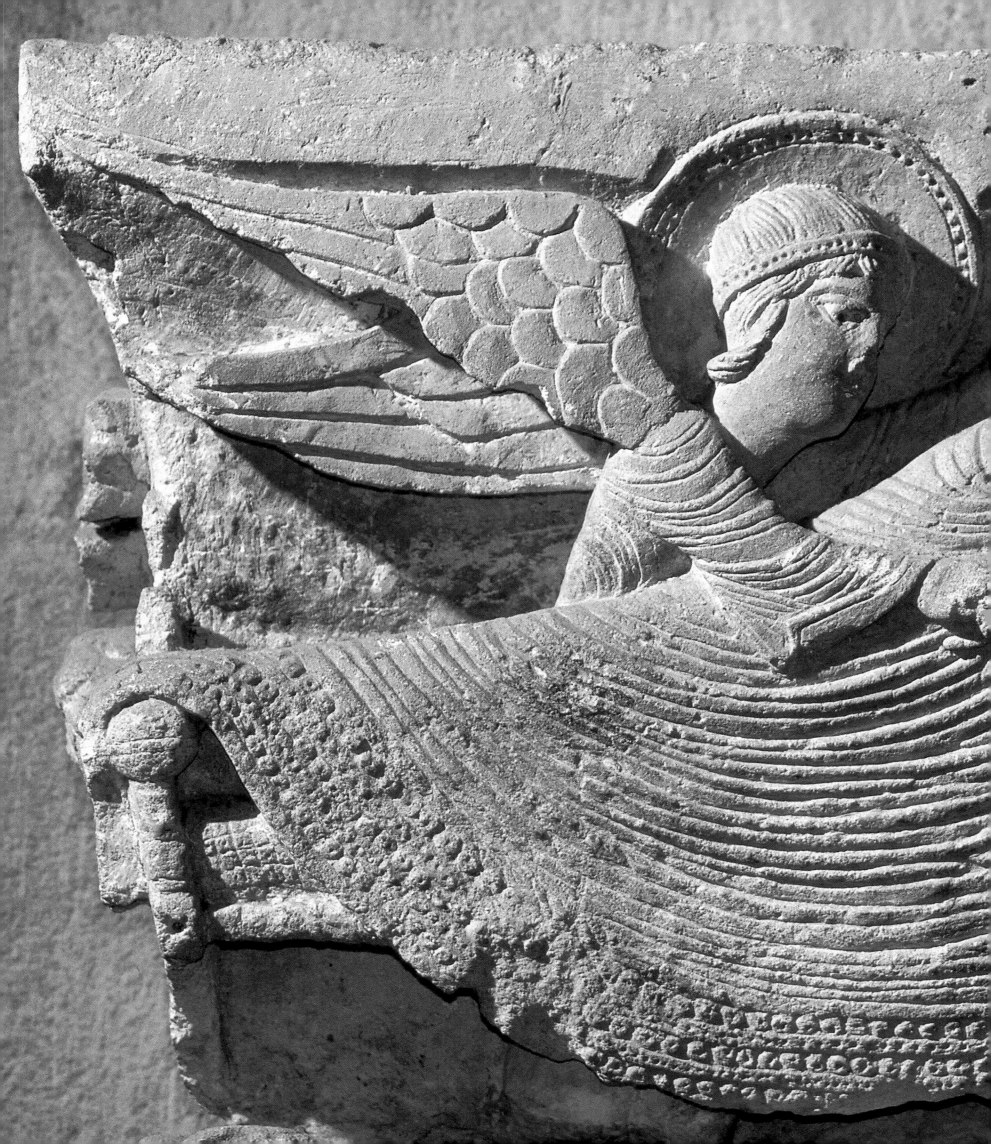

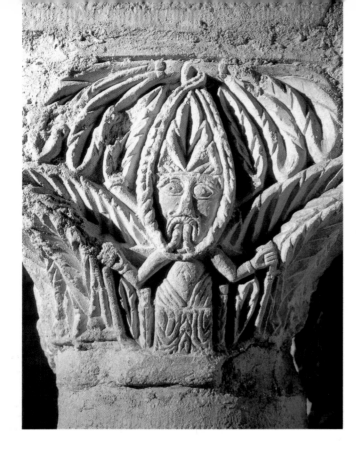

On THE EVE of the year 1000 Burgundy split into two territories, one on each side of the Saône River. The former western Burgondie became part of France; the eleventh century marks the beginning of the young duchy, in which the reigning dynasty was a branch of the Capetians descended from Robert the Pious. Faithful to the king, its history was peaceful in the region including Autun, Avallon, and Semur-en-Auxois, to which was added Châtillon, Dijon, and Chalon. Around the little state orbited the independent counties of Nevers, Auxerre, Tonerre, and Mâcon.

To the east of the Saône, between the Vosges and Jura mountains, the county of Burgundy—later called Franche-Comté—was joined by marriage to the Germanic empire in 1033 and gave its name to a vast kingdom that extended as far as the Mediterranean. Besançon, seat of an important diocese, is also the crossroads of age-old routes—roads, rivers, mountain passes—which open the region toward the Rhine, the Alps, and Italy. Long reduced to a land of merely strategic interest, the region absorbed the artistic influences with which it came into contact.

A border land, Frankish Burgundy was also an area of intense commercial and religious traffic at the crossroads of Europe. What is more, destiny made it the most important center of western monasticism. Without the religious orders of Cluny and Cîteaux and their extraordinary influence, Romanesque civilization would not have experienced the same flowering.

The phenomenon of Cluny did not appear suddenly. The idea of renouncing society and adopting the ascetic life goes back to the beginnings of Christianity. Christ's words addressed to the young rich man ("If thou wilt be perfect, go and sell that thou hast, and give to the poor, and thou shalt have treasure in heaven: and come and follow me"; Matthew 19: 21) showed the way for the first groups of anchorites who longed to live far from the world. The status of monks came somewhat later when to the concept of personal discipline was added that of submission to a rule approved and controlled by the pope. The rule written in the sixth century by Saint Benedict of Nursia, a former Italian eremite, founder of the monastery at Monte Cassini, while not the first of its kind, was the one most commonly embraced by western Romanesque monasticism. Its doctrine, which extolled an ideal of wisdom and balance, exhorted members of religious orders to imitate Jesus Christ through a life of poverty, obedience, and chastity, regulated according to a schedule that harmoniously interspersed prayer with intellectual, household, and agricultural work. Although mortification and spiritual trials were accepted as tools, they were used to shape accomplished men of God and do not have the heroic and excessive character of eastern eremitism. The recommended virtues lean rather toward fidelity toward and love for the community, level-headedness, common sense, and humility.

This human face of the Benedictine order explains its success and its spread throughout Europe. In the face of competition from the austere Irish monasticism of Saint Columban the monks moved some distance away from their original objectives and practices by opening themselves to society, becoming priests in order to supervise the laity and to repair the deficiencies of some of the secular clergy. They turned their monasteries into centers of spiritual and cultural reflection where novices and clerics were trained in the first schools for *oblats* (children entrusted to monasteries for the purpose of being trained as monks) under the aegis of eminent masters and with the help of libraries, those vectors of medieval knowledge.

Without Benedictine monasticism there would have been no Carolingian renaissance, which signaled the awakening of the West. When the disorganization of monastic institutions became evident at the end of the ninth century, the result of territorial disintegra-

Preceding pages
Autun, cathedral of Saint-Lazare, capital depicting the sleep of the three Magi

Dijon, abbey church of Saint-Bénigne, capital of the crypt, 11th century

Opposite
Souvigny Bible, late 12th century. Bibliothèque Municipale, Moulins
The influence of Cluny proved significant in the realm of the pictorial arts. The frescoes of the chapel of Berzé-la-Ville, a neighbor of Cluny, is a splendid example. But the colored image also inhabits books. Illumination, which goes back to ancient Egypt, was a favored medium of the Romanesque West. It was carried out mostly in monasteries, from the time that the book recovered its importance in the Carolingian renaissance. Its object lay above all in its relationship to the text it "illuminates" (illuminare). Monks copying in a scriptorium, working in relays, wrote the text by hand in black on parchment leaves. This Bible is the best known of the series made in the last third of the twelfth century. The Latin text uses a Gothicized Carolingian script. The Creation is illustrated here in eight "stories" read from left to right and from top to bottom. It begins with the separation of light and darkness, then of the waters, sky, and earth, followed by the creation of the sun and moon, the fish, birds, and mammals. The birth of Eve from Adam's rib precedes the episode of original sin. The promi-

creauir dš celum
et uacua. ⁊ tenebrı
ferebatur ſup aqu
lux: Et uidit deuſ
a tenebrıs: apellaı
factumq̃: ē. ueſpe
ıxıt quoq
aquarũ: ⁊
ffecıt dš firmameı
firmamto abhıs
factum ē. ıta: Hoc
tum ē. ueſpere ⁊ ı
ıxıt uero
celoſunt ı
factumq̃:
terram: congreg
marıa: Et uidıt
ner tta herbam u
pomıferũ facıenſ
ſem ın ſemeı ıpſo ı
ꝓtulıt tta herbaı
gmuſ ſuı. lıgnũ
qdq̃: ſemıtem ſecɫ
et bonũ: factıq
ıx aute ⁊
mento e
er ſunt ı
⁊ luceant ınfırm
Er factum ē.ıta: fe
lumınare maı uꝛ
eēt nocħ. ⁊ ſtella
celı uꝛ lucerent ſuị
duıderent lucẽ a
bonũ. ⁊ factĩ eſt ı
ıxıt etıaı
anıme uıı
fırmamto
ꝛomem anımã ıı
rauͭ aque ınſpeı
ſuum; Et uidıt dš
cenſ; Creſcıte ⁊ mı
marıs. auſq̃: mı
eſt ueſpe et maı

nence of gold in the illumination marks the manuscript as a luxury object. Its illuminations combine Byzantine influence and proto-Gothic formulas.

tion and troubles provoked by the Norman and Saracen invasions, the Benedictines instituted the reforms that guaranteed its renewal. Burgundy then became a place of refuge from whence spread the influence led by Vézelay and Cluny, founded at the beginning of the tenth century.

TIME AND SPACE AMONG THE MONKS

Monastic time unfolds outside of human time. It was organized around minutely ordered prayer, both by day and night, to leave no opportunity for relaxation of body or of mind.

Eighteen hours of wakefulness awaited the monk when he arose, as the world still slept. In the order of Cluny, which was not the most demanding, the night of communal prayer alternated vigils (around two o'clock) and matins, with short periods of sleep and reading. The daytime was organized by Prime, Terce, Sext, Nones, Vespers, and Compline, which preceded a light meal and bedtime shortly after seven o'clock at night. To this were added private and communal masses. A single substantial meal came after Nones, that is, ten hours after the beginning of the day. It was followed by a siesta in summer (the rule was created in Italy). Household work, gardening, and writing filled the end of the morning and the middle of the afternoon. Time thus was regulated by an implacable law. Breaking it was a serious transgression, which was confessed during the chapter meeting. To react at the first stroke of the bell was the duty of all.

Monks took vows of silence. Joy, ecstasy, boredom, agitation, torment, fear, and suffering alike were borne mutely. So language took the form of signs. Each monastery had its own code of gestures. At Cluny no fewer than twenty-two positions of the fingers referred to clothing, thirty-six to food, of which many related to the different kinds of bread.

Behind the walls of the monastery a complex human society lived independently, organized in a group of buildings whose function and disposition were fixed in Carolingian times. Its center was an abbey or priory church, where services took place. Its choir faced the east, except when the building site did not permit it. Joined to the southern wall of the sanctuary, the cloister was a quadrangular enclosure—often on two levels—which laid out four covered galleries with arcades opening onto a small garden and

difficult and often interrupted; the monks slept fully dressed, "ready to rise," with a blanket and a pillow.

The latrines were close by. The rules of the order concerning hygiene were exacting (if often imperfectly obeyed). The monks were expected to maintain clean clothes (breeches and frock) by washing them; clean hands and feet, and to take two hot baths a year, using a cake of soapwort; clean nails; and to trim their beards and have their hair cut, shaved, or tonsured according to a timetable that varied from one monastery to another. On Saturday, they saw to the maintenance of the premises.

Those in the infirmary had many advantages, besides better food. It was the only place that offered individual cells furnished with beds and sometimes heating from the kitchen. Bleeding was practiced as a panacea against all ills, and care was based on a medieval pharmacopoeia composed of decoctions, powders, and balms derived from medicinal plants (rosemary, sage, mint, and so on) grown in the garden or gathered in the wild. This empirical, although organized, medicine transmitted by the monasteries was the only one that the Romanesque Middle Ages knew.

From the time of the Carolingian reforms, religious orders were also centers of learning. Cluny, which had 570 books, introduced a scriptorium (writing and painting workshop) where scribes and illuminators copied, translated, and illustrated the folios (pages) of parchment with a patient and meticulous hand. The arduous task required relays of workers—it took an average of a year to make a book—so great was the demand. For the monks and nuns, the work was trying: cold made the fingers clumsy and froze the ink; the feeble light fatigued the eyes prematurely; the upright posture was hard to maintain. It mattered not: each manuscript letter was a step toward eternal salvation.

The heart of the monastic life, the chapter hall was where the community gathered in the morning, under the auspices of the abbot or prior. There, a chapter of the rule was read, the errors of the brothers were admitted or denounced, disciplinary action decided, daily tasks assigned, and important decisions voted on.

The remaining monastic structures lay beyond the principal cloister and its adjacent halls. These included abbey house, novices' buildings, laity and guest quarters, stables and cow sheds, pantries, bakery, smithy (near running water), mills, hives, kitchen gardens, orchards, vines, and the wine press. Cluny, a veritable city, had several churches, cloisters, and cemeteries.

connecting the principal monastic halls. Monks walked on the right, in procession or alone. In the center, or in the angle of the cloister, the lavabo served for ablutions; the inhabitants purified their hands in its basin, fed by several streams of water, before entering the church or refectory. In the latter, the *prandium* took place, the only substantial meal of the day. There the monks broke fast *(disjunare)*, the term itself revealing how much this moment of the midmorning was welcome. At Cluny the standard fare of the three hundred monks consisted of bread and two cooked dishes, a porridge of boiled grains and beans and a platter of vegetables.

The enormous dormitory opened off the upper floor of the cloister. There the monks passed their most trying hours, enduring the constant lack of privacy, so oppressive to live with; the cold winters, which ravaged the body; and the stifling heat, which the roof accumulated in summer. Sleep, on a mat or pallet, was

TOURNUS, ABBEY CHURCH OF SAINT-PHILIBERT, DETAIL OF THE WEST FACADE, EARLY 11TH CENTURY
The Lombard bands and the sawtooth patterns; the small and irregular masonry; and the few and narrow openings demonstrate transitional features of the First Romanesque.

Opposite
CLUNY, ABBEY, GENERAL VIEW, LATE 11TH–18TH CENTURY
Once the center of a monastic empire, the special realm of prayer, a veritable city of monks, the motherhouse has left to it only a few remaining elements to evoke the power of Cluny in the year 1000. Of the immense third abbey church, known as Cluny III, with nave flanked by double aisles, the impressive vestiges of the larger of the two transepts have survived. Its height of 105 feet (32 meters) was amazingly audacious for the time. It is crowned by the famous "Holy Water" bell tower, eight-sided like a baptismal font, seen in the background.

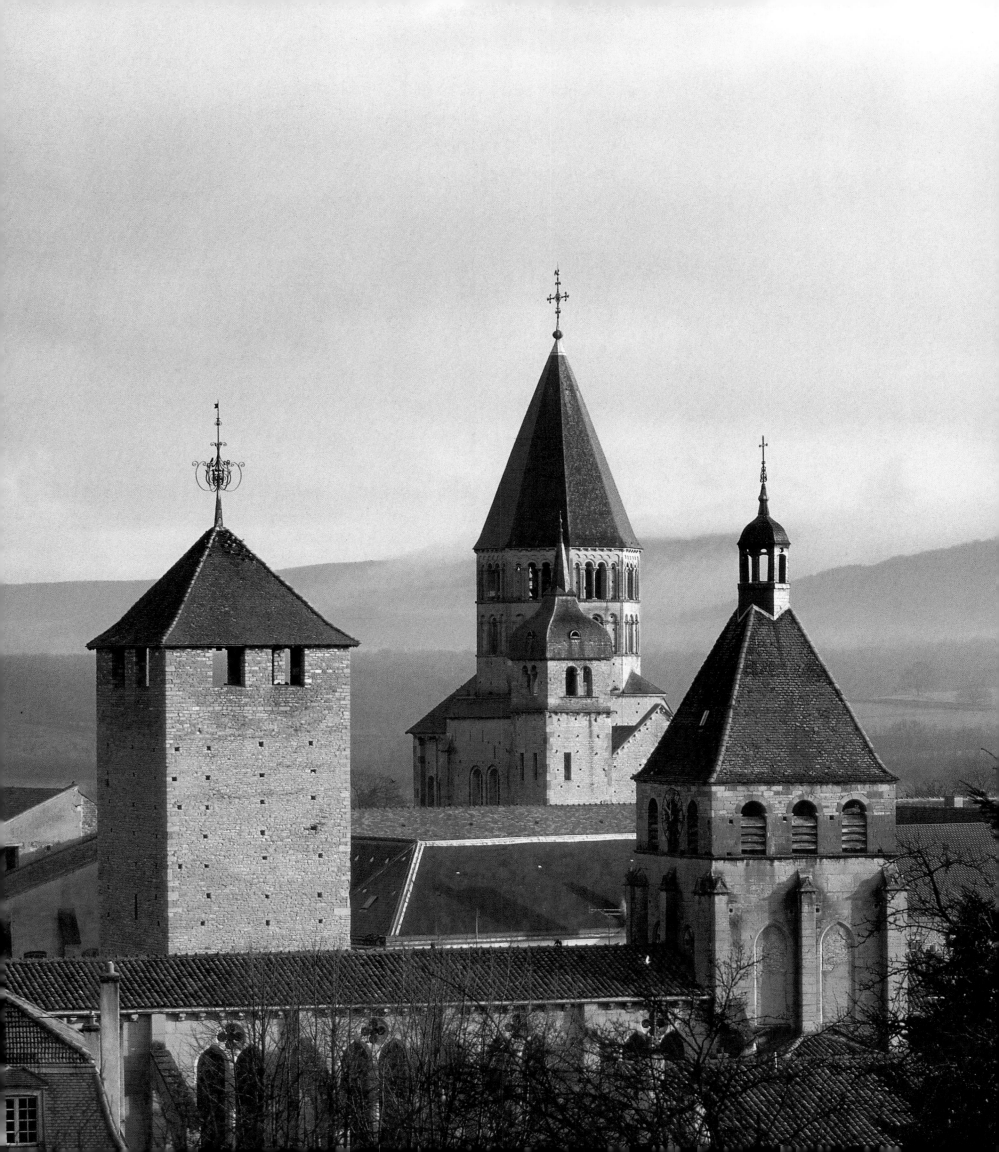

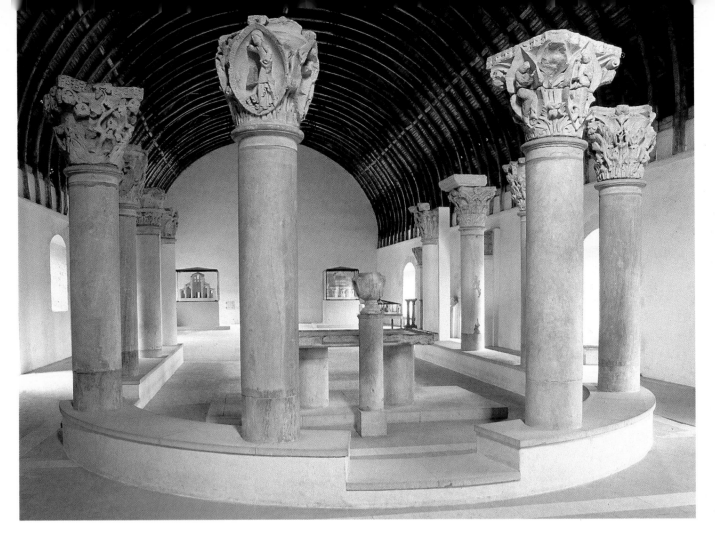

CLUNY

Founded on September 11, 910, in the county of Mâcon, the abbey of Cluny enjoyed tremendous influence in the Romanesque world. Nine hundred years later almost to the day, the majestic ruins of its church were destroyed with explosives. This was the rise and fall of a monastery once known as "the center of the world" or "the second Rome," the splendor and agony of its abbey church, which was, until the reconstruction of St. Peter's in the Vatican, the largest sanctuary in Christendom.

The abbot, who ruled, like a monarch, a congregation of some ten thousand monks at the turn of the twelfth century, submitted neither to the bishop nor to the king. He was answerable only to the pope, under whose protection the monasteries and their possessions were placed; these were, even at the beginning, far from inconsiderable. The abbey was located on a former *villa* (agricultural estate), whose lands, divided by a river and comprising fields, vines, orchard, woods, and mills, were worked by peasants.

Relieved of agricultural work, the monks devoted themselves to prayers as advocated by Benedict of Aniane, making Cluny a model of the type offering day-to-day help to passing pilgrims and the poor. In the eleventh century, supporting the spread of spirituality in the West, the order erected hospices with chapels as distant as northern Spain, where it helped to build up ecclesiastical facilities against the Muslims.

Cluny was able to adapt its spiritual and economic imperatives to nascent feudalism, maintaining advisory relationships with the nobility of the provinces and the wealthy and powerful of the West. Through gifts from the laity, tithes, and village incomes, the abbey amassed a veritable treasury of ecclesiastical objects made of gold and the greatest fortune in real estate in Europe, with more than two thousand holdings from Lombardy to Scotland.

A center for the intellectual elite, Cluny exercised its influence on the Romanesque world in the realm of architecture and sculpture, where the successive abbeys of Cluny II and III (following the designation of archaeologist Kenneth J. Conant) stand out. Although its style is not directly recognizable within the immediate surrounding area, its ideas about the ordering of volumes, monumentality, and rich figurative decoration were widespread. The majestic Cluny III, which was 614 feet (187 meters) long, encompassed double aisles and two transepts, whose two right crossings are to date the meager survivors. Only the majestic octagonal bell tower, called the Holy Water, still stands proudly, recalling a bygone splendor.

Overleaf
DIJON, CATHEDRAL
OF SAINT-BÉNIGNE,
CRYPT, EARLY 11TH
CENTURY
*On the eve of the year
1000, the Lombard
Abbot William of
Volpiano, who had
been summoned to
Burgundy, had a
Romanesque basilica
built in Dijon with a
sanctuary in the east
in the form of a three-
story rotunda, inspired
by the architecture of
the Holy Sepulchre in
Jerusalem. It was conse-
crated in 1018. Of the
rotunda, razed during
the Revolution, this
extremely early
Romanesque crypt, orig-
inally its lowest level, is
all that remains. The
capitals of the three
circles of concentric
columns, some of them
sculpted, constitute a
precious example of
Romanesque sculpture
in its infancy.*

CÎTEAUX

The golden age that Cluny experienced in the twelfth century foreshadowed a rapid decline, as an out-of-control monopoly suffered setbacks from excessive political involvement and a serious financial crisis, having overextended itself through the creation of urban schools and hospitals. In the first half of the 1100s, those who sought to join an order turned to a new Benedictine congregation: founded by Robert de Molesmes in 1098 in the forested wasteland of Cîteaux, it found a champion in the person of Saint Bernard, abbot of Clairevaux, who beginning in 1112 gave his heart and soul to the Cistercian movement. Thanks to this brilliant orator and astonishingly charismatic preacher—he called for the crusade, rooted out heresy, attacked the dialecticians, Abélard first and foremost, urged purification—the order spread within forty years to a network of more than three hundred abbeys. They would become the victims of the same kind of hierarchy as Cluny's, which led Benedictine monasticism to its downfall.

The ideology of Cîteaux rested on the stripped-down reading of Saint Benedict's Rule, as originally written. Saint Bernard, who ceaselessly denounced the profligacy of Cluny, extolled true poverty, a return to manual labor, and a more sober liturgy, in which sacred song nonetheless took on a capital importance. Grounding himself in the Scriptures, Saint Bernard taught that "in matters of faith and in order to know the truth, hearing is better than sight." The quest for spirituality transpired not only through an appreciation of the silence of the cloister but also through the praise of God reverberating in the human voice to the vaults of the church, which returned it, magnified, to the ears. The search for acoustic perfection thus became a determining factor in the design of Bernardine architecture.

ARRANGEMENTS IN THE EASTERN END OF THE CHURCH

The face of a religious building is expressed from the beginning through its plan. Burgundy explored the solutions passed down by Carolingian and Roman traditions, the better to free itself from them, and opened up new ways that brought the architectural forms of the eleventh century to their zenith.

The medieval interest in the crypt presaged the creation of the Romanesque choir with its apsidal ambulatory, where, on the eve of the year 1000, all the weight of the liturgy was focused. The emphasis on the eastern end of the building began early on in the crypts of Saint-Aubin (tenth century) and the cathedral of Clermont-Ferrand, where a gallery for circulating around the relics was designed. During this evolution we find two examples of eastern extremities in the form of a rotunda. That of Flavigny-sur-Ozerain, whose traces can be seen in the crypt, goes back to Carolingian times. The most spectacular example belongs to Saint-Bénigne in Dijon, designed by the Lombard Abbot William of Volpiano, summoned by the abbey of Cluny. Begun in 1002, this important product of the First Romanesque displays a longitudinal nave with double aisles, which extends to the east in a three-tiered rotunda, of which only the underground level escaped destruction in the eighteenth century. Its design was directly linked to the processional liturgy brought back into vogue by Volpiano. Made up of three concentric spaces surrounded by, respectively, eight, sixteen, and twenty-four columns, and with a diameter of 56 feet (17 meters), the crypt returns to the central-plan circular design, which was quite widespread in Roman and Early Christian architecture and continued in Carolingian experiments. The originality here lies in the superposition of three sanctuaries (underground, median, upper), which contained most of the altars in the church.

A generation later there appeared, in the church of Saint-Philibert in Tournus, a real choir with ambulatory. The principle was already a central preoccupation of the architects of Abbot Bernon of Cluny, who even before the year 1000 had opted for a single sanctuary to the east, oriented to the east, when they built the second abbey. This decision sounded the death knell of the "double-ended" (with two facing choirs) Carolingian and Ottonian churches, which had enjoyed a certain success.

The chevet at Tournus belongs to another intermediate stage. Whereas the semicircular apse is indeed surrounded by a semicircular ambulatory that connects with it, the three modest radiating chapels are still of an archaic rectangular form borrowed from pre-Romanesque churches.

Saint-Étienne of Nevers, which has not been much remodeled, presents a successful solution with a

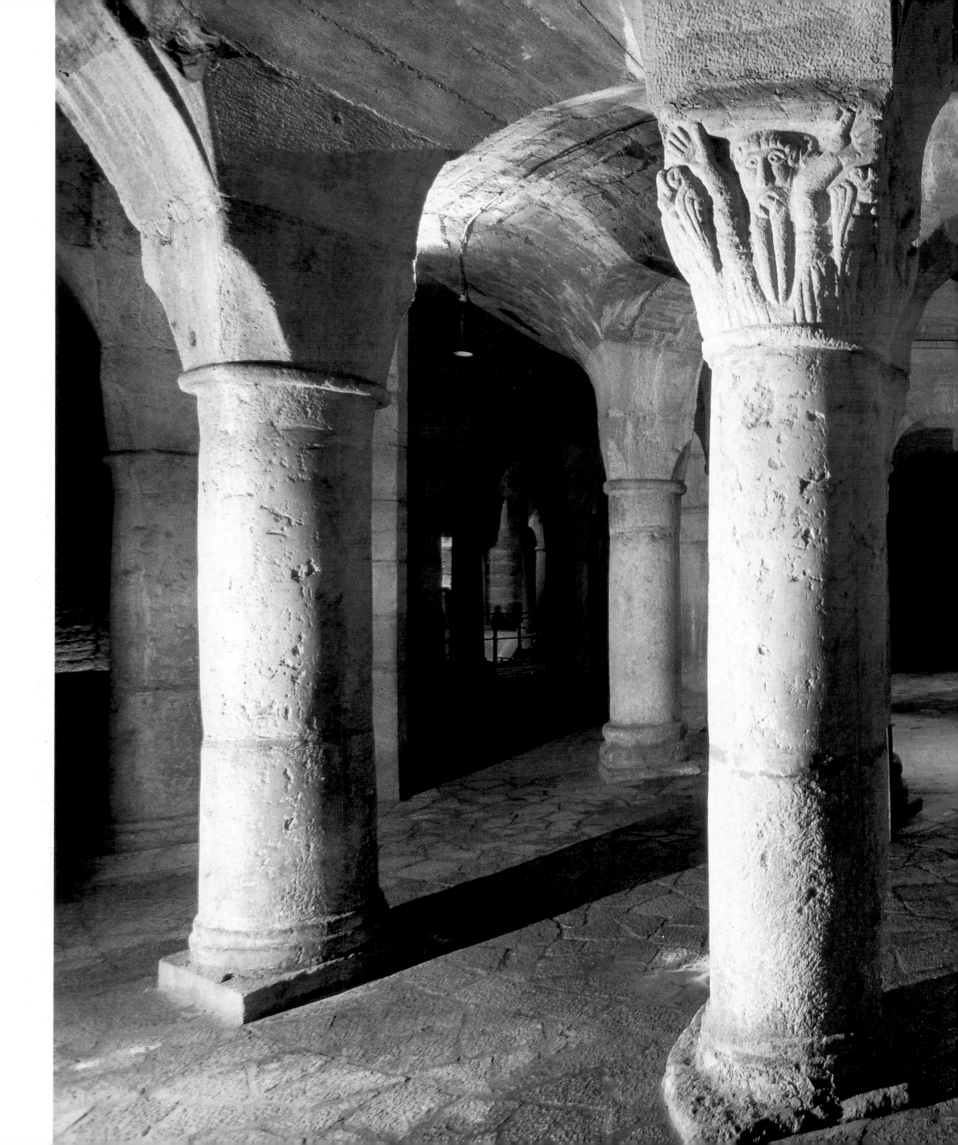

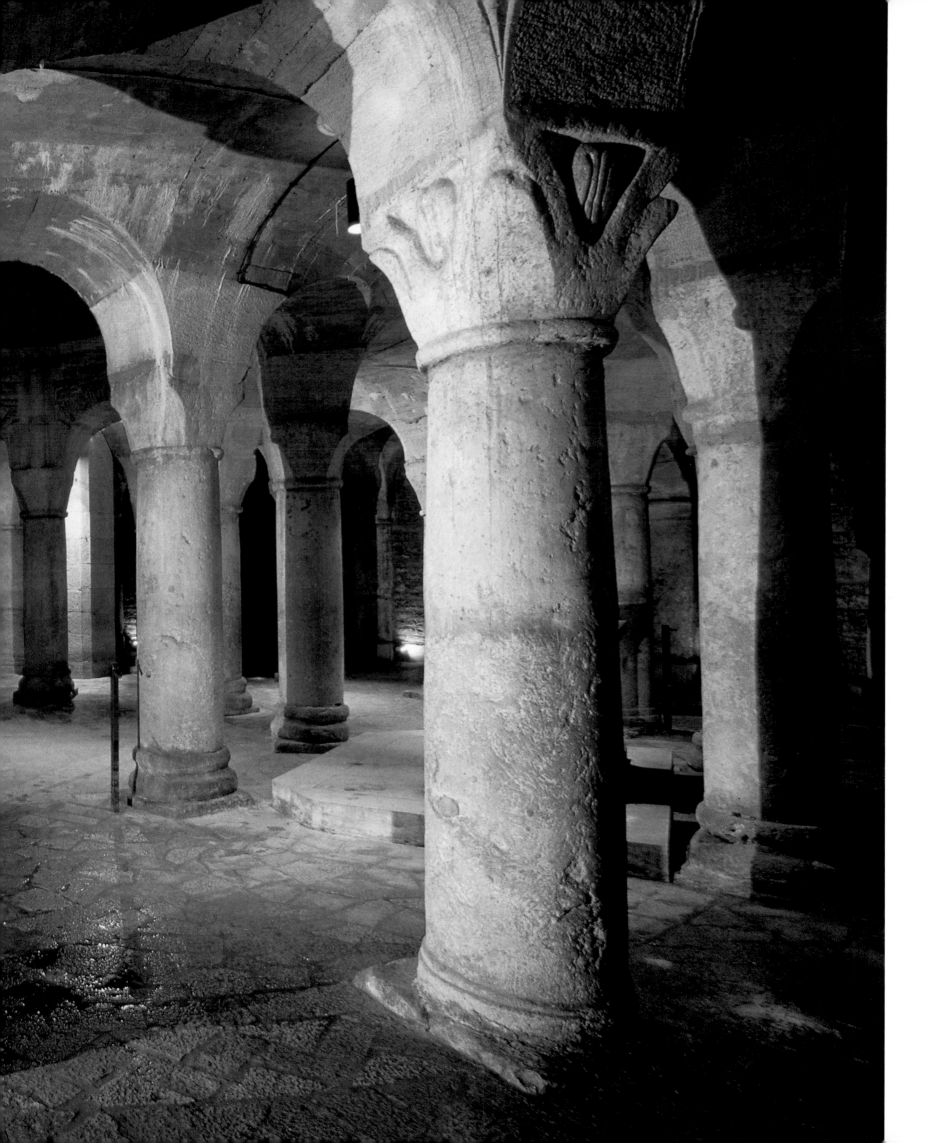

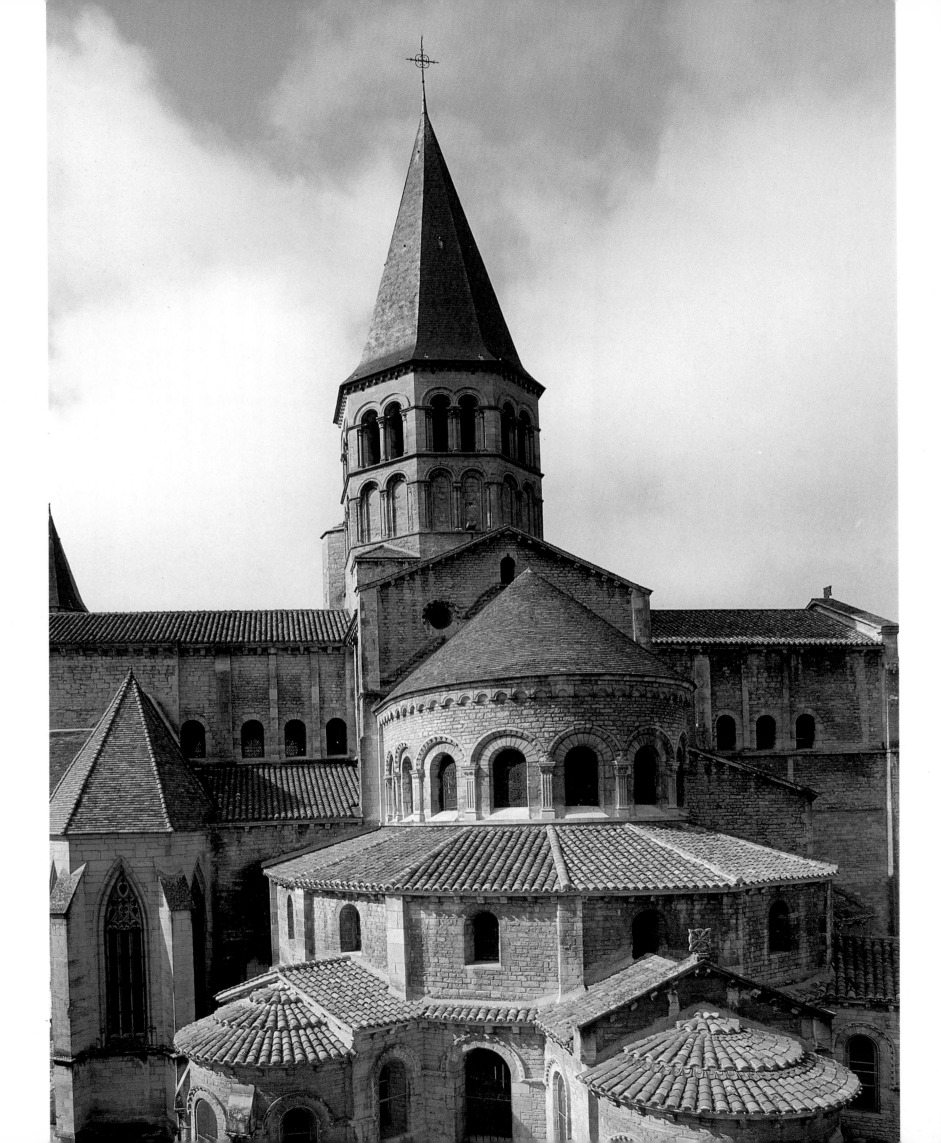

tiered chevet with three absidioles in a semicircle and two facing chapels, dominated by a massive transept. Unlike at Tournus, a real unity exists between the apsidal volumes, created by the alignment of the roofs and an interrupted stringcourse that outlines the edge of the whole.

PARAY-LE-MONIAL

The former church of the priory of Paray-le-Monial reflects the ordering of volumes as it had been conceived for Cluny III, of which it is the faithful replica in lesser dimensions. The ascending movement that constitutes the appeal of the tiered Romanesque chevets is here fully realized, while the gaze assimilates the breakdown of volumes up to the majestic tower surmounting the crossing of the transept.

Cluny III's immense and expansive chevet disposed no fewer than fifteen radiating chapels and absidioles around its ambulatory and to the east of its double transept. The illumination, very advanced in this part of the building, was provided by high and low windows, anticipating the Gothic vision of light.

THE ARRANGEMENT OF THE CHURCH'S WEST END

Early Christian basilicas, which were preceded by an atrium (courtyard), began with a narthex, a sort of gallery where the future members of the Christian community who had not yet been baptized stood. The narthex outlived its function, becoming transformed into the porch in the Carolingian period, when the design of twin towers was perfected. This new antechurch proved popular in the Romanesque period under the name of *vestibulum* or Galilee. This last term evokes the region where Christ went as a preacher to bring enlightenment "to the Gentiles." Become by the end of the period a meeting place for the faithful laity, it was the last stage of the processional liturgy before it penetrated into the church properly speaking.

Most porches were surmounted by an upperstory tribune-chapel dedicated to the archangel, Saint Michael. At the church of Saint-Vorles in Châtillon-sur-Seine (981–about 1015), the avant-corps takes the form of a western transept. At the abbey church of Saint-Philibert of Tournus it rises, with an austere air—again borrowed from the Carolingian spirit—

between the towers it joins. The interior—built after 1006—is very impressive, with its thick stone piers that bear the supports of the upper room, which opens on the nave. That of Cluny II, which has disappeared, consisted of a great empty space surmounted by two square towers (the Barrabans). At Paray-le-Monial (1050–80), access to the upper story was gained by a staircase built into the thickness of the wall of the facade. The Charolais church of Perrecy-les-Forges presents the most beautiful Burgundian example of a porch opened by semicircular arcades,

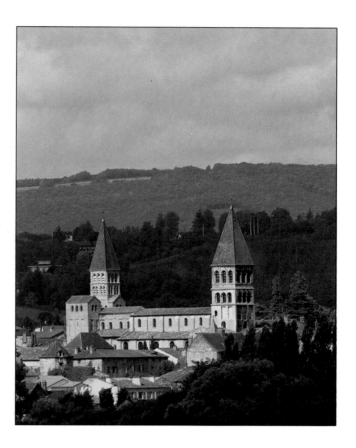

as at its neighbor, Mont-Saint-Vincent, where the preRomanesque influence was still strong.

The jewel of such structures in Burgundy was built at Vézelay, following construction of the nave, between 1140 and 1160. This consists of an antechurch closed by a facade (remodeled in the nineteenth century by Viollet-le-Duc), famous above all for its three interior portals opening onto the church. Its imposing dimensions and the presence of stone benches recall its important role in containing gatherings of pilgrims—Mary Magdalen was venerated in the basilica—for penitential processions led by the monks. It also transcends its function as a simple threshold through the theme of the central portal, which exalts divine light, baptism, and the developing church, which the faithful looked

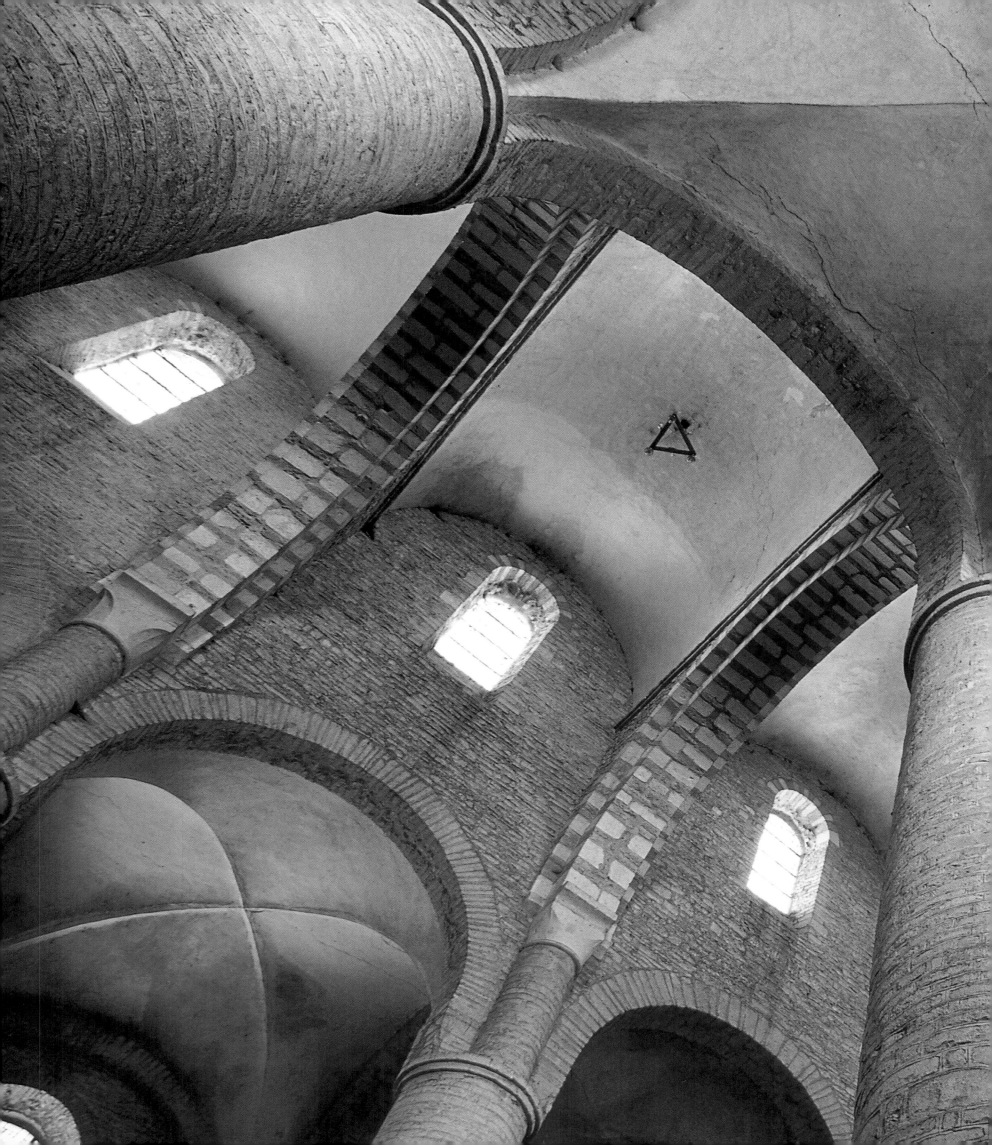

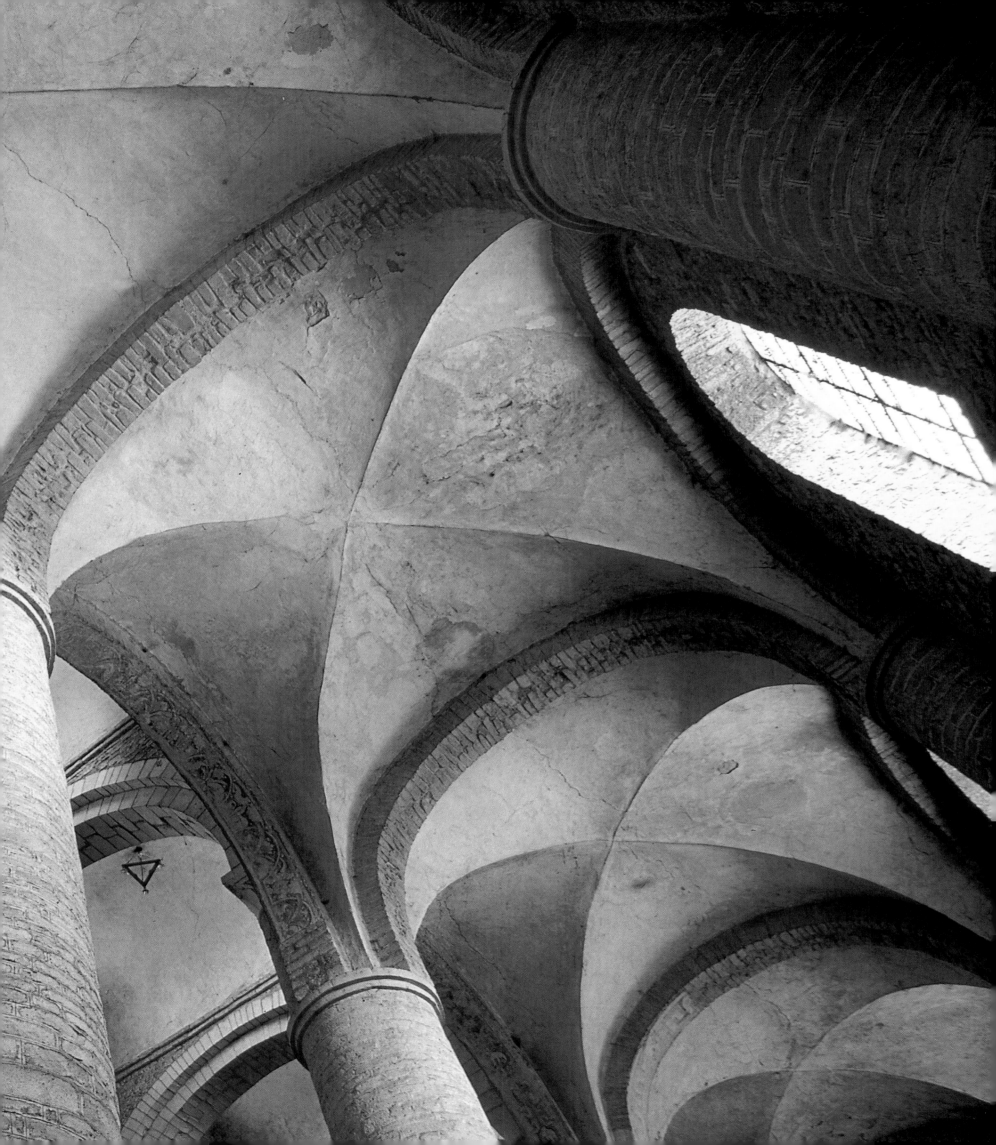

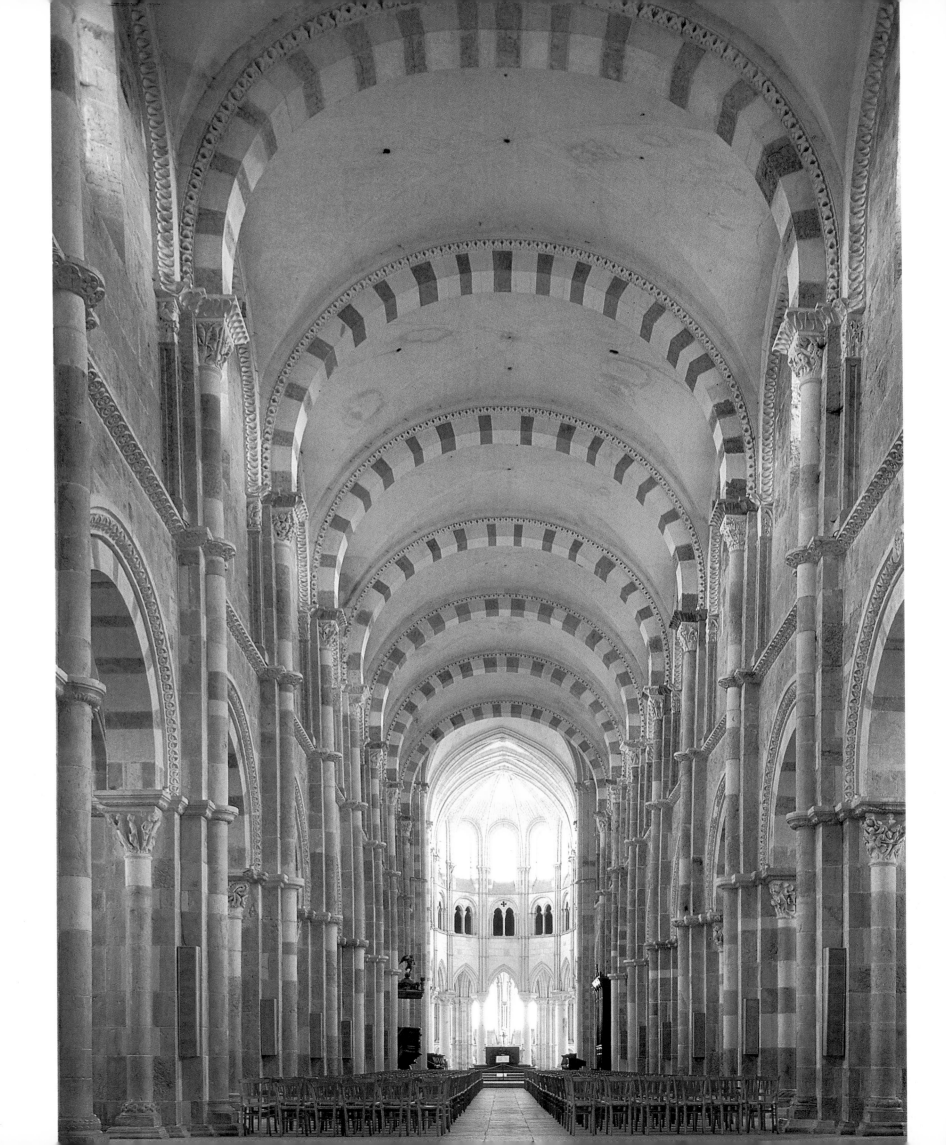

on as they prepared to enter the nave and proceed to the sanctuary where they would receive the Eucharist.

VAULTS AND ELEVATION

The architects of Burgundy particularly concentrated their attention on the vault and its supports, trying many solutions that finally led them to the unification of the roofing. The barrel vault of the western gallery of Saint-Philibert in Tournus, one of the first vaulted central naves, is divided by transverse barrel vaults, which we again find in the main space of the same church, an original system that did not attract much of a following except among the Cistercians. The groin-vaulted aisles, on the other hand, are very widespread, whatever design may have been chosen for the nave: semicircular barrel vault for the small churches of the Brionnais, pointed barrel vault in the style of Cluny at Paray-le-Monial, Saint-Lazare d'Autun, and Druye-les-Belles-Fontaines. Investigations of balance culminated in Anzy-le-Duc, which displays the first uniform use of groin vaulting, as well as later on in Gourdon and Véze-lay, opening the way for the Capetian rib vaults.

The Vézelay-style nave gains its charm from transverse ribs of alternating ocher and white vous-soirs. The origin of this style remains unknown. The Cluny-inspired elevation is extremely dynamic. Here is the kingdom of the pointed arch, of the nave with three levels and a false triforium, friezes of rosettes (as in the cathedrals of Langres and Besançon), and fluted pilasters punctuating the walls, as at Autun, where they were inspired by the ancient gate of Arroux at the entry of the town.

The vertical impulse of the Cluny-inspired abbey summarizes all the audacity of its architects, who raised it to 100 feet (30 meters) under the vaulting over a nave 33 feet (10 meters) across, thus prefigur-ing Gothic proportions.

CISTERCIAN CHOICES

The former abbey of Fontenay is one of the most complete Cistercian groups in Europe. The second "daughter" of Clairvaux, its abbey, erected from 1139 to 1147, perfectly illustrates the precepts of Saint Bernard. The blind nave, roofed in pointed barrel vaults with transverse ribs, is flanked with aisles whose

transverse barrel vaults ensure its stability, a solution found in Tournus. For the Cistercians, the monastic liturgy took place in the nave, which explains the mod-est dimensions of the sanctuary with its flat end, pre-ceded by a transept that gives the church its cruciform shape. Besides acoustics, illumination was the object of extensive investigation, which led to indirect light-ing by way of the side aisles and especially the east and west walls, pierced with numerous bays, which favored the illumination of the central space.

With the death of the holy abbot in 1154 his strictures melted away: Clairvaux rebuilt a curved apse, and Fontenay covered its forge and chapter hall with rib vaults.

THE PORTALS: THE PINNACLE OF THE IMAGE

The development of monumental sculpture reached its summit with the conquest of the western facade. In Burgundy, this favored surface was framed with ornamental and historiated decoration. Following the First Romanesque sculpted lintels in Roussillon, sculpture reached the tympanum by the end of the eleventh century. The extension of carved relief to the arches above the doors marks the last stage in this evolution and produced a series of masterworks, all to be found on the main portals, which between 1100 and 1150 contained most of the surface that was sculpted. Such doors accentuate the principal entry at the west of the building. Cluny and Vézelay established the design of triple doors, which became widespread among Gothic facades (Saint-Denis, Chartres).

The Romanesque portal of the twelfth century tries for grandeur, risks color. It balances, through its presence in the west of the church, the flowering of the chevet to the east. While the lintel of Saint-Genis-des-Fontaines gives the impression of being an afterthought, portals a century later bring about a per-fect integration with the monuments, due to their triple role: architectonic, didactic, and aesthetic.

Christ sits in triumph on the western portal. The image of God made a man was thrust on the faithful in various forms, depending on the scriptural sources that inspired it. The tympanum became the favored medium since, symbolically, entry into the house of God takes place through Christ. "I am the door: by me if any man enter in, he shall be saved" (John 10: 9).

Burgundian Capitals, from Cluny to Vézelay

WE ARE STILL unsure of the meaning of the abstract concepts that the iconographic program of the capitals of Cluny attempted to bring to life, especially since the arrangement of the capitals, as reconstituted in the Musée du Farinier in Cluny, remains uncertain. It nonetheless seems possible to detect, through the themes chosen, a symbolic progression, sometimes read on many levels. Thus, starting with a Corinthian capital, a metaphor in itself for the vegetable kingdom, we go to one that depicts a beekeeper and a hive, an evocation of human life through work, or perhaps an allegory of the virginal conception of Christ (it was believed in the Middle Ages that bees reproduced by parthenogenesis). There follow mutilated faces, which have been interpreted as athletes, a probable tribute to the classical culture that inspired Cluniac thinking. Is it the concept of Reason meant to be illustrated here, or at least the activities of the mind? Supporting this hypothesis, the next two capitals praise the spiritual virtues of monastic life: theological virtues on one—Faith, Hope, Charity, Humility(?)—cardinal virtues on the other— Justice, Strength, Prudence, Temperance—which are all means of reaching God. The four Evangels are symbolized here by the four streams of Paradise, which feed four luxurious trees full of fruit, representing the Divine Word that feeds the soul. After the meditation on these texts, the program ends with an evocation of monastic services, through the eight notes of the plainsong, so dear to Benedictine monasticism.

The role of architectural sculpture goes far beyond simple ornamentation, however beautiful it may be. Taken individually or as a whole, each of these capitals bears a theological message, an iconographic originality that seems to have sprung suddenly from the Burgundian soil. Subsequently, following the example of Cluny, great sequences of capitals (a hundred or so) were placed in the naves and transept of Vézelay, Saulieu, and Autun, vying with each other in variety and fantasy. The written and oral sources they drew on juxtapose the sacred and the pro-

fane, the solemn and the picturesque. The saints, present everywhere, add to the glory of the church. Inspired by hagiographic literature, the capitals sometimes depict the most venerated among them, such as Saints Peter, Paul, Stephen, Martin, Anthony, and Benedict, sometimes others less often represented, like Saint Eugénie at Vézelay, with her extraordinary story of a woman disguised as an abbot.

These series of capitals have as a single common denominator the illustration of the struggle that pits Christ and the Church against the forces of evil, manifest in many aspects, from Satan and his helpers to the individuals who serve him: Woman, the temptress, whom he makes his instrument; entertainers; the false prophet Balaam or Simon Magus (the Magician), creator of illusion. The sin of idolatry is recapitulated by the adoration of the Golden Calf, that of avarice by the parable of the rich man; even suicide is castigated, with the image of Judas hanged or of the demon of despair driving a blade into the body. While all these historiated capitals repeat the same themes, no doubt under the influence of Cluny, they nonetheless display very different styles.

Below left
SAULIEU, BASILICA OF SAINT-ANDOCHE, CAPITAL DEPICTING THE APPEARANCE OF JESUS TO MARY MAGDALEN, MID-12TH CENTURY

Below right
VÉZELAY, BASILICA OF THE MADELEINE, CAPITAL DEPICING THE MYSTIC MILL, AFTER 1120

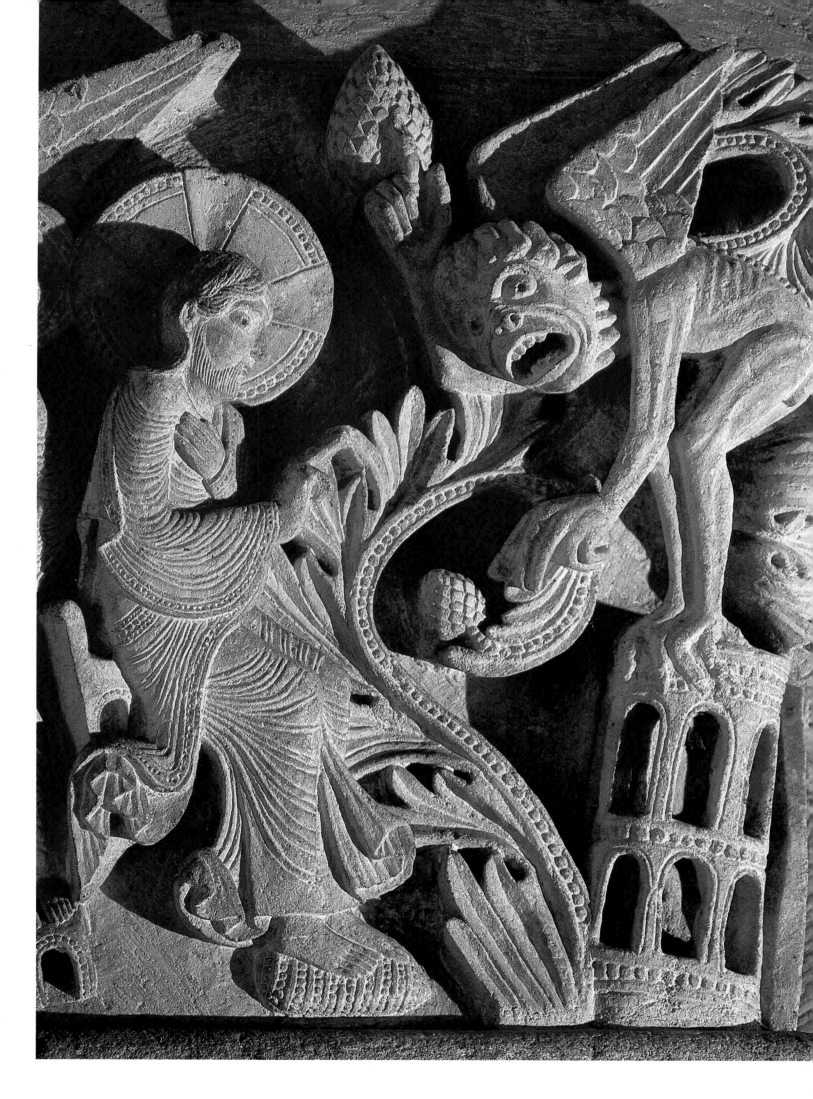

AUTUN, CATHEDRAL
OF SAINT-LAZARE,
CAPITAL IN THE NAVE
DEPICTING THE
TEMPTATION OF JESUS,
C. 1120
*The great cycles of Bur-
gundian capitals, more
or less contemporary,
often take up identical
themes; the Temptation
of Christ in Autun may
symbolize the soul in
its struggle with evil, a
common theme. The
gesticulating body of the
Devil, screaming with
his mouth wide open,
seems to embody despair
as he confronts the
serene face and calm
attitude of Jesus. Véze-
lay presents more dia-
bolical figures—at least
fifteen, simultaneously
terrible and ridiculous—
than any other religious
building. The simian
features and the lean
angular body of this one
can also be seen in the
representation of Hell
on the Autun portal.*

The most widespread theophany in the Romanesque Middle Ages is that of Christ in Majesty, enthroned in a hieratic posture. The glory that surrounds him, most often a mandorla, is delimited by the tetramorph formed by the four grouped symbols of the Evangelists: the eagle of Saint John, the young man of Saint Matthew, the bull of Saint Luke, and the lion of Saint Mark (seen at Mars-sur-Allier, Cervon, and Til-Châtel). Elsewhere, angels accompany the divine figure, praising him, pointing toward him, or bearing his mandorla. Sometimes they are standing, raising their long wings at Anzy-le-Duc and Perrecy-les-Forges, or bending their knees under the effort, on the north portal of Charlieu and at Saint-Julien-de-Jonzy, both created by the same artist in a very dynamic style that borrows from classical models. On the west facade of the former priory church of La Charité-sur-Loire, Christ blesses the abbey—an offshoot of Cluny—in the person of Monk Gérard, its founder.

The central portal of the antechurch of the basilica of Vézelay, one of the most fascinating in the region, depicts an eschatological vision whose complexity makes it difficult to understand. Christ on his throne sends his apostles on an evangelical mission. He is the messenger of the Father and gives them the gift of the Holy Spirit, symbolized here by the rays that shoot from his open hands. "And ye shall be witnesses unto me both in Jerusalem, and in all Judaea, and in Samaria, and unto the uttermost part of the earth" (Acts 1: 8). The scene depicted is not specifically that of the Ascension, nor that of Pentecost. Saint Peter, seated to the right of Christ, and Saint

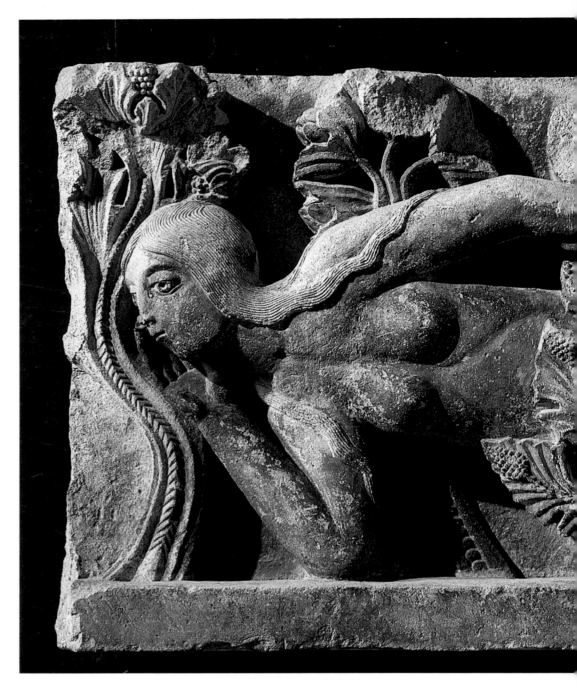

THE PORTAL OF THE CATHEDRAL OF AUTUN

Sculpted about 1130 in a limestone not native to the region, the portal of the cathedral of Autun belongs to a group of great historiated Romanesque portals created in France between 1120 and 1140. It is the work of the sculptor Gislebertus, whose name may be read in the center of the inscription on the lintel.

At the cathedral, erected at the summit of the town, the body of Saint Lazarus was venerated. Bishop Étienne de Bagé, a disciple of Cluny, undertook to build a sanctuary worthy of the important relic, preserved in a monumental tomb (dismantled in the eighteenth century; Musée Rolin preserves fragments of sculptures in the round). The size and grandeur of the portal, housed in a porch laid out on a slope, was related to the importance of the place. An immense Christ, seated on the heavenly Jerusalem, dominates the entire upper portion of the tympanum in a compressed composition, seemingly disorganized but in reality very rigorous. The sculptor focused attention on the weighing of souls, in which the archangel Saint Michael and Satan work respectively for Heaven and Hell. If, as always, the grinning devil cheats by putting all his weight on the balance beam to "win back" a soul, the message delivered by this majestic work is the most important tenet of Christian faith: redemption. Life eternal is promised to all those who are willing to turn toward God.

FRAGMENT OF A LINTEL FROM THE CATHEDRAL OF SAINT-LAZARE DEPICTING EVE. MUSÉE ROLIN, AUTUN
Formerly in the north portal of the cathedral of Saint-Lazare, this lintel, crafted by Gislebertus, also responsible for the Last Judgment on the west facade, presents a most original vision of original sin. The scene of Eve seizing the fruit from the jaws of the serpent is bathed in sweetness and sensuality: Eve's breasts are

the most important portal comes last. By his sacrifice on the cross (merely suggested here by the horizontal position of his arms and the cruciferous nimbus), the God "who was made flesh" triumphs over death.

The measurement of terrestrial and celestial time is usually marked in Romanesque facades by a zodiacal calendar. Its twelve symbols appear on one of the enclosing arches of the tympanum, joined to a cycle of the labors of the months, established according to the seasonal requirements of nature and local rural customs. At that time, the reading of the sky and the movement of the stars was linked to the concept of divine creation. At Vézelay, a crane with a raised foot, a symbol of vigilance, appears in a half medallion placed beside the sign of Cancer, corresponding to the summer solstice, between June 21 and 24. It was still believed, in the twelfth century, that the stars revolved around the Earth. God is the master of time through the intermediary of Nature, who inexorably renews her cycle year by year. This explains why calendars glorified the nourishing Earth and the labor she required month after month. In the same line of thought, the "mistakes" of nature (bad weather, bad harvests) or other unaccustomed displays of the heavens are interpreted as signs from God as well.

We cannot leave Burgundian sculpture of the twelfth century without mentioning a trait common to all of its different styles: a strongly marked expressivity, a "mannerism" arising from artists who made light of all difficulties. On the portals of Anzy-le-Duc, Autun, and Vézelay, as on the capitals of Cluny, which preceded them, the thin figures are unnaturally elongated, their outlines angular, their movements jerky. This distortion of forms, sought for didactic ends, is reinforced by the low relief of their bodies, which are covered with a light drapery of many thin parallel pleats that wrap around elbows and knees, fly away, zigzag, or inflate at the bottom of the clothes to signify the celestial wind. The very dense composition of Gislebertus at Autun forces the characters to adapt themselves to the constraints of the frame and arranges them in a hierarchy according to their spiritual dimensions. In the same way, their disproportionate heads—which seem to spring from the pedestal—and hands concentrate the gaze on the significant symbolic gestures in the image. The frenzy that animates the bodies at Charlieu and Saint-Julien-de-Jonzy is inspired by Hellenistic models. In spite of their marvelous craftsmanship, the two works mark the decline of Burgundian sculpture.

finely modeled and her long hair emphasized; her face is dreamy, her body sensual. Earthly Paradise is symbolized by stylized vegetal motifs cleverly arranged in their subordination to the frame.

Paul, standing, both carry keys, attributes that identify them as the founders of the new and universal church. The other disciples have their heads facing different directions, to accentuate the centrifugal movement of the composition and to point toward the lintel and the curvature of the tympanum, where representatives of the peoples of the Earth appear.

This portal can be understood only in conjunction with the two smaller ones on either side, which follow a "chronology" of events. These begin on the right portal, where the Incarnation of God is illustrated through the episodes of the Annunciation, the Visitation, the Nativity, the Annunciation to the Shepherds, and the Adoration of the Magi. To the left, the resurrected Christ reveals himself to the pilgrims of Emmaus before his ascension. In the iconographic progression,

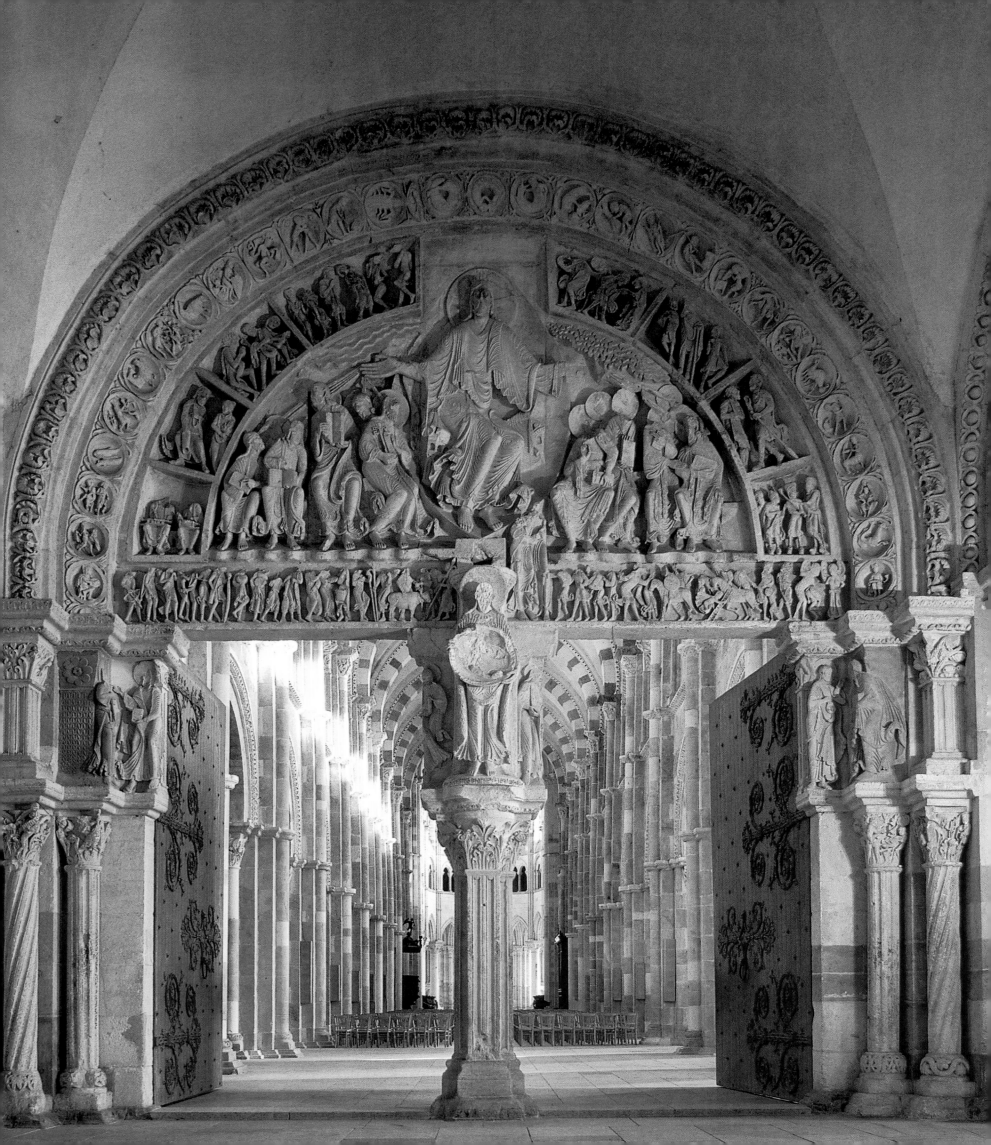

On the great central portal of Vézelay, the immobility of the immense Christ who calls down the Holy Spirit contrasts with the turbulence that surrounds him: the Apostles spreading the Good Word are matched with the people who are already converted and those who have not yet received the Gospel. The creatures of the Earth, some real, some fantastic, follow in a line starting from the extreme left of the lintel, in the form of nomads armed with bows, peoples of the land and sea, warriors, pygmies, and strange beings with large ears and bodies covered with feathers. The ethnographic journey continues to the right of the tympanum with Armenians shod with clogs and ends with mythical dog-faced baboons, which precede the miraculous healing of the paralyzed and the lepers. All, by their presence, emphasize the universality of the Church.

The illustrated calendar was in use in Roman antiquity, which left pavements of mosaics representing the Four Seasons or personifications of the year. The Roman calendar was used most often to decorate the edges of portals and sometimes for doors and baptismal fonts; it can be found on a pillar at Souvigny.

At Vézelay the calendar that unfolds in thirty and a half medallions on an inner arch of the portal covers the period of the solar year. The twelve signs of the zodiac accompany the labors of the months, in which rest and amusement have their place. This mirror of the profane life, predominantly rustic, refers to a play of numbers that the ancients already practiced, thanks to their knowledge of astronomy. The "terrestrial" medallions are geometrically arranged in relationship with the "celestial" medallions. Thus, the equinoxes of winter and summer, represented by the Ram and the Scorpion, which illustrate the two moments of the year when the length of the day equals that of the night, appear symmetrically at an equal distance from the axis of the tympanum where the Logos incarnate, seated in his glory, evokes the sun.

FRANCHE-COMTÉ

Although it became part of the Germanic Holy Roman Empire in the eleventh century, Franche-Comté remained French-speaking. Like the western portion of Burgundy, it also experienced a set of diverse tendencies that shaped its Romanesque art in the twelfth century.

The most important, that of the Holy Roman Empire, is reflected notably in the spread of timber-roofed churches, which did not become vaulted until the Gothic period. The borrowing of Ottonian forms can be seen in the arcaded naves, where quadrangular pillars—or those with chamfered corners—alternate with cylindrical supports, as at Faverney, Baume-les-Messieurs, Arbois, and Lons-le-Saunier. The cathedral of Saint-Jean in Besançon adopted a Carolingian plan with two facing apses. A more specifically Rhenish style is evident at Froidefontaine, with round but stockier piers.

Chevets are polygonal, flat, or constituted of a triple apse, as at the former priory church of Lieu-Dieu and at Saint-Lupicin, both products of the First Romanesque that bear the exterior marks of influence from Como, perhaps by the intermediary of Tournus. Walls and towers are punctuated by lesenes and Lombard bands at Boussières, Melisey, and Saint-André-de-Bâgé, the principal Romanesque building in Bresse.

The influence of Burgundy increased in a second phase, thanks to the roads linking its principal monasteries with those of Franche-Comté. The Cistercian order is behind the vaulting of a number of buildings in the south of the region, most often banded pointed barrel vaults (Saint-Maurice-de-la-Ferrière in Jougne) and groin vaults in the aisles (Château-Chalon). Cluny II, which controlled many monasteries in the area, corrupted the masterworks of Romainmôtier and of Payerne, today in Vaudois Switzerland, and of Baume-les-Messieurs, Gigny, and Notre-Dame de Mouthier-Vieillard in Poligny on the French side, notably by the addition of towers.

The church of Saint-Christophe in Camplitte and the priory church of Marast recall, respectively, the influence of Champagne and Lorraine.

Franche-Comté is poor in sculpture. The cycle of capitals in the cathedral of Besançon offers an exception. Created late, in the middle of the twelfth century, in a heavy picturesque style, they reflect the conservatism of the Romanesque in Franche-Comté, which made use of designs perfected in neighboring regions. The cathedral, however, boasts a circular altar, consecrated in 1050 by Pope Leo IX, of great beauty. Hollowed out in the style of Languedoc altars, it has eight great lobes to hold the hosts to be consecrated.

Western France:
A Mosaic

A SPIRIT OF independence drove the dukes of Aquitaine, counts of Poitou, in the eleventh century. The Aquitaine of that time was an imposing group of provinces that occupied half of the western lands of France, from the Loire River to the Pyrenees, from the Atlantic Ocean to the heart of Auvergne (with the exception of the county of Toulouse), in all, composing a third of the entire country. In comparison with the royal domain, it was an enormous area. Guillaume V (990–1020) went so far as to give himself the title "duke of all the Monarchy of Aquitaine," so true was it that the whole of his domain resembled a kingdom. He and his successors maintained excellent relations with the great foreign sovereigns, notably with the kings of England.

The consolidation of the duchy was owed to the famous Gui Geoffroi (Guillaume VIII, 1058–1086). He reacted harshly to his vassals' attempts at independence, burning Limoges in 1082, making Saintonge his own by driving out the Angevins, and in 1070 successfully claiming the inheritance of the duke of Gascony, which gave him Bordeaux and all the lands as far as Spain. The most independent of the Guilhems was no doubt his son, the ninth of the name. The most powerful man in France, he was also one of the first troubadours, whose rather libertine poems *(cansos)* also foreshadowed courtly love in their sensitivity. He refused to swear allegiance to King Louis VI, whom he pretended to ignore, and challenged the Church over his excommunication, which he earned through his lack of scruples in marital affairs.

In spite of the rivalries between vassal lords, which were part and parcel of feudalism at the time, the lands of Aquitaine enjoyed real political unity. They constituted a formidable mosaic of provinces with different personalities. Some, like Poitou and Angoumois, proved to be very strong, while others, like Aunis, the Vendée, Berry, and Gascony, which looked toward Spain, behaved as satellites.

Romanesque creativity in the lands of the West was promoted less by help from the dukes than by the rise of monasticism. It also benefited from a terrain that produced easily worked stone and a prosperous economy supported by a network of roads, composed of ancient Roman avenues and more recent routes linking priories to their mother abbeys. The convergence of major roads and their offshoots, which crisscrossed the countryside, led to the prodigious impact of pilgrimage to Compostela on the western regions.

CHAMPAGNOLLES, SCULPTED CORBEL *The eclecticism of Romanesque subject matter extends to the more or less discreet presence of erotic figures. While some of them carry moralistic messages (like the naked woman devoured by snakes), many have no particular symbolism. Taken individually, some of these representations are surprising or shocking, but they should nevertheless be viewed as part of the iconographic program of the building. From this perspective, their presence marks the Church's acceptance of the world in all its diversity, a world it is entrusted to lead to salvation. The Church was not unaware of the idolatrous practices of the times—although it disapproved of them—nor of the fact that representations of genitals on houses were believed to be endowed with a talismanic power. This kneeling figure, exposing a megaphallus, comes from the region stretching from Poitou to the Gironde, where a concentration of obscene reliefs is found.*

The Middle Ages produced women with strong personalities, the very beautiful Eleanor of Aquitaine the most fascinating among them. Bold and adventurous, she is one of the great political figures of her time, traveling the world from Constantinople to Antioch as she accompanied her devout husband Louis VII, king of France, on the Second Crusade, then, after her first union was dissolved, in 1152 journeying to London, where she was crowned queen of England at the side of her new husband, Henry II Plantagenet, count of Anjou, duke of Normandy. She reigned over an immense country, which extended from London to the Pyrenees, and watched over the entire Atlantic coast (Eleanor would write the first compendium of maritime laws). She controlled its towns, lands, and châteaux in Normandy, Maine, Anjou, Touraine, Poitou, Guienne, and Auvergne. By its very size the Plantagenet empire threatened the rise of the Capetians, and warfare between them eventually led to the fall of the Anglo-Angevin dynasty. Guienne then remained the only continental relic of a bygone power.

EXPERIMENTS ON THE LOIRE

Laid waste by the passage of the Normans, the lands of the Loire underwent a recovery that first took shape in Angevin territory at the turn of the eleventh

century: the beginnings of the region's Romanesque history are linked to the work of a single man, Count Fulk Nerra, who ruled as far as Saumur and proved to be a great builder. Thanks to him the river regained not only its economic but also its strategic importance, as attested by the numerous keeps that he had built, which would inspire the square towers of the Loire churches. His son Geoffroy Martel likewise appointed himself the patron of monasticism, which reestablished itself around such prestigious institutions as Cunault, Saint-Aubin, and Fontevrault.

Simultaneously with the period of the First Romanesque, the Loire developed an early artistic center, one that owed less to its innovative character than to an exploitation of concepts from antiquity and the early Middle Ages. The same may be said of its stonework, which imitated that of the late Roman Empire. It sometimes took the shape of stringcourses of slanting bricks, harmoniously integrated into the rubble-stone masonry to level the stone courses, which we already see in the south and west walls of the tenth century pre-Romanesque church of Savannières. Elsewhere we see walls in a herringbone arrangement or patterned with petals or hexagons, which embellished the sober gables and tower-porches (Saint-Mexme in Chinon, Azay-le-Rideau).

When decorative elements from older buildings were not available for reuse, figurative ornamental friezes, which drew on an older or eastern iconographic grammar transmitted through small reliefs in ivory and precious metals, took their place. Made of easily worked tufa, they became widespread. Their distribution—notably in tiers on the facade—prefigures the great Aquitaine frontispieces (principal facades or prominent element of the principal facade) or the crosses that embellish the pediments of Berry.

In this uniformly adulatory reappraisal of the past, the ornamentation of the keystone of the archivolts, decorated with plant and animal motifs, following the example of Saint-Mexme in Chinon, is a creation that Poitou and Angoumois freely turned to their own account. They also made use of the precocious column-buttresses in architecture and wall painting, both entirely local.

The Second Romanesque style of this region is marked by a converse flow and absorption of outside influences from every direction. In Anjou these are included, to a limited extent, in a preestablished style that remains very sober but that, in the twelfth century, adopts a giganticism, which in some buildings, such as Saint-Aubin, takes on surprising dimensions. The projecting transepts are accompanied by aisles to the east, following an idea that came from the abbey church of Conques in Rouergue; the great choirs resemble those of the basilica of Saint-Martin of Tours, the abbey church of Fontevrault, and the cathedral of Angoulême. The latter, along with Saintonge, may have inspired the opulent sculpted decor that overran Cunault.

In Touraine, whose capital had become one of the largest economic centers in the lands of the west through pilgrimage and its fairs, an artistic catholicity exploded in numerous building sites: Saint-Martin in Tours, no longer extant, borrowed from Saint-Sernin in Toulouse and Marmoutier in England, while Aquitaine subtly influenced the portal sculpture of the vestibule of Saint-Ours in Loches and in the priory of Saint-Léonard in L'Île-Bouchard. On the other hand, Le Liget, Tavant, and Genneteil became famous for their important painted narrative cycles, whose origins may be found in the indigenous production of illuminated manuscripts, and which spread to Poitou and Berry.

THE MYSTERIES OF FLEURY (SAINT-BENOÎT-SUR-LOIRE)

The middle Loire was divided into various possessions: Blois belonged to a count, Orléans was property of the king, as was the majestic abbey of Saint-Benoît (formerly Fleury III) nearby, reworked in several stages from the first half of the eleventh century until the end of the twelfth.

Dating back to the seventh century, the religious establishment of Saint-Benoît experienced a first golden age under Charlemagne. Following the lead of Cluny, in the year 1000 it authored a movement of monastic reforms and assumed, like Saint-Martin in Tours, the role of intellectual and artistic beacon. Abbots Abbon and Gauzlin maintained relations with the great abbeys of their time. Keeper of the relics of Saint Benedict, the father of the Benedictine order, the monastery of Saint-Benoît was endowed by Gauzlin (r. 1004–30) with an enormous tower-porch at the west of the church, begun after the fire of 1025 as "an example for all of Gaul." This construction, the fruit of a considerable financial campaign, has few peers on the same scale—one is Lesterps in Charente—since it is not descended from the Ottonian westwork. Its bulk, having been designed to be independent of the church, is in fact not a conventional antechurch. Com-

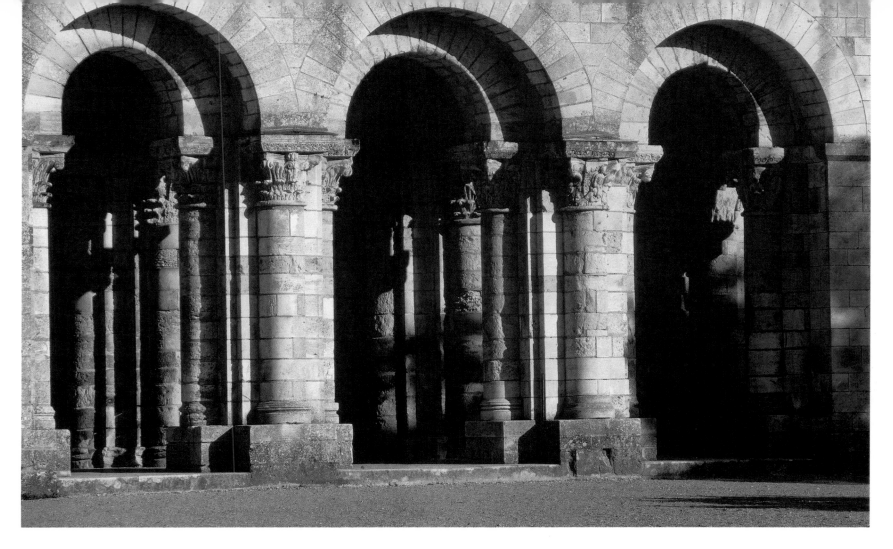

SAINT-BENOÎT-SUR-
LOIRE (FLEURY),
ABBEY CHURCH, DETAIL
OF THE GROUND FLOOR
OF THE TOWER-PORCH,
11TH CENTURY

posed of a quadrilateral (today, open on three sides), the ground floor is divided into nine groin-vaulted bays, which are delimited by massive pillars with attached columns. On the upper floors only the plan is repeated, while the window openings are placed in three great oblong bays whose uniformity has been marred by two Gothic windows. The three chapels at the east, preceded by three domes on pendentives, as well as the covered walk of the fourth floor, undoubtedly were built subsequently to Gauzlin's tenure.

The importance of such a building lies in its symbolic value. It is the earthly manifestation of the heavenly Jerusalem, as described in the book of the Apocalypse: a square city, pierced by three gates at each of the cardinal points.

The sculptures of the porch-tower of Saint-Benoît are particularly problematic. The mystery begins with handsome reliefs affixed to the exterior walls, as their stylized workmanship raises the question of whether they are contemporaneous with the building. The 128 capitals of the structure form an impressive grouping whose dating, still unresolved, is supplied by hypotheses based on stylistic comparisons. The stakes are considerable, given that the period most often proposed—the middle of the eleventh century—is very early, and on it depends the history of the

Romanesque capital. The shaping of the capitals of the ground floor into corner volutes, which spreads the decoration to the anterior and lateral faces, has its roots in the Corinthian form, which is manifested as much in the distribution of beautiful acanthus leaves as in animal forms. Most of the narrative capitals take part in an apocalyptic cycle, which reinforces the spiritual message of the tower. Some capitals on the second floor take up the human body and integrate it into the designs. Sculpted before they were set in place, they are earlier than those of the ground floor, displaying slender figures whose movements are adapted to the plant or architectural decoration.

Several workshops participated equally in creating sculpture for the abbey church, contributing various styles and provoking the encounter of interregional aesthetic languages. As far as the architecture is concerned, besides the sumptuous nave built last of all in a transitional Romanesque in which the influence of Capetian Gothic can be detected, it is the large choir that sums up the essential originality of the building. Bordered by an ambulatory with two radiating chapels, it is particularly long, ending in a half rotunda and crossed by a false double transept, a compromise of enigmatic origin; traces of a similar structure have been found in the excavation of the early church of

SAINT-BENOÎT-SUR-
LOIRE (FLEURY), ABBEY
CHURCH, DETAIL OF A
CAPITAL ON THE
GROUND FLOOR OF
THE TOWER-PORCH,
11TH CENTURY
*An angel and a devil
fight over a soul, sym-
bolizing the struggle
between good and evil.
This primordial theme,
the inspiration for mon-
umental Romanesque
sculpture in many differ-
ent guises, is represented
in this site in a group of
allegorical images illus-
trating the book of the
Apocalypse. The soul
was depicted in the Mid-
dle Ages in the shape of
a sexless infant, from
the Latin* infans, *mean-
ing "speechless," indi-
cated by the absence of
a mouth here. Its arms,
which are unusually
long, remind us of the
importance of gestures,
and their didactic signifi-
cance, in Byzantine and
Romanesque iconog-
raphy.*

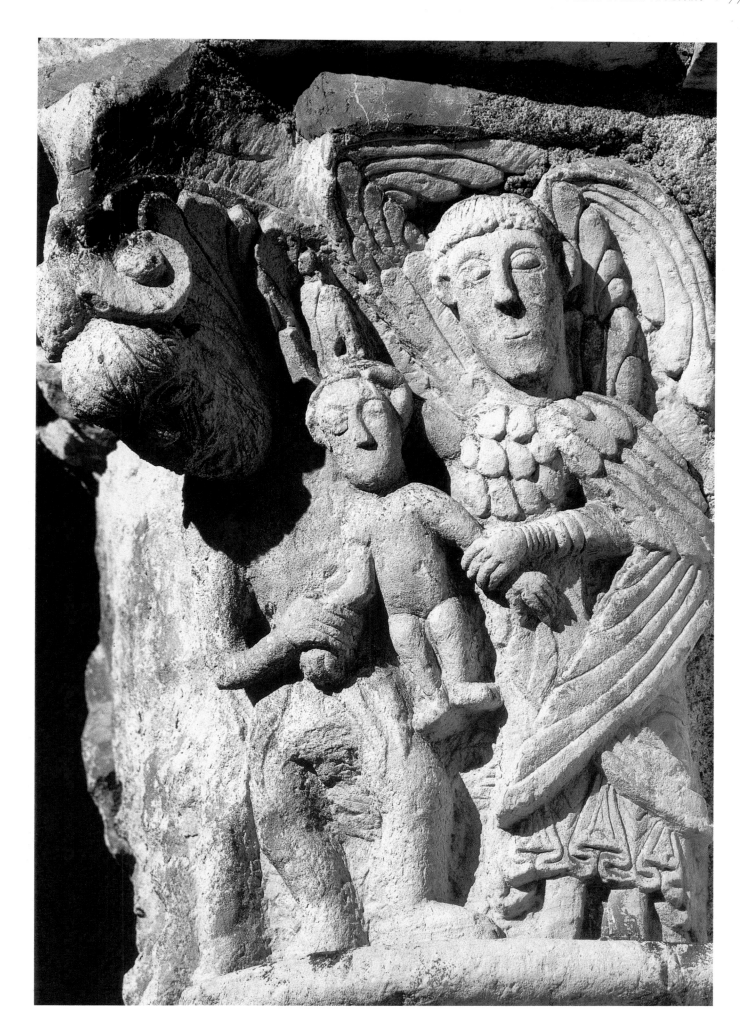

Marmoutier. The raised apse over the crypt has retained the same level of elevation as the second-story triforium and third-story windows of the nave, whose continuity exalts the harmony of the interior space.

POITOU, CHARENTE, AND VENDÉE: AUSTERITY AND RICHNESS

The golden age experienced by these regions would never have taken place without the excellence of their stone: good limestone was a necessity for the number and the quality of the works created there.

Following the Carolingian tradition and as a response to the devastation wrought by the Normans, the prodigious outburst of building in the Poitou established architectural forms answering to three tenets: simplicity, rounded forms, and light. The churches are vast, their aisles and nave elevated to about equal height, according to the principle of the hall church, and are divided by two rows of columns or pillars which spring unbroken to the beginnings of the vaults, generally a continuous barrel vault. This exerts such thrust that aisles, similarly barrel-vaulted or groin-vaulted, are very often necessary to support or buttress it. It also requires sizable walls that need reinforcement with buttresses and transverse ribs. Although the illumination is indirect, unlike in the churches of Burgundy, the quest for light necessitates very high arcades on both sides of the nave that are completely open to the aisles, pierced with windows, giving ample space for the light that thus penetrates softly. The vaulting of the choir in a half dome offered several choices, among which the one developed, most remarkably, is that of the tiered chevet with an ambulatory and radiating chapels (numbering four at Saint-Hilaire in Poitiers, five at Saint-Savin-sur-Gartempe).

The typical Poitou facade is very simple, ending in a gable. In the eleventh century sculpture still played a very small role, the local preference being for structure over decoration. The occasional examples of sculpture, such as at Saint-Nicolas-de-Brem, employ the technique in which lines form the transition from one plane to another, used in pre-Romanesque reliefs and metalwork. The tower-porch, which recalls the western avant-corps of Carolingian churches, survives in some facades of the first half of the eleventh century, as at Maillezais and Château de Talmon and the tower of Saint-Porchaire in Poitiers.

The great pilgrimage churches of Saint-Savin-sur-Gartempe and Saint-Hilaire in Poitiers, luminous and daring, admirably illustrate the breadth of Poitevin architecture; their size (four aisles at Saint-Hilaire) makes them unusual, since the subsequent style tended to be more modest.

Aunis, on the edge of Poitou, continued these architectural forms in a more rustic style. Saintonge and Angoumois display small buildings, most with a single nave and initially with timber roofs in the Carolingian tradition. The art of relief began to make a timid appearance. Only a few monastic churches, such as Notre-Dame of the former Abbaye-aux-Dames (1047) and Saint-Eutrope, both in Saintes, are more imposing, returning to the Poitevin type. Saint-Eutrope contains the most impressive crypt in France, reflecting the evolution undergone by religious architecture in response to the requirements of increasing pilgrimage. It is a low church, semisubterranean, illuminated by windows, with a transept and choir with ambulatory. The whole gives an impression of power, due especially to the stout pillars with engaged columns that support the upper sanctuary. The four-lobed profile of these piers and the heavy banding of the vaults provide an early illustration of the new architectonic forms that would prevail in the following century.

At the turn of the century, improvements in construction and stonecutting—courses with thinner joints—opened the way for new experiments in plans, such as a trefoil with eight chapels at Saint-Michel in Entraigues, and vaulting. At Saint-Pierre in Melle, three identical barrel vaults buttress one another; at Civray and Saint-Pierre in Chauvigny, and in Poitou as well, the spread of pointed barrel vaults marks a step in the search for a better balance. Finally, the dome, rediscovered in Périgord, moved toward the Loire by way of the cathedral of Angoulême.

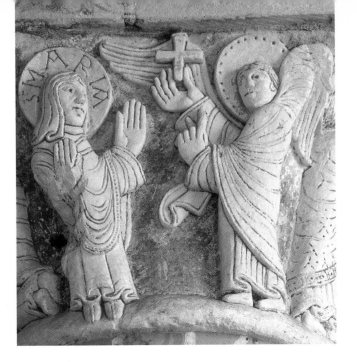

CHAUVIGNY, CHURCH OF SAINT-PIERRE, CAPITAL DEPICTING THE ANNUNCIATION, FIRST HALF OF THE 12TH CENTURY
One of the capitals in the choir bears the signature, extremely rare for the period, of its creator: "Gofridus me fecit" (Geoffrey made me). In this Annunciation the messenger, the archangel Gabriel, arrives from the right rather than the left, which is more common. The divine message he brings to the Virgin Mary is summed up by the presence of a small cross that he holds aloft, symbolizing the Incarnation of God and perhaps prefiguring his sacrifice.

Opposite
SAINT-SAVIN-SUR-GARTEMPE, ABBEY CHURCH, NAVE SEEN FROM THE WEST, LATE 11TH CENTURY

Overleaf
CHAUVIGNY, CHURCH OF SAINT-PIERRE, CHOIR SEEN FROM BELOW, 11TH CENTURY
The apsidal choir is the most sacred part of the church. In Aquitaine the columns are often medium-size and capped with enormous historiated capitals, their images made even more readable with the application of polychrome. In Saint-Pierre it was reapplied according to the archaeological fantasies of the nineteenth century, emphasizing shafts, capitals, arcades, and half-domed vaults.

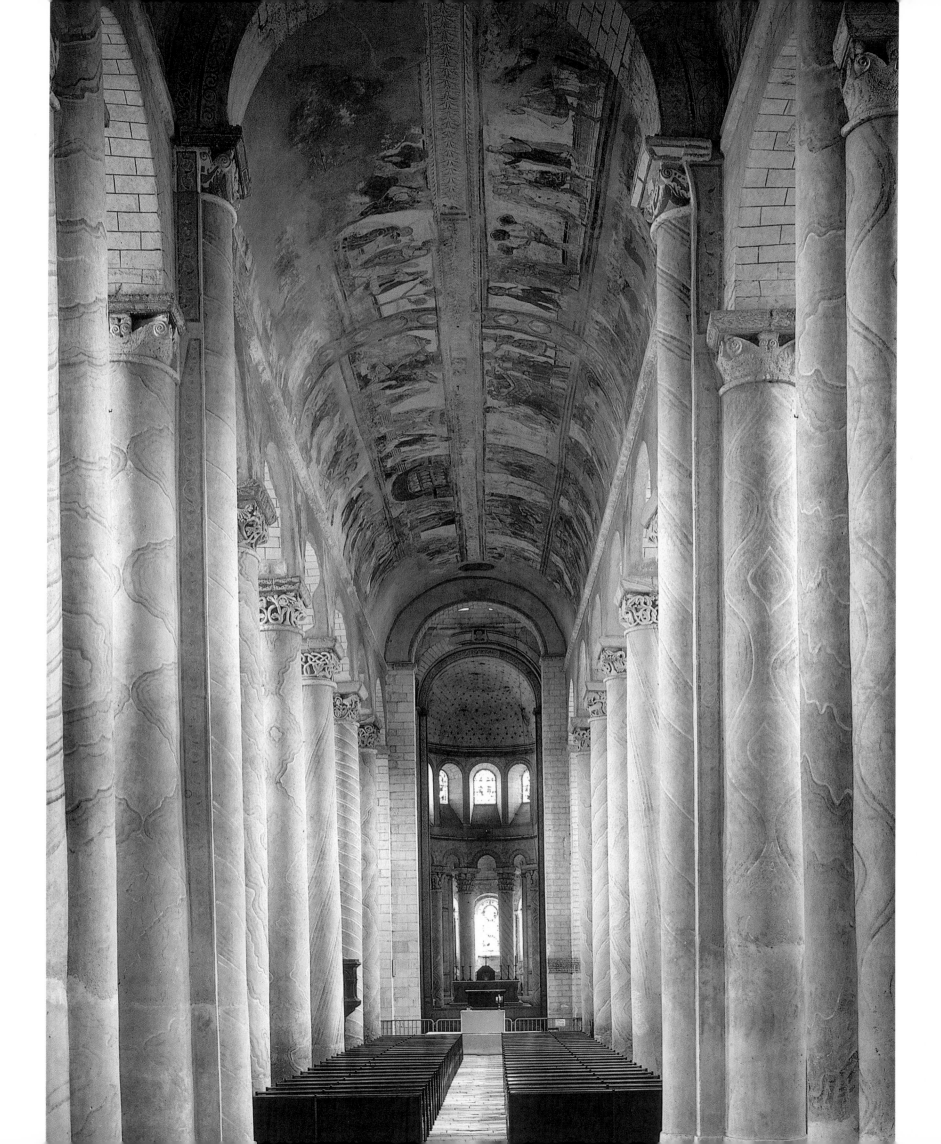

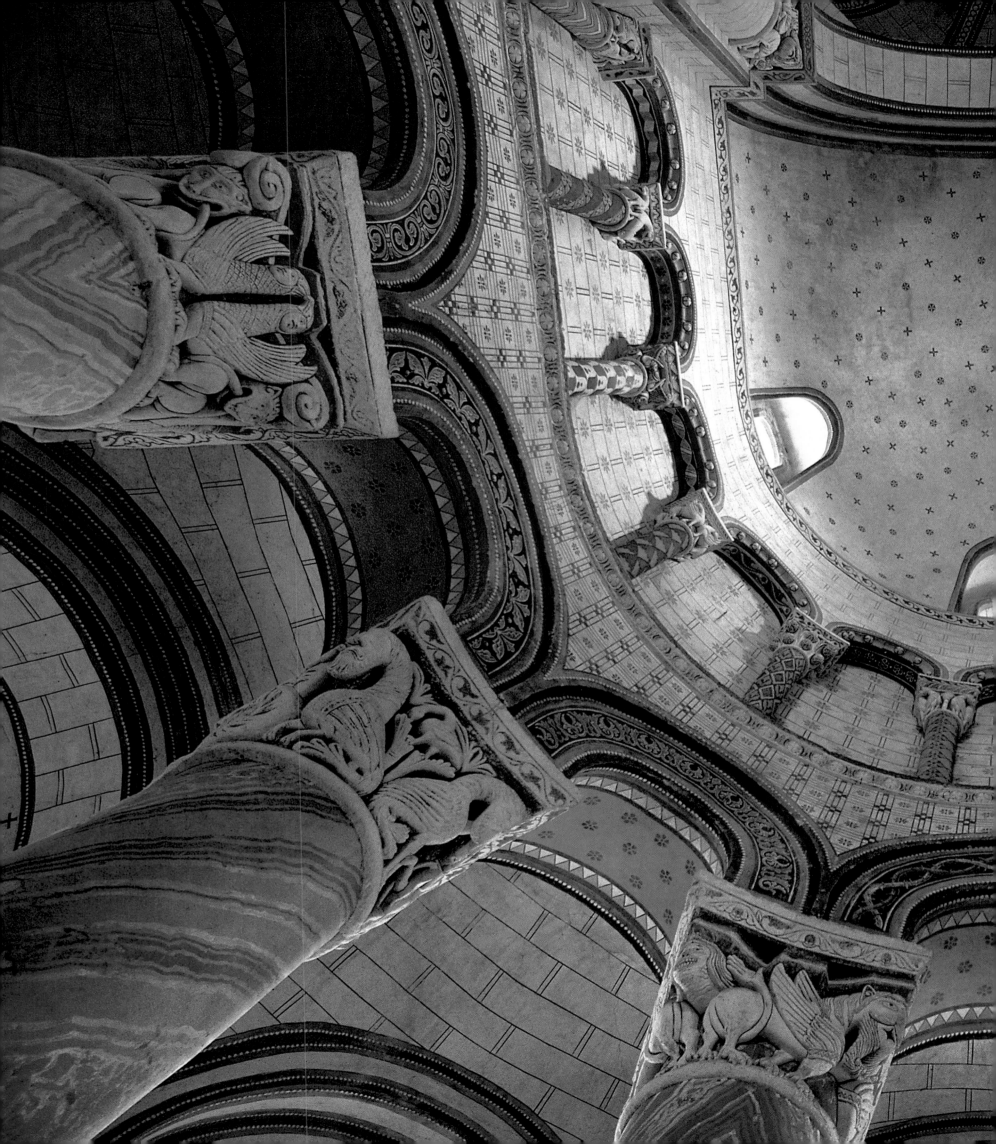

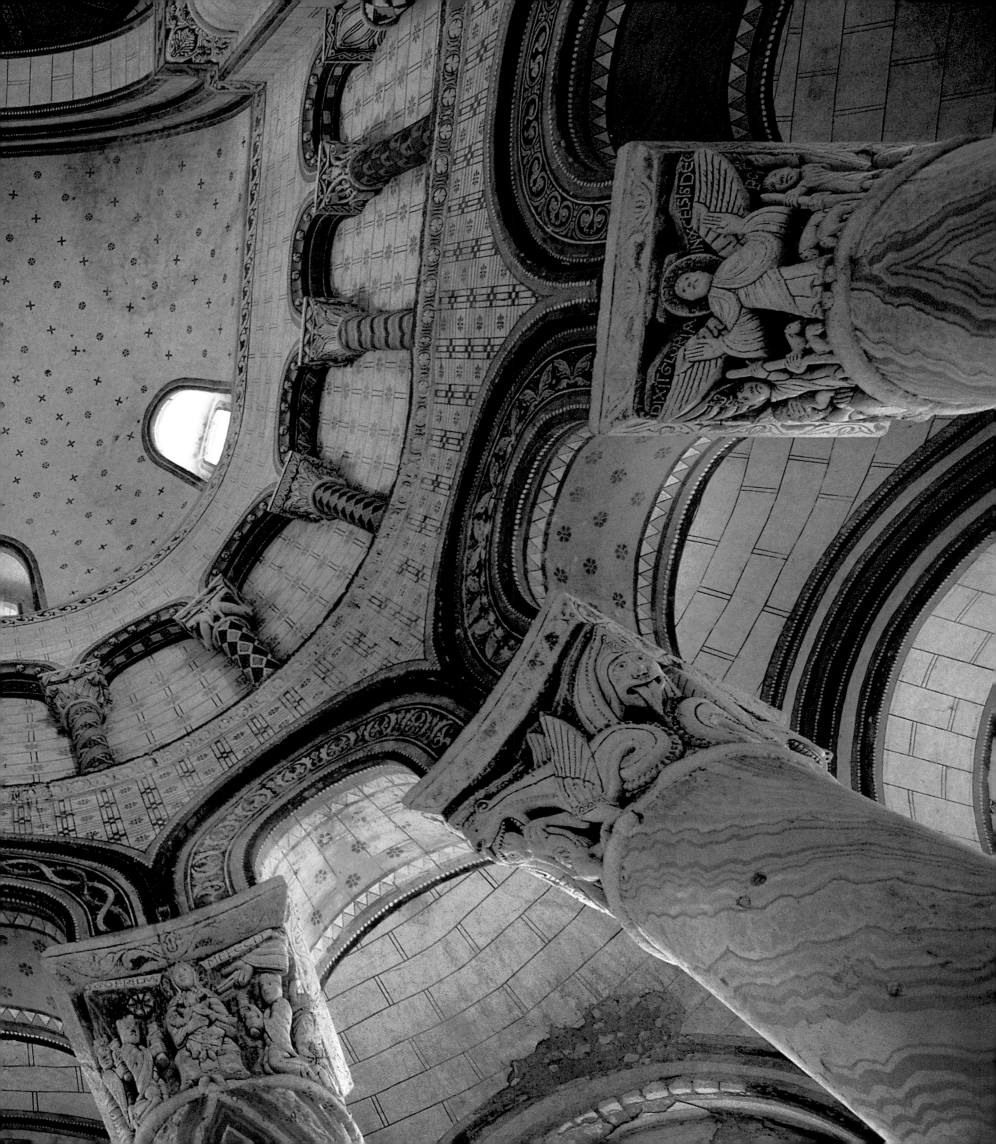

The Example of Angoulême

This marvelous work—alas, mutilated in the nine-teenth century by the ravages of Paul Abadie, architect of the Sacré-Coeur in Montmartre—allows us to understand the extent of the changes that occurred around 1120 in Angoumois. The very concept of the facade has been turned upside down. At Angoulême we find a rectangular screen-facade imported from the Périgord, which we must imagine stripped of its gable and of its "Abadien" pinnacle turrets (in Abadie's time, it was thought that the architecture of western France was summed up in the single "school" of Poitou).

Unrelated to the profile of the rest of the building, the frontispiece is articulated by four great reliev-ing arcades, which join a central fifth arcade that is larger and higher. The subdivision of the surface con-tinues with a network of smaller blind arcades. All are supported by half columns—or colonnettes—which form a vertical rhythm, broken horizontally by a suc-cession of cornices and stringcourses, which divide the sculptural program into several registers. The con-cept of the facade here is radically different from that of Burgundy, where the central focus is concentrated on a large, central sculpted portal. At Angoulême, the viewer is faced with a great central bay surmounted by a historiated tympanum, or with a Christ in Majesty dominating the whole (as in Pérignac).

Once this system was set, it spread in the 1130s to Saintonge, Gironde, and upper and lower Poitou, where there are many examples with variations (Celle-frouin, Gensac-la-Pallue, Nizan). The division of the walls is most often tripartite, for the churches of the twelfth century are of relatively modest dimensions, and many among them remained content with this single articulation for decoration.

The other great innovation, retained in the Gothic period, concerns the generosity of the sculpted decor. The process began with the archivolts, which are cov-ered with plant, anthropomorphic, and zoomorphic designs. Then a mad exuberance took over, cultivated in Saintonge and exported to the adjoining regions. Vast programs overran the frontispieces, cornices, and modillions of the perimeter of the churches, the out-lines of the windows, capitals, pillar bases, and the arches of the portals, which grew considerably larger (Rioux), becoming the fundamental canvas for a pro-fane and sacred iconography that presents the impor-tant allegorical themes of the West. Thus stream forth depictions of Vices battling Virtues, parables of wise and foolish virgins, the labors of the months, and the strange figures of the bestiaries, which can be seen in Aulnay, Chadenac, Fenioux, and Foussais.

Whereas the distribution of the decor is rela-tively well spaced on most facades (for example, at Saint-Jouin-de-Marnes and Villesalem), it may be taken to extremes so as to occupy the smallest cranny in the field available to the sculpture. The facades of Civray and Notre-Dame-la-Grande in Poitiers pro-vide astonishing demonstrations of such ornamental lushness, then at its peak. This baroque profusion even enlivened the stone masonry, which is articulated in monochrome marquetry, lozenges, circles, or her-ringbone pattern.

Opposite
RIOUX, VIEW OF THE CHEVET, 12TH CENTURY
Like the churches of Geay and Talmont-sur-Gironde, Rioux has a polygonal apse. It stands out by virtue of its extremely rich architec-tonic decoration, resem-bling the ornamental profusion seen in the twelfth-century churches of Saintonge.

ANGOULÊME, CATHEDRAL, DETAIL OF A FRIEZE ON THE WEST FACADE, 12TH CENTURY
This generous fron-tispiece (a prominent part of the facade) fol-lows an important and varied iconographic program. Beneath foli-ated acanthus scrolls, horsemen confront one another in a fight to the death. It might rep-resent one of the battles between Christians and Muslims, in which King Alfonso I of Aragon and his ally Guillaume, duke of Aquitaine, partici-pated, both of whom we are tempted to identify among the Crusaders. Like Roman panegyric trophies, this frieze hon-ors the army raised by the duchy and proclaims the triumph of Chris-tianity over the infidels.

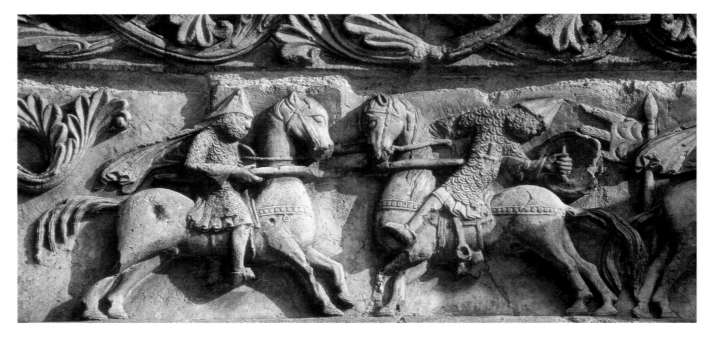

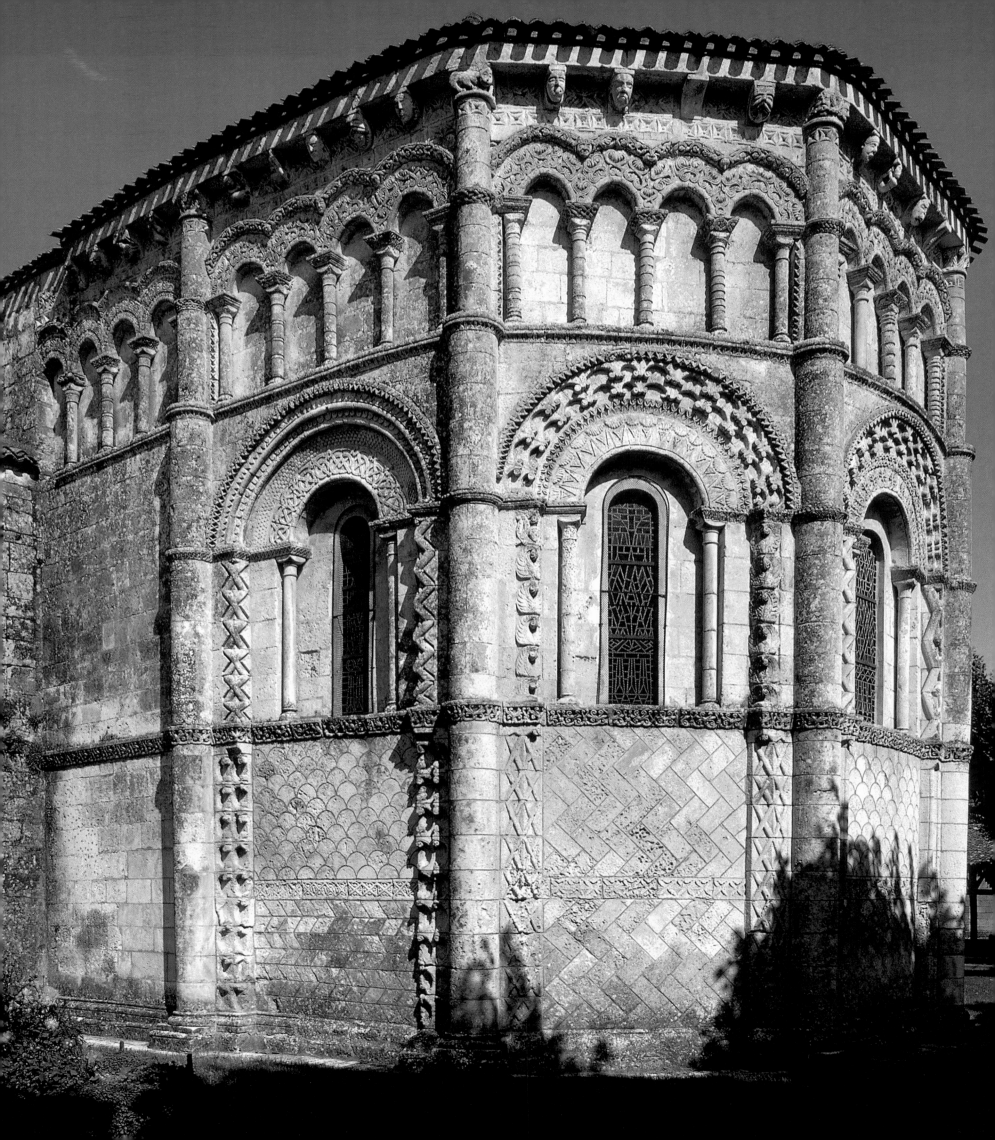

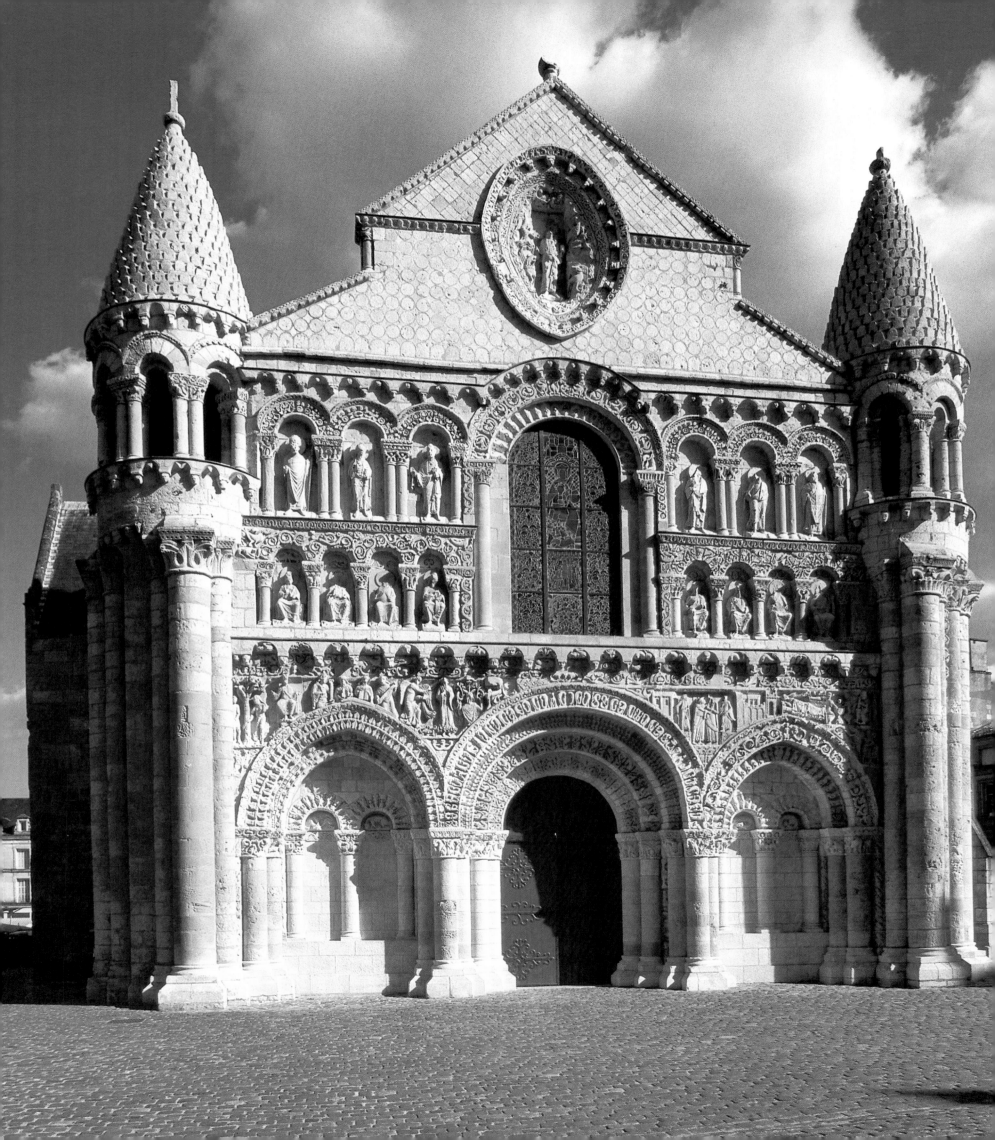

GOOD AND EVIL

For those who lived in France in the first centuries of the millennium, day-to-day life came down to a duel between Good and Evil. The two principles clashed within them, in their minds, in their bodies, and around them, in nature, in others. Romanesque churches, which are a microcosm, a mirror of the visible and invisible worlds, proposed a totalitarian symbolism to the faithful that "shows" the path of truth, a truth peopled with strange beings whose reality matters less than the values they are meant to incarnate.

Virtues and Vices are represented independently as examples in a global iconographic context, most often in the setting of the Last Judgment. There they take the form of human allegories, almost always feminine. Faith, Hope, Charity, as well as Fortitude, Justice, Prudence, and Temperance are identifiable by means of attributes or an accompanying inscription. The Vices of Pride, Envy, Avarice, and Gluttony are more specifically masculine; Anger and Lust are feminine. The Vices greatly inspired artists, who represented them in a fashion at once terrible and comic. The attribute of Avarice is the purse; Lust, the most censured, sees the most sensual parts of the body attacked by snakes and toads. It is understood that the woman who uses her body to seduce will be punished. In the crypt of Tavant in Touraine she is even shown committing

suicide from despair. At Saint-Pierre in Chauvigny, in Poitou, she is symbolized by the Whore of Babylon, with the long hair described in the Book of Revelations.

The confrontation of Vices and Virtues becomes a *psychomachia*—a fight within the soul. The term comes from a poem written in the fifth century by an author named Prudentius. Composed in an epic style, it presents the armed Virtues in single combat against their opposites, in which they always emerge victorious. Aulnay, Saint-Hilaire in Poitiers, Civray, and Parthenay contain images of these warriors; they are also painted on the walls of Saint-Gilles in Montoire and those of Vicq in their helmets and coats of mail.

The Devil, vainglorious, shows up everywhere; he presides with Saint Michael at the weighing of souls, attempting to carry off to Hell all those he can. He is terrifying because he can take many forms: sometimes discreet, crafty, and seductive—he is the devil of temptation, the one who misleads mankind and corrupts free will—sometimes terrifying—winged and clawed, he devours mankind, opening a huge toothed maw (as represented in Chauvigny). In Poitou, where he perpetuates the legend of the dragon killed by Saint Radegonde, he is called the Ghoul.

LIMOUSIN: GRANITE AND ENAMEL

The Romanesque churches of Limousin

The Devil's Bestiary

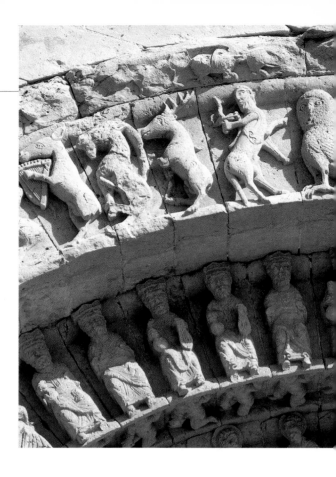

THE WORLD OF real animals provided an inexhaustible wellspring of symbols, whereas legendary and monstrous beasts, with a few exceptions (such as the phoenix and the unicorn), constitute specific incarnations of Satan. Violence, lust, hypocrisy, laziness, stubbornness, pretension, and indifference to God were all represented through hybrid creatures that combined elements of mammals, reptiles, fish, birds, and human beings in fantastic compositions. The exterior arch of the south portal of the church of Aulnay-de-Saintonge presents a fine series of individually sculpted figures lined up on each of forty voussoirs (the wedge-shaped stones forming the arch). Primarily depicted erect and in profile, these strange figures were composed from certain schematic types, whimsically reproduced and reconfigured in order to create a number of varied forms. Thus, the bearded man with an owl's body, a repeated figure, assumes a new form on the twenty-third voussoir, there topped with a swan's head taken from its neighbor.

A close study of the archivolt reveals the relationships between standardized forms, a common practice in the Romanesque bestiary and already generalized in the vocabulary of ornamental motifs, notably, in the acanthus leaf. These fantastic images, deformed by their subordination to the architectural support, in fact, may have been derived from this motif.

REAL ANIMALS

The donkey. Like the monkey, it represents the incarnation of ignorance, coupled in this case with stubbornness and pretension bordering on the ridiculous when depicted trying to play the lyre.

The billy goat. Because of its lubricity and stench, the goat represents carnal appetite. Lust is often depicted on its back.

The she-owl. To the Christians, the Athenian image of wisdom represents the Jews, who were thought of as preferring the night of ignorance to the light of revelation.

The fox. According to a classical tradition repeated in the medieval bestiaries, the fox feigns death when hungry. Birds looking for easy prey approach and are devoured forthwith. Thus, the fox represents the Devil who uses trickery to attract licentious and irresponsible men.

The sheep. The sheep represents imitative stupidity. It appears here with hands joined, reading a scroll held out to it, and is wearing a priestly robe—a common mockery of men of the cloth.

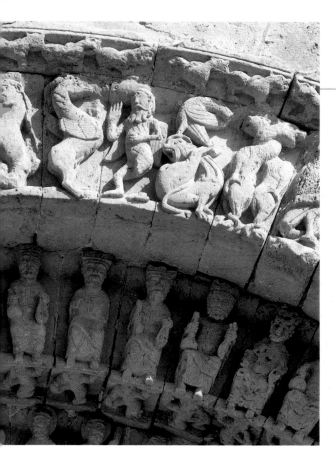

IMAGINARY ANIMALS

The basilisk. The most dangerous of all the animals, it has a serpent's tail and the torso and head of a rooster. The name comes from the Greek *basileus*, or king, and it is the king of the serpents, and, symbolically, demonic animals. "His smell makes trees fall" and "kills birds in flight," while men who look at him die. It especially represents lust. Its antidote is a crystal bell.

The centaur. Following classical tradition, a horse with the head and torso of a man (or a woman) illustrates sensuality and violence, and therefore demonic qualities as well. When the centaur is near, the Siren is not far off.

The chimera. With a lion's head and a serpent's tail, it spits fire.

The dragon. The largest serpent, it comes from Ethiopia. Its tail strikes violent blows, believed to be capable of knocking down an elephant, its principal adversary and symbol of natural goodness. In Christian iconography, in this case passed down from Greek and Middle Eastern antiquity, victory over the dragon represents the triumph of true religion over idolatry, and is therefore attributed to numerous saints.

The sphinx. Like the centaur, the sphinx is a hybrid being, half man (or woman) and half animal—usually a lion in the imaginary Romanesque bestiary. Male and female sphinxes, represented as a pair, are characterized by their mysterious immobility.

The Siren. Exclusively female demons, Sirens seduce men with their songs and embody temptation and dangerous pleasure. They have lower bodies in the form of fish or, less frequently, birds, depicted with a single or forked tail and long hair, considered a token of sensuality. At the end of the twelfth century, the popular fairy Melusine of Poitou, without her usual serpent's tail, figured prominently in similar fantasies.

The griffin. A lion with eagle's wings, the griffin goes back to Assyrian art. It symbolizes sometimes Christ, but more often Satan.

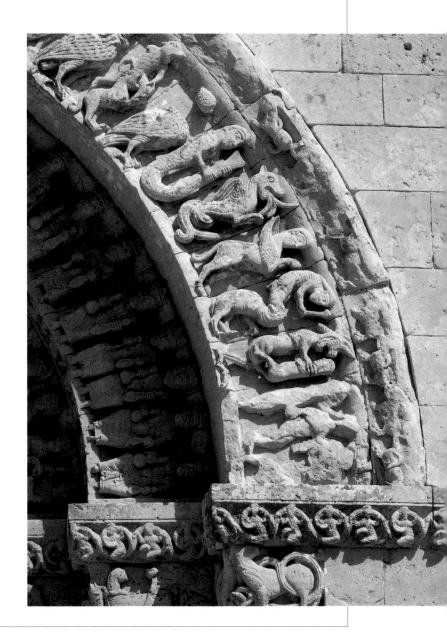

display a strong family resemblance, especially in the look of their exteriors. Before 1100 the style was already set, with an ordering of granite masses calculated to satisfy a love for the rational. Their spareness, which sometimes borders on dryness because of the damaging restorations of the nineteenth century, is enlivened by a new type of simple molding subordinated to the architecture; it outlines the windows, covers the transoms, surrounds the bases of pillars. The windows of Limousin are generally arched with a torus and flanked by colonnettes set in the jambs. The facades are sober, even austere, at first finishing in a gable (Sagnat), then surmounted by a tower-porch characteristic of the region, distinguished by the use of a dome over the first bay in the nave (Meymac, Saint-Yrieix). The tower-porch of Évaux is the only one entirely dating to the eleventh century, the others having been built or rebuilt in several stages. The most beautiful tower is at Lesterps (140 feet, or 43 meters high), which opens on the ground floor on three sides pierced with three arcades. In the facade or at the crossing, the towers of Limousin are often decorated with gables, which allow an elegant passage from the square block of the base to the octagonal structure above. The earliest, from the beginning of the twelfth century, is at Collonges, composed of red sandstone; it opens the way for those of Saint-Léonard-de-Noblat and Saint-Junien.

The churches of Limousin are mostly aisleless (Arnac-Pompadour) or have narrow aisles (Saint-Junien). In some the piers themselves are pierced by a passageway (Bénévent). At Salles-Lavauguyon, the perfect 1:3 relationship between nave and aisles recalls the canons of the Roman architect Vitruvius and the enduring nature of the traditions of antiquity.

Although the pointed barrel vault is held in high esteem here, Limousin is nonetheless a land of experimentation. At Saint-Léonard-de-Noblat, transverse barrel vaults and hemispherical domes on pendentives were added. We find the latter laid out at Solignac in the manner of the churches of nearby Souillac and Cahors in the Quercy region, which also have trefoil chevets. The proximity of Languedoc influenced Corrèze, where, unlike in the rest of the region, sculpture flourished, as demonstrated by the capitals at Brive. The tympanum of Collonges recalls the style of the Master of Moissac, as does the superb tympanum of Beaulieu, which illustrates the triumph of the Cross over the forces of Evil, incarnated in the

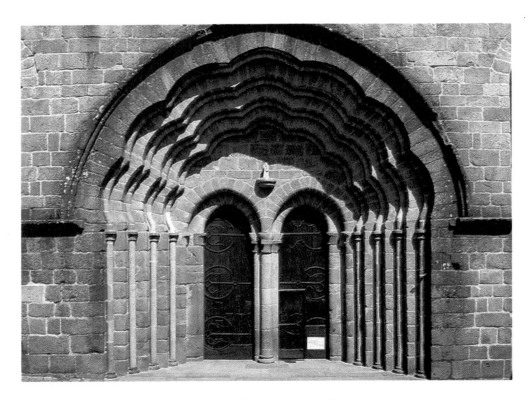

seven infernal beasts that symbolize the Vices. Finally, from Christian Spain, we find scalloped or multilobed arches borrowed from Islamic art at Dorat and Vigeois, echoed in the portals.

The churches of Limousin, a land of pilgrimages, have galleries at Saint-Junien and Beaulieu and beautiful crypts, from the relatively modest (a rectangular example at Châtelponsac) to the majestic (La Souterraine). Instead of an ambulatory, the crypt at Dorat has an original circular gallery.

DORAT, COLLEGIATE CHURCH, WEST PORTAL, 12TH CENTURY
Limousin decoration was often restricted to architectonic fantasies. The scalloped archivolts of Dorat and La Souterraine demonstrate a relationship to Mozarabic art, promoted by the pilgrimage routes toward Spain.

RELIQUARY OF SAINT STEPHEN, 12TH CENTURY. CHURCH OF SAINT-PARDOUX, GIMEL-LES-CASCADES
This reliquary, originally from the church of Saint-Étienne in Braguse, depicts the main episodes in the life of Saint Stephen (Étienne) on the principal face. At lower left, he is shown preaching, and Christ appears in the clouds to him; at lower right, he is arrested and, above, stoned.

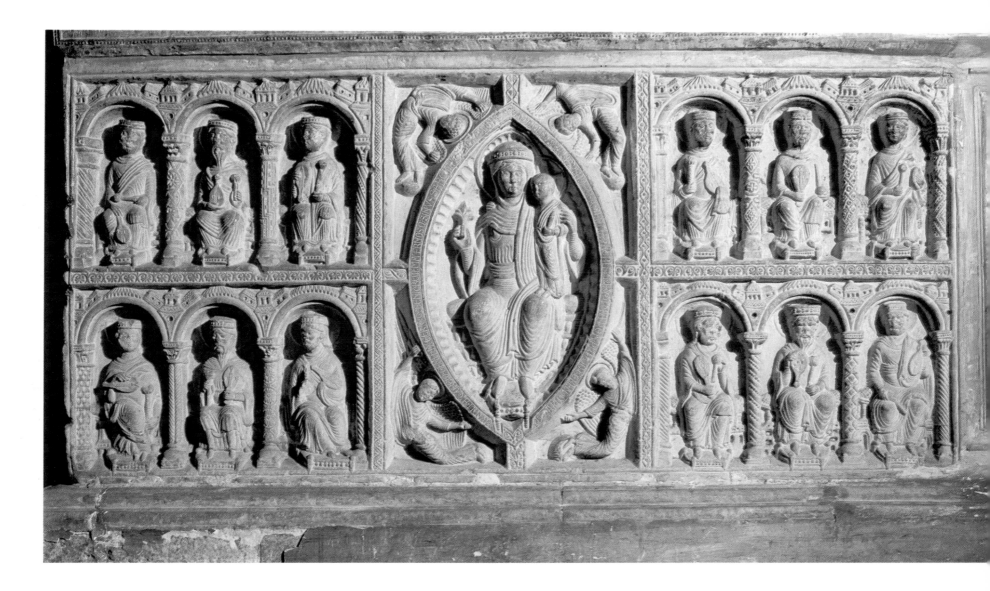

SAINT-JUNIEN, COLLEGIATE CHURCH, NORTH FACE OF THE SAINT'S TOMB, LATE 12TH CENTURY
The object of an important pilgrimage on the Limousin route to Compostela, this tomb recalls the cult dedicated to the hermit Junien, who lived in the sixth century in a forest on the site of the present town. Famous for effecting miraculous cures using the waters of a spring, the hermit also aided sufferers who came from far away to pray for help in fighting against the plague.

ENAMELS: AN ART OF FIRE

Enamel—the preferred technique for Romanesque sacred objects, from reliquaries to bishop's and abbot's croziers, from incense burners, chalices, and ciboriums to tomb plaques—attained its full glory in the twelfth and thirteenth centuries in Limousin, the main center of production in Christendom. Southern Romanesque enamels came from not only Limoges but also western France and northern Spain, produced in important abbeys such as Conques, in Rouergue. About 1100, the technique of champlevé enamel supplanted that of cloisonné, which originated in the Byzantine world, but not until the second half of the twelfth century did the "work of Limoges" gain an international reputation, promoted by the Plantagenets and the full flowering of the pilgrimages.

While many of the precious objects that have come down to us were manufactured in series, some were unique. Unfortunately, even before 1200 many were subject to theft and mutilation, leaving only scattered fragments of many important pieces of enamel.

Like the jeweler's art and stained glass, the art of enamel is an art of fire that aimed to cover a metal object with a play of colors in order to re-create, through chromatic illusion, the effect of precious stones. The champlevé technique consists of decorating a copper—or, more rarely, gold—support with a liquid paste that looks similar to glass, applied to hollows cut into the thickness of the field, creating a smooth and homogeneous surface. (In the cloisonné technique, the enamel is applied and fired in raised cells.) With the secularization of the workshops of precious arts in the thirteenth century, Limoges no longer concentrated its production in the Saint-Martial abbey, establishing many enamel workshops in the town.

PLANTAGENET
ENAMEL, MID-12TH
CENTURY. MUSÉE DE
TESSÉ, LE MANS
*This enameled plaque
from the cathedral of
Le Mans was made to
decorate the tomb of
Geoffrey V of Anjou,
called the Fair (d. 1151),
father of Henry Planta-
genet, the future King
Henry II of England. In
spite of its exceptional
dimensions (25 by 13
inches, or 63 by 33 cen-
timeters), it is not large
enough to have served
as a tombstone; it no
doubt appeared on the
principal face of a
"mausoleum"—as it was
called in the period—as
a commemorative por-
trait, not as an effigy. It
shows Geoffrey meting
out justice, armed with
a sword that threatens
to strike those who
transgress the laws and
a shield to protect the
Church. This work
belongs to the genera-
tion of two-dimensional
funerary portraits—
most often set in mosaics
or cut into stone—before
the appearance of statu-
ary. Its conception, still
highly pictorial, reveals
the influence of contem-
porary illumination.*

GRAVES AND TOMBS

For all, the rule of burial in consecrated ground was absolute, but the fate of the poorest was simply an anonymous pit. We know very little about popular Romanesque funerary art. The little cemetery of the priory church of Chalard contains a rare group of granite tombstones from the twelfth century given the shape of a cruciform church bordered on the edges with semicircular arcades. Some have carved attributes that reveal the trade of the deceased: here a prior, identifiable by the cross and the stole, there a blacksmith with pincers, there again a woodcutter and his ax, or the shuttle of the weaver. Further away, recumbent figures on an arched background are represented clothed in long tunics.

The most sought-after resting places were inside the church, which housed the remains of the directors of the ecclesiastical community and the local nobility, depending on available space. The number of funeral slabs on the ground or against the walls became ubiquitous. By the beginning of the twelfth century a commemorative monument was erected in a niche for the great Abbot Bégon at the abbey church of Conques. The same is true for the sarcophagus of Pierre de Saine-Fontaine, founder of Airvault, decorated with small figures in archways and supported by two atlantes. The niches of Montbron are festooned in Eastern style, as is the portal. At Saint-Hilaire of Poitiers, a cross patty, or cross formée, is surrounded with rinceaux and foliage.

As an affirmation of their lineage, the seignorial families and reigning dynasties favored the use of funerary art. Few tombs remain today in their original locations, and it is the museums that have saved them from destruction. The tombs from Javarazay at the Musée de Niort returned to the classical idea of a happy and completely profane evocation of the deceased's life: a lord and lady ride through the countryside with a hunting party, complete with falcons, dogs, bows, and nets. More common—although most have disappeared—were the plaques of copper and bronze that provided a ground for an engraved or bas-relief depiction of the deceased. The copper tombstone plaque of Geoffrey Plantagenet, duke of Anjou, engraved about 1155 (Musée de Tessé, Le Mans) and marvelously enameled, represents him alive, armed with sword and shield. As the century proceeded, the recumbent figures gained in relief. The handsome stone tomb of Laleu, carried by lions, at the museum of La Rochelle, was still worked in shallow relief. The strange effigy of a Knight Templar wrapped in his shroud at the Musée du Poitiers was created before 1200. Finally, recumbent figures in high relief—a style that later spread to all of southern France—of the Plantagenets at Fontevrault mark the transition to Gothic sculpture. The earliest, those of King Henry II and his son Richard the Lionhearted from the beginning of the thirteenth century, are on the edges of the style of the times: eyes closed, stretched out on a draped mortuary bed, following the ritual of their funeral ceremonies.

Objects of veneration, the monumental shrines of saints have a very different feeling. The monument raised about 1170 for the hermit Saint Junien, founder of the abbey in the Limousin town of the same name, is a vast rectangular basin of imported limestone, sculpted on three sides, the fourth having formerly rested against the master altar. It was not the person of the saint who was venerated here but, rather, God through the means of the saint's remains. Christ in Glory dispensing blessings appears on the east face, the twenty-four Elders of the Apocalypse on the north and south faces, along with the Virgin holding the baby Jesus, seemingly come to life in the midst of a very rich decor.

PÉRIGORD: A SKY FULL OF DOMES

The principal features of the Périgord group, even though they are repeated tirelessly, are not restricted to the region. The spread of the rectangular plan without aisles and with flat chevet, the simple elevation of single-story walls, their robustness due to the thick infill faced with square or medium courses of stone, the fortified feeling of buildings recalling the troubles experienced in this frontier region after the marriage of Eleanor of Aquitaine: all these elements are not sufficient to define a "school." And their originality lies not in the use of hemispherical domes resting on pendentives but in their arrangement. Their alignment in rows, which is found in a great family of churches, is not, again, restricted to the region, but spread to other provinces in the west, following the path of limestone. Light and durable, limestone is the ideal material to minimize the risk of collapse. Thus, from Saint-Caprais in Agen to Sainte-Croix in Bordeaux, from the cathedral of Angoulême to the churches of Saintonge (among them, Saint-Léger in Cognac, Gensac-la-Pallue, Châtres, Abbaye-aux Dames in Saintes) to the abbey of Fontevrault near the Loire, this type of covering proved attractive to architects

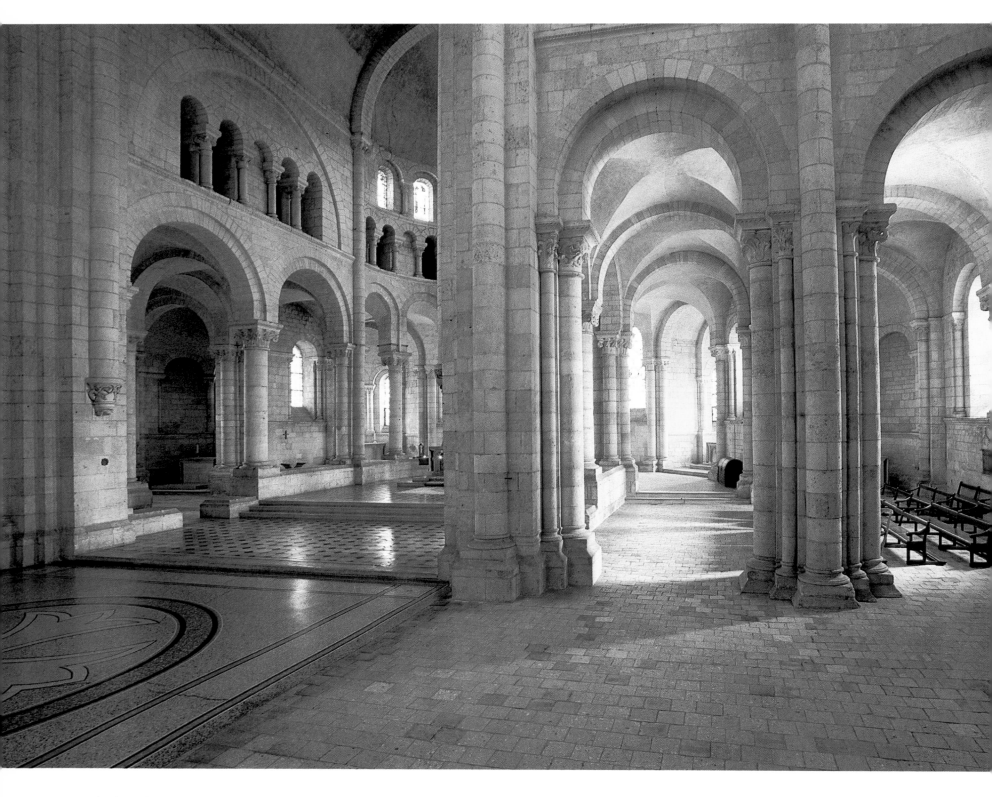

looking for an alternative to the barrel vault. The latter was relinquished in Périgord because it was not well understood how to buttress it (with the exceptions of Cadouin, Saint-Privat, La Chapelle-Saint-Robert), and it gave way to domes, which became a local specialty. We may today count thirty or so buildings that have preserved them, either over the nave (Trémolat) or over the entire church (Saint-Étienne-de-la-Cité in Périgueux, Cherval). They are white and majestic, surrounded with a corbeled course at the base, which allowed access to

the workers who used it to support wooden arches serving as formwork. As a cost-cutting measure only the lower courses of masonry were of cut stone; the rest were composed of rubble covered with a high-quality facing designed to create the illusion of solid stone. These domes appeared at the time of the First Crusade, in the last years of the eleventh century; their origins lie not in the Islamic world but, rather, in Byzantium, through the intermediary of the basilica of Saint Mark in Venice, rebuilt in the eleventh century in the style of

FONTGOMBAULT,
ABBEY CHURCH,
INTERIOR VIEW,
12TH CENTURY
No better integration of light and architecture exists. The east-facing choir, along with the ambulatory and aisles, receives the morning light, associated with the illumination that the

incarnated Christ brought to the world. In the choir, 75 feet (23 meters) long, the accent lies not on the effect of verticality but rather on the width of the arcades and the bays of the triforium.

Constantinople. Far from a slavish imitation of Byzantine models, we see here an original adaptation by local architects of concepts that were foreign to the territory: where the aisles of Byzantine churches were vaulted to buttress their domes, France omitted them to make space for walls bearing gutters punctuated with great relieving arches that supported them, accompanied by massive pillars. Even the profile of the domes is different, truly hemispherical in Byzantium, slightly ovoid here, while the arches that frame them, semicircular there, are here pointed. Finally, in the West, a typically Romanesque chevet with radiating chapels was often added, as in Souillac and Angoulême.

Only the enormous cathedral of Saint-Front in Périgueux, a major stop on the road to Compostela, returns to the plan of the Eastern Greek cross bordered with aisles and vaulted with five domes, in the image of the basilica of the Holy Apostles in Constantinople, subsequently destroyed by the Turks. Like the cathedral of Angoulême, Saint-Front suffered the radical renovations of Abadie in the nineteenth century, which have destroyed a large part of their archaeological interest.

BERRY: GREATNESS AND SIMPLICITY

Aisleless, timber-roofed (Bommiers, Neuilly-en-Dun), flat chevet (Ruffec): these decisions were made in the rural structures that succeeded a (now-vanished) first generation of the Romanesque. These simple churches are entered through a single portal in the avant-corps of the screen-facade. The buttresses are there, simple (not in half-columns, as in Limousin), always spaced in the same manner and stopped by cornices with sculpted modillions and delicate billeted string-courses that derived from Auvergne. A large cross with an interlacing design, of Carolingian origins, often ornaments the gable, compensating for the lack of sculptures on the portal tympanum (Jussy-Champagne, Chârost). Carved capitals supply the decorative effect, ringing changes on the theme of the reinterpreted Corinthian capital and on plant motifs proper to Berry, such as the fillet of leaves held by a cord. They may display elephants, lions, and gazelles, for the bestiary of Berry is strangely exotic (Vorly, Dun-sur-Auron, Méobecq), and the animals mingle with highly obscure saints, such as Saint Outrille. Brer Fox also is popular in the region, and his story was often repeated. The fable of the fox was so popular in

medieval France that the animal's proper name in the fable (Reynard) actually replaced the Old French word for fox *(goupil)*. The portal of Saint-Ursin in Bourges, signed by Girauldus, is one of the most unusual in the Romanesque world in its entirely profane character. The row devoted to the fable of the fox lies between a calendar of the labors of the months and a deer hunt. The episode of the crane plunging his beak into the fox's throat to pull out the bone that is choking him precedes that of his burial, officiated by Chantecleer the Cock and Bruin the Bear. The moralistic story puts the faithful on guard against the tricks of the Devil, who preys on the innocent.

Inside, the charming "Berry passages" (a triple archway opening on the choir by a wall that separates it from the nave) are particular to the region. They reinforce the contrast between the refinement of the chevet and the simplicity of the nave.

For the rare large churches in Berry, nothing was too splendid. The chevets, expanded with numerous absidioles and chapels, constitute the focal points of Châteaumeillant, Fontgombault, Selles-sur-Cher, and Déols. Fontgombault is one of the great successes of monastic architecture, joyous in its size and light; the "fountain" of the hermit Gombault was richly sheltered by the great powers of the twelfth century. Its nave was built after the consecration of the abbey, in 1141. The choir is impressive both in its length and its height (56 feet, or 17 meters). The recess of the apse takes up the formula of stilted arches resting on columns, used in Auvergne and Poitou, and a law of holy numbers given in the rule of Saint Benedict is employed: seven arches, seven high windows, fourteen arcatures on the triforium.

In Romanesque architecture, the round form was considered perfection. The basilica of the Holy Sepulcher in Jerusalem had already inspired the architects of Charlemagne, who had used the concept for his Palatine Chapel in Aix (Aachen). The return of the First Crusade in 1099 brought a new wave of imitations of the prestigious monuments of the East to the West, as demonstrated by Charroux. The rotunda of Neuvy-Saint-Sépulchre (new town), founded about 1040, was inspired by the sanctuary in Jerusalem. It is attached to a small basilical building consecrated in the same period, with which it is clumsily coupled. Its circular plan, with an annular ambulatory surmounted with galleries, was intended to be a sort of reproduction for pilgrims to Neuvy—a bit of the Holy Land in Berry.

A ROMANCE IN COLOR

Seduced by the charm of the old stones bleached by the centuries, we too easily forget that color was omnipresent in the churches, highlighting the sculptures and animating the walls. The half dome of the apse was the preferred canvas, on which Christ in Majesty was most commonly depicted. He is accompanied, in the other parts of the building (walls, colonnettes, embrasures of windows, vaults), by the figures of saints, allegories, or other narrative cycles illustrating various episodes of the Old and New Testaments.

As monumental art, wall painting has the same didactic function as sculpture. To ensure an easy reading and comprehension of the themes, the artists worked with a restricted palette of colors used freely and applied in solid blocks of color, rarely shaded; the clearly drawn outlines stand out against a uniform background, with no superfluous details to clutter the composition. Romanesque wall painting in no way seeks to imitate reality. The flat images—exhibiting little or distorted perspective—economizes in the representation of nature, suggesting in a summary fashion a few landmarks with the help of highly stylized accessories. In this way a column, a tower, a facade symbolize a town, while a tree is the sign of abundant vegetation. The anatomical model is equally standardized in a few outlines designed to denote the large masses of muscle. The principal parts of the body, when they are exposed (as with Adam and Eve), are set off in separate geometric compartments (abdomen, pectorals, sternum, etc.) and seem to be treated independently. Priority goes to posture and gestures, which can be clearly distinguished against the highly unified background, sometimes dark (blue), in Auvergne, Burgundy, and the southeast, sometimes light, in the Loire valley, the west, and central France.

Grouping families of wall paintings works better through their style and technique than through their iconography. All follow the basic procedure of applying pigments on a ground of lime plaster, preceded by a preparatory drawing (sinopia). There were three procedures. The first, fresco (*buon fresco,* or true fresco), essentially Italian and little used in France, consisted of painting rapidly—in blocks of seven hours—and with no possible correction, with water-based pigments on a wet ground. The technique of *secco* painting, also known as *secco fresco,* calls for more demanding preparation of the walls but uses a dry ground. This is brushed

NOHANT-VIC, CHURCH OF SAINT-MARTIN, DETAIL OF WALL PAINTING, FIRST HALF OF THE 12TH CENTURY *The intense look exchanged between Christ and Judas a few moments before Jesus' arrest reveals all. The master who supervised the decoration of this humble Berry church had an incontrovertible sense of theatrical staging and a distinctive style, with outlined facial features, small mouths, shadowed cheeks, and extravagant drapery whose folds ripple and billow.*

with a fatty substance (pork grease) and covered with a double application of colors, successively matte and glossy—made possible with the addition of wax—as in Burgundy and Auvergne. Romanesque France more commonly made use of matte painting, obtained on a thin dry ground, moistened to receive a single layer of colors mixed with liquid glue. Here repainting was possible and additions (features of the face, details of drapery) could be done dry, which generally explains why they have subsequently crumbled away.

Within French territory, the western regions are the richest in wall paintings. The jewel among them is the ceiling of the church of Saint-Savin-sur-Gartempe in Poitou, where the most elaborate artistic program known to date covers the vaulting of the nave, choir, crypt, porch, and porch gallery. It was painted by several teams of artists within a fairly restricted time period, before and after 1100. The continuous barrel vault, which displays the most famous narrative cycle, covering 4,500 square feet (412 square meters), illustrates scenes from the old Testament drawn from Genesis and Exodus in four registers of paintings. Their arrangement is chronological, beginning in the western end, requiring the viewer to go up and down the nave to follow its progress.

The creation of the stars is followed by the story of Adam and Eve, succeeded by that of their sons Cain and Abel, the Flood, Abraham, Joseph, and Moses. Some of the compositions have a remarkably cinematographic setting. The swallowing of the pharaoh's chariot in the Red Sea is painted in a dramatic style and symbolizes, like the whole of the cycle, the struggle between the all-powerful divinity and the forces of darkness that reign on the Earth. As is often the case in Romanesque painting, those who incarnate Evil, like Cain or the right-hand figure in the tale of the Tower of Babel, are represented in profile. For all the refined quality of this group, the artists did not execute it without hesitations or second thoughts. Thus, the figure of Eve in the Temptation scene today finds herself bearded like Adam, after the painted-over correction has disappeared, revealing that the artist decided to reverse the position of the two protagonists.

Like the sculptural program, the painted decor forms a coherent whole within the church. At Saint-Savin the Old Testament, depicted in the nave, introduces images from the New Testament, which one could formerly contemplate from the choir. The eschatological vision of the Second Coming and of the heav-

enly Jerusalem is located in the porch. Directly linked to the cult of saints venerated in these places, the martyrdoms of Saint Savin and Saint Cyprian are illustrated in the crypt in anecdotal fashion, with a propensity, characteristic of the time, to attract attention by the realistic representation of some of the forms of torture, in this case, the wheel and iron hooks.

Examples of wall painting abound in the Poitou. In the rock-walled crypt of Montmorillon, near the abbey, the Virgin in Glory occupies the half dome of the apse. She places her hand on the Child in a gesture taken from Byzantine art. At Poitiers, no fewer than four buildings retain their decoration: Notre-Dame-la-Grande, Sainte-Radegonde, Saint-Hilaire, and the baptistry of Saint-Jean. The latter contains an Ascension showing Christ surrounded by angels, Apostles, and four splendid horsemen, who might be the Roman emperors responsible for the triumph of Christianity.

Many paintings have been protected from the ravages of time by the whitewash that covered them after they fell out of fashion. A fire in 1940 led to the uncovering of those at Château-Gontier. At Saint-Hilaire in Poitiers their presence was unsuspected; their discovery has brought to light one of the most beautiful groups in western France. At Salles-Lavauguyon in Limousin they are now the object of a promising rediscovery and a particularly attentive restoration because of the humidity from which the church of Saint-Eutrope has suffered. The walls, long soaked with water, have developed a layer of moss and algae, which must be treated with fungicides. The removal of the whitewash and the consolidation of the pigment layer is bringing the varied and lively colors back to life. The attention given to these walls may end up revealing an important iconographic program. We are perhaps in the presence of a rare French example on such a large scale. The backcountry of the Loire is filled with masterworks: Vicq, Brinay, Le Liget, Tavant, Montoire, Guérets, Chalivou-Milon are admirable examples where Gallo-Roman, Byzantine, and Carolingian heritages meet and mingle with the local styles, often very picturesque.

Preceding pages
SAINT-SAVIN-SUR-GARTEMPE, ABBEY CHURCH, VAULTING OF THE NAVE, LATE 11TH–EARLY 12TH CENTURY

Opposite above
BRINAY, CHURCH OF
SAINT-AIGNAN,
DETAIL OF THE WALL
PAINTINGS DEPICTING
THE CHILDHOOD OF
CHRIST, 12TH CENTURY

SAINT-SAVIN-SUR-
GARTEMPE, ABBEY
CHURCH, DETAIL OF
THE WALL PAINTINGS
OF THE PORCH, C. 1100

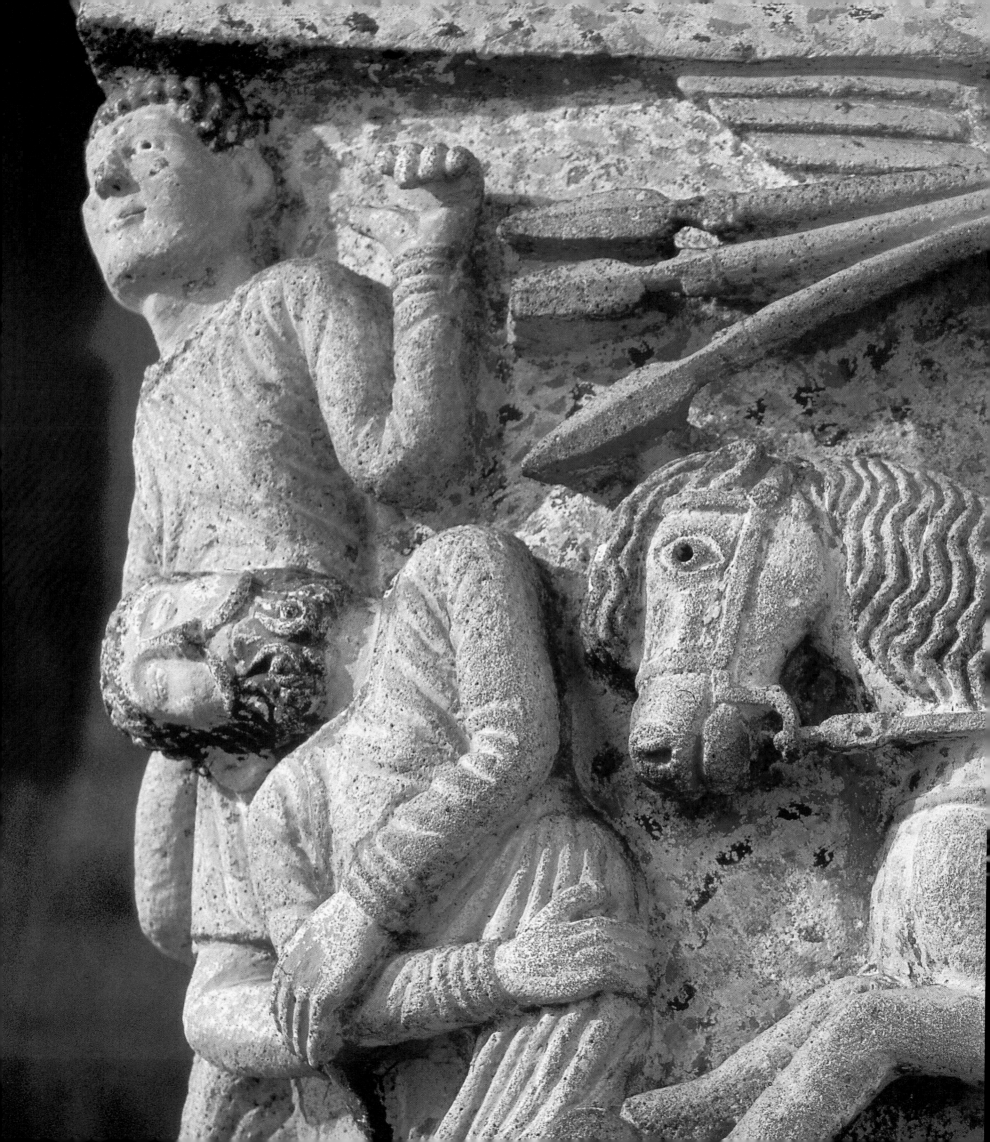

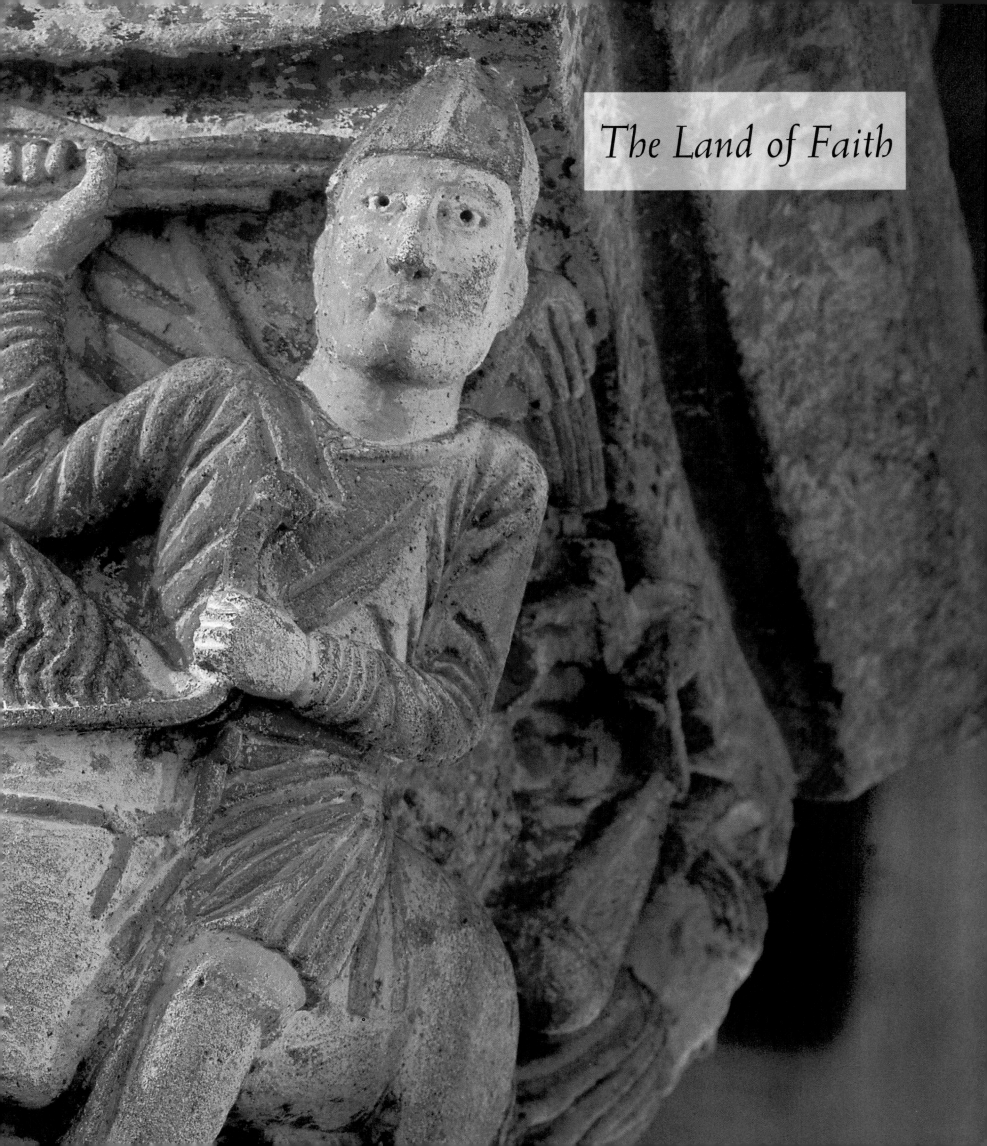

The Land of Faith

Auvergne is not the heart of France: it is a country within a country. Its inhabitants, like islanders who take pride in their difference, are endowed with a collective consciousness that carries on the region's customs.

BETWEEN NORTH AND SOUTH

Early integrated into Aquitaine, which by the beginning of the eleventh century held two-thirds of the Massif Central, Romanesque Auvergne was shared among many powers, including the powerful duke to whom it belonged and the king it recognized late (Hugues Capet was only recognized at the end of his reign). Here as elsewhere the incapacity of the last Carolingian kings to govern opened wide the door to the institution of feudalism, which was somewhat anarchic; the phenomenon is illustrated strongly in Auvergne, which has an abundance of châteaux. Its fragmentation into counties was accompanied by quarrels between lords, which distressed and weakened the province in the eleventh century.

It fell to the omnipresent diocese of Clermont to maintain the unity of the region, all of which it recovered. Its administrative center lay in the hands of the bishop, actually a feudal lord who succeeded in imposing his temporal authority and supplanting the rival count, who in the twelfth century was forced to move his fiefdom to Montferrand. It was to Clermont that Pope Urban II summoned a council in 1095, on the last day of which he preached the First Crusade to Jerusalem, which elicited an immediate outburst of enthusiasm. If this episcopal town was chosen for the scene of such an important announcement, it is because it became, in a century, the nerve center of a highly populated region, moved by an intense faith, supported by numerous religious establishments enriched by the donations of the faithful. The order of Cluny, represented by the monasteries of Mozat, Saint-Flour, and Souvigny, had to compete with both those of Aurillac and of La Chaise-Dieu, great spiritual and intellectual centers that greatly augmented the economic development of Auvergne. The two powerful chapters of Notre-Dame-du-Port in Clermont and Saint-Julien in Brioude, to which we owe the construction of the major churches of lower Romanesque Auvergne, accumulated their possessions through the pilgrims who came to pray over the

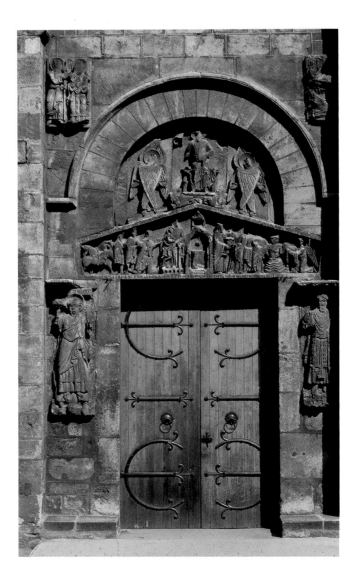

relics of the saints of Auvergne, contributing, by their passage, to the opening of this reclusive province to the rest of the world, and in particular to northern France. In this way, a farming land also became one of trade.

Oscillating between north and south, the province was torn between, on the one hand, the royal authority, supported by the bishop and the count of Clermont, and on the other hand, Aquitaine, favored by the count of Auvergne, who lived in Riom. The two parties clashed violently when conflict broke out between the two successive husbands of Eleanor of Aquitaine, King Louis VII of France, who disowned her, and Henry II Plantagenet, king of England, in the twelfth century. This war between the English and the French was still bitterly contested at the beginning of the thirteenth century. Philippe Auguste, aided by the bishop of Clermont and the lords of Bourbon, fought several military campaigns before finally incorporating "this Land of Auvergne" into the realm of the Capetian crown in 1213. The bishop kept his town,

CLERMONT-FERRAND, NOTRE-DAME-DU-PORT, SOUTH PORTAL, 12TH CENTURY
Churches of Auvergne have few sculpted portals, most of them lacking frontispieces due to the harshness of the winters. The portal of Notre-Dame-du-Port embellishes the southern entrance of the transept with the largest sculpted program in the area.

Opposite
ORCIVAL, BASILICA OF NOTRE-DAME, SEEN FROM THE CHEVET, 12TH CENTURY
The stepping of the masses directs the gaze upward from the small radiating chapels and the ambulatory toward the apse and the transept, until it reaches the narrow rectangle of the main body of the church, crowned by the tower of the octagonal crossing. In spite of its local differences, the tiered chevet links the major churches of lower Auvergne to the Toulouse-Compostela family of sanctuaries with relics.

Preceding pages
SAINT-NECTAIRE, ABBEY CHURCH, CAPITAL IN THE CHOIR DEPICTING A HORSEMAN OF THE APOCALYPSE, 10TH CENTURY

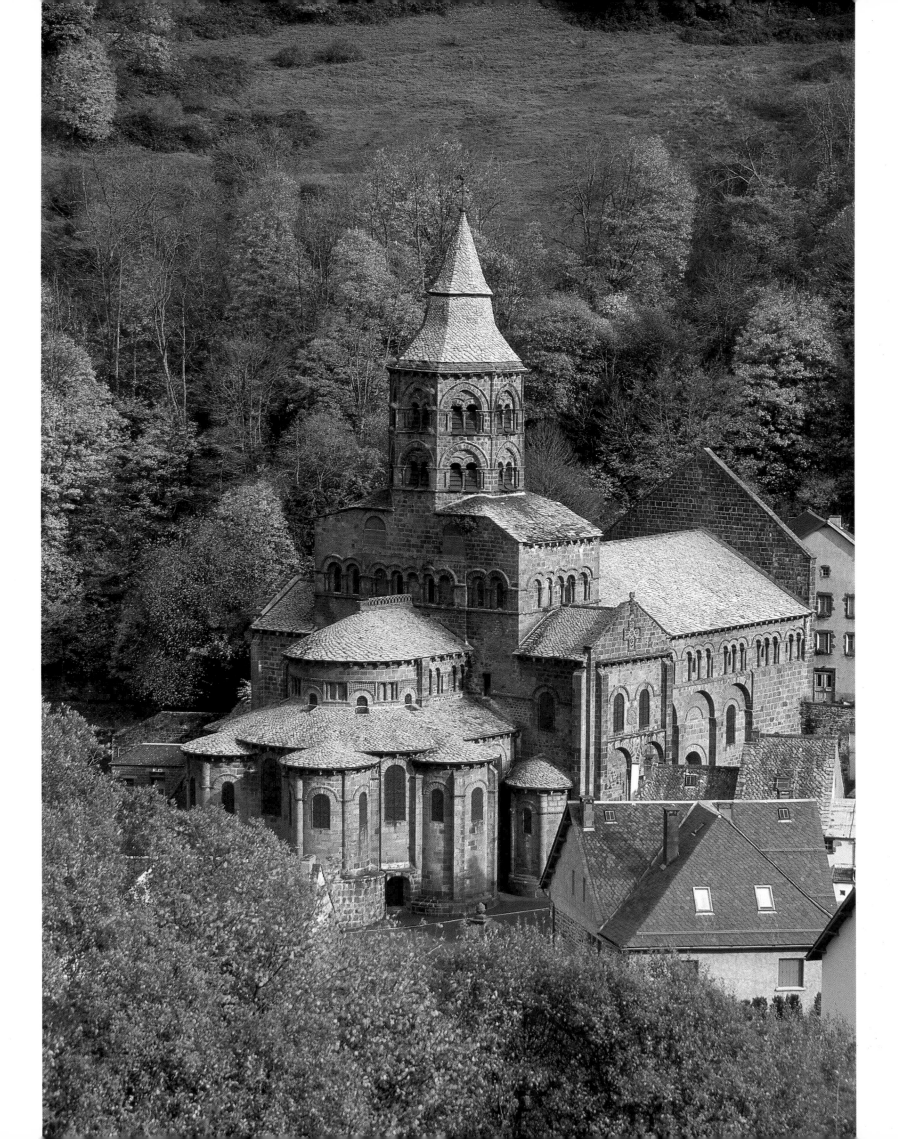

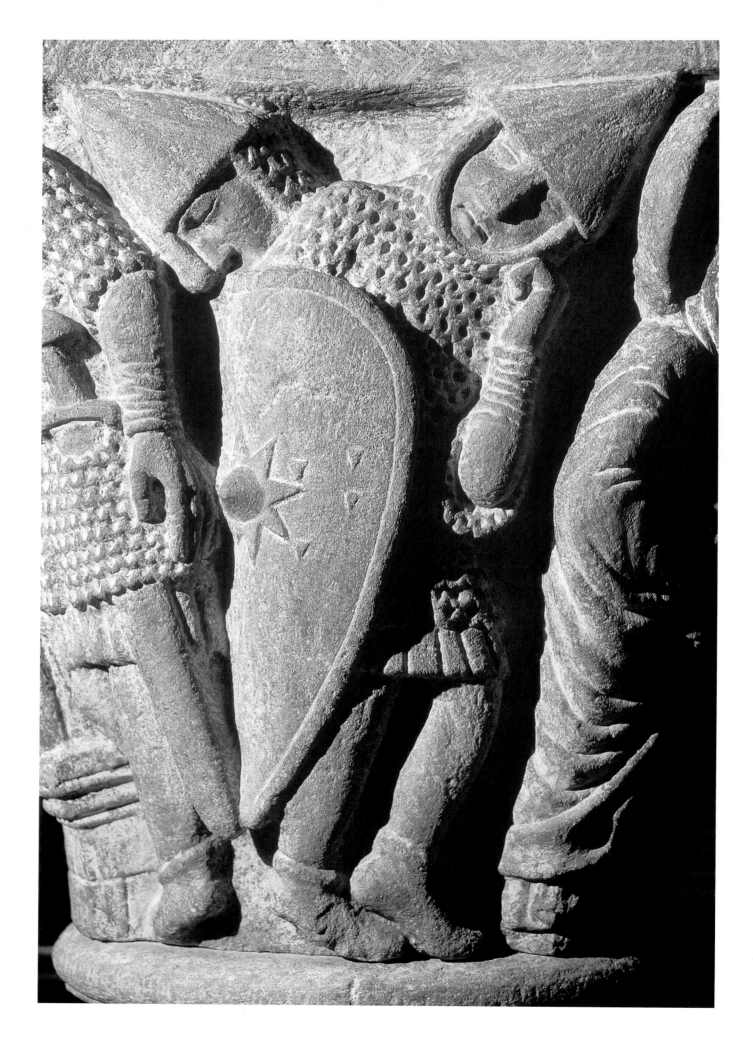

MOZAC, CHURCH OF
SAINT-PIERRE, CAPITAL
KNOWN AS "THE HOLY
WOMEN AT THE TOMB,"
12TH CENTURY
*The workshop that
created this group drew
on Gallo-Roman and
Early Christian art for
the human figures with
squat torsos and large
heads. They ably por-
trayed the heavy sleep of
the soldiers guarding the
tomb of the resurrected
Christ. Since the theme
of the Holy Women at
the Tomb is here treated
in the same manner as
in Saint-Nectaire,
Issoire, and Brioude, it
has been proposed that
some of the capitals
from Mozac inspired the
sculpture of Auvergne.*

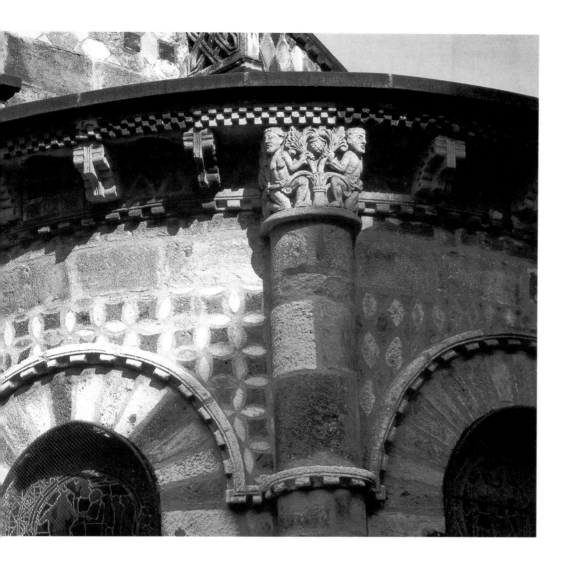

These churches, situated in lower Auvergne, geographically close since they were built in the Limagne Plain within a radius of about twenty miles around Clermont, hardly exceed a half dozen in number. They were built of arkose (yellow sandstone) and volcanic stone. Most depended on their role as centers of the cult of relics, and they exhibit a structure appropriate to the pilgrimage church: a gallery, which surmounts the aisles, mirrored by a deep transept, a semicircular choir, and an ambulatory that opens on radiating chapels and encircles a semisubterranean crypt. On the other hand, the originality of this group in Auvergne can be perceived in their common silhouette, compact in appearance and displaying a harmony attained by the arrangement of stacked volumes. This is particularly clear in the eastern end of the buildings, where the chevet follows an ascending movement that leads to the imposing octagonal tower; this movement is tempered by a succession of horizontal lines that endows the whole with a look of solidity and robustness.

Nowhere else, except perhaps in Normandy, do we find such continuity of stylistic forms concentrated in space and time. The homogeneous character of the monuments derives from the proximity of the building sites, their contemporaneity, and finally to the close ties that united them, through the intermediary of the clergy and the master builders.

Ennezat, Saint-Nectaire, Issoire, Orcival, and Saint-Saturnin, the major churches of the Limagne Plain—which make up one of the most astonishing architectural ensembles in Romanesque France—undoubtedly share a prototype from the tenth century: the former cathedral of Clermont, which unfortunately was replaced by a Gothic building. Notre-Dame-du-Port was built around the middle of the twelfth century for the parish of the rich merchant town of Clermont—*portus* means "a place of commerce" in Latin. It immediately stood out from the other fifty-odd sanctuaries that then filled the city and played a significant role, reflected in its name, Sainte-Marie-Principale—the Principal Saint Mary—which it bore from the beginning despite the fact that the cathedral of Clermont was also dedicated to the Virgin. The name also signals the development of the Marian cult, which had become an important phenomenon by the twelfth century. The building's prominence also indicates the rise of a new social class, that of the urban merchants, who used their

CLERMONT-FERRAND, CHURCH OF NOTRE-DAME-DU-PORT, DETAIL OF THE CHEVET, SECOND HALF OF THE 12TH CENTURY
The ornamental repertory of the Clermont group finds its fullest expression in the chevet. While the doors are accentuated by volcanic stone voussoirs of different hues and a row of billet molding, the stones used in the upper walls obey a polychrome geometry. The cornice is punctuated with the decorated capital of buttressing columns and chip-carved modillions, which originated in Arabic Spain. A decorated checked band runs the length of the gallery.

which was no longer the first and foremost in the province, while the count moved to Montferrand.

MAJOR CHURCHES OF THE LIMAGNE PLAIN AROUND CLERMONT

In the twelfth century Auvergne became a land of transit to Le Puy and the great sanctuaries of the southwest that punctuated the journey to Santiago of Compostela. The Church, benefiting from the economic revival that took place here, was composed of an erudite clergy, which controlled artistic creation. All of these factors led to the rapid flowering of a group of major churches. Some appeared at the end of the eleventh century, while the majority were built in the first half of the twelfth. They are the product of a Romanesque art that had achieved its maturity, which became the dominant style in the medieval countryside of this region, bypassing almost entirely early Gothic.

financial might to participate in the religious expansion in their own commercial neighborhoods. The generosity of their gifts sometimes led to forgiveness for a social rise that the clergy found too rapid, if not downright suspicious.

AN ART IN TIERS

Let us observe Notre-Dame-du-Port and her sisters. The process begins with a paradox; standing before the west facade, the visitor is at first disappointed: the great naked wall, the modest size of the portal, and, finally, the ugly tower that has surmounted it since the nineteenth century reveal the lack of attention these master builders paid to the western part of the buildings of this group. We find the same "nonfacade" at Saint-Nectaire and Saint-Saturnin, stripped of articulation and sculpture, a prudent response to the bad weather that their location on an outcropping exposed them to. The two towers rebuilt in the nineteenth century at Saint-Nectaire remind us that Issoire and Notre-Dame-du-Port also had towers. Walking along the latter church on the southern side, we follow a succession of arcades—blind buttresses in the same number as the interior bays, surmounted by small arcades in groups of three, corresponding to the level of the galleries. We see that the southern flank was thought to be the most important when we reach the arm of the transept, whose gabled facade displays one of the very rare sculpted portals in Auvergne, with the characteristic forms of the region: a tympanum inside a horseshoe arch resting on a triangular lintel designed to add support to the weight of the wall.

We thus find ourselves drawn by the east end of the church, where the chevet opens out, the most beautiful part of the Auvergne sanctuary. The multilevel chevet of Saint-Austremoine in Issoire is progressively defined in a pyramidal movement, creating a play of structure with pure geometric elements. A marvel of balance and rigor, it is also one of the most lavish examples of the ornamentation so particular to lower Auvergne, which is concentrated on the eastern end of its churches. This visual vocabulary stems from Gallo-Roman and Early Christian traditions, still alive in Romanesque Auvergne. Judging by surviving fragments of paving, this vocabulary derives from the first centuries A.D., when both traditions offer very similar

decorative motifs. We also think of classical antiquity at the sight of the small niches with colonnettes whose capitals support an entablature. As for the chip-carved modillions so meticulously sculpted, we may attribute them to an Eastern influence, which had long (and incorrectly) been extended to the whole of the decor. The extreme care taken in the construction of the building is manifest even in the cutting of its stones: at Orcival, the journeyman's marks repeat the same angled striations called fern-leaf, characteristic of Romanesque churches of the Limagne Plain and an obvious proof of the extreme rapidity with which the group was built.

The multiplication of chapels intended for the celebration of services by the clergy, the ample size of the transept end of the ambulatory, designed with processions in mind, the crypt that hints at its presence—all these elements remind us that the liturgy was concentrated at the east of the building in the cult of the saints. Our return to Notre-Dame-du-Port will teach us more.

Entering by the west facade, here we are on the threshold of the church, in the antechurch, an interesting pre-Romanesque survival common in Auvergne. A dark gallery incorporated into the architectural whole, it is distinguished by thicker walls and an upper floor forming a high hall, open on the church (which is quite noticeable looking back from the nave). Before us is a short nave, covered with a continuous barrel vault, relatively dark because of its indirect lighting.

The variety of vaulting in the transept, where the same stepping of volumes already evident from the exterior unfolds, originated from a concern about solidity. Beginning at the extremity of one of the transept arms, we follow a harmonious progression as we watch the pointed barrel vault make way for a higher semicircular barrel vault in the oblong mass, intended to buttress the octagonal dome that surmounts the crossing, where we now find ourselves. The latter is broken up in space by four diaphragm walls, of an ancient design, which seem to hang from the void, although they rest on four pillars and distribute the weight of the tower that soars above. As if to better emphasize this height, the architect has ornamented the diaphragm walls with a decoration of honeycombed stone mosaics similar to that of the chevet.

Facing us is the choir, elevated by several stairs, surrounded by an ambulatory opening on four radiating chapels. Its vault is lower than that of the nave,

Preceding pages
CLERMONT-FERRAND, NOTRE-DAME-DU-PORT, VAULTING OF THE TRANSEPT CROSSING, LATE 11TH CENTURY

Opposite above
ISSOIRE, CHURCH OF SAINT-AUSTREMOINE, 12TH CENTURY

Opposite below
SAINT-NECTAIRE, ABBEY CHURCH, CHEVET, 11TH CENTURY

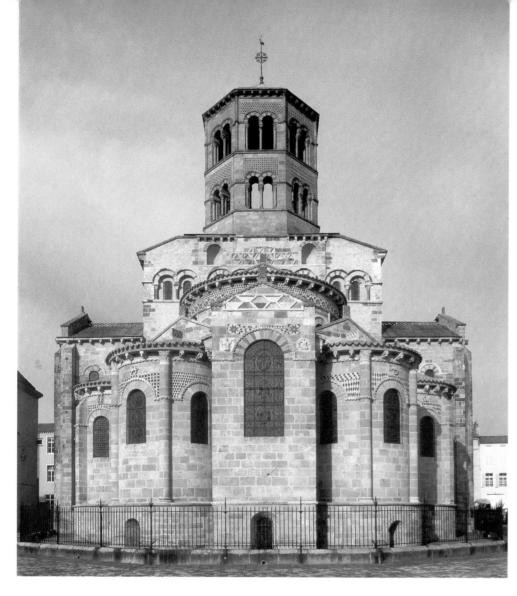

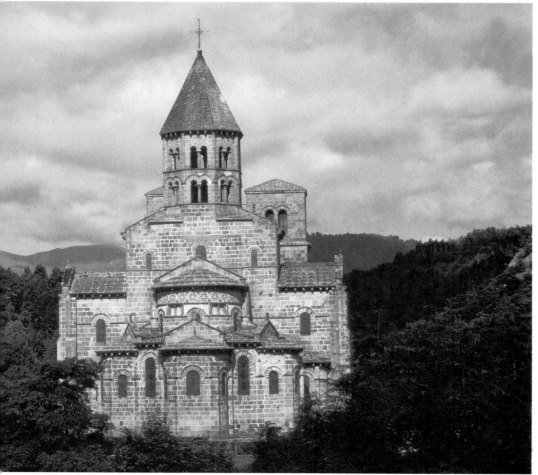

and that of the apse half dome is lower still. After the ascending progression of the transept, we see here a descending movement; the arrangement of the volumes becomes more modest, appropriate to the silent veneration of the relics originally preserved under the choir. The eight columns that surround the sanctuary are thin, elegant, on a human scale to facilitate the reading of the capitals. These latter support the characteristic raised arcades, which intentionally accentuate the distance to the center of the recess of the apse (Orcival). In a similar spirit of harmony, liberties have also been taken with the arrangement of the five windows that pierce the walls of the apse half dome: with the exception of the one on the axis, the others are not placed over the arcades of the semicircle. We now mount the stairs of the sanctuary, pierced with openings that allow the light of the lamps designed to illuminate the relics in the crypt to filter through. Moving toward the ambulatory, we take care to stay to the left, following the pilgrims of yesteryear who kept the principal altar on their right as a sign of respect. Between the radiating chapels covered by half domes, historiated capitals echo those on the columns of the choir that support the springing of a clever circular barrel vault; each abacus, in a supreme refinement, is curved to follow the curve of the ambulatory.

Now we descend belowground (in reality, only halfway belowground, since the crypt is furnished with windows at ground level, under the elevated choir). Here lay the relics. Today we still see, in this place of saints' bodies, the Black Virgin, which replaced a Virgin with Child that has disappeared. The plan of the crypt is identical to that of the choir, which it supports with four stocky columns whose placement is in the exact axis of those of the upper sanctuary.

PRECOCITY AND PERMANENCE

The crypts of Auvergne are not among the most beautiful nor the most spectacular in France. Two of them, however, retain their pre-Romanesque structure, which helps us to understand better the development of architectural experimentation that led to the conception of the Romanesque choir with its ambulatory and radiating chapels.

In the former cathedral of Clermont, consecrated in 946 by Bishop Étienne II, there remains a crypt built in the first half of the tenth century, damaged and

incomplete but of great archaeological importance. The choir there is only in its beginning state, since it is composed of a central rectangular hall divided into three small naves continued to the east by three niches. The whole is enclosed by a stout wall thick enough to support the foundations of the upper choir. On the other side of the wall ran a narrow *ambulacrum,* or walkway, of which there remains only the turning part. Four radiating chapels, formed in irregular squares, were symmetrically ordered, apparently closed by small doors, increasing the mystery as to the real function of these recesses: were they places where relics were venerated or stored?

This archaic plan was not widely imitated, except at Mozat, which suffered even greater mutilation by subsequent remodeling. Thus, we must turn to Billom to discover a well-preserved underground construction that reveals the design adopted for all of the major churches. The end wall of the central hall in Clermont is here transformed into a semicircle punctuated with columns and pillars (although it remains quite thick). This gives us the origin of the arrangement of an ambulatory opening on the choir. In it we see the fruition of the multiple experiments undertaken beginning in the Carolingian period, and especially those undertaken in the course of the tenth century, for the organization of the eastern end of the church in accordance with liturgical necessity. Archaeological investigation has revealed, at Thérouanne (Pas-de-Calais, first half of the tenth century) and in the crypts of Burgundy (Flavigny-sur-Ozerain, Saint-Germain d'Auxerre, Saint-Bénigne of Dijon), the appearance of the *ambulacrum*, its development in various permutations, the evolution of a semicircular design, and, finally—thanks to the genius of the architect of the former cathedral of Clermont—its maturation into the choirs of Notre-Dame-du-Port and its colleagues in the Limagne Plain.

In Auvergne the blossoming of churches at the end of the eleventh and the beginning of the twelfth centuries actually marks the final phase leading to an exemplary design. Archaic forms persist here and there, of course, to spark our greater curiosity, like the axial rectangular chapel inherited from Carolingian times that was retained at Issoire and Saint-Dier in Auvergne and Souvigny and Saint-Menoux in the Bourbonnais. Ancient materials, if not forms, found a place in the three crypts described above, their foundations built from enormous cut blocks taken from Roman buildings, and in Chamalières, which set cut-down antique columns to support the arcades of the porch.

The latter, like Cournon, Chauriat, Manglieu, Saint-Myon, and many others, has retained elements of the style of the Limagne Plain, whereas others stand out by virtue of their eccentricities. Menat boasts a curious ovoid dome that covers the crossing of the transept; Beaumont, in the suburbs of Clermont, has a chapel built in the caves of Jonas; and, finally, the fortified church of Royat belongs simultaneously to the eleventh century and the late Romanesque.

The church of Saint-Amable of Riom reflects the decline of the Romanesque in Auvergne. It took as its building material gray volcanic rock, called Volvic stone, which had never before been used, and it became the preferred material of the Gothic period in the region; it composes the rebuilt cathedral of Clermont.

BRIVADOIS: THE CASE OF BRIOUDE

Between upper and lower Auvergne, Brivadois is a land of mountains and rivers, rich in spectacular sites still scattered with many rural Romanesque churches. The region, with few towns, owes its early development to the exceptional impact of pilgrimage to the tomb of Saint Julian at Brivas—present-day Brioude—as it intersected with important roads of Auvergne.

Although a part of the diocese of Clermont, the many small churches of Brivadois could not help but be influenced by the brilliance of the monastery of Brioude and the no less important La Chaise-Dieu (Casa Dei), of which for the most part they were dependencies. In this way they developed the common traits specific to the region, among which some are the direct echo of the landmark Saint-Julien. These characteristics include the tower-porch, aisleless plan, pentagonal chevet punctuated with arcades, windows underlined with ovolos richly sculpted with rinceaux or friezes of animals. Lavaudieu (Vallis Dei) displays the only cloister in Auvergne that survived the Revolution. Of modest proportions, with a timber-roofed nave and rustic paving, it remains one of the most stirring places in all of Romanesque France. The abbey church of Blesle, nestled in a picturesque old town, has an unusual atmosphere created by the same phenomenon of additions and

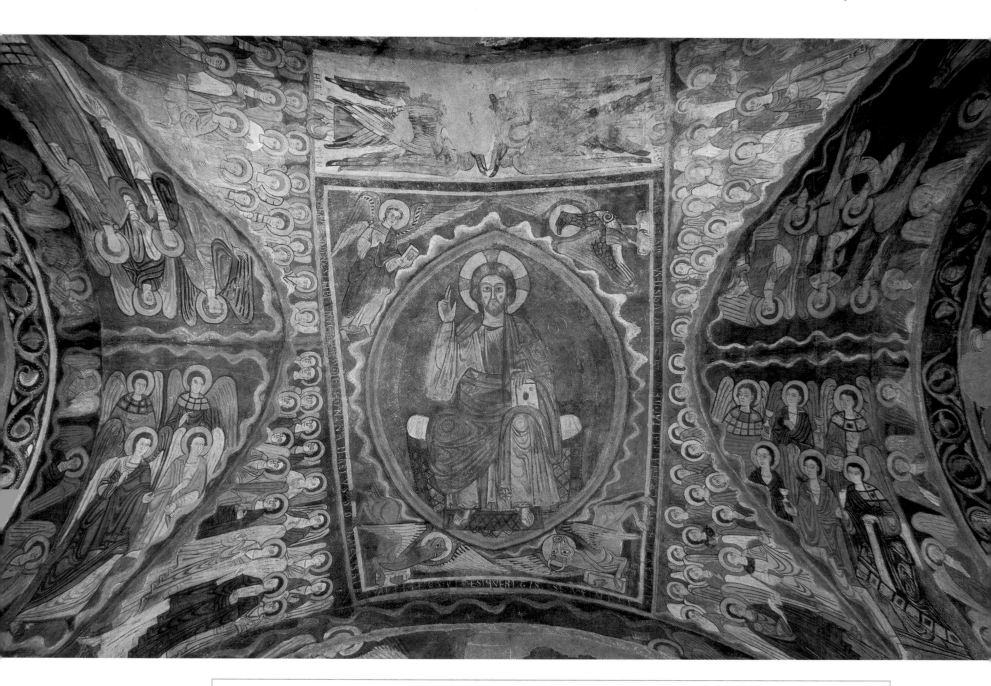

WALL PAINTING IN BRIOUDE

●

The decoration at Brioude, dating from the beginning of the thirteenth century, is still Romanesque in workmanship. It includes a complete iconographic program tied to the function of the upper room, used as a funerary chapel with remains set out on display during the time of the canon-counts of Brioude. The paintings of the vaulting, where Christ appears in glory surrounded by the hierarchy of angels—almost a hundred in all—are less remarkable than those on the walls, in which an unforgettable spectacle unfolds. The archangel Michael, executor of divine sentences, presides over the whole with great ceremony in his role as guide to the place of the dead. The flames of Hell show an imposing, grotesque, grimacing Satan of greenish hue, assisted by an army of demons bustling about the damned, who represent different sins. The opposite wall depicts the soul's path toward goodness, its struggle against evil in the form of a battle of souls in which the Virtues, clothed in long robes, trample the Sins, such as Pride and Wrath.

The large fresco painting in the refectory of the cloister of Lavaudieu shows Eastern influences. Working on a single wall inside a pointed arch 20 feet (6 meters) high, the artist opted for monumental proportions. The fresco portrays an immense Christ in Majesty holding a strange scepter and an enthroned Virgin with halo and crown, symbolizing the Church (Ecclesia) and making the gesture of prayer, with the palms raised to the heavens.

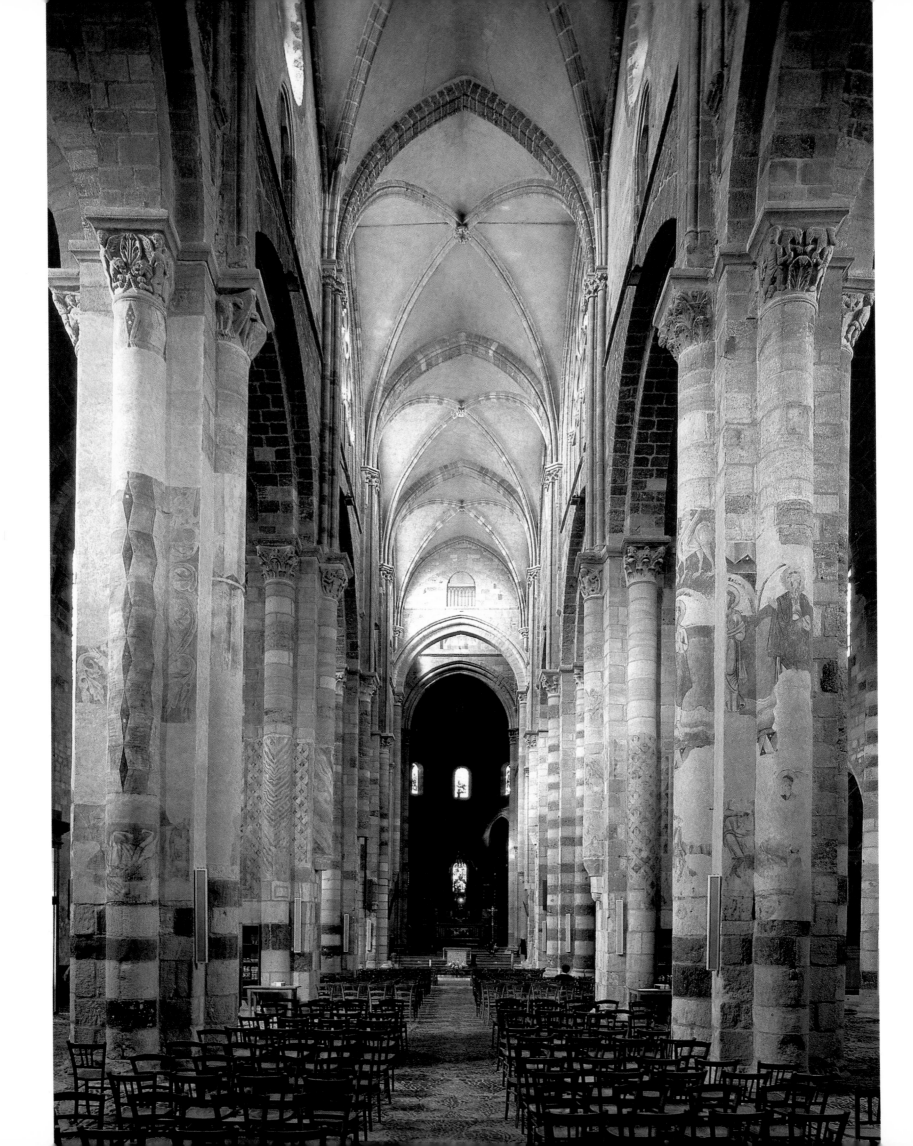

BRIOUDE, CHURCH OF
SAINT-JULIEN, NAVE,
LATE 12TH–13TH
CENTURY
*The subtle design made
by the masonry of the
most original church in
Auvergne is due to
chance alone, since these
walls were intended to
be covered with painted
decorations, of which
only fragments remain.*

reconstructions—in the course of the twelfth and
thirteenth centuries—experienced at Brioude. Ample
proportions prevail at Chanteuges, especially in the
side aisles, as at Brioude, here covered with an odd,
almost flat groining. The ruins of a château belonging
to the dauphins of Auvergne at Saint-Ilpize houses
one of the rare fortified chapels of the country,
perched above the gorges of the Allier. Following the
example of Prades, Sainte-Maie-des-Chazes, Bounon-
cle, and Mazérat-Aurouze, its choir is semicircular
inside and polygonal on the outside.

THE BASILICA OF SAINT-JULIEN IN BRIOUDE

Among all the churches that line the Allier Valley, the
basilica of Saint-Julien of Brioude is itself worth the
journey—certainly, because it is beautiful, but espe-
cially because it is unique. After the uniformity of the
Limagne Plain monuments, most of them constructed
in a single building campaign, the largest Romanesque
church in Auvergne (245 feet, or 74 meters, long),
which took more than a century to erect, is all diver-
sity. Its idiosyncrasy appears on all levels, from its
curious orientation toward the northeast to its long,
narrow nave with very wide aisles, its choir with four
columns, or its nonprojecting transept. All of its ele-
ments disconcert: the glimmering beauty of the mate-
rials, the unusual irregularity of the nave and aisles,
due to variations in the spacing of pillars from one bay
to another. The same is true for the variable courses
and the shaping of the stones, which shows that the
church was built in horizontal sections and by several
generations of master builders. Thus, the choir was
rebuilt at the end of the twelfth century by an archi-
tect who was already turning toward the Gothic style
but felt compelled to respect the local Romanesque
tradition, represented by the marvelous antechurch
built opposite the choir a century earlier, in order to
make sense of the distance that separates them. Built
with a two-story elevation, the antechurch is the most
beautiful element of the structure; its vaults make use
not of rubble, as in lower Auvergne, but cut stone, its
cruciform pillars are impressive in their strength, and
its tribune is covered in the center with a small dome
on predominately red squinches.

CONTRASTS OF UPPER AUVERGNE

Upper Auvergne presents an architectural style very dis-
tinct from the major churches of lower Auvergne. The
simplicity of the religious buildings that stud the vol-
canic mountains of Cantal, far from the major roads,
leads us to see in them a humility that contrasts with the
grandiose character of the countryside of forests, pas-
tures, and mountains (Dienne, Saint-Urcize, Bredons).
In the valleys a sprinkling of small towns and villages,
dependencies of the former episcopate of Saint-Flour,
including Aurillac, Salers, Mauriac, and Murat, share
modest churches of rustic appearance, which borrowed
original and varied arrangements from the adjoining
regions of the Rouergue, Limousin, and Languedoc.

These churches have in common reduced dimen-
sions, a simple plan often without aisles or ambulatory.
In addition to their stone roofs, the exterior element
that distinguishes them is the narrow bell tower (most
of them reconstructed, since they were destroyed in
the Revolution). Erected sometimes at the west end
(Saint-Urcize), sometimes at the south, they usually
precede the choir as a substitute for the imposing
octagonal towers of lower Auvergne (Virargue, Chali-
nargues, Lascelles, Roffiac, Ydes). At the same spot in
the interior, attention is focused on the triumphal arch
that embellishes a part of the choir. Here, too, the plan
shows its greatest inventiveness: it started with the
concept of the chevet with two different profiles,
polygonal and semicircular, from Brivadois, but
recessed the niche-chapels directly into the thickness
of the original wall, as at Roffiac, which has five niche-
chapels. Limousin left its mark on the treatment of the
windows, emphasized with a torsade, or twisted-cord
molding, as at Anglards-de-Salers and Saignes. The
influence of the Rouergue is present in the choir and in
certain elements of the sculpted decor, such as the cor-
bels with grotesque figures, which replaced the chip-
carved modillions of lower Auvergne. The latter has
contributed, for its part, the billeted stringcourses, the
triangular arches, and the half barrel vaults already
mentioned. The triple flat arches with geometrical
motifs framing the openings are a local contribution.

Upper Auvergne has lost all or part of its great
Romanesque abbeys in Saint-Flour, Mauriac, and
Aurillac. The last, located at the end of the Jordanne
valley, at the intersection of the roads coming from
lower Auvergne, Rouergue, Quercy, and Limousin,
was a "new city" (*villanova*) of monastic origins. Its

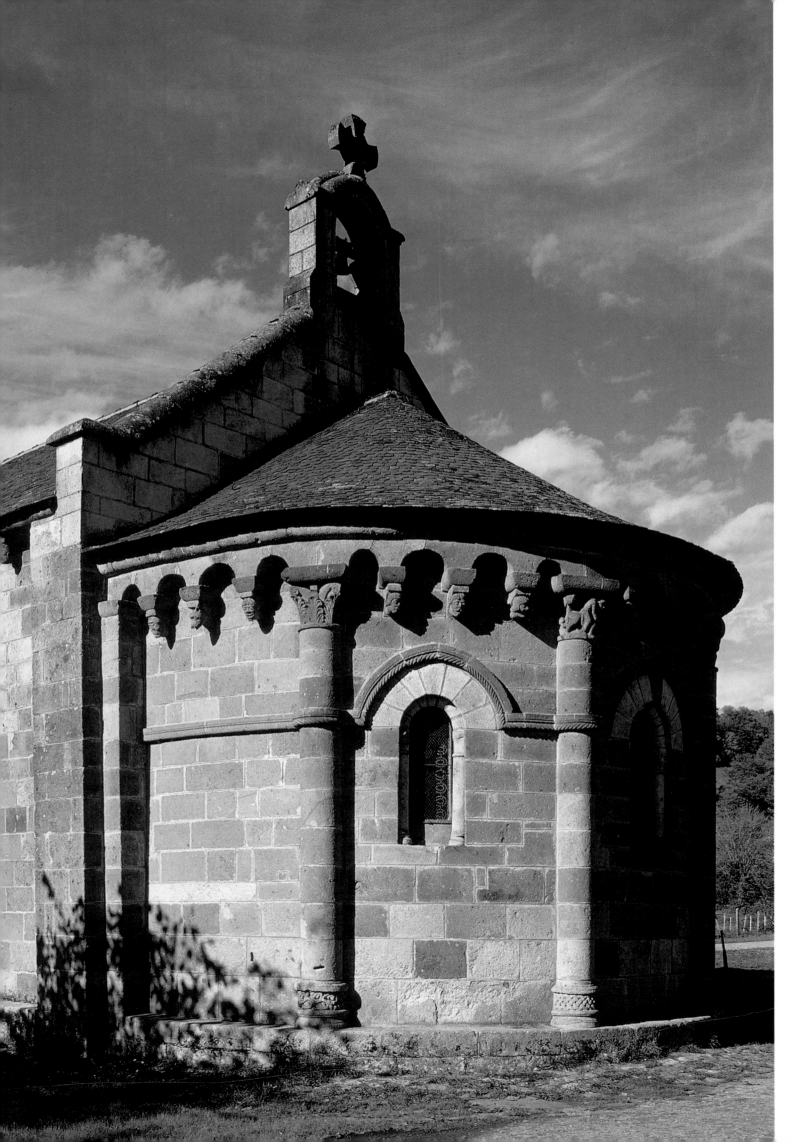

YDES, CHURCH OF
SAINT-GEORGES,
CHEVET, 12TH AND
19TH CENTURIES
*This chevet from upper
Auvergne, composed
of only a semicircular
apse, is unusually elabo-
rate for this region.
Limousin features
(windows decorated
with twisted-cord mold-
ing and a blind arcade
under the cornices) are
combined with modil-
lions in high relief, from
which the carved heads
of men and women with
grotesque expressions
emerge.*

Opposite
YDES, CHURCH OF
SAINT-GEORGES,
RELIEFS FROM THE
PORCH, SECOND HALF
OF THE 12TH CENTURY
*The two protagonists of
the Annunciation, the
archangel Gabriel and
Mary, were placed in a
very convincing setting
recessed in arcades
that give the illusion of
niches. They are part
of a deep porch that
recalls those of nearby
Limousin. The angel,
whose clinging drapery
emphasizes his body,
holds up a cross, which
symbolizes the divine
Incarnation, toward
the Virgin, who in turn
raises her arm in a ges-
ture of humility and
surprise, her hands
hidden in the Eastern
tradition of respect.*

Mauriac, extensively restored in the nineteenth century, today remains the greatest Romanesque monument of upper Auvergne. Austere in appearance, it is one of the isolated cases in Auvergne in which the nave is illuminated directly and was vaulted for this purpose in pointed barrel vaults. As in many nearby churches and according to a Limousin custom, the bases of supports (pillars, piers, columns, and so on) are generously sculpted with interlacing designs, rinceaux, and palmettos. Mauriac's main interest lies in the handsome west portal, which offers one of only two examples of elaborate monumental sculpture in the region (the other is the church of Ydes). The tympanum and the lintel, mutilated by the Huguenots, depict the Ascension, executed in the tradition of the portal of the cathedral of Cahors and revealing the influence of the Master of Moissac.

THE BORDERS OF BOURBONNAIS

To the north of the mountains of Auvergne, beyond the "Occitan gates"—the lands of Ébreuil and Gannat—which marked the linguistic boundary between the *langue d'oc* and the *langue d'oil* (Provençal and Old French), stretches the sweet countryside of Bourbonnais. Here the Massif Central dies away into little hills. Farther east of Vichy, it is extended, like an outstretched finger, in the lone Montagne Bourbonnaise, with its vigorous granite profile and wild landscapes.

Included as far as Souvigny in the northern limits of the diocese of Clermont, in the Romanesque period the region had been in the hands of the Bourbon family since the tenth century. The many churches built in the area in the eleventh century are divided between the three dioceses of Bourges (west and north of the province), Autun (to the east as far as Souvigny), and Clermont (all the southern Bourbonnais).

The Limagne Plain of Bourbonnais runs through the region, stretching from the northern extremity of Auvergne to Saint-Pourçain-sur-Siuole. Its two most important monuments, at Ébreuil and at Veauce, reveal an architecture that, while still simple, marks an evolution leading to the finished style of the churches of the group around Clermont.

Ébreuil, founded by the monks of Saint-Maixent who fled from the Norman invasion, is in fact a rare example of the architecture of lower Auvergne before its apogee. Here we find a church of the old basilical

abbey, founded in 894, was one of the most prestigious in all of Christianity; it gave the Church its first French pope, in the person of the learned monk Gerbert, who became the great Sylvester II in the year 1000. Of Romanesque Aurillac there today remains but few rare vestiges to be found in the church of Saint-Gérard or preserved in the museum.

The church of Notre-Dame-des-Miracles in

style; the nave from the eleventh century is not vaulted, but its great arcades foreshadow those of the major churches. The originality of Ébreuil lies in its tower-porch, of very interesting construction despite the restorations of the nineteenth century, which seem not to have spoiled it too much. Inspired freely and on a more modest scale by Saint-Benoît-sur-Loire, it has three restrained stories in white stone and opens on the church in seven arcades, which are divided around a rectangular plane. The upper stories are punctuated with blind arcades ordered with arch molding sculpted with designs of half disks similar to billeted stringcourses. Built in the twelfth century, or a century after Saint-Benoît, it nonetheless is part of what seems to be a well-established tradition of tower-porches in Auvergne (Mozat, Châtel-Montagne) before they gave way to twin towers on the facade. We cannot leave Ébreuil without mentioning its set of wall paintings, the largest in the region. In tones of mixed blues and greens, the handsome figure of Saint Austremoine, who converted Auvergne, robed in sacerdotal clothing, makes the gestures of prayer. More noteworthy, the church contains one of the great and rare profane scenes of Romanesque pictorial art illus-

SALERS, PORCH AND BELL TOWER, 12TH AND 19TH CENTURIES

CHÂTEL-MONTAGNE, PRIORY, SEEN FROM THE SOUTHWEST, 12TH CENTURY

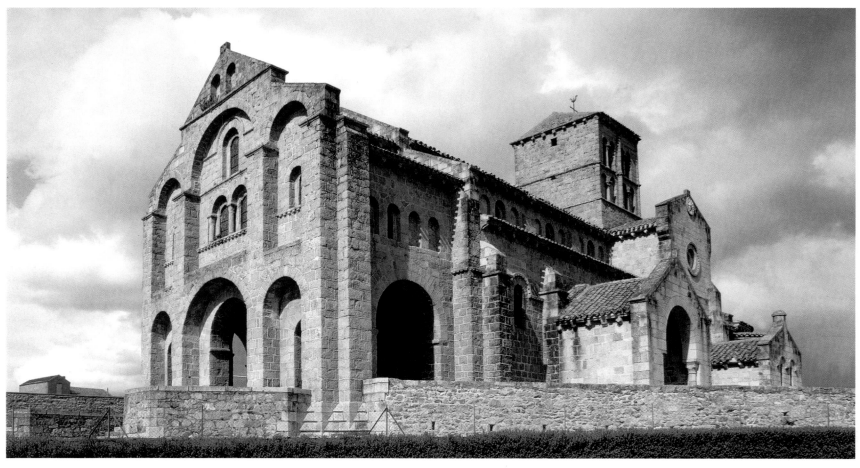

trating the theme of the hunt, which is developed in a frieze around the tribune of the porch: hunting the deer and the hare, falcons and dogs are mingled with fantastic animals like the dragon and the griffin.

The freest interpretation of the architecture of the Limagne Plain is found at Veauce, near the monastery of Ébreuil, to which the church belonged. Here our interest is drawn to the chevet, the nave having been truncated in the middle of the eighteenth century. Built of a very white limestone, adeptly cut and engraved with the initials of the stonecutters, it is composed of an apse surrounded by an ambulatory but without radiating chapels. The projecting transept with chapels facing east is raised, but its builders did not revert to making one side longer than the other nor to stacked vaults; on the other hand, it has the most exaggerated stilted arcades in Auvergne.

Châtel-Montagne surprises in many respects: its size, first and foremost, in relation to the mountainous site it occupies; the play of influences it draws from, next, ranging from the Burgundian repertory (false triforium, illumination through high windows) to the heritage of Auvergne (aisles vaulted in semicircular barrel vaults, a dome on squinches, characteristic tiered chevet). Composed of a hard granite of subtle yellows, Châtel-Montagne has elaborated one of the rare structured western facades in Auvergne. Imposing, at once powerful and graceful, it is grafted onto an ancient gable wall and encloses a porch that opens on the ground floor in three semicircular arcades resting on thick buttresses integrated into the wall. The upper level, pierced with three arcade-buttresses that reproduce the dimensions of those of the ground floor, ends in a gable.

THE ECHO OF BURGUNDY

The transition from the Limagne Plain near Bourbonnais to Bourbonnais itself takes place naturally, without any radical modification of the architecture. Vicq, Chantelle, Gannat, Franchesse, and Huriel, all turned toward the art of Auvergne, can be distinguished through their high (sometimes exaggeratedly so, as at Cognat) gables, which surmount the extremities of the transept, marking the transition between choir and nave or shaping the facade. The latter has acquired a small open porch in an avant-corps, featuring a sculpted triangular lintel inherited from Auvergne (Bellenaves, Meillers). The art of relief, using the traditional ornamental vocabulary from Auvergne, seems less timid in Bourbonnais.

The sculpted portals in the facade are charming in their rusticity. Some of the elements appear to be forerunners of the Romanesque style in Burgundy: the triangular lintel of Autry-Issards, housed in a sloped porch, rests on two large fluted pilasters, which reveal the influence of the Cluniac style. A mandorla bordered with beads, which has lost a Christ dispensing blessings, is carried by the archangels Michael and Raphael, who bow down against a background of arcades from which hang oil lamps; an inscription, "All things of Holy Work, God Made Man remade," illuminates the image and reveals the name of the author: "Natalis me fe(cit)": Noël made me.

Once we cross the borders of the diocese of Clermont, the Burgundian imprint becomes stronger, as at Mines, Le Montet, Izeure, and, especially, at Saint-Menoux, with its impressive tiered chevet. Its ambitious dimensions and the quality of its decor make it the handsomest monument in the region and pose a striking contrast to the modest size of the present village, recalling that the place used to be the locus of an important pilgrimage in honor of Saint Menulphus, a bishop of Irish origins and missionary from Brittany, who died in this town and was buried below it. Since he had performed many acts of healing in his lifetime, his relics were the object of a solemn translation into the present church, which dates from the second half of the twelfth century. At that time pilgrimage to the site was in full swing, so great were the powers attributed to the relics against illnesses of the head, and especially their ability to release the "*bredins*" (patois for the simple-minded) from their madness. A new sarcophagus, of doubtful date, into which those who were mentally disturbed could introduce their head or draw closer to the relics, in hopes of being "*débrédiné*," took full advantage of this power. Set up behind the altar, it was known as the "*débrédinoire*." Judging by the number of saints invoked, madness seems to have been one of the major concerns of the time. The illness manifested so many symptoms—debility, epilepsy, fainting, migraines, to name a few—and anatomical understanding was so imperfect that madness was naively associated with demons and saints in its causes and development, as reflected in the names it then went by: Saint Acaire's, Saint Mathurin's, or Saint John's illness.

Souvigny offers the priory church of Saint-

Pierre. Two of its famous abbots, Saint Mayeul in 994 and Saint Odilon in 1049, passed their final days in the former priory, chronologically the first of the five "daughters" of Cluny. Since their tombs drew a growing number of pilgrims, the church was rebuilt in the eleventh and twelfth centuries, in a style quite close to the architectural preoccupations of the mother abbey.

THE CULT OF IMAGES

To make the reality of God less abstract in the church, historiated capitals, no matter how didactic, solemn, or funny they could be, did not suffice. To educate the faithful, a tangible figure whose presence would fill this place of worship was needed. This need led to the three-dimensional image, the divine kingdom made visible to the faithful, a symbol toward which their devotion and their hopes could be directed.

The transformation of the cult of saints into a cult of images took place in the Massif Central. The renaissance of three-dimensional sculpture fed the belief in miracles, which brought about a revival of religious practices that, in return, legitimized the use of sculpture and caused its flowering in the twelfth and thirteenth centuries. Although dispute about the limits of idolatry and superstition did not end, it seems that the figures of Christ on the cross and the Virgin in Majesty enjoyed, from the time of their first appearance, a status apart and a total immunity from doubt.

Besides, it was hard to assess what the pilgrim had come to venerate. Was it the "statue-idol," related to worship of the pagan mother-goddesses of antiquity, which long persisted in France during the early Middle Ages? Was it the relics contained within the reliquary-statue and whose magical character seemed self-evident? Was it the person of the Mother of God herself, made tangible by a sculptor?

This ambiguous relationship between the believer and the object of veneration does not seem to have overly concerned the Church; it had long before resolved questions about the representation of three-dimensional images. Many people in the Carolingian period still confused the ancient pagan gods and goddesses with Christian statues, a confusion in no way clarified by the predilection of Charlemagne and his entourage for classical culture and their desire to integrate it into the Western Christian empire. Likenesses of the Frankish emperor and, before him, of Emperor

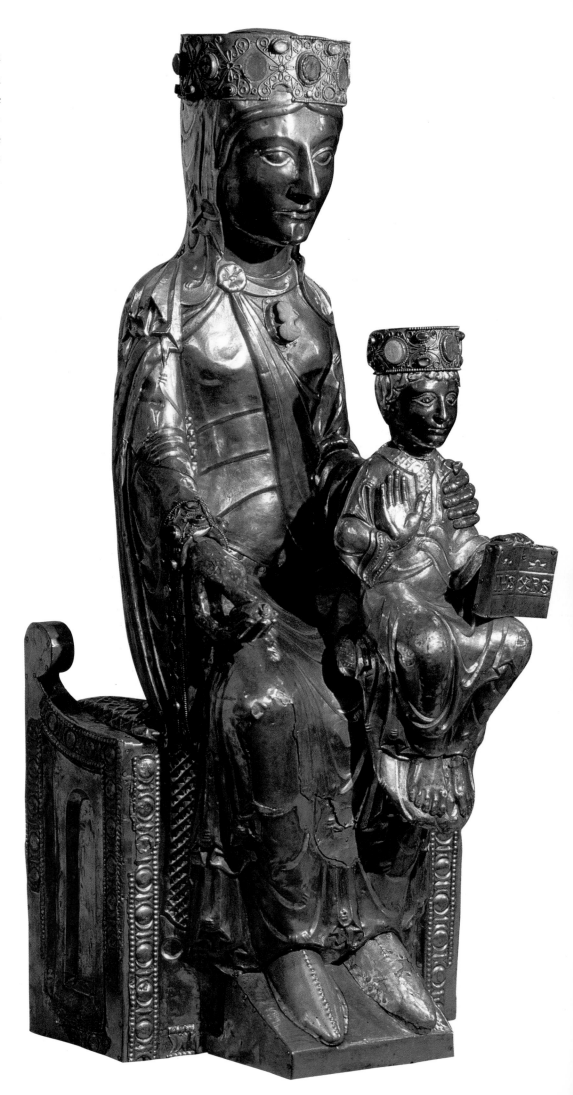

VIRGIN AND CHILD
(THE SILVER VIRGIN),
11TH OR 12TH
CENTURY, SILVER
REPOUSSÉ ON A
WOODEN ARMATURE,
23½ x 9 IN. (60 x
23 CM). BEAULIEU-
SUR-DORDOGNE
*Limousin and Auvergne
have maintained an
important tradition of
preserving objects in
their original locations,
even if some of them are
displayed behind bars or
in a strongbox, like the
Virgin of Beaulieu. The
sparkle of precious met-
als (gold, silver, gilded
silver or copper), pre-
cious stones, and enam-
els greatly increased the
mystical value that
popular faith accorded to
reliquaries and devo-
tional statues. The pres-
ence of ancient cameos
or intaglios—here visi-
ble on the crowns—also
reinforced their magical
attributes. In the mind
of the Church, conscious
of the fragile boundary
between objects of
Christian worship and
the pagan idols that pre-
ceded them, the material
luminosity of metals
and gemstones had to be
transcended by the "true
light," that of God.*

Justinian of Byzantium had been made, and these cer-
tainly recalled imperial Roman statues.

In many areas, such as Auvergne, remote regions
still incompletely converted to Christianity continued
to practice pagan rituals. It was in order to root out
definitively a latent idolatry that the Church consented
to, then encouraged, the creation of Christian images,
which were already being made in many places.

Thus, after centuries of distrust, by the year 1000
the Church promoted what was at first a trickle, then
a flood of sculptures in the round. The first examples
of the genre were systematically furnished with relics,
which, making their veneration "seemly," masked any
worship based on superstition.

IN THE BEGINNING, WOOD

Hieratic and motionless—this is how the Romanesque
Majesties appeared. Obeying a rigid frontality related to
the presence of the throne, their representation left little
room for formal variations. Nonetheless, in this great
family found from the Île-de-France to the Pyrenees by
way of Burgundy perceptible distinctions exist that per-
mit stylistic groupings by region, even by workshop.
Whether masterpieces by virtue of superb craftsmanship
or expressions of the most humble skill, they are before
all else the felicitous result of different groups of artisans
contributing their skills to create a statue in the round.

The impression we have of these images today is
completely different from their original appearance:
they now reveal the wood that was hidden beneath
the gesso, paint, or metal. Wood is at the heart of
Romanesque creation, not only in construction, for
example, roofs and doors, but also in the lighter eccle-
siastical furniture integrated into the church—in the
sculpted altar and in the caskets and reliquaries made
by the wood sculptors, who belonged to a different
guild from the carpenters. The wood, which became
the soul of the statue, passed through several stages in
its realization, each stage calling for its own special-
ists, with their own techniques and tools. Of funda-
mental importance was the choice of the species—oak,
walnut, linden, or birch—and the selection of a well-
dried log. To minimize the subsequent cracking that
is the sculptor's first concern, the central portion of
the trunk was avoided and only the sapwood used.
In Auvergne, this risk was reduced by making the
Majesties from separate panels assembled by joints,

which allow for the wood's expansion and contrac-
tion. Some works so constituted give the illusion of
having been made from a single piece.

Although the wooden core of the statue was only
intended as the support for an ornamental covering, it
was executed with a surprising degree of precision.
This is particularly true of the Virgins whose covering
of gold has survived. Thus, that of Orcival, whose
metal plaques were removed in the course of its last
restoration, revealed a core whose workmanship had
the look of a finished work—a work in its own right.
In places it even seems to have operated independ-
ently of the fine metalwork, for the folds of the drap-
ery in the wooden core do not correspond to those of
the repoussé silver made to cover it.

The marks left by the tools are also quite visible,
teaching us a great deal about the techniques of direct
sculpture: after the general outlines of the figure were
realized, the artist refined the forms with the aid of a
burin and small gouges. The surfaces of many of the
painted Virgins were left quite rough in order to
ensure a better adhesion of the polychrome covering.
The exaggeration of the features and the proportions
of the faces, as well as the sharp folds of the clothing,
can be attributed to the fact that they were designed
to compensate for the "softening" effect of the layer
of color on the highlights.

After sculpture came the preparation of the sur-
face, followed by the application of paint. This step
was entrusted to a specialist of greater or lesser
renown, according to the means available, in order to
give the best illusion possible of flesh and clothing
and to give life to the face and its expression. A fine
linen cloth covered with gesso served to isolate the
painted layer from the wood, masking any defects of
the latter, and allowed for some refinement of the
image. The polychrome was almost identical to that
used for illumination, similar to distemper, which
combined ground pigments, glue, and egg. Most of
the majesties have been repainted so often that is dif-
ficult to obtain a precise idea of the twelfth-century
chromatic scale, whose colors were still few in num-
ber and doubtless endowed with a symbolic value.

CHRIST CRUCIFIED

Images of Christ on the cross spread throughout the
West at the same time as that of the Virgin with Child

The Virgins

THESE FIGURES of the Virgin Mary, Mother of God, holding the Christ Child on her knees give striking proof of the extent of the cult of Mary in the eleventh and twelfth centuries. Known variously as images—or *imagos,* a general term at the time designating any statue in the round—Maiestas, or Majesties, or Thrones of Wisdom, these figures were believed to be endowed with many virtues. Subject to an idolatrous cult, the image of Mary was prayed to, touched, lit up, decked with flowers, and carried in procession among crowds; she was offered precious stones, jewels, and sumptuous clothing, when she was not herself covered with precious metal; she was thanked by means of ex-votos. The fame of these Virgins, whether simple or spectacular, spread beyond regional borders. Their state of preservation bears witness to their great success; beyond the deterioration due to the normal aging of their materials, they show signs of erosion—the feet of the Virgins in particular—due to the rubbing of hands and lips, that is, if they escaped mutilation or theft by those who cherished them most.

The first Virgins in the round were reliquaries, which preceded actual statues of the saint. In the tenth century the cathedral of Clermont was rebuilt after the Norman raids and embellished with a figure in pure gold of "the Mother of God and our Savior, her Son," in which relics of Mary were enclosed. Two centuries later, this golden statue—which no longer exists—was often copied: many statues of this type are found in the southern half of France, with a heavy concentration in the Massif Central and surrounding areas. The marvelous Virgin of Orcival from this period is one of the rare figures, among all the Majesties in Auvergne, still to be covered with its silver, gold, and copper decorations, in the tradition of the first religious figures in the round covered with precious metals. Most of these Romanesque Virgins were painted in polychrome, which was certainly less costly, and this became the normal ornamental technique.

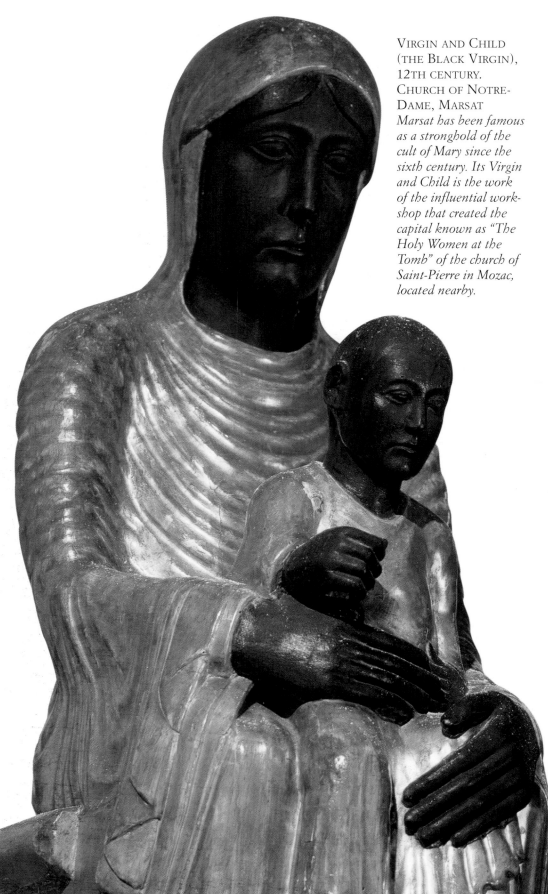

VIRGIN AND CHILD (THE BLACK VIRGIN), 12TH CENTURY. CHURCH OF NOTRE-DAME, MARSAT
Marsat has been famous as a stronghold of the cult of Mary since the sixth century. Its Virgin and Child is the work of the influential workshop that created the capital known as "The Holy Women at the Tomb" of the church of Saint-Pierre in Mozac, located nearby.

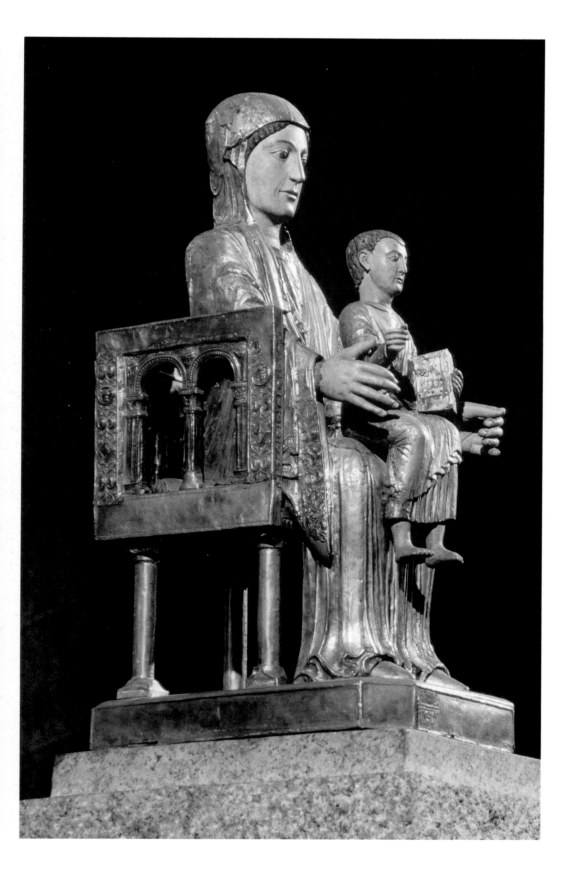

Unlike the young, maternal, and very feminine Gothic Virgin, the Romanesque Dei Genitrix (Mother of God) was a more mature woman, with a sacred and sometimes proud bearing. Her rigid position, produced by a straight back, arms held close to the body, and strictly parallel legs, repeats the angularity of the throne on which she is seated. Dressed in a tunic covered with a chasuble that envelops her, she modestly reveals only her serious face and long, calming hands. Her son echoes this solemn attitude, his features less those of a baby than those of a small man. Facing forward, he uses his right hand to bless, while the other holds the Book. The duality of this image comes from the fact that Christ is depicted both as Mary's child and the living Divinity seated in majesty. The Virgin's throne brings to mind that of the Old Testament King Solomon, whose wisdom prefigures that of Christ, and is also derived from the ancient iconography of the imperial throne, symbol of supreme power. As the seat for her child, the Mother of God in turn becomes the throne of divine wisdom and offers the Word Incarnate to the world, whom she holds with a protective gesture, but at a respectful distance from the hollow of her lap. These two figures radiate a charismatic presence, reinforced by their majestic calm and the symmetrical arrangement of the folds of their garments, which fall in elaborate pleats.

Opposite
CHRIST ON THE CROSS,
11TH CENTURY. SAINT-
MICHEL D'AIGUILHE,
LE PUY-EN-VELAY
*Representations of
Christ on the cross,
carved in wood, began
to spread in the eleventh
century. The vision of
Christ dying instead of
triumphant expresses
the reality of the sacri-
fice in human terms. His
limbs, elongated in the
Byzantine tradition, con-
vey release after suffer-
ing, the relinquishment
of the body to the con-
templation of the believ-
ers. Rarely represented
in the Romanesque
Middle Ages except
when absolutely neces-
sary, the body is treated
according to a stereo-
typed vision: highly
compartmentalized
thorax and abdomen,
general rigidity, unde-
veloped musculature.
Yet, although it is not
exalted, the body is
imbued with a nobility
that elicits an emotional
response.*

and the images of saints, at the end of the eleventh
century. Treated three-dimensionally in polychromed
wood, they were inspired by a theme already taken up
previously in Byzantine and Carolingian illumination,
ivory reliefs, and gold work. Two styles of representa-
tion of the supreme sacrifice of God appear most
frequently: Christ in Triumph and the Death of Christ,
or Christ Crucified. The first and more ancient presents
Christ victorious and hieratic against the Cross, the
body straight and rigid, the arms horizontal, the eyes
open, with a fixed look, a truly divine presence in the
choir of the church where He is a focus for the respect-
ful contemplation of the faithful. The Death of Christ,
on the other hand, is shown in the reality of his crucifix-
ion, a reality that nonetheless rejects the horror of mor-
bid details. The relaxation of the body, the arms angled
upward, the head, which hangs a little forward in the
hollow of the right shoulder, and finally the closed eyes,
discreetly express the redemptive suffering. Rather than
pain, a calm after the agony is seen in the elegant lines of
the body and the harmony of its outlines.

The Christs of Cantal and the upper Loire form a
group of great artistic quality. The churches of Auzon,
Lavoûte-Chilhac, Blesle, and Valuéjols display "living"
Christs who do not seem to suffer from the nails and in
whose face may be read an expression of serene resig-
nation, particular to the sculptures of the region. These
works already anticipate the subtlety of Gothic natural-
ism, while the Virgins in Majesty, with their severe
frontality and neutral expressions, remained rather
firmly anchored in the Romanesque Middle Ages.

The beautiful Christ of Arlet is an example,
among many others, of a new type that became
commonplace in the twelfth century, especially in

Auvergne. It portrays Christ both suffering and tri-
umphant: a fairly rigid body but with bent legs; a
morphology with no trace of the effects of torture but
with flexed arms; the head inclined but the eyes open,
their expression intended to inspire the compassion
of the faithful. This Romanesque Christ is not only the
New Adam, the Redeemed God who has won victory
over sin and death by his sacrifice, it is the Christ who
sacrificed himself for love and who becomes in turn
an object of love. In the eleventh century, representa-
tion of the death of Christ constituted a revolution
in Christian iconography, the result of a profound
change, which tended to humanize the Son of God,
that had taken place in the minds of the faithful.

Since the beginnings of Christian art, the Church
showed great restraint in depictions of the sacrifice of
Christ. Represented at first in the form of symbols—
the Cross, the Lamb—and in biblical foreshadowings,
the crucifixion itself was only suggested. It was only
in the sixth century that Christ Crucified was repre-
sented, and then as alive, the obvious symbol of salva-
tion, and this style of representation endured until the
eleventh century, when the shameful character linked
to the representation of death dissipated. Romanesque
artists still manipulated the latter with a certain cir-
cumspection: at the very most the face of Jesus is
emaciated, or the muscles of the body stiffened, but
visible stigmata resulting from the ordeal are absent
or very discreet. Not until the Gothic thirteenth cen-
tury, and especially, the end of the Middle Ages,
would a wealth of morbid details begin to proliferate,
designed to unleash in the faithful a violent emotional
rapport with the images and to bring the event back
to life in all its horror.

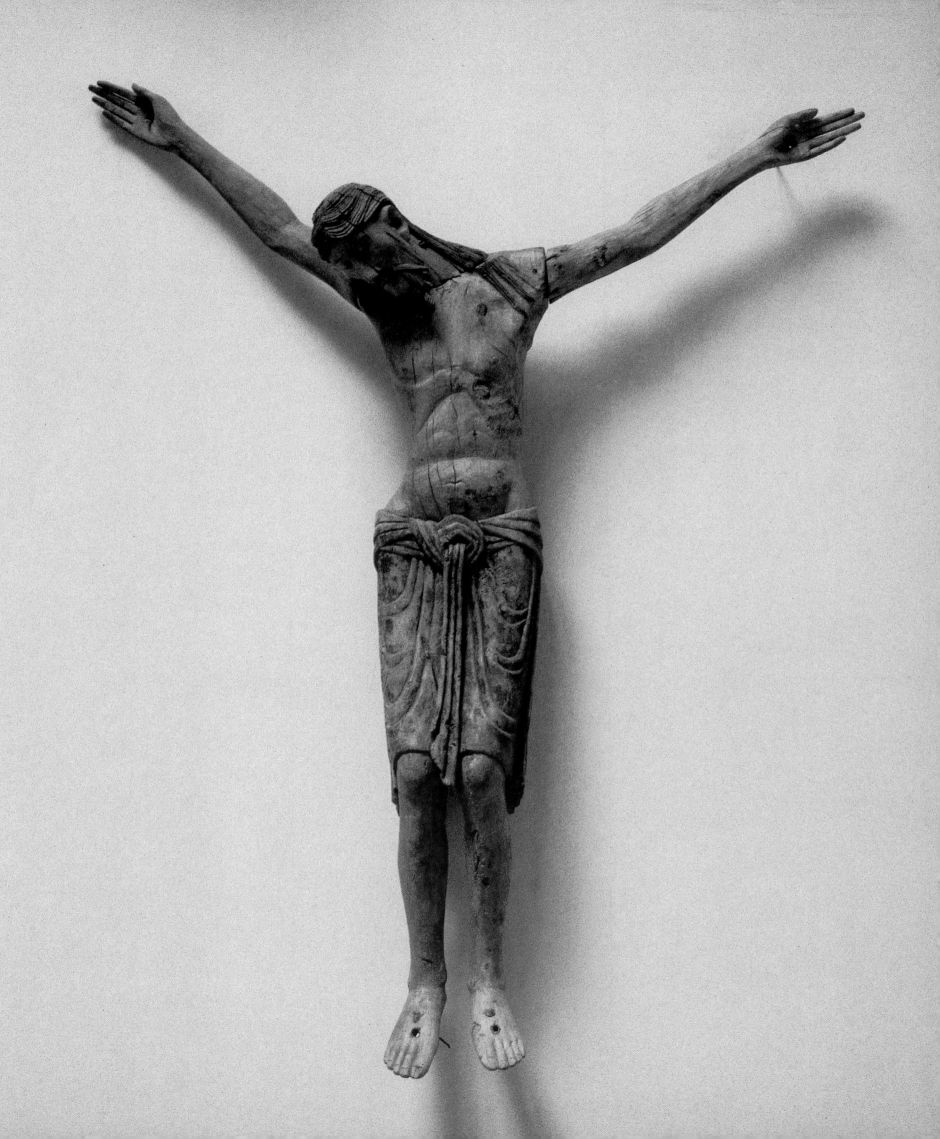

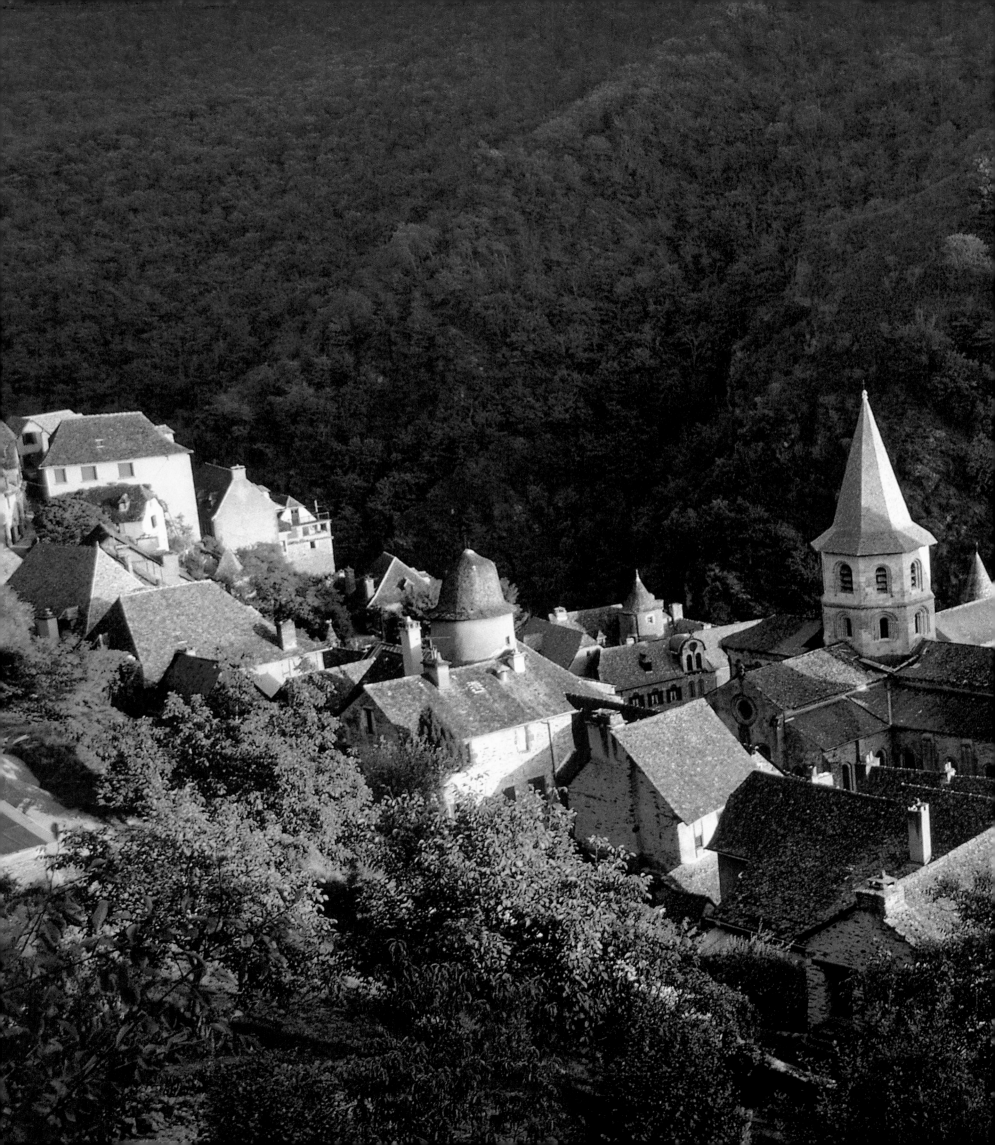

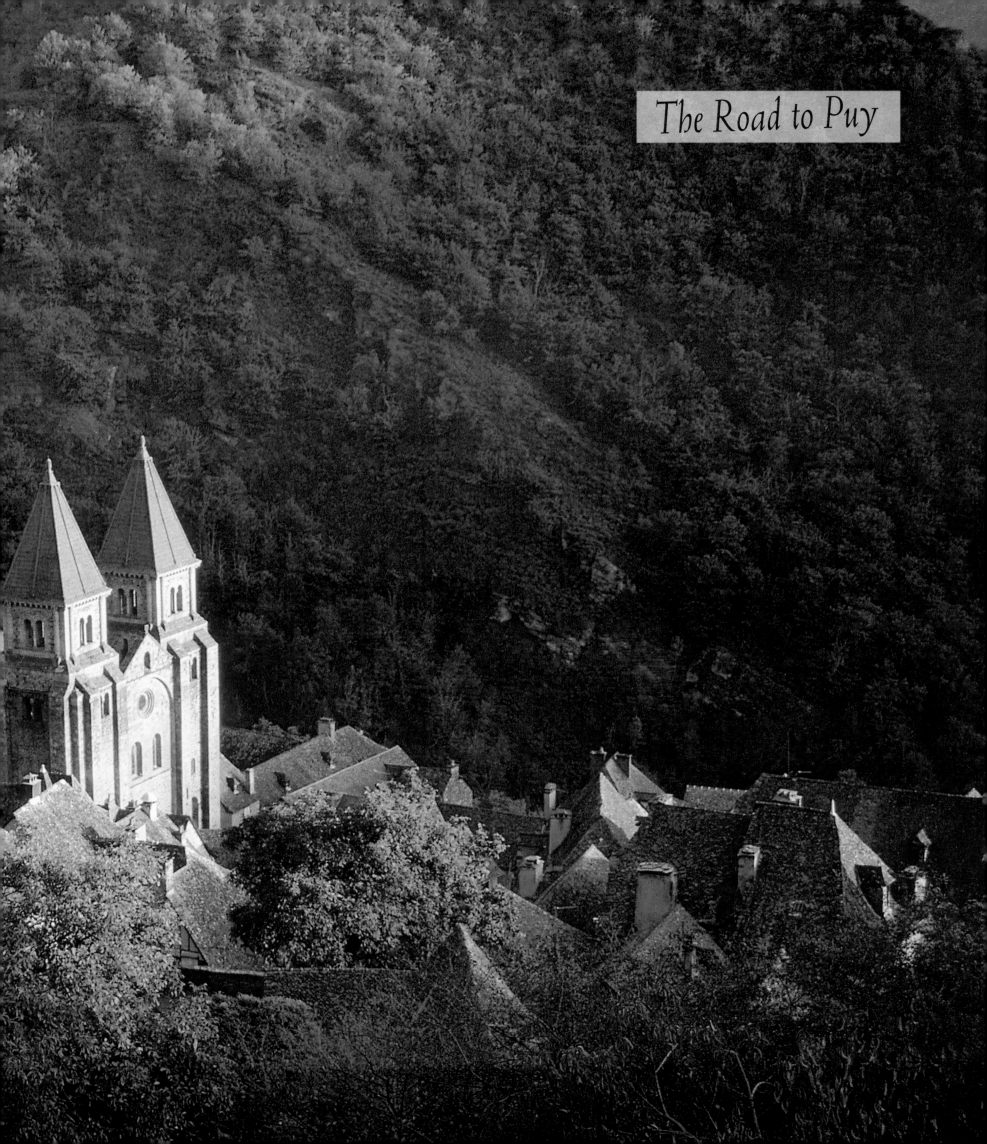

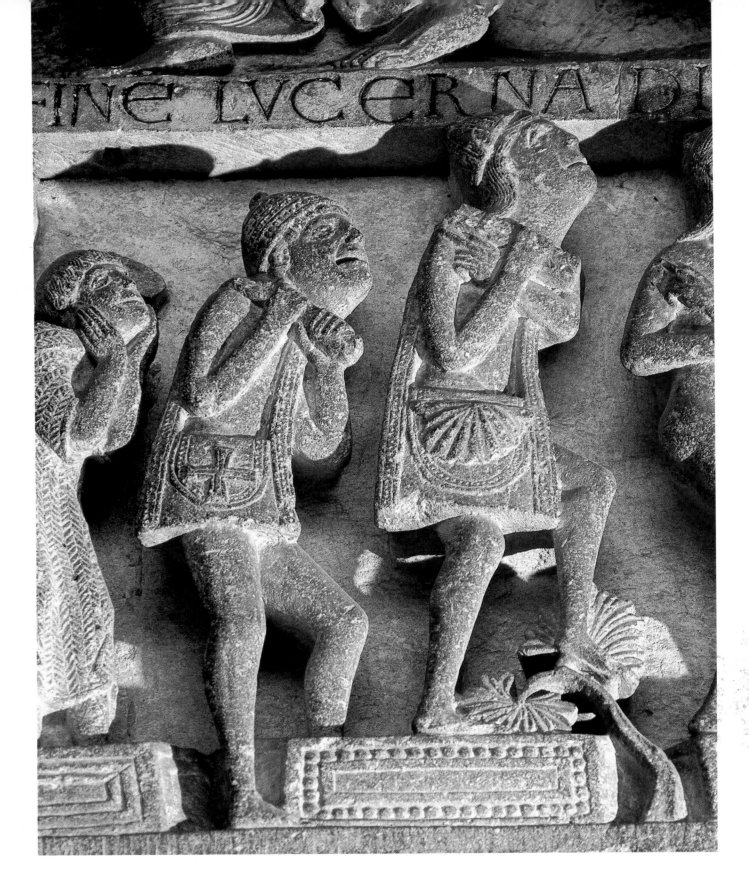

FINE LVCERNA DI

On THE EVE of the year 1000, pilgrimage became a mass phenomenon that opened France to the world. Wandering in pursuit of a religious vocation in fact often hid a desire for travel, for the discovery of the unknown.

Pilgrimage could also be used for punishment if so ordained by the religious and judicial authorities. By nature spontaneous, pilgrimage was surrounded by a complexly structured organization in the twelfth century, where all concerned sought to serve the glory of God and found personal benefit. These included the religious orders, protective and nourishing, which developed many connected branches; the merchants, innkeepers, and ferrymen who set up in business along the way; the cities that were born or grew larger from the increased traffic; and even the peasants, who began to sell their surplus for currency, which was thus introduced in the countryside.

ROMANESQUE PILGRIMAGES

Jerusalem is the most ancient of Christian pilgrimages. The influx of pilgrims to the Holy Lands began with the first spread of Christianity and increased throughout the early Middle Ages, as travel narratives demonstrate. The event of a lifetime, pilgrimage to Jerusalem brought the guarantee of pardon for sins. With the Muslim conquest of the city in the eighth century and the destruction of the Holy Sepulcher in 1009, expeditions were restricted but not forbidden. They swelled on the eve of the millennium of the Passion of Christ, that is, at the end of the first third of the eleventh century, while it finally became possible to journey to the Middle East by land when Hungary converted to Christianity.

Beginning in 1095, pilgrimage to Jerusalem turned into one crusade after another, in the course of which the pilgrims' mystical disposition was often transmuted into support in battle, thus forming a supplement to the defense of Palestine. Rome, cradle of the Church and major pilgrimage site in the West, certainly had the honor of possessing the tombs of the Apostles Peter and Paul and those of the first martyrs, venerated in great number in the basilicas or directly in the ancient catacombs, fantastic ossuaries that were quickly mined as an incomparable source of relics. Potentates and clerics sometimes made several voyages to Jerusalem within a lifetime, opening the way to pilgrims of more modest means.

In the West at that time, however, Rome was not the great Romanesque pilgrimage. Repeated attacks by the Germanic emperors beginning in 1084 discouraged travel, and the international success of the pilgrimage to Santiago of Compostela overshadowed it for a while, although it was never entirely abandoned.

Compostela, in Galicia, served as the beacon for Romanesque Christianity. The esteem enjoyed by the tomb of the Apostle Saint James the Greater is explained by various events responsible for the popularity of the famous pilgrimage. First, the kings of Aragon claimed the protection of the saint's standard, who was called Matamores, in the struggle they waged against Islam beginning in the ninth century. The history of the cult of James began with the "discovery," at just the right time, of the tomb of an apostle taken from a necropolis shortly after the year 800, at a time when a decimated Christian Spain needed a holy figure to use as a weapon of war. The sudden passion for Santiago of Compostela, which saw its peak in the twelfth century, concerned the aura of the saint who was chosen by Christ to witness the Transfiguration and whose body, interred in his sarcophagus, had not suffered the dismemberment commonly practiced on the remains of other martyrs. French churches competed vigorously to attract pilgrims. As they lacked a sufficient number of tombs, they most often presented relics as their lure—and these, too, drew in crowds.

In Romanesque France, rare are the churches that did not possess relics for the faithful to venerate. The cult of holy remains, and belief in their thaumaturgic powers, made them the instruments by which the miracles of God were made manifest. Their role as intercessors placed them at the heart of the psychology of faith on the eve of the millennium.

Saint Martin, the most famous of French saints, venerated at the abbey of Tours, beginning in the fifth century held the record for visits. Saint-Martial in Limoges, Saint-Gilles-du-Gard, Saint-Saturnin in Toulouse, Saint-Front in Périgueux, Saint-Léonard in Noblat, Sainte-Foy in Conques, Saint-Eutrope in Saintes, Saint-Hilaire in Poitiers, Saint-Étienne in Nevers, Marie-Madeleine in Vézelay, and Saint-Remi

THE RISE OF THE PILGRIMAGE TO COMPOSTELA

●

After the "discovery" of the remains of Saint James the Greater in northern Spain, monasteries and hermits began to organize pilgrimages. This organization took on extraordinary dimensions with the involvement of French religious authorities, principally the abbots of Cluny, who built their order into a spiritual and cultural presence that could not be ignored in the western part of Europe in the eleventh century. The spread of Cluny's influence should not, however, obscure the competition during the following century among other Benedictine abbeys also eager to become established along the Camino Francés: regular canons of Saint Augustine, Cistercians, monks from the monasteries of La Chaise-Dieu and Aurillac, as well as the orders of the Hospitallers. Seeking to extend their influence, all of these groups contributed to the organization of pilgrimages in the direction of Santiago, resulting in an exceptional infrastructure that benefited all of southwestern France, which became an important site for the evolution of arts and ideas.

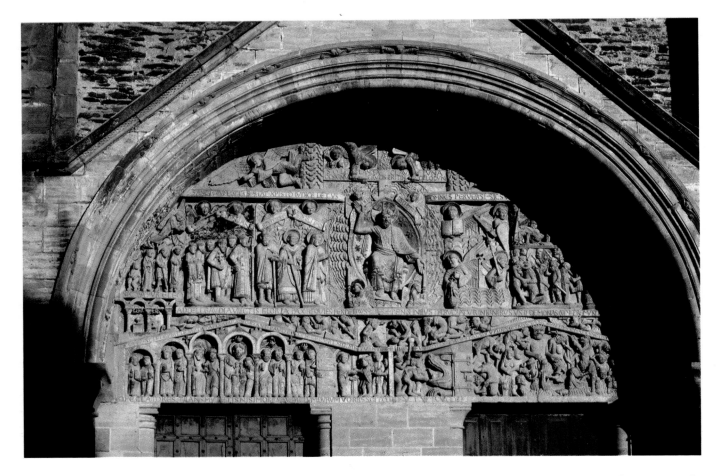

in Reims were among the most important centers of devotion, to which we must add the principal Marian pilgrimages of Chartres, Puy, and Rocamadour. The Virgin, having been taken directly into Heaven, left few relics that could be venerated (clothing, shroud, and so on); this explains why she was the particular object of a symbolic adoration in the form of statues representing her with the Child. As for the archangel Saint Michael, whose immaterial nature exempted him from any relic whatsoever, he was invoked in France in the highest parts of the churches, where a hall was often conse-crated to him. The rocky Norman isle that bears his name raised an abbey, reputed to be invincible, that commemorated the memory of his appearances.

THE CULT OF HOLY BODIES

The remains of the first martyrs of the Church did not become the object of a public cult until the eve of the Edict of Milan, which in 313 brought the Christian religion out from its clandestine existence in the cata-combs. Subsequently, the presence of the holy body in religious buildings developed slowly, either incorpo-rated into a structure built directly on the burial site (the *confessio*) or translated to a church dedicated to

the relic. The ritual of consecration became wide-spread toward the end of the early Middle Ages, to the point that in the year 1000 it seemed inconceiv-able that a church in the West would not contain relics, no matter how modest they might be: men fought, stole, and died for them, while a flourishing trade in them sprang up.

Relics belonged to one of two distinct categories: those that could be called "real," which came from the body itself and might be one of many various anatomical parts, such as bones, ashes, teeth, nails, hair, viscera, and flesh; and the indirect, also called representative, a category of relics more widespread in the West, increasingly common as the cult of the saints spread and pilgrimage increased. These objects, which were called *brandea*, had been in contact with some or all of the body and thus "acquired" supernat-ural virtues. Among the most precious and the most valuable were the shroud of Christ, the wood of the Cross, and the crown of thorns, all of which also had a historical value. In the same category fell clothing and objects that had belonged to the venerated figure and, by extension, the countless solids and liquids that had been brought into contact with the relics: pieces of cloth and medals sold in their turn as relics by virtue of having touched the bones; flasks of oil or

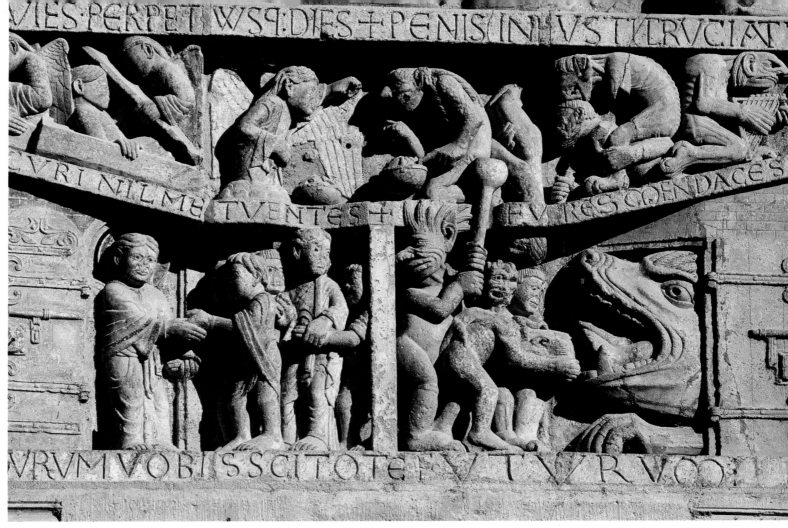

of holy vinegar in which they had been soaked; and lamp oil, candle wax, flowers, even the dust that had surrounded the shrine or the sarcophagus.

The history of relics is that of their extreme mobility. Rare were the holy bodies that remained in their sepulchers or their original reliquaries. With the Carolingian kings promoting a greatly accelerated building campaign, and despite official prohibitions, a phenomenal international market in relics arose, supplied by the Roman catacombs, where new holy bodies were "discovered" whose bones were divided up and sold. The Christian East also exhumed remains beginning in the fourth century and distributed them in fragments, large and small, according to demand, thus becoming the largest supplier of relics to the West. Constantinople formed the center of this trade, and it paid dearly as a result: in March 1204 an orgy of pillage took place, as clerics and knights abandoned themselves to looting and bore off relics and reliquaries and other coveted cult objects to their complicitous homelands in Italy, France, and England. We know now that the Byzantines had protected themselves from this "piety" by perpetrating a vast fraud: an excess of pieces of the true Cross and thorns from the holy Crown, to cite only two, flooded the market in the form of facsimiles, which later provoked

quarrels among clerics and undermined the credibility of the Church at the end of the Middle Ages.

Authentic or false, the relic, shipped under heavy guard, ended its travels with a processional ceremony welcoming it into the place of worship, sheltered in a small reliquary, a shrine, or a sarcophagus. The relic would be carried through the streets of the cities and in the countryside to prevent wars, epidemics, and natural disasters.

IN SEARCH OF THE SUPERNATURAL

The origins of the supernatural in the medieval period go back to well before the arrival of Christianity: the ancient Eastern, Roman, Celtic, and Germanic rites formed a background of paganism in France that persisted long after the conversion of the countryside.

In minds that are certain that evil is omnipresent and that it is necessary to avoid sin by any means, superstition and real faith are not opposites; the country folk would leave offerings (*oblationes*) before a reliquary, burn candles, and expect help, even a miracle. The Church took care to remind the faithful that it was God who acted through the saints, just as He gave the king of France, his chosen one, the power to heal. But did not the Church tolerate herbal remedies, the curative powers of springs, of the earth, of stones and gems? The people came to the church of Saint-Julien in Brioude to seek healing they had formerly sought from the town's waters. In the cult of saints and of relics, everything contributed to making the faithful more aware, to stimulate their emotions, their imaginations, their respect: the object of veneration, first of all, his or her merits and high deeds, the miracles accomplished during his or her lifetime and especially after death, the location of the sanctuary—spectacular or isolated—the staging of the veneration in the enclosed space of a crypt, an altar, a recess, or a chapel, the holy atmosphere in this semidarkness, the light of ever-burning lamps, the sound of prayers, the smells of incense and flowers, and, finally, the splendor of the reliquary, which encloses the mortal remains of the saint, who lived on in the miracles that it effected.

If it is true that the people were not overly concerned about the authenticity of relics, they were certainly aware of the concrete effects the relics had been guaranteed to produce. Relics constituted the medicine of the Middle Ages, and each saint was endowed with

specific healing powers. Human ailments were so closely associated with the saints' thaumaturgic power that some of them took on the names of the saints who healed them. Thus, epilepsy, so common in the Middle Ages, was called Saint Giles's malady; leprosy, Saint Ladre's malady *(mal Saint-Ladre)*, hence the etymology of *maladreries* (leper colonies).

WHO AND WHY?

The common image of the pilgrim is that of the "walker for God" who leaves carrying a pilgrim's staff and beggar's bowl. The well-to-do rode horses, and entire families sometimes formed caravans, or they risked the winds and the pirates aboard ship.

There was not a single vow of pilgrimage, but many. Although the pilgrim populations included invalids and the seriously ill, pilgrims often took to the road out of simple devotion *(pietatis causa)*, to pray at the holy sites in hopes that the voyage would contribute to the salvation of their souls.

For some, this journey was the last, deliberately prepared. Pilgrims put their personal affairs in order, divided up their worldly goods, made known their last wishes. Once they arrived at the journey's end, they waited for death so as to be entombed *ad sanctos*, that is, as close as possible to the holy bodies, head turned in their direction, so as to benefit from their intercessionary power on the day of the Last Judgment. This

last act gave the departed a status almost equivalent to that of a martyr or a crusader, whose virtue would reflect on family and lineage. Thus, we see no fewer than six Saxon kings buried in Jerusalem in the sixth and seventh centuries.

The most commonly expressed pilgrim's vow concerned the healing of the body. There were also those on whom pilgrimage was imposed as penitence *(in poenum)*. The journey, which itself became a punishment, here took on a purificatory role, accentuated with acts of asceticism, fasts, and mortifications. The payment for sins was fixed according to very precise catalogues, or *penitences,* established by ecclesiastical courts, which imposed a sentence of exile and a penitence accomplished publicly or privately through those saints who were most effective in the remission of sins. Civil courts commonly used pilgrimage as punishment for a wide range of infractions and crimes. The mighty were not spared; many potentates in the Middle Ages bowed to ask forgiveness before the Church, which had condemned them for abuse of power. At this level, penitential pilgrimage became a political act, such as Henry II of England praying before the tomb of the martyr Thomas à Becket, whom he had had assassinated. Generally speaking, emperors, kings, and popes quickly understood the moral, political, and diplomatic benefits they could gain by putting themselves under the protection of the saints and by authorizing the construction or embellishment of sanctuaries. Thus, at the

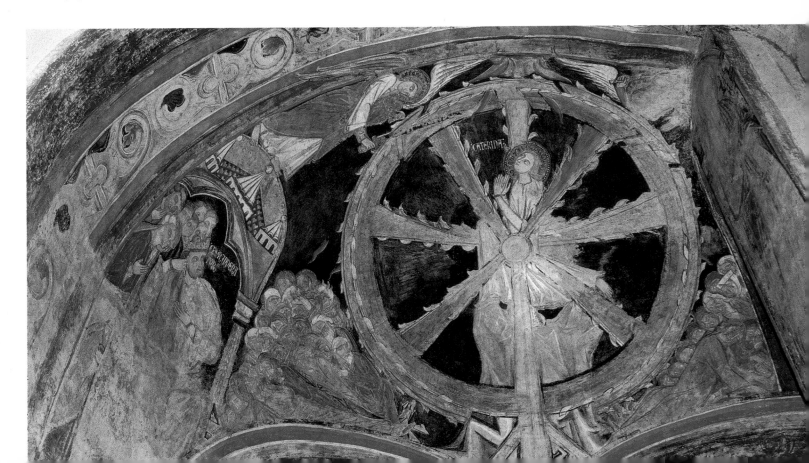

edges of a sometimes doubtful spirituality, the superstitions of the people and the glory of those who governed came together.

THE INFRASTRUCTURE

During the time that the pilgrimage lasted, the existence of the pilgrim and the crusader obeyed a specific structure and organization very different from anything in their previous everyday routine. At its apogee, in the twelfth century, this organization assured the pilgrimage a success whose extent has not always been taken into account. For Europe had taken to the roads, and France, which found itself at the crossroads, was transformed into a land of welcome for those individuals who covered considerable distances. Wherever the traveler was most vulnerable, the religious framework ensured shelter and food, ready to accommodate both the solitary pilgrim and the groups that streamed in on important occasions. Once the goal of the journey was established, the itinerary was set by stages. On these rested the very organization of the pilgrimage.

On the evening of a day of walking like many others, the pilgrim, exhausted from having trekked the 12 to 24 daily miles (20 or 40 kilometers), depending on whether the road crossed mountains or plains, hastened to a place of shelter before nightfall. The pilgrim was likened to Christ, whom every Christian must welcome; thus, those unable to afford hostelries and inns (whose reputation, besides, was doubtful) could rely on charity, often from individuals but especially from the many hospices built by the religious orders "wherever they are necessary." The largest were at the city gates, near roads or bridges, and at the foot of mountain passes; others were set in the middle of nowhere, indispensable refuges for those who hazarded difficult and isolated routes.

In these establishments the rites of hospitality were repeated endlessly: first the bruised feet were soothed by washing, a symbolic gesture that recalled Jesus humbly washing the feet of his Apostles. Then came a meal, its contents depending on local conditions and the hospice: bread, wine, beer, cider, soup, vegetables, and sometimes even meat, the hospital of Roncevaux being famous for its generosity in this regard. Sleeping arrangements varied; men and women, to whom clean nightshirts had been distributed, were separated in the dormitory, where they

slept together in groups in real beds or dozed on simple stone benches, as we may see in the Hospice of Pons in the Charente. Church porches and vestibules filled the same function for those who arrived late at night, when other possibilities for lodging had been exhausted.

The healthy pilgrim did not use the services of this organization indefinitely. It was permissible, as a general rule, to remain one night, no more than three

MOISSAC, CATHEDRAL OF SAINT-PIERRE, SOUTH PORTAL, DETAIL OF THE RIGHT SIDE OF THE TRUMEAU DEPICTING THE PROPHET JEREMIAH, C. 1130–35

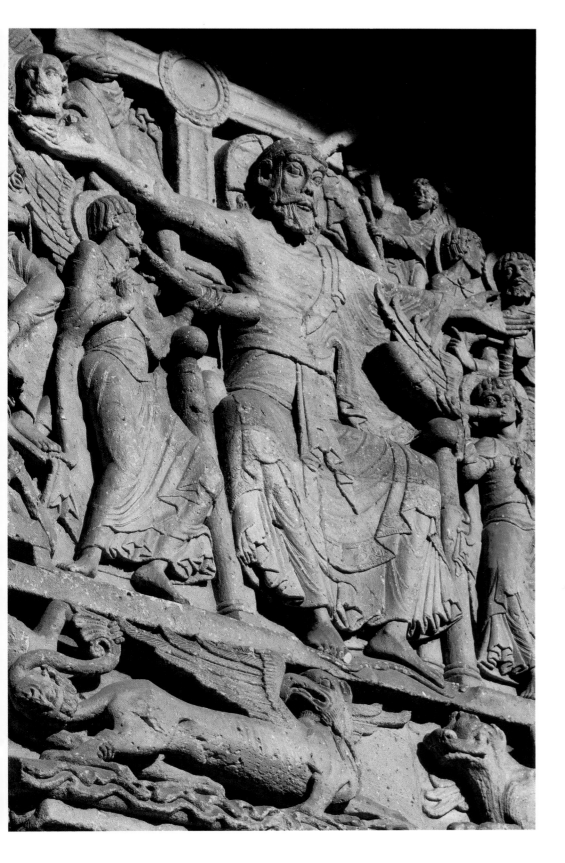

BEAULIEU-SUR-
DORDOGNE, ABBEY
CHURCH OF SAINT-
PIERRE, SOUTH PORCH,
DETAIL OF THE
TYMPANUM

family would not be set back by this premature death.

Monasteries also graciously welcomed guests who were passing through. Two kinds of accommodations were foreseen: some destined to visitors of high rank, the other to pilgrims and the ever-increasing numbers of the poor who knocked at the gates.

FROM THE ROADS OF FRANCE TO THE CAMINO FRANCÉS

After the recovery of the relics of Saint James the Greater in Galicia during the struggle against the Muslims, the cult of the Apostle (who was incorrectly credited with the conversion of Spain) seems to have had only a local impact until the tenth century, the date at which pilgrimage became international, until 997, when the town of Compostela was taken by the troops of Abu Amir al-Mansur. It began again in the eleventh century, while the king of Navarre secured the beginnings of the reconquest of the country with the help of the abbeys of Burgundy and Champagne and the volunteers who came to fight. French, English, Flemish, and Italians, followed by Poles and Hungarians, made the twelfth century the golden age of Compostela. This phenomenon was owed to the splendor of the cathedral, begun in 1078, as well as to the efficient organization of the pilgrimage, which received as much support from lay as from religious powers.

In the fourth decade of the twelfth century a guide for the pilgrim was circulated called the *Book of Santiago of Compostela*, undoubtedly written by Aimery Picaud of Parthenay in Poitou. Of the complex network of roads (the subject of much dispute among historians) in the region, whether or not they all led to Compostela, the *Guide* recommended four major routes that passed by the principal French sanctuaries. The southernmost "route" benefited pilgrims who came from Italy and the far-off lands of the East. From Arles, it went through Saint-Gilles, Saint-Guilhem-le-Désert, Murat, Castres, and the Montagne Noire to Toulouse, a major stage in the itinerary, from which it took its name, the Via Tolosa. From Béarn, the route passed through the cities of the southwest (Auch, Morlaàs, Lescar); after Oloron, pilgrims began to cross the Pyrenees by way of the Valley of Aspe and the Somport. At Puente la Reina in Spain the pilgrims joined those who had arrived by the three other routes.

The northernmost, as well as the most prestigious, was the route from Tours, the Via Turinensis, taken by

in cases of extreme weariness, somewhat longer in case of illness. The members of the order oversaw the care of body and soul—every hospice had a chapel—and if death arrived, burial was guaranteed in the cemetery. Sarcophagi cut right into the rock are also visible at Pons, proof of the ultimate mark of charity. In the large hospitals it was possible for the dying to dictate their wills to a scribe assigned to this duty, so that the

the northerners (Walloons, Flemish, English, and Normans) and Parisians. Leaving the capital, it headed south, passing through Étampes or Orléans, then stopping at Tours to venerate the tomb of Saint Martin. The author of the *Guide* apparently preferred crossing the country to the west by Châtellerault, Poitiers, Melle, Saintes, Bordeaux, Dax, and Ostabat. At this point the route merged with the almost parallel route coming from Limousin, the Via Lemovicensis, which left from Vézelay, in Burgundy, to cross central France by way of La Charité-sur-Loire, Nevers, Bourges, Saint-Léonard-de-Noblat, Limoges, and Périgueux. It then descended to the Pyrenees by way of La Réole, Bazas, and Saint-Sever. For the Burgundians, the Alpine peoples, Germans, Austrians, and, later on, those coming from Bohemia, the point of departure was Puy-en-Velay, taking the Via Podensis. After the difficult crossing of the Aubrac and the Rouergue, they came to the abbey of Conques, jewel of the journey, then Moissac, Lectoure, Condom, Eauze, and Aire-sur-l'Adour. Although winding in places, the routes link up near the pilgrimage sanctuaries, which became new points of attraction, following the example of Rocamadour.

Beyond Ostabat—north of Orthez—the three last-named routes, as well as their numerous variants and transverse roads, met in a complex maze. Pilgrims traveled through the Basque country and Navarre as far as Saint-Jean-Pied-de-Port, where the climb to the Ibaña pass by the Roncevaux pass had a reputation for being arduous—a total of sixteen miles to climb and descend. Finally came Spain, with Pamplona and Puente la Reina. Here the roads to Santiago joined into one: the Camino Francés, which owed its name to the pilgrims who came from France. Unlike the French roads, which were poorly fixed and fluid, the Camino, as the Spanish called it for short, was famous for its traditional character, its relative stability, and its rapidity, owing to the good maintenance of some sections.

The ten stages of this journey were better suited to a trip on horseback than to traveling on foot. Pilgrims crossing the interior lands of Navarre, old Castillo, León, and Galicia exhausted themselves covering the excessive daily distances.

THE VIRGIN OF LE PUY-EN-VELAY

Pilgrims came from all over the country to venerate the Virgin of Puy in the twelfth century. These visits, which had increased steadily over the course of sev-

eral centuries, had made the little basin on the upper reaches of the Loire an important site of Marian pilgrimage in France. Having become the starting point of the road to Compostela, its served as a passage between Burgundy and Aquitaine, Provence, and Limousin, competing with Conques and Vézelay to accommodate travelers.

According to popular legend the Virgin had sanctified the place by an appearance on a dolmen in very ancient times. In spite of its pagan origins, the dolmen was proudly displayed into the eighth century. Because it was said that this slab of stone had powerful thaumaturgic powers, especially against fevers, it had been moved to the cathedral of Notre-Dame and set into the paving of the building, where it served as a threshold.

Majestic, composed of colored volcanic stones of different shades, the facade of the cathedral was ordered with horizontal rows of imposing arcades, three-lobed arches with white and dark voussoirs, and bays and pointed gables with geometric mosaic decoration. The originality of this imposing wall competed with the architectonic audacity of the church, which clings to a rocky shelf and, in order to expand to the west, had to thrust its arches into the void, like pilings. There stood the immense, deep porch, yawning darkly and drawing in the crowds of pilgrims who climbed, on foot or on their knees, the hundred steps that led to the sanctuary. Between the seventh and eighth steps, an inscription cut into the stone exhorted the faithful to enter only with an unsoiled heart. A true antechurch, the porch was formed of several bays and aisles with chapels closed by two doors. The latter illustrated the well-known episodes of the Childhood of Christ and his Passion, but we must wonder whether the Christians knew that these strange signs engraved on the perimeter of the north portal were Kufic characters that sang the praises of Allah, and that the Saracens who were established in the West also came, oddly enough, to give offerings at the feet of the statute of Mary.

Following the example of Conques or Saint-Hilaire in Poitiers, the cathedral of Puy, faced with the flood of visitors, was forced to expand to the west several times. Its nave with six bays, simple aisles, and galleries, crossed by a transept with twin absidioles, was covered by a conventional barrel vault, replaced in the twelfth century by a line of oblong octagonal domes resting on squinches, such as those seen under the crossing towers of churches in Auvergne. Two of these domes (which survived the radical "restoration"

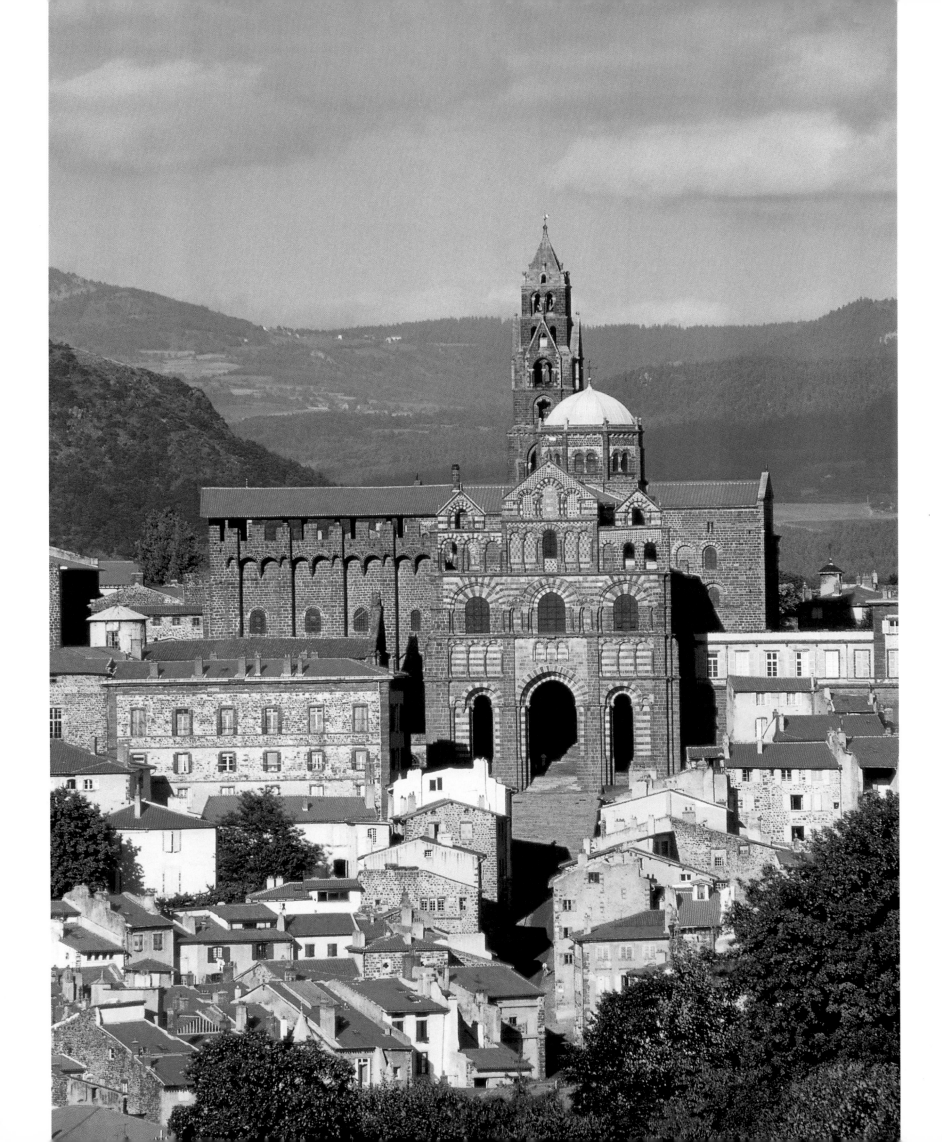

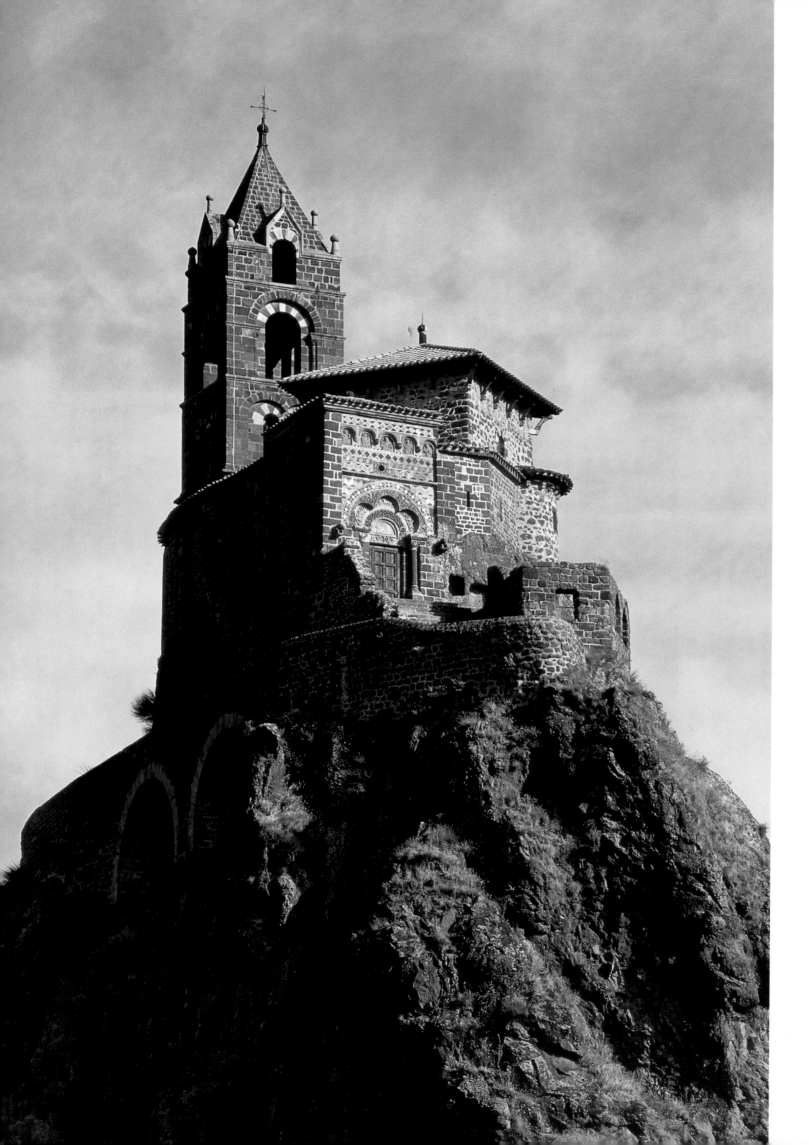

LE PUY-EN-VELAY,
CHAPEL OF SAINT-
MICHEL D'AIGUILHE,
10TH AND 12TH
CENTURIES
This striking little monument, perched atop a stone pinnacle 260 feet (80 meters) high, stands as a testament to its risk-taking architects, forced to adapt the building to the site. The plan here includes a curved nave that follows the crest of the rock and is surrounded by an ambulatory preceded by a vestibule. The building, partly pre-Romanesque, was a very popular pilgrimage site from the moment of its consecration and throughout the Middle Ages. At that time the rock sprang from a sea of greenery.

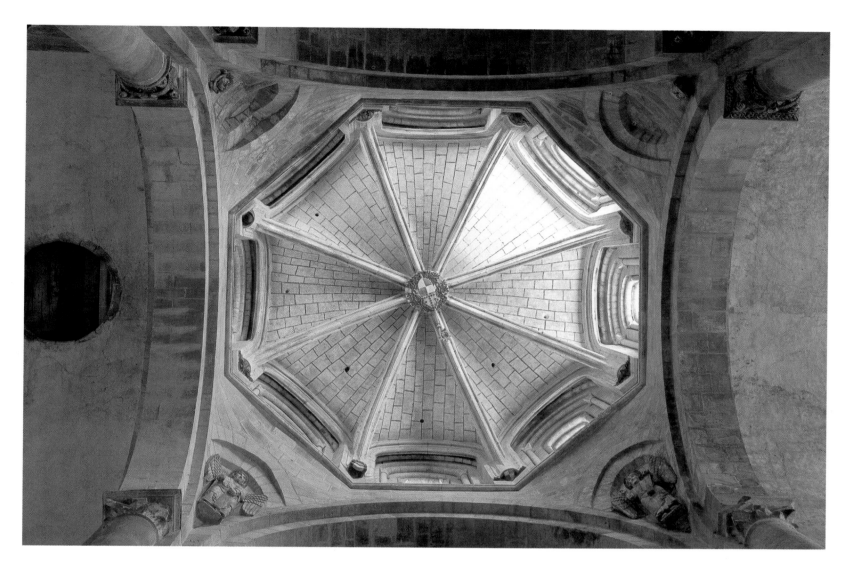

CONQUES, BASILICA OF
SAINTE-FOY, DOME
OF THE TRANSEPT
CROSSING, C. 1125
*The transept, which
holds an important place
in the architecture of
pilgrimage churches,
takes on considerable
physical proportions at
Conques. The crossing
occupies the intersection
of the nave and the
transept, the focal point
of circulation preceding
the choir and the ambu-
latory. It stands over a
crypt and forms, with
the tower that crowns it,
a vertical axis from
earth to heaven.*

suffered by the monument in the nineteenth century)
display origins not in Eastern influence but in the
many short-lived regional experiments, which can still
be seen at Saint-Martin-d'Ainay in Lyons or the
church in Champagne, in the Rhone valley.

The unusual, well-preserved Romanesque clois-
ter displays the same ornamental repertory as the
large facade, as does the gracefully decorated porch,
consisting of voussoirs of alternating colors, geomet-
ric designs, and three-lobed arches.

The pilgrimage to Puy ended with the impressive
climb to the top of the stone pinnacle where the
Chapel of Saint-Michel stood on the edge of the city.
There in 962 the archangel, who required places of
worship in high locations, received the most audacious
of the architectural creations of the Middle Ages.

FROM PUY TO CONQUES

Leaving Velay, our pilgrims turned to the southwest,
where Conques awaited, the only sanctuary on the

journey that the *Guide* bothers to mention. In the vil-
lage of Bains, on the edge of the Gévaudan plateau, a
church from the twelfth century dedicated to Saint
Foy (Faith)—whose relics it preserved in a spectacu-
lar tenth-century statue-reliquary of the saint, covered
with gold and studded with jewels—reflected the feel-
ing of the monastery well beyond its immediate hold-
ings. Its gabled facade, typical of Velay, is ornamented
with semicircular and multilobed arches with gri-
macing faces, especially cats, symbols of evil in the
Romanesque bestiary.

Once across the barrier of the Velay mountains,
pilgrims began the descent to the Allier valley. Perched
on a rocky spur surrounded by magnificent scenery,
they were welcomed by Saint-Privat and its priory,
joined by those who came from Auvergne; they
undoubtedly ended up in the minute chapel of Saint-
Jacques that still stands on the strategic rock of
Rochegude. On the other side of the Allier stretched
the Gévaudan plateau, whose capital at this time,
Saugues, took a day's journey to reach. Saugues,
which possessed a hospital and several churches, was

CONQUES

———•———

Pilgrims surely never forgot for the rest of their days the vision of this small town tucked halfway up the valley of the Ouche River, bathed in sun, its houses ranging around the abbey as if wishing to serve it better.

This scene began with a theft. During the Norman invasions, the founding Carolingian monastery languished in its wilderness. It coveted the relics of Saint Foy, preserved in the abbey of Agen. Many attempts to remove them took place before the turncoat monk Ariviscus—who won the trust of the brothers of Agen after staying within their walls for ten years—committed the sanctum sacriligium. *This deed was greatly publicized, in turn making the relics' authenticity and power credible, after their solemn translation to their new abode on January 14, 866.*

After that, Agen was visited less frequently, while Conques grew larger following a succession of miracles that took place there. In order to have a building worthy of the new and very rich statuette-reliquary created by the jeweler's workshop during the ninth and tenth centuries, the original church was demolished and another rebuilt, which in turn proved incapable of containing the crowds drawn by the golden statuette. The present Romanesque abbey church was built by Abbot Odolric (d. 1065) and undoubtedly finished by the first years of the twelfth century, with the exception of the portal, which was set last. Its cracked upper part was restored under Bégon. It appeared spanking new to the eyes of the visitors at the time, shining with the dazzling colors of its polychrome.

Conques enjoyed an extraordinary period of glory in the eleventh and twelfth centuries because northern Spain and the abbey in Rouergue depended on each other for their mutual success. The former had been heavily supported in its crusade against the Muslims and then assisted in the organization of new dioceses of Aragon by Conques, which provided them with bishops. The latter found itself transformed into an obligatory stopping point on the route to Spain; Crusaders came to be blessed there, while freed Christian captives on their return left their chains at the feet of Saint Foy.

The pilgrims gathered around a miraculous fountain in the center of the small square enclosed by the church. This fountain was so revered that the nave of the new Romanesque church was truncated so that the fountain would not have to be moved. The majestic portal seen on the facade today was not formerly visible from the exterior, as it had been sheltered by an antechurch to which access was gained by a south door, as in Vézelay. Generations of the faithful experienced the visual shock of the impressive Last Judgment looming over them, sparkling with the fresh and lively colors that made it more visible in the half-light. Created before 1130, it is one of the last examples of the family of large tympanums. It took its theme from Cluniac Burgundy and the compartmentalized composition from the sculpture of Moissac, but the plasticity of its hundred figures in the round, with squat silhouettes and round heads animated with eyes pierced with an auger, belongs to a style peculiar to Conques. In spite of the finality of the gesture of the right hand raised toward Heaven for the elect and the left lowered in the direction of infernal chaos, the Conques Christ in Majesty is not threatening. The immense cross raised behind him signifies that he is above all the Redeemer, who triumphs over death, emphasized by the angels bearing the instruments of his Passion.

CONQUES, BASILICA OF SAINTE-FOY, AMBULATORY
The semicircular end of the apse is bordered with columns that support strongly stilted arcades. The ambulatory surrounding it is the most important path of processional circulation both around the high altar and around the crypt located below. In the middle ground, encircling the choir, can be seen the beautiful and rare grilles from the late twelfth century that once protected the relics of Saint Foy. The iron was forged in spirals, volutes, and lozenges, with points on top to discourage viewers from climbing over.

seething with an intense religious activity and gathered pilgrims from all over the Massif Central. Saint-Médard, which represented the Auvergne style, attracted visitors especially for its polychromed wood Majesty. The other Romanesque church had an octagonal tower whose porch sheltered the pilgrims before the departure of the processions.

After passing through Saint-Alban-sur-Limagnole, where the first English martyr was venerated in a church with a rectangular bell tower, pilgrims entered the Aubrac plateau by way of Aumont, which they crossed heading toward Auvergne, Toulouse, and Lyons. The hospital-monastery of Aubrac, doubt-

less the equal of the great hospices of the Pyrenees, had been built by Adelard, viscount of Flanders, a former pilgrim himself, in the beginning of the twelfth century two leagues south of Nasbinals. Even today the large chapel is still very impressive, the starkness of its single nave vaulted with a pointed barrel vault, articulated by transverse ribs and the triple bays of the facade side, formerly mirrored by those of the flat-backed choir, which recalled the simplicity of Cistercian architecture.

After crossing the Lot River, the pilgrims arrived in Rouergue and in sight of Espalion, which was built principally on the left bank in the twelfth century, at

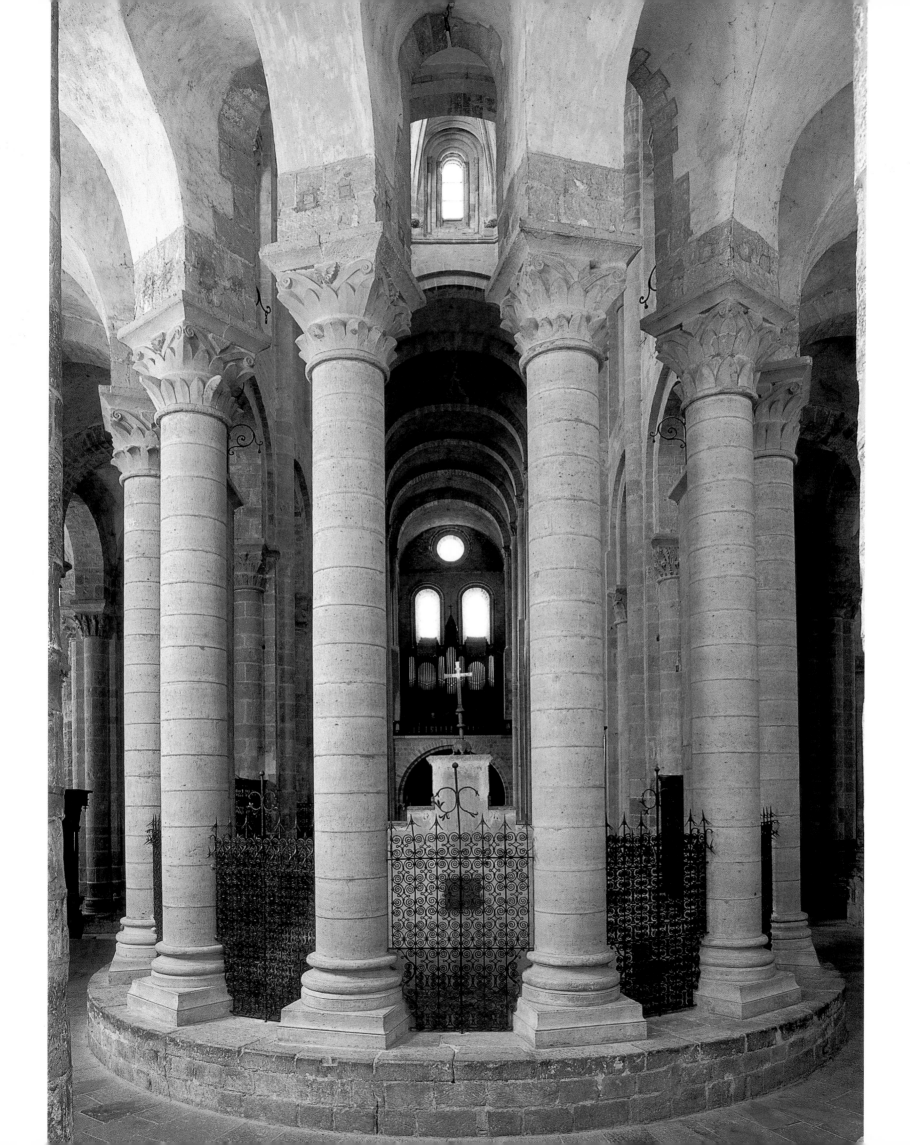

the foot of the church of Perse, which served it as a parish sanctuary until the town spread to the other bank, after a bridge was built. Proudly raising its unusual rectangular bell tower on the hillside, the monument, of pink sandstone with fine stonework, was then still a possession of Conques. Saint Hilarion, Charlemagne's confessor, who had been decapitated by the Saracens, was venerated there. Legend holds that he picked up his head, washed it, and carried it to his mother. Around the year 1100 the sanctuary looked like a building site. Although the transept was in place, opening on chapels with angled sides, the beautiful heptagonal apse—arrayed with large blind Rouergue-style arches and buttresses resembling those that had just been built at Conques—was unfinished, as was the later nave, lacking aisles, like those of the small churches of the region.

The sculpture of the south portal has been seen as being related to that on the facade of Sainte-Foy in Conques. The tympanum illustrates the very rare theme of Pentecost, accompanied by that of Christ of the Second Coming and a Last Judgment, both compressed into a single lintel. The naive workmanship of the relief bears no relation to that of the big abbey.

In an enchanting natural setting, one hour from Espalion by foot, the church of Saint-Pierre of Bessuéjouls contains the most remarkable little chapel in Rouergue, on the floor of its tower-porch. It is still reached by a narrow staircase, which gives no hint of the remarkable impression inspired by the walls of pink sandstone and their rich decor from the end of the eleventh century, composed of interlacing patterns, palmettos, circles, and basket-weave tracery, a continuation of the Carolingian tradition that was visible at Conques before its reconstruction. The handsome Romanesque altar displays the figure of Saint Michael slaying the dragon, the usual dedication of high chapels opening on the nave.

FROM CONQUES TO MOISSAC

After Figeac, the pilgrim entered Quercy, marked by a change in the landscape but not of political affiliation, since Rouergue, just left behind, was already within the sphere of influence of the counts of Toulouse. Nonetheless, the abbey founded by King Pépin the Short was very powerful and controlled the town connected with it.

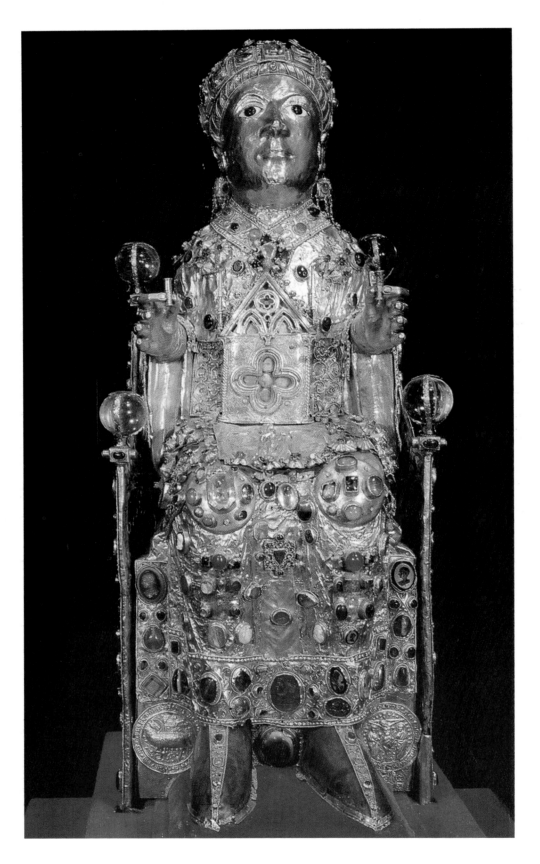

Four obelisks marked the limits of its jurisdiction, within which every individual was granted asylum. It had embraced the rule of Cluny to differentiate itself from Conques, its close rival, from which it had adopted for its abbey church, consecrated in 1093, the architectural system of the pilgrimage church with an ambulatory and radiating chapels. The pilgrims, who

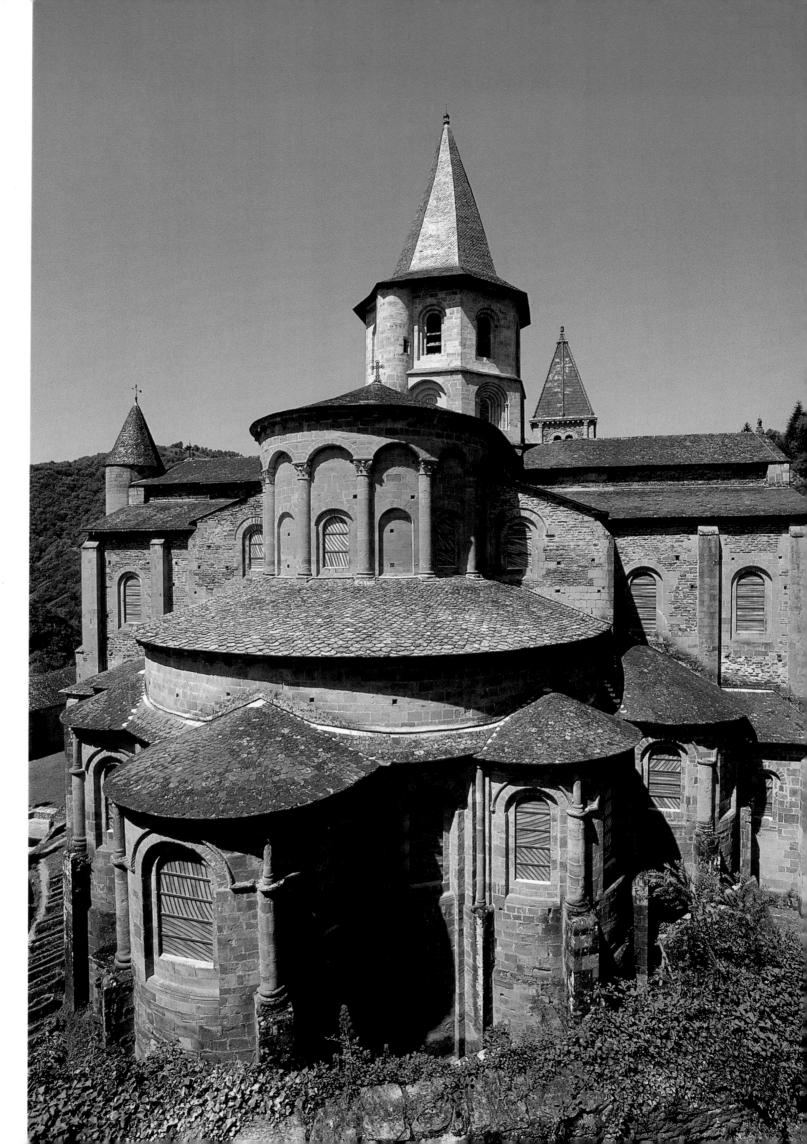

Opposite
RELIQUARY STATUE OF
SAINT FOY, 9TH AND
LATE 10TH CENTURY.
TREASURY OF THE
ABBEY OF CONQUES
*In Miracles de Sainte
Foy, 1.13, Bernard
d'Angers recounted his
experience on seeing the
reliquary: "When we
arrived before her, we
were so closely packed
together due to the large
number of the prostrate
faithful that we were
unable to bow down as
well. I was angry and
remained standing,
looking at the image. I
formulated my prayer in
these exact terms, 'Saint
Foy, you whose remains
are resting in this simu-
lacrum, help me on
Judgment Day.' At this
moment I looked over
at my student Bernier,
smiling. I now thought
that it was awkward and
senseless for so many
reasonable people to
pray to a mute and life-
less object. But these
were vain words, a mean
idea springing from an
unjust heart: this sacred
image is not consulted
like an idol, through
sacrifices, but is rather
honored and revered in
memory of the venerable
martyr in the name of
Almighty God. Yet I
was scorning her as if
she had been Venus or
Diana, and had treated
her as a simulacrum."*

CONQUES, BASILICA OF
SAINTE-FOY, CHEVET,
MID-11TH CENTURY
*In the golden age of pil-
grimage, Conques was
an obligatory stop on
one of the most traveled
routes toward Santiago
de Compostela: the Puy
route.*

came in large numbers from Rocamadour or Puy, also went to pray before the Virgin in the church of Notre-Dame, miraculously born, it was said, from a rosebush that flowered in winter.

The route to Cahors was rich in hospitals and hospices. The powerful Benedictine abbey of Marcilhac ruled over dozens of fiefs along the road, among them Rocamadour, until the twelfth century. The ruins of the Romanesque abbey church indicate it had the same plan as that of Conques, following the example of Saint-Sauveur in Figeac and of Beaulieu. A Christ in Majesty sits enthroned above the porch, flanked by the sun, the moon, and angels bearing the instruments of the Passion.

Cahors, site of a spring already venerated in antiquity, was one of the greatest cities of Romanesque France. Located within the territory of the count of Toulouse, it was nonetheless ruled by its all-powerful bishop. Pilgrims who passed through in the first years of the twelfth century witnessed it in the throes of a building campaign, with the cathedral still under construction. This urban area of the Midi then prospered, laid out according to a plan still in evidence today: two main streets formed the axes that divided up the dense urban area, folded into a peninsula outlined by the Lot. The district of Badernes (from the Latin *dernos*, low area) and that of Soubirous (from *soubeiran*, high ground) to the north framed the cathedral, with the districts of the merchants and their corporations.

The rebuilding of the cathedral had begun at the end of the eleventh century in the tradition of the churches of Périgord. Its large single nave (145 by 65 feet, or 44 by 20 meters) was covered by two domes on pendentives and lacks a transept. At the time of its consecration in 1119, it had not yet received its western portal, which later was moved to the north wall, where it remains today.

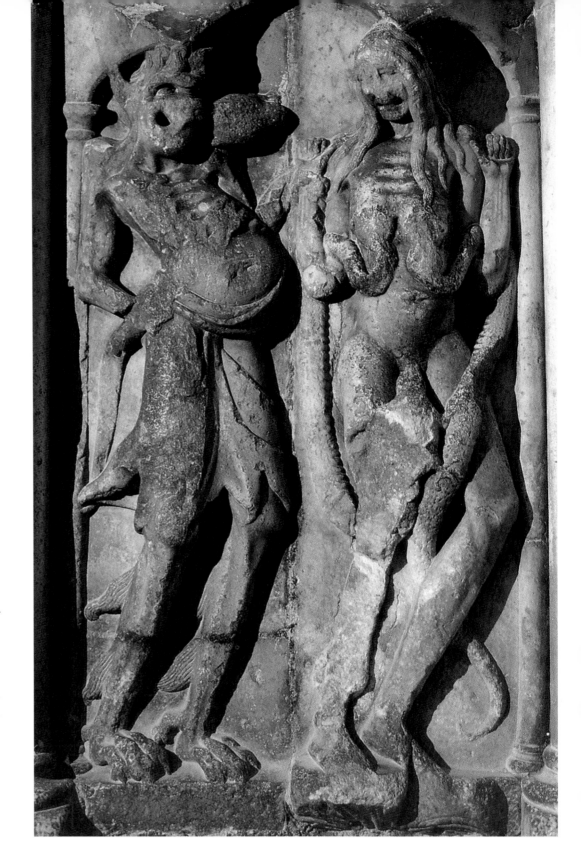

FROM MOISSAC TO RONCEVAUX

The possessions of Moissac slowly dwindled in the land of Lomagne, beyond the Tarn and Garonne Rivers. The abbeys had a priory at Saint-Nicolas-de-la-Grave, a village that they had founded in 1135. At Condom, Benedictine authority predominated until the city was torn between French and English powers following the marriage of Eleanor of Aquitaine to Henry Plantagenet. The church of Sainte-Germaine and that of the Pradeau district are relics of religious activity at this important time.

A mile from Larresingle, one of the rare Romanesque bridges in France still stands with its four semicircular arches: the modest work of Artigues is a moving testimony to the history of pilgrimage. Once twelfth-century travelers crossed it, they received aid from a commandery of the Spanish order of Santiago and a convent of the Dames de Fontevrault at Vopillon.

Opposite
MOISSAC, ABBEY
CHURCH OF SAINT-
PIERRE, DETAIL OF
THE LEFT EMBRASURE
OF THE SOUTH PORTAL,
C. 1130
*One of the most fright-
ening images in the
Romanesque iconogra-
phy depicts the allegory
of Lust chastised, oppo-
site her master, the
Devil. Temptation of the
flesh and sin originated
with the woman in the
eyes of the Church,
which had this horrifying
vision placed at eye
level on the threshold
of the building to warn
the faithful. In her
tormented nudity, the
young woman with
bound hair writhes in
pain, while a toad and
snakes devour her geni-
tals and breasts. The
hairy devil, with claws,
displays a swollen
belly—another site of
sin—and mocks the
damned woman.*

MOISSAC, ABBEY
CHURCH OF SAINT-
PIERRE, DETAIL OF THE
TYMPANUM OF THE
SOUTH PORTAL, C. 1130
*The Moissac Christ in
Majesty is the most pow-
erful of those depicted on
the great French portals
of the first third of the
twelfth century. His ter-
rible gaze is accentuated
by a careful framing of
hair and a beard combed
into distinct locks.
Matthew and John, part
of the tetramorph sur-
rounding Christ, exem-
plify the expressiveness
of the sculpted figures,
conveyed by their faces,
their animated drapery,
and the dancing move-
ment of their bodies.
About 1130 the style of
the Master of Moissac
spread to Souillac,
Cahors, Ydes, and
Angoulême.*

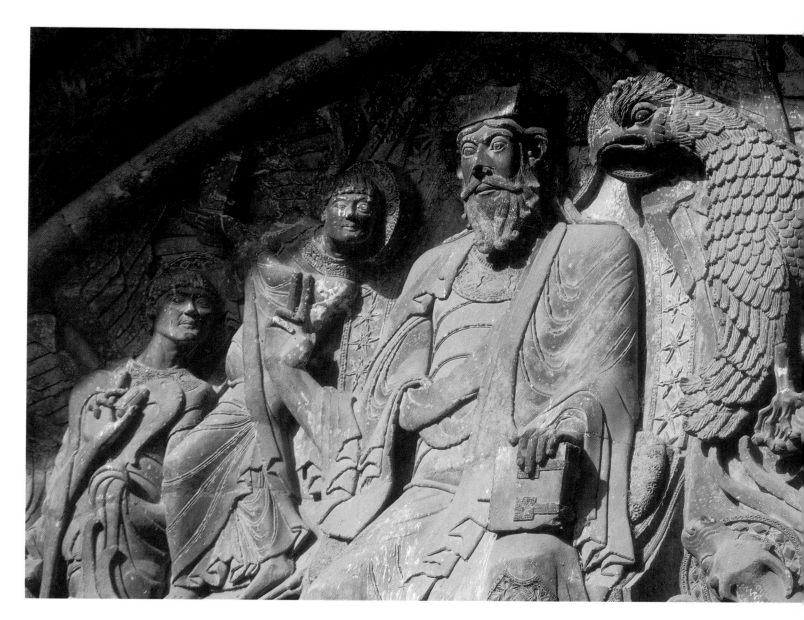

MOISSAC

———●———

*Following the Roman road Cadorca took one due south in the direction of Moissac. The town of Lhospitalet,
whose name conveyed the presence of a hospital, welcomed the pilgrims to its establishment, created in the
eleventh century, while further on in Montlauzun a leper hospital was erected. Next, travelers passed through
the narrow and damp gorge between the Quercy and Tarn Rivers in order to reach Moissac, one of the major
Romanesque monasteries in the west. The Benedictine monks from Moissac had built it during the seventh
century along a major transportation and river route, whose strategic importance made the abbey vulnerable
to Arab, Norman, and Hungarian invasions. Following the example of Cluny, the presence of the monastery
stimulated the birth of a center south of its walls in which agricultural activities—the cultivation of vineyards
in particular—enhanced the abbey's power. The prosperity of Moissac over the course of centuries in fact began
with its association with Cluny in 1047: Saint Odilon made it a special stage on the "route" to Puy. Moissac's
landholdings extended over the Languedoc Midi as far as Spain, and its cultural influence was strong on the
surrounding areas. The monks controlled a bridge over the Tarn, and pilgrims who wanted to shorten their
southern itinerary flocked to it. When these pilgrims visited Moissac they did not have access to the monastic
buildings (of which only the splendid historiated cloister, the most ancient of this type in France, survives, the
monks' refectory and the dormitory having been sacrificed to the railroad crossing). The abbey church of Saint-
Pierre, formerly covered with domes, like the cathedral of Cahors, opened its imposing portal, lodged inside a
tower-porch, to the faithful.*

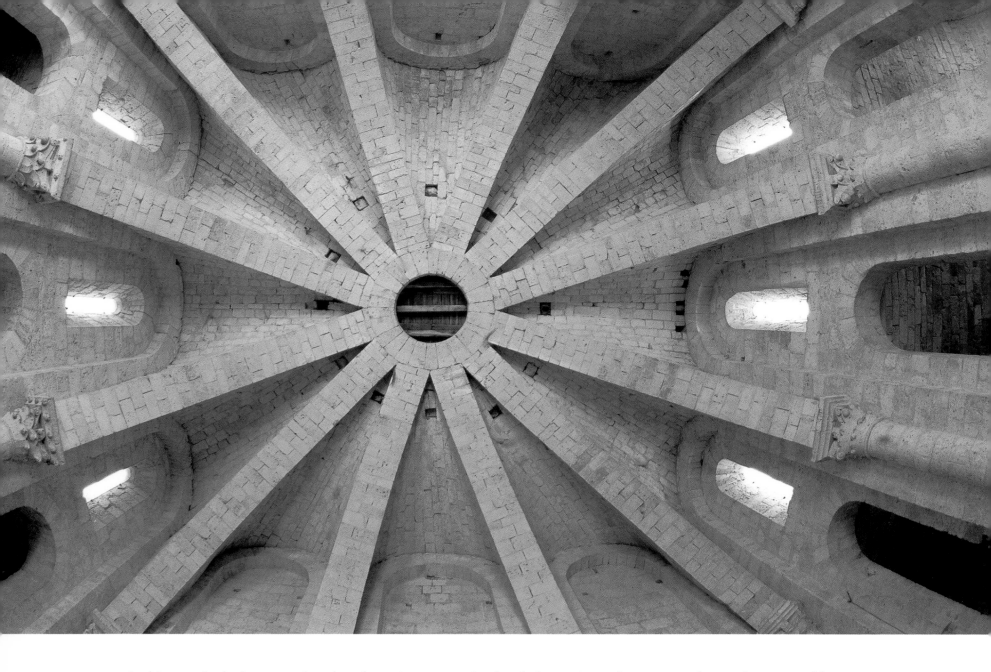

At this stage in the journey, miraculous fountains became common: at Manciet, the fountain of Saint-Jean-de-Malaurey healed disorders of the eyes and ears, as did that of Salles-d'Armagnac; the fountain of Nogaro was reputed to cure rheumatism. Belief in the curative powers of these springs accompanied the local cults, some of which developed through contact with the principal pilgrimage roads. One of these was Sainte Quitterie (Quiteira), whose fame spread beyond the Adour valley. The legendary episodes of her history are typical of the hagiographic literature of the Romanesque period: born into a family of nine daughters, her father decapitated her because she refused to marry. The marvelous spring where pilgrims came to pray at Aire-sur-l'Adour, in a southern neighborhood of the city, is supposed to have sprung from the ground where the severed head of the martyr struck the earth. It was invoked against headaches, madness, and rage.

The amazing tale of Quitterie's life had also drawn attention to the saint's tomb. Having gathered up her head, she put it into her apron and carried it to the church, which opened to receive her; she went down in the crypt, where she stretched out in a tomb which she had had prepared, and, finally, expired. The remarkable Early Christian sarcophagus in white marble sculpted in the fourth century that the faithful came to venerate in the crypt is still there today, with its Christ wearing a toga and its historiated scenes. Its popularity demonstrated that the ancient origins of a cult object reinforced, in the eyes of the faithful, its sacred and authentic character.

The beautiful and little-known Romanesque fortified church in Mazères has a floor of packed earth, but its large apse recalls great religious activity that once predominated in the churches of the Adour valley. Its highly imaginative capitals follow an iconographic program that is among the most diverse in the southwest, depicting the struggle between Good and Evil, with the Creation and the Sin of Adam and Eve, the many vices, and, finally, Heaven and Hell, where

MOISSAC, ABBEY CHURCH OF SAINT-PIERRE, VAULTING OF THE UPPER ROOM OF THE BELL TOWER

beatitude in the former and suffering in the latter are detailed. Animals from a Romanesque bestiary—especially lions—fill the place, as in other important groups of capitals in the south, such as Moirax, Saint-Caprais in Agen, and Saint-Sever. The influence of the latter was strong at Mazères, as was that of Saint-Sernin in Toulouse.

The urban region of Madiran, not far from Mazères, was a *sauveté*, one of the new towns founded by the Church that were so numerous in Gascony. A capital in the spacious church shows a peasant banking a vine root firmly attached to a stake, reminding us that the wine of this small region was made by monks in the eleventh century. In the vast crypt is another indication of the heavy traffic that this region enjoyed when it was located on the road taken by those who were planning to cross the pass of the Somport. Pilgrims who came from Provence made up the bulk of the tide who braved this difficult passage. It was gradually abandoned in the twelfth century in favor of the pass of Ibañeta further to the west, just before the pass of Roncevaux. The roads through Gascony, Berne, and the Basque countries were so numerous and tightly knit that it is impossible to pinpoint definite routes for this final journey, since all paths converged within a short distance, backed by a network of intersecting roads with a highly dense infrastructure of shelters.

Monuments set along the mountain streams and valleys recall the apogee of the Romanesque Pyrenees. At Oloron-Sainte-Marie, the marble of the marvelous portal details the commerce that was carried on in this region; the calendar depicts scenes from local peasant life: hunting wild boars, smoking salmon, preparing cheese and ham; the two chained Saracens on the pier mark the participation of Béarn in the reconquest of Spain by the local hero Gaston IV, called the Crusader, shown here in the ancient style of the equestrian statue. A victorious Christianity was no less admiring of the beauty of Mozarabic art. The dome of the church of Sainte-Croix is ribbed in a star shape. The same is true for that of the church of the Hôpital-Saint-Blaise, where the multilobed arches and the stone latticework of the windows are pierced with an openwork geometrical design similar to the one that once ornamented the apocalyptic portal of the church of Morlaàs.

Everywhere the art of the sculptor prevailed, bringing the chevets to life, from the most beautiful, in Lescar and Saint-Paul-les-Dax, to the most majestic, in Saint-Sever, with its six chapels, where cornices, modillions, and historiated friezes vie with each other in inventiveness.

Gascony, the Basque country, and Navarre, which channeled most of the pilgrim population toward the mountains, are pitilessly castigated by the *Guide*. Their ferrymen's dishonesty, it says, is equaled only by their violence. It recognizes, however, the hospitality of the Gascons, whereas it finds the Basques "a people full of malice, black in color, with ugly faces, they are debauched, perverse, perfidious, licentious, drunken. . . . For a penny, the native of Navarre or a Basque will kill a Frenchman."

As it approached Spain, the flood of pilgrims ended in the hospitals and hostelries of Navarrenx, Saint-Palais, Ostabat. At Harambels the chapel of Saint-Nicolas of the priory is one of the Romanesque remains of the great period. By Saint-Jean-Pied-de-Port the pilgrims crossed Mount Cize, leaving behind hundreds of crosses that they had planted, following Charlemagne's example. Then came the invigorating stage of Roncesvalles, the Camino as far as Santiago, and the end of weeks of effort.

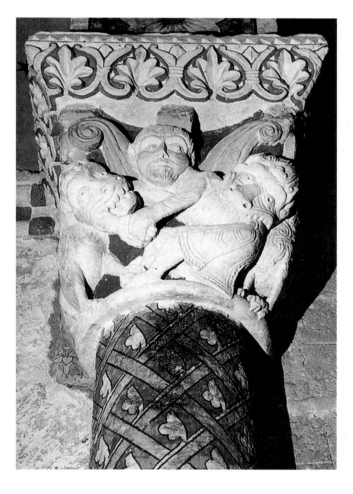

SAINT-ENGRÂCE, CAPITAL, SECOND HALF OF THE 12TH CENTURY
The anguished narrator of Psalm 22 beseeches God, "Save me from the lion's mouth." The theme of the punished sinner is common. Here the rigorous treatment of the figures marks the infiltration of the Hispano-Languedoc style into the Pyrenees.

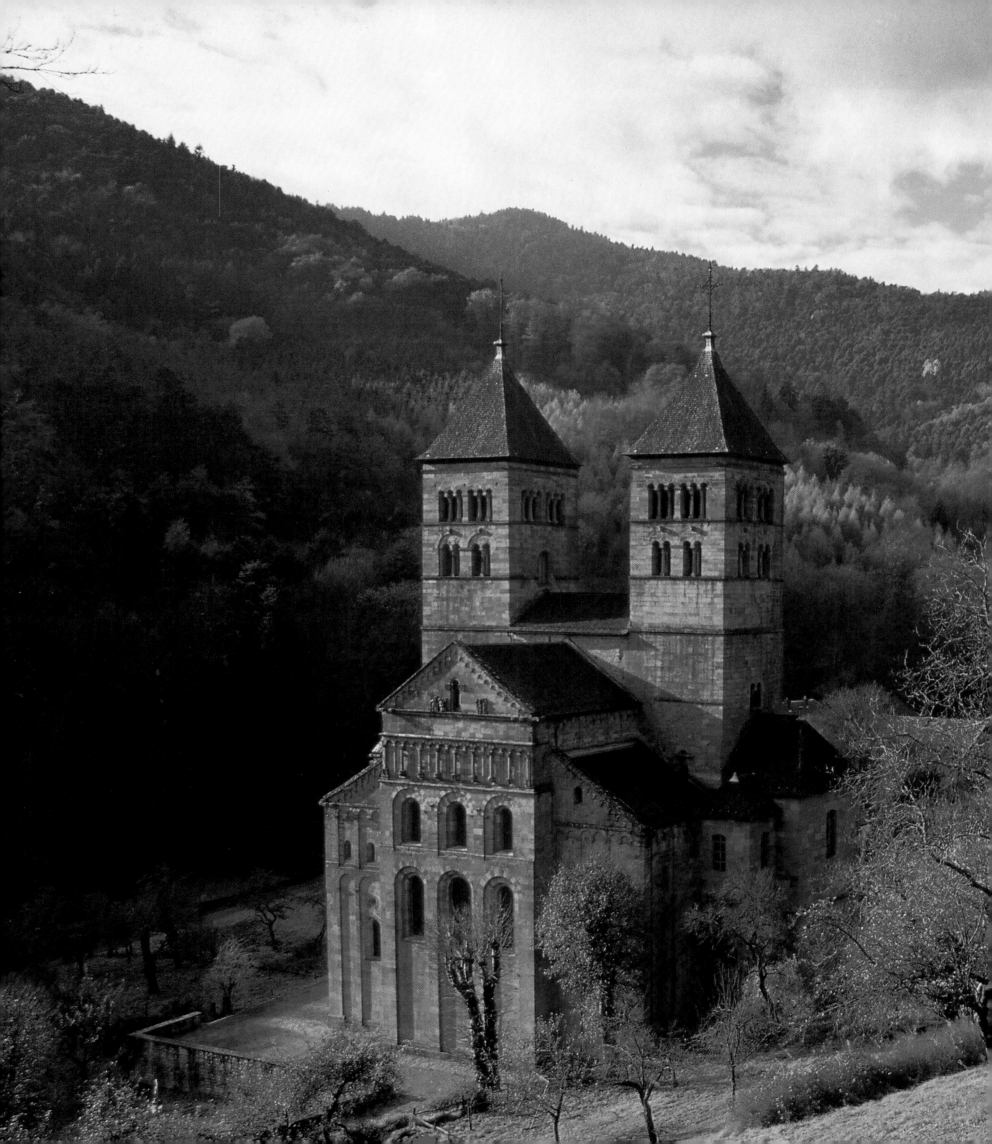

The Gates of the Empire

ROMANESQUE Alsace and Lorraine were in Germanic lands. The two regions, today so different both physically and culturally—one turned to the east, the other to the west—were long coveted, fought over, and divided up, in order to gain control over their routes of communication and because they were borderlands. Nonetheless, they share a prestigious past that has shaped their identity: they take us to the heart of the ancient Carolingian Empire.

To understand the birth of these two regions we must go back to the ninth century. In 843 the Treaty of Verdun sanctioned the dissolution of the immense *imperium* of Charlemagne, dividing it into three independent countries, each headed by one of his rival grandsons: Charles the Bald became the eastern Frankish king, Louis the German received the western Frankish kingdom (from the Rhine to the Elbe); finally, Lothair, the eldest son, inherited the imperial title and a "corridor country" extending from the North Sea to southern Italy: the *Lotharii regnum*, or Lotharingia, from which Lorraine would later emerge. The sons of Lothair having died without heirs, Charles and Louis divided up his lands. The latter received the eastern half of Lorraine, including the former imperial capital of Aachen (Aix-la-Chapelle), in 870, followed in 880 by the western half, which became a frontier at the gates of the kingdom of France, a wealthy and populous—and therefore desirable—region.

Lotharingia having been broken up, the two Frankish kingdoms, left face-to-face, would never again be united; they became France and Germany. The separation of the two nations was evident by the end of the twelfth century in the difference between their languages; Latin dialects developed into French, and *Theudische*, a term for the dialects of the Germanic languages, into German.

ON THE TRAIL OF THE EMPERORS

After the decline of the Carolingian Empire the western Frankish kingdom saw the appearance of a new Saxon dynasty that revived the tradition of the empire in the tenth century, called "Ottonian" after the name of three of its emperors. Otto I, called the Great, enthroned at Aachen in 936 and anointed in Rome by the pope in 962, rekindled the great political and cultural ambitions of Charlemagne, as he and his heirs redrew the frontiers of a new Holy Roman Empire,

which extended the annals of the Carolingian renaissance through the arts. Faced with a still-fragmented Capetian France and a Byzantine Empire threatened from the outside, imperial German power reached its zenith in the eleventh century; in 1033, under the reign of Conrad II, first emperor of the Salian dynasty, the kingdom of Burgundy and a large part of ancient Lotharingia reverted to the Germanic sphere of influence. Under Henry III expansion took place to the east: Bohemia, Poland, and Hungary became German fiefs. Finally Italy, still passive, remained a German possession up to the lands south of Rome.

In 1044 the kingdom of Lorraine was divided into the duchies of Upper and Lower Lorraine. Present-day Lorraine corresponds to the Upper Lorraine of that time, whose borders with the kingdom of France (which remained stable throughout the Middle Ages) were located to the west of the Meuse River, at the level of Bar-le-Duc. Alsace belonged to neighboring Swabia—the Vosges Mountains, and not the Rhine (as today), formed the border between the two countries. In both, real power was held by the bishops. In Alsace, the dioceses of Strasbourg and Basel enjoyed independent status as imperial free cities; in Lorraine, those of Metz, Toul, and Verdun divided up the lands with the powerful families that gradually dispossessed the duke. In the Romanesque period the two regions still shared the destiny of the empire to which they belonged, but the political fragmentation just described would lead to their "difference." Alsace, today in the French Rhineland, remained profoundly German, while Lorraine turned more toward France.

The universalist ideal of imperial power, especially from the time of the Ottos, was also imposed on the Church, to the detriment of the power of the Holy See. Five successive popes in the course of the eleventh century were German, among them, the famous Alsatian Pope Leo IX (r. 1049–54), a popular figure long revered in Alsace-Lorraine and an energetic architect of Church reform.

The nomination of lay figures to high ecclesiastical rank by kings led to the Investiture Controversy and inaugurated a long period of open conflict between the German emperors and the Holy See. In 1076 emperor Henry IV called a council of German bishops who no longer recognized the pontifical authority of Gregory VII. The latter retaliated by excommunicating the emperor and releasing all of his subjects from their oaths of fealty to him, thus striking a heavy

Preceding pages
MURBACH, ABBEY CHURCH, SEEN FROM THE NORTHEAST, SECOND QUARTER OF THE 12TH CENTURY
All that remains of the abbey church of Murbach, formerly a major site of Rhenish monasticism, is its eastern section, which displays a sharp, slender profile tempered by a play of horizontals. The very geometric shape of the choir, with a flat rear wall ending in a gable, is echoed in the two adjoining aisle chapels. The transept terminates at both ends in a tower 115 feet (35 meters) high, formerly topped with spires.

ROSHEIM, CHURCH OF SAINT-PIERRE-SAINT-PAUL, ONE OF TWO GROTESQUES, 12TH CENTURY
Small grotesque figures are common in the nonreligious art of Romanesque churches, in which humor abounds.

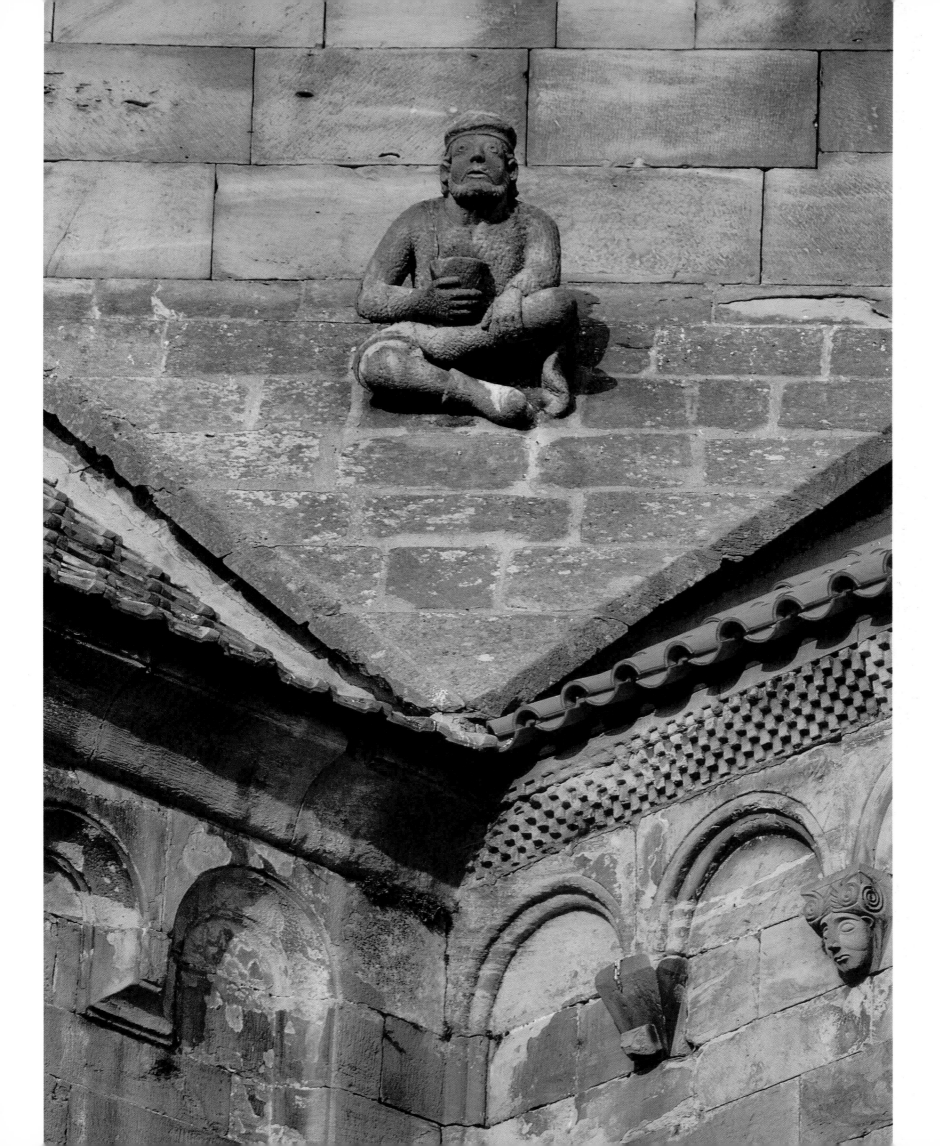

blow at the political stability of the empire. Within the year Henry IV went in penance to Canossa, in Italy; the excommunication was lifted without the conflict having been resolved. Although the Concordat of Worms (1122) put an end to the Investiture Controversy (proclaiming the temporal submission of bishops and abbots to the king, partly owing to the impact of the reforms of Cluny), these troubles had shaken the supremacy of the German Church.

Nonetheless, under the Hohenstaufen in the twelfth century, the idea that Germany could once again reside at the head of the Christian world went unquestioned. By recognizing an antipope over Alexander III in 1159 the very powerful Frederick I Barbarossa (r. 1152–90) provoked a schism that ended up dividing the west into two camps until 1177. Four antipopes followed in succession, faced with a pope who was irrevocably opposed to the German takeover, until Frederick submitted, a wise decision that allowed him to strengthen his own position in the empire. In a final burst of energy he headed the Third Crusade (1189–92) with Philip Augustus and Richard the Lionhearted, in the course of which he died. Some years later the pope consolidated his role as supreme head of the universal Church and arbiter of the West. A new era was beginning.

THE OTTONIAN ACADEMY

Early Romanesque architecture in Germany greatly extended Ottonian forms, themselves echoes of creations from the Carolingian renaissance. The first building that draws our attention recalls the great days of Charlemagne; it is Romanesque in date rather than in style. In ancient Lotharingia the Carolingian survival was most vigorous. The church of Ottmarsheim in Alsace, near Mulhouse, is an eloquent example. In 1049 Leo IX consecrated this Benedictine abbey built around 1030, some twenty years previously. As often happened, consecration was delayed until the pope was in the area. What he saw at Ottmarsheim was nothing more nor less than a faithful (but smaller) replica of the impressive Palatine Chapel of Charlemagne, built two centuries previously (798) in his capital of Aachen. Based on a central octagonal plan, the church is dominated by an eight-sided calotte, or flattened dome, surrounded by an ambulatory with eight sides (sixteen at Aachen),

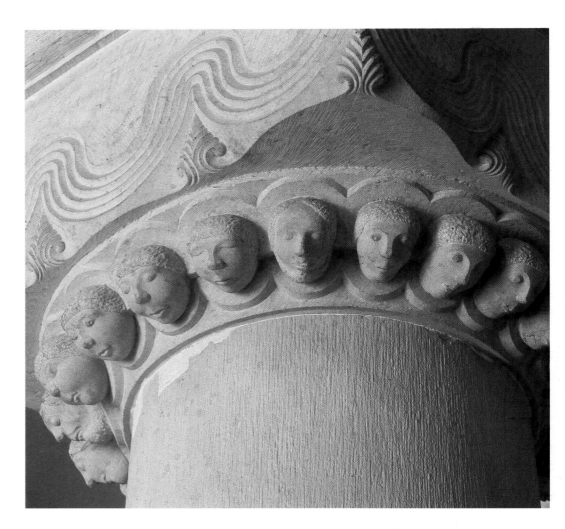

surmounted by galleries following the same scheme and intended for the nuns during services.

The apparent origin of this plan may be found in the Early Christian legacy of baptisteries and funerary chapels *(martyria)*, which were themselves inspired by classical models (central-plan temples and mausoleums). Yet while the concepts of the polygon with aisles and galleries, apse facing east, and a central dome began with the Carolingian version, the Ottonian interpretation is not devoid of creativity. The conception of overlapping volumes is the same, but their articulation is clearer, the flat segments sharper, the central body more delicate. The flat-backed choir mirrors the western porch and creates a new equilibrium; obtained by a sophisticated calculation of the modules, the proportions of the building, when seen from the exterior, give a harmonious effect and provide a limpid reading. Here we realize the striking—and very characteristic of Carolingian and Ottonian churches—contrast between the sharply delineated exterior aspect of the building, which appears to be easily understood, and its more complex interior structure, made of volumes at once independent and overlapping.

A rare example of the early Romanesque in east-

ROSHEIM, CHURCH OF SAINT-PIERRE-SAINT-PAUL, CAPITAL WITH TWENTY-ONE HEADS, AFTER 1132
The workshop responsible for the perfection of Rosheim's sandstone masonry and the high quality of its reliefs made the church one of the most important examples of Alsatian Romanesque art. Sculpture was used sparingly in the region, and the human form did not enter its repertory until the twelfth century, accompanied by designs inspired by plants and real and legendary animals, sometimes arranged in surprising ways. The repeated anthropomorphic pattern of this capital renders it above all ornamental.

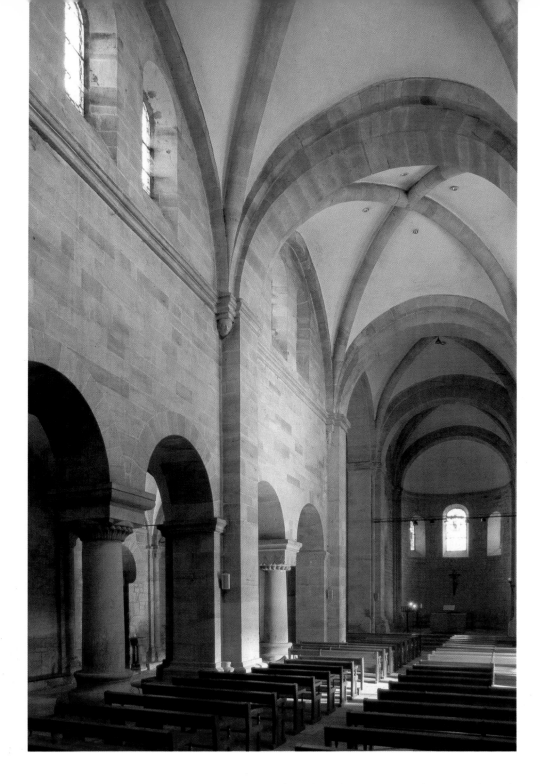

ROSHEIM, CHURCH OF
SAINT-PIERRE-SAINT-
PAUL, ELEVATION OF
THE NAVE, AFTER 1132
*One of the largest build-
ing sites in Alsace was
established here after the
church burned, and the
work of its masons and
sculptors who trained
here later spread through-
out the region. The alter-
nation of supports in the
nave and the arcades
outlining the large, win-
dowless walls are charac-
teristic of Ottonian
architecture.*

ern France, the church at Ottmarsheim is thus far
from being a simple copy of the Palatine Chapel at
Aachen, since it illustrates the care taken in the formal
and aesthetic investigations of Ottonian art, which in
itself made possible the transition from the Carolin-
gian heritage to realization of the Romanesque in
some parts of the empire. Thus, two other Alsatian
constructions take up the principle of the central
plan, with in each case a variation. The chapel of
Saint-Ulrich at Avolsheim follows a four-lobed plan
dating back to the tenth century (this original disposi-
tion was restored at the beginning of the twentieth
century). It is built around a circular core demarcated
by four apses and covered with a thirteenth-century

dome with an octagonal tower above, crowned with
a spire. The initial purpose of this church remains
unclear, whereas the cemetery surrounding the little
chapel of Epfig suggests a funerary function for this
second Alsatian monument. Its plan, based on the
Greek cross, is really a hybrid plan integrating three
equal arms (choir, transepts) with a single nave, con-
stituting a compromise between the central plan and
the basilican plan. The southern and western arms are
linked by a portico-porch added in the twelfth cen-
tury, which is pierced with arcades. Unique in the
regions of Alsace and Lorraine, this arrangement is
more usual in the countryside to the east of Paris, and
it probably responded to the requirements of proces-
sional liturgy.

The Romanesque churches of Alsace and Lor-
raine appeared late, around the middle of the twelfth
century, in the shadow of the imperial cathedrals of
Speyer—a Romanesque church "of Gothic dimen-
sions"—Mainz, and Worms, as well as Sainte-Marie-
du-Capitole or, in German, Sankt Marien im Kapitole,
in Cologne. These landmark monuments all played a
determining role in the elaboration of the Rhenish
Romanesque style. Under their influence, a group of
high-quality Alsatian and Lorraine churches display
common characteristics deriving from the gradual
transformation of Ottonian formulas: they all have a
high facade featuring towers, often furnished with a
western mass (westwork, or *Westbau*), which stands
out like a prow; a two-ended design opposing two
apses preceded with a transept is sometimes substi-
tuted for the traditional basilican plan. The interior
volumes are divided differently according to whether
the church is a basilica type with a low and projecting
transept (Eschau), a basilica with nave and transept
of equal height, or, especially, a basilica with a classi-
cal crossing, developed by Ottonian architects and
common throughout Alsace (Andlau, Lauttenbach,
Surbourg, Rosheim). Finally, most of them employ
alternation in the supports of the nave ("strong" pil-
lars with engaged columns or pilasters alternating
with "weak" piers formed of a simple column), a con-
sequence of the "bound" system that joins each vault
in the nave with a pair of vaults half the size of those
of the aisles.

In the church of Saint-Pierre-Saint-Paul in
Rosheim this system of construction, begun in a
grandiose style at Speyer and then at Mainz, has left
its most authentic imprint. The elevation of the nave,

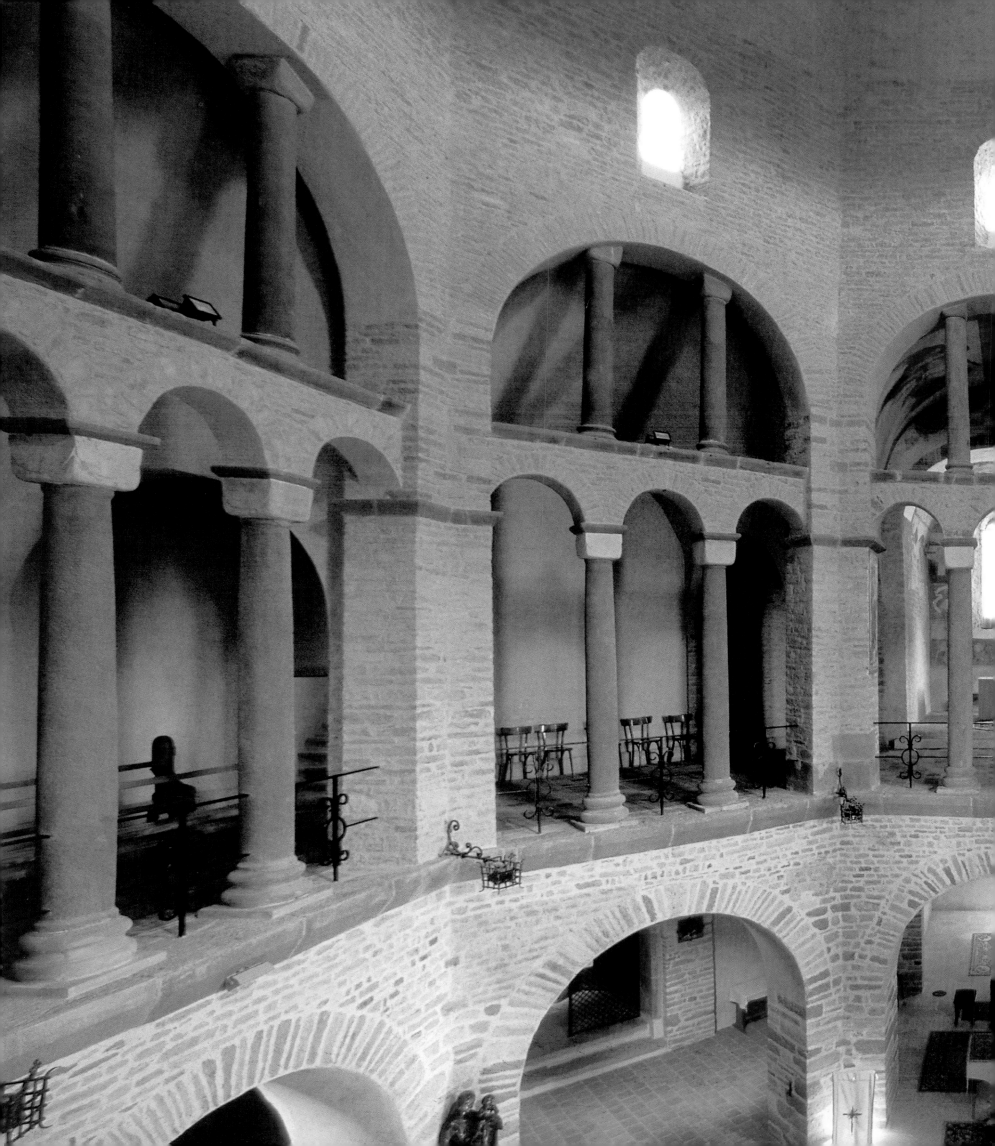

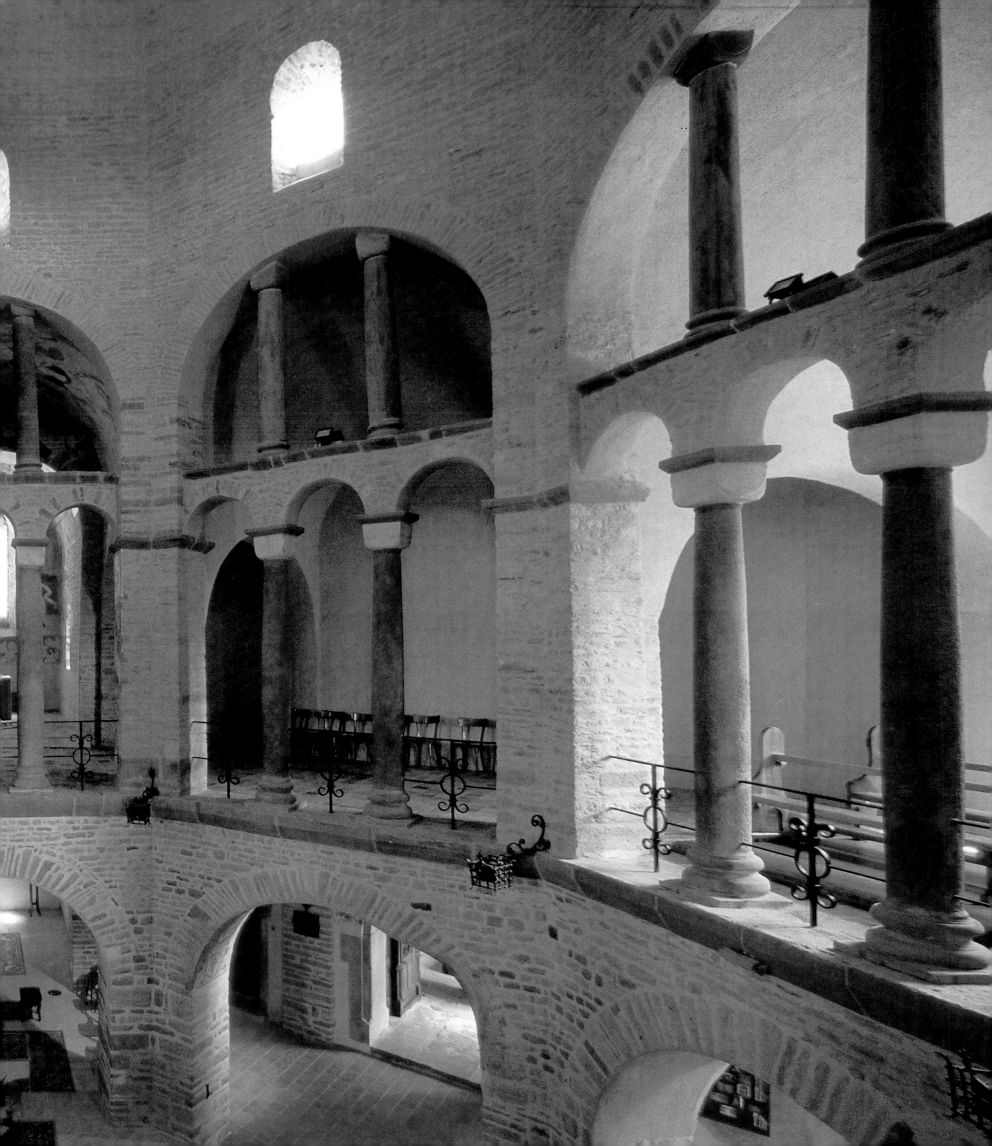

THE ABBEY OF MURBACH

●

The best-known Romanesque building in Alsace owes its fame not only to a remarkable architect but also to its splendid site: a narrow valley surrounded by forests and the Vosges Mountains. The founding of the abbey by Saint Firmin at the beginning of the eighth century marked an important stage in the expansion of Benedictine monasticism in Alsace. Protected by Charlemagne, it was one of the principal centers of the Carolingian renaissance. The monks and their abbot, all from noble families, lived there in a refined intellectual atmosphere, judging from the inventory of their library and the exchanges made between this monastery and the other great abbeys to the east, notably, the abbey of Reichenau on Lake Constance, the most influential of them all. After its heyday Murbach was pillaged in the tenth century by Hungarians ravaging Alsace, but it recovered a temporal power closely bound to the local feudal system and the politics of the Holy Roman Empire. Here again, the Rhenish elements (windows one on top of the other, the shape of the towers) are mixed with Lombard elements (pilaster strips, Lombard bands, miniature gallery to decorate the chevet). In any case, the main influence came from neighboring Burgundy. In the eleventh century, the Cluniac reform was followed by most of the Benedictine monasteries in the Germanic countries. Hirsau (in Swabia, now destroyed), an ardent proponent of the ideas and style of Cluny II, spread the design of a basilica with nave and flanking aisles, a projecting transept, a tripartite choir without crypt, sometimes a flat rear wall—a remnant from Ottonian times—and the placement of towers at the major points of the building (facade, transept, crossing).

as at Sélestat and Saint-Dié in Lorraine, displays a series of columns and massive pillars that support huge bare walls, impressive in their simplicity.

AT THE CROSSROADS OF INFLUENCE

Like many other churches of the upper Rhine, the former Benedictine abbey church of Marmoutier is composed of sandstone. Only the western part of the building is of interest; the powerful facade, restored in the nineteenth century, offers an eloquent example of the survival of Ottonian forms in the architecture of the Rhine. Massive in appearance, it is imposing, like Speyer, with a square central bell tower closely flanked by two octagonal towers. These frame a two-story structure entered through a porch with three semicircular arcades and enclosing a chapel on the upper floor, to which access is gained by stairways built in the towers. This westwork, an Ottonian invention, is Romanesque in its arrangement, lighter and better integrated into the ensemble. This evolution came about through the encounter of the local architectural heritage with the various stylistic trends in circulation at the time, whose origins and effects have not yet been completely analyzed. After Catalonia and Burgundy, we find here the strong influence of northern Italy, crucial in the rebuilding of the cathedral of Speyer. At Marmoutier the facade is ornamented with delicate Lombard bands, which at Rosheim articulate

the exterior walls of the nave and the aisles. We find them in many places as the most obvious mark of the influence of these stoneworkers and master builders, who early on exported their technique, which became part of the current architectural vocabulary.

The abbey of Sélestat also proved receptive to the influence of Burgundy. The present church of Sainte-Foy, which belonged to the monks of Conques, is a Rhenish structure—highly restored in the nineteenth century—broken up with Burgundian elements, among which the most memorable is the very beautiful octagonal tower crowned with a stone spire that surmounts the crossing. It was through French-speaking Lorraine that the Alsatian monks became aware of the novelties of Burgundy; which explains the presence of elements from the Lorraine here, including the form of the pillars and the use of buttresses.

The cult of relics and procession liturgy required a specific organization at Neuwiller-lès-Saverne, which is invisible from the exterior. Under the choir is found the *confessio* of Saint-Adelphe, famous for performing miracles; this ninth-century crypt was pierced with two lateral openings, which allowed the pilgrims in procession to contemplate the reliquary. Its originality lies in the eleventh-century construction of an independent two-story chapel that abuts the wall of the chevet, allowing the pilgrims an increased number of stations during processions, thus responding to the new requirements of the liturgy. The chapels of Saint-Sébastian and Sainte-Catherine actually constitute

Preceding pages
OTTMARSHEIM, ABBEY CHURCH, INTERIOR VIEW, 11TH CENTURY
Extremely open tribunes crown the arcades that delimit the central space for parishioners. The arches of the tribunes are divided into two sets of three by colonnettes of pink sandstone with cubic capitals of an elegant simplicity. The contrast between this airy tier and the massive character of the lower pillar-walls is reinforced by a very prominent band that separates the two levels. The same principle is repeated in the eastern apse; square in plan, it surrounds two superposed sanctuaries, one below for the faithful, the other on the upper level for the monastic liturgy. Forming a counterpart to the western porch, it imposes an east-west orientation on the church's square plan.

SÉLESTAT, PRIORY OF SAINTE-FOY, SECOND HALF OF THE 12TH CENTURY
The absence of Lombard bands in this monument points to the influence of French master builders from Alsace.

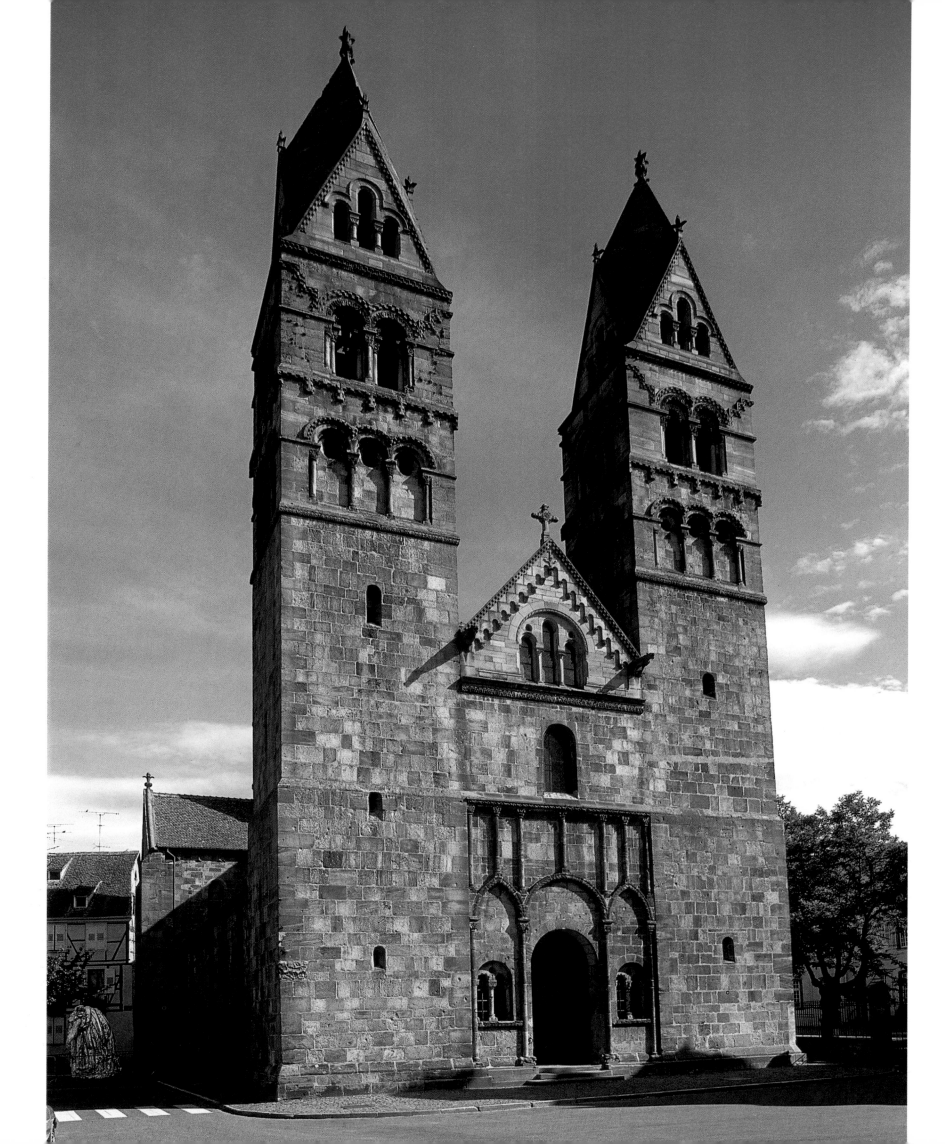

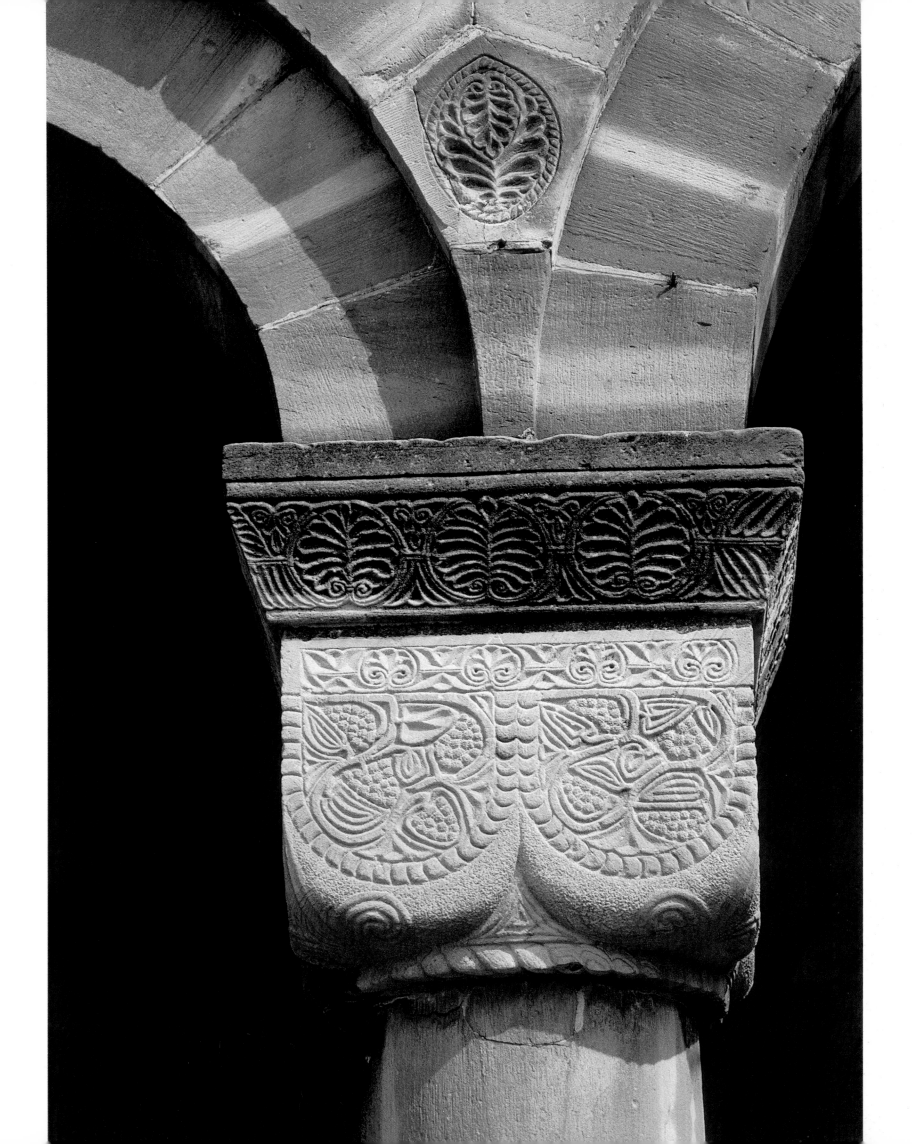

separate churches in themselves, incorporating a basilica plan of three naves and an apse.

The former abbey church of Saint-Jean-Saverne raises the issue of vaulting. By the eleventh century most of the churches of Ottonian inspiration had abandoned the timber roof that had covered naves since the Early Christian era. Various experiments were undertaken in order to arrive at the ideal solution. Groin vaults covering the aisles or the crypts led in the twelfth century to the rise of rib vaults over the nave; the corded-rib vaults at Murbach (of Lombard origin), perhaps the oldest in the region, rival those of Gueberschwihr, as well as the dome-shaped vaults of the aisles of Saint-Jean-Saverne, in ingenuity. At Rosheim, Sélestat, and Andlau, or in the porch of Lauttenbach a few years later, rib vaults reached a flawless level of quality. In company with a contribution from Lorraine, they lead us to think that their elaboration in the region of the upper Rhine, along with the Île-de-France, constituted an important stage in their evolution.

THE VOSGES MOUNTAINS

The region of the Vosges Mountains, subject to the Holy Roman Empire, and, further west, Lorraine also present churches marked by imperial Rhenish architecture. Notre-Dame-de-Galilée in Saint-Dié presents a sober facade with a tower-porch and an alternation between strong and weak piers, as well as a daring use of groin vaults to cover the central nave. In the Meuse valley the cathedral of Verdun, with a rich Carolingian past (despite its present eclectic appearance, due to restorations), is one of the rare examples among the French abbeys or cathedrals to have adopted the double-ended Carolingian design in the tenth century. This design, which opposes two facing apses (eastern and western), each generally accompanied by a transept, enjoyed great popularity in the ninth and tenth centuries and long persisted in Germany. It seems that it was abandoned in France due to the influence of Cluny, which valued (and required) a single sanctuary oriented toward the east and, in order to emphasize it, furnished it with an ambulatory and radiating chapels, where the altars are concentrated, thus opening the way for pilgrimage architecture. From this point on, the orientation of churches to the east became definitive. The two poles of the cathedral of Verdun were built at different times; the rectangular

Rhenish choir at the western end was finished before 1024, while the eastern apse, from the 1140s, retained its Romanesque base, whose polygonal formula derives from the south. The importance given its crypt is characteristic of Lorraine, where the most astonishing among them, at Bleurville, features no fewer than eleven naves. The church of Dughy is still covered with a timber roof in the style of imperial basilicas, whereas those of Gorze and Mont-devant-Sassey follow a Rhenish plan, which raises square towers above the transept.

DECORATIVE DUALITIES

The disappearance of the timber roof, replaced by vaulting, and a better division of volumes in churches led to a change in the choice of materials selected to cover the walls. With the availability of sandstone from Vosges quarries, small rubble gradually gave way to medium and large cut stone, used to cover the interior and exterior walls of these buildings. This evolution toward a higher quality of building materials corresponds to the appearance of sculpted decoration, until then very rare in Germanic countries. Sandstone turned out to be easy to work, and a monumental decoration was initially manifested by the articulation of walls in pilaster strips and arcades, which eventually covered the perimeter of the church from the apse to the facade, as in Pfaffenheim. At the beginning of the eleventh century, when sandstone was employed only for the essential structural portions of the building, sculpture began to enliven the cornices, consoles, and gables. The same is true for the interior walls, which are adorned with geometric motifs in which we recognize the barbarian vocabulary, transmitted through objects of gold work, exemplified by the crypt of Strasbourg Cathedral and the aisles of the church of Sankt-Ulrich in Altenstadt. Interlacing motifs quickly became the favored ornament, the result of a taste for stylized abstraction cultivated in the early Middle Ages. This style was spread through the influence of Lombardy, which for four centuries had made use of these very simplified, hardly recognizable plant designs, transformed into pure decorative elements, emphasizing windows and door jambs, sarcophagi and altar fronts (Neuwiller-lès-Saverne, Murbach) with friezes. The classical heritage can be seen in the rosettes, palmettos, and rinceaux whose use persisted until the twelfth cen-

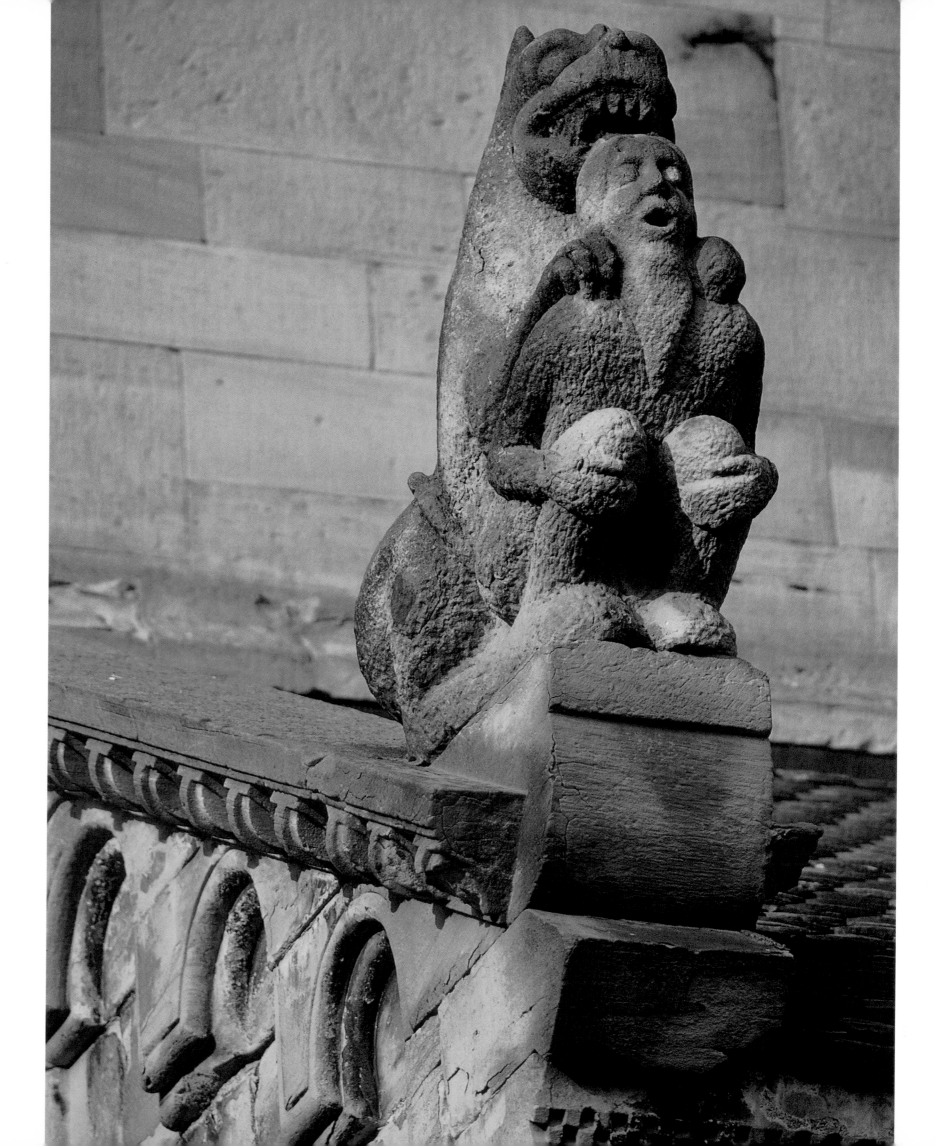

tury, as in the capitals of Rosheim and in Murbach's portal of the south transept.

Zoomorphic figures further enriched the ornamentation of the area. Springing from a proto-Roman tradition, this bestiary of real or imaginary animals constitutes an important element of the pictorial vocabulary of Romanesque sculpture in Alsace. At first used sparingly, these bas-reliefs hollowed into basins found their place, following the Italian style, at the edge of consoles, on the high courses of gables, or on capitals, often accompanied with masks and burlesque figures. During the slow progression from bas-relief to sculpture in the round, dragons vied with chimeras, griffons, Sirens, and basilisks at Alspach, Dorlisheim, Sélestat, Sigolsheim, Kayserberg, and, again, in the crypts of Strasbourg Cathedral. At Rosheim, an eagle on the verge of flight and two ferocious lions, maws open and holding a man between their paws, inhabit the heights of the facade of the church of Saint-Pierre-Saint-Paul, while two gargoyles crouch at the foot of the bell tower; one holding a goblet and the other his beard. These statues in the round, the first in Alsace, highly visible from the ground, remind us that popular Romanesque imagery, no matter how didactic it may have been, can be subject to a complex, even ambiguous, interpretation. Such is the case with the bestiaries whose illustrations are drawn from mythic narrative or legends, their cosmographies preserved in the libraries of the monasteries. The figure of a lion, familiar in Alsatian imagery, is characteristic of an antithetical symbolism since it may represent Christ or Satan, depending on the iconographic context. If it is in ser-

vice of Good, it is a symbol of force and courage and may signify the Resurrection or the Divine Mercy of Christ; it is also the creature that keeps watch over the dead, hence its presence in funerary art. But it is especially the ferocious lion, already mentioned in the Old Testament, whose maw is often associated with the "belly of hell" (Jonah 2:2). David and Samson, bold precursors of Christ, fought against it. At Rosheim, it is indeed two man-eating lions that mock us, as they make ready to devour their prostrate victim.

NARRATIVE CYCLES

Columns, capitals, abacuses, and imposts rediscovered in the nineteenth century during excavations made around the former abbey church of Eschau have allowed the reconstruction of a gallery of the former cloister of the Benedictines at Eschau, today preserved in the Musée de l'Oeuvre Notre-Dame in Strasbourg. The capitals, ornamented with perfunctory palmettos, support very beautiful historiated abacuses that represent part of the program devoted to the Childhood of Christ, accompanied by engraved inscriptions that narrate episodes—miracles and parables—relative to his ministry.

The Christological cycles, starting with the Annunciation and going up to the Baptism, group together the most widely sculpted themes in the twelfth and thirteenth centuries. The baptismal font of the church of Saint-Thomas, in the same city, offers a good example. The church of Saint-Thomas also preserves an excep-

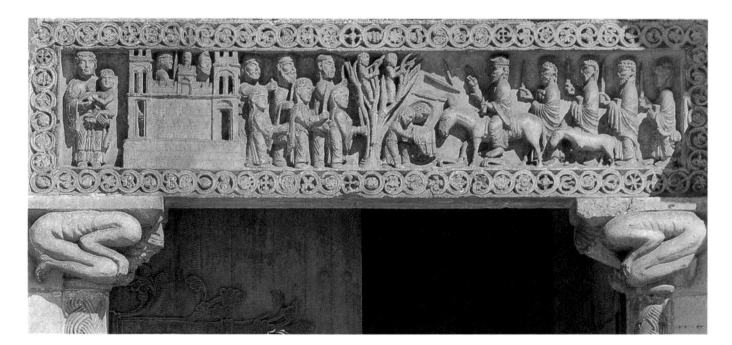

ALSATIAN SCULPTURE

●

About 1130, the sculpture of Alsace grew bold on capitals as well as portals and facades and created stories in narrative friezes on the west walls. Andlau and the neighboring abbey of Mount Sainte-Odile were two important pilgrimage sites that engendered strange and lasting legends. At Andlau a she bear was said to have showed the saint where to build her convent. From then on, bear keepers—although they were usually considered marginal in medieval society, like other performers—were always welcome, and for centuries the abbey kept bears to commemorate this marvelous episode. Covering the north and west faces of the church porch, 96¾ feet (29.5 meters) long, Andlau's famous historiated frieze gives an epic flavor to its scenes of combat (between a Danish hero and a bear) and hunt scenes (stag hunting, griffin hunting, the chase of a fox with a stolen goose). Indeed, it presents a varied bestiary, including nereids astride fish, a centaur drawing his bow, and animals derived from Eastern textiles: a dromedary, a lion killing a gazelle, devouring dragons, and the sly scorpion, often associated with the Jews (found in Sigolsheim as small figures with pointed hats). The Devil is here, too, of course, beside the protagonists (the money changer, the wine merchant) in the scenes of tricks played on innocent victims. Here, as elsewhere, wine is present. At Sigolsheim, the donor kneeling at the church's portal is a wine merchant offering a cask. At Andlau, where vineyards had long skirted the forests, Christ is prefigured in the shape of the Old Testament Samson, who incarnates courage and innocence, and whose wedding is depicted here along with the serving of wine. There is nothing shocking in this. From its beginnings the church associated this noble product of the earth and of human labor with its own didactic mission. In depictions of bunches of grapes in the first basilicas, wine assumed the sacred nature of the blood of Christ and the mystery of the Eucharist.

ANDLAU, ABBEY
CHURCH OF SAINT-
PIERRE-ET-PAUL,
DETAIL OF THE
PORTAL LINTEL
This church has the most beautiful group of sculptures in Alsace decorating a portal, including a historiated frieze on the lintel narrating the story of Adam and Eve.

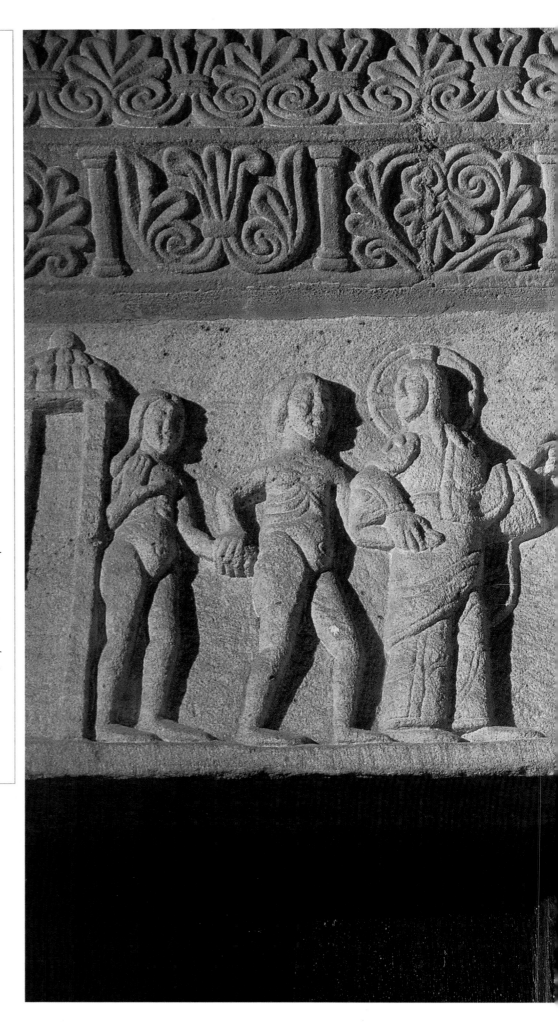

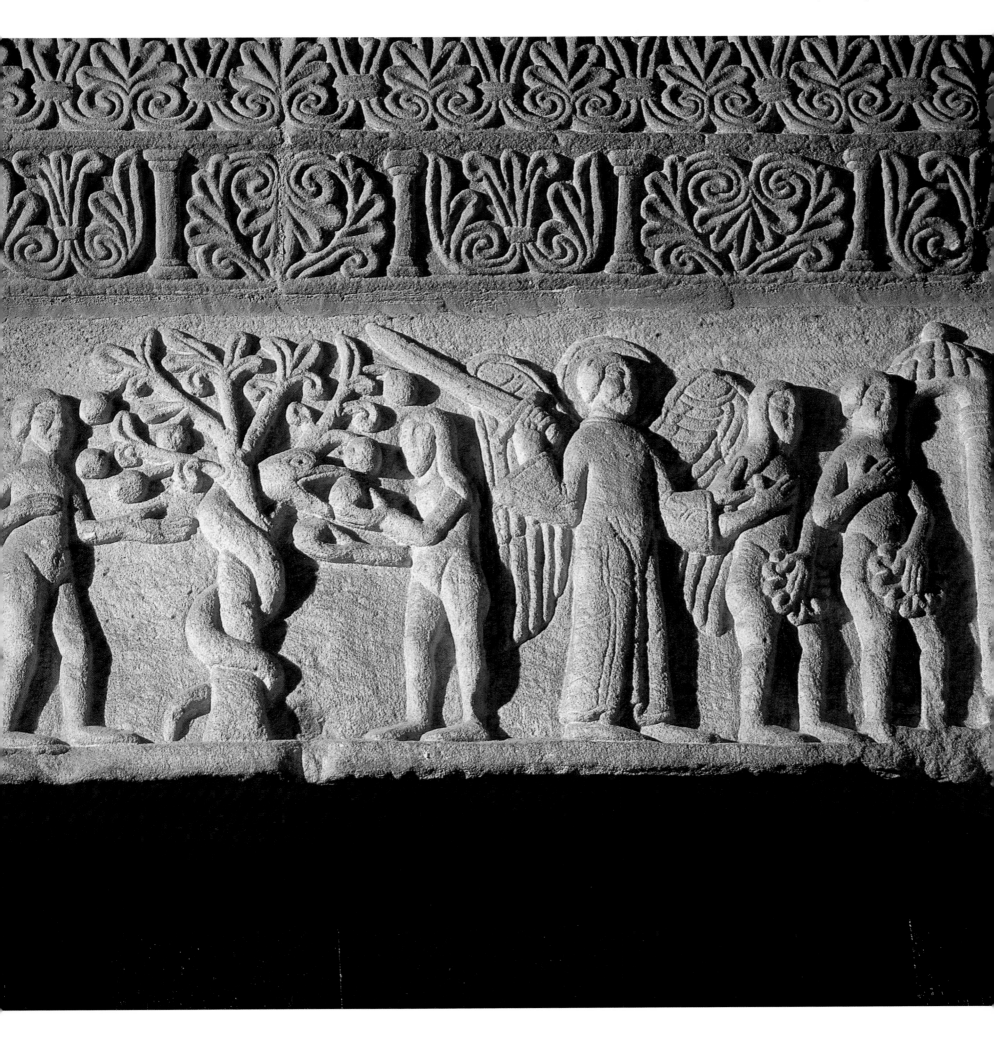

tional Romanesque tomb made for Bishop Adeloch, a rectangular basin supported at the corners by four lions and crowned with a saddle-back cover. Sculpted in shallow relief, it is decorated inside with a network of arcades alternating with palmettos and figures. On the posterior face Adeloch speaks with a female figure (the Church?), while on the sides allegories of the Earth and the Ocean symbolize the temporal space, as on Roman triumphal arches or Carolingian ivories.

These three last works were undoubtedly executed by the same artisans sometime about 1130. The aesthetic quality cannot match the best Burgundian creations; the style in Alsace and Lorraine remained fairly rustic. However, the delicacy of some details, such as the drapery and facial expressions (derived from the minor Byzantine and Carolingian arts of gold work, ivory, and weaving), demonstrate an important evolution in Alsatian sculpture between the eleventh and thirteenth centuries. The same is true for metalwork. The extraordinary strap hinges of forged iron that ornament the doors of the church of Saint-Jean-Saverne (mid-twelfth century), among the rare examples to have come down to us in a well-preserved state, display a highly elaborate decoration. It combines circles, spirals, and rinceaux applied in high relief, recalling the technique of cloisonné, so popular in Celtic and barbarian gold work.

INFLUENCES FROM THE WEST

The network of influences that Alsace encountered has not yet given up all its mysteries. As with its architecture, its sculpture resulted from various influences. For Eschau and Andlau, there are two possible iconographic and stylistic sources, both Italian: one from Modena (Emilia), where the famous sculptor Wiligelmo created the beautiful decoration of the cathedral facade about 1120; the other from the old Lombard tradition, which had been omnipresent in northern Italy since the seventh century, enriched by an eastern influence in the form of precious objects that came by way of Venice, decorated with mixed animal and plant motifs. This Lombard style was slow to represent the human form, which it treated with a certain uneasiness. The relationship between Alsatian works and Italy does not necessarily mean they were made by Italian sculptors who came north; more likely, they seem to be the production of local

STAINED-GLASS WINDOW OF THE SEATED EMPEROR, KNOWN AS *CHARLE-MAGNE'S WINDOW,* FROM THE CATHEDRAL OF STRASBOURG, HEIGHT 9 FT. 2 IN. (2.8 M), C. 1200. MUSÉE DE L'OEUVRE NOTRE-DAME, STRASBOURG
Stained glass immediately suggests Gothic stained glass. The immediate origins of this art, however, are to be found in the Romanesque twelfth century, which had already mastered it and left a great deal of evidence of this fact.

artists who were sensitive to a strongly implanted Italian style.

The other influence that marks first Lorraine and then Alsace during the second half of the twelfth century comes from Burgundy, just beyond the frontiers, with which the region had had numerous contacts since the rise of Cluny's monastic influence. In the sculpture of the small churches of Lorraine, archaic local tradition and the imprint of Burgundian monasteries meet. At Pompierre, the church at the

STAINED GLASS

With Romanesque art a previously rarely used technique began to flower: stained glass, which throughout the Middle Ages maintained close ties with manuscript illumination and, from its inception, betrayed a Byzantine influence. Stained-glass windows made before the twelfth century have all disappeared; there are only a few remaining fragments left to show that even though pre-Romanesque stained glass existed, the new art developed after 1050 and competed with wall painting to the point of making it disappear. The Musée de l'Oeuvre Notre-Dame of Strasbourg preserves the famous head known as the Wissembourg Head*, of uncertain origin, considered the oldest figurative Romanesque glass found to date, perhaps executed about 1070 on white glass. The most spectacular of pictorial techniques, stained glass projects effects of multicolored light from on high. This light, which gives the illusion of precious stones, is associated with divine symbolism. The image in glass presented a vision that elevated the soul and showed it the path to salvation. The technique is complex, juxtaposing strong colors in a charged composition. In his twelfth-century treatise on various arts, the monk Theophilus described the various methods of blowing the glass, intentional variations in thickness, the art of cutting the sheets in many pieces like a mosaic, and how to set them in lead. Calculating the amount of color to add was the most delicate operation, since the colors do not absorb the same amount of light; blue transmits light while red retains it.*

edge of the road presents a simplified Christological cycle, with three registers on the tympanum of the portal, both the most interesting and the best preserved in the area, with finely executed voussoirs and embrasures. The humble church at Vomecourt-sur-Madon near Mirecourt, on the other hand, exhibits a much more archaic decor.

At the same time that Burgundian innovations made an impression in the architecture of the region, sculpture renewed its repertory, introducing more narrative cycles to the portals and capitals. The return to a classical stylistic grammar advocated by Cluny is clearly seen on the stylized Corinthian capitals at the cathedral of Saint-Dié, which, following the example of Sélestat, was highly influenced by Burgundy. The cathedral of Verdun boasts a lion portal that stands out from the whole of Lorraine sculpture, in spite of a somewhat heavy-handed execution. Christ and the tetramorph are surrounded by beautiful arches of acanthus leaves apparently made by the same hand. Mont-devant-Sassey, however, betrays the influence of Champagne.

Alsace's receptivity to the contributions of Cluny came about as a consequence of the Holy Roman Empire's defeat before papal authority. The classical elements by which it was accompanied permeate the sculpture of the cathedral of Basel, in Switzerland. Rebuilt in 1185, it is one of the last Romanesque building projects whose influence in Alsace up to the end of the century cannot be ignored.

Blessed by its geography, by the intensification of European commerce, by the dynasty of the Hohenstaufen that resulted from it, Alsace underwent a metamorphosis about 1170 that turned it into a region focused on its cities and merchants. The new artistic development took place in an urban setting rather than in the countryside. Made an imperial city in 1201, Strasbourg was visited by the emperors and prospered rapidly. In spite of this development, Gothic art did not make headway until the thirteenth century. The impact of the great building projects of Champagne and the Île-de-France led to the birth of a transitional style between Romanesque and Gothic that continued for a long time (until 1230), characterized by an increase in ribbed vaulting, pointed arches (introduced early from Burgundy), and the spread of sculpted portals. The sculpture strongly expresses the hybrid character of this period. While the allegorical Romanesque iconography persisted, with a certain clumsiness in the postures and gestures of the figures, the treatment of the drapery grew more supple as the plasticity of the forms evolved, influenced by the masterworks of the cathedrals, such as the tympanums of the churches of Eguisheim, Kaysersberg, and Guebwiller.

The Byzantine legacy has been suggested throughout this chapter, but it is most present in the arts of color. In the Carolingian and Ottonian periods, artists sought their models in Byzantine illumination and enlarged them to monumental decoration.

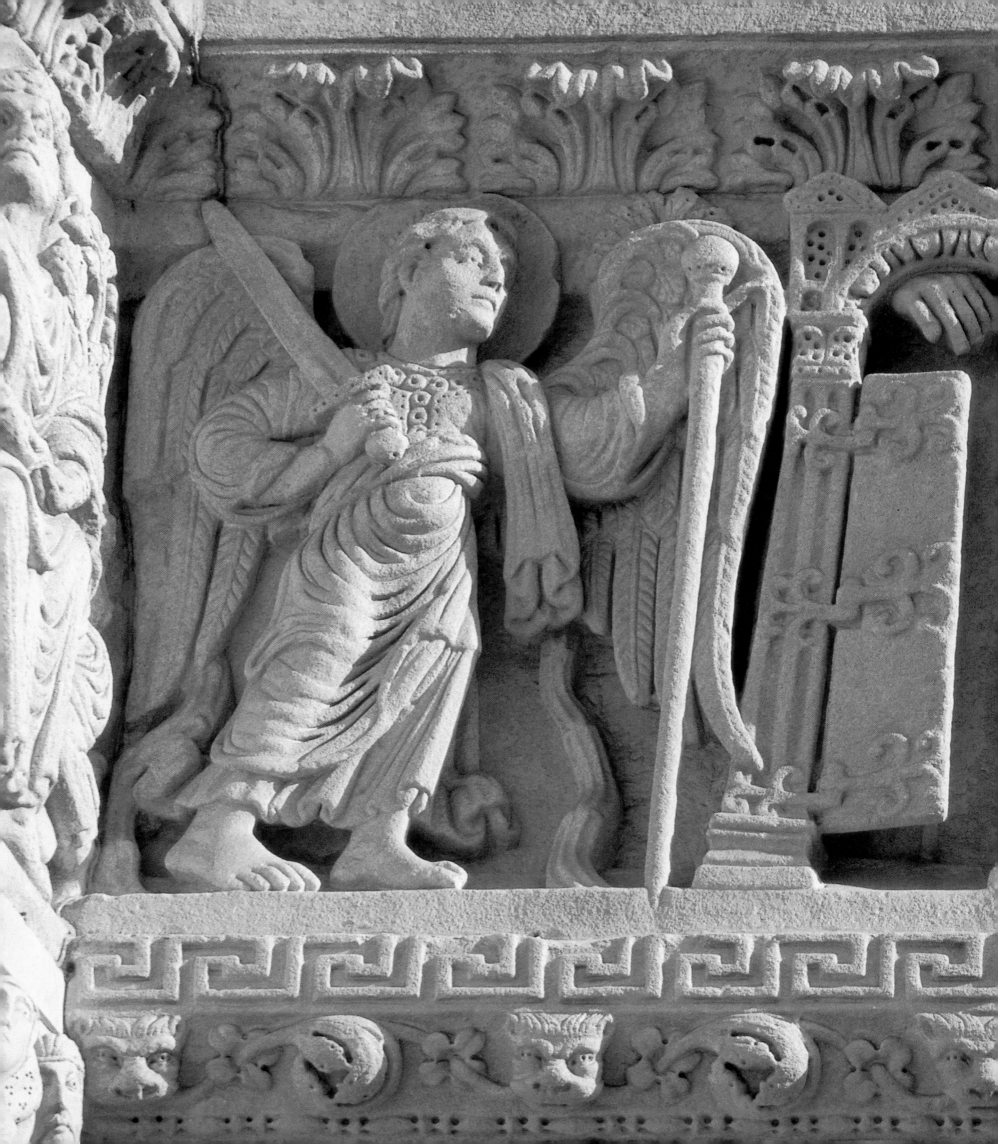

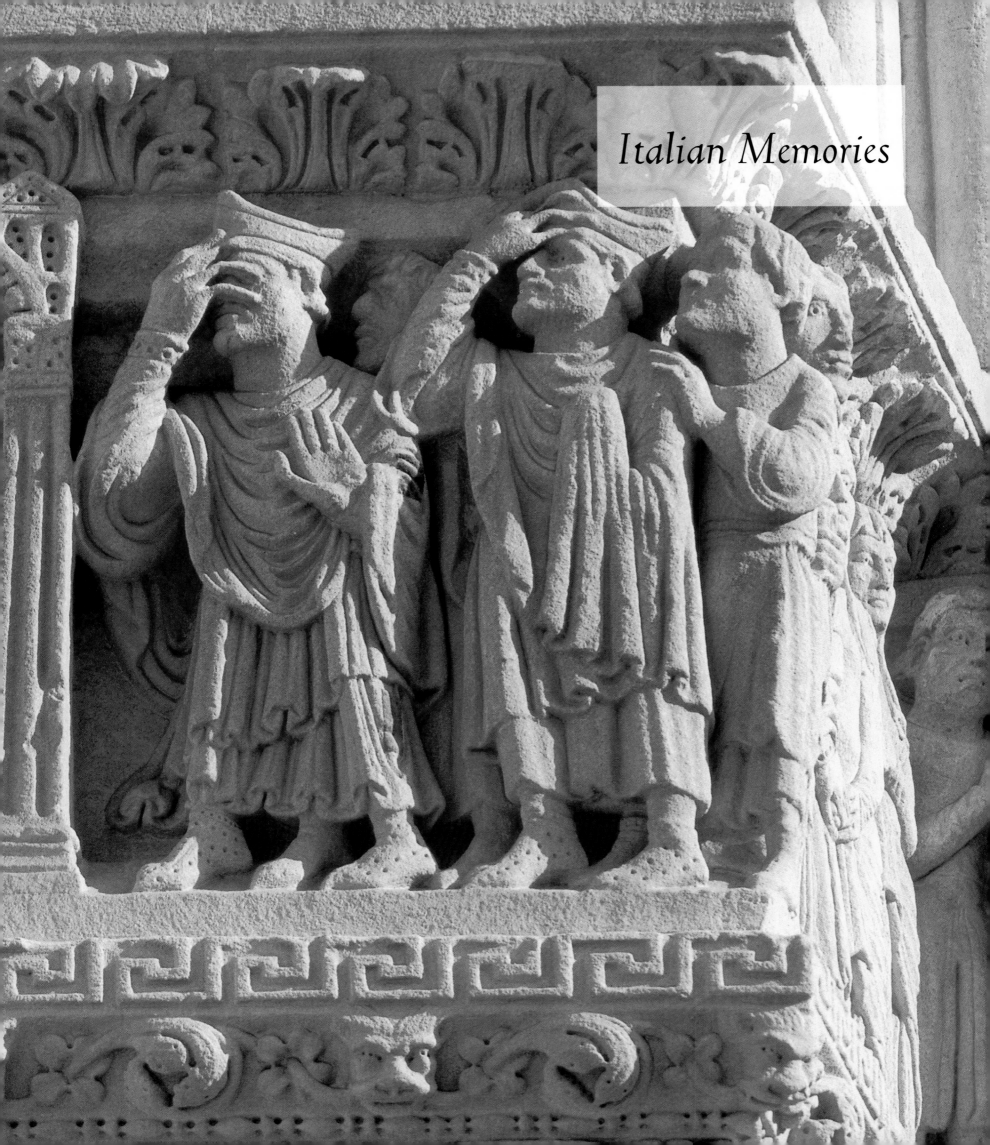

Giving onto the Mediterranean or turned to the Alps, devout or wild, accessible or hermetic, Provence is multiplicitous depending on whether it is married to the sea or the mountains. The region here considered corresponds, in the largest and ancient sense of the term, to Provençal territory as far as the Italian frontier.

On the eve of the year 1000, ambiguity already reigned over the name of the province, its borders, and its true masters. An ancient part of the vast kingdom of Burgundy-Provence, in 1033 it was attached to the Germanic Holy Roman Empire, to which it officially belonged until the thirteenth century. In reality, this distant authority had little effect on this large sphere of influence, whose western borders extended slightly beyond the Rhone River and whose eastern frontiers were based in Piedmont and Lombardy. In the Provence of the eleventh century—then ruled by a marquess—the names of twenty or so families, including such names as Fos, Marseille, and Baux, less and less subject to the counts, reflect the fragmentation of the coastal side into viscounties, which spread trouble and disorder.

At the same time, the foundation of the abbey of Montmajour in the tenth century and the renovation of the ancient Provençal monasteries of Saint-Victor in Marseilles and Lérins indicate the development of regional monasticism, whose influence would only increase.

Economic growth came about through the improvement of agriculture and trade, leading to the growth and emancipation of the cities, principally those favored by the proximity of the lower Rhone (Marseilles, Avignon, Arles, and Tarascon); the present-day region of the Var even at that time suffered a lag. The merchants of Pisa and Genoa who reigned over Mediterranean trade invested in the towns of the delta. Marseilles opened to the east as a port of departure to the Holy Lands for pilgrims and warriors embarking on the First Crusade.

In the twelfth century, in the absence of a male heir, the marquessate passed by the female side to the counts of Toulouse and those of Barcelona. By this division of 1125 Provence was fixed within the borders we know today: the west bank of the Rhone and the north bank of the Durance became possessions of the count of Toulouse, forming at that time another marquessate. The real beneficiaries were the Catalan counts, to whom went the territory that fell between the Rhone, the Durance, the Alps, and the sea, which officially became the county of Provence. During the Catalan period, Provence flourished in all respects. The towns, which became communes, were administered by consuls. The court, located at Aix-en-Provence by the end of the twelfth century, encouraged—as in Toulouse—troubadour poetry. Alfonso II (1152–1196), count of Provence, who became king of Aragon, did not spend much time in his capital, instead delegating his powers to Catalan and Aragonese representatives, known as *bailes,* who administered *baillies,* or bailiffships. This efficient system allowed the county to survive a period of major conflicts beginning in the thirteenth century—between the pope and the Holy Roman emperor, between Pisa and Genoa—and local guerrilla warfare against the houses of Baux, Forcalquier, and, especially, Saint-Giles, the counts of Toulouse.

In 1246 Charles of Anjou, brother of Saint Louis, wed the daughter of the count of Barcelona and became count of Provence. This was the beginning of Capetian domination.

MAN AND STONE

Despite vandalism and destruction, Provence is one of the regions in France richest in Romanesque architecture.

Here men knew how to build: we become aware, in reading the old stones drunk on sunshine, that the art of construction was entrusted to men of experience. The many masons' marks that we find, improperly called journeymen's marks, do not belong to this region alone. They have turned up in various regions, notably,

THE BRIDGE OF AVIGNON

In the Middle Ages the construction of a bridge was a major accomplishment, requiring considerable expense and many workers. The enterprise was such that the genesis of a medieval bridge, which had no lack of mishaps, was often tied to a legend. Such was the case of the bridge spanning two arms of the Rhone, 3,000 feet (900 meters) long, joining Avignon to Villeneuve. In 1177 Bénezet, a young priest from Vivarais, was led to the destined site of the bridge by an angel dressed as a pilgrim, who ordered him to build it. Rejected by the bishop, who suspected him of being an impostor, the young man nonetheless convinced the prelate and the people of his good faith by carrying enormous foundation stones on his shoulders. Volunteer workers as well as many gifts made possible its completion in eight years, as well as the creation of the Fraternity of Pontiff Brothers. In the Middle Ages the relics of the young saint, who died at the age of nineteen, were kept in a chapel dedicated to Saint Nicholas (patron saint of sailors) built into the second pier of the bridge, creating a pilgrimage site. The narrowness of the road bed (about 9 feet, or 2.5 meters) is not surprising. It permitted the passage of pedestrians and "standard" carts, although two vehicles could not pass each other.

Provence—from hard or soft limestone, sometimes supplemented with marble—are the descendants of local products of the late Roman Empire, whose remains, still numerous today, inspired Romanesque craftsmanship.

In the design of a building it is useful to remember, behind the noise of the tools, who had conceived the whole. When it was not a lay master builder, it was a man of the Church who filled the role. It is enough to contemplate the splendid recumbent statue of Abbot Isarn (1020–1047) in the crypt of the abbey of Saint-Victor at Marseilles to understand the aura of these builder-monks. Executed at a time when the abbey sought to increase its renown, this tomb is one of the very first Romanesque examples of funerary sculpture, reappearing after a long absence. The use of marble and the quality of its execution renew the ties with classical tradition. Contrasting with the importance of this "personalized" sarcophagus, intended to be displayed in the church, tombs in human form cut into the very rock of the abbey of Montmajour and its priory of Carluc are moving in their humility.

in Poitou, Alsace, and the Auvergne. The lapidary signs carved in the stones of Saint-Trophime in Arles, of the chapel of Val-des-Nymphes near La Garde-Adhémar, or of the abbey of Sénanque are movingly humble and enigmatic. Comparisons made of identical or similar signs among different churches indicate the itinerary of a workshop—often small—or the simultaneous contributions of a master to several construction sites. Thus, the path of one Ugo leads from Saint-Paul-Trois-Châteaux to Notre-Dame-d'Aubune and Saint-Restitut. These men carried on the ancestral tradition of fine stonework. The well-cut stones of the twelfth century in

THE REVIVAL OF CIVIL WORKS

Although a glittering array of religious buildings illustrates the surge in regional building, civil architecture in stone was rare, its testimony precious.

Some isolated examples of private dwellings in stone from the end of the twelfth and the beginning of the thirteenth centuries have survived in the southeast. The "Romanesque house" of Saint-Gilles-du-Gard, with its elongated facade, stands out for its

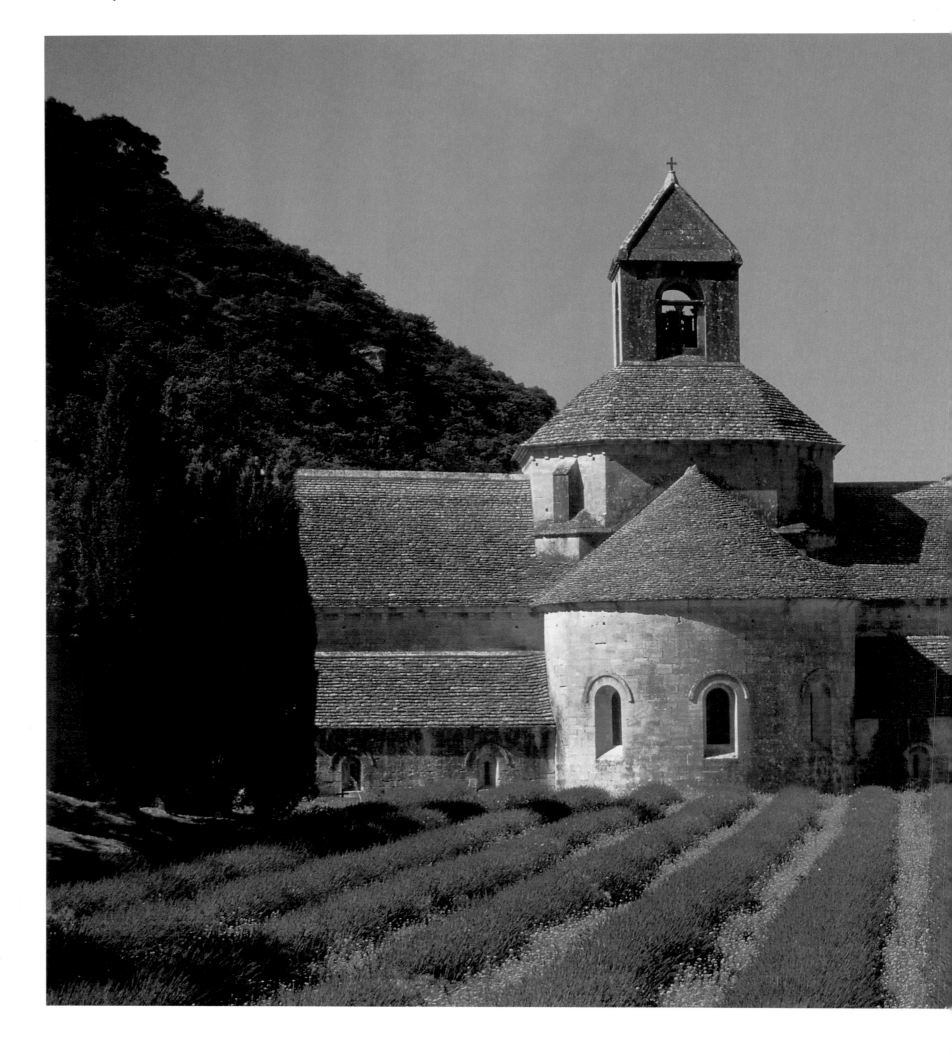

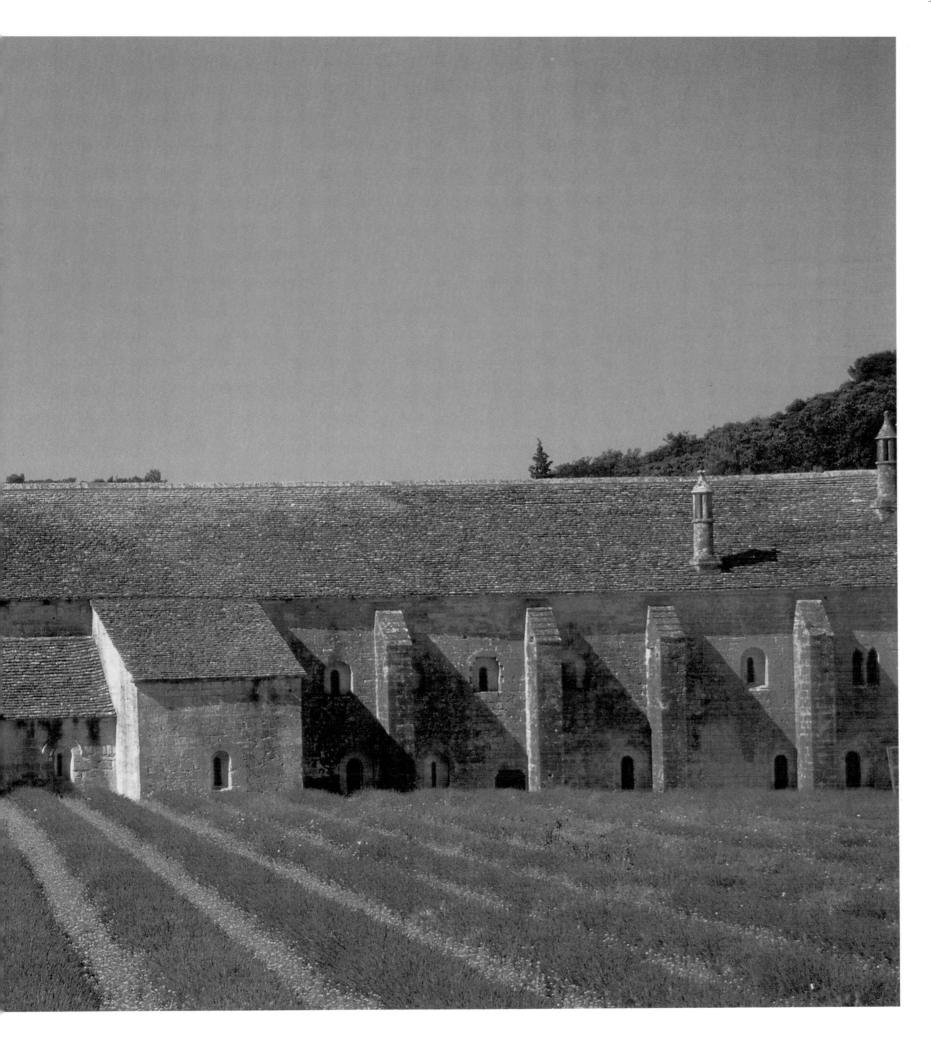

cornices supporting rectangular windows, less common in the region than semicircular arches. This city has preserved two other houses, both more disfigured, displaying the same characteristics of an almost windowless ground floor pierced with a vast portal—a sign of wealth in these urban dwellings—relegating the openings to the upper part of the structure. As in Languedoc or Germany they have the look of "house-towers," with carefully shaped stone masonry and vaulting in the upper floors. The Porchères tower at Saint-Michel-l'Observatoire, the Philippe tower at Lauris, and that of Saint-Christol-d'Albion are different from the houses of the merchants of Digne, Sisteron, Hyères, Brignoles, or Cluny in Burgundy. Some residences display a handsome sculpted decor, like one in the village of Simiane. This unusual building, the former keep of the château of the counts of the region, has a remarkable interior, organized on two levels with plank floors. On the upper story twelve radiating niches, separated by pilasters topped with capitals carved with foliage and grimacing heads, support a like number of ribs of the dome, itself pierced with a central oculus, which spreads light evenly to the space.

TRENDS AND TRADITIONS

Fed by the confluence of the great east-west and north-south thoroughfares, the Provençal Midi was able to develop a Romanesque style distinctive to the region which valued originality more than innovation. Throughout these three periods—the First Romanesque of the tenth and eleventh centuries, the High Romanesque of the mid-twelfth century, and finally the late Romanesque, which continued for an exceptionally long time, until about 1230—this land of passage was able to retain the lessons learned from

bordering regions, successive cultural traditions that have marked it, and brief trends that crossed it, thus creating a happy marriage of influences. This phenomenon, however, is not borne out in a homogeneous fashion throughout the province. There are two faces of the ancient Provençal Midi: one, western and fruitful, turned toward the sea, profited from the seashore and river traffic (delta of the lower Rhone, Durance valley); the other, more impenetrable, an interior Provence turned toward the mountains, poorer and more secretive.

In the pre-Romanesque period, Provence was bordered by two important spheres of influence: northern Italy and Catalonia. Art forms flowed from these areas through Roussillon and the Alpine passes. Curiously, they left no mark on lower Provence, which was less receptive to them. The almost complete lack of monuments from the First Romanesque in this part of the south is explained by the fact that in their penetration toward southern France, Italian trends traveled by way of the rivers, valleys, and Alpine passes. If we include among the early buildings those destroyed by the Saracens or rebuilt during the economic development of the twelfth century, we see that examples of religious architecture around the year 1000 are rare. On the other hand, many can be found in upper Provence, heir to Carolingian contributions and local Early Christian traditions that were firmly rooted in the mountains.

These churches characteristically have a simple plan, most often basilican, of modest dimensions and with massive walls built up of thick mortar and irregular courses. The most evocative remains are scattered throughout the middle Durance valley, between Manosque and Sisteron; the Saint-Donat chapel emerges solitary from a sea of vegetation near Montfort. Recently restored, it is impressive in the harmonious spareness of its very geometrically divided mass, which already reveals a specifically Provençal style of Romanesque building. Above its large central apse, flanked by two chapels, rises a wall with a setback upper portion. Since it is a pilgrimage chapel it has a transept, an extremely rare element in the region. The interior, as at Volonne, is composed of a central nave separated from the narrow aisles by round piers underpinning semicircular arcades. This area also preserves the two crypts with nave and aisles of Vilhosc and Saint-Geniez-du-Dromon.

Former priories for the most part, these churches were stationed along the defiles and narrow passes

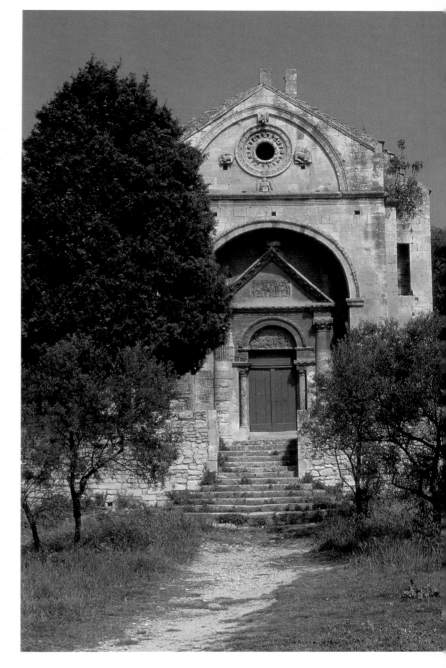

MARSEILLES, ABBEY CHURCH OF SAINT-VICTOR, CRYPT, SARCOPHAGUS OF ABBOT ISARN, MARBLE, SECOND HALF OF THE 11TH CENTURY
The effigy of the abbot, resting serenely as he awaits resurrection, is covered by a long epitaph, revealing only the head and bare feet. The face, shown fixed in eternal youth, was not intended to be a realistic portrait. Pilgrims came to venerate the idealized image of the abbot with his symbol, the pastoral staff.

SAINT-GABRIEL, CHAPEL, FACADE, 12TH CENTURY
Standing alone in its natural setting in Provence, the monument eloquently reveals a profusion of classicizing decoration.

leading to Italy or the northern Alps. The influence of Lombardy made its way to the French side and became established, at first slowly in the border regions, then more vigorously in the twelfth century. In interior and eastern Provence, it left its imprint on the articulation of walls in pilaster strips (Moustiers-Sainte-Marie, Peille, La Brigue, Senez), festooned decoration (Châteauneuf-de-Contes), and the nuances of color in the materials (Seyne). The last-named monument, from the end of the thirteenth century, illustrates the endurance of the "Romanesque style" of Provence and of the Lombard tradition in the mountain churches. Here and there shallow-relief sculpture survives; at the small chapel of Sainte-Croix in Montmajour of about 1170, a fretted frieze shows the abiding quality of southern pre-Romanesque sources. Some facades adopted the formula of the canopy-porch with marble columns supported by lions or telamones (columns carved in the form of a male figure), for instance, at the cathedrals of Digne and Embrun, which also used alternating white and black courses, a mode of decoration widespread in northern Italy and Tuscany.

THE CLASSICAL HERITAGE

Monasticism, in the primitive form of eremiticism, made an early appearance along the Mediterranean coast of France, which had early converted to Christianity. Provence harbored many anchorites; some of their former isolated shelters in "the desert" (Île Saint-Honorat), in caves, and other places used before the existence of priories still exist, as at Montmajour and Saint-Donat. With the arrival of Benedictine reforms, monks joined together in the communities known as monasteries, which flourished and participated in the economic growth of the twelfth century

in lower Provence. This was accompanied by the enrichment of cities, especially episcopal cities. Thus, the high point of the Romanesque was organized around several leading cities (Avignon, Aachen, Arles) and important abbeys (Montmajour, Saint-Victor in Marseilles). With little help from the feudal aristocracy, certain large building projects—including the abbey of Montmajour and the cathedral of Saint-Paul-Trois-Châteaux—were never finished, in spite of the efforts of the church. However, Provence's ideal position along the routes of three principal pilgrimages in the Christian world generated the gifts necessary for an architectural flowering, as pilgrims stopped to venerate the local saints, such as Saint Trophime in Arles, Saint Gilles in the city of the same name—then a seaport—or

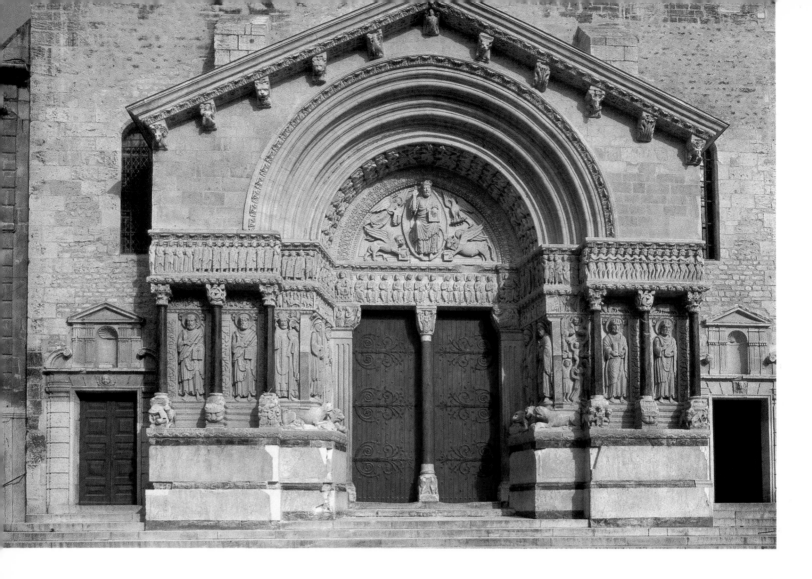

*ARLES, CHURCH OF
SAINT-TROPHIME,
FACADE, SECOND HALF
OF THE 12TH CENTURY
The sculpted facades of
Saint-Trophime and
Saint-Gilles-du-Gard are
the most important in
Provence. The principal
portal, conceived as a
Roman triumphal arch—
recalling that of Saint-
Rémy-de-Provence—is
flanked by two much
smaller doors also orga-
nized in an antiquarian
spirit, capped with
pedimented niches. The
iconography is drawn
from the Last Judgment.
A Christ in Majesty,
surrounded with the
tetramorph (the symbols
of the four Evangelists),
towers above the
Apostles, the elect, and
the damned, forming a
long frieze reminiscent
of classical entablatures.
The hieratic figures in
the niches between the
columns evoke Roman
statuary, the columns
resembling those of a
temple peristyle.*

local cults of Mary. Montmajour, once surrounded by water, was able to drain its marshes with the profits from a religious festival that it organized every year.

The second Romanesque phase in Provence is marked by the felicitous combination of local traditions and the heritage of Roman antiquity. The latter is ubiquitous, not only as an influence but also in the reuse of building materials, as in the chapel of Saint-Maximin in Riez and at Brignoles. The former cathedral of Vaison-la-Romaine utilized ancient marble columns, pieces of sculptures incorporated into the walls, and fluted pilasters on the chevet; at Châteauneuf-de-Contes, an ancient inscription is set into the facade. In the church of Saint-Raphaël, an ancient pagan altar supports the present altar table; in Arles, at Saint-Trophime, ancient Early Christian sarcophagi serve as an altar. Above all, Romanesque artisans incorporated the lessons of the Gallo-Roman monuments still in place (some of which have come down to us). They refined their stonework, replaced timber-frame roofs with barrel vaulting and domes, adopted the use of pediments, entablatures, and oculi, and reproduced faithfully the ancient decorative grammar, with its repertory of ovolos, beads, hoops, palmettos and rinceaux, roses and acanthus leaves, Ionic and Corinthian capitals. The churches of Carpentras, Saint-Restitut, Saint-Gabriel, Notre-Dame of Val-des-Nymphes, Sisteron, Notre-Dame of Salagon, Saint-Trophime in Arles, and Saint-Gilles-du-Gard marvelously illustrate the apotheosis of this antique style. The facade of Saint-Gilles (from about 1200), pierced by three arched portals, unmistakably evokes a Roman triumphal arch; its colonnade in facade recalls the porticoes and stages of Roman theaters; and its majestic statues wrapped with beautiful drapery recall pagan sculptures in the round.

Far from taking the form of a servile imitation, the revival of this tradition brought about a rethinking of the very conception of the religious building. The quest for balance and harmonious proportions displayed by Roman architects led the Romanesque master builders to control technical difficulties by masking them under an extreme simplicity of forms. Thus, they resolved the problem of the semicircular barrel vault, whose weight endangered the stability of walls and could even lead to their collapse (Val-des-Nymphes), by increasing their thickness, limiting their height, and adding exterior buttresses. The pointed barrel vault, employed in Saint-Trophime in Arles,

MOSAIC FLOORS

⬤

Widely used in Romanesque art, mosaic floors began as a particular feature of Provence and the lower Rhone, then spread to many regions of Romanesque France. This technique, employed to finish the most sacred parts of the buildings (transepts and apses), traditionally juxtaposed squares of stone or marble (tesserae) according to a prepared design in a ground of plaster grout. While mosaics have a limited chromatic range (red, ocher, white, black), their style is mixed with Mediterranean elements and the legacy of barbarian ornamentalism, influenced by the personal style of the artisans who made up the mosaic team. Stylization is appropriate to the medium, with the accentuated linearity of its shapes, an attribute of the monumental pictorial arts.

Far from being simply decorative, these large floor mosaics convey theological messages. They might illustrate sacred texts as well as hagiographic narratives, encyclopedic books of natural history and legendary geography, or epic literature drawn from courtly poetry. Sacred and profane mix in the form of characters and animals, real and fantastic, which populate a surrealistic Romanesque vision of the world.

In the priory church of Ganagobie, the transept and the three apses are liberally covered with a program of floor mosaics whose creation dates to after 1135. The mosaic panels imitate superposed carpets, and the rectangular borders, richly decorated with interlacings, frame representations of familiar, exotic, and fantastic animals, drawn from the collections of bestiaries. These hybrid monsters reflect the evil that inhabits the world; chimeras, Sirens, harpies, griffins, and satyrs are associated with the Devil and must be struck down. The asymmetry of the compositions, grimacing faces, and contorted bodies animate the whole with an astonishingly anarchic movement.

GANAGOBIE, PRIORY CHURCH, DETAIL OF FLOOR MOSAIC, C. 1140 *This knight striking down the dragon personifies the moral struggle between good and evil, less in the style of a* psychomachia *than that of a crusade or a medieval verse epic. The slayer of the great serpent could very well be Saint George, whose cult originated in the East and spread to the West by way of the Crusades. The buckler here appears as a halo, and the lance as the instrument of the justice of God. The liveliness of the colors and composition, the surrealistic character of the beast, and the rich framed motifs reveal the transposition of Eastern textiles to mosaic.*

Notre-Dame-des-Doms in Avignon, Digne, the former cathedral of Forcalquier, and the priory of Ganagobie, proved more stable; it rested on pilasters or, in upper Provence, on tall engaged columns, as in Sault.

At Montmajour the architects compensated for the slope of the rock by building the abbey church on a lower-level crypt ending in an ambulatory with radiating chapels. This system was not retained in the upper church, where, in a search for balance and elegance, the sanctuary offers a double profile, semicircular in the interior and forming a polygon on the exterior, its sharp angles fulfilling the role of buttresses with more purity. The upper church of Montmajour, with its aisleless nave and simple apse, punctuated with arcades on colonnettes, presents the quintessential image of the Provençal Romanesque from the mid-twelfth century. Aisles figure in only a dozen or so monuments, including Saint-Paul-Trois-Châteaux, Sisteron, Saint-Trophime in Arles, Hyères, and Orange. Some of these are so narrow (little more than three feet wide) that they look more like corridors. The apse is generally semicircular.

Polygonal apses are another adaptation from Roman architecture. The idea of an apse with differ-

ent profiles on the interior and exterior, besides at Montmajour, was repeated at Notre-Dame in Cavaillon and at Lagrand, where a pentagon is inscribed in a triangular chevet of the same form as that of Saint-Quenin in Vaison.

Some plans may have originated farther east than Rome, perhaps imported by the Crusades. The central plans common to Byzantine architecture show up in octagonal and trefoil form respectively at La Trinité and Saint-Sauveur on the isle of Saint-Honorat and in tetrafoil form at Saint-Crois in Montmajour.

SOUTHERN INFLUENCES

Through the rise of Cluny III and the appearance of new Gothic building projects in the second half of the twelfth century, echoes from Burgundy and the Île-de-France changed the look of some Provençal churches. The transept made its appearance, in Montmajour and Saint-Gilles, as did the ambulatory. The idea of the triple western portal, which replaced an older portal in the facade of Saint-Gilles, also came from the great Burgundian abbey, itself strongly influenced by the classical revival. The rib vaults that here cover the immense crypt, 165 feet, or 50 meters, long—at the time, Saint-Gilles was the fourth leading pilgrimage site of the Christian world—also rise up over the high single nave of the church of Thor from about 1200, bolstered on the exterior by thick buttresses.

Provençal Romanesque's openness to other influences at the very end of the twelfth century is manifested still more in the high-relief statues interspersed among the two most important sculpted groups in the southeast. The sculptures of Saint-Gilles, whose dating is controversial (about 1190), were executed by many hands and acquired their elegant proportions from Roman sculpture in the round. But while the suppleness of the drapery of some among them recalls ancient statuary, others that display more vigorous lines point to Burgundy. At Saint-Trophime in Arles a large central portal belongs to the same family as those of Saint-Gilles, its arches adorned with a rich classical ornamental grammar and its lintel extended by an architrave treated as a narrative frieze. The statues with their majestic frontality, beneath an elevated peristyle, frame a Christ in Glory and a tetramorph of refined modeling. In spite of their late dates, these groups do not mark a final phase of Provençal Romanesque decora-

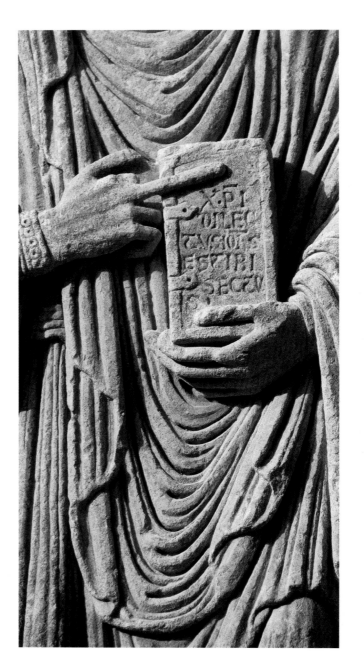

tion but a pause. In fact, they did not attract a following; nearby regions affirmed their own artistic personalities, Provence constituting only one expression of the southern Romanesque among many.

Despite the quality exhibited by the art of relief in Provençal churches, it is above all else the noble simplicity of their appearance that lends them their beauty. At Montmajour this simplicity borders on austerity; the lines and masses of the abbey clinging to its rock are organized in a pure geometry that the painter Paul Cézanne would have appreciated. Cistercian art found fertile ground in the region in its quest for sobriety; the three principal abbeys, Sénanque, Silvacane, and Le Thoronet, called the three "sisters" because of their similarity, in their turn exerted a considerable influence on the purity and the rigor of the Provençal Romanesque.

ARLES, CHURCH OF SAINT-TROPHIME, DETAIL OF THE NORTH EMBRASURE DEPICTING SAINT JOHN, SECOND HALF OF THE 12TH CENTURY
The hieratic figures of the Apostles, including this figure of Saint John holding his Gospel, and draped nobles represent the Romanesque memory of an antiquity that the Middle Ages never entirely forgot.

SAINT-GILLES-DU-
GARD, ABBEY CHURCH
OF SAINT-GILLES,
DETAIL OF THE
FACADE, SECOND HALF
OF THE 12TH CENTURY
*In this scene of Jesus
washing the feet of
an Apostle, the latter
expresses his surprise by
pointing two fingers at
his own forehead. The
identical gesture can be
found in Early Christian
sarcophagi, which may
have served as a model.*

LE THORONET,
MONASTERY, PAVILION
OF THE FOUNTAIN
*The monks' lavabo is a
handsome round basin
pierced with spouts,
which pour water into a
larger basin meant to be
used for the ablutions of
the brothers before they
entered the church. The
purifying gesture was
accompanied by a prayer
that begins with the word*
lavabo *(I shall wash).*

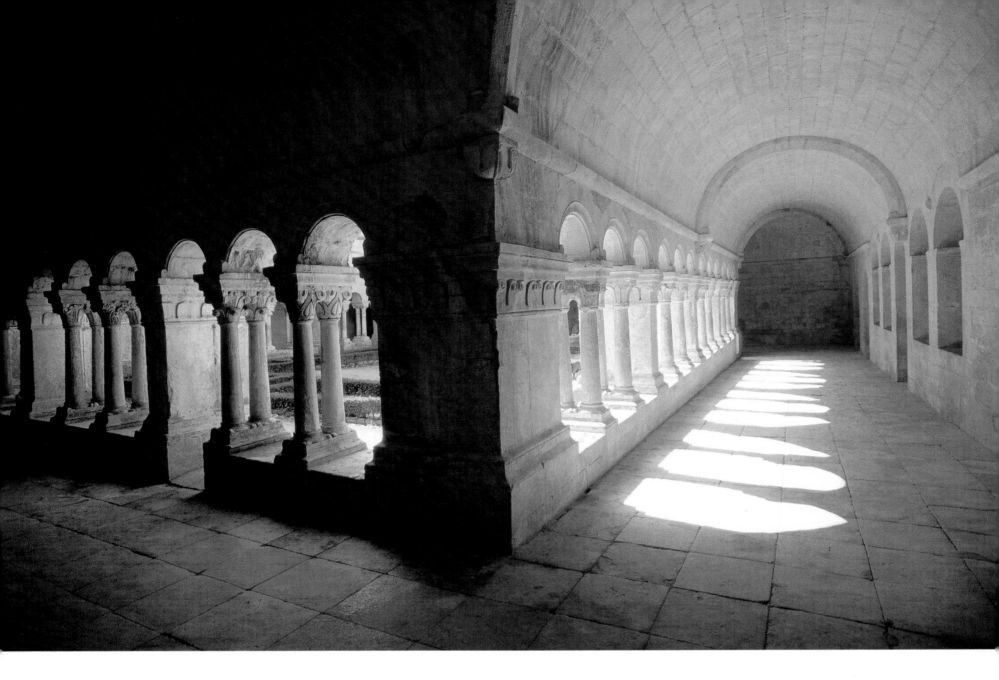

SÉNANQUE,
ABBEY, CLOISTER,
13TH CENTURY
*The cloister—"enclo-
sure"—formed the
heart of the medieval
monastery, the site for a
part of communal reli-
gious life. Built against
the church, it was a
place of silence, of light,
of cool air; there the
monks read, meditated,
and prayed. Surrounding
a garden, the four gal-
leries each established a
time distinct from con-
ventual time: prayer,
dormitory, refectory,
services, following a
rigorously established
order.*

Linked to the architectural guidelines of the rule of Cîteaux, they nonetheless revealed a certain flexibility toward local influences, seen in the presence of a bell tower, the form of the chevet—not flat-backed, as at Fontenay in Burgundy, but furnished with chapels—or the orientation, as at Le Thoronet, which faces north. Always on the cutting edge of architectonic experiments, the Cistercian master builders borrowed various styles of vaulting: continuous barrel vaults, then pointed barrel vaults, and, finally, rib vaults, for Le Thoronet's chapter hall and small pavilion of the fountain.

TOWERS, BELL TOWERS, AND KEEPS

By erecting a bell tower, the Cistercian abbeys of Provence were simply following a Provençal custom. The bell tower most often took the form of a square tower pierced with bays. A more elaborate version is found at Notre-Dame-d'Aubune, with the moderate addition of classical pilasters and fluted colonnettes. The campanile of the church of Sainte-Marie in Moustiers, beyond its decoration with Lombard bands, alternates double and twin bays on three stories. The tower in Uzès, called the Fenestrelle Tower—the sole remaining trace of the former Romanesque cathedral—is round and composed of ten gradually setback stories; the most beautiful of the towers in the southeast, it is a type that is unique in France, doubtless inspired by Tuscan campaniles. Provence's crossing towers are generally set on a dome. That of Notre-Dame-des-Doms in Avignon is an octagonal, ribbed dome-lantern on squinches. Since the crossing is a narrow rectangle, as in Auvergne, the transition to the square plan is made by a series of arches in corbeled construction. This popular formula was later supplanted by the cloister arch or the light rib vault, as in Montmajour.

The former fortified monastery of Saint-Honorat

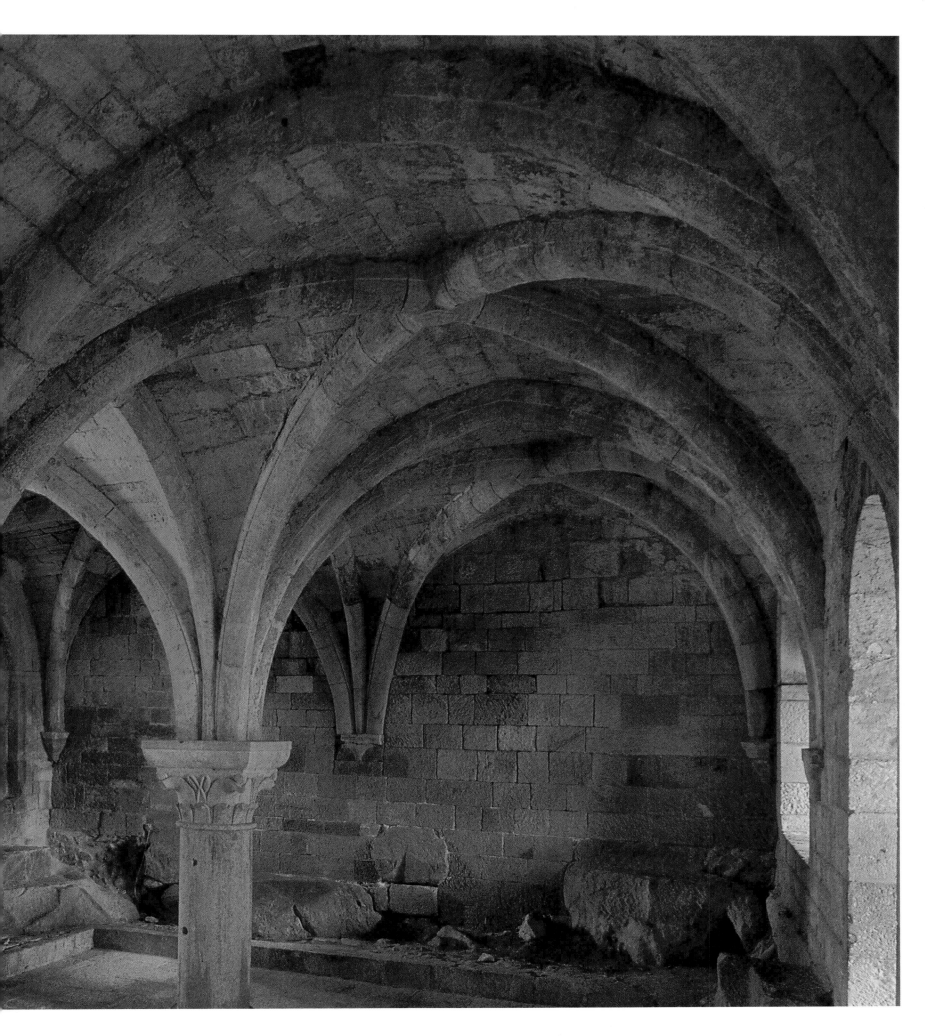

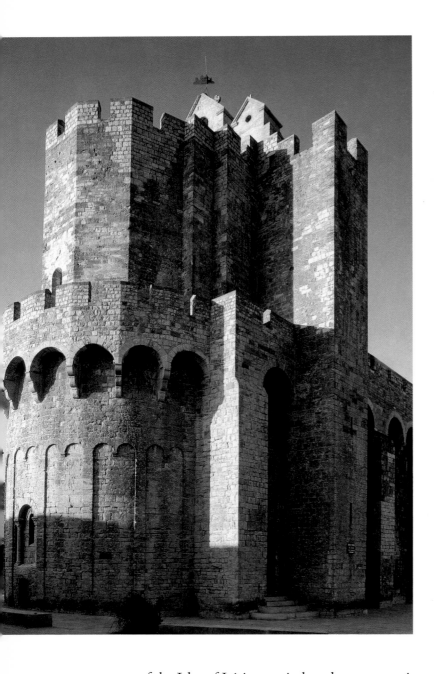

Salome, Mary Jacob, and their servant Sarah, who are still the object of an important pilgrimage by the Gypsies. A high chapel is enclosed in the keep.

LANDS OF THE RHONE AND THE ALPS

The France of Romanesque times did not have the hexagonal shape that it has today. On the maps of the eve of the year 1000 its territory is cut off sharply to the east of the Massif Central, facing the kingdom of Burgundy, the puppet kingdom ruled by the Rodolphian dynasty, from the name of three of its kings. "Ruled": the word does not reflect the reality of this fragmented country, whose "capital" moved between Vienne, Aix-les-Bains, Basel, and the powerful abbey of Saint-Maurice in Agaune, in the present-day Swiss Valais. As for the kings, whose title itself varied, they abandoned their rights and their fiefs to the families of growing authority (the Guigues in Dauphiné, the Humberts in Savoy—the real architects of the area), to the monasteries, and, especially, to the bishops who exercised an incontestable temporal power at Basel, Vienne, Lyons, Valence, Grenoble, and Viviers. The kingdom of Burgundy died in 1033, incorporated into the Germanic Holy Roman Empire. The Saône and the Rhone give a general idea of its western limits, although they were not actually frontiers; rather, they bear witness to such political aberrations as a "French" Velay caught between Vivier and Forez, both "German." The Holy Roman Empire wielded no more control than the former "kings" of Burgundy, as central power was far off and had little connection with the political landscape of the region, which was only, as far as the empire was concerned, a minor borderland.

Feudal society in this area evolved more strongly than it did beyond the Rhine. The strength of the prelates—invested by the sovereign—compensated for the deficiency of central power; in principle, they governed the episcopal cities, whose prestige went back to the beginnings of Christianity. The archbishop of Lyons, the primate of Gaul, proclaimed himself count and formed, with his canons, a sort of religious aristocracy. The kingdom of Vienne experienced a glorious period under the ministry of Guy of Burgundy, the future Pope Calixtus II (r. 1119–24). Meanwhile, the bishops of Viviers became the masters of an enormous domain on the right bank of the Rhone, coveted by the counts of Toulouse, whose lands were on the southern borders.

Paralleling the religious principalities were the

on one of the Isles of Lérins reminds us how traumatic the raids of the Magyars and the Saracens were in the eleventh century. Fearing the return of the latter, this monastery of ancient foundation, which in normal times spread over the island, decided to fortify itself in 1073 because of its exposed position on the shore. The enormous Romanesque "keep," three of whose walls bathe their feet in the sea, contained all the components of a monastery of refuge: a cellar for food, a cloister under the open sky with a Roman cistern designed to collect rainwater, a chapel that served as a strong room for relics. Many of the churches located on the fringes of the French Mediterranean were fortified for the same reasons, at the time of their construction or later. The twelfth-century church of Saintes-Maries-de-la-Mer in the heart of La Camargue is a veritable fortress, accented with Lombard bands linking the buttresses that support a parapet walk. The aisleless interior is elevated in the choir by a crypt where lay the relics of the holy women who followed Christ: Mary

LES SAINTES-MARIES-DE-LA-MER, CHURCH OF NOTRE-DAME-DE-LA-MER, CHEVET SEEN FROM THE NORTHEAST, FIRST HALF OF THE 12TH, 13TH, AND 14TH CENTURIES
Conceived as a modest design, the edifice from the beginning had a nave without aisles and an apsidal choir. As in many Provençal churches, the entrance faced south, to offer protection from the mistral, while the west facade remained windowless. Faced with the threat of a Muslim invasion, the religious community built ramparts and reinforced its military vocation within the confines of Languedoc and Provence. The marshy island of La Camargue, on the other hand, began to empty of inhabitants in the face of the advance of sea and salt. The small town regrouped itself around its church-refuge and later prospered as a stop on the pilgrimage route to Compostela. During the Gothic period the building was fortified and equipped with a keep, turning its chevet into a hermetic prow.

Preceding pages
LE THORONET, RIB VAULTS OF THE CHAPTER HALL, LATE 12TH CENTURY

large lay principalities. On the left bank of the middle Rhone the counts of Albon, established to the west of Vercors, extended their possessions to Grésivaudan, Champsaur, and Briançonnais, that is, the territory extending from the Rhone to the Alps, which would be called Dauphiné. In the twelfth century Guigues IV was the first lord of the region to be named Dolphin. Given a French spelling (Dauphin) a few years later, the name eventually became attached to the heirs to the French throne *(dauphin)*. In spite of this expansion, the counts of Albon were at that time only the vassals of the ecclesiastical princes. They also had rivals in the counts of Savoy, whose lands, from Vienne to Grenoble, formed an irritating enclave within theirs. In reality, the authority of these families of counts lay only in the prestige linked to the size of their holdings. Many feudal lords gained their independence from the counts and carried out their own judicial and military proceedings; thus, the Bocsorels, Faucignys, and Aynards in Savoy and the Bardonèches in the eastern Alps were the holdings of common lords, often interdependent, who fragmented the territory's integrity even more. Because of its strategic role of watchdog at the gates to the Alps, however, the county of Savoy managed to preserve its autonomy from the crown of France for nine centuries.

Using roads cut by the Romans, Christians appeared early in these mountainous lands and organized the first dioceses around Geneva, Grenoble, Belley, Die, Gap, and Embrun. As everywhere else, the decline in the morals of the nonmonastic clergy led to a reform emanating from the order of Cluny to combat especially the buying and selling of Church offices (simony) and living in a state of concubinage or marriage. The orders of Cîteaux and of the Carthusians, founded in 1084 by Saint Bruno, introduced invaluable contributions to the reestablishment of discipline. The Grande Chartreuse, the motherhouse of the Carthusian order, established a cenobitic monasticism in the wooded wilderness of the massif that bears its name, where it took root in spite of such disasters as an avalanche that crushed the abbey in 1132. The order of the Antonins, founded at the end of the eleventh century, was well established in Dauphiné, where its various outposts came to the aid of travelers and the sick.

RULES AND MYSTERIES OF VARIETY

The middle Rhine and Dauphiné welcomed Romanesque forms, which they used as a basis for further

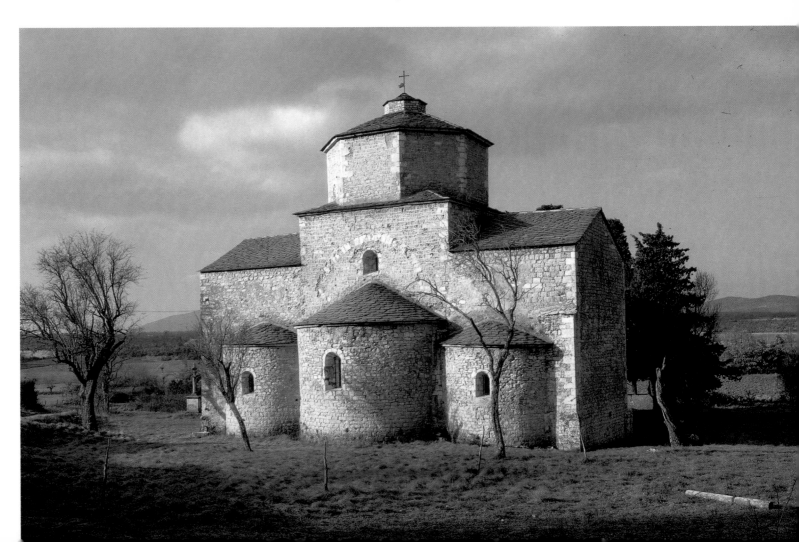

SAINT-MARTIN-D'AINAY

●

Its problems of relationships and dates concerning both architecture and sculpture make the basilica of Saint-Martin-d'Ainay one of the most fascinating monuments in France. Consecrated in 1107, it displays elements stylistically very different from each other, underlining the crossroads position of the ancient region of Lyonnais. Its famous porch with bell tower is an eloquent synthesis, with its three levels articulated by a projecting stringcourse and decorated with bichromatic lozenge inlays reminiscent of Auvergne and Velay and its sculpted cartouches incorporated into the walls in friezes in a pre-Romanesque formulation. The original decoration of the apses with completely decorated pilasters suggests comparison as much with antiquity as with the Carolingian tradition, or with the sculpture of Brionne and even the sculpted altar border by Gilduin at Saint-Sernin in Toulouse.

development. Their churches, located far from towns and major roads, were small and sturdy. Churches become more numerous near the Rhone, and the artistic trends of the neighboring areas are concentrated in them. The great river thoroughfare brought together the Ottonian heritage and Provençal and Burgundian influences. Auvergne and Velay were affected by this play of influences in the immediate neighborhood of its banks; the contributions of the Lombard First Romanesque also filtered in through the Alps.

Traveling through the regions that border the Rhone corridor, various aspects of their multiform monuments can be observed. Across from Tricastin, mentioned above (Saint-Restitut, Saint-Paul-Trois-Châteaux), west of the Rhone, stretches lower Vivarais, containing the Ardèche and Cévennes Mountains. Its schist churches reflect elements of the Provençal style. Vinezac, in the land of silver mines, features a tall, polygonal apse; Bourg-Saint-Andéol has Lombard bands; the chapel of Saint-Sulpice displays a Mediterranean whiteness. Further west, Saint-Jean-de-Pourchasse and Payzac recall upper Auvergne with their distinctive rectangular bell towers, while Thines is surprising in the novelty of its two-colored apse, clearly influenced by the style of Velay. Set amid the rocky slopes of Vivarais, the former abbey church of Cruas is a structure of some originality, dating mostly from the eleventh and twelfth centuries, of mixed stylistic sources. It exhibits a rare enlarged monastic gallery over the nave, enhanced during a recent restoration.

In the area of middle Rhone, the important sculpted iconographic program of the cathedral of Saint-Barnard de Romans is at the crossroads of the classicizing tendencies of Provence and Burgundian trends, conveyed by the workshops of Lyons and the

cathedral of Saint-Maurice in Vienne. Essentially Gothic, although it was begun during the twelfth century, this cathedral has a majestic nave, Romanesque on its first level, with fluted pilasters lacking capitals and spiral fluted columns characteristic of the Cluny style. The sculpture of Vienne exhibits complex interactions of styles and influences. The capitals of the cathedral and those of the church of Saint-André-le-Bas are among the most beautiful in France; they demonstrate the activity of highly skilled workshops and the refined interpretation of classical architecture through the art of Cluny III. Those of the vast cathedral of Valence also provide a glimpse of local production.

Saint-Pierre in Champagne, located on the road to Vienne, caught the fringes of the trends that traveled up and down the Rhone valley. A pilgrimage church with galleries, it is covered with five octagonal cloister vaults over cross arches, similar to those of Notre-Dame in Puy-en-Velay. They are unique in that, with the exception of the first, they each cover two bays. Each rests on powerful diaphragm arches pierced with three-lobed clerestories. The other idiosyncrasy lies in the hidden upper hall above the dome of the transept, accessible by means of narrow passages in the thickness of the walls. At Lyons, the oldest portions of the primatial church of Saint-Jean derive from the late Burgundian Romanesque. The apse, with its fluted pilasters and its triforium, bears witness to this connection, while the absence of an ambulatory is peculiar to the churches of Lyons. To the right of the facade, the choir school from the twelfth century preserves a beauti-

VIENNE, CATHEDRAL OF SAINT-MAURICE, CAPITAL, EARLY 12TH CENTURY
The abundant vegetative decoration of this Corinthian capital subtly attests to the survival of the traditions of antiquity in the Vienne area.

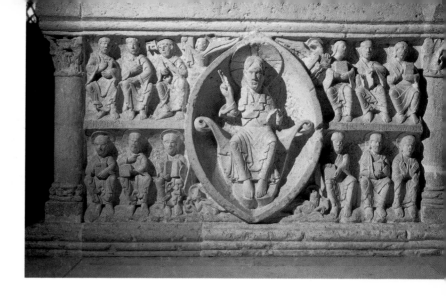

ful Romanesque structure with its arcade with colonnettes and its niches filled with figures.

OVER HILL AND DALE

The regions around Lyons are rich in small rural churches. To the west, the hills and plain of Forez, through which the Loire flows, is sprinkled with well-constructed buildings, although their exterior aspect seems simple, even archaic, such as Saint-Maurice-sur-Loire, with its flat-backed apse, and Saint-Romaine-le-Puy, with its reticulated stonework and crudely decorated frieze. The bell towers are more noteworthy, as at Saint-Rambert-sur-Loire, with its miter arches from the Auvergne. The latter's influence also made itself felt inside the church of Champdieu, while that of Rozier-Côtes-d'Aurec is ornamented with arcades on pilasters that are typical of Rhone valley churches. Architectural subtleties can be seen in Saint-Rambert, where the arcades of the nave become larger toward the choir to increase the perspective, and in Pommiers and Chamalières, on the borders of Velay, where oculi recessed into the masonry act as an acoustic vessel.

In Beaujolais, where vines and the Beaujeu family prospered during the Romanesque period, proximity to Burgundy changed the emphasis to finely sculpted portals, exemplified by Belleville and Salles-Arbuissonnas; the bell towers with pyramidal roofs are characteristic of the area. The church of Avenas contains a famous altar from the twelfth century, sculpted for its small monastery located on the well-traveled Lyons-Beaujeu-Cluny-Autun road. This handsome piece of ecclesiastical furniture and the valuable altar of green marble belonging to Clery in the Alps near Taranto as well were designed to draw attention to the most sacred part of the church, where the Eucharist is celebrated. The churches of the Dombes form a very homogeneous little group. The facade of Saint-Paul-de-Varax features a curious frieze that retells the life of Saint Paul and the Last Judgment.

Two notable groups of wall paintings can be found east of Lyons. At the abbey of Saint-Chef in Dauphiné, pilgrims came to venerate the "*chef*" (head) of Saint Theudère. In the northern arm of the transept is nestled a chapel overlooking the choir and dedicated to the cult of the archangels and the martyr Saint George. The painted decoration found there, of modest dimensions, is among the most interesting in the region. The iconographic program, consistent and complete, illustrates a vision of the heavenly Jerusalem.

Overlooking the French shores of Lake Leman, the château of Allinges has preserved a castral chapel with paintings in its apse that date to about 1070, like those of Saint-Chef. They reflect the influence of Ottonian pictorial art from the important Germanic abbey of Reichenau, on Lake Constance. The Christ in Majesty, surrounded by the tetramorph, seraphim, the Virgin, and Saint John the Baptist, illustrates the Byzantine style imported by the Holy Roman Empire. Its influence is particularly noticeable in the beautiful Greek that frames the personification of the four Virtues. Very different from the depiction at Saint-Chef, Paradise here is represented more simply in the Byzantine style by small flowering shrubs.

The most important monument in Savoy is the powerful church of Saint-Martin of Aime in Tarentaise. The rusticity of its river-stone masonry laid in a herringbone pattern, a gallery of niches that punctuates its apse, and the principle of the transept in the form of the Greek letter tau, with its two facing square towers, make this former basilica, consecrated in 1019, a good example of the churches of the Alpine First Romanesque, the result of the circulation of Lombard models along the Rhone and the Rhine. Ancient milestones on the pilgrimage roads that climbed to the passes of Petit-Saint-Bernard and Mont-Cenis, these mountain sanctuaries often have crypts, as at Saint-Jean-de-Maurienne, where excavation revealed the imposing dimensions of the primitive building and its early capitals. Above the valley of Chambéry the crypt of Lémenc encloses a curious hexagonal building covered with a hemispherical calotte, or flattened dome, carried by six columns that rest on a low wall surrounding a hollow recess; an ambulatory completes the roundness of the whole. It probably served as a baptismal church. In this region devastated by the Saracens, repopulation and conver-

sion, both priorities at the end of the tenth century, explain the hasty construction of this late baptistery.

THE TAMED ISLAND

In the tumultuous history of Corsica, Romanesque art unfolded during a brief period of calm, reflecting the renewal of the Church on the island. The monuments that date from this time, formerly counted in the hundreds, today number only a few dozen, of which half are in ruins. The small size of this architectural heritage does not detract from its extreme beauty, emphasized by the variety of the landscape.

During the early Middle Ages in Corsica, which followed a flourishing Roman occupation, no legitimate authority managed to establish a foothold, even under the Frankish empire. For the Saracens who plundered the island early on, its shores served as strategic landmarks for their pirate raids on Italian Liguria or the French coast rather than lands to colonize. Freed from the Saracens, Corsica found itself embroiled in the disputes between the pope, its suzerain, and the German emperor, each pressing claims on the peninsula. The object of complex rivalries, the island was later juggled among three Italian powers: the papal state, represented by its legates, and, especially, the seagoing republics of Pisa and Genoa, fighting for supremacy in the western Mediterranean and varying their policies to suit their shifting alliances. While this anarchic situation persisted, an indigenous aristocracy seized power, dividing the island's heights into independent domains whose borders changed constantly.

What emerges from the Corsican eleventh century, about which so little is known, is the beneficial influence of the Pisan bishops, who beginning in 1050 took it upon themselves to reorganize the island's Church by establishing monasteries and dioceses in the name of the pope. This contribution was reinforced in the course of the very brief period of peace that followed the investiture in 1091 of the Republic of Pisa at the head of five Corsican territories. Thus was reestab-

lished in the valleys, or *pièves*, the system of parishes peculiar to Corsica, amounting to subdioceses—*piévanies*—whose churches were led by *piévans,* or cobishops. The role of *piévan* churches was not limited to the religious sphere, it also spread to judicial life and trade. Having become meeting places and the heart of new urban areas, they formed the basis of a demographic and administrative reorganization. The rebuilding of the cathedrals brought about a similar phenomenon for the coastal regions, very often on the abandoned sites of former Roman places of worship, which had served as the nucleus of the earliest Corsican Christianity.

RENAISSANCE

Romanesque architecture, which was widespread in the second half of the eleventh century, persisted in Corsica until about 1250. It gave these churches consistent outlines and style, characterized especially by the quality of the stonework—with sharp masonry joints—revealing the talent of the Tuscan masons. The harmony of their proportions constitutes the other great quality of these buildings of modest dimensions, with the very simple lines dictated by the single nave (with the exception of the cathedrals of Nebbio and Mariana), covered with a timber roof and ending in a semicircular apse. The roof, when it has been preserved, consists of two slopes of "*teghié*" (flat stones), under which runs a cornice resting on modillions or blind arcades.

These architectural forms recall those of Tuscan or Lombard churches, visible in Lucca, Pistoia, or Pisa. By the end of the eleventh century, the Pisan influence prevailed, as skilled and unskilled Corsican workers brought to the building site of Pisa's cathedral, opened in 1063, especially remembered the use of thin pilasters to decorate the walls, found in the apses on the island, as at Mariana. Later, in the second quarter of the twelfth century, the cathedral of Pisa was enlivened with an alternation of bright and dark facings, a design principle that spread across the island. Trinité d'Aregno and San Michele in Murato, both in northern Corsica, where Pisan influence was more strongly felt, offer good examples of this charming dichromatic conceit, which combines dark green and white in the one case, yellow and green in the other, in a regular checkerboard pattern. The enigmatic iconography of Aregno (men holding a roll, coins, severed hands) could well symbolize the fines and sanctions imposed in these places of justice.

BALAGNE, AREGNO,
CHURCH OF LA
TRINITÉ, DETAIL
OF THE PORCH

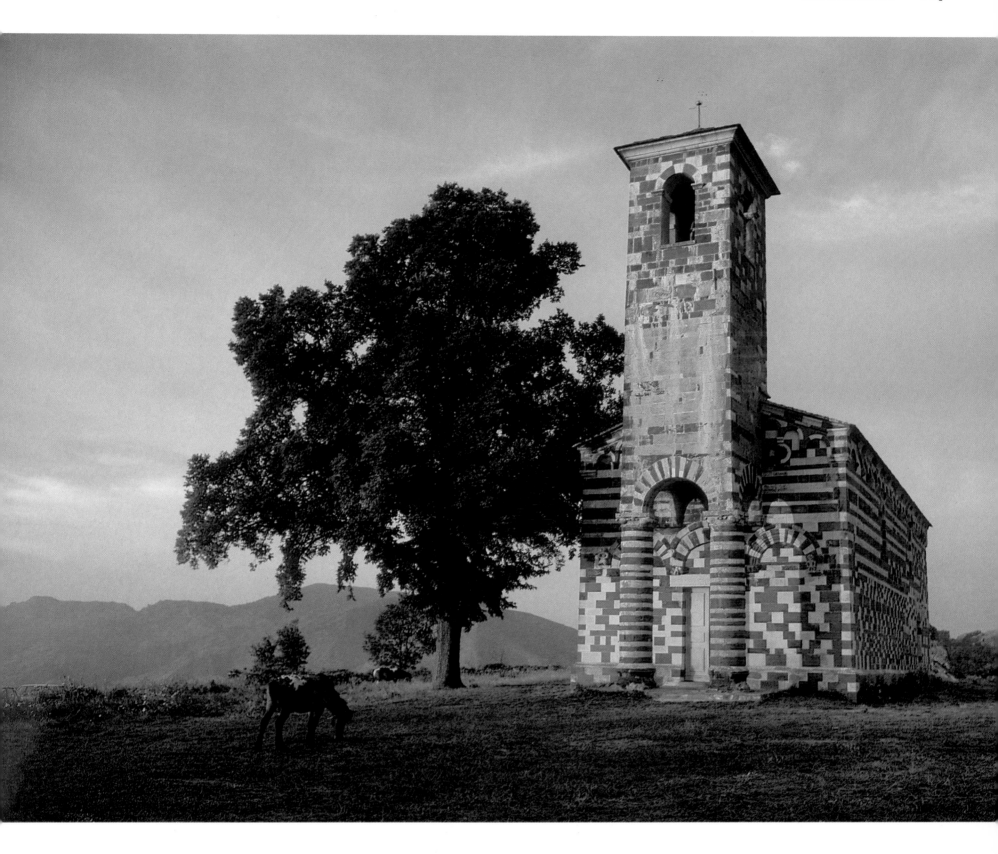

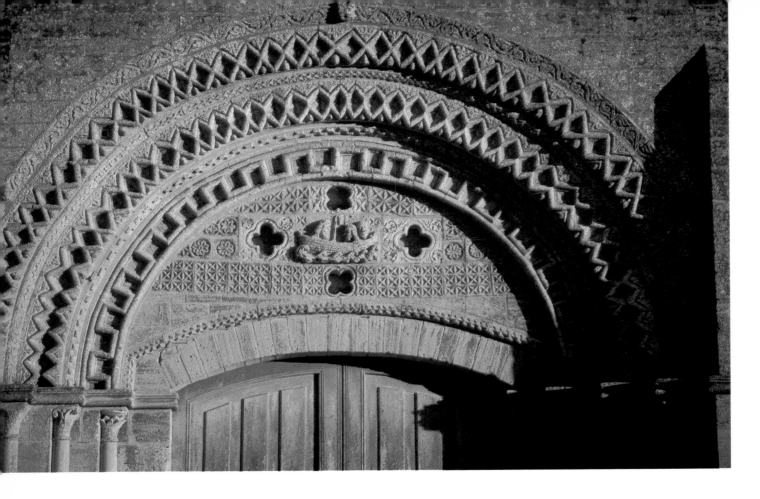

TOUR-EN-BESSIN,
PORTAL OF THE WEST
FACADE, 12TH
CENTURY

TOUR-EN-BESSIN,
PORTAL OF THE WEST
FACADE, 12TH
CENTURY
*The coast of the old dio-
cese of Bayeux presents
an extraordinary abun-
dance of Romanesque
art. The archivolt of this
portal marvelously sums
up the Norman taste for
total abstraction, linking
this people to their
ancestral origins.*

Opposite
BOSCHERVILLE, ABBEY
CHURCH OF SAINT-
GEORGES-DE-
BOSCHERVILLE,
LANTERN TOWER AT
THE CROSSING, LATE
11TH–EARLY 12TH
CENTURIES
*Normandy is one of the
few Romanesque regions
to have true lantern
towers, which diffuse
light to the center of the
building. Heirs of the
Carolingian "light tow-
ers," they were in use
until the Anglo-Norman
Gothic. Boscherville's
tower is supported by
four arches and pierced
by two bays per side.
The vaulting in eight
compartments is of a
later date.*

Normandy is one of the major players on the Romanesque stage. This is because its short and tumultuous history as an autonomous country, during which it had the audacity to consider itself the equal to the kingdom of France, took place between 911, the date of its creation, and 1204, when its glorious moment definitively ended. That is, the beginnings, the peak, and the decline of this duchy correspond to the development of the Romanesque style. It quickly spread throughout the region without any initial tentativeness, demonstrating its originality and anticipating the next period, which would be born in the Île-de-France.

A checkerboard of lands in the image of the many peoples who inhabited it, the country that bears the name of the Northmen is one and many. To the Saxon invasions were added those of the Salian Franks, who came from the outfalls of the Rhine and settled especially in the Cauchois and the Seine, on the ancient tin route. Under their domination Christianity progressed and monasteries appeared, including Jumièges and Fontanelle, founded by Saint Wandrille. In 709, after having had a vision, Aubert, bishop of Avranches, consecrated Mont Tombe to the veneration of Saint Michael. Monks cleared the land, wrote, taught.

At the end of the eighth century the Norwegians, then the Danes, advanced and landed with the conquering spirit that would never desert the Normans. The different waves of invaders dealt a fatal blow to the Carolingian policy of unity.

TO BUILD A COUNTRY

The death of Charlemagne in 814 left the empire vulnerable to invasion. In Normandy the train of events unfolded predictably: the loops of the Seine and the lands they enclosed were taken in three weeks. The monks, whom the Vikings attacked with particular violence, fled toward Auvergne and Burgundy. In 845 Paris was taken in a few days, followed by Beauvais and Chartres. By 911 Charles the Simple no longer had a choice: he gave the Normans what they already had taken. At Saint-Clair-sur-Epte, with an unwritten treaty, the king of France closed himself off from the most direct road to the sea for two centuries.

The Viking chief who concluded this pact was called Rolf ("the rover"); he became known as Rollon. He worshiped Thor and Odin but converted to Christianity and swore—a condition of the treaty—that Normandy would adopt the civilization of the defeated. It is true that Christianity took root and that the Norse language was replaced in two generations with the Romance language, yet its politics and law did not follow suit. Ducal Normandy was organized in an early and particular kind of feudalism, which in

Preceding pages
BAYEUX, CATHEDRAL,
THE ROMANESQUE
BAYS OF THE NAVE

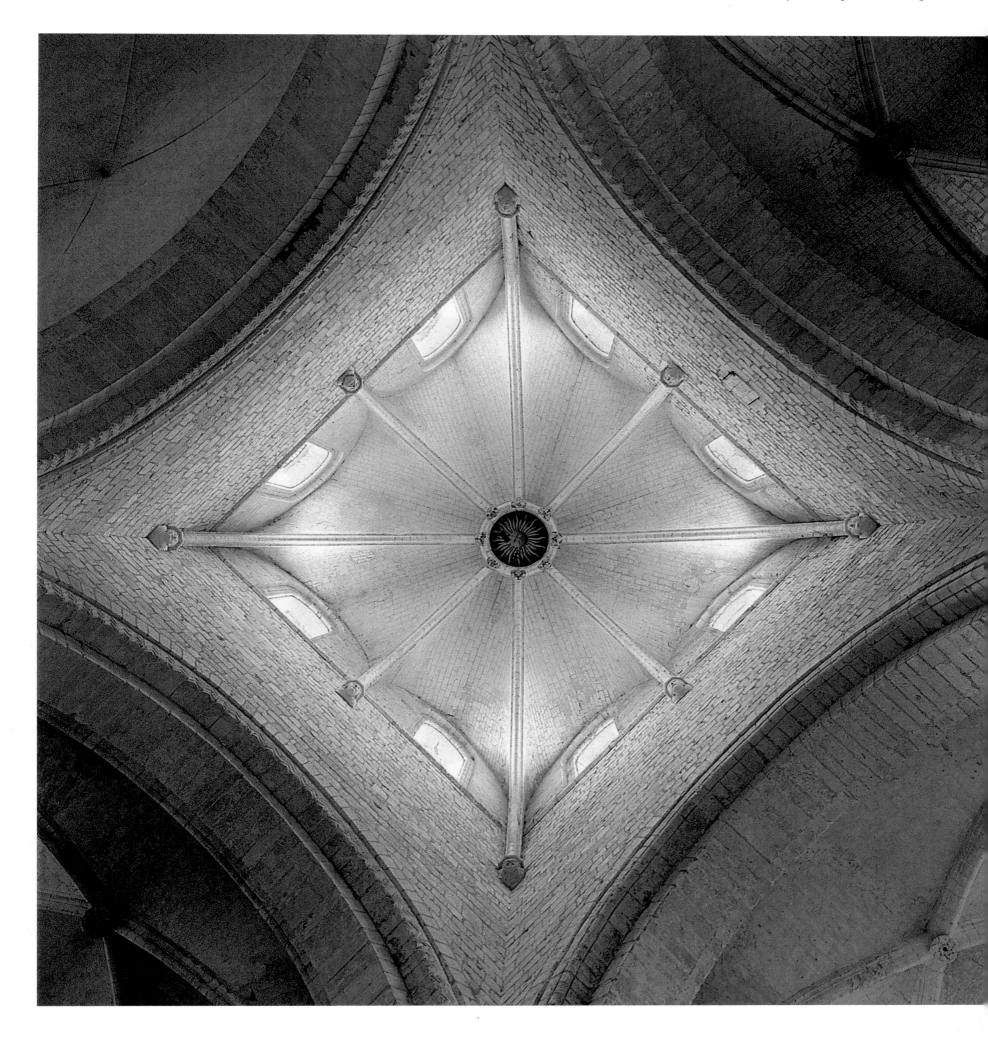

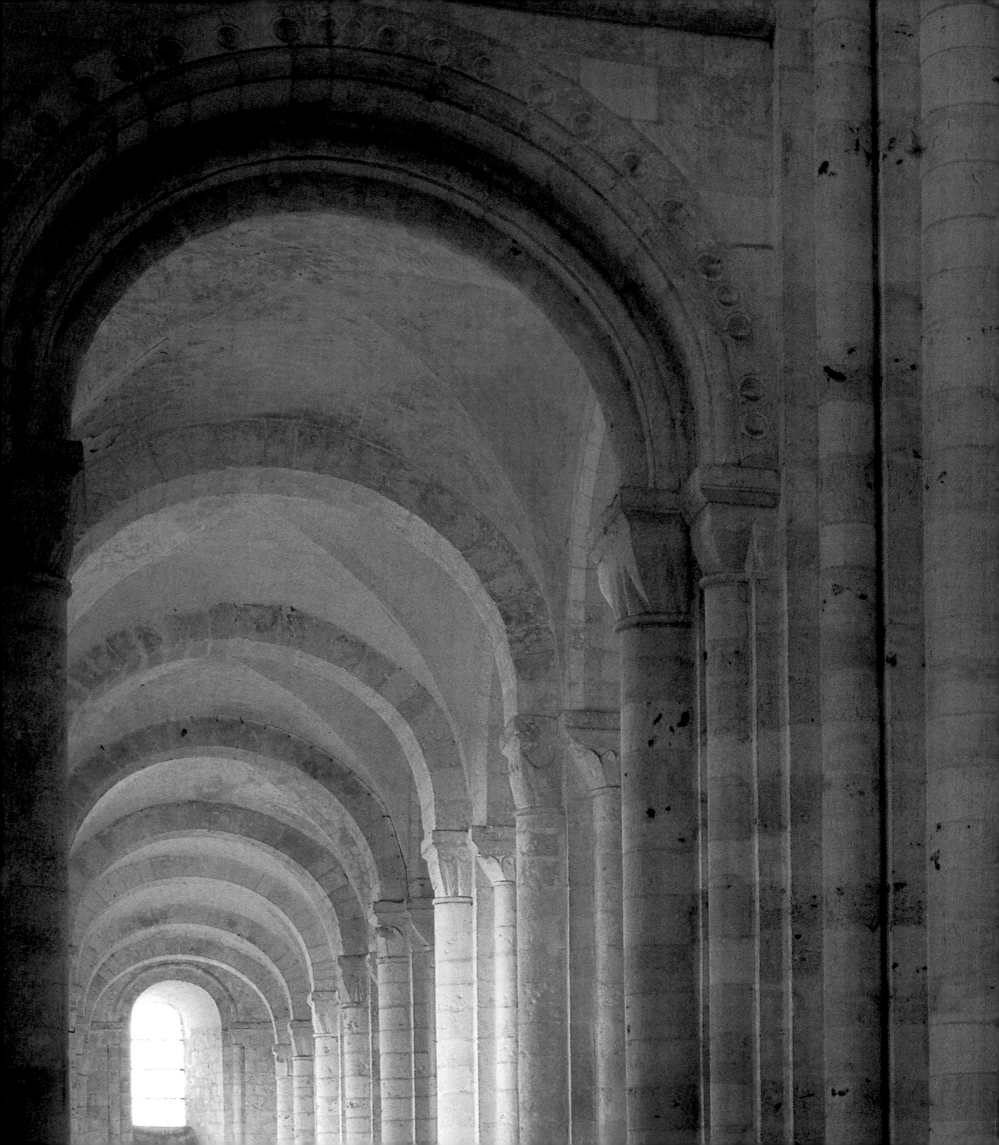

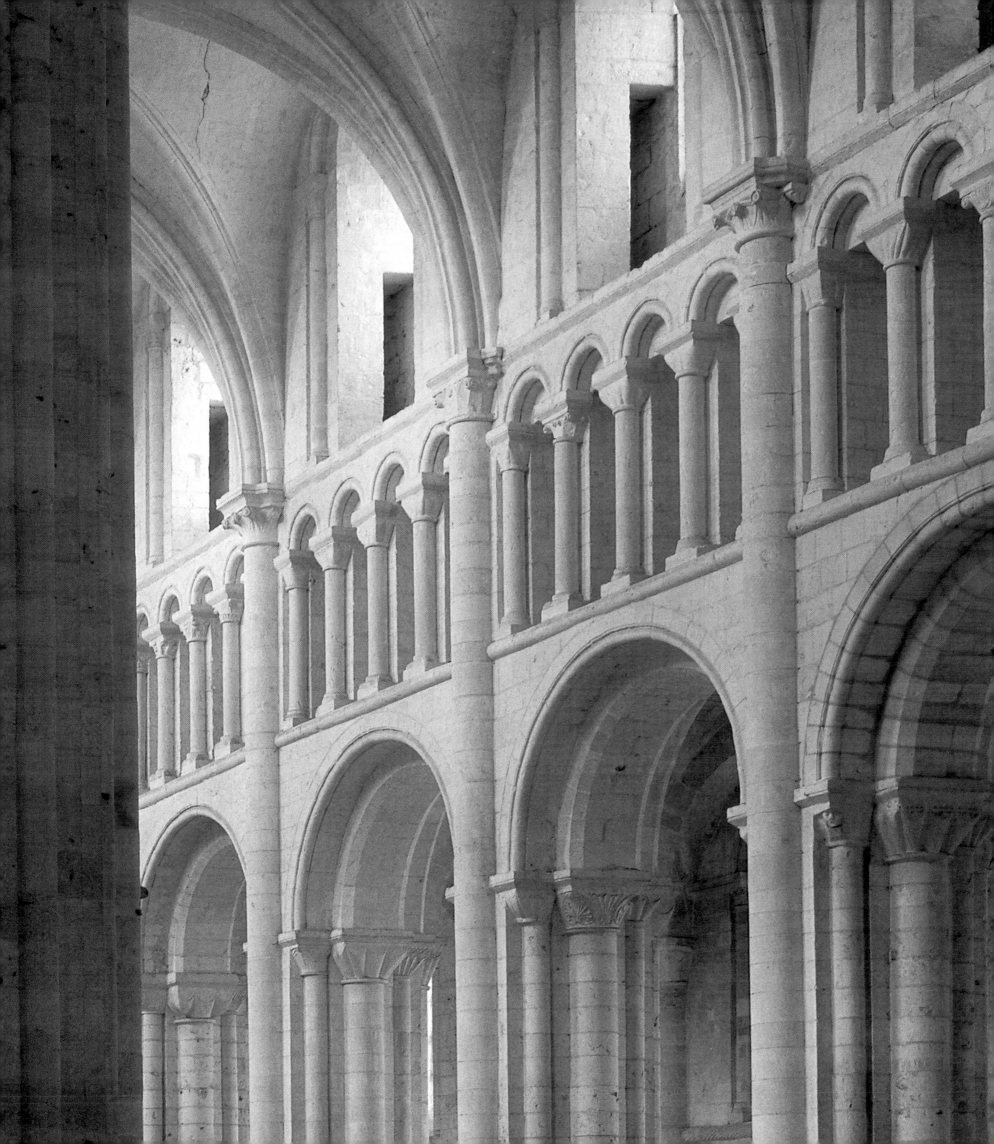

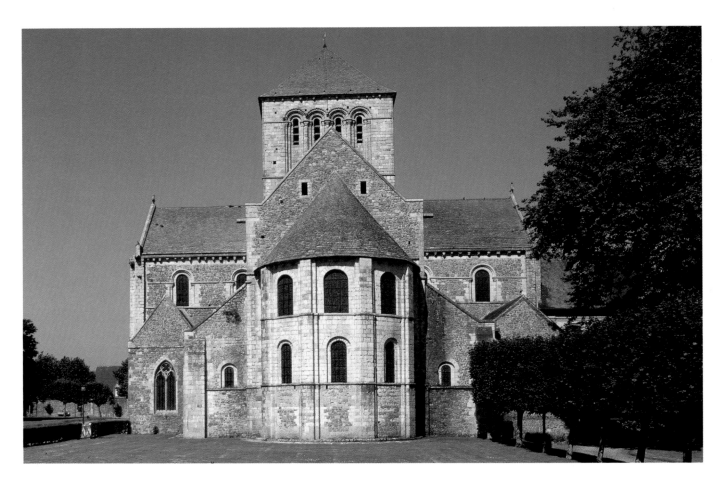

LESSAY, ABBEY CHURCH OF LA TRINITÉ, 11TH CENTURY
The homogeneity of the Norman style justified the slow and respectful restoration of the church after World War II. It is characterized by purity and elegance, with a projecting transept, a solid square tower, and an ample apse that lacks an ambulatory and radiating chapels, as was usually the case in this region, remaining content with a well-proportioned hemicycle.

Opposite
CAEN, ABBAYE-AUX-HOMMES, CHURCH OF SAINT-ÉTIENNE, INTERIOR VIEW

the area of the obligations of vassals served as a model of efficiency in the West.

Within forty years the integration had become an accomplished fact. Guillaume-Longue-Épée (William Long-Sword) succeeded Rollon and begat Richard, an orphan at ten following his father's murder, plotted by the king of France. He had to make his own way, fighting throughout his youth to assert his authority (like his successors) and taking care to avoid the ever-present traps of jealousy and competing rivalries. He reigned for more than fifty years over a land of sailors and peasants and reformed the clergy with the help of the Lombard Volpiano. He died in all humility at the abbey at Fécamp, which he had had built, and by his own request was buried outside the church.

The young Duke Robert won back Vexin from the hands of Henri I of France but failed in his attempt to conquer the British Isles. He subdued Brittany and imposed his rule there. Robert, called the Magnificent, died in the middle of the Anatolian desert, returning from the Holy Lands. He left behind Guillaume le Bâtard (William the Bastard), seven years old, faced with hazards and rebellions, who successfully defended his life and the future of his land.

Endowed with a solid stature and the natural authority it often commands, Guillaume combined a passionate, even brutal, temperament—he had the hands and feet of the vanquished cut off when they surrendered after a siege—with a shrewd patience, reputed to be inexhaustible. He surrounded himself with trusted civil servants, devoted warriors, and a faithful family; for all, he was absolute master. The lords—and even the abbeys—were required to furnish men at arms. The duke protected the Church, which in turn lent its stability to the state. It was above all the monasteries that played a leading role. The able Lanfranc, who also came from Lombardy and who founded one of the most important canon schools in the Christian world at Bec, won over William, who found in him a friend, a right hand. He intervened in the thorny affair of William's marriage with Matilda of Flanders, which Pope Leo IX opposed, more for geopolitical reasons than because of the alleged consanguinity. William ignored it, and he built the Abbaye-aux-Hommes and the Abbaye-aux-Dames in Caen in expiation.

Caen and Falaise became the poles of the duchy; Rouen was too far from the center and enemies threatened on all sides. Angevins, Manceaux, French, Bretons—all suffered crushing defeats and were brutally curbed. At this time, Normandy was encircled by a chain of fortresses. But it had not yet reached the summit of its glory. In 1066, through the victory at

Preceding pages
BOSCHERVILLE, ABBEY OF SAINT-GEORGES, INTERIOR VIEW, LATE 11TH–EARLY 12TH CENTURIES

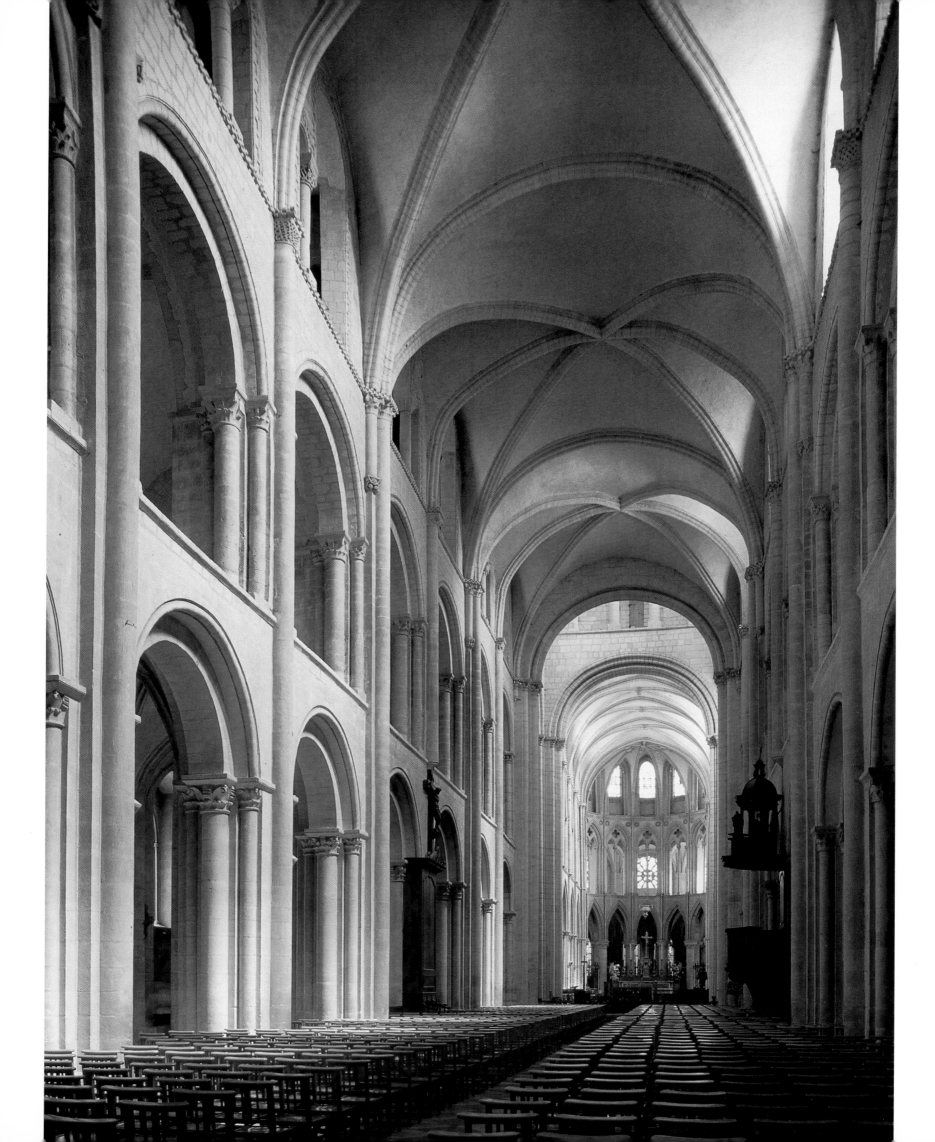

Hastings, which crowned William king of England, Normandy took the island across the channel.

THE BUILDERS

The profusion of churches, large and small, points especially to the close relations that existed between lay and religious powers in Normandy. The architecture here displays such fullness, such assurance, that for a long time Romanesque art was called Norman. The dukes contributed greatly by favoring in the course of their reign this abbey or that city, but the intelligence and determination of two great men of the church proved instrumental to this flowering. William of Volpiano, who came from Lombardy in response to the appeal from Cluny to help in reforming Benedictine monasticism, established himself with a dozen companions at Fécamp, from whence his considerable influence spread. Lanfranc designed Saint-Étienne in Caen and was its first abbot before being named archbishop of Canterbury, from whence he propagated the Norman style in the south of England. Finally, the prelates named by William, many from within his own family, were responsible for the appearance of luminous, long, and soaring churches made from beautifully dressed fine limestone in the second half of the eleventh century.

This creative ferment materialized in a land almost devoid of architecture before the Romanesque period. Nothing had survived destruction by the Vikings. The remains of a small church with two naves, Notre-Dame-sous-Terre, under the abbey church of Mont-Saint-Michel; Saint-Pierre in Jumièges, pre-Romanesque in its porch with stepped towers and the first bays of the nave; and the chapel of Saint-Saturnin in the abbey of Saint-Wandrille, built in a three-lobed plan and dressed in a herringbone pattern, all reflect architectural experiments from the end of the tenth century and the influence of Carolingian art, strongly present in the neighboring north. Saint-Pierre represents only a small part of the prestigious ensemble that was Jumièges, which today stands in majestic ruins. The pride of the Seine valley since its founding in 654, it experienced a first zenith under the Carolingians, as one of the most important religious and canonical centers in the Holy Roman Empire, before being sacked by the Vikings. It achieved a second moment of glory under Volpiano and Duke William—who had the abbey consecrated in his pres-

ence in 1067—before ending ignominiously as a quarry, like Cluny. The beauty of the immense facade of the abbey church of Notre-Dame is breathtaking. Framed between two square towers with octagonal upper parts (they have lost their spires), it demonstrates how much the "harmonic facade" of Normandy, narrow and high, here furnished with a western mass opening into a porch, owes to the Carolingian heritage.

At Bernay, the oldest Romanesque church in Normandy—the choir is presently dated to 1030 and the nave to before 1050—whose Benedictine plan was designed under Volpiano, the nave displays one of

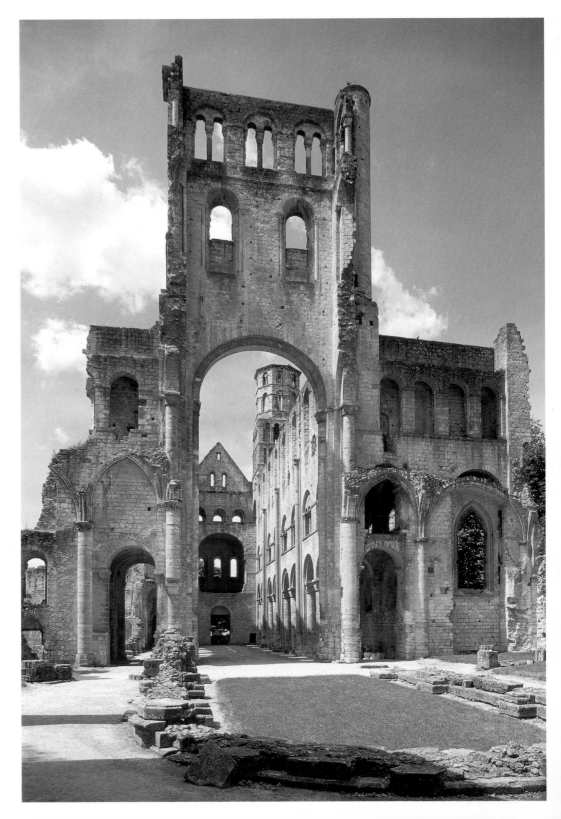

the first Romanesque triforiums, not entirely integrated successfully into the whole, giving it a somewhat "floating" look.

Unity and Lucidity

Architectural activity unfolded in Normandy from 1050 to 1125, followed by a long pause until the arrival of the Gothic in 1170. Its full development in the last third of the eleventh century corresponds to the maturity of the duchy and the invasion of England, leading to the birth of an Anglo-Norman art, which should not be confused with the style that flowered in continental Normandy. The latter exhibits a group of characteristics that were rapidly fixed and of a great stylistic unity. In spite of its borrowings, from Carolingian architecture, Burgundian influences, a style of stonework from the Loire, and some preexisting indigenous elements, in many regards it marks a real advance in relation to the other Romanesque creations in France, foreshadowing the fundamental ideas of the Gothic. This combination of sources confers on the Norman style an incomparably original look, composed of the high narrow facade in the form of an H, called the harmonic facade, consisting of two towers framing a gable, and whose verticality prefigures the outline of the cathedrals to come. With the exception of the church of the Trinité in Caen, the envelope of these buildings recalls the severe Carolingian walls in their sobriety, even austerity. In the interior, the elevation of the nave is divided into three

stories by a generous arcade, triforium, and clerestory, as in Saint-Étienne in Caen, Cerisy-la-Fôret, and Saint-Georges-de-Boscherville. Galleries are rare, but a continuous passage built into the thickness of the walls at the level of the windows became widespread. The choir, often lacking an ambulatory and radiating chapels, takes up the elevation of the nave.

At the crossing of the transept, a ribbed dome supports a spectacular lantern tower whose two stories light the central bays of the church. This element, which recalls the "towers of light" that crowned Carolingian transepts, was limited to the Norman sphere and later taken up in Gothic cathedrals. The tower was the most carefully designed part of the building, like the vaulting requiring painstaking structuring and support. With the exception of the arched barrel vaults of the abbey church of Mont-Saint-Michel, the builders of Normandy chose to ignore the latter and passed directly from the timber roof, which allowed them to build daringly high churches, to the rib vault, which here made an early appearance.

Thus, the churches of Saint-Étienne of the Abbaye-aux-Hommes and the Trinité of the Abbaye-aux-Dames, founded in Caen respectively by William and his wife Matilda in the 1060s, were originally covered with a timber roof over the central nave—later rib-vaulted—and groin-vaulted over the aisles. Both have a "harmonic facade," but in different styles; that of Saint-Étienne achieves a striking effect by its extreme starkness, inherited from Carolingian facades, a style familiar to the Lombard Lanfranc; at

JUMIÈGES, ABBEY CHURCH OF NOTRE-DAME, BACK OF THE WEST FACADE SEEN FROM THE NAVE, 11TH CENTURY
The grandiose ruins of this once illustrious establishment allow us to understand its austere facade. Flanked by openwork towers and preceded by a porch— of which we can see the gallery on the level opening onto the nave— it is indebted to the Carolingian tradition.

RIB VAULTS
—————•—————

About 1100 rib vaults appear for the first time at the abbey of Lessay and the English cathedral of Durham, no doubt in response to the architects' ongoing quest for interior unity. The builders of Lessay immediately encountered difficulties in creating a true cohesion between the powerful pillars and the ribs of the vaulting. It was not until a few years later, at Saint-Germer-de-Fly, in a religious building already in the first-generation Gothic style, that a veritable continuity is manifested between the pier and the ribbing of the vault. Unity was achieved in the two abbeys in Caen with a later version of the rib vault that was more elaborate, adapted to the highly articulated walls of the nave, which were initially conceived to be freestanding. The groins of their vaults were thickened with moldings to extend precisely the clustered pillars of the broad piers of the nave. In Lessay the vaults took the form of a star, while in Caen they were divided into six sections, an early use of sexpartite vaults.

This method of vaulting was relinquished in the twelfth century for a return to the fine timbered ceiling—not through loss of the technique but simply because the rib vault was always only one option in Romanesque architecture. Even when they had rib vaults, the Norman Romanesque churches were not prefigurations of Gothic churches; the very thick Norman rib vaults (12 to 16 inches, or 30 to 40 centimeters), although they contributed to the flowering of the cathedrals through their early use, have an altogether different aesthetic.

The Lessons of the Bayeux Tapestry

A long and thin grayish brown linen cloth, barely 20 inches (50 centimeters) wide, made up of eight unequal pieces that total 230 feet (70 meters) in length, hangs in a museum specially designed for it in Bayeux. This masterpiece, universally acclaimed since the eleventh century, is a tapestry executed in needlepoint in blue, yellow, and red wool. It depicts some fifteen hundred ships, horses, castles, and figures that narrate through images, in a sort of medieval comic book, the invasion of England by William the Conqueror in 1066. Fifty-eight scenes, some framed by interlaced trees, some by highly stylized architectural elements, are accompanied by a brief text in Latin, embroidered in capital letters, explaining the episodes. The text could afford to be concise, for the events were still very much alive in public memory when the embroidery was created (between 1066 and 1077). Destined for the new cathedral of Bayeux, the tapestry decorated the north and south sides of the nave. The inventor of this phenomenal "publicity stunt" was none other than the half brother of William the Conqueror, Bishop Odo (or Eudes), one of the most erudite men of his time and instigator of the Norman landing. He became count of Kent and undoubtedly had the work executed by Saxon workshops, which had earned an unsurpassed reputation in matters of illumination and embroidery. Through its narration of the Battle of Hastings—the causes, preparations, landing, and the fighting—this work, unique in its genre, furnishes a mine of information concerning Saxon and Norman customs in the mid-eleventh century.

THE DUCAL SHIP

The ships alone bear the marks of the Vikings. These *drakkars,* or *snekkjas,* have a long and colorful hull. Their figureheads—a dragon or griffin's head—were intended to terrify the enemy. Here, the ducal ship navigates with a tailwind. The clinker hull is made with overlapping planks, like a slate roof; the ship's shallow draft allowed it to bring warriors almost to the water's edge. These men from the north bequeathed us the essentials of their nautical vocabulary, still in use today.

HAROLD'S OATH

Before Duke William, Harold swears an oath on relics and claims to recognize him as the future king of England.

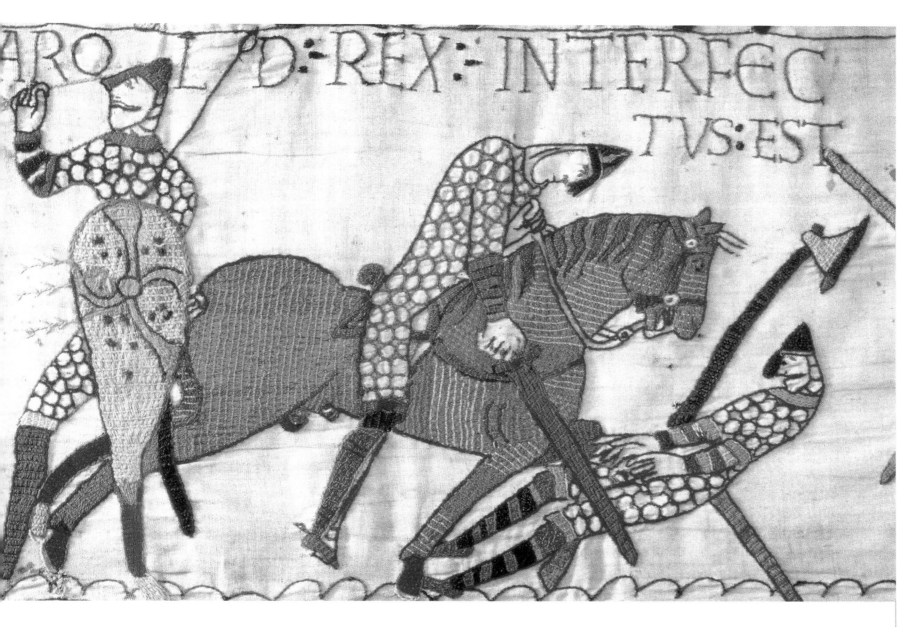

ARO L D REX INTERFEC TVS EST

The Death of Harold

The Norman knight was supplied with a supple, split coat of mail, which allowed a certain freedom of movement, a helmet with nosepiece, and an almond-shaped shield, made of leather and metal. Long lances faced each other in the heat of the battle. The Saxons preferred the axe to the round-tipped Norman swords.

The Feast in Honor of the Duke of Normandy

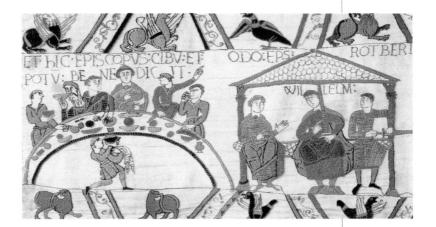

At the feast of Hastings, the cooks bring skewered fowl and fish, recommended by the Church. People ate with their fingers; only knives are present. The wine was Norman, since the warriors had left *cum vino* (with wine). To avoid too meaty a diet, ordinary meals were based on legumes (dried peas, fava beans, beans) and fresh vegetables, such as cabbage and leeks. At the duke's table, round wheat loaves are plentiful.

the Trinité the proportions are stockier, the articulation of the exterior walls more elaborate.

In the same ducal capital, but not as well known, rises the stirring church of Saint-Nicolas, still lying alongside a former cemetery. Built at the end of the eleventh century by the monks of the nearby Abbaye-aux-Hommes, it has remained unaltered. The porch with three arcades that forms its entrance is exceptional for the area. The most beautiful part of the church is the apse, still covered with a stone roof. Similarly, the very beautiful chevet of Cerisy-la-Fôret, semicircular with three stories of windows, typically Norman, anticipates the unity of the Gothic choir. This former abbey church, mutilated in its length, has had restored to it a ceiling like the one it had originally. Examples of flat chevets of local origin are seen at Jobourg and at Thaon, influenced if not by Saxon art, in any case by pre-Romanesque art. Next to the great urban churches these two examples represent a charming rusticity. Varengeville, isolated on a cliff, facing the city, presents a poignant aspect.

THE CHOICE OF ABSTRACTION

Architectural decoration found a modest but nonetheless original expression in Normandy. In the absence of the sculpted tympanum it is limited to stringcourses, cornices, moldings and arch moldings that defined portals and ran along naves, and embellished capitals and modillions. That it did not develop more elaborate sculpted decoration is all the more puzzling as the region is rich in limestone, it has Poitou, fecund in sculpture, as a neighbor, and, especially, because a "school" of sculpture began to appear at Bernay about 1065, embodying a refined but shortlived style. Subsequently, unlike the western tendency to elaborate relief to the point of restoring sculpture in the round, the region developed a long list of geometric motifs in which abstraction replaced figurative and narrative form.

This regression, widespread throughout the entire region, can be explained by a desire to affirm a "national" identity following the conquest of England. Older local artistic conditions were undoubtedly revived and an idiosyncratic ornamental vocabulary created, composed of hoops, ribbons, sawtooths, gadroons (Manéglise near Le Havre, Étretat, Saint-Georges-de-Boscherville, the Trinité in Caen, and

Tour-en-Bessin), and, more rarely, the heads of men or animals (a series of rabbit heads on the portal of Putot; modillions at Thaon and Jobourg). Also present are representations of facing or interlaced animals, like those sculpted in flat relief on the archaic tympanum of Bully-sur-Orne, on the arcades of Barneville-Carteret, or on the braided spandrels and medallions of the arcades of the Romanesque nave of Bayeux Cathedral.

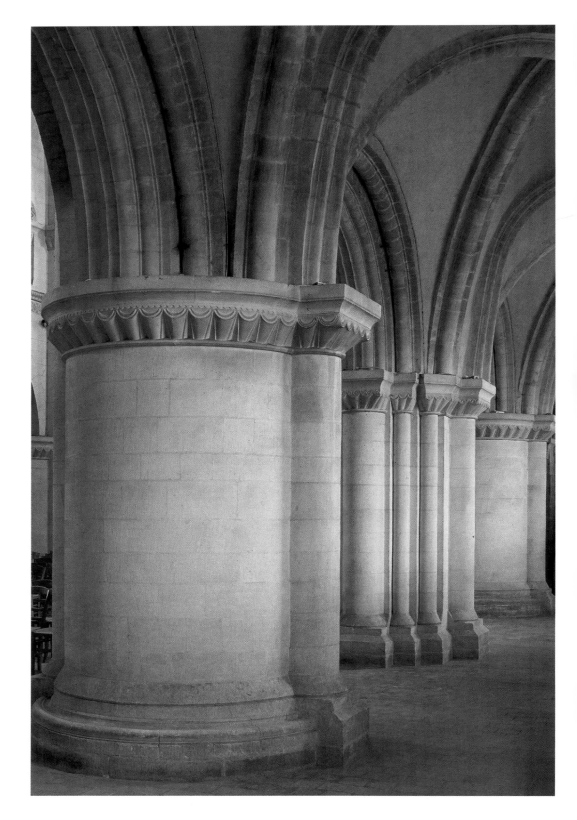

OUISTREHAM, CHURCH OF SAINT-SAMSON, PIER OF THE NAVE, 12TH CENTURY

Opposite
CAEN, ABBAYE-AUX-DAMES, CHURCH OF LA TRINITÉ

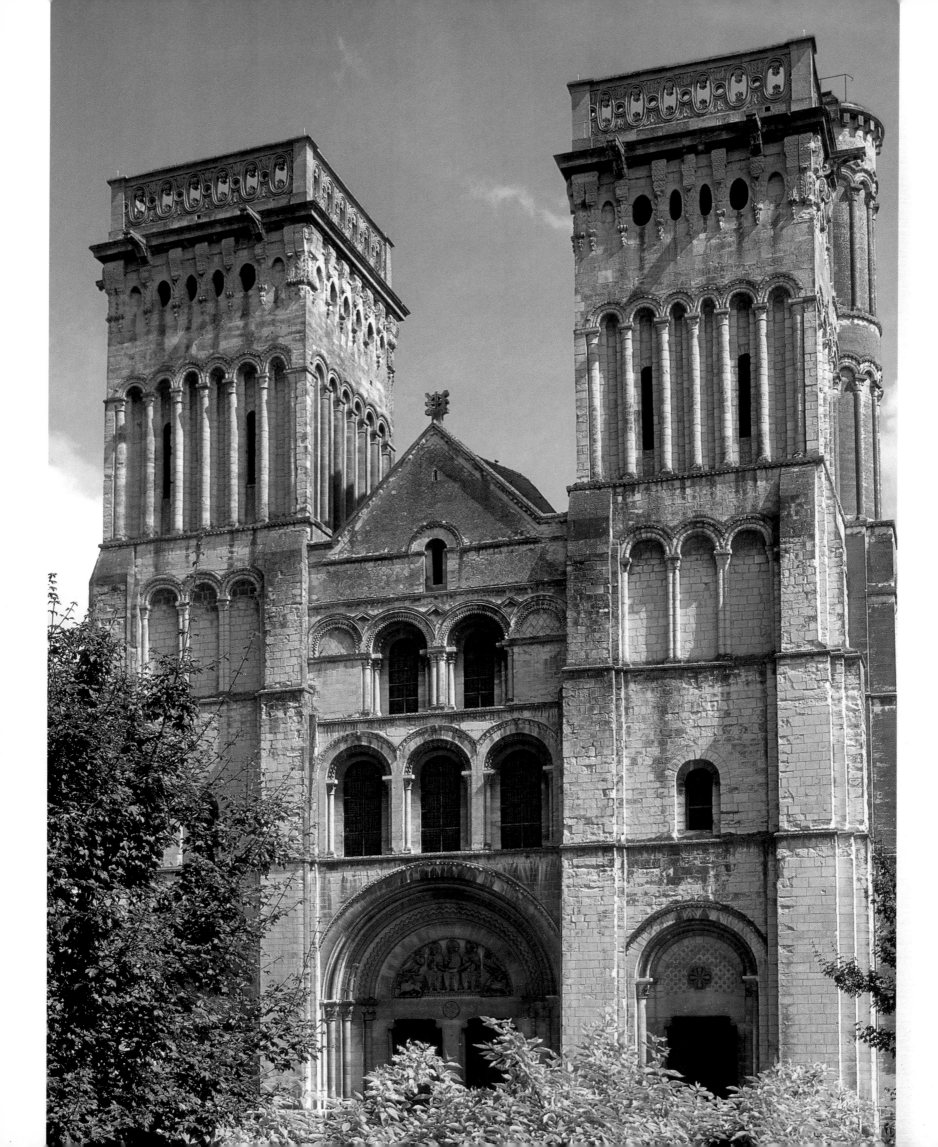

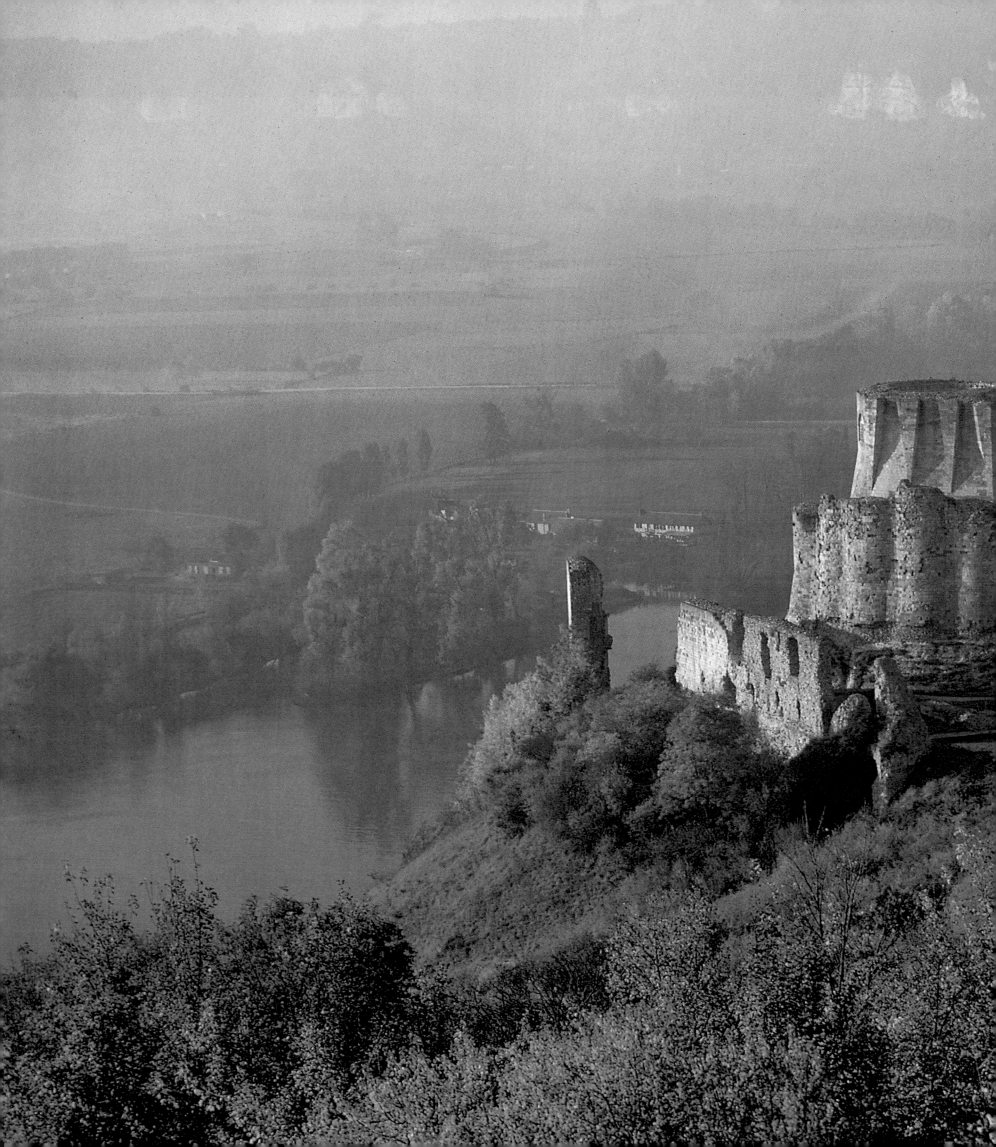

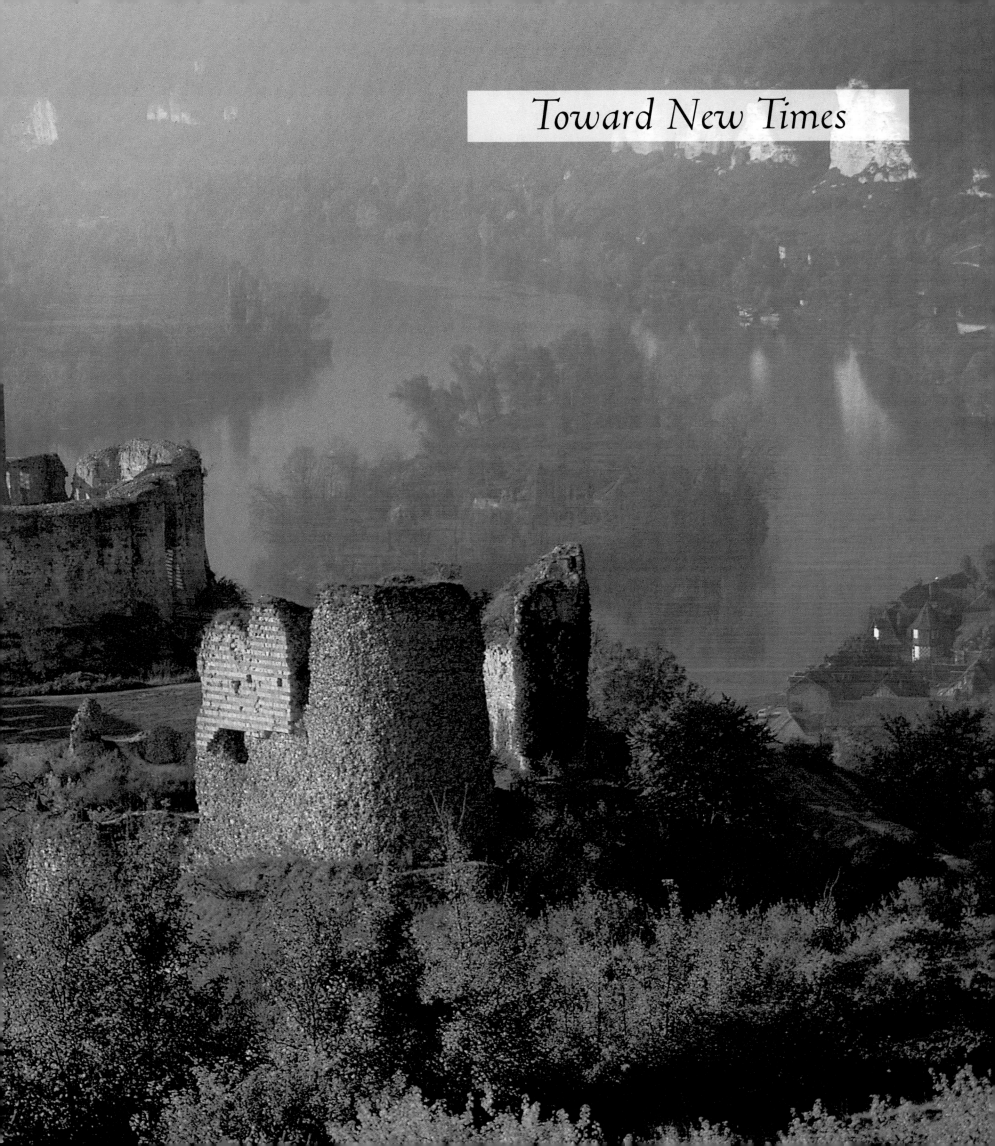

FROM THE TIME that Hugues Capet, elected in 987, once again raised the challenge of monarchy by divine right, the province that was called France, which surrounded Paris, strove to extricate itself slowly from the slump in which the last Carolingians had left it. The young Capetian dynasty pursued two goals: to conquer and hold the territories that it thought would return to it, and to relearn the art of kingship.

It would take two centuries for the Île-de-France to become a coherent geopolitical whole, two centuries to go from anarchy to order, two centuries to consecrate the Gothic flowering that represented its future. This patience was repaid, since it would become the vessel and the stronghold of the kings, the jewel case of Paris, and the crucible of a new art, which was already being contemplated by Abbot Suger in the second decade of the twelfth century, while the portal sculptures of Moissac and Autun were not yet completed. From that time, it seemed as if events followed each other more quickly here than elsewhere. Romanesque art, which persisted until the end of the century in the southern regions, where it continued to shine, here became the early victim of a tide that swept all before it within a few years.

The king had nothing of his own, or almost nothing. What was called the royal domain amounted only to the possession or control of a few cities—Senlis, Compiègne, Laon, Paris, Dreux, Orléans, Melun, Étampes. Its shape was heterogeneous, infiltrated by the holdings of unsubjugated vassals. Although the king had little land, on the other hand he had many and varied rights, which allowed him to coin money, to be at home wherever he enjoyed rights of shelter, to receive revenues from tolls, taxes on fairs and markets, and the profits from justice.

THE SHIFTING TERRAIN OF MEN AND GOODS

Le Mans gave birth to a phenomenon in 1070 that took on national importance in the twelfth century and promoted the solidarity of new populations: the granting of communal charters. After Noyon, Amiens, Laon, Beauvais (1099), and Compiègne, the towns closest to Paris demanded their freedom one by one. Inhabitants everywhere organized themselves into peace associations to ensure their own armed protection. In the growing towns surrounding the cities,

neighborhoods demanded ramparts like those around the oldest parts of the city.

Many did not taste freedom until the thirteenth century: freeholders, serfs, agricultural workers, whose conditions of life deteriorated while elsewhere fortunes increased. The cities were filled with the poor and the marginal, but work was not obligatory and begging implicitly accepted. The "freedom" of the poor was the power to beg for survival, and that of the man who was hounded by debts was the power to flee to new horizons to make a new life. Although the administration of the cities and rural areas was highly structured, with their *prévôts* (stewards), mayors, sergeants, *voyers* (in charge of the roads), and itinerant bailiffs who rendered justice, it would not seek a fugitive.

During the Romanesque period, the lands around Paris, Brie, Beauce, and the Vexin experienced a major flowering of agriculture. Strange as it may seem today, the Parisian basin was a wine-producing country. The prosperity of the burghers of Paris, the "water merchants," essentially issued from the transport of wines by river to the lands of the north.

THE ARCHITECTURE OF WAR

Inseparable from the feudal landscape, Romanesque military architecture belongs to a transitional phase. It is preceded in time by the simple conical mound surrounded by a rampart of earth or wooden fence and a moat. The bailey, the outermost wall of a castle or its keep, the first line of defense, was connected by a footbridge. At the top of the embankment stood a tower. The fortified site of Puiset, one of the most secure in Beauce, was enclosed at the end of the eleventh century by an oval rampart 1,400 feet (420 meters) long,

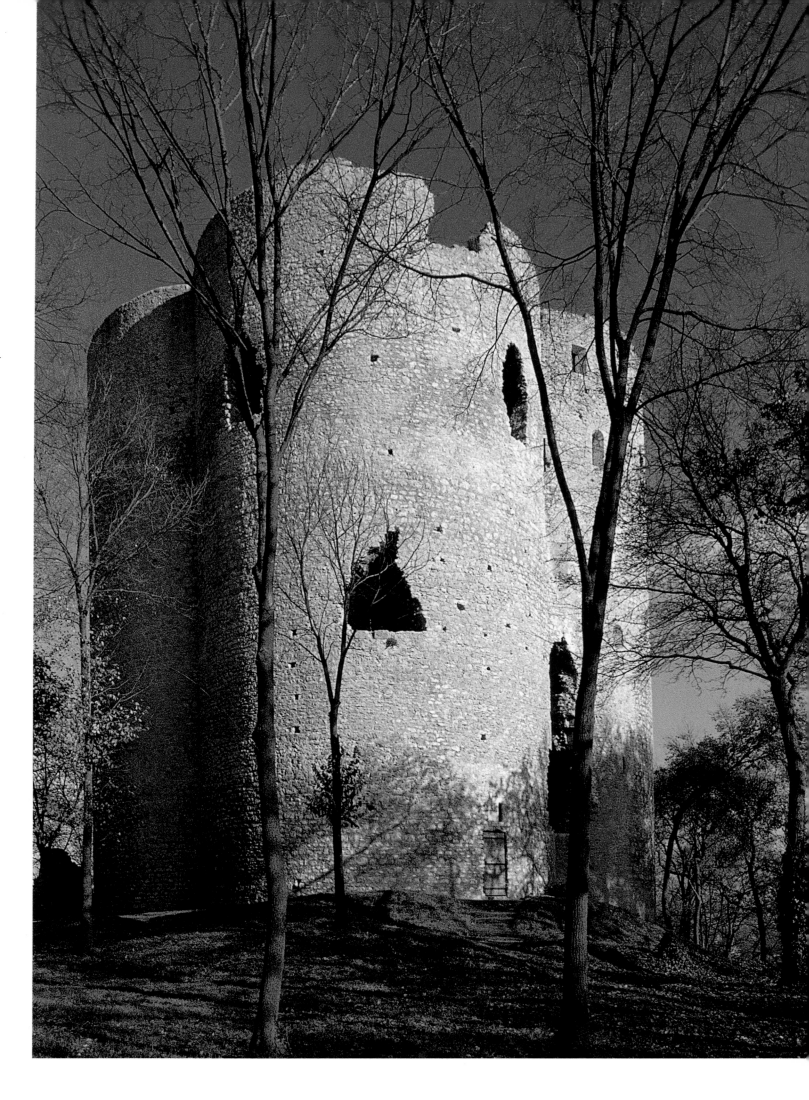

ÉTAMPES, GENERAL
VIEW OF THE KEEP,
C. 1140
*A city that belonged to
the Capetians, Étampes
boasted a château, of
which the Guinette
tower—from the Old
French verb* guigner, to
*see from afar—remains.
A royal keep, it was
original in its time not
only in its tetrafoil plan
but also in the comfort
of its domestic arrange-
ments. Its plan, which
seems to have been
innovative, was nonethe-
less altered, since the
straight walls that
linked the towers were
more vulnerable to bat-
tering rams than the
curved walls of cylindri-
cal keeps.*

made of earth and crowned with a wooden fence, stout enough to protect the lord's house, a village, its church, and its market, thus demonstrating the defensive possibilities of this kind of construction, while elsewhere stone was the rule. In the twelfth century, this structure was reduced under Hugues de Puiset to a small central château surrounded by an abbreviated circular wall. The line of attack was diminished in order to defend it better, while the fortified whole shed its role of refuge for the poor population to fulfill a purely military function, sheltering a garrison alone.

The village and the town of the Romanesque period grew up at the foot of a château. These are urban areas of accretion of feudal origins, common in medieval France, similar in scope to settlements of monastic origins. Both ensured their own security by taking over their ramparts.

Of the ancient wooden observation towers erected well before the year 1000, there remain a few hillocks, subsequently fallen into obscurity. In former Hurepoix the ruins of the keeps of Magny-les-Hameaux and Maurepas reveal stonework of millstone grit bound by chalk mortar, while the narrow loopholes are surrounded by cut stone. The fortress at Rochefort-en-Yvelines, between Rambouillet and Étampes, emerges from out of the brush with an irregular profile conforming to the outline of a knoll 425 feet (130 meters) high. The remains of its keep indicate a stonework herringbone pattern, or *opus spicatum*, in use until the twelfth century. That of Chevreuse, where a coin found on the site attests to a construction before 1050, was 62 feet (19 meters) tall and reinforced by flat buttresses, which were quite widespread throughout the entire western half of France, as well as in England.

The enormous tower of Senlis, which defended a royal palace since fallen into oblivion, for the first 20 feet (6 meters) displays fine masonry courses of sandstone set with narrow joints. The angles are reinforced with a stone chain bond. A well 33 feet (10 meters) deep still exists inside, an element necessary for withstanding a blockade. To outlast a siege arms and food in the form of wine, grain, and living animals (fowl, pigs) were stored on the ground floor.

An advance in military architecture can be seen in Houdan. Its outline, an irregular circle, is flanked at the four cardinal points with semicylindrical towers—a design found around a square center at the Guinette tower in Étampes, built under Louis VII. It reflects the experiments carried out in the twelfth century by engineers seeking to refine the angles of observation, demonstrating the subtleties, defensive as well as offensive, of the Gothic keep.

In this evolution the "César" tower built on an artificial mound at Provins, in the county of Champagne, appears as a curiosity. The most original of French keeps, built after 1150, its design led to a blind alley. Its octagonal body planted on a square base is flanked with small cylindrical turrets that free themselves from the walls as the latter become narrower. While this design reduced blind spots, it proved vulnerable, given the thinness of the walls.

Solutions effective against fire (vaulting on all floors), against having the defense only at the top (loopholes at each level), and for an offensive conception for the building (principal door on the ground floor, revetment wall enveloping the base to make the projectiles thrown by assailants ricochet) were not put into place until the end of the twelfth century, under Philip Justice.

VIGNORY, CHURCH OF SAINT-ÉTIENNE, INTERIOR VIEW, 11TH CENTURY
The construction of this church, unlike the procedure for most churches, began with its west end. The aisleless nave is bordered with great arcades, false tribunes, and high windows pierced in the unarticulated walls typical of the Carolingian heritage, which was very present in Capetian Romanesque art. This was also the source of the timber construction as well as the thick, cubic piers surmounted with imposts deliberately made to contrast with the columns of the choir.

THE ARCHITECTURE OF GOD

Romanesque religious art of the Île-de-France for a long time was characterized as secondary. This label sprang from its eccentric development around the Capetian realm and the fact that it was hemmed in by the Carolingian architectural tradition, which long persisted in the region, and the early appearance of Gothic art, already apparent in some churches built in the twelfth century and later finished in the new style. Romanesque art had a short life here. The assertion that Romanesque art developed mainly in the country-

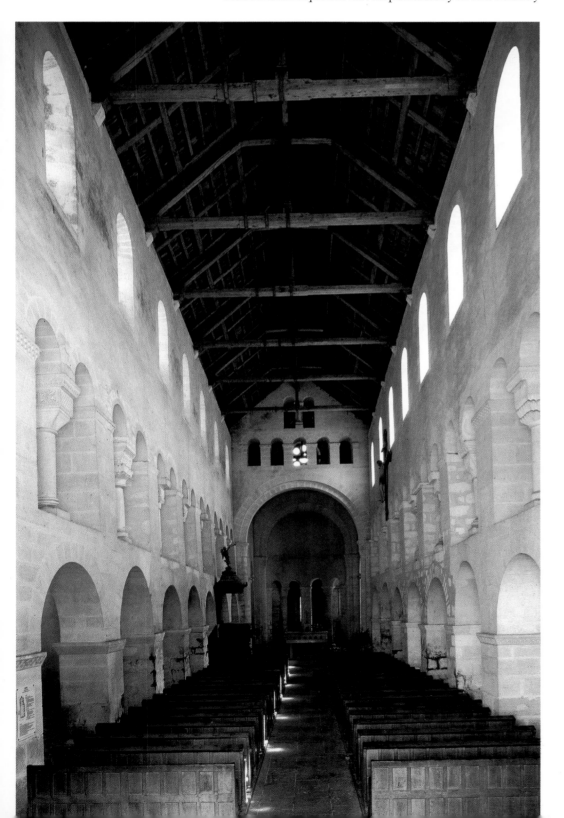

side, while Gothic art was the product of the cities, is especially true of this region since, with the exception of Beauvais, Paris, Chartres, and Étampes, which possess interesting examples from the eleventh and twelfth centuries, most of the churches belong to a rural landscape. Nevertheless, they are not rustic in appearance but often luminous and slender, qualities later featured in Gothic architecture.

Pre-Romanesque borrowing is strong in the Romanesque art of the Parisian basin. At Beauvais, the old cathedral, called the Basse-Oeuvre, clearly reflects the Carolingian heritage bequeathed to the buildings constructed after the year 1000. These churches have aisles covered with timber roofs, unarticulated walls, and gable-wall facades (Château-Landon), sometimes decorated with a porch or a tower-porch (Paris, Saint-Germain-des-Prés). The eastern part is composed of a simple apse (Berzy-le-Sec) or a rectangular choir (Fleury-en-Bière) and transepts that project little.

The Romanesque forms of the twelfth century blossomed rapidly, soon replaced by the experiments of the early Gothic style. The architecture of the region displays a distinctive ambiguity due to the coexistence of two styles with different tendencies. By the eleventh century, the former abbey church of Morienval had introduced the punctuation of walls with engaged columns and piers, which soon became common. Nonetheless, it is not, as has been thought, a prototype of the choir with ambulatory. The passage, too narrow and difficult of access, is unsuitable for processions. On the other hand, the crypt of Notre-Dame in Chartres (1020), with a semicircular plan that also undoubtedly applied to the upper choir, is one of the first examples in France of the genre, along with the older example of Vignory in Champagne, which in the same period was also furnished with radiating chapels.

The use of groin ribs became more common, followed by rib vaults, which, in spite of their similarity of appearance, served a very different architectonic function. The rib vaults of Morienval's ambulatory, which were thought to be very old, are actually only groin ribs decorated with torus moldings. The rib, or ogive, vault, even if it was not invented in the Île-de-France, nonetheless here found the mainspring of its utilization and perfection.

The facade evolved ever vertically. The Gothic style took over Normandy's harmonic facade with two towers, exploiting it in its own way (Saint-Leu-d'Esserent, Chartres cathedral).

PARIS, CAPITAL AT LAST

Paris, in perpetual transformation, fortunately has been able to preserve some of the vestiges from its affecting Romanesque past.

Of the young capital *intra muros* there remains only a single, but astonishing, architectural witness, nestled into the Île de la Cité. At the same time, the chapel of Saint-Aignan was one of the town's twenty-three religious buildings; in the shadow of the cathedral, on the rue Chanoinesse, one and a half bays of the nave dating from the twelfth century and the modest remains of an apse have survived. The nave is partially filled in, hidden at the base, but the groin vaults of the aisles and the semicircular barrel vault with transverse arches that covered the nave can still clearly be seen. The capitals with palmettos or with fruit indicate a sculpture of the High Romanesque.

The Merovingian cathedral of Paris dedicated to Saint Stephen (Saint-Étienne) was decorated during the first half of the twelfth century. The Sainte-Anne portal produced at this time was reused in the west facade of the present cathedral of Notre-Dame in the thirteenth century. The tympanum represents the Virgin in Majesty presenting the Child, accompanied by two censer-bearing angels, King Childebert, a bishop, and a cleric. On the lintel, episodes from the life of Mary are complemented by prophetic figures on the arches. During its reinstallation, this group, a Romanesque creation dated before 1150, saw the addition of a Gothic lintel consecrated to the mother of the Virgin, the source of its present name.

It is no easy task today to visualize the great abbey of Saint-Germain-des-Prés (Saint-Germain-of-the-Meadow) in its meadow or that of Saint-Martin-des-Champs (Saint-Martin-of-the-Fields) in the fields. The former preserves a part of the original Romanesque church, built between 990 and 1014, after the damage caused by the Norman invasions, with its famous tower-porch, whose lower part may have served as a model for the tower-porches of Champagne. An elevated gallery opens on the nave, as was the custom in the towers of this kind in the Carolingian period. The upper part is from the beginning of the twelfth century, as is the window story of the nave.

Saint-Martin-des-Champs was also *extra muros* throughout the Middle Ages, surrounded with its own rampart. Founded by the Capetians and richly endowed, it became a Cluniac priory to extend its power over the Parisian crown. The chevet with ambulatory (about 1130, restored) contains seven radiating chapels under a continuous covering that evokes the Gothic; the curious three-lobed axial chapel has a very prominent profile.

The hill of Montmartre, even further from Paris, is the hill of the martyrs named in the Life of Saint Denis as the site of that bishop's execution. The present-day church of Saint-Pierre was dedicated to him until the twelfth century. This monument, the most Romanesque of the Parisian churches, reveals elements going back to 1147. The chevet is noteworthy for the bell tower and the three chapels facing the transept. Inside, an elevation on three levels, with a false gallery under the gables, runs along the thick rib vaults at the entry to the choir, primitive examples of an art in transition.

ROMANESQUE CHAMPAGNE

Romanesque Champagne owes its status as a land of passage to its geography, free of obstacles; in the eleventh century it was the intermediary region between Paris (it begins twenty-four miles, or forty kilometers, east of the capital) and the frontiers of the Holy Roman Empire. It is bordered to the south by the plateau of Langres (at that time governed by Burgundy) and to the northeast by the barrier of the wild forests of Ardennes, sparsely peopled.

The political geography was no more unified than it was in the Île-de-France. The Romanesque in Champagne was nourished by a prestigious past, whose heritage permitted the elaboration of a varied style reflecting the artistic concerns of ancient times. Thus, Ardennes reworked the basilicas inherited from the Gallo-Romans: stark nave walls resting on arcaded pillars, flanked by lower aisle walls made of light materials, and covered with thatched roofs—which have disappeared or been replaced by stone. As was the custom in Champagne, the nave is covered by a timber roof. The modest dimensions of the ecclesial space open to the laity contrasts with the eastern sections designed for the clergy; the transept and choir are partially vaulted, and rib vaults may have made an early appearance here. An important element of the building in the basilican tradition, the triumphal arch (an arcade opening on the sanctuary) is by far the most richly ornamented, with archivolts, paintings, sculpted capitals (Machault), or consoles. With the

BOËSSE, PORCH SEEN FROM THE INTERIOR, MID-12TH CENTURY
With its open porch in the facade, this rural church of the Gâtinais belongs to a homogeneous local group. Equivalent in its function to the porches of Champagne, it is distinguished stylistically by a gallery bordered with an openwork wall of eleven arcades and an entry bay, all barrel-vaulted. The capitals of the monolithic colonnettes are sculpted in shallow relief with stylized palmettos and foliage. Furnished with side openings as well, this vestibule played a role in the processional liturgy.

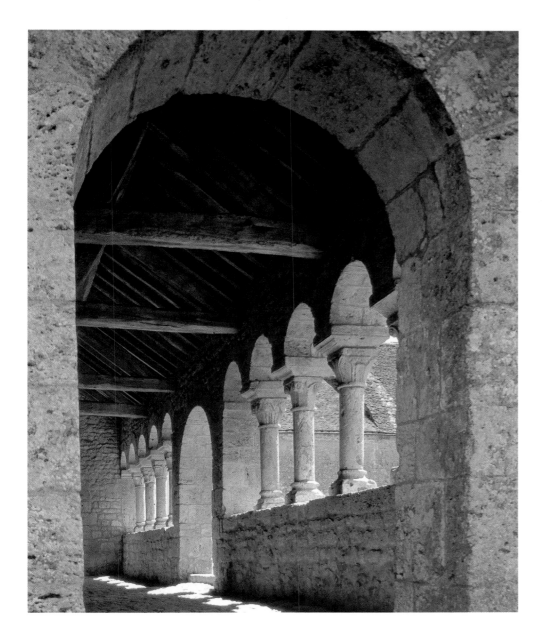

exception of those around Reims, the chevets of Champagne are flat (Chémery-sur-Bar), in the style of Carolingian and Cistercian churches. The facade-gable shines in its simplicity; in the absence of a transept, the tower of the church was placed in the west, forming a porch (church of the city walls of Sedan, Warcq). Champagne also has a tradition of low galleries in front of the nave, which are called Champagne porches (Cauroy-lès-Hermonville) and might be made of stone or wood. The churches of Ardennes contain a very homogeneous group of about sixty baptismal fonts in simple forms covered with animal masks or human heads (Bogny-sur-Meuse). These were sculpted in Meuse Valley marble in the twelfth century by a workshop that no doubt specialized in such forms but whose location remains unknown.

Champagne was much beloved by the Carolingian kings, who maintained many residences there.

The imprint of their art, present also in Ottonian civilization, is visible almost everywhere in the region. Provins, which has the largest number of Romanesque buildings, was the stronghold of the counts of Champagne, who endowed the city richly. A former private oratory, the chapel of the palace, founded and dedicated in 1176, reserved its upper story for the count's family, while the lower chapel welcomed officers and servants. This formula clearly recalls the palatine chapels of the Carolingian period, whose upper story communicated with the apartments of the king's palace. The principle enjoyed great success, and it was subsequently applied to the Sainte-Chapelle in Paris.

The persistence of Carolingian forms is manifest in the important churches of the High Romanesque. At Montier-en-Der, the former abbey church is a great timber-roofed basilica, whose nave since 998 has had a three-story elevation furnished with galleries. A western avant-corps dominated by two towers recalls the Carolingian westwork, as at Saint-Pierre in Jumièges in Normandy. In the same group, the superb and luminous church of Vignory, from the second half of the eleventh century, reveals false galleries with clerestory. The greatest of these wood-ceilinged basilicas was Saint-Remi in Reims, earlier than Vignory. This church, one of the great pilgrimage sites of northern France, seems disappointing on first view, as its facade was too heavily restored in the thirteenth century. This impression vanishes with the awesome sight of its Romanesque nave, whose impressive length and expansive width fit into the admirable dimensions of the interior space, whose added rib vaults do not mar the whole. The basilica, which remains the largest French church before 1050, contains eleven arcades, deep galleries, and a vast transept. The piers are of an astonishing originality for the time, composed of thick engaged columns or divided into fourteen shafts; the capitals are made of stucco, whose use confirms the Ottonian influence in this building. It is believed today that important artistic relationships existed between Normandy, the Île-de-France, the north, and Champagne, those regions most strongly marked by the Carolingian past. The collegiate church of the counts of Saint-Quiriace in Provins marks the Romanesque apogee and a late Burgundian influence. Initially planned to accommodate the dimensions of a cathedral, it was never finished. In the single transept, choir, and ambulatory, the Romanesque tradition is happily married to early Gothic.

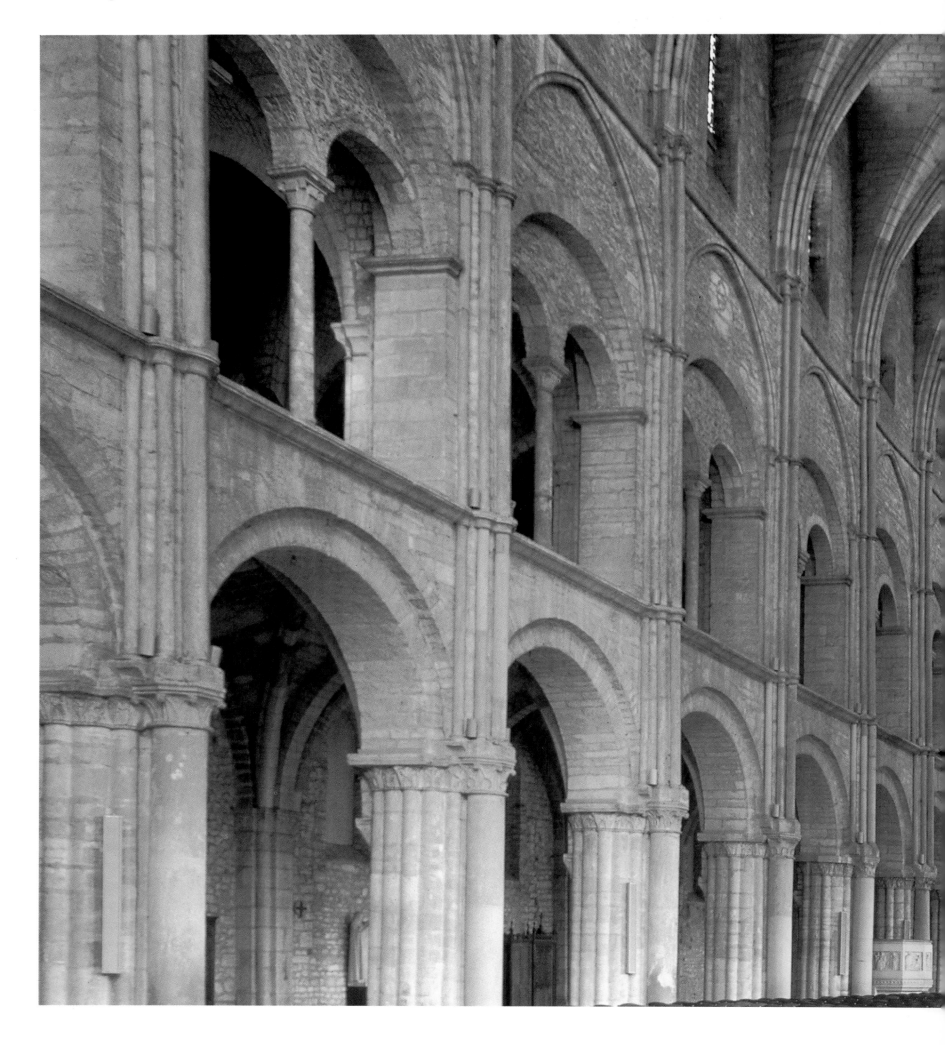

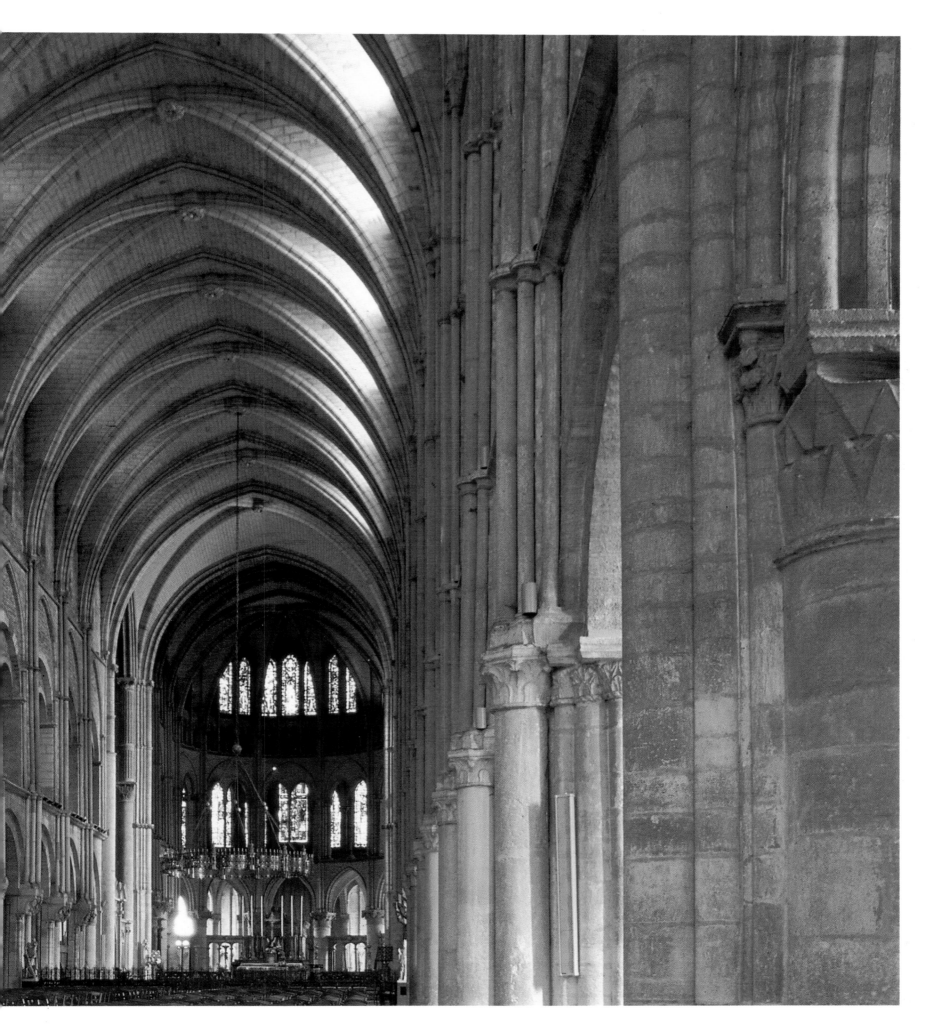

FROM ONE FEAT TO ANOTHER

The brief passage from the Romanesque to the Gothic in the monumental arts of the Île-de-France found its most convincing demonstration in the second quarter of the twelfth century. Until then, the style used for capitals and framing reliefs remained an extension of the solid local Carolingian tradition—interlacings, rinceaux, and spirals in shallow relief—mixed with outside influences from the Norman, English, Meuse River, Loire, and Burgundian traditions. They reflect, in general, an art of relaxed composition, with rounded modeling (soft drapery) and highly schematized forms (large heads, enormous eyes in Bury), whose popular accents persisted (the handsome capitals of about 1140 from the ancient collegiate church of Saint-Étienne, now in the Musée de Dreux). While the Gothic style eventually abandoned historiated decoration on the capitals inside churches, the early influence of the new tendency led to a more vigorous style in some buildings. In spite of the great number of portals in the Île-de-France that used only layers of geometric motifs (lozenges at Épône, stars at Gassicourt) for decoration on the tympanum, we know that by the end of the eleventh century narrative iconography also occupied this surface, even if it has rarely survived. The curious tympanum of the deconsecrated church of Mervilliers commemorates a donation made by a knight kneeling before his sovereign, in front of a cleric who blesses them. These naively sculpted characters are organized like figures in a frieze whose floating character well illustrates, in the years around 1100, regional sculpture's indifference to the subordination of the frame.

Artists concentrated their attention on the structure that framed the portal—its arches and the angled jamb that extended it. Their decoration calls on a repertory of toric or flowered motifs or of hoops and chevrons, seen most frequently (Villers-Saint-Paul). At Gassicourt, where the exterior archivolt is enlivened with arcades with modillions and circular piercings, the portal is surmounted by an oculus, an element often used in Romanesque art. In them might be imagined the future rose windows of the cathedrals. Its contours, richly molded and embellished, are simple in comparison with the portal of Saint-Étienne in Beauvais of about 1130, where the metamorphosis is obvious. The twelve colonnettes that divide it accentuate the symbolism of the wheel of fortune, around which ten characters riding up and down represent the ascension and decline of human destiny.

At the same time the important lessons of Toulouse, Vézelay, and Autun accelerated the rapid transformation of the Romanesque portal into the Gothic portal with the introduction, at the jambs, of the first statue-columns. Thin and solemn on the southern portal of Notre-Dame of Étampes, by their angular gestures and the circumvolution of the folds that accentuate their postures they express the influence of neighboring Burgundy, with its persistent loyalty to the Romanesque. It seems that the same sculptors worked on the royal portal of Chartres (1145–55), but under the direction of another, more creative, master, who emphasized the statues' verticality, asymmetry, and

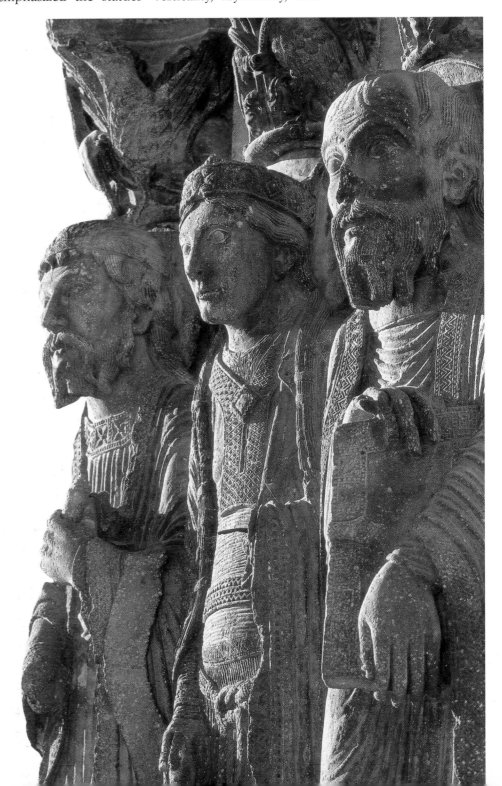

SAINT-LOUP-DE-NAUD, DETAIL OF THE LEFT EMBRASURE OF THE PORTAL, C. 1160
Following the examples at Saint-Denis and Chartres, statue-columns, with their emphatic verticality, became widespread. They represented patriarchs and prophets who prefigured the new Church, whose foundations they symbolized by forming part of the building's supports.

homogeneity. The statue-columns represent crowned kings and queens, who embody the ascendancy of Jesus. Associated with the prophets and the patriarchs, they constitute the symbolic foundation of Christ's Church and can be likened to columns of support. On the archivolts new figures that stretch out following the curves of the tympanum arches were derived from Poitou and Saintonge. The sculpture of the central tympanum was modeled with a remarkable degree of rigor and relief. At once the culmination of Romanesque art and the first burst of the Gothic, the work on the western facade of Chartres, while it invented little that was new, imposed an impressive classicism and a strong iconographic coherence.

Saint-Loup-de-Naud, imbued with the example of Chartres, achieved the same unity of its three portals. At Châlons-en-Champagne, the discovery of fragments of the gallery of the now-vanished cloister of Notre-Dame-en-Vaux has made it possible to reconstruct an exceptional proto-Gothic group, with foliated or historiated capitals and statue-columns supporting the arcades; it constitutes one of the major contributions to the understanding of transitional sculpture.

On the threshold of a new Middle Ages, it is clear that there are few experiments that Romanesque art did not make first. The expansion and perfection of the system of rib vaulting in the next period almost makes us long for the curiosity of the Romanesque architects, who had already imagined many kinds of vaulting. But the Gothic genius rests less in pure invention than in its approach to positive and negative volumes and its use of light. Gothic architects gradually dematerialized the walls, which gave way to stained glass, with its multicolored reflections. While on the central portal of Chartres the prestigious cathedral school extols profane knowledge to reach the clear and organized wisdom that the liberal arts dispense (including astronomy, geometry, music), inside, the stained glass upholds spirituality by its magical colors and an illusion of divine light bathing the sacred space, like the prelude to eternity.

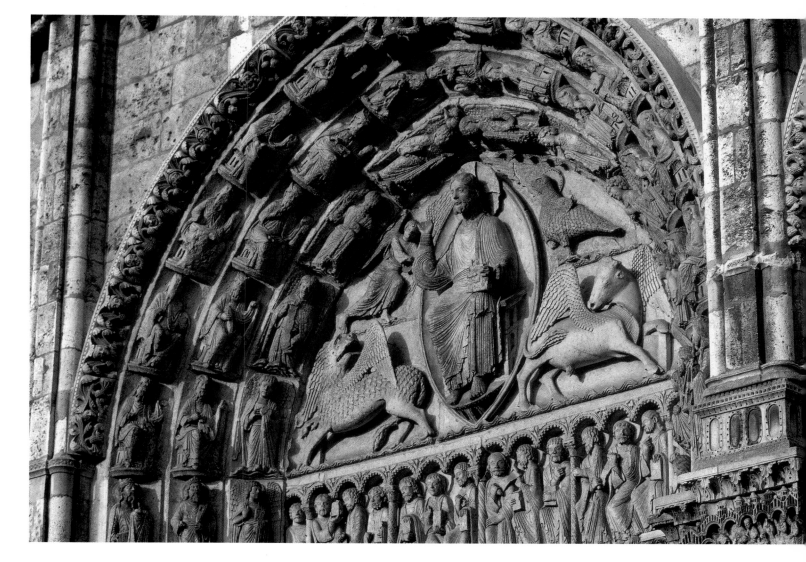

CHARTRES, CATHEDRAL OF NOTRE-DAME, WEST FACADE, DETAIL OF THE ROYAL PORTAL, C. 1150
Beyond its architectural importance, Chartres offers a vast iconographic program that makes the cathedral into a mirror of the visible and invisible world. The royal portal, which survived the fire that damaged the Romanesque building, is not really at the crossroads of the Romanesque and Gothic styles. Its originality of style and the coherence of its themes place it beyond the status of a transitional work. The Christ in Majesty at the end of time, surrounded by the tetramorph, achieves an astonishing degree of plasticity that inspired Gothic sculptors.

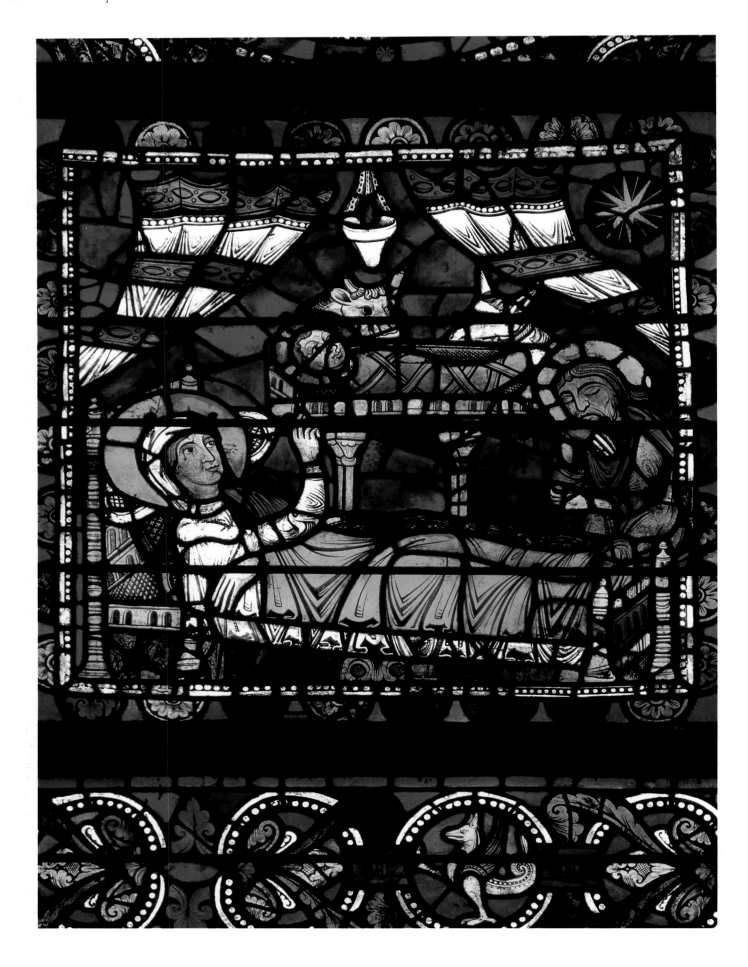

CHARTRES, CATHEDRAL
OF NOTRE-DAME,
STAINED-GLASS
WINDOW DEPICTING
THE NATIVITY,
12TH CENTURY

Opposite
CHARTRES, CATHEDRAL
OF NOTRE-DAME,
STAINED-GLASS
WINDOW DEPICTING
THE ANNUNCIATION,
12TH CENTURY

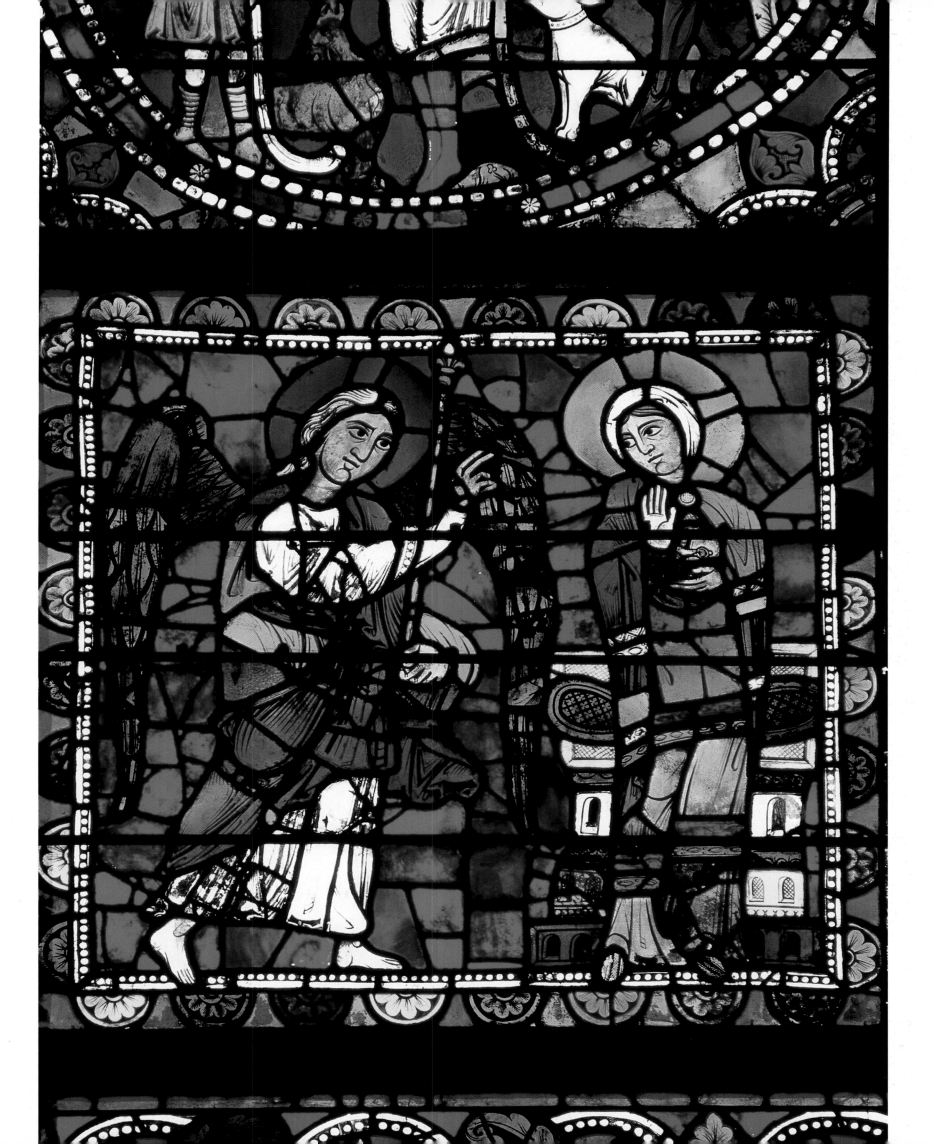

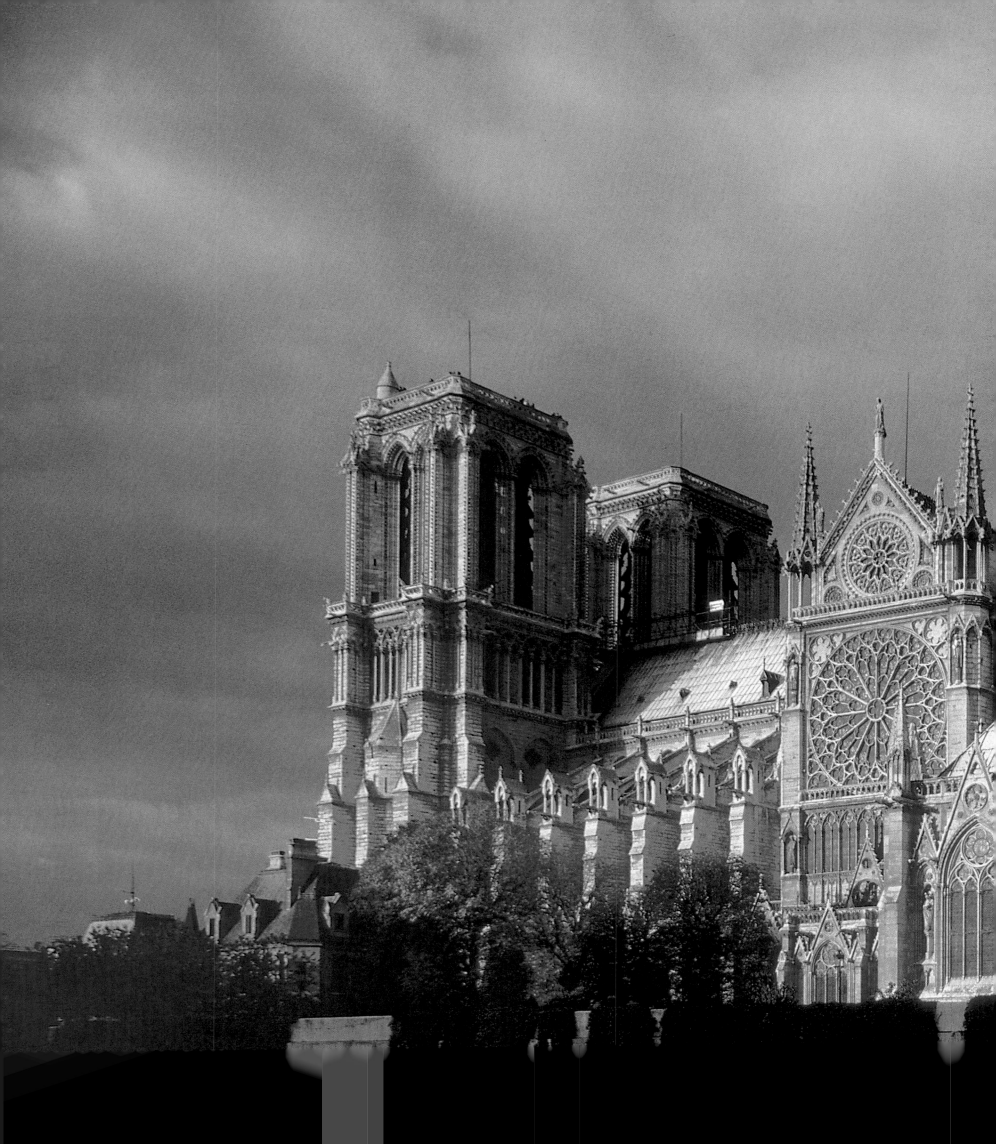

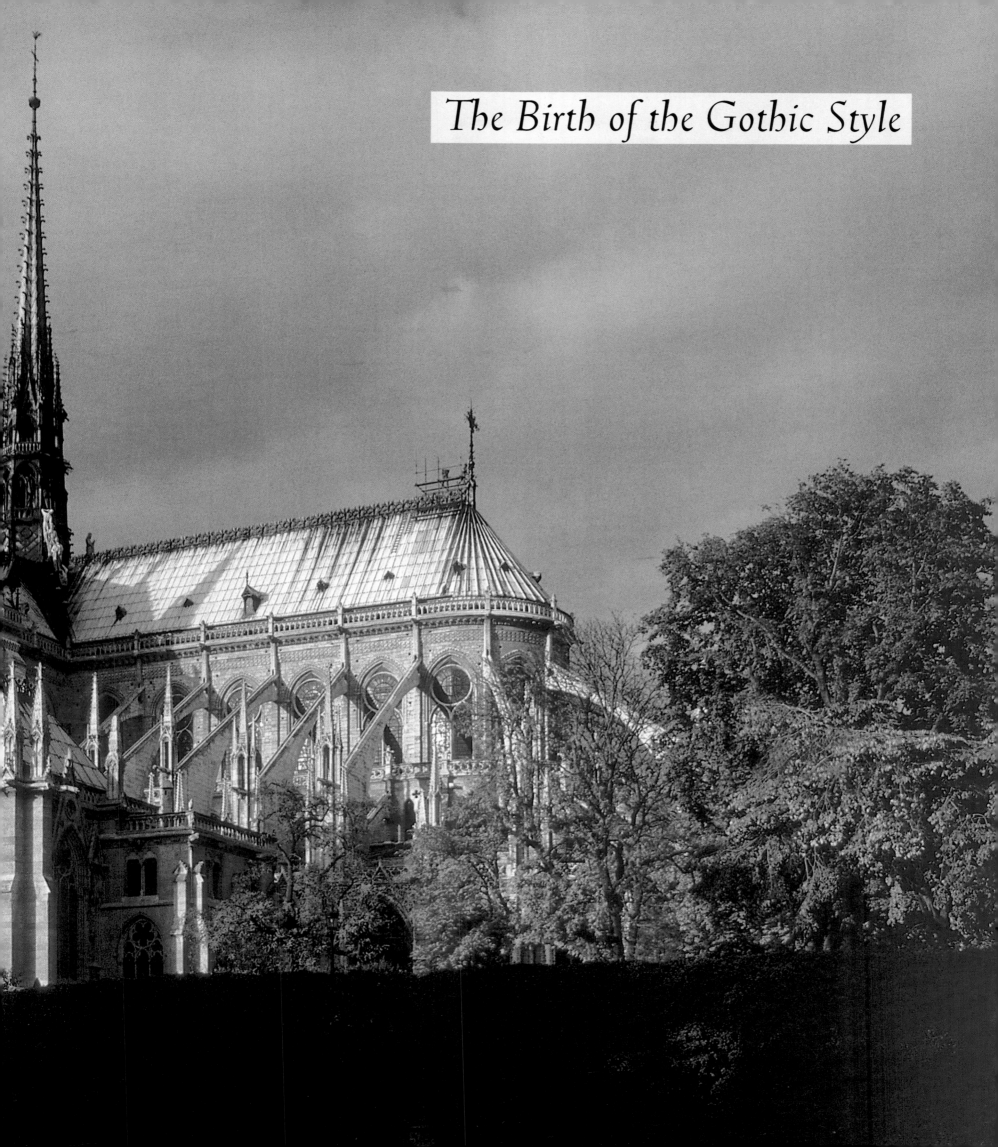

The Birth of the Gothic Style

T HE GOTHIC STYLE was really born between 1132 and 1144 at the abbey of Saint-Denis, under the impetus of Abbot Suger. It bears noting that the adjective "Gothic" is pejorative, meaning "suitable to Goths, or barbarians," and was an invention of the sixteenth century to designate a style rejected by the Renaissance, which was enamored of Greco-Roman antiquity. At the time the earlier mode was known as the "French style," since it was born in the Île-de-France and its diffusion was tied to royal expansion, of which the basilica at Saint-Denis was, from the beginning, the symbol.

Around A.D. 250 Saint Denis and his companions, Saint Éluthère and Saint Rustique, were decapitated by the Romans before the idol of the god Mercury on one of the hills overlooking Paris, known afterward as Montmartre, the martyrs' hill. According to legend Saint Denis then picked up his head and walked to the site of the abbey to point out the place where he wanted to be buried. Early on, his tomb became a site of pilgrimage. Saint Geneviève built a magnificent basilica there in 475; King Dagobert (r. 629–39) founded a Benedictine monastery there. Most of the French kings were buried at this site.

THE ABBOT SUGER AT SAINT-DENIS

Born in 1081 to one of the poorest, most humble families, Suger was entrusted to the abbey as an "oblate" at the age of eight or nine years. On the benches of the abbey school he befriended the son of King Louis VI, the future Louis VII. This friendship lasted until his death in 1151. He became minister to the father and then the son, whom he even replaced as the kingdom's regent from 1147 to 1149, when Louis VII left for the Second Crusade. On his return the king granted Suger the title "father of the country."

Suger spent his whole life at the abbey, as if in the bosom of a beloved family, where the greatness of God, that of the king, his representative in the "temporal" domain, and that of the abbey all converged. Suger worked constantly for them all, with not only an astounding and indefatigable vitality but also a keen gift for administration.

In 1132 he undertook the reconstruction of the old abbey church. He began with the facade, the towers, and the two bays of the narthex over which they stood. This construction, completed in 1140, is still Romanesque in its massive, defensive character—it is

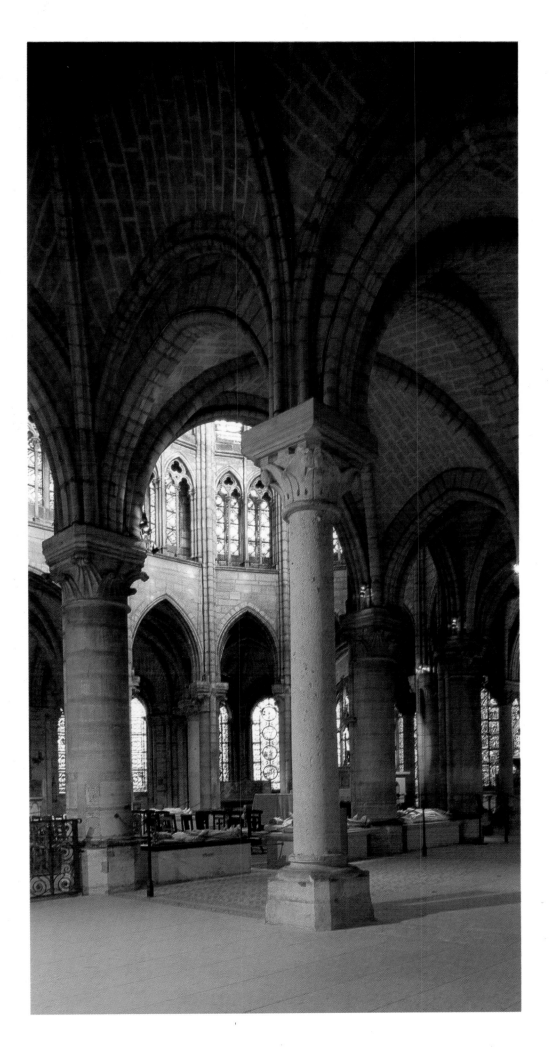

even furnished with crenellations—and in its use of semicircular arches. But the pointed arch had already made an appearance here, and the sculptures of its three portals—unfortunately, today severely mutilated—give evidence of an innovative spirit. At the center is the Last Judgment, to the right the last communion of Saint Denis, to the left his martyrdom and that of his companions.

From 1140 to 1144, Suger had the crypt, the choir, and the double ambulatory along with its chapels built, marking a stylistic revolution. Suddenly, a new style was born, made manifest at the inauguration of the church on June 11, 1144. When, in the thirteenth century, the completion of the church was entrusted to Pierre de Montreuil—the creator of the southern rose window of Notre-Dame Cathedral—he respected Suger's work in constructing the nave and transept, with the exception of the upper parts of the choir. It is moving to stroll through the ambulatory, the first great success of nascent Gothic art. However, comparing the pillars and vaulting with those of Laon and Notre-Dame-de-Paris, we note that the dynamic of the masses had not yet been perfected: the pillar is too slender, almost a colonnette, whereas the arches of the vaulting are somewhat heavy.

Since Suger had wanted the building to be generously filled with light, the chapels have large bays. The art of stained glass likewise flowered at Saint-Denis. But of Suger's stained glass—which celebrated Christ in his genealogy (the Tree of Jesse), his life, and his Passion, demonstrating the concordance of the Old and New Testaments, and narrating the legend of Charlemagne and the First Crusade—only fifteen panels remain, which have been remounted together. In that of the Annunciation Suger himself is represented, dressed in a Benedictine habit and prostrate at the feet of the angel and the Virgin.

The abbot loved to organize sumptuous ceremonies. On holy days people thronged to Saint-Denis; at the time, religious ceremonies offered almost the only entertainment. It was a moment of popular rejoicing and relaxation. Nothing was too good for the Lord: Suger increased the number of sacerdotal ornaments and pieces of the goldsmith's art. At his death the treasury of Saint-Denis was almost as opulent as that of Santa Sophia in Constantinople, the richest in the world. A few pieces remain, now in the Apollo Gallery in the Louvre, such as an ancient vase in porphyry to which Suger added a mount depicting an eagle.

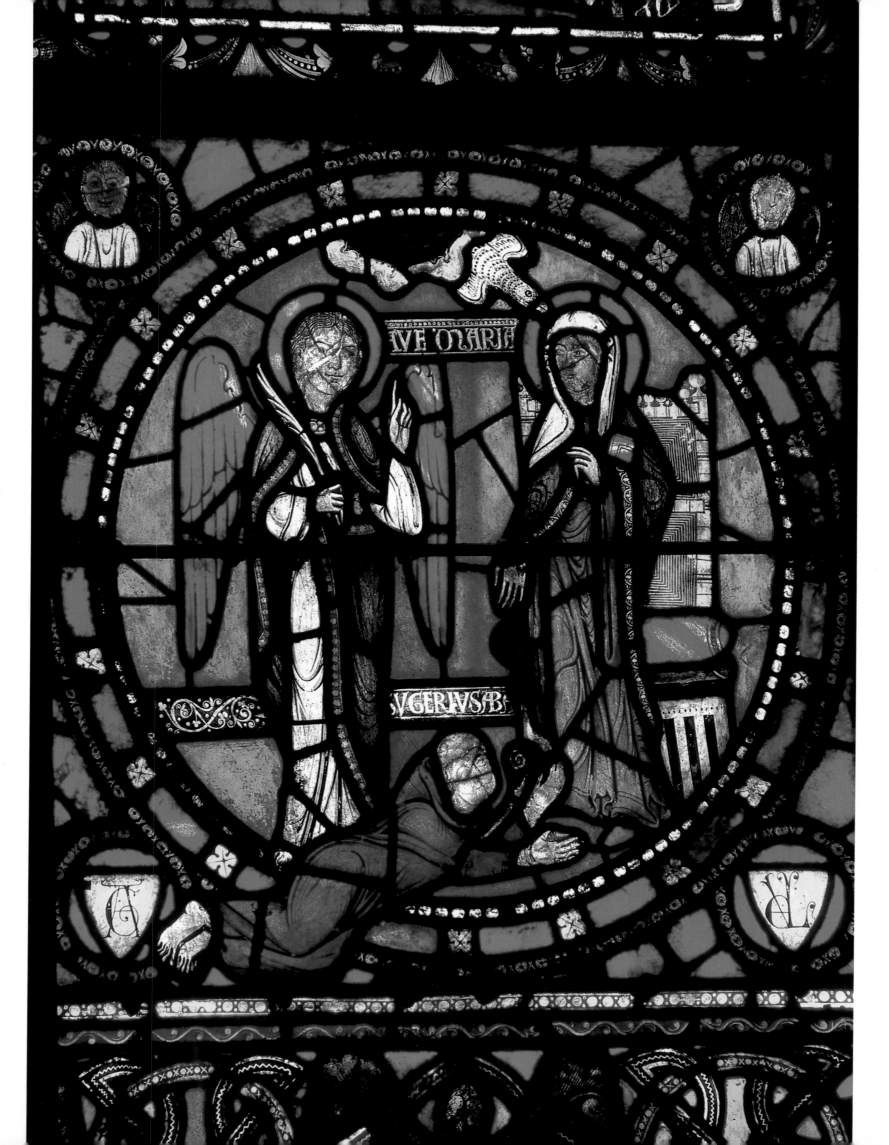

Opposite
SAINT-DENIS, BASILICA,
STAINED-GLASS
WINDOW OF THE
ANNUNCIATION,
12TH CENTURY
*Abbot Suger had himself
represented in this
window of the Annun-
ciation, where he is
depicted prostrate in
prayer at the feet of the
Virgin.*

ABBOT SUGER AT THE GOTHIC MOMENT

The passage from the Romanesque to the Gothic may be seen in the abbey church of Saint-Denis, conceived by Abbot Suger. Vestiges of the Romanesque spirit persist in such elements as the vestibule of the two bays, built before 1140 (reminiscent of Jumièges, Vézelay, or Moissac), while its innovation lay in the rib vaults found throughout the church. Similarly, Cluny and Vézelay had already used the formula of three portals in the west facade, but these were small lateral portals. They become larger at Saint-Denis. Their structure and iconography alternate between new elements (the statue-columns) and conventional ones (the calendar, the treatment of drapery). The piers in the facade did not attain a balance due to the ambiguous placing of the blind arcades, the new rose window, and the portals.

Abbot Suger was also responsible for rationalizing the role of stained glass within the ecclesiastical space. Each of the stained-glass windows has a didactic role that implies a specific placement within the building. While Saint-Denis did not achieve homogeneity, it offered the delightful blossoming of new colors, among which a deep blue predominates. This chromaticism can be compared to the techniques of contemporary illumination and enamel, which henceforth evolved together.

Suger's ideas include new themes, such as the Tree of Jesse. The first of its kind in stained glass, it presents a geometric pattern from which emerges the genealogical tree of Christ. The rich border of vegetative motifs also became standard.

LAON, CATHEDRAL,
C. 1150–1200
*This view of the eleva-
tion, at the level of the
transept crossing,
shows the architect's
predilection for a profu-
sion of columns.*

ART: ANTICHRIST OR DIVINE REFLECTION?

As leader of this artistic revolution, Suger was its defender within the church, the world responsible for the life or death of art. Art did have an enemy: Saint Bernard, the founder of the austere monastery of the Cistercians, which had broken with the Benedictine order of Cluny, whose morals he considered lax. Bernard had undertaken a violent campaign against the sumptuousness of the vestments and objects serving the cult, as well as against the ornamentation of churches. While it is true that the Cistercian buildings are also works of art, they are very spare.

Animated by a faith no less strong than that of Saint Bernard but more human, more open to the beauty of the world, and more indulgent of his fellow humans, Suger mounted a well-constructed theological defense of art in his writings. For the abbot, as for any Christian, human nature is good, being the work of God, yet also imperfect and incomplete, since humanity, in turning away from God, provoked the partial corruption of the world. The contemplation of works of art, as spiritualized objects and reflections of the true light—of God—allows the soul to elevate itself, purify itself, and travel the mystical path leading to divine communion.

LAON AND THE FIRST GENERATION OF CATHEDRALS

The example set by Suger was followed: in a few years, the important towns in the royal domain set to work constructing great cathedrals. Sens began to rise very soon after Saint-Denis, Laon about 1150–55, Noyon about 1150, and Senlis in 1153. Ten years later marked the beginning of the construction of Notre-Dame-de-Paris.

These "first-generation" cathedrals share distinctive traits. As a general rule, the nave has sexpartite vaults and a four-story elevation: vast arcades opening onto the aisles, gallery, triforium, and high windows beneath the vaults. The vaults are supported laterally with buttressed walls. In the "second generation," the nave has quadripartite vaults and a three-story elevation—arcades, triforium, and high windows—and the vaults are supported by flying buttresses. There were exceptions to this rule: the cathedral of Sens has three levels and no gallery; at Bourges, a second-generation cathedral, the nave vaults are sexpartite.

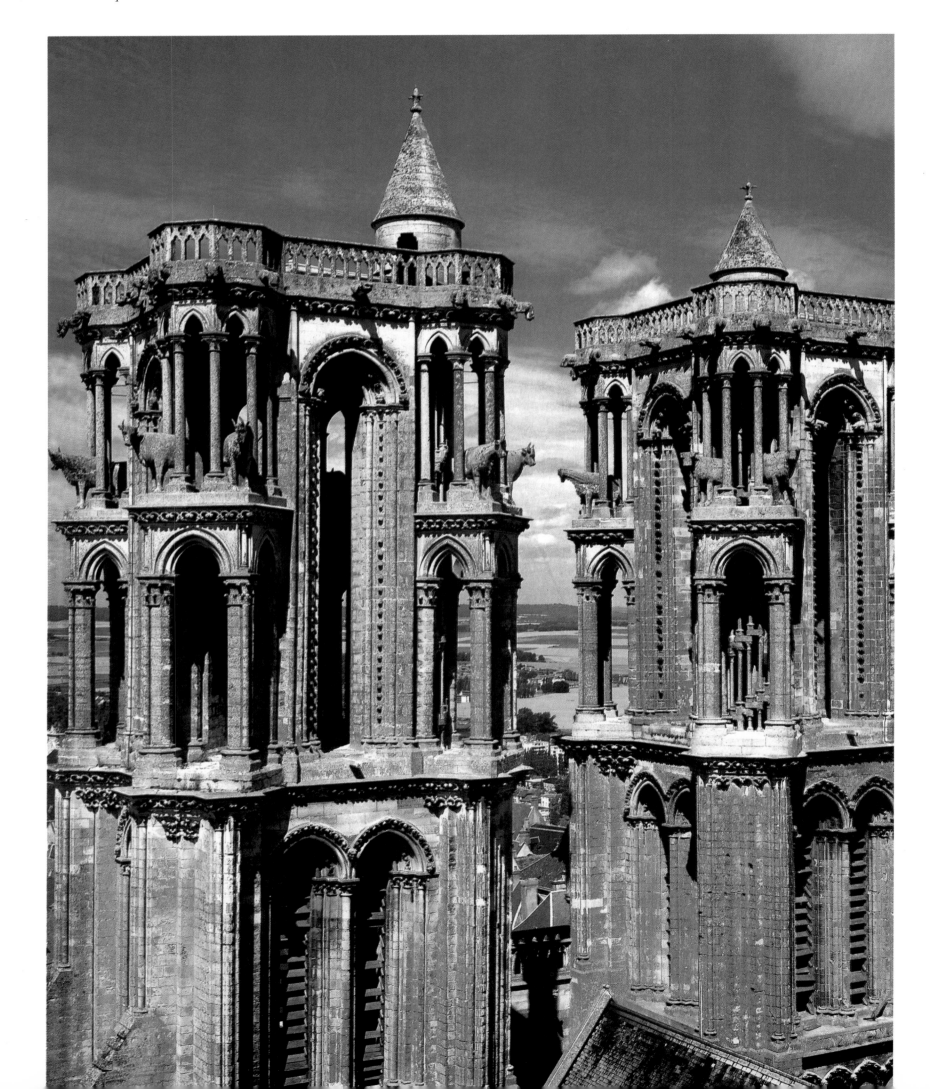

Opposite
LAON, CATHEDRAL,
THE HIGH TOWERS,
1150–55 AND 1200
*The Laon architect's
love for volumes and
columns is revealed
even in the high towers:
square and open, they
are flanked by octagonal
turrets. The sculptures
of sixteen oxen looking
out from the towers may
recall the animals that
helped transport stones
for the building.*

LAON, CATHEDRAL,
FLYING BUTTRESSES,
13TH CENTURY
*Flying buttresses were
added in the thirteenth
century to relieve the
load on the original
buttress walls. Placed
between the vaulting
and the tribune roofing,
they transfer the thrust
of the nave vaults to
powerful abutments.*

The Gothic vault, or rib vault, is made up of curved masonry panels set on arches or ribs, which might be pointed arches or semicircular arches with diagonal ribs (also known as ogives). The vault is quadripartite when there are four segments, sexpartite when there are six. The sexpartite vault extends over two bays of a nave, the quadripartite vault over only one.

The Romanesque semicircular vault exerts a continuous thrust along the walls supporting it, which makes it necessary to build thick walls infrequently pierced with openings. The Gothic vault, on the other hand, exerts its thrust only on the points where the arches end, and the supporting columns, then the pillars, or "piers," alone bear this weight and transfer it to the ground; hence the walls, which no longer play a supporting role, can be lightened and furnished with large bays.

We are fortunate to have the cathedral of Laon preserved almost intact in the manner it was built between 1150–55 and 1200. The only later reworkings are the substitution of a flat chevet for the semicircular chevet, as well as the precautionary addition of flying buttresses to reinforce the original primitive buttressing walls. The thrust of the Gothic vault is not only vertical but also on the bias. To counter the second effect, the architects of the first cathedrals supported the naves through the construction, on the second story, of a circulation corridor, the gallery. It served as a relay, for with the help of the buttressing walls above it, it provided a powerful abutment to the lateral thrust. The invention of the flying buttress about 1170, which conducted the lateral thrust directly from the large vault to the abutment, allowed the suppression of the gallery and the buttressing walls. With this crucial invention, the second-generation cathedrals could reduce the levels to three and heighten the aisles. The naves became higher, too, since the flying buttresses provided more efficient support.

The vaults of the nave in Laon are sexpartite, those of the aisles and the ambulatory quadripartite. A sexpartite vault distributes most of its weight on the four extremities, whose support must be reinforced; at Noyon and Senlis, a "strong pier" alternates with a "weak pier," which is not very aesthetically pleasing. At Laon, the piers are equal—except for the last two double bays of the nave, near the transept—and the alternation is raised to the level of the colonnettes extending the piers, which are either three or five in number.

While the name of Laon's architect has not come down to us, his personality shines through his work. A lover of volumes—so well enhanced by the handsome yellowish stone of Laon, which has not aged—especially curved volumes, he increased the number of colonnettes, which he emphasized by marking them with horizontal bands (they are "ringed"). He even used them to decorate the magnificent pierced towers, the highest of which exceeds 245 feet (75 meters); about these towers Rodin said, "They are like standards proclaiming far and wide the rightful pride of man." They were supposed to number seven, with six framing the north, south, and west facades two by two, and the last surmounting the crossing of the transept as a lantern tower; two of those intended for the transept, however, were never completed.

The exuberant multiplication of these towers, the refinement of the lantern tower surmounting a rare octopartite vault (with eight segments), the construction of the covered porches on the principal facade and of a large gallery on the second story of each of the transepts—all of these elements reveal the architect's desire to make his cathedral an inexhaustible summary of everything known at that date, a distillation of architectural beauty.

THE CROWNING OF SENLIS

Senlis, an important town since Romanesque times, witnessed the election of Hugues Capet in 987. It remained one of the favorite residences of the kings of France, who loved to hunt in the surrounding forests and had found in the area a place where their dynasty was definitively accepted. Begun in 1153, the cathedral did not include a transept, which was added around 1240, along with the highest of its towers. Unfortunately, it burned down in 1504; its aisles, the facades of the transept, and especially the tall windows and the vaulting of the naves were reconstructed on a higher level than that of the original vaults.

Of the twelfth-century cathedral there remains in particular the first levels of the elevation, in which we note the alternation of strong and weak piers, as well as the main facade. The latter is pierced with a large portal giving onto the nave and two doors opening into the aisles and features three rose windows

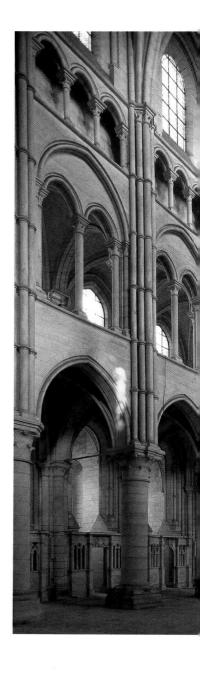

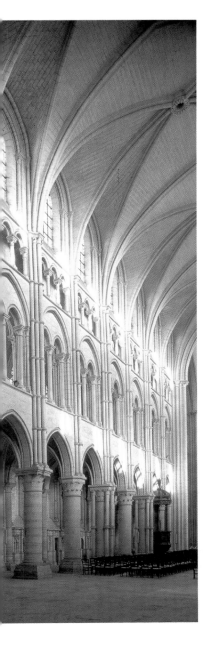

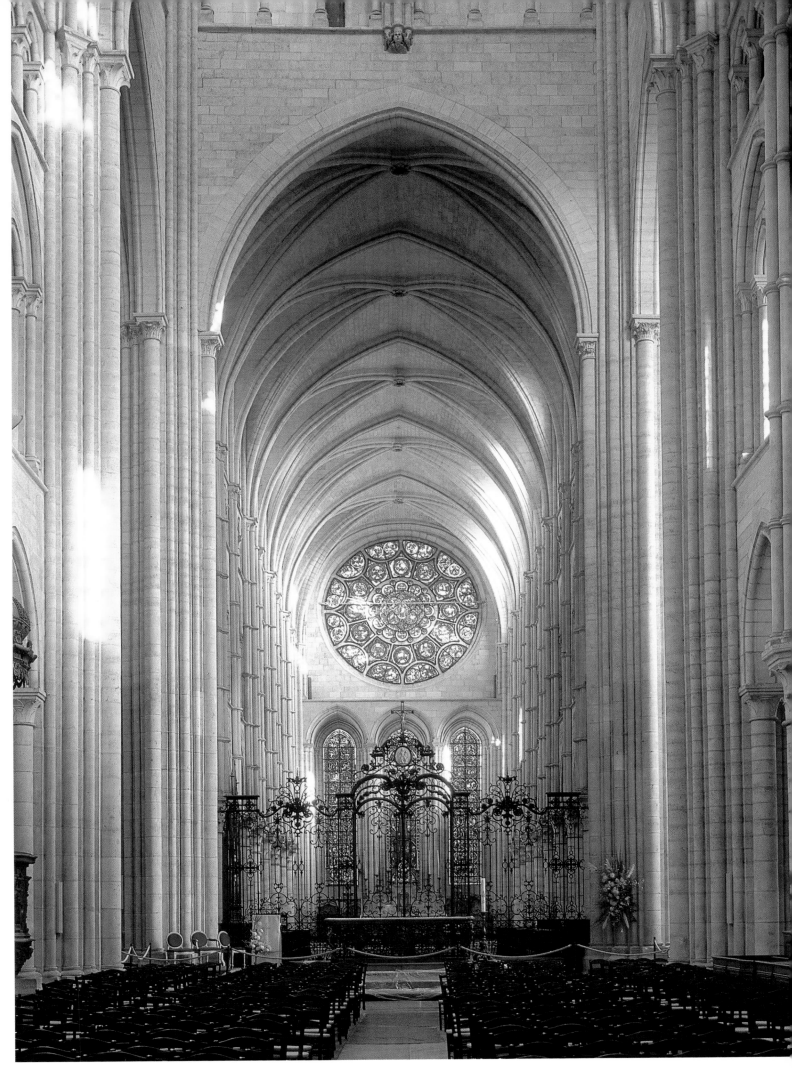

LAON, CATHEDRAL, ELEVATION (*ABOVE*) AND CHOIR (*RIGHT*), BETWEEN 1150–55 AND 1200

Laon has remained as it was originally built, in the pure style of the Gothic "first generation": elevation with four levels (arcades, galleries, triforium, high windows), sexpartite vaults (with six vault shells, or curved sections of masonry) resting on two bays. It sums up all architectural knowledge of the time in one impressive accomplishment.

above the doors. Executed about 1185–90, the group of sculptures on the central portal, a masterpiece of twelfth-century Gothic style, constitutes a major innovation: the first appearance of the theme, so frequently repeated subsequently, of the Virgin's death (on the lintel to the left), resurrection (on the lintel to the right), and coronation (on the tympanum). In the tympanum arches we see the saints in Heaven, patriarchs, prophets, and the ancestors of the Virgin celebrating the event. The embrasures are decorated with statue-columns depicting individuals who prepared for the coming of Christ: John the Baptist, Samuel, Moses, Abraham—ready to sacrifice his son Isaac when God, to test his faith, commanded him to do so—the old man Simeon, the prophets Jeremiah and Isaiah, and King David. The bases of these statues are decorated with small bas-reliefs depicting the labors of the months. The organization of a Gothic portal like this one is symbolic: below, small scenes evoke human life and offerings to God; the embrasures depict the "great models," whose examples we are supposed to follow; on the tympanum, the principal figure on the portal, who might be Christ, the Virgin, or a saint, leads us into the spiritual world, symbolized by the molding of the arches.

The Coronation of the Virgin was one of the favorite themes of Gothic art. Through it is expressed the cult of the woman, her beauty, her tenderness, as well as a religious doctrine that evinces optimism in its insistence on the salvation and generosity of divine grace. Mary is the first human being to whom the New Covenant and the eradication of original sin were offered; it is the new humanity that Christ crowns in the form of Mary.

Notre-Dame-de-Paris

The original architect of the cathedral of Notre-Dame-de-Paris is as unknown to us as that of Laon. His character, as revealed to us by his work, is different: we can perceive a mystic whose love for his art and the divine drove him to go beyond the reasonable, balanced, and still prudent fullness of Laon. The height of the nave under the vaulting was 80.5 feet (24.5 meters) at Sens, 79 feet (24 meters) at Laon, 59 feet (18 meters) originally at Senlis, 74.5 feet (22.7 meters) at Noyon; the architect of Notre-Dame-de-Paris pushed it to 108 feet (33 meters). No less auda-

ciously, he added a second aisle and a second ambulatory. Let us imagine books between two bookends of the same height: such are Sens, Laon, Senlis, Noyon. Let us now imagine large books with smaller ones on either side and bookends lower still: such is Notre-Dame-de-Paris. It can be seen that the main piers introducing the choir tilt away from each other; in the nave, this tilt is less perceptible to the naked eye but it is real, for the nave walls each deviate about four inches (ten centimeters) from the vertical. The building is in no danger of collapse—the visitor runs no risk!—but the architect went to extremes, given the technique of the buttressing walls. The invention of the flying buttress, which he himself no doubt began to utilize, came just in time to reinforce his work. Like the architect at Laon, the creator of Notre-Dame loved pure architecture: the original building was austere. We must imagine it with a four-story elevation, like that of the first bay of the nave, the only area still bearing witness to this original elevation: large arcades, gallery, small rose window in the triforium, window beneath the vaulting. It was about 1230 that the high windows were extended downward and the small rose windows of the third level eliminated. Between 1250 and 1270 Jean de Chelles and then Pierre de Montreuil enlarged the transepts by a single bay, which they fitted with rose windows that were extremely innovative in their lightness; those at Chartres, older by only a few years, still contained a large proportion of stonework.

Perspectives on Infinity

The original architect of Notre-Dame was also very inventive. Just as he defied the laws of gravity, he seems to have wanted to go beyond the architectural means at his disposal. Did the alternation of the thrusts of the sexpartite vault pose a difficult problem? He was able to transform this inconvenience into an aesthetic advantage. His discovery was to bring the alternation of the strong pier and weak pier to the level of the row of pillars separating the aisles, the strong pier being made up of a cylindrical column surrounded by colonnettes. In this way the look of the colonnade avoided monotony. He made every effort to avoid repetitions and symmetries, at the risk of greatly complicating the design of the planes and their execution. The choir is narrower than the nave, itself

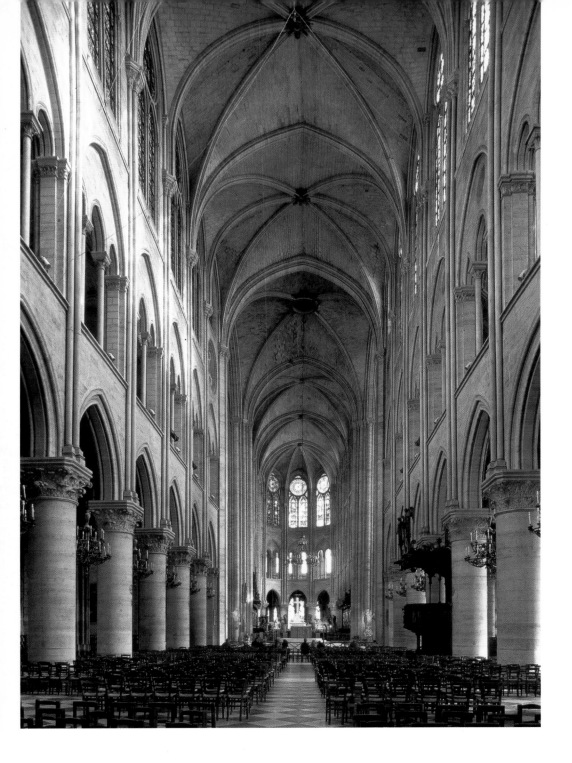

less broad than the transept: the crossing of the transept thus forms not a square but a trapezoid. The two ambulatories and the northern and southern aisles have different widths, between themselves and in relation to the others. The nave, instead of being constructed as an extension of the choir, is about three degrees off, a peculiarity of which Notre-Dame-de-Paris is not, however, the only example; if we look, for example, from the north aisle toward the south aisle, we see not a simple alignment of the columns but, rather, a forest in which the shafts of the columns draw the eye one to the next, in an endless movement, seemingly evolving without order, yet forming a harmonious whole. We experience an impression of infinity, although the height of the building is finite.

FIGURES OF HEAVEN AND HELL

Notre-Dame-de-Paris is also a true museum of Gothic sculpture, since sculptors worked on it for two centuries: the Virgin and Child of the Sainte-Anne portal, meant for the previous church and refitted to the new cathedral, was produced about 1145–55, while it was not until 1351 that the choir screen in painted stone narrating the life of Christ was finished—the work of Pierre de Chelles, Jean Ravy, and Jean Le Bouteiller. The group of the Virgin and Child still bears the imprint of the solemn schematization that characterize the great Romanesque compositions; the choir screen bears witness to the smiling and spiritualized realism toward which the Gothic progressively tended.

Unfortunately, all the great sculptures of the embrasures and the piers of the portals are nineteenth-century copies, replacing those that were destroyed in the eighteenth century by Jacques-Germain Soufflot, then by revolutionaries. There remains, however, the Virgin of the pier on the northern portal: she bends forward to show the child Jesus—who has, alas, disappeared—and this movement absorbs her whole being, her clothing forming a large wave that moves toward Christ.

We should compare it with the crowned Virgin and Child offered for the veneration of visitors on the transept crossing: the fourteenth-century sculptor represented Mary as a pretty, charming, and refined woman. Other women are less commendable, such as the nude devil on the central portal of the principal facade, representing the Last Judgment, who urinates on a bishop's head; or a woman who distracts students in one of the bas-reliefs on the southern facade portraying university life. Mary is again celebrated on the left portal of the principal facade (1210–20), combining two scenes, as depicted in Senlis, of the Virgin dying among the Apostles and coming to life among the angels, into one. The scene of the coronation of the Virgin, less hieratic than that of Senlis, is a universally admired masterpiece. And there always seem to be different details to discover in these sculptures, which represent the ages of man, the calendar, the seasons, the labors of the months, the lives of the saints, including Saint Marcel and Saint Stephen, and pious legends, such as that of Theophilus, narrated on the tympanum of the northern portal.

The Secrets of the Gothic Architect

I**T IS AMAZING** that these first architects, exemplars of an eminent science and artists of highly refined thought, have not left us their names. This anonymity certainly disappeared in the thirteenth century, as evidenced by the famous inscription on Pierre de Montreuil's tombstone, which celebrates him as a "doctor of stones" (a play on the university degree Doctor of Letters or Science). It seems that the success of the first Gothic architects laid the foundations for the prestige of its members, who remained members of the popular class, although very honored ones.

The master of the work (the director of the project) was not the architect but the Church, in the person of the bishop and his chapter. The Church was very specific about the dimensions of the edifice and selected among many projects. Assisted by a draftsman and perhaps a foreman-mason (who laid out the position of the stones), the architect devised the building's plans and made the drawings and the patterns for each molding and column, which went to the stonecutters. The latter did not set them, for this was the task of the masons, aided by the cement millers who prepared the mortar.

In the Middle Ages the rights of the inventor, like those of the artist and the author, were not protected. Furthermore, employment laws did not exist. The various artisans protected their professions in two ways: through skill acquired after many years of apprenticeship, which, for the best, made their work inimitable, and through knowledge of a body of secrets, which were never divulged.

THE THREE- AND FOUR-POINT ARCH

The fundamental secret of the Gothic architect is the method, invariable in its principles, by which he drafted his drawings and plans with a compass and ruler and secondarily with a square.

For example, let us take the setting out, or calculation, of two of the most popular types of pointed arches, the four-point arch (also known as the four-centered arch; it includes the ogee arch) and the three-point arch (also known as a three-centered arch; it includes the trefoil arch). Starting from a particular point, the architect drew two perpendicular axes and, on the horizontal axis, he located two points marking the inner extremities of the pointed arch; let us call the segment joining them the "base" of this arch. In the four-point pointed arch, the centers of the arcs are the points marking the first and the third quarters of the base and the endpoints on the base. Their radius is thus equal to three-quarters of the base. In the three-point pointed arch, the centers of the arcs are the points marking the first and third thirds of the base. Their radius is thus equal to two-thirds of the base. Next, parallel curves are drawn from the same centers, indicating the exterior lines of the arch.

THE DIMENSIONS OF THE MATERIAL

The architect drew a quadripartite vault in many stages. First he drafted one of the pointed arches in elevation and the entire vault in plan, without showing the connecting material, as if the vault were reduced to the arcs of its interior. In a second drawing, he repeated this same elevation and the same plan, this time including the dimensions of the material. In a third drawing, the construction lines of the preceding drawing were omitted. In the last two drawings he studied the lines of the diagonal rib arches.

In any geometric form, if one dimension is a whole number, any other will be a fractional number: if the measurement of the radius of a circle is a whole number, that of its circumference is a fractional number, since the circumference of a circle is equal to its

radius multiplied by 2π (2 x pi, or 3.14159265). If the measurement of one side of a square is a whole number, that of its diagonal is a fractional number, since the diagonal of a square is equal to its side times √2 (the square root of 2).

The design of a cathedral is a group of geometric figures. For a drawing to be possible, it was necessary to find a way to proceed from one segment measuring a whole number to another segment measuring a whole number, avoiding the use of any segment with a fractional measurement as a reference. Such a method was probably invented about 1100–50, when the discoveries of the great Greek mathematicians, including Pythagoras, Euclid, and Archimedes, became better known in France, perhaps through the writings of Arabic scholars. Early on, in fact, Islamic civilization became a crucible for two scientific traditions: the Greek tradition, especially geometry, and the tradition of India, which had a highly developed arithmetic.

This method worked for drafting not only the structure of the building but also all the figures decorating it and its windows, even the rose windows. Let us take, for example, the trefoil, the quatrefoil, the sexfoil (six-lobed figure), and the trefoil (three-lobed) pointed arch. Using his secret drawings as a basis, the architect made others—such as those in the Musée de l'Oeuvre de Notre-Dame, Strasbourg—that he could show the foreman, since they no longer included construction lines. These drawings he made by placing his master (secret) drawing over a blank sheet and marking the essential points by piercing them with the point of a compass.

For the Gothic architect this method also had a symbolic import: the initial point was considered the symbol of God, the two axes the symbol of Christ. The fact that the dimension of the material was added last expressed, in the language of geometry, that spirit and idea precede matter—that God conceived the world before creating it. Whole measures symbolize what the human mind

can see and fractional numbers what it has yet to learn: the secrets of God. In making each drawing, the architect accomplished a ritual through which he associated himself with the creative act of God; for him, work was prayer.

THE GOTHIC AESTHETIC

Far from being gratuitous, the Gothic aesthetic was imbued with symbolic meaning: the building, which the visitor can only summarize and survey through thought, is similar to the world, of which we have but partial knowledge; it is infinitely varied, and God alone can know it in its entirety. The finite and the infinite—the imperfection, on the one hand, of even numbers, repetitions, symmetries; the perfection, on the other hand, of everything that is unique as the reflection of God, such as the number 1, the odd prime numbers, 3, 5, and 7, and asymmetries—such were the subjects the architect of Notre-Dame contemplated in his dialogue with God through the forms and numbers governing his building. It is likely that the number 40—the measurement in feet of the width of the nave, a symbolic figure since it is the number of days Christ spent in the wilderness—produced the main measurements of the cathedral, in the same way that the world followed from God's creative act.

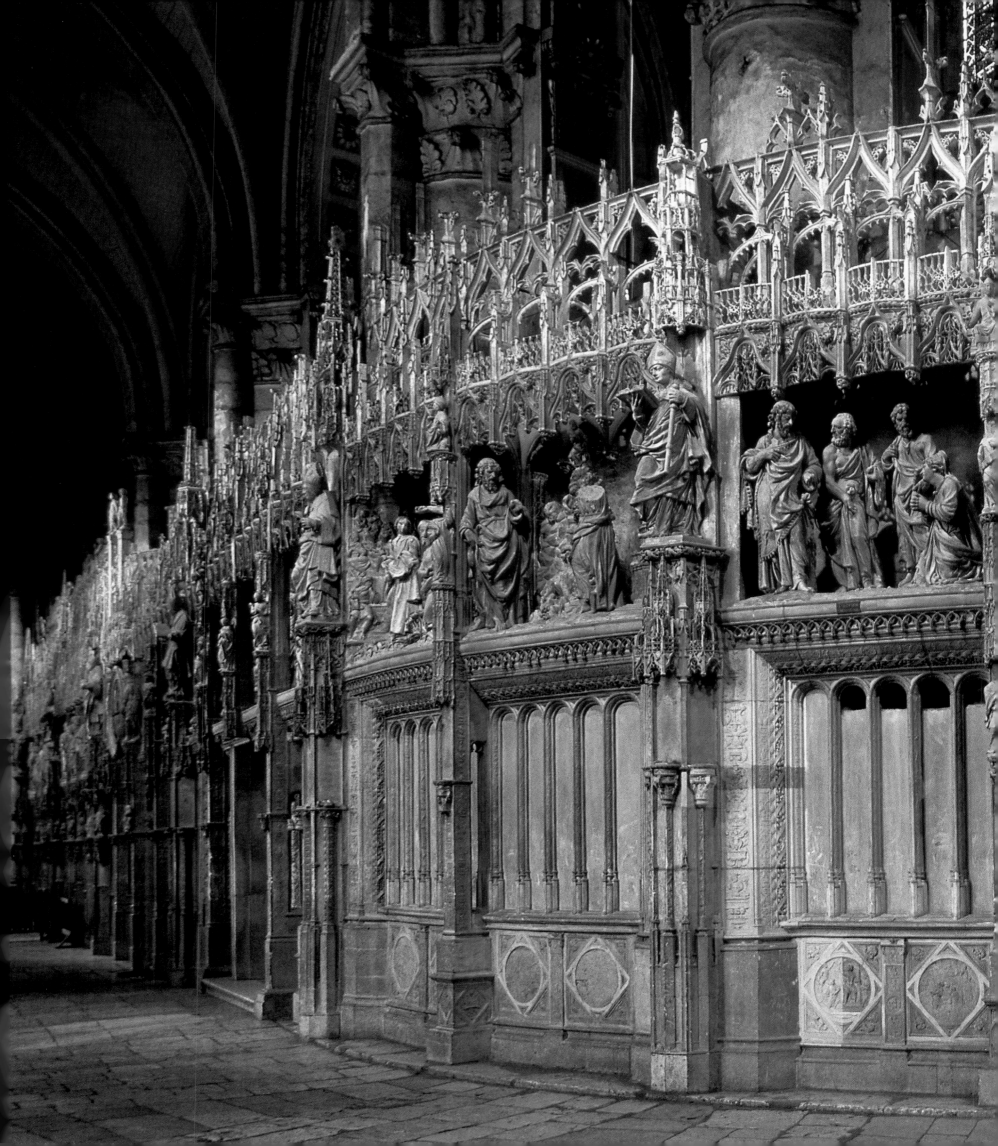

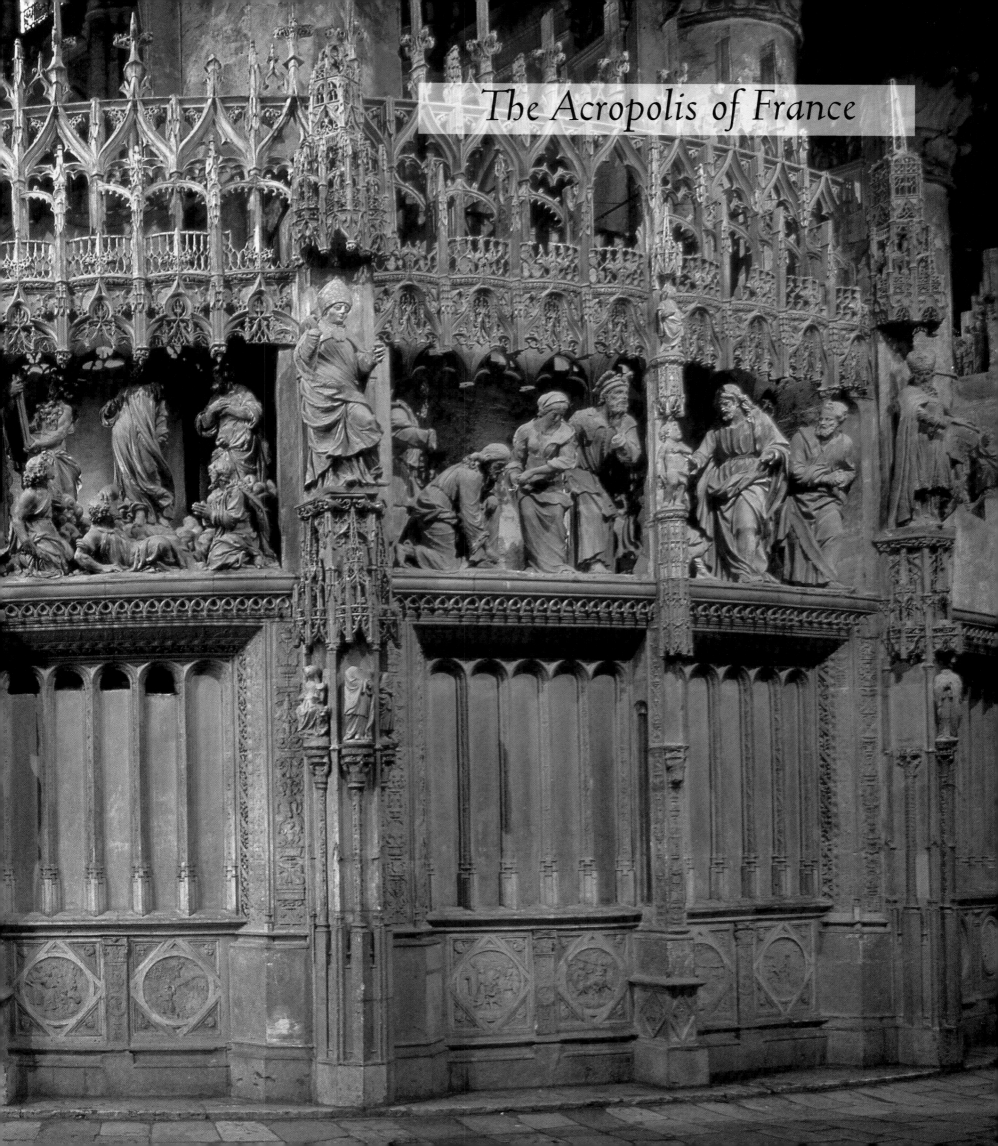

At the beginning of its history, Chartres was the capital of the country of Carnutes where, according to Julius Caesar, yearly gatherings of the druids of Gaul were held. After the conversion of the country in the third century, Chartres became a cult site of Marian pilgrimages. Many churches preceded the present cathedral on this site, but they all disappeared due to accidents or as casualties of war. In 858 a Carolingian church was built, of which the "Saint-Lubin cloister" remains, the most secret part of the crypt. Charles the Bald made a gift to it of a remarkable relic, the Virgin's tunic, the "Holy Chemise," which had been given to Charlemagne by the empress of Constantinople, Saint Irene. Destroyed by a fire in 1020, this church was replaced by a cathedral, begun by Saint Fulbert, itself almost completely destroyed by a fire in 1194. Only its crypt remains, the largest in France, with its two arms of 361 feet (110 meters) long, as well as the two towers and the western facade, built between 1134 and 1170.

CREATED IN ONE SWEEP

All of Europe was moved by the misfortune of the destruction of the cathedral. Gifts poured in from everywhere, offered by simple people as well as princes, for its reconstruction.

The architect entrusted with this task remains anonymous. A man of genius, he built the first "second-generation" Gothic cathedral; the vaults of its nave, indeed, are quadripartite, on a three-level elevation—arcades, triforium, high windows. He had to build on top of the ancient crypt and to integrate the two towers and the western facade. He was forced to build a very wide nave, 54 feet (16.4 meters), since this was the dimension between the two towers, itself equal to the breadth of the former nave. This space, designed to accommodate the mass of pilgrims, was too broad to be vaulted and had simply been covered with roofing. Desiring to make the nave soar, he raised it to 119 feet (36.35 meters), as opposed to the 108 feet (33 meters) of Notre-Dame-de-Paris. He strengthened the construction with double flying buttresses tied together with colonnettes and leaning against gigantic abutments, whose massive effect he lightened by a series of successive recesses. Around the choir apse they are reinforced by a second series of (single) flying buttresses and abutments. In the fourteenth century a third flying buttress was added above the first two. Of the nine towers planned, seven remained unfinished.

The rapidity of the construction, essentially completed in twenty-six years, from 1194 to 1220, the unity of its conception, the beauty of the stone of Chartres, which is ageless, the many obstacles overcome, and the ancient religious significance associated with the site, as well as the special grace attached to all beginnings—all contributed to making the cathedral of Chartres a work of art created in one sweep, universally venerated. "It is the Acropolis of France," marveled Rodin.

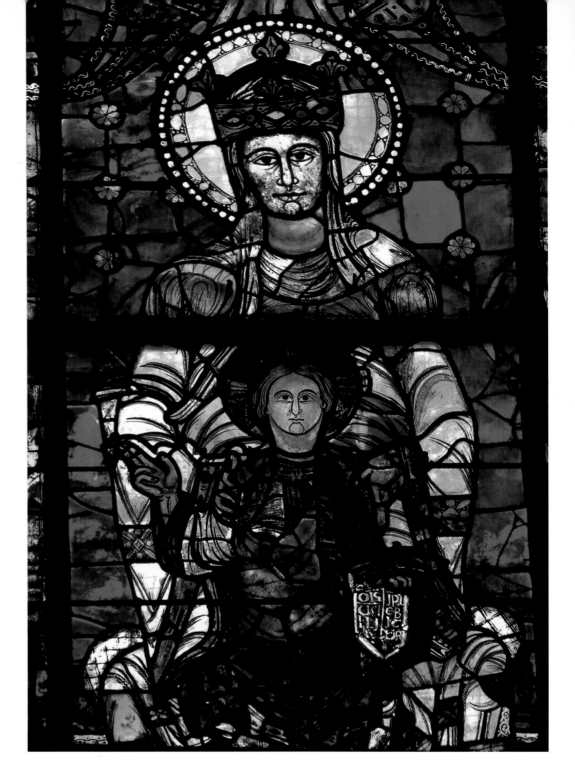

Preceding pages
CHARTRES, CATHEDRAL, CHOIR SCREEN, EARLY 16TH CENTURY
The cathedral was furnished with a magnificent choir screen in polychrome stone, depicting in four groups the lives of Christ and the Virgin. Begun according to the plans of Jehan de Beauce, it was finished two centuries later, still in the Flamboyant Gothic style.

Opposite
CHARTRES, CATHE-
DRAL, STAINED-GLASS
WINDOW, KNOWN AS
"NOTRE-DAME DE LA
BELLE VERRIÈRE"
("OUR LADY OF THE
BEAUTIFUL STAINED
GLASS"), C. 1150
The first Gothic stained-glass artists divided the colored space into a glimmering mosaic. The "Chartres blue," deep and mysterious, shines with a particularly preternatural brilliance.

CHARTRES, CATHEDRAL,
SOUTH ROSE WINDOW,
13TH CENTURY
The Gothic rose window, a large stained-glass circle, testifies to the wonder provoked by the hereafter. This rose, which celebrates the coming of the Savior and the promise of union with God in Heaven, depicts Christ surrounded with the four Evangelists and eight angels, then, in the outer circles, with the twenty-four Elders of the Apocalypse.

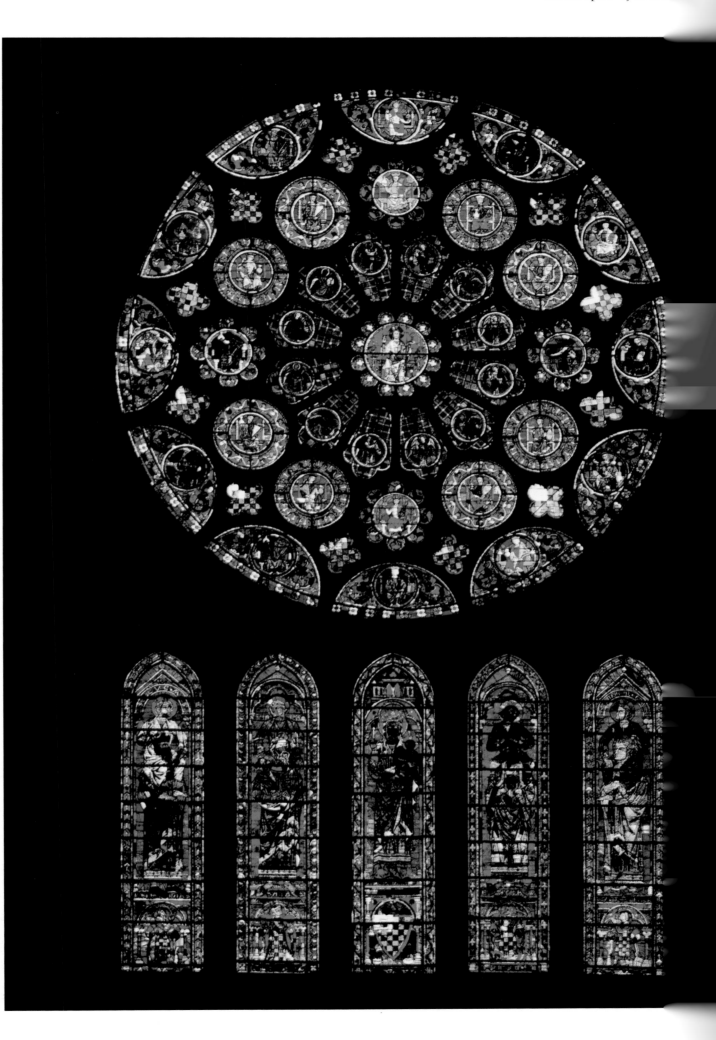

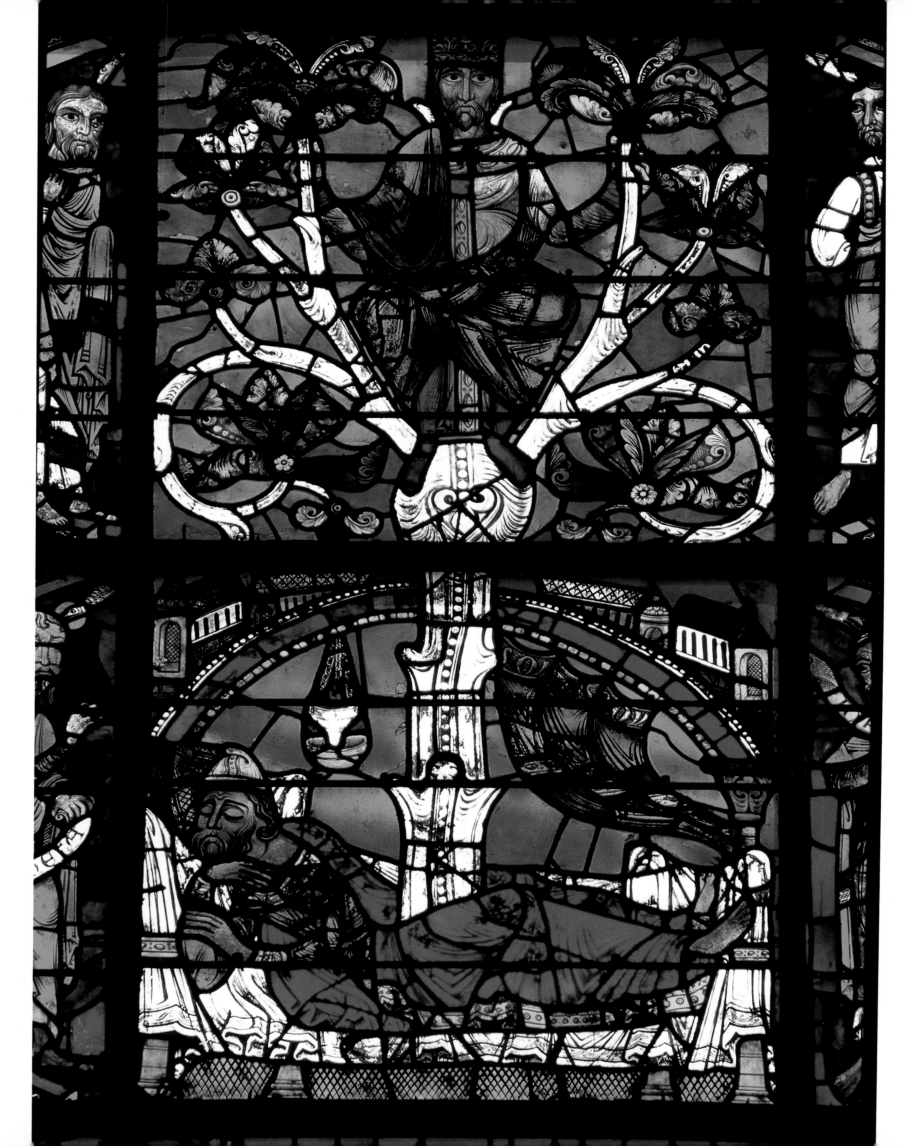

"A Supernatural Light"

The cathedral possesses the most remarkable collection of extant Gothic stained glass in France: of 186 openings, 172 are still fitted with their twelfth- and thirteenth-century stained glass. A few of them, such as those on the windows of the western wall, as well as "Notre-Dame de la Belle Verrière" ("Our Lady of the Beautiful Stained Glass"), decorated the previous cathedral, and were created about 1150. But most were made between 1200 and 1250 to decorate the newly built cathedral.

These figurative stained-glass windows encapsulate a medieval vision of the world, natural and supernatural, of past, present, and future history: they are an encyclopedia. Appreciating them for their colors and light alone is not sufficient. It takes long study to understand what these stained-glass windows want to tell us.

The large rose windows offer scope to a highly structured expression of religious belief. The north rose window evokes the Old Covenant: man had broken with God, but God had made an alliance with Abraham and, through him, with Israel, the prophetic people destined to announce the advent of the Messiah. The Virgin Mary holding the infant Jesus on her knees is in the center, for she both closes and crowns the epoch of the Old Covenant. She is surrounded, in a first circle, with four columns of eight angels; in a second, by the twelve kings of Judah, from David to Manasseh; and, in the last circle, by twelve small prophets.

The southern rose window complements its opposite with the New Covenant between man and God, sealed by the advent of Christ on earth, the promise of union with God in Heaven. Christ in Glory occupies the center of the rose window, surrounded in a first circle by the four symbols of the Evangelists—the angel of Saint Matthew, the lion of Saint Mark, the ox of Saint Luke, and the eagle of Saint John—and eight thurifer angels (bearing torches and censers); in the second and third circles are the twenty-four Elders of the Apocalypse, each playing an instrument, since music, perhaps more than speech, reflects the divine and brings us closer to it.

Pierre Mauclerc, count of Dreux and duke of Brittany, was the donor of this rose window and the five lancet windows (tall, narrow windows) it overlooks. His portrait and those of his wife, Alix de Thouars, and their children are depicted on the lower levels of these lancet windows. On the higher levels are the Virgin and Child and the four great prophets, each bearing one of the Evangelists: Isaac carries Saint Matthew; Jeremiah, Saint Luke; Ezekiel, Saint John; and Daniel, Saint Mark. These stained-glass windows thus reflect, through images, the interdependence of the Old and New Testaments as well as the dependence of contemporary people on the great individuals who preceded them, even though the knowledge of modern people is more advanced.

A Story in Images

The stained-glass windows are divided into three levels. The top level, that of the rose windows, is the most mystical. The second level, that of the high windows, presents full-length portraits of the "great models," those who show us the way and on whose example we should meditate.

The first level, that closest to the ground, depicts the life of Christ in images; this constitutes, we should not hesitate to point out, the ancestor of the comic book. The Virgin is celebrated everywhere, especially in the stained-glass windows—in the window representing the Tree of Jesse, which evokes her genealogy and that of Christ, the last branch; in the medallion of the Nativity; in "Notre-Dame de la Belle Verrière" (Our Lady of the Beautiful Stained-Glass Window), whose mysterious deep blue complements the majesty and serenity of its composition; and, above, in a small rose window, Mary is depicted with bared breast, suckling Jesus.

An entire stained-glass window is devoted to the stories of the miracles of the Virgin, and another to her life, which unfolds in twenty-five scenes, including the annunciation of her birth, her parents Anne and Joachim, her fulfillment as mother and mediator, with Jesus blessing the crowd. Another stained-glass window is devoted to her death, burial, and assumption. The funeral scene is very beautiful; the horror of her death is reflected in the pained faces of the Apostles.

Elsewhere, tales from the Old Testament are retold, such as the stories of Joseph and Noah, the latter shown making his wine and tasting it, already quite tipsy. The great early saints share a window, like Mary Magdalene, who finds Christ's tomb empty; Thomas, leaving to convert India, the "Malabar"; or Paul and Andrew. And the more recent saints share a window:

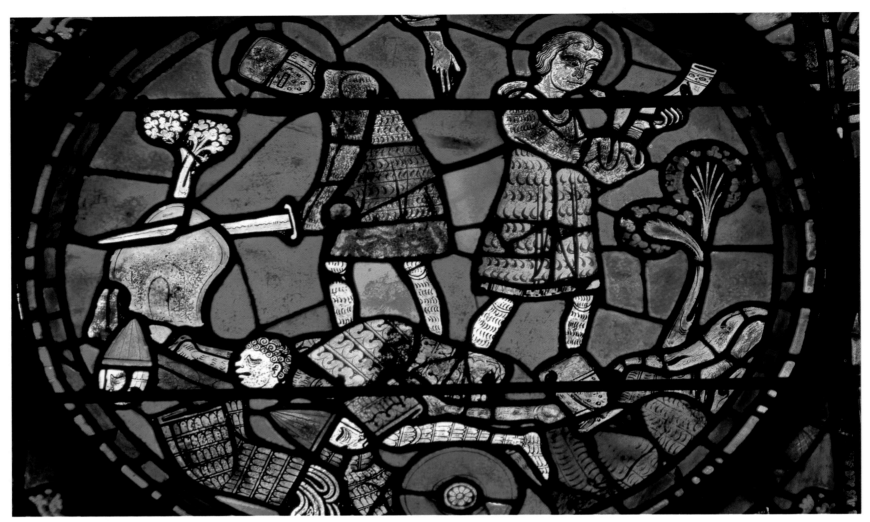

Martin, dividing his coat with a pauper, then in a dream seeing Christ dressed in this coat; and Thomas à Becket, assassinated on December 29, 1170, in Canterbury Cathedral by the followers of Henry II Plantagenet, king of England. The lives of the local saints are not forgotten, such as Lubin, the shepherd who became bishop of Chartres, whom we see tending his sheep and also wearing the episcopal miter.

Swept up in the pleasure of storytelling, the masters of stained glass invented scenes as well as realistic and comical details. One example is found by comparing the text of the parable of the prodigal son—whose meaning reflects the infinite mercy of Christ—and the stained-glass window illustrating it. The creator of the window interpreted the parable in thirty scenes, including the following: the prodigal son demands and obtains his share of the inheritance; he leaves; he enters into a house of pleasure; the "girls" welcome and humor him; elsewhere, he plays at dice, loses, is beaten and robbed; he tries to return to the girls, but one of them chases him away with a cudgel; he offers his services for hire and ends up tending pigs; he decides to go back home; he makes the journey in

rags, arriving at his father's house, who dresses him in new clothes; they kill the fatted calf; during the festivities his jealous brother protests; and two angels announce Christ, who gives his blessing.

People have always loved a good story. Some of Chartres's windows present narratives with very little religious pretext, for example, the life of Charlemagne and the favorite adventure tale of the time, the *Chanson de Roland* (Song of Roland), in the medallion of the death of Roland. Betrayed by Ganelon, Roland and Oliver are attacked by the Saracens at the Pass of Roncesvalles (Roncevaux) in the Pyrenees. Roland alerts the emperor "with the flowing beard" by sounding his horn until he bursts a blood vessel in his brain. Next, before he dies, he tries to break Durendal, the invincible sword, to prevent it from falling into the hands of the enemies, but the sword is stronger than the rock and becomes embedded in it.

Hence, as we explore the stained-glass universe of Chartres, we see revealed to us an overflowing of life: the doors to the cathedral have been flung wide, and everything has been absorbed into the stained-glass windows, not without a certain exuberant disorder. For

CHARTRES, CATHEDRAL, STAINED-GLASS WINDOWS, 12TH CENTURY
In the Middle Ages, the colored glass of stained-glass windows served as a substitute for precious stones, whose light differed from ordinary light since it was refracted. Such light anticipated the true Light, that of Heaven and the end of time. Writing about the windows of Chartres in the nineteenth century, the sculptor Auguste Rodin asserted that "here we are illuminated with a supernatural light." This impressionistic vision was the aim of the master craftsmen who fabricated the stained glass.

those who lived in medieval times, religion was not parenthetical, separate from life. On the contrary, everything was to be shown and offered to God. Not that everything was good and complete—far from it; indeed, for this very reason divine grace was invoked to shed itself on the totality of existence, just as the illumination, amelioration, and progressive redemption of man were solicited from the internal workings of the divine.

The characteristic actions of the different professions whose guilds had donated stained-glass windows were described on the lower portions. We see the clothier measuring cloth by the yard, the wine merchant leading a horse-drawn cart to deliver a cask. The porters, tanners, and poor guilds managed to offer a single stained-glass window—for them, a substantial gift—while furriers and merchants gave several. Other donors, nobles, and members of the high clergy, such as Pierre Mauclerc, Mahaut de Boulogne, Thibaut IV, count of Chartres, and the lords of Beaumont and Montfort, had themselves painted.

A Falsely Naive Art

We should make it clear that the art of the stained-glass makers was extremely sophisticated and complex; there was nothing naive about it. It can appear that way because of its conventions, although these, on the contrary, evolved after profound reflection on the laws of optics, a reflection differing little from those of the Impressionists at the end of the nineteenth century.

For example, thick black lines drawn in grisaille came into use because from afar, the light of the colored surfaces tends to overwhelm the darker lines, making them appear thinner than they are. This is why the faces have such large eyes, which make them seem stunned. From a distance, blues and reds—the main colors used in Chartres—merge to form violet spots; the stained-glass masters took care to avoid this effect through various means. On a stained-glass window large areas of a single color do not produce happy results; the artists tended to make "mosaics" of their works insofar as possible.

Another characteristic that appears naive is the fact that kings always wear their crowns and bishops their miters, even when sleeping or falling off horses. This is because a king and a bishop must be easily identifiable by the spectators. The small scale of the scenes requires symbolization: a tower indicates a town, a few people a crowd; a lamp indicates that the scene is taking place at night or in a dark place.

THE STAINED-GLASS MASTERS OF CHARTRES

●

The 21,000 square feet (2,000 square meters) of stained glass at Chartres are the fruit of a gigantic effort, the sum total of a series of minute operations carried out by a very small number of master stained-glass workers. The glass was provided by the glassworks, usually situated on the edge of a forest, which produced the glass by heating a mixture of one-third river sand and two-thirds ashes of beech and fern with wood fires to about 2700°F (1500°C).

The full-scale drawing was transferred to the glass, which was then cut, not with a diamond, an invention of the sixteenth century, but with a heated piece of iron; the cutting, which was irregular, was smoothed with a pincers, or "notcher." Each spot of color required a different piece of glass. Furthermore, certain important areas of color had to be divided among several pieces of glass; a historiated stained-glass window was made up on average of forty pieces of glass per square foot. Last, each piece was painted, and baking fixed the color in the material.

Most of the workshops at Chartres usually painted each piece in three layers to suggest modeling. The first was uniform, the second indicated shadows, the third showed modeling. The designs were outlined in grisaille, which was obtained by mixing iron oxide, pulverized glass, and either vinegar or wine and urine. Then the window was "leaded." The large surfaces of the stained-glass windows were supported by structures composed of iron pieces five centimeters thick. At first simple, these structures became complex and decorative in the thirteenth century, including circles, squares, lozenges, and quatrefoils, the ensemble of iron designs referred to as tracery.

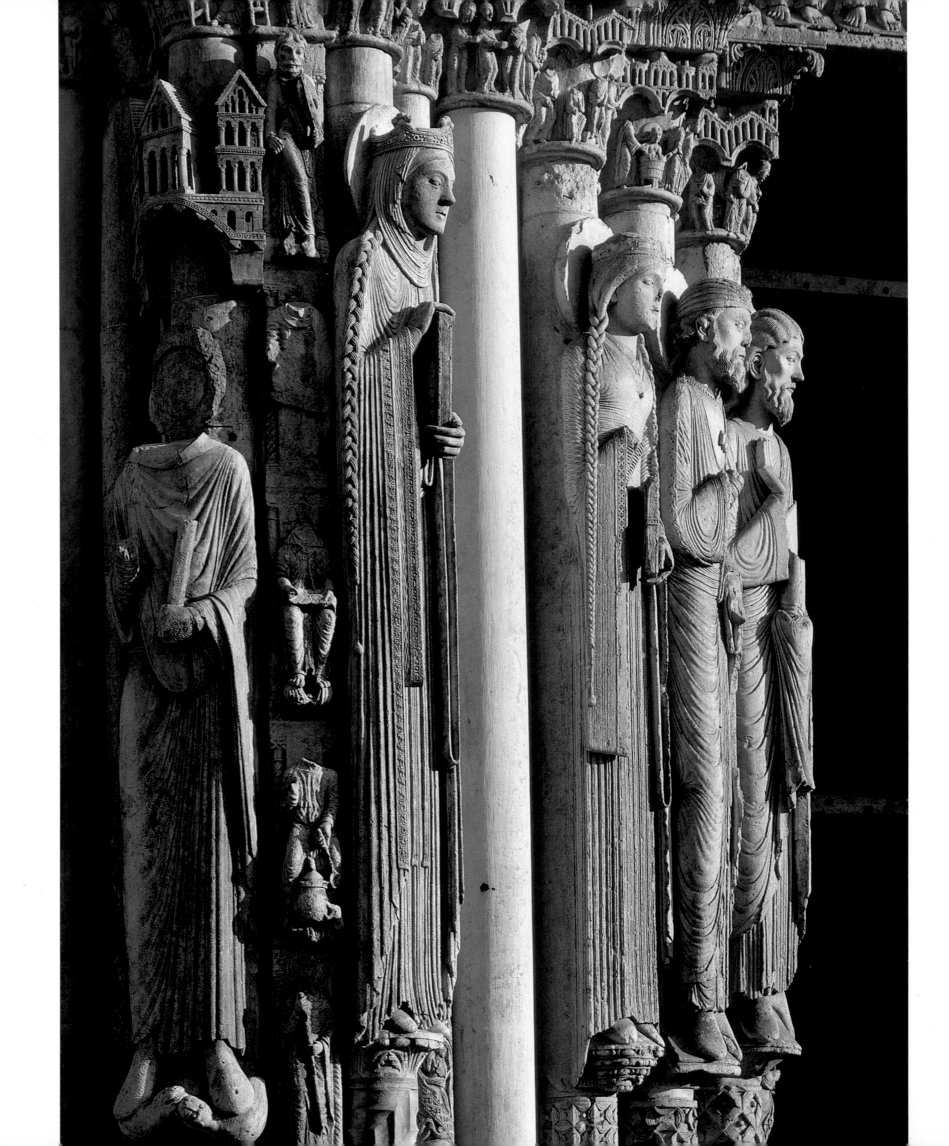

CHARTRES, CATHEDRAL,
SOUTH PORCH,
SCULPTURE OF SAINT
GEORGE, 1224–50
*The sculptors of Chartres
shook off all the last ves-
tiges of the Romanesque
aesthetic. The artist of
Saint George represented
him realistically, as a
contemporary knight.*

Opposite
CHARTRES, CATHEDRAL,
STATUE-COLUMNS OF
THE ROYAL PORTAL,
C. 1150
*The statue-columns of
the embrasures, which
represent characters
from the Old Testament,
are still Romanesque in
the decorative treatment
of their elongated bod-
ies, but already Gothic
realism is visible in
their faces.*

FROM THE FIRST GENERATION TO THE APOTHEOSIS

The stained-glass masters of Chartres, like those of Bourges, Reims, and Rouen—and, more generally, those of the "first generation" of Gothic stained-glass makers—shared a certain idea of "stained-glass beauty." Following the example of goldsmiths and enamel workers, the former mosaic workers of Byzantium, Ravenna, and Venice, and illuminators as well, they attempted as much as possible to divide the colored space into a dazzling mosaic. The representation remains solemn and schematic, and the lead strips are thick.

A "second generation," among whose masterpieces are the stained-glass windows in the Sainte-Chapelle and the northern rose window of Notre-Dame-de-Paris, sought more lightness, naturalness, and elegance. The borders and the mosaic backgrounds ceded importance to the scenes represented. The architects, in opening the walls more and more to the outside, gave wide scope to the masters of stained glass.

Nonetheless, about 1260–70, an evolution in taste took place: people wanted more light and less color in the buildings. The architects, having cultivated a refined art, wanted floods of light to illuminate clearly their stone jewels. The surface devoted to painted historiated scenes in stained glass was reduced, either by alternating a lancet window in "grisaille" (white glass highlighted with a drawing in grisaille) with a historiated lancet or by placing the historiated scenes in the center of the lancet window, between two grisailles. The recipe for obtaining the color "silver-yellow"—invented in Egypt in the sixth century and preserved by the Arabs, among whom it was found by a scholar attached to the court of Alfonso X, the Learned, king of Castile—arrived at France at the end of the thirteenth century. It had a far-reaching effect as it meant that the historiated areas of the stained-glass windows could be considerably lightened.

Furthermore, the stained-glass masters began to imitate easel painting rather than the goldsmith's art, enamels, or mosaics. They depicted full-length figures surrounded by imaginary architecture. After 1325, they adopted representation in perspective. After 1440–50, under the influence of the Flemish school of painting, Jan van Eyck in particular, they pushed their concern for realism even further. At the end of the fifteenth century and the beginning of the sixteenth—at the very moment of its technical apotheosis—the art of stained glass began to decline. It would not experience a renaissance until the end of the nineteenth and the twentieth centuries, with the great names of Henri

Matisse, Georges Braque, Fernand Léger, Jacques Villon, and Marc Chagall, while Georges Rouault, in his paintings, revived the spirit of the old stained-glass windows.

Adam in God's Thoughts

The cathedral is almost as richly endowed with sculptures as with stained-glass windows: it has about four thousand sculpted figures, against about five thousand figures in stained-glass windows. The western portal, known as the Royal Portal, escaped the fires in the previous cathedral for which it had been sculpted in 1150. It celebrated Christ in three essential moments: his Incarnation, Ascension, and his glorious return to earth at the end of time. The tympanum on the right bay presents a Virgin and Child, and the lintel shows scenes linked to the birth of Christ, such as the Annunciation and the Annunciation to the Shepherds. On the tympanum of the left bay is Christ rising to heaven, carried by two angels and emerging from a cloud. On the tympanum of the central bay Christ appears in glory, surrounded by the symbols of the Evangelists; at his feet, on the lintel, the twelve Apostles; above him, Heaven, symbolized by twelve angels on the first row of the tympanum arches and by the twenty-four Elders, musicians of the Apocalypse, on the two others. The large statue-columns of the embrasures represent figures from the Old Testament, some of whom remain unidentified. Laughing, full of charm, the queen with long braids decorating the right embrasure of the central bay is, in all probability, the queen of Sheba. The capitals above these statues narrate the lives of Christ and the Virgin in more than two hundred scenes, full of verve.

In the arching of the bay on the right are each of the seven "Liberal Arts"—those taught at the universities according to the cycle of the trivium and the quadrivium—in the guise of women, accompanied by a portrait of those who excelled at them, including Aristotle for logic; Cicero for rhetoric; Euclid for geometry; and Pythagoras for music. Clearly, homage was paid specifically to ancient culture and, more generally, to the value of knowledge. Chartres was a great intellectual center. The "School of Chartres," whose greatest names included Gilbert de la Porée, Yves, Bernard, and Thierry de Chartres, Guillaume de Conches, and Jean de Salisbury, combined the study of the "divine science" of theology with that of music and mathematics, in which it saw a reflection of the creative thought of God.

The sculptures of the north portal, like the south portal, set in a porch, were made after 1230. This portal has as its subject, like the north rose window, the Old Covenant. On the pier of the central bay, Saint Anne carries the child Mary; she is surrounded by the twelve main predecessors of Christ, among whom we note in particular Melchizedek and John the Baptist. Along one of the piers is Saint Modesty, the model for young girls in the thirteenth century, gracious, dignified, happy with life. The Old Testament is illustrated by many lively, profound scenes. In one, Tobias restores sight to his father, who while asleep had become blind from sparrow droppings in his eyes; in another, Adam is depicted as still in God's thoughts, shown with his shoulders and head emerging behind the Creator's head; and God kneads Adam's head on his knees, like a sculptor working clay.

The sculptures of the south portal were created between 1224 and 1250. Like the south rose window, they celebrate the New Covenant. On the central pier, "Christ teaching" welcomes us with an expression perhaps sweeter and tenderer than that of the "Handsome God" of Amiens, to which it is often compared. He is surrounded by the twelve Apostles. The tympanum delineates the Last Judgment. The left bay is devoted to the martyrs, that on the right to the confessors (the saints who did not undergo martyrdom). We note in particular Theodore and George dressed, like the knights of the times, in a robe under their suits of mail, sword in hand, bearing lances and shields.

The sculptures of the cathedral span over a hundred years, from 1140 to 1250. They bear witness to the vitality of the evolution of the school of Chartres: the Royal Portal, Romanesque in the elongation of the bodies of the statue-columns, is Gothic in the importance of its symbolic program and the realism of its scenes and portraits. On the north portal, and especially on the south portal, as in Reims and in Amiens, the Gothic style has broken free of the Romanesque aesthetic. Chartres nonetheless remains unique, in particular due to its elongated, angular faces stamped with mysticism.

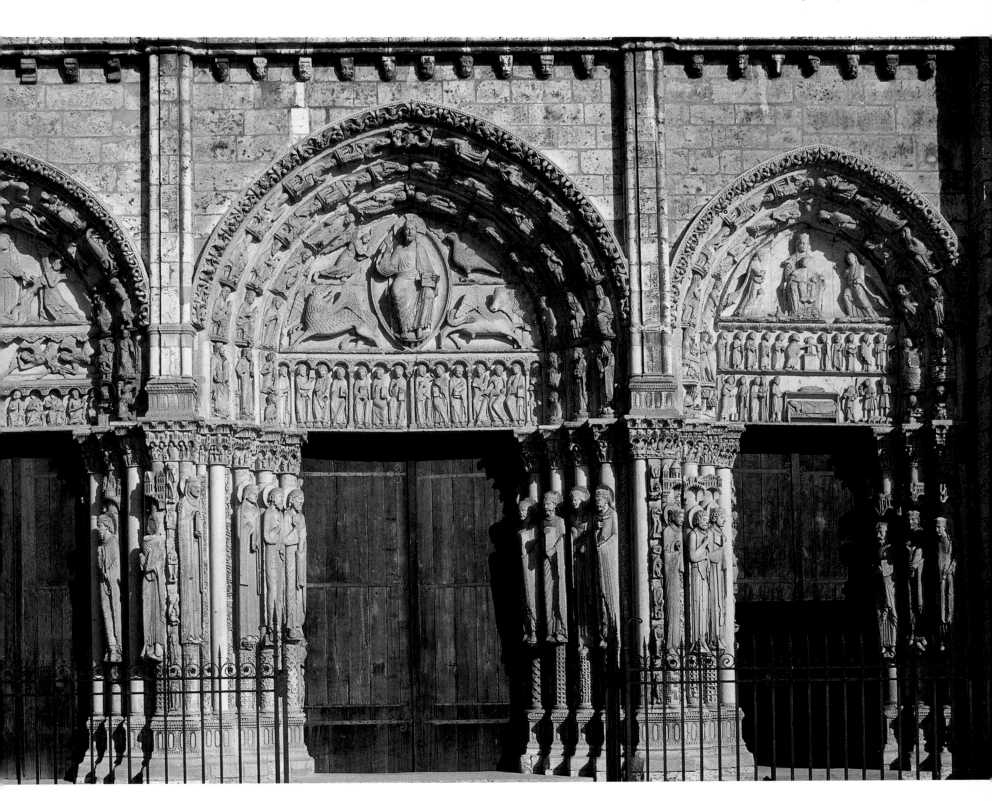

CHARTRES, CATHEDRAL,
THE ROYAL PORTAL,
C. 1150
*The Royal Portal,
which celebrates Christ
in the Incarnation,
the Ascension, and the
Second Coming, is one
of the most beautiful
examples of the slow
emergence of the Gothic
style from the Roman-
esque in sculpture.*

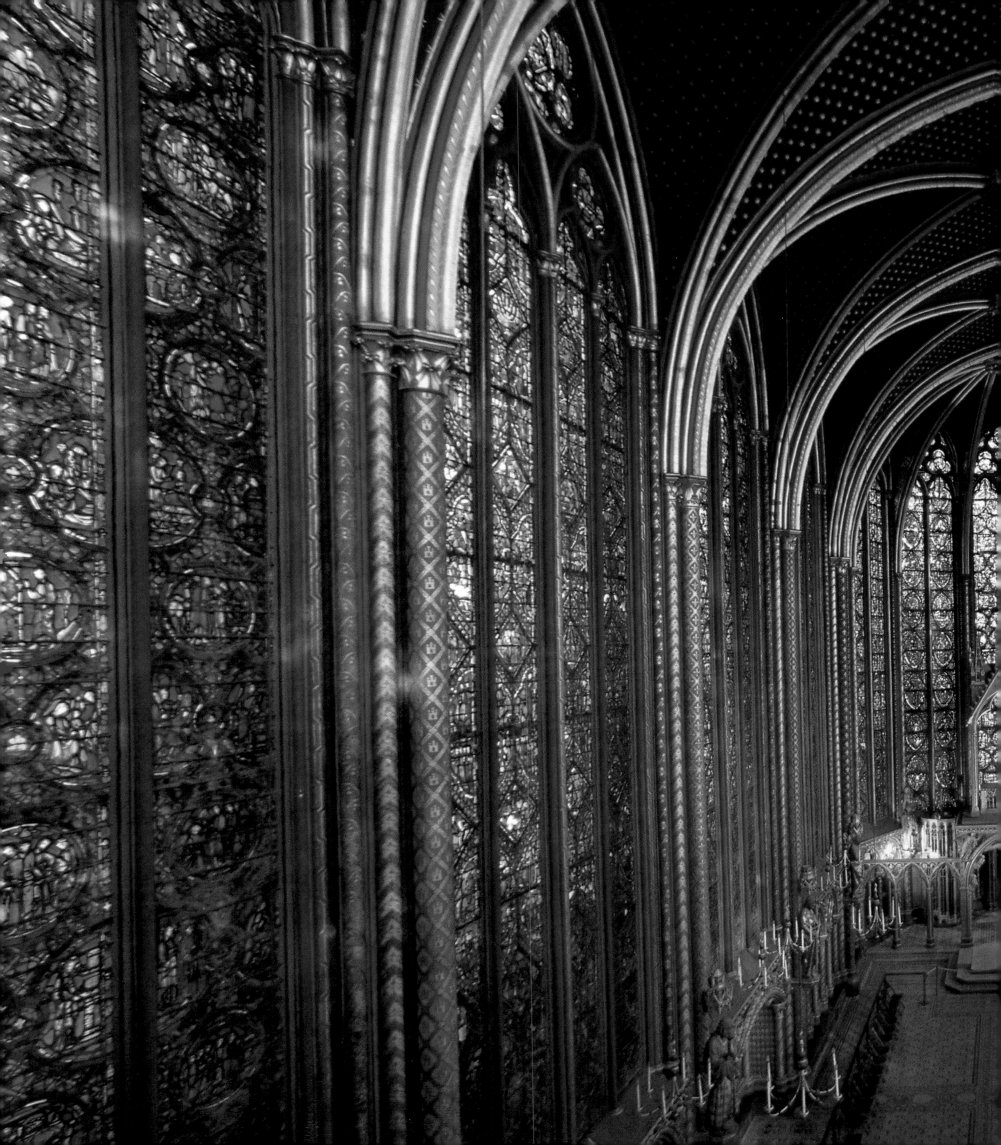

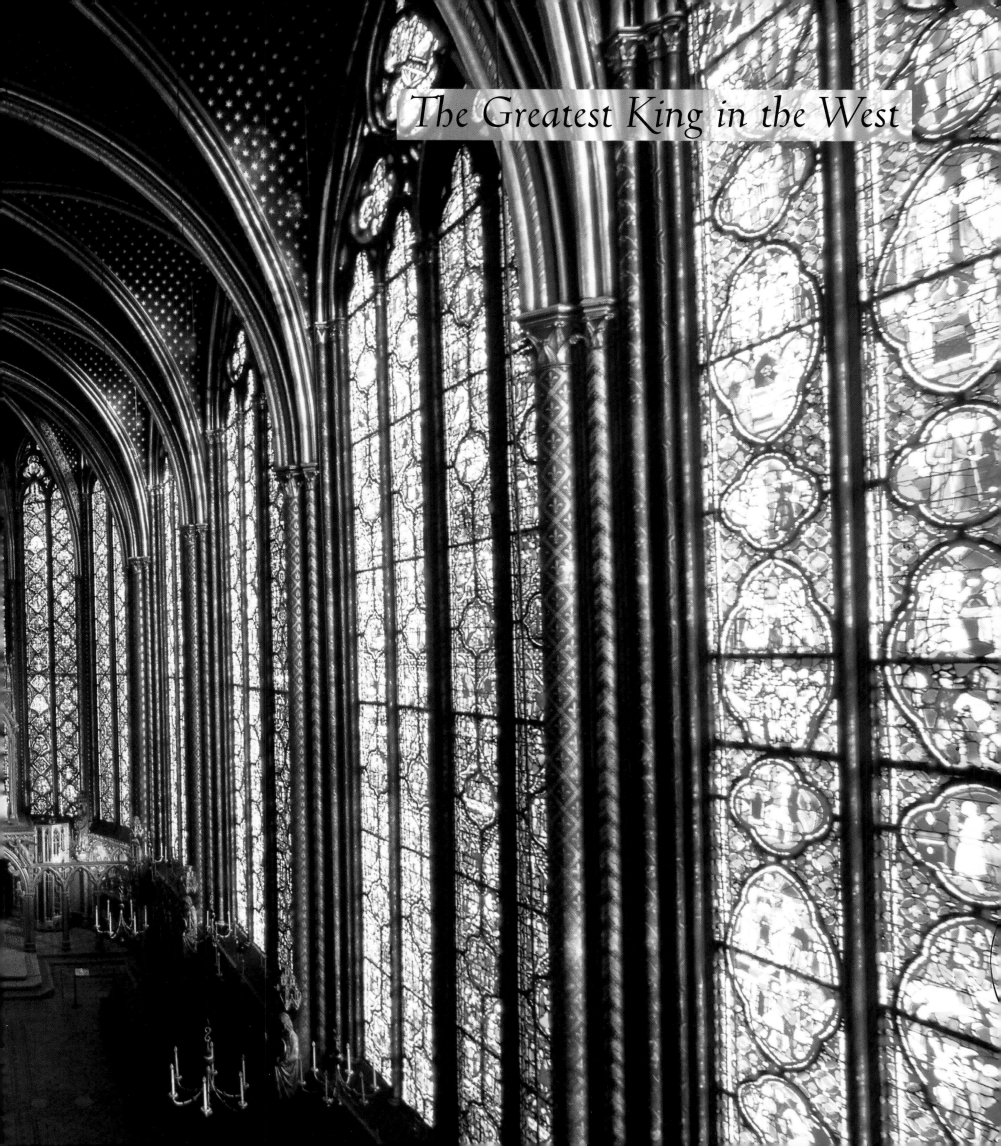

PRAISE FOR LOUIS IX is unanimous. He was, according to the Mongolian prince Sartaq, "the greatest king in the West." French nationalists praised him to the stars, but so did Voltaire before them, in a fine page in his essay on morals.

It is true that the excesses of hagiography have to some extent falsified the image of this king: his true grandeur lay elsewhere.

THE LAST FEUDAL KING

Born in 1214, he reigned for forty-four years, from 1226 to 1270. Louis IX was above all a warrior. Until the age of thirty, he rode on horseback all across France in order to curb some of his vassals who, taking advantage of his youth, attempted to diminish the Capetian power that his ancestors had, from father to son, worked to increase, in particular, since Louis VI at the beginning of the twelfth century. Louis kept these vassals in check and pursued the goals of his forefathers. To the lands of Normandy, Anjou, Maine, Touraine, and part of the Poitou and the Artois annexed to the royal domain by Philippe Auguste, Louis added the regions of Nîmes-Beaucaire and Béziers-Narbonne. Furthermore, the marriage of his brother Alphonse of Poitiers to the daughter and heir of the count of Toulouse, Raymond VII, paved the way for the definitive annexation of the rest of Languedoc. The king was also at war during the two crusades he undertook, the Seventh Crusade, which lasted from 1243 to 1254, and the Eighth Crusade, during which he died in 1270, outside Tunis.

And yet he was sincerely, in the sense of the seventh Beatitude of the Gospel of Saint Matthew, a peacemaker. He was behind the Treaty of Paris that in 1259 ended a more than century-old war with the English. Very infrequently interrupted under the reign of Philip the Fair, this peace lasted until 1337, the date of the beginning of the Hundred Years' War. The king brought the same sincerity to the charitable life, welcoming the poor at his table every day. In his time the practice of mortifications of the flesh was revived; he wore a hair shirt and often shoes without soles, which allowed him to mortify his flesh by walking barefoot, like a pauper, without impugning the dignity of his royal majesty.

Saint Louis, as he became known, remained a feudal king. Surrounded by his vassals who worshiped him, he was the symbol of their authority, prestige, and power; he was the keystone of their hierarchy. Through his personal charisma, he knew how to assure the cohesion of all of his lieutenants, always prepared to fight; at the same time, he pursued the centralized, antifeudal work of his fathers. Jean de Joinville, his friend and biographer, and one of France's greatest writers, described him rendering justice at the foot of an oak in Vincennes or in the garden of the palace on the Île de la Cité in Paris: "Many times it happened that in summer he would go sit in the Bois de Vincennes after mass and, leaning against an oak, would have us sit down around him. And everyone who had matters to discuss would come and talk to him, without the obstacle of guards or any other. . . . And he would have a carpet laid out for us to sit around him, and all the people who wanted to talk to him would gather around. And he would hold forth in the manner I described to you before the Bois de Vincennes."

The fine image of the judge-king, accessible to all, reminds us of his interest in the law. Under his reign the first drafts of collections of common law were drawn up, the Book of Justice and Pleading and Counsel to a Friend. The Paris Parliament was born progressively: first the Counsel of the King became an office and met more and more often in special sessions to judge appeals; next, with this activity growing in importance, the Parliament was founded as an institution independent of the Counsel. The law and the judiciary thereby advanced, and royal authority grew in the area of justice at the expense of the authority of feudal lords.

The reign of Saint Louis was a high point, which, like many happy times in human history, thought itself eternal. And yet this success was the result of an equilibrium, a consensus reached with difficulty and momentarily attained, then broken with the reign of Philip the Fair. Under the latter, monarchic centralism asserted itself more openly and moved irrevocably in the direction of ousting the old feudal social order, which offered less and less resistance.

THE CAPITAL OF A KINGDOM

The thirteenth century, like the century before it, was a time of great economic prosperity. Gone was the hard period of the beginning of the Middle Ages, in

Preceding pages
PARIS, SAINTE-CHAPELLE, UPPER CHAPEL, 1241/43–48
Stained glass is here emphasized more than at Chartres. There seem to be no walls holding up the chapel, as if it were made of a single, continuous stained-glass window, sparkling with colors that change throughout the day as the light moves.

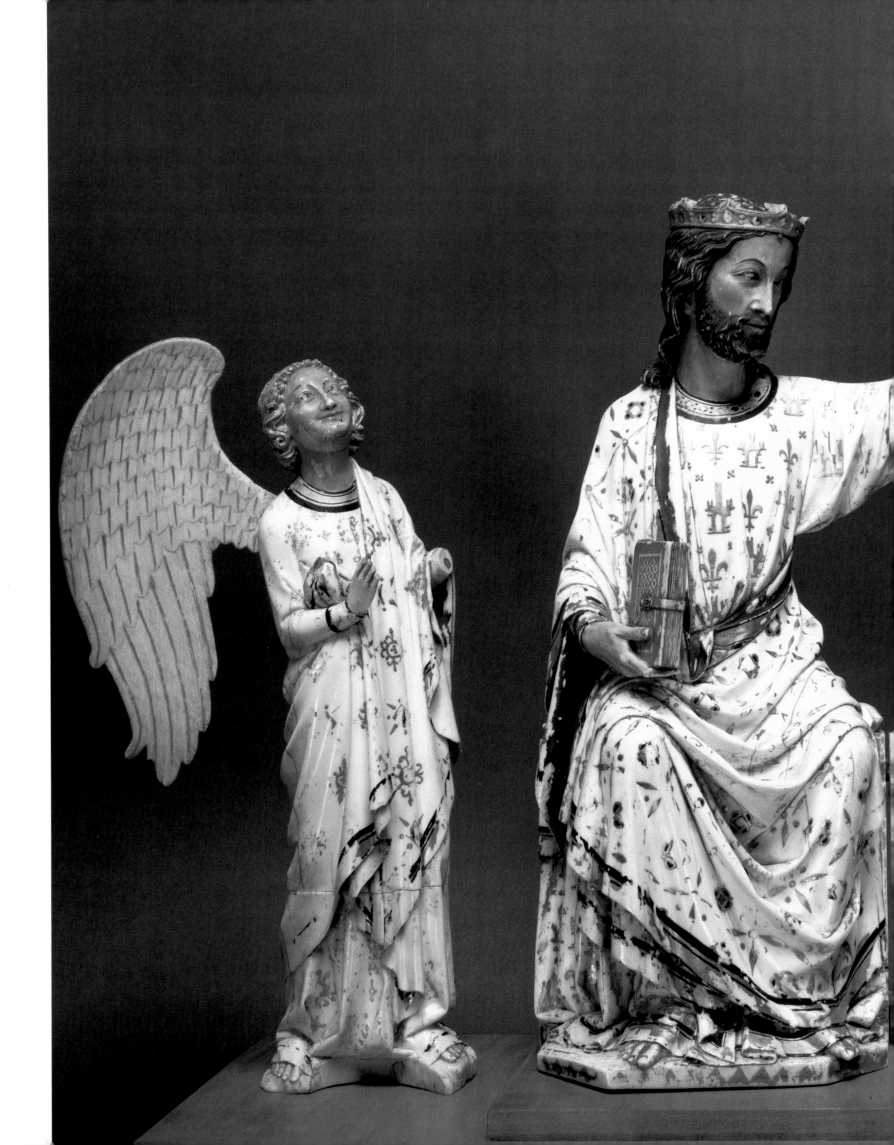

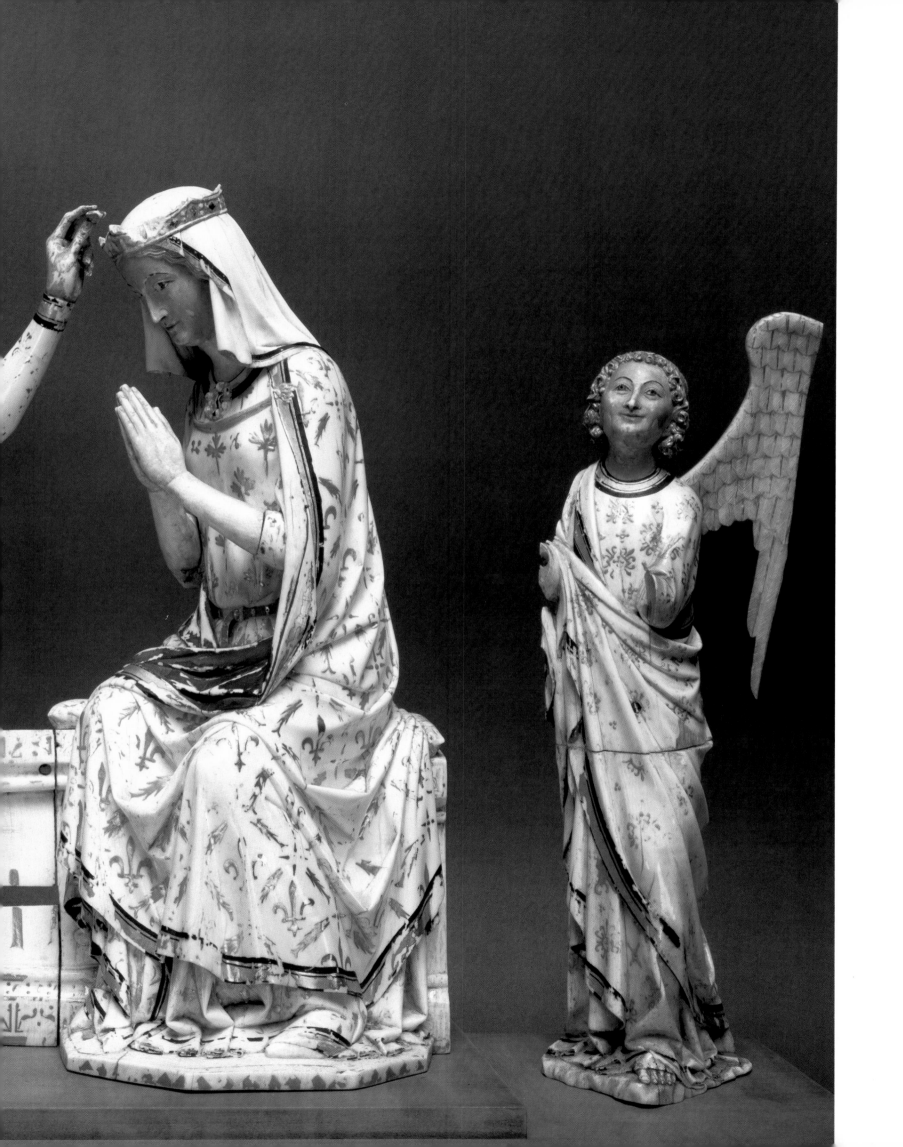

THE MASTER ILLUMINATORS: THE FIRST "SCHOOL OF PARIS"

Under the reign of Saint Louis, Paris became the capital of manuscript illumination in Europe. The School of Paris remained active and retained its reputation throughout the Gothic period, in spite of a slight eclipse during the Hundred Years' War. This art, in fact, underwent a considerable development in response to the demands of its growing clientele, composed not only of the clergy and religious institutions but also the king and his court, nobles and rich bourgeois, the university and well-off students.

In Paris manuscript illumination workshops prospered and multiplied, packed close together at the foot of Mont Sainte-Geneviève, on the rue Saint-Jacques, the rue Erembourg-de-Brie (which became Boutebrie), and the rue de la Parcheminerie. Division of labor was the rule among book artisans. The parchment vendors furnished the raw materials. Scribes copied the texts, leaving room for the illuminators, who themselves had particular specialties, some as simple painters of "rubrics" (the initial letters), others as true illustrators. When they finished, they handed the book over to the binders.

The illuminator began by drawing the design. Before he began painting, he sometimes applied the gold leaf. He obtained the effects of modeling by laying tint over tint, as in the art of stained glass, with which the illuminator had much in common. Finally, he added the lines of the drawing in pen.

which the seigneuries—and their religious counterparts, the monasteries—lived in quasi-independence; trade had resumed and with it production intended for sale. The towns, in constant expansion, demanded and obtained franchises granting them the right to manage themselves through elected officials, mayors, and municipal magistrates. The most important religious figure in Gothic times was no longer the abbot of a monastery ruling over other monasteries, like the abbots of Cluny, but rather the bishop, who, like the cathedral, was a symbol of religious faith and prestige, as well as the success of the urban community. New religious orders sprang up—the orders known as Mendicants, since they possessed no lands, the order of the Franciscans, founded in Italy by Saint Francis of Assisi, and that of the Dominicans, founded in France by a Spaniard, Dominic (Domingo de Guzmán)—and all set up their establishments in towns to preach to their populations.

Paris was already a great city. Visitors were dazzled when they contemplated the beauty and richness of its monuments, the number and loftiness of the towers and belfries that studded the city. Philippe Auguste had endowed it with a new city wall forming two circular loops on either side of the Seine. The right bank was devoted to economic activities; merchandise was unloaded on the "shore," beside the Hôtel de Ville (city hall), to be stored and sold at the markets (les Halles) nearby. The left bank, on the other hand, was devoted to convents and monasteries and intellectual life. The Île de la Cité, where the king's palace,

the cathedral of Notre-Dame, and the bishopric stood, comprised the political center. The principal thoroughfares in Paris formed a large north-south axis composed of, on the right bank, the parallel streets of Saint-Denis and Saint-Martin and, on the left bank, the rue Saint-Jacques, intersected by the rue Saint-Honoré and the rue Saint-Antoine running east and west.

Paris asserted itself as the economic capital. All trades flourished there. In 1260, the king granted the provost Étienne Boileau the task of compiling the *Livre des métiers* (Book of Professions), which defined the domain of the professions and the rules applying to each of them. Moreover, he did not hesitate to intervene in the economic domain again in 1266, by instituting a monetary reform that limited feudal rights and affirmed those of the crown.

From this epoch dates the tradition combining elegance and naturalness that characterized (and still does today) the products of Parisian craftsmanship and art. The Middle Ages made no distinctions between these two notions; the group of the Coronation of the Virgin in ivory enhanced with painting and gilding, in the Musée du Louvre, offers one of the finest examples.

The most beautiful illuminated religious works of the period still in existence are the Psalter of Blanche de Castille, the Paris Psalter, and the great Bible Moralisée, a monumental work including two columns of text, on one side the text of the Bible, on the other, commentary, each page illustrated with eight medallions—a total of 5,200 for the whole

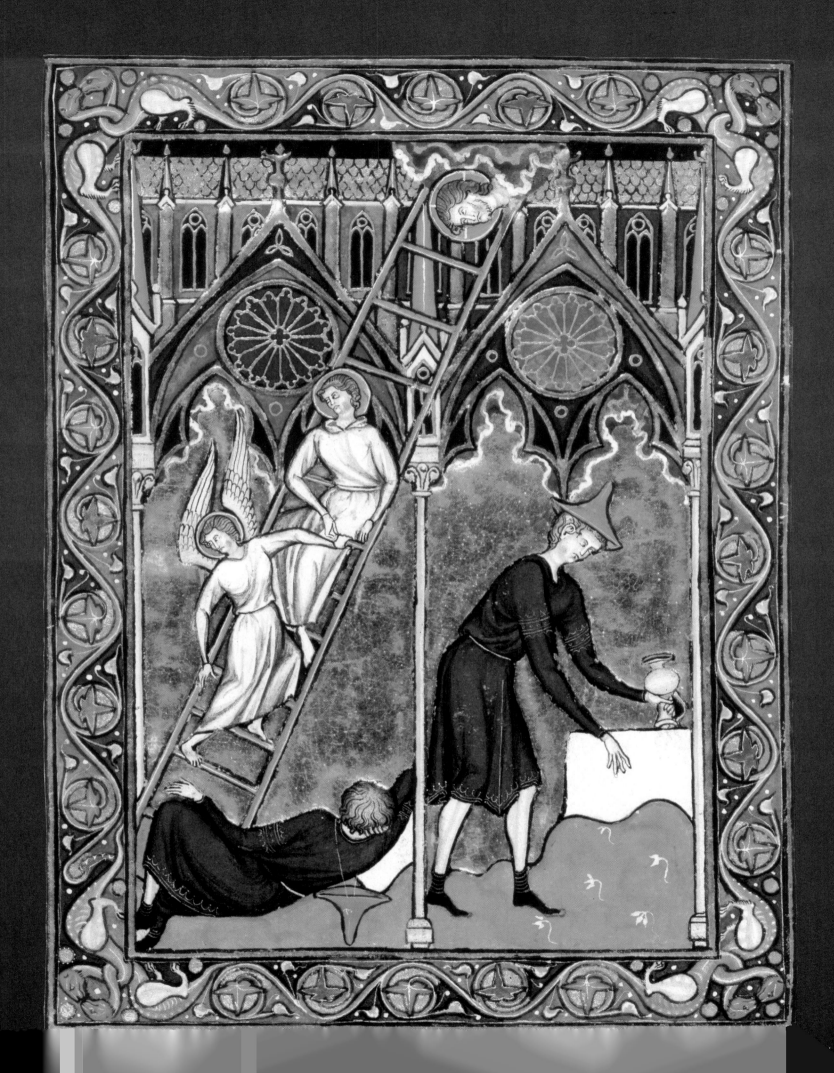

work! But the greatest masterpiece is without a doubt the Psalter of Saint Louis (1253–70), with its splendid full-page illuminations. The book opens with a series of 78 illustrations of the Old Testament, including Abel murdered by Cain, Noah gathering pairs of animals in his ark, Lot leaving Sodom as its towers are collapsing, the sacrifice of Abraham, the rape of the daughters of Shiloh. The story of Joseph alone merits twelve images and that of Samson, eight, compared with ten for that of Moses; the interest of the stories rather than their theological importance dictated the number of illustrations. On each page one, two, or three scenes are shown, arranged chronologically. They are framed by architectural elements, very close in style to Sainte-Chapelle, set in gold leaf.

The thirteenth of these images depicts, on the left, Jacob's dream and, on the right, his sacrifice. In his dream, Jacob saw a ladder leaning against the earth and touching the heavens; angels climbed up and down it. Then God spoke to Jacob and promised him "the land whereon thou liest, to thee will I give it, and to thy seed; And thy seed shall be as the dust of the earth, and thou shalt spread abroad to the west, and to the east, and to the north, and to the south. . . ." (Gen. 28:13–14). When he awoke, Jacob raised the stone on which he had slept and poured oil on its tip.

Gold, blue, and brown were the preferred colors of the psalter's illuminators. The figures, drawn with grace and a particular elegance, owe the fact that they appear to be dancing or flying to the suppleness of their lines. The work is striking in its youth, gaiety, and optimism.

The art of illumination in the thirteenth century did not reject the illustration of secular works, such as the *Roman de la Poire* (Romance of the Pear, 1275). One of its illuminators evoked the story of Tristan and Isolde, the most famous love story of the time. In one of his medallions, we see them embracing. The second illustrates the lovers asleep in the Morois Forest, according to the account of the poet Béroul of about 1170. There, after having fled the castle of King Mark, Isolde's husband, they spent happy days sheltered in a hut, eating wild plants. One day they fell asleep in the forest. This is how the poet evokes the scene:

> . . . *Wind did not stir nor leaf tremble;*
> *A ray of light fell on Isolde's face,*
> *which shone brighter than a mirror.*
> *Thus the lovers slept.*

Unfortunately, King Mark surprised them, but a naked sword placed between them suggested, falsely, that their love had remained chaste.

By the freshness of their inspiration and the deftness of their execution, these illuminations of the first "School of Paris" announced the masterpieces that would illustrate the work known as Philip the Fair's Breviary by Master Honoré, the Belleville Breviary by Jean Pucelle, the Très Riches Heures du Duc de Berry (The Very Rich Hours of the Duc de Berry) by the Limbourg brothers and Jean Colombe, the Livres d'Heures de Rohan (Book of Hours of Rohan), Antiquités judaïques (Jewish Antiquities), and the Livres d'Heures d'Estienne Chevalier (Estienne Chevalier's Book of Hours) by Jean Fouquet.

How can we explain the importance of this art and the remarkable value of the works it produced? The Romanesque period experienced a combined flowering of wall painting and illumination. In the Gothic period architects, by reducing the wall surface, deprived the painters of opportunities for large wall paintings, although those of the Papal Palace in Avignon, the chapel of the Hôtel de Jacques Coeur in Bourges, and Albi Cathedral, to name but a few, are masterpieces.

But the art of painting tended more toward illumination, stained glass, and tapestry. At the beginning of the fifteenth century, however, the growing taste for portrait painting, the desire to decorate churches with paintings and, in particular, with altarpieces, and the "invention," or rather the perfection, of oil painting in Flanders stimulated the rapid development of oil painting. Yet the creators of large compositions, such as Jean Hey (the Master of Moulins), Nicolas Froment, Enguerrand Quarton, and Jean Fouquet, were also great illuminators. The art of oil painting is the direct heir of illumination, which would progressively be supplanted by the art of engraving.

ROYAUMONT AND SAINTE-CHAPELLE, THE OFFERINGS OF A BUILDER KING

During the forty-four years of his reign, Saint Louis had a great number of charitable institutions and religious monuments built, of which the most remarkable are the abbey of Royaumont and the Sainte-Chapelle in Paris.

Shortly before his death, Louis VIII, Saint Louis's

ROYAUMONT, ABBEY, EAST BUILDINGS, 1228–35
The building in the background contained the chapter hall on the ground floor and the monks' dormitory on the second floor. The building on the left housed a veritable factory that ran on water-wheels, which ranks as one of the most sophisticated technical achievements of its time.

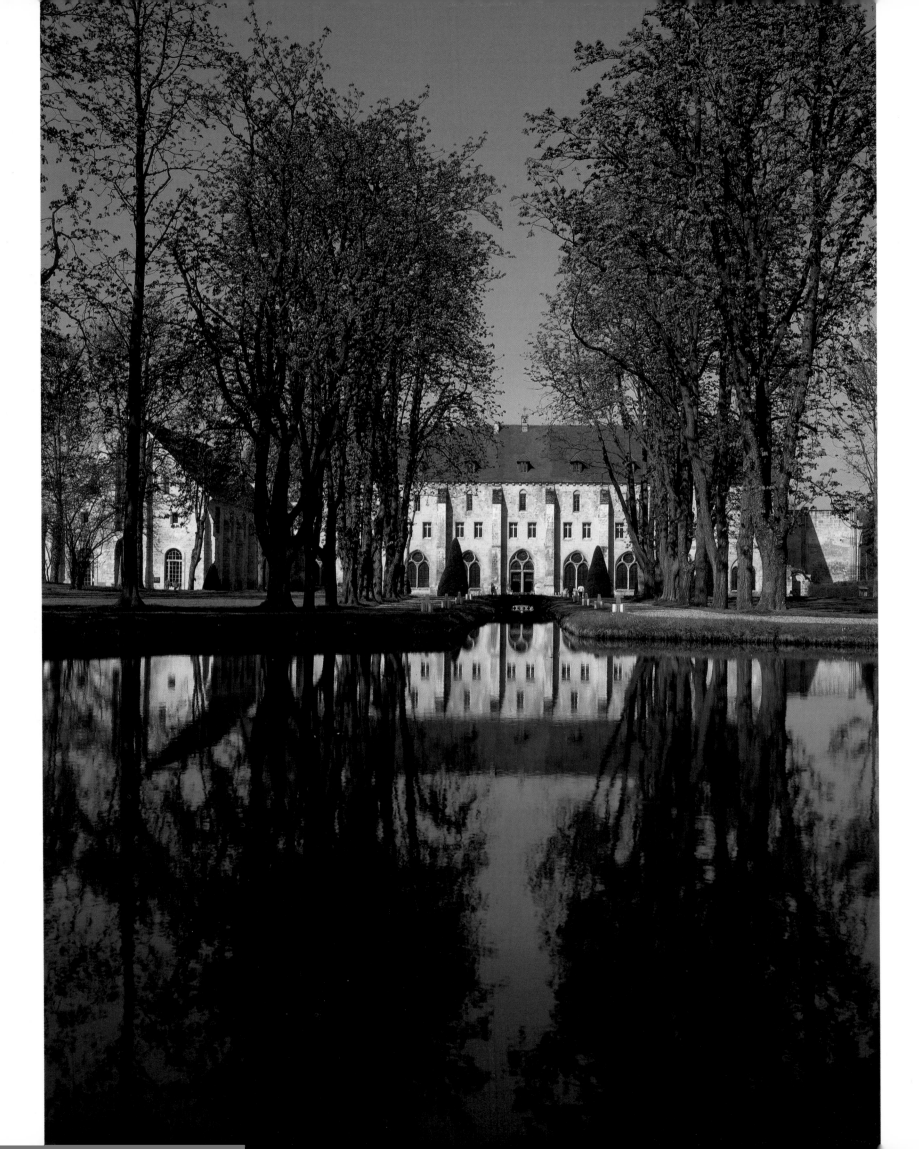

father, had requested that a monastery be founded in honor of the Virgin. By 1229 the first buildings were completed and a few monks of the Cistercian order moved in. When the construction was finished in 1235, Royaumont sheltered four hundred monks.

It was a large abbey. The church, in particular, was magnificent—345 feet (105 meters) long, it reached 92 feet (28 meters) in height beneath its large vaults— comparable to the abbey of Saint-Denis. Unfortunately, the abbey was sold during the French Revolution, and its buyer destroyed the church for its stones.

The abbey was designed around a cloister. To the north was the church; to the east and south the monks' buildings; to the west the storerooms and quarters to house guests and lay brothers.

The monks' refectory is one of the most beautiful Gothic rooms surviving to our times. Its twelve rib vaults rest on a row of five pillars. The room stretches perpendicularly to the southern building of the cloister and, extending beyond it, is fitted, on three sides, with nine large windows. The monks' dormitory was situated on the second floor of the east building, whose ground floor included, notably, the chapter hall, where the monks attended spiritual conferences or discussed questions related to abbey life. Adjoining this building was that of the "latrines and workshops," which bear witness to the great ingenuity of the architects of the time. Like a windmill, it stood over a stream that cut across it lengthwise. Upstream, the water turned a paddle wheel, providing energy for a number of machines on the ground floor, used by the monks in their work. A little further downstream, it was used to drain the latrines, located on the part of the second floor that extended over the courtyard.

Saint Louis loved to spend time with the monks of Royaumont. He had a suite of rooms there and attended services. When he joined the gatherings in the chapter hall he sat not with the monks but, out of modesty, on straw on the floor. He took his meals in the refectory and visited the sick in the infirmary, paying special attention and helping to feed one of the brothers, Brother Legier, who was afflicted with leprosy.

The Sainte-Chapelle came into being to house a very special relic. The emperor of Constantinople possessed the crown of thorns set on the head of Christ during his Passion but, in order to raise money, had pawned it to the Venetian moneylenders. After two years of negotiations, undertaken through the

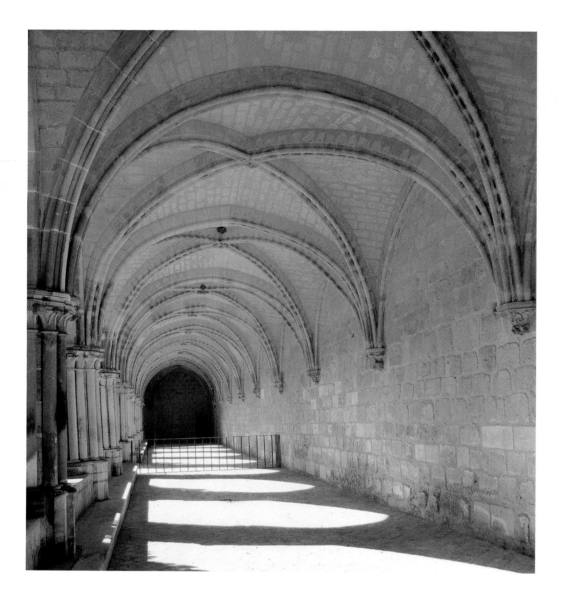

intermediary of the Venetian Nicolas Quirano, Saint Louis bought it in 1239 for a considerable sum. The relic was brought across the kingdom with great rejoicing, and the king went to meet it in procession at Villeneuve-l'Archevêque, near Sens. On August 18, 1239, the relic triumphantly entered Paris, carried by the king and his brother, Robert d'Artois, both of them barefoot as a sign of humility. One of the stained-glass windows in the Sainte-Chapelle commemorates this event.

The relic was initially exhibited in the Saint-Nicolas chapel near the palace. The king acquired three other relics: a piece of the True Cross, a fragment of the "holy lance" that pierced Christ's side, and a part of the "holy sponge" soaked with vinegar, brought to the lips of the crucified Christ when he cried out, "I thirst."

The king wanted to build a reliquary worthy of this remarkable treasure: the Sainte-Chapelle, begun about 1241–43, was completed in 1248. Today it is a

bit crowded by the buildings of the Palais de Justice, but when it was built, at 106.5 feet (32.5 meters) in height without its spire, it dominated all the other palace buildings and the ramparts of the Île de la Cité. This was how it still appeared in the fifteenth century in one of the illuminations of the Très Riches Heures du Duc de Berry.

Its lower chapel is somber, surrounded by powerful walls supporting its upper story. It could not have a high ceiling. If it had been reduced to a nave without aisles, the curve of its pointed arches would reach almost to the ground, neither very aesthetic nor practical. In order to avoid this inconvenience, the architect designed a nave and two narrow aisles in which one can see the "braces," like interior flying buttresses.

In the upper chapel the walls and the mullions have almost disappeared, reduced to a fine skeleton of stone opening to the outside with sumptuous stained-glass windows. The tall windows occupy all the space between the abutments. While the latter are almost a meter thick, the architect went to great pains to make them seem narrower by surrounding each with a web of nine fine colonnettes.

A masterpiece of what came to be called the *style rayonnant* (radiant style), the luminous culmination of second-generation Gothic, the Sainte-Chapelle offers insight into the period's taste in color. The brilliance of the stained-glass windows changes as the day progresses, becoming almost violet during the late afternoon, while the wall paintings remind us that all churches were painted and gilded, both inside and out.

The sculptures, stained-glass windows, and paintings of the upper chapel were conceived as a whole to develop a single theme: the glorification of Christ's Passion, the center and pivotal moment of human history, foretold by the Old Covenant and opening the period of the New Covenant.

Christ's Passion and Resurrection are represented in the central stained-glass window over the relics of the Passion, those tangible signs of Christ presented for the veneration of the faithful in a reliquary in the gallery. All around are stained-glass windows depicting the lives of Christ, Saint John the Evangelist, and Saint John the Baptist.

The Apostles, whose twelve monumental statues stand against the abutments, make up a procession toward Christ, as do the martyrs celebrated in forty small wall paintings inscribed in the quatrefoils. Six of the statues of the Apostles are original. The others are replicas, because the original either was lost or became too damaged and was placed in the Musée de Cluny. The statue of Saint James the Greater is especially appealing; amply bearded and holding in his hand a pilgrim's staff, he appears affable and serene. Figures from the Old Testament also do homage to Christ, and their stories are depicted in an infinite shimmer of color and in great detail.

A very beautiful symbolic idea is expressed by the arrangement of the stained-glass, which, in the apse, includes depictions of the prophets and a central stained-glass window celebrating Christ and the two saints John: they evoke, to the left, Isaiah, prophet of the Incarnation, and to the right, Daniel, Ezekiel, and Jeremiah, prophets of the redemption.

According to Louis Grodecki, the 1,134 scenes depicted in these stained-glass windows were created in under four years by only three workshops, or a maximum of twenty people. The artists therefore worked quickly and passionately, even though they often used the same cartoons to illustrate different scenes. In the fire of inspiration, they found an original style with respect to that of Chartres or Bourges: the colors are light and varied and the backgrounds reduced to a minimum; they favored clarity in the narration of scenes, which they tried to paint as naturally as possible. The scenes shown include Adam and Eve in earthly paradise, Moses with the Ten Commandments, the Ark of the Covenant, Ruth and Boaz, Samson and Delilah, the drunkenness of a daughter of Judah, David and Goliath, Bathsheba at her bath, and Job on his dunghill. The most novelistic episodes of the Bible offered particular inspiration to the stained-glass masters, who narrated the stories of Judith and Esther in, respectively, 42 and 124 scenes.

One of the most beautiful stained-glass windows of the Sainte-Chapelle illustrates the episode of Emmaus as told in the Gospel of Saint Luke. After his resurrection Christ, appearing on a road near Jerusalem, strikes up a conversation with one of the other walkers, who was a former disciple. During the meal eaten in the town of Emmaus, the disciples recognize Christ when he blesses and breaks the bread. Rembrandt later depicted this scene with great expressive intensity, but the stained-glass in Sainte-Chapelle is no less moving in the sweet spiritual complicity it betrays.

ROYAUMONT, ABBEY, THE CLOISTER, 1228–35
Saint Louis, who built the abbey, loved to spend time in this cloister, where he shared the monks' simple way of life.

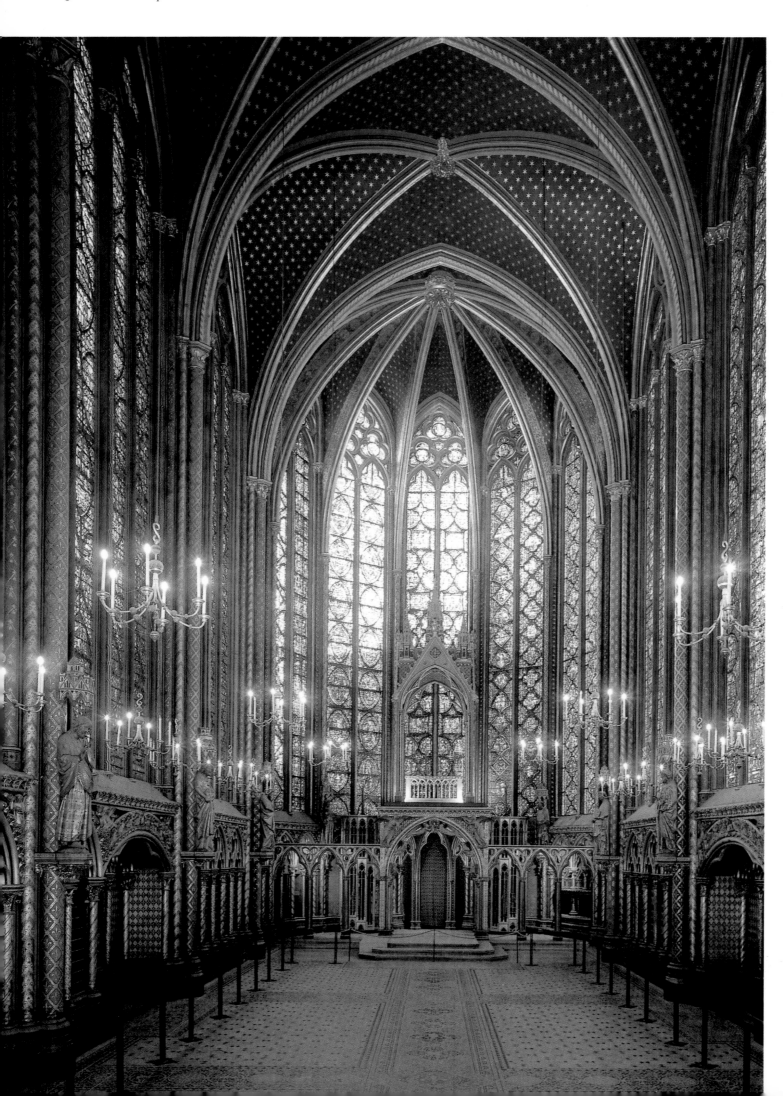

PARIS, SAINTE-
CHAPELLE, UPPER
CHAPEL, 1241/43–48
*Itself like a precious
reliquary, the Sainte-
Chapelle shelters the
remarkable relics of
the Passion of Christ,
including the crown
of thorns. The upper
chapel, placed above
the lower chapel, was
reserved for the elite.*

Opposite
PARIS, SAINTE-
CHAPELLE, UPPER
CHAPEL, DETAILS OF
THE STAINED GLASS,
1241/43–48
*At Sainte-Chapelle, a
new style, different from
that of Chartres, took
hold: the colors are
bright and cheerful, the
design more natural and
elegant, and a greater
emphasis was placed on
historiated scenes than
on mosaic borders and
backgrounds.*

the Romanesque period, the monasteries and their schools were the principal centers of culture. In the eleventh and twelfth centuries, the episcopal schools took up the baton. At the beginning of the thirteenth century, masters and students asserted their independence with regard to the bishops. They founded the universities, a word derived from the Latin expression "universitas magistrorum et studiorum," a grouping of all the masters and students. In 1200, the cathedral schools of Paris—where one taught from a "chair," or *cathedra*, meaning "seat"—fused all into a single body, with the approval of King Philippe Auguste and Pope Innocent III. In 1225, the Université de Paris received its charter.

In the Middle Ages a university was divided into four faculties (branch of learning or teaching). The students followed first the courses in the faculty of arts, according to the cycle of the trivium (grammar, rhetoric, and logic) and the quadrivium (arithmetic, geometry, astronomy, and music). Next they chose to study letters at the same faculty or to enroll in one of the three specialized faculties: theology, law, or

AN INTELLECTUAL EFFERVESCENCE

Paris—political, economic, and artistic capital—established itself as intellectual capital in the thirteenth century.

During the early Middle Ages and again in

medicine. Each faculty was headed by a dean. The dean of the faculty of arts, which had the most students, was the rector, or head of the university. The students lived in college buildings on the left bank, on the slopes of the Sainte-Geneviève hill. In 1252, Robert de Sorbon founded a college to accommodate poor students, the ancestor of the present-day Sorbonne.

The masters taught in rooms they rented and were paid by the students. In the fifteenth century they began to teach in the college buildings. The courses took the form of *lectio*, reading and textual commentary, and *disputatio*, discussion on a theme. Books at this time were rare; the professor would have read a great many of them, and a large part of his course consisted of dictating excerpts from them. For the same reason, famous authors compiled *florilegia* (selected passages), or "summaries," which, rather than encyclopedic presentations of the scope of knowledge, were books claiming to take the place of all others.

In the thirteenth century the major faculties gained international renown and students flocked to them from all over Europe—to Paris for theology, Oxford for science, and Bologna for law, especially Roman law. Later, in the fourteenth and fifteenth centuries, kings who founded their own universities forced the students of their countries to go there exclusively.

In the thirteenth century the Université de Paris was in an uproar. The philosophy of Aristotle, known mainly through Arabic translations, gave rise to passionate opinions pro and contra. To understand the importance of this crisis, we must backtrack. The first Christian intellectuals, the Church Fathers, had compared the Bible and the Gospels with the wisdom of antiquity, especially the two greatest Greek philosophers, Plato and Aristotle. Plato (428–347 B.C.) easily passed the examination; it even appeared to some that the philosopher and his school (Platonists and Neoplatonists) had a vague foreknowledge of Christian revelation.

Christianity, however, did not agree very well with the philosophy of Aristotle (c. 384–322 B.C.), whose idea of God had nothing in common with Christian doctrine. In his *Physics*, in fact, he announced that "everything that is, is moved by something," whereas God is the "Unmoved Mover," giving movement without himself being moved.

With Saint Augustine (354–430), and later with the greatest philosophers of the beginnings of the Middle Ages, Boethius (480–524) and John Scotus Erigena (ninth century), Christian thought assimilated part of Platonic thought. His influence is perceptible in the twelfth century, in the writings of Abbot Suger on art, in the teaching of the school of Chartres, and even in the symbolism of Gothic architecture.

But in the thirteenth century Aristotle was in fashion. Even after a church council in 1210, followed by the papal legate, Robert de Courzon, in 1215, condemned his writings, this did not stop the defenders of his highly structured philosophy from attempting an assimilation already undertaken by the Islamic thinkers Avicenna (Ibn Sina, 980–1037) and Averroës (Ibn Rushd 1126–1198), or those of Judaism, such as Moses ben Maimon, known as Maimonides (1135–1204). In 1231, the ban was lifted.

Saint Thomas Aquinas, born in 1224 or 1225, joined the Dominican order, then, in 1252, came to Paris, where he taught theology after 1257. From 1266 to 1274 he wrote the *Summa Theologica*, which incorporated Aristotelian ideas; he adopted Aristotle's methods of logic and even his vocabulary ("final cause" and "efficient cause"; "active intellect" and "passive intellect"), but without giving in on the essential: his God was a loving god, not an "Unmoved Mover."

The immense work of the *Summa* is very structured. Its basic division is the "article," set up like a *disputatio* of the time: a series of arguments for and against, an appeal to an authority, a "determination" (solution to the problem), and a response to objections.

A parallel is often drawn between Gothic architecture and scholastic thought, to borrow Erwin Panofsky's title, between the cathedrals and the great theological and philosophical works of the thirteenth century, such as Thomas Aquinas's *Summa*. Both reveal the soul of the period according to two different modes of expression. In this high point of culture, the mind, curious and self-confident, conquering and triumphant, was ready to encounter a vast world of thought and knowledge that opened up with the routes to the East.

The time was not yet ripe, however, for a fundamental shift in the conception of truth, or relativism: all knowledge still had to be organized into a harmonious and hierarchical world. This made for a unified,

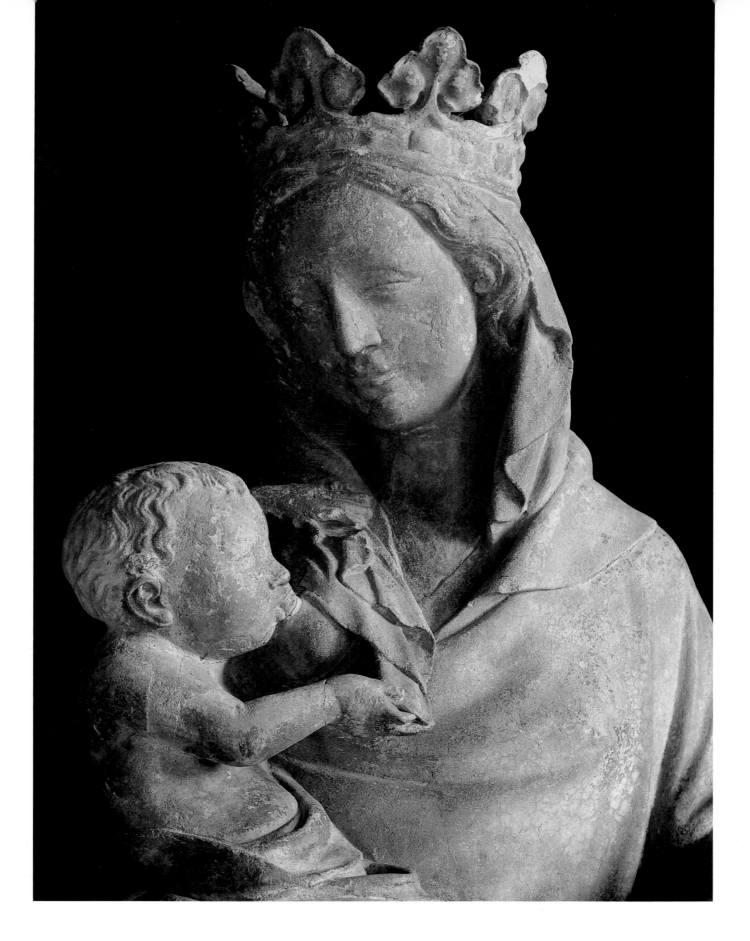

but not "totalitarian," vision, for the feudal tradition remained alive in all domains, granting each level a certain autonomy and respecting diversity. It was a time of great syntheses and recapitulations, which also describes the cathedral in its attempt to be the sum of all geometric figures, of all known architectural forms, while encompassing, through its iconographic program, the whole of knowledge and the history of creation, including its fate.

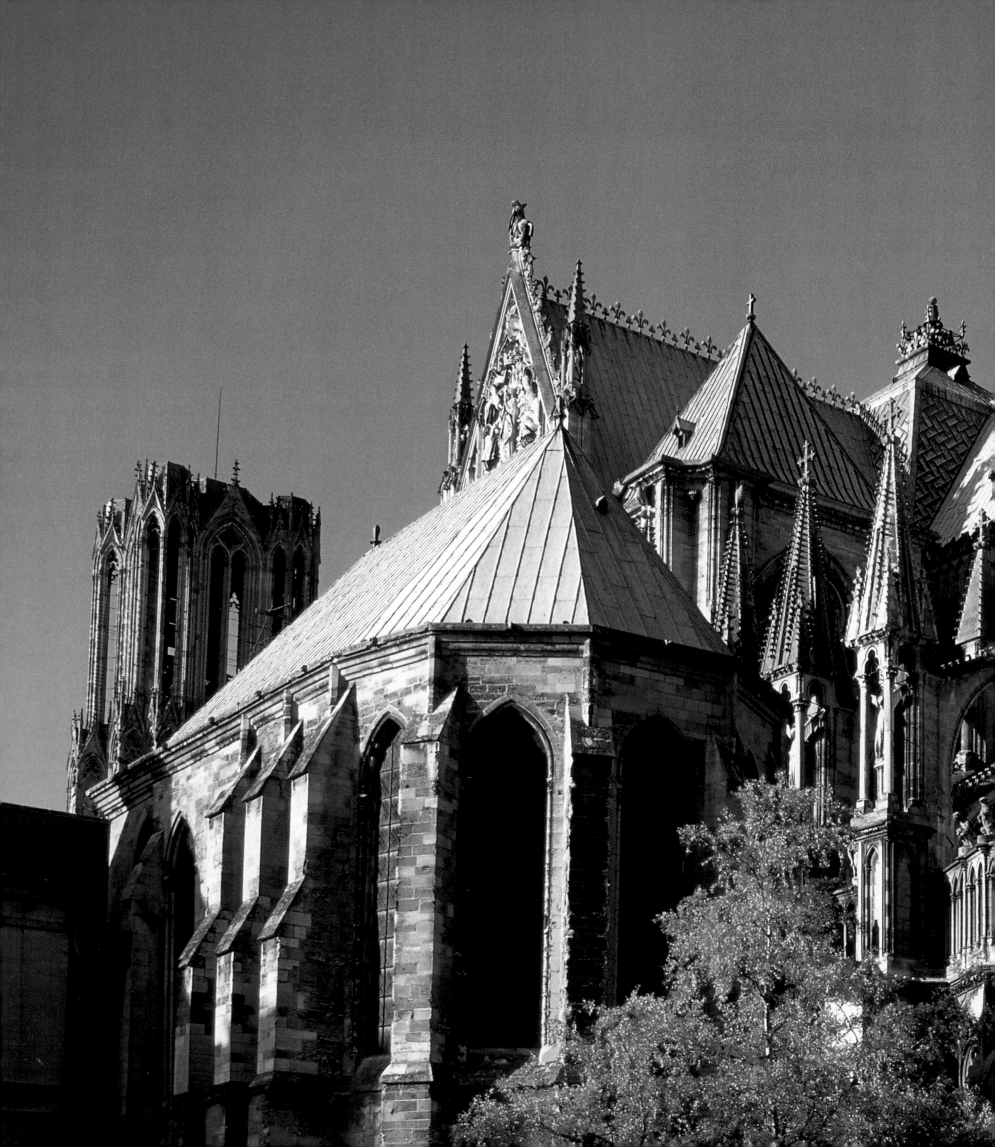

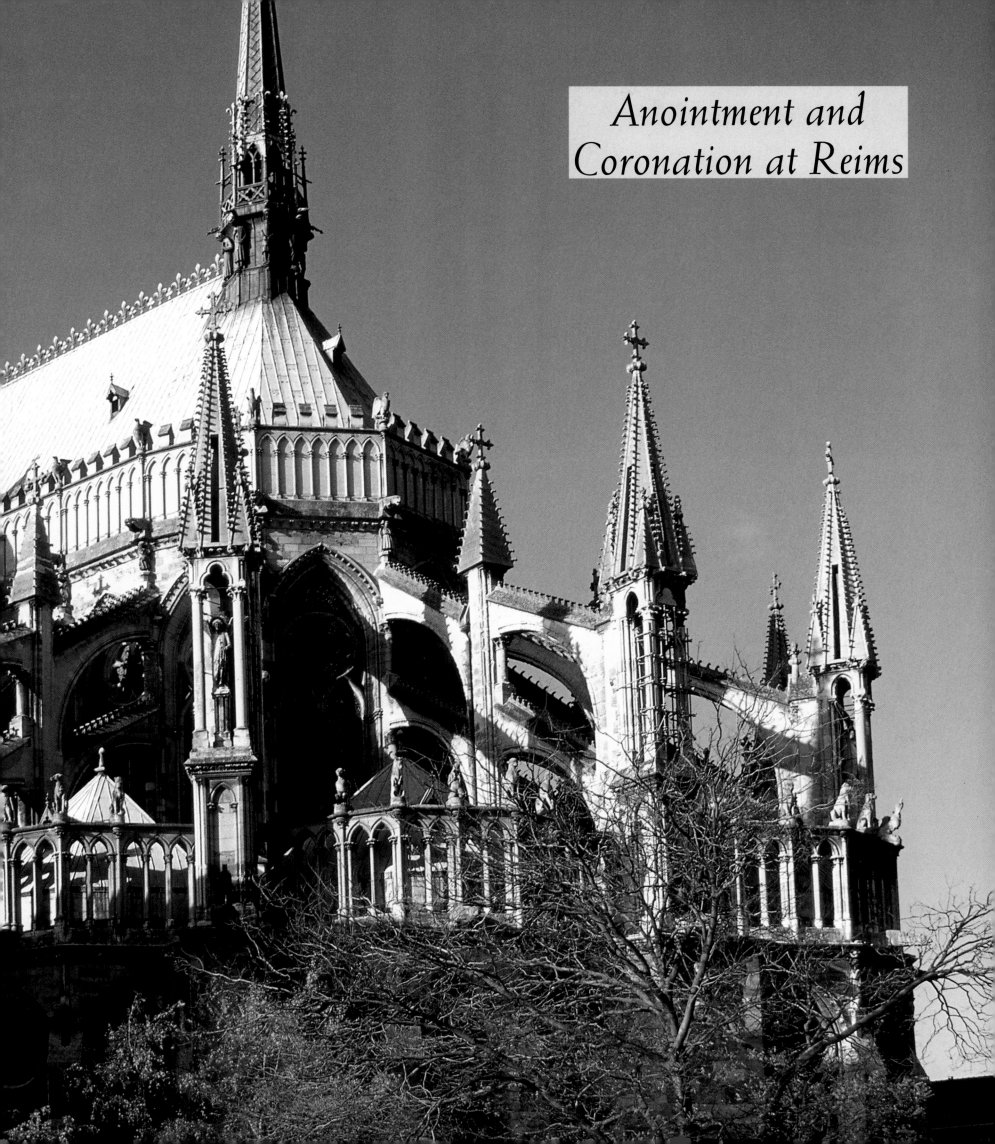

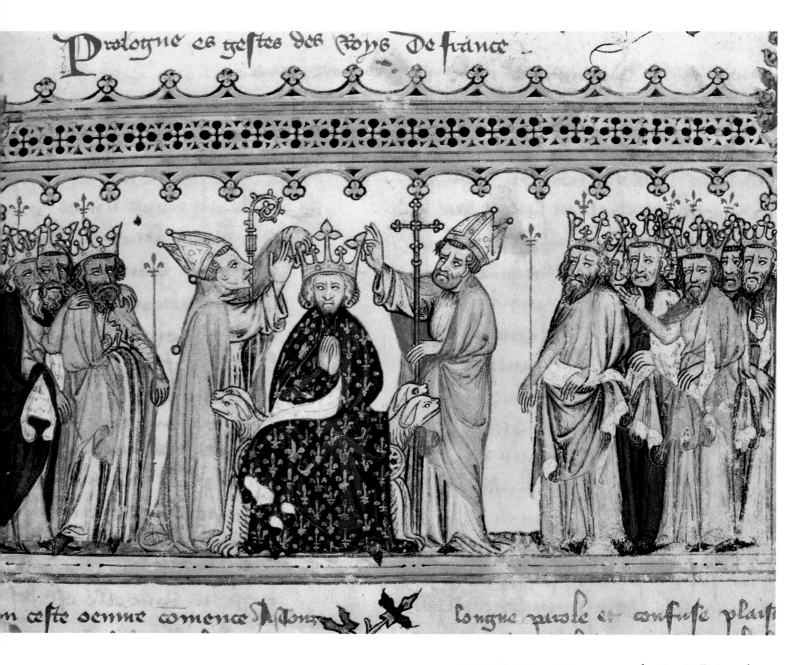

LES GRANDES
CHRONIQUES DE
FRANCE, FOLIO 1,
ILLUMINATION OF
THE CORONATION
OF A FRENCH KING,
14TH CENTURY.
BIBLIOTHÈQUE
MUNICIPALE, REIMS,
MS 1469

FRENCH HISTORY REALLY begins in Reims about 498 A.D. when the Frankish king Clovis manifested his conversion, under the influence of his wife, Clotilde, by being baptized by Saint Rémi, the bishop of Reims. He thereby sealed the alliance of the Frankish crown with the Church against the Visigoth kings who controlled most of France and who embraced the Arian heresy. The anointment and coronation of the French kings commemorated, at the beginning of each reign, the ancient bond between royalty and the divine. It was a rite through which the new king requested divine benediction.

BY THE GRACE OF GOD

On the morning of the anointment and coronation a procession led by the bishops of Laon and Beauvais

Preceding pages
REIMS, CATHEDRAL OF
SAINT-REMI, VIEW OF
THE CHEVET

came for the king at the archbishops' palace, the Palais du Tau, where he had spent the night. He took a seat in the choir, in memory of the times when kings were elected; the bishops raised him from his seat and asked the assembly if it accepted him as king. Next, he took an oath in Latin.

The king climbed to the altar. The archbishop blessed the sword known as Charlemagne's and returned it to the king, praying God to grant him courage in battles. He then anointed the king seven times with chrism, or consecrated oil—on the top of his head, the chest, between the two shoulders, on each shoulder, and on the joints of each arm—so that no part of his being might forget its mission. According to legend, at the baptism of Clovis a dove brought the holy phial containing the holy chrism from heaven.

The king then put on the ermine-edged cloak of anointment and coronation, which was blue with gold fleurs-de-lis. The archbishop gave him the ring, the scepter, and the "hand of justice" (a scepter ending in a hand of ivory or precious metal), then took "Charlemagne's" crown from the altar and, assisted by the peers of the kingdom forming a circle around the king, crowned him; an anonymous fourteenth-century illumination represents this scene in all its grandeur. After leading the king to his throne, as a sign of respect for his temporal power, the archbishop prostrated himself, embraced the king, and exclaimed, "Vivat rex aeternum!" (May the king live forever).

Doves were released, and joy broke out in a grand Te Deum; the anointment mass began. At the offertory, the consecration offerings were brought: a golden loaf, a silver loaf, a large gilt-silver goblet filled with wine—a sign of the prosperity the king wished to bring to his country—and a red velvet purse embroidered with gold, containing thirteen gold pieces. Why these thirteen pieces of gold? According to Frankish custom, at his marriage the bridegroom was supposed to pay for his bride. Clovis had paid one sou and one denier for Clotilde. At that time one sou equaled twelve deniers, so the coronation's thirteen pieces of gold recall the coins once paid for Clotilde. After the consecration, the high chaplain received the kiss of peace from the archbishop. He gave it to the king, whose peers received it in turn. The king then took communion with both bread and wine, a privilege he alone was allowed to share, along with the priests, on the day of his anointment and coronation. Remarkably, the consecration chalice with which all the kings of France have taken communion since the twelfth cen-

tury has survived, a moving relic. The anointment and coronation was completed, as are all French celebrations, with a banquet, in the Palais du Tau.

A HYMN TO JOY

Begun in 1211, the new cathedral of Reims, where future French kings would be crowned, was to be the most beautiful ever. Jean d'Orbais, entrusted with the task of building it by Archbishop Aubri de Humbert, wanted it, above all, to be magnificent in size. At 125 feet (38 meters) high, its nave is the tallest Gothic nave ever achieved—taller than Sens (80.5 feet, or 24.5 meters), Laon (79 feet, or 24 meters), or Notre-Dame-de-Paris (108 feet, or 33 meters)—and especially taller than the most famous Romanesque churches—Cluny (98 feet, or 30 meters) and La Charité-sur-Loire (88 feet, or 27 meters).

More than these churches, which he surely had visited, Jean d'Orbais wanted to surpass the fine buildings of antiquity; these he had not seen, but his imagination had been kindled by marvelous, and exaggerated, tales of travelers. He wanted his towers to be taller than the Great Pyramid, his colonnade to be more beautiful than the Parthenon, and even for his high passageways to outdo the splendor of Babylon's hanging gardens, one of the seven wonders of the world, gone forever.

He wanted his work to be not only higher but also of a finer aesthetic than the first cathedrals. He preferred an elevation of three levels to the traditional four levels: large arcades, triforium, high windows. He rejected the sexpartite vault, whose design, seen from the ground, he thought lacking in harmony; since it was almost square, the vault stretched over two bays. He chose the quadripartite vault, which fit well into a single bay and formed a harmonious, elongated rectangle. Since it was begun by Jean d'Orbais alone and continued by his successors according to his plans, this cathedral has great stylistic unity. Jean d'Orbais definitely freed himself from Romanesque aesthetics. The distance of time gives justice to each artistic school; today we appreciate Romanesque works as much as Gothic ones. But the artist is always intolerant. He believes that those who went before him were mistaken, that they failed to find true beauty, that they left the world empty, and that all is yet to be done. For the Gothic architect, the Romanesque aesthetic appeared somber, sad, overly massive and

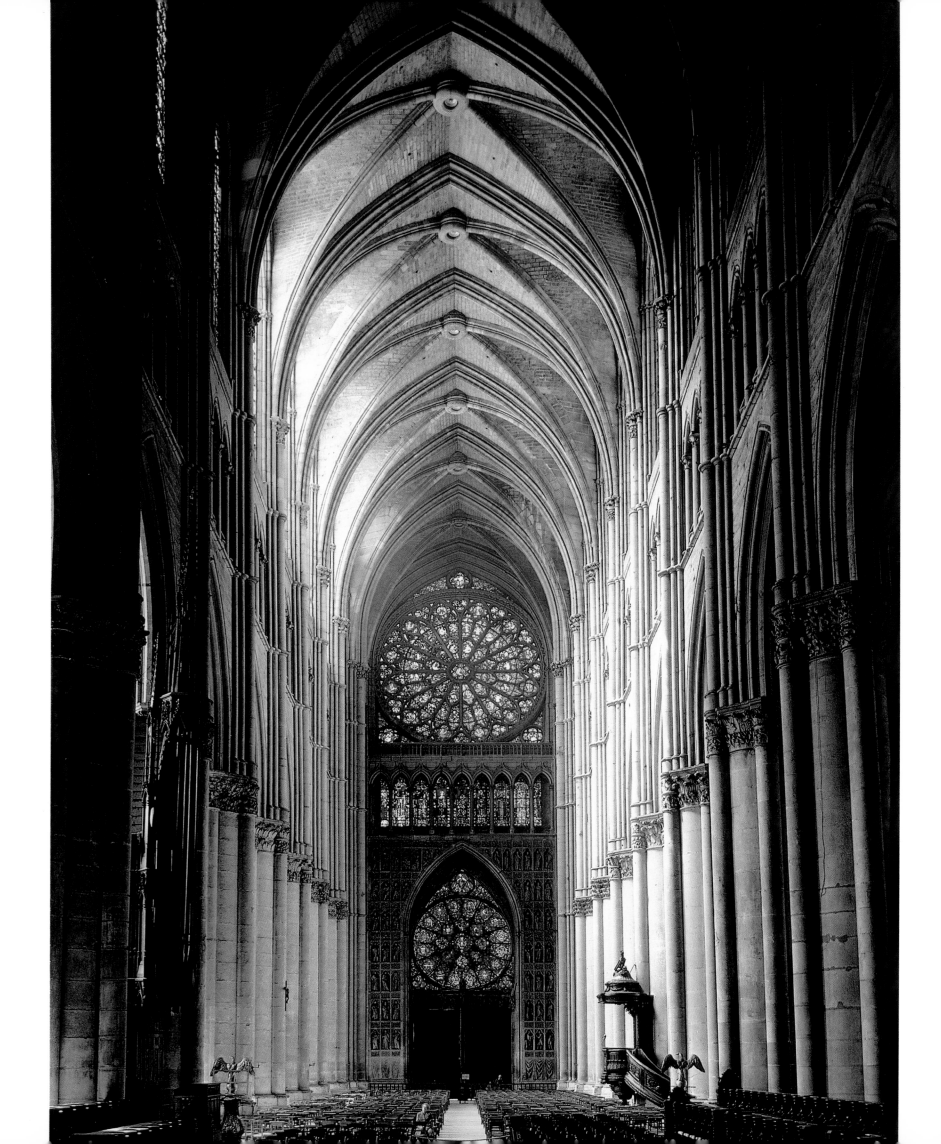

REIMS, CATHEDRAL
OF SAINT-REMI, BACK
OF A PORTAL SHOWING
A KNIGHT TAKING
COMMUNION

Opposite
REIMS, CATHEDRAL
OF SAINT-REMI, VIEW
OF THE NAVE WITH
THE ROSE WINDOW

ings to which relief has been added as an afterthought.

At Saint-Denis, as on the western facades of Chartres and Notre-Dame-de-Paris, sculpture gained autonomy with respect to the architecture, but it remained confined to the portals; the human figure "in the round" (or full relief) remained very stylized there, still similar to the statue-column.

At Reims, all this changes. The main facade is a great stroke of genius, a magnificent "hymn to joy" in stone. Sculpture is everywhere, on every story, and the human figure is once and for all freed from the column. Monumental groups were the glory of Romanesque tympanums; here, to attain a volume previously unknown, they left the tympanums for the space above the tympanum arches and beneath the gables. To the left, the Crucifixion uses the ascending movement of the arch to suggest the hill of Golgotha; the group of the Coronation of the Virgin by Christ spreads out in the center. The original statues of this group, too damaged by the cumulative effects of war and pollution, had to be put into the Musée de Tau and replaced with a modern copy; it weighed more than 26 tons.

An extraordinary movement of innovation and progress, a true advance toward plenitude, animated the workshops in Reims. The Virgin and the Saint Elizabeth of the Visitation mark the beginnings of these experiments. In representing them in the dress of Roman women, draped with togas with deft folds, the sculptor displayed his erudition, although their squat bodies still recall the statue-column. Mary's face, however, is miraculous, haunting and unforgettable.

With the Virgin of the Annunciation, the old man Simeon and the Virgin in the Presentation in the Temple, a new level was reached. The faces and shape of the whole have attained "the state of grace." The weight of tradition, nonetheless, remains in the overly direct, overly regular fall of the clothing, which does not reveal the bodies beneath it.

With Eve, the angel of the Annunciation, "the Smiling Angel," and "the Knight's Communion," a totally new style freed from the past was born. The shape of the whole is still elongated, but the slight tension of the figures breaks the clothing into varied folds, revealing the body, its movement, and a little of its volume. Joy bursts forth in the expressions of the mystical, dreamy, and smiling faces. The smiling angel is a bit more restrained, classical; he does not forget that he is "above us." The angel of the Annunciation

heavy. Reims claimed victory over this aesthetic in a radical manner: vast, slender, fitted with large windows that poured a flood of light into the nave, the building is itself a manifesto.

This transition from one style to the next, this victory of the Gothic, was also repeated in the style of the sculptures and the place assigned them. In the Romanesque churches sculpture remained discreet, subordinate to the architecture. It decorated the capitals and portals; the portals of Autun, Vézelay, and Moissac, masterpieces that they are, remain large bas-reliefs, a part of the buildings, like splendid draw-

has a more feminine grace, and laughs freely and joyously.

The art of these masterpieces is simultaneously realistic and idealistic; each of these faces, so varied and alive, has its own individuality while also being lit from within, animated by a spiritual joy that makes them even more beautiful and serene.

IN A STONECUTTER'S WORKSHOP

Sculpture particularly favors contemplation. While the architect finds his truth by drawing a great number of quick sketches until he discovers harmonious proportions for the whole, the sculptor finds it but once, slowly and gradually, as dictated by the law of the stone or wood. By patiently paring away the material, by removing successive layers following the

"onion" technique, he approaches his idea, as it appears to him little by little, in the long climb from certitude to illumination. All internal torment becomes externalized in the struggle with the material. The sculptor must be the stronger of the two! Sculpture, little understood by tormented souls like Charles Baudelaire, is a slow progression toward serenity.

In the Middle Ages, the sculptor of the most beautiful masterpieces was not radically different from the ordinary stonecutter of, for example, column moldings. Belonging to the same profession, enjoying the same status, that of artisan, he was simply a more qualified, better appreciated professional, self-taught, who had ideas and perhaps had traveled a bit.

It was not until the seventeenth century in France that a distinction was made between the sculptor/artist and the stonecutter/manual laborer. During the nineteenth century, and up until the time of Rodin, the

REIMS, CATHEDRAL OF SAINT-REMI, DETAIL OF CENTRAL PORTAL OF WEST FACADE
Mary reacts with gravity to the angel of the Annunciation, animated by exultation, set in the trumeau of the west facade's central portal. The Reims school of sculpture, which gradually evolved far beyond the rigid models of the past, here achieved one of its masterpieces.

JEAN FOUQUET, *CONSTRUCTION OF THE TEMPLE OF JERUSALEM,* LATE 15TH CENTURY

sculptor did not work the stone; he made models of clay, while the cutting of the stone was entrusted to a "practitioner" who reproduced the clay model, often enlarging it. At the beginning of the twentieth century, and especially after World War I, sculptors like Constantin Brancusi protested against this practice, which deprived the sculptor of a sense of the material. They led the way to a return to the direct cutting of the stone, and to a renewed familiarity with the gestures and frame of mind of the cathedral sculptors.

CHAMPAGNE OF THE COUNTS

During the four centuries from 900 to 1284 Champagne was a great fiefdom, which is to say, an almost independent state. After 1100 the counts of Troyes became counts of Champagne and represented a rival power to the Capetians. It was not conquest that put an end to the region's independence but rather the marriage of the last heir, the countess Jeanne, who brought her fiefdom as dowry to Philip the Fair. The counts of Champagne, intelligent and liberal—Henry I, in fact, was called "the Liberal"—encouraged artistic creation, founded many aid institutions, and stimulated the economy of their fiefdom, whose prosperity they ensured.

Champagne was located on the principal trade route of medieval Europe, which joined the two most important economic regions: Flanders on the one hand, with its ports of Bruges and Ghent, linked to England, Russia, and northern Europe; and northern Italy on the other, with the ports of Pisa and Venice, open toward the East. Champagne provided a meeting ground for Flemish and Italian merchants and bankers and encouraged these encounters, which turned into the well-known Champagne fairs. They took place each year during precise times, in about six sessions of about seven weeks, two in Provins, two in Troyes, one in Lagny, and another in Bar-sur-Aube. This event generated in Champagne an industry of

high-quality cloth, already flourishing in Flanders and northern Italy. Immediately following these two, Champagne became the third most important economic region in thirteenth-century Europe.

The economy in the Middle Ages ran primarily on self-sufficiency: each manor house, each feudal domain tended to produce its own basic needs. Commerce dealt with only a small part of production: rare and precious products. Hence, an air of luxury surrounded the world of trade, intensified by the enormous insecurities of travel. Storms, reefs, and pirates threatened sea transport; robbers and some feudal lords were no less dangerous on the land routes. On the other hand, profits were great when the trip was successful.

PROVINS: THE PLEASURES OF TRADE

With its 80,000 inhabitants in the thirteenth century, Provins was the third-largest city in France, after Paris and Rouen. The lower city grew under the protection of the count's château, the citadel, and the Tower of Caesar, which occupied the upper city. Three miles (five kilometers) of ramparts surrounded the whole. Economic and commercial activity, initially tied to the monastic institutions of the lower city, took on a life of its own. Commerce and the spirit of commerce filled the place, especially during the periods of the fairs, in May and autumn. At that time all the wares considered most beautiful and tempting were on display: Russian furs, Dutch linen, French wine, Spanish leather, dyestuffs, silks, spices, perfumes from the East.

As in Venice or Bruges, each commercial city had its "house," or inn, where a trader could find rest and shelter for himself, his mounts, and his merchandise. This became a sort of club in which traders found their compatriots and could entertain clients. Thus, there was the House of Cambrai, of Ypres, Marseilles, Toulouse, Rouen, Aurillac. Beneath the city, a mysterious network of vaulted rooms and underground chambers dug into the rock served as warehouses for the traders, keeping the secrets of their business in darkness.

The bankers were Lombards, Jews, or Knights Templar. The order of the Knights Templar had two establishments in Provins, the commanderies of Val and Madeleine. Soldier-monks, the Templars contributed to the conquest of Jerusalem, their comman-

deries dotting the route and guarding the way. The pilgrimage to the Holy Land was long and costly. To reduce the risks of robbery, pilgrims fell into the habit of placing their funds with the order of the Templars before they set out; on presentation of receipts, the commanderies handed over funds as they were needed. As the financial mission of the Templars grew, they became bankers for kings, popes, and large commercial establishments. In order to avoid paying for false documents, they invented a system of secret signs. Thus, the Templars cultivated mystery. Did they, as they were accused after their arrest in 1307, hide treasures (which to this day have never been discovered), live according to a secret hierarchy, different from the apparent one, and practice a clandestine, heretical religion, mixing the revelation of Mohammed and the esoteric traditions of the East with the Christian message? These questions remain the object of passionate debate.

The streets of Provins were lined with the stalls of craftsmen, for they worked in the open air, before their clients' eyes, like the tailor, the furrier, the barber, and the apothecary depicted in an anonymous fifteenth-century illumination. This procedure was dictated by the strict rules governing the trades. Each person could thereby verify that the artisan did quality work, using the best materials possible. Working at night was forbidden, since artificial light does not produce work as good as that done by daylight.

The fabrication of cloth, especially the famous "black cloth" of Provins, evolved into a veritable industry, employing a great number of workers and utilizing three thousand looms. It occupied the outskirts of the city. The dyers set up their washtubs along the Durtient (Dyefast) river—whose dying properties enjoyed great renown, and whose apt name was an early example of advertising. The division of labor was highly developed: the manufacture of cloth required no fewer than fifteen major operations. Modern in its modes of production, this industry— an exception in the Middle Ages—remained traditional in its institutions. The "Corporation of Master-Weavers and Drapers of Provins" rigorously fixed the criteria for quality and distinguished the requisite and forbidden methods of fabrication in its rules and statutes. Each piece was verified by sworn guards who, as guarantee, affixed a metal seal to it.

The crisis in this industry led to the decline of Provins. Flanders, northern Italy, and then Champagne

Overleaf
PROVINS, VIEW OF
THE RAMPARTS,
12TH–13TH CENTURIES
*A flourishing industry
and trade made Provins
the third-largest city in
the kingdom. Its mighty
fortified walls, 3 miles
(5 kilometers) long,
proclaim its status.*

had long profited from what we call "industrial and technological advances" in this domain. But their success encouraged imitators, who entered the market and sold for less, thus reducing prices. To deal with this crisis the employers of Provins made their laborers work harder. Still, taxes imposed on trade receipts fell and, in order to maintain yield, taxes were raised. By extending the length of a day's work by one hour, Mayor Guillaume Pentecôte struck a match to the tinder; a workers' revolt broke out, and he was killed. Other revolts took place in 1281, 1315, and 1325, which drained Provins at the difficult moment when it joined the kingdom of France: the grandeur of the city was a thing of the past.

PROVINS IN CELEBRATION

Before these times of mourning Provins had been a very lively city. People spent time and limitless energy on colorful celebrations that combined religion, poetry, and burlesque. During Rogation Days (the three days preceding Ascension), a feast of the Dragon and the Lizard took place, enlivened by all the young people of Provins. A group carrying a long pole topped by a wooden dragon's head departed the church of Saint-Quiriace, in the upper city. The other group, carrying a Lizard over a banner of the Virgin, left from Notre-Dame-du-Val in the lower city. They went through Provins in a noisy procession, and when they met, they mimed a battle. Through this fictive combat, the people of Provins reduced the hostilities and mistrust that could build up between the inhabitants of the two neighborhoods. Innocents' Day was the feast of "little fools," in which the children elected a bishop; during the feast of the "big fools" the deacons and subdeacons also elected a false bishop, who was then paraded through Provins. On this occasion, drinking, playing dice and tennis, and dancing in the churches were allowed. On Easter, a donkey was

installed in the bishop's pulpit. The kindly priests participated in these celebrations with good humor. In May, during a celebration whose poetry would have been appreciated by Gérard de Nerval, the canons of Saint-Quiriace selected the young girl who sang and danced the best—a beauty queen, in other words—and crowned her with flowers.

Provins was the preferred residence of the counts of Champagne. From the heights of their castle, they could look out over the city's animation in these times of prosperity and find satisfaction in the results of their wisdom.

With the fabulous revenues that the taxes on trade brought in they maintained a sumptuous court, surrounded by artists. Count Thibaut le Chansonnier (Thibaut the Songwriter, 1201–1254) organized poetry competitions, as well as balls, banquets, and concerts. He was himself one of the greatest *trouvères* (narrative poets) of the thirteenth century. Baptized in the arms of King Philippe Auguste at Saint-Quiriace, a sign of the king's respect for the county, Thibaut was also a warrior and a pious man, who fought in the Crusades.

TROYES: POETRY IN THE STREETS

In the Middle Ages builders used local materials, which were easy to transport, as much as possible. The look of a town thus came from its materials, themselves a reflection of a particular earth and sky. Provins, built in quarry stone, is a gray-white town with green as well, like its abundant moss and vegetation. Troyes, on the other hand, is brown, from the wood of its half-timbered facades, yellow, from its cob walls made of straw and unbaked clay, and red, from the flat tiles of its roofs. In contrast, the churches, to honor God, were made of cut stone, a costly material to transport and work. As it made possible the construction of tall, deep buildings with a strikingly different appearance, it suggested a force greater than human nature.

In the Middle Ages building sites inside the town walls, which could not be enlarged, were rare. People therefore built corbeled gabled houses overhanging the street, which sometimes hid the sky, as in the rue des Chats. As need arose, additions were made to existing buildings; the fluidity of half-timbered constructions lent itself well to this practice. The whole formed a unique and extremely varied fabric, since it was the work of many builders—all unconstrained by

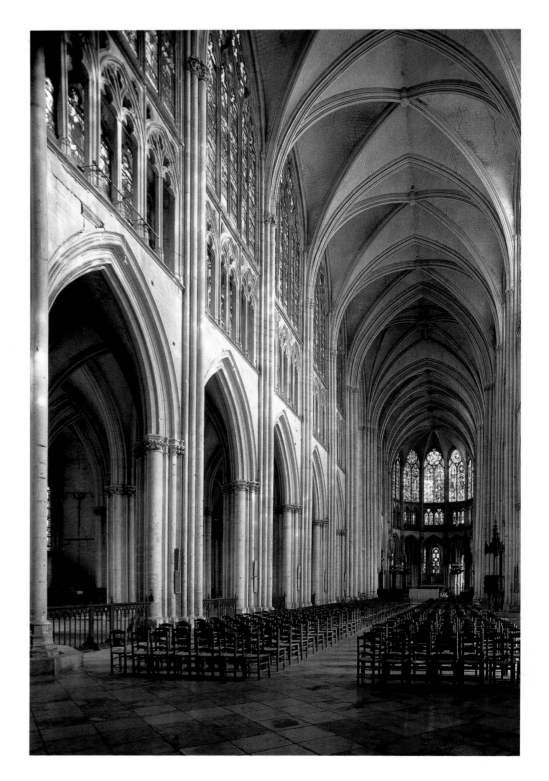

building codes—adapted over the course of time to the tastes and desires of different owners and occupants. In the oldest part of the town, logic gives way to fantasy. In order to reach his home, an inhabitant might have had to go under a porch, follow a small passageway, cross a courtyard, climb three steps and then a spiral staircase, follow a corridor overhanging another courtyard, turn a corner, go down other steps.

Through the open window you could hear birdsong mixed with the cries of children at play, the singing that accompanied work, the regular beating of

tools—for the neighborhood was also a workplace—the conversations of women on their doorsteps, and the cries of merchants passing through. The courtyard was considered an extension of the home, the street simply a larger courtyard. The life of the inhabitants was more collective than private: wash hung on the buildings' facades, the courtyards rang with family dramas and domestic quarrels—one of the favorite themes of medieval theater—and everyone enjoyed the whisperings of love, the betrothals being planned, and the smells of the feasts.

Religious life occupied a large part of people's free time, and the Church graciously offered splendid ceremonies and processions like charged, brightly colored, living paintings to satisfy the people's longing for the festive, the marvelous, and the spectacular. Medieval theater was an extension of the liturgy. At first it consisted of small scenes that members of the clergy performed in the churches to illustrate the Scriptures. For example, at Easter the scenes of the Resurrection and the Pilgrims from Emmaus were performed. About 1150 these representations became larger and left the church interior for the square in front of it. Stage sets, called *mansions,* were erected that juxtaposed the various sites of the action. For the *Jeu d'Adam* (Play of Adam), there were three sets: earthly paradise, earth, and the mouth of Hell. Next, a differentiation was made between miracles, which evoked the life of a saint, and mysteries, which illustrated the Gospels. The mystery play evolved into a more cosmic work, depicting all of humankind's destiny, and represented Christ's Passion, including the Crucifixion. *Le Mystère de la Passion* (The Mystery of the Passion) by Arnoul Gréban, composed about 1450, includes 35,000 lines and more than two hundred characters and took several days to stage. A mystery play was a total spectacle, including danced parts, music, songs, and processions; it alternated among mystery, the marvelous, realism, and even farce.

The city in the Middle Ages had its faults: living space was limited, and each family, as on a farm, lived in a single room that was used for everything; dwellings had little light and hygiene suffered from a lack of drainage. And fire was always to be feared.

While the counts ruled Champagne, Troyes was particularly prosperous and full of life. It was the capital of the county, the seat of the bishop, and the site of celebrated fairs, a "warm fair" in the summer, a "cold fair" in the winter.

There was no remedy for the decline of Provins. Troyes began to decline as well, but it righted itself at the end of the fifteenth century, after its troubled times passed. The ups and downs of the art of Troyes reflect its history: its great moments were the thirteenth century—its cathedral was begun in 1208 and the Saint-Urbain basilica in 1262—and the sixteenth century.

The building of the cathedral progressed very slowly; the choir and the transept date from the thirteenth century, the four last bays of the nave from the fourteenth, the next three from the fifteenth, and the facade and the first two bays from the sixteenth. Its dominant style, nonetheless, is "second-generation" Gothic. It has quadripartite vaults and a three-level elevation, including a pierced triforium and a double ambulatory. With a height of 95 feet (29 meters) beneath the nave vaulting, it has harmonious but not very elongated proportions. This is because the architect wanted to accomplish something quite different from mere height. In a major innovation, the choir offers the first example of the complete piercing of a bay; the entire panel between the large arches is opened into a vast window.

The Saint-Urbain basilica was commissioned by Pope Urban IV. A native of Troyes, he wanted to build a basilica on the site of his father's modest cobbler shop. It has a short nave flanked by two aisles and a transept. Its three facades include vast porches. It, too, was an innovative building for its time. The thickness of the stone was reduced to a minimum, so that it resembled a grille against a background of light. The interior simplicity is complemented by the complexity of the external supporting and reinforcing structures, which, with their forest of abutments, flying buttresses, ornaments, pinnacles, and turrets make this basilica a veritable stone reliquary.

The results of a constant technical progress, the reduction of the surfaces of the walls, accompanied by opening them up to as much light as possible, had a highly symbolic significance for Gothic architects, representing the progressive spiritual emancipation of man through his quest for greater participation in divine illumination.

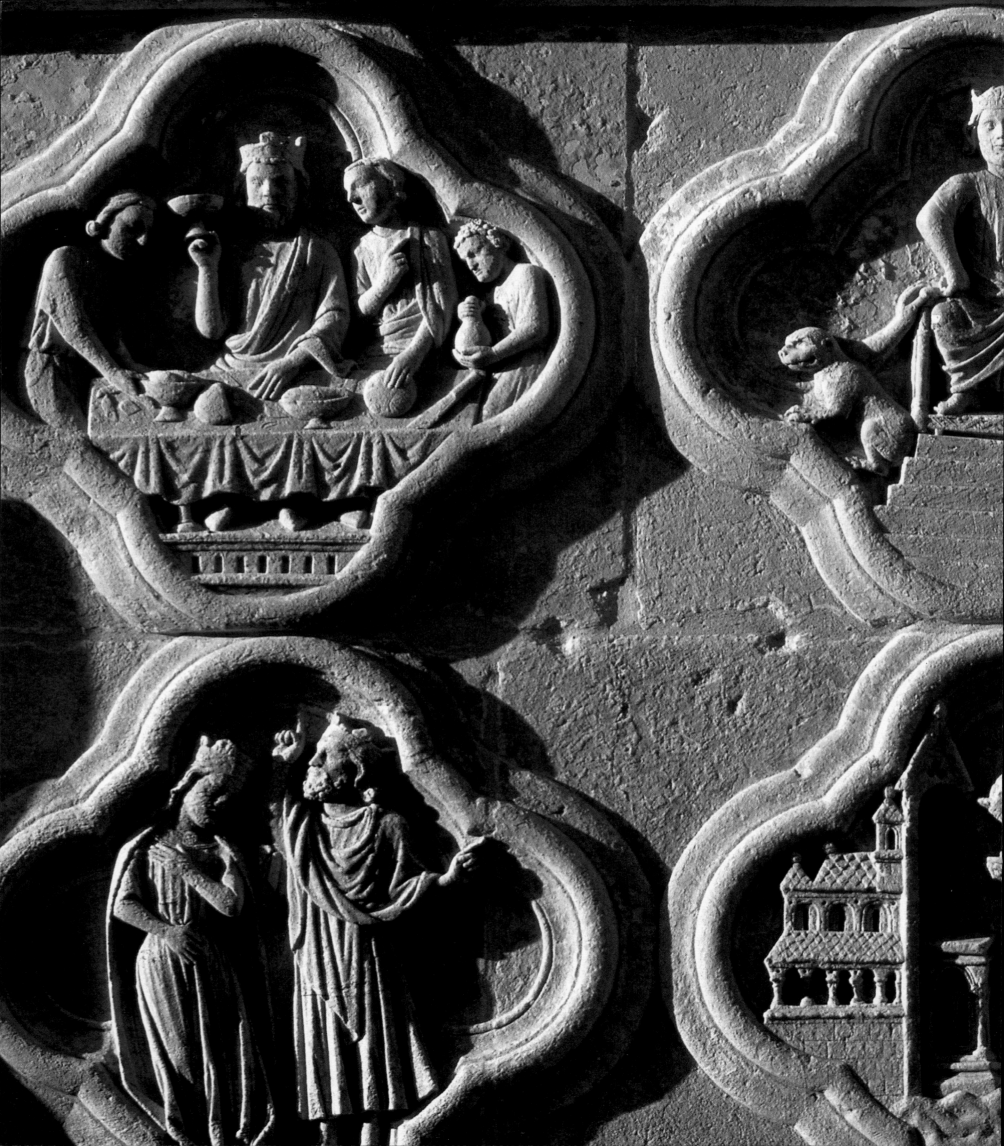

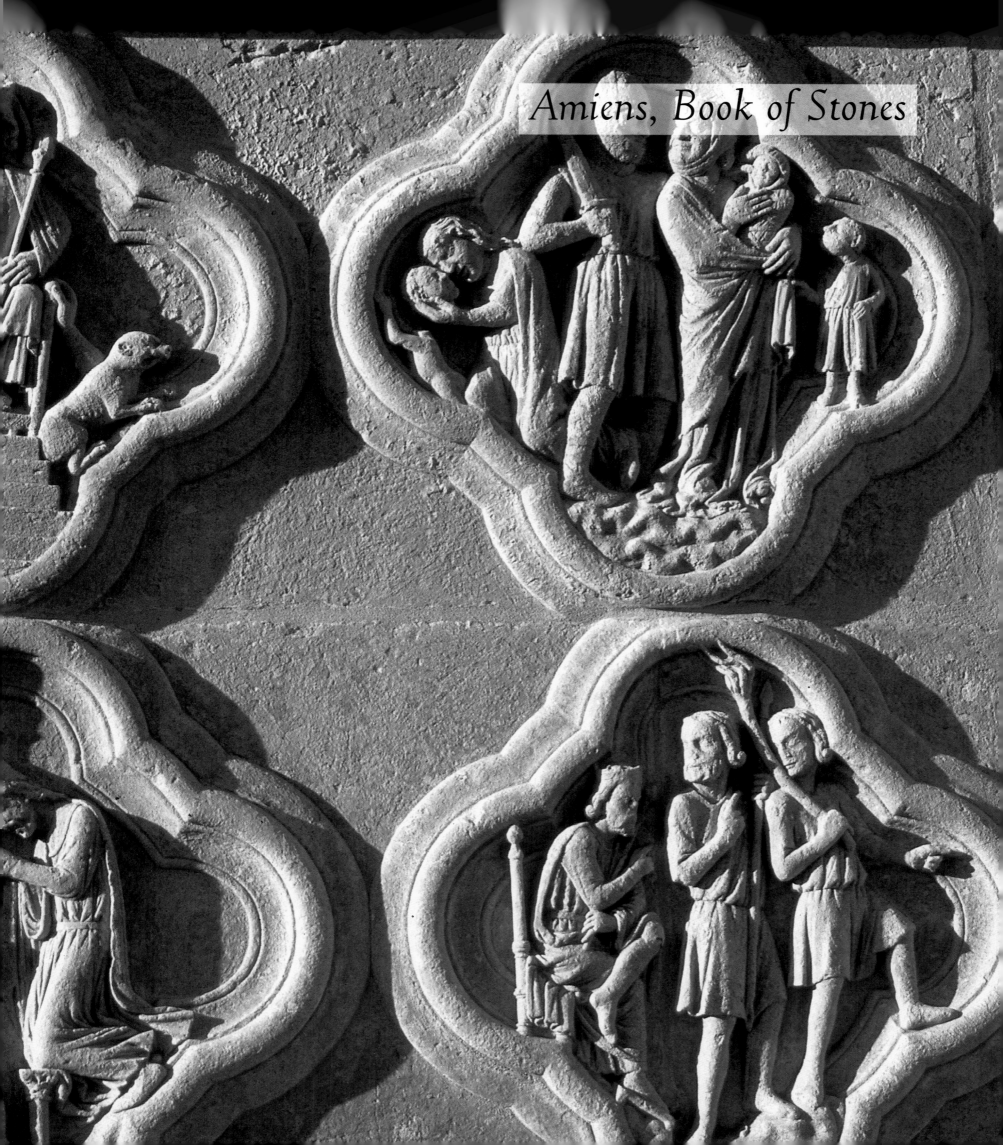

AMIENS, CATHEDRAL,
CHOIR SCREEN, WALL
PAINTING, 15TH
CENTURY
*The face of this angel,
sketched from that of a
child of the period,
demonstrates the move-
ment of Gothic art
toward a pleasing and
spiritual realism.*

Opposite
AMIENS, CATHEDRAL,
NAVE AND NORTH
AISLE, 13TH CENTURY
*The Gothic cathedrals
strove to be ever higher,
more slender. Amiens,
with its 139 feet (42.3
meters) under its great
arches, is the culmina-
tion of this evolution.
The quadripartite vault
(with four curved webs
of masonry covering a
single bay) here reaches
its most perfect form.*

Preceding pages
AMIENS, CATHEDRAL,
DETAIL OF THE CENTRAL
PORTAL OF THE WEST
FACADE, 1220/25–36
*The sculptures and the
stained-glass windows of
a cathedral were placed
following a hierarchical
order. The space most
distant from the human
gaze symbolizes the other
world. At an intermedi-
ate level are the great
models to follow: Christ,
the Virgin, the prophets,
the Apostles, and saints,
and also, often, the civil
authorities. At a lower
level may be seen, as in
these scenes framed by
quatrefoils, paintings of
everyday life and stories
from the Bible and from
history.*

THE GOTHIC STYLE, dependent on the prin-
cipal building material of the time, stone,
offered a limited number of architectural
forms, and all the architects during this period used
the same drawing method. Nonetheless, each cathe-
dral is different. This is because the style and the
method of drawing were supple enough to allow each
architect to adapt them to suit his needs and create
highly personalized works. Each cathedral thus reflects
a different temperament: a solid character in Laon,
mystical in Notre-Dame-de-Paris, triumphant in
Reims, technically innovative in Chartres, from its
inventor-engineer. Robert de Luzarches undertook
the construction of Amiens in 1220; he was a refined
artist with the sensibility of a goldsmith but a lofty
vision, so his extremely elongated cathedral is
supremely elegant. With a height of 139 feet (42.3
meters) beneath the big vaults—a little less than the
157 feet (48 meters) of Beauvais—and 44 feet (13.3
meters) for the aisles, the architect went to the limits
of daring, and even a bit beyond; the four pillars of
the transept tended to lean, and at the end of the fif-
teenth century it was necessary to gird the building
with an iron chain inside the triforium.

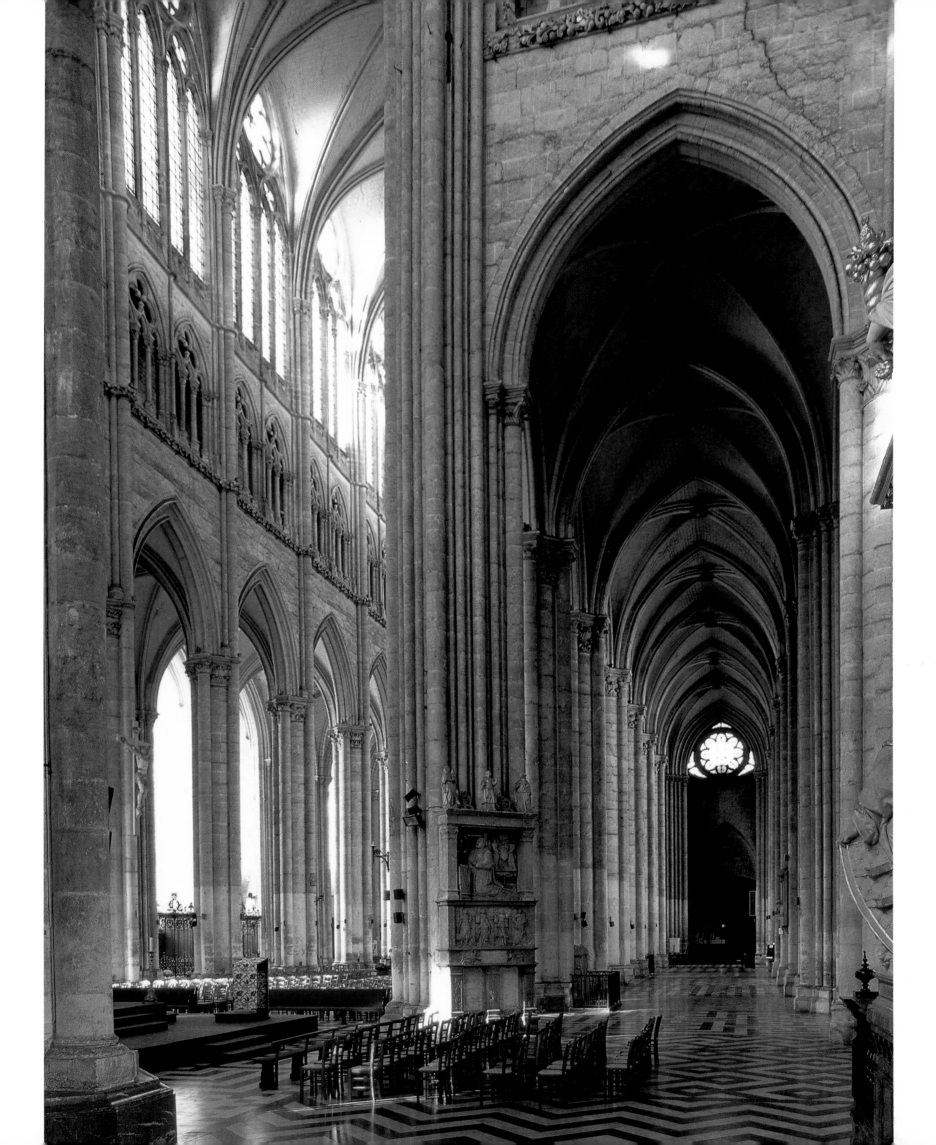

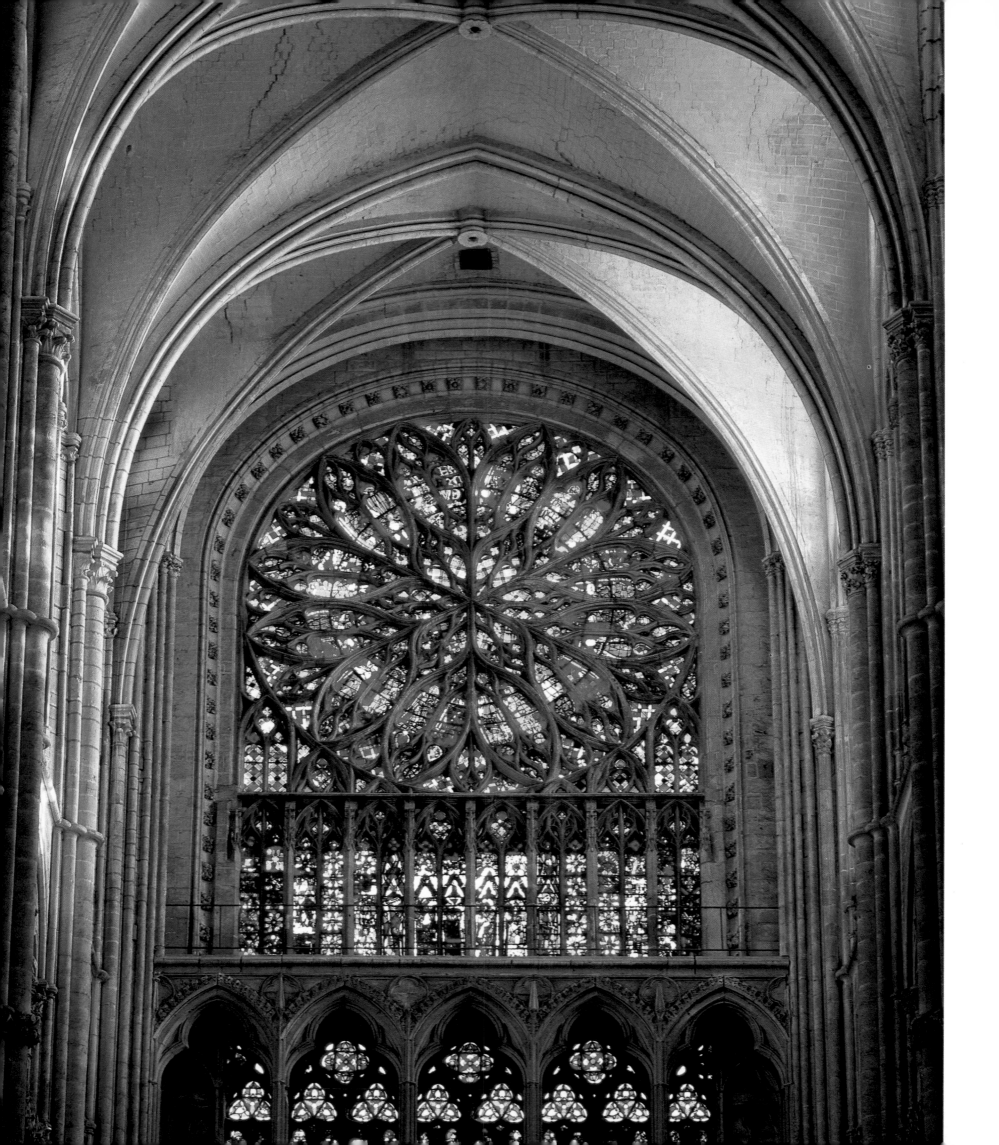

MATTER BECOME LIGHT

The architect wanted his cathedral to be exceptionally light. The second and third levels of the elevation form a quasi-continuous whole, since the high windows almost directly echo the triforium, which is "blind" in the nave and pierced in the choir. Very elongated, these openings occupy the entire width of the panel between the posts of the vaults. Moreover, the chapel windows take up all the space between the abutments, while the great arcades allow the light they diffuse to enter directly into the nave.

Amiens conveys an airy joy. Here, due to the height of the principal and secondary vaults, the slenderness of the pillars, and perhaps the whiteness of the stone as well, the idea of a nave surrounded by aisles disappears. A single, very light, and very precious canopy seems to float above us as if in a single, immense room.

The architect wanted, in particular, to erase any sense of the weight of the material in his building. As Eugène Viollet-le-Duc wrote in his *Dictionnaire raisonné de l'architecture du XIe au XVIe siècle* (Analytical Dictionary of Architecture from the Eleventh to the Sixteenth Centuries), "One can breathe freely here, barely conscious of the piers or the structures; one does not see the monument, so to speak: it is like a great reservoir of air and light."

The method of Gothic drafting made it possible to know the essential measurements of each of the building's components—down to each stone—and to express them in whole numbers. Thus, their volumes and then their weights could be determined, which the architect balanced through calculations, applying the basic principle of geometry at the time, Archimedes' law of the lever: "Commensurable magnitudes are balanced by distances inversely proportional to their weights." Robert de Luzarches wanted to make his nave, to paraphrase the poet Saint-John Perse, "a single, long unbroken phrase." He undoubtedly did not appreciate the contrast between the two first bays of the nave of Notre-Dame-de-Paris—which create a powerful narthex to support the towers—and the other bays. This is why he reduced the thickness of the towers, which, although finished by other architects in the fourteenth and fifteenth centuries, certainly correspond to his wishes, since they are not very tall. But, according to his drawings, the highest point of the building is the thin spire that stands over the crossing of the transept.

SCULPTURE, THE LANGUAGE OF STONE

The three portals of the main facade, executed between 1220 or 1225 and 1236, are famous for the scope of the program they depict: they develop the entire Christian vision of the visible and invisible worlds in the language of stone.

The sculptures are divided into three levels. On the lowest level are two rows of continuous scenes framed by quatrefoils, including on the three visible sides of the abutments; on the middle level, large sculptures of figures, just under 8 feet (2.4 meters) high, also follow one on the other, without a break; on the upper level the tympanums and their arches unfold.

Just as the decoration of the Sainte-Chapelle in Paris is organized around the stained glass and the relics of the Passion, here the three portals as a group focus on the statue of Christ in the center, known as the "Handsome God," on the trumeau (pier between the double doors) of the main portal, thus occupying the converging point of the horizontal axis—composed of the middle level—and the vertical axis. With the right hand he gives his blessing, with the other he holds the Gospels; his feet crush a basilisk, symbol of death, and the asp, symbol of sin and the devil. Among the many sculptors who worked on these portals, one of the most esteemed was surely chosen to create the statue of Christ. The artist, in whom one senses the accomplishment of maturity, sculpted a Christ full of serenity and balance, as well as dynamism, and a sort of visionary goodness.

Around him, in the embrasures of the portal, each of the twelve Apostles carries an identifying symbol: Saint Peter holds the keys and a cross; Saint Paul, former Roman soldier, a sword; Saint James the Less, a fuller's rod. Above Christ, the tympanum depicts scenes of the Last Judgment, while the eight archivolts depict some of the many inhabitants of Heaven: angels, martyrs bearing the palm, the Elders of the Apocalypse playing music.

Beneath the statues of the Apostles are quatrefoils illustrating the virtues and vices. In order to make such abstract notions comprehensible in such a reduced space, the sculptors carved small, lively scenes that speak for themselves. Strength, for example, is symbolized by a knight wielding a sword, wearing a helmet and coat of mail, a wild animal decorating his shield; cowardice is represented by a man aban-

AMIENS, CATHEDRAL, TRANSEPT, SOUTH ROSE WINDOW, 15TH CENTURY
The master builders of Amiens provided the widest possible openings, as illustrated in this Flamboyant-style rose window in the south wall, so that the stone would offer the least possible obstacle to the admission of light. The building seems to be, in the words of Eugène Viollet-le-Duc, "a great reservoir of air and light."

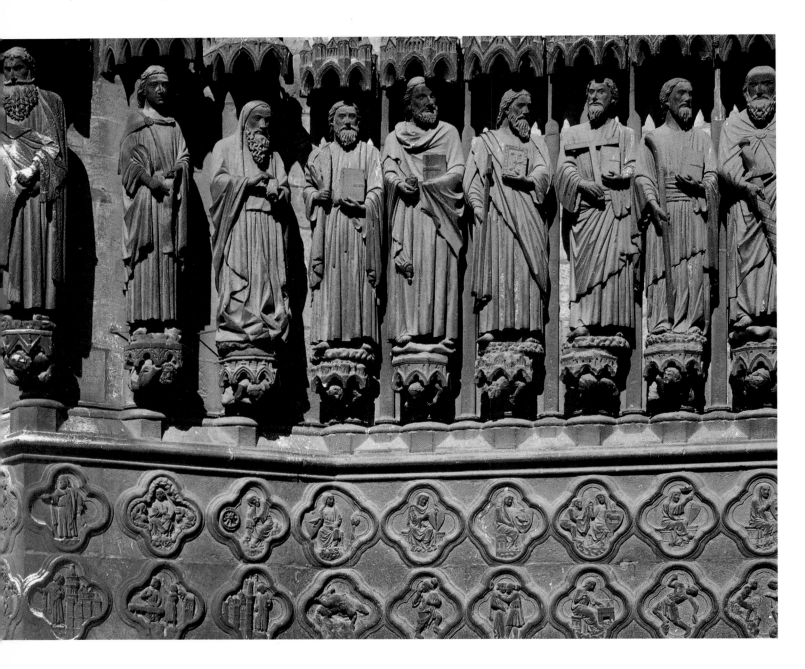

AMIENS, CATHEDRAL, DETAIL OF THE CENTRAL PORTAL OF THE WEST FACADE, 1220/25–36
On this portal the prophets are lined up with the buttresses and the Apostles surround Christ, who is placed on the trumeau between the doors at the point of horizontal and vertical convergence (the intermediate level) of the three portals, between the two axes. This illustrates that the arrival of Christ, foretold by the Old Testament, is at the center of human history and opens a new world.

Opposite
AMIENS, CATHEDRAL, TRUMEAU OF THE CENTRAL PORTAL OF THE WEST FACADE, 1220/25–36
Each of the schools of sculpture in the thirteenth century had its own style: slender and mystical at Chartres, joyous and glorious at Reims, filled with tragedy and drama at Strasbourg. Here at Amiens, as in this Christ known as the "Handsome God," is expressed the realism of the north illuminated by faith.

doning his sword and fleeing with arms raised at the sight of a rabbit.

There is room for fantasy, too. On the casing of the door, the fables of the fox and the rooster and the wolf and the crane are illustrated, even if they were used for their symbolic meaning. The fox and the wolf, who both think they have outwitted the rooster and the crane but are themselves outwitted, symbolize the devil who ends up vanquished. This gave the sculptors a fine opportunity to evoke the *Roman de Renart* (Romance of Reynard the fox); the episode in which Reynard makes Chanticleer the cock sing is one of the most popular in the work. It also offered them a fine opportunity to fix the humor of the fable of the fox and the crane in stone.

The facade of Amiens pays particular homage to the Old Testament prophets; all along the three visible faces of each of the abutments, large statues of the six-teen prophets of Israel follow one another. The four greatest ones, Isaiah, Jeremiah, Ezekiel, and Daniel, face each other on either side of the central portal; they thus continue the line of Apostles. The quatre-foils beneath each of the prophets evoke episodes in their lives or elements of their prophesies. Hence, we see Jonah emerging from the belly of the whale that swallowed him, or Daniel in the lions' den. Another episode of Daniel's life is illustrated: in the middle of the feast in which the king of Babylon, Belshazzar, had offered drink to "his princes, his wives, and con-cubines" from the sacred vessels of Israel, fingers appeared tracing on the wall the mysterious words "mene, mene, tekel upharsin," evoking measurements of weight. Daniel interprets the meaning: Babylon had been "weighed," and thus its downfall was near; it took place shortly thereafter.

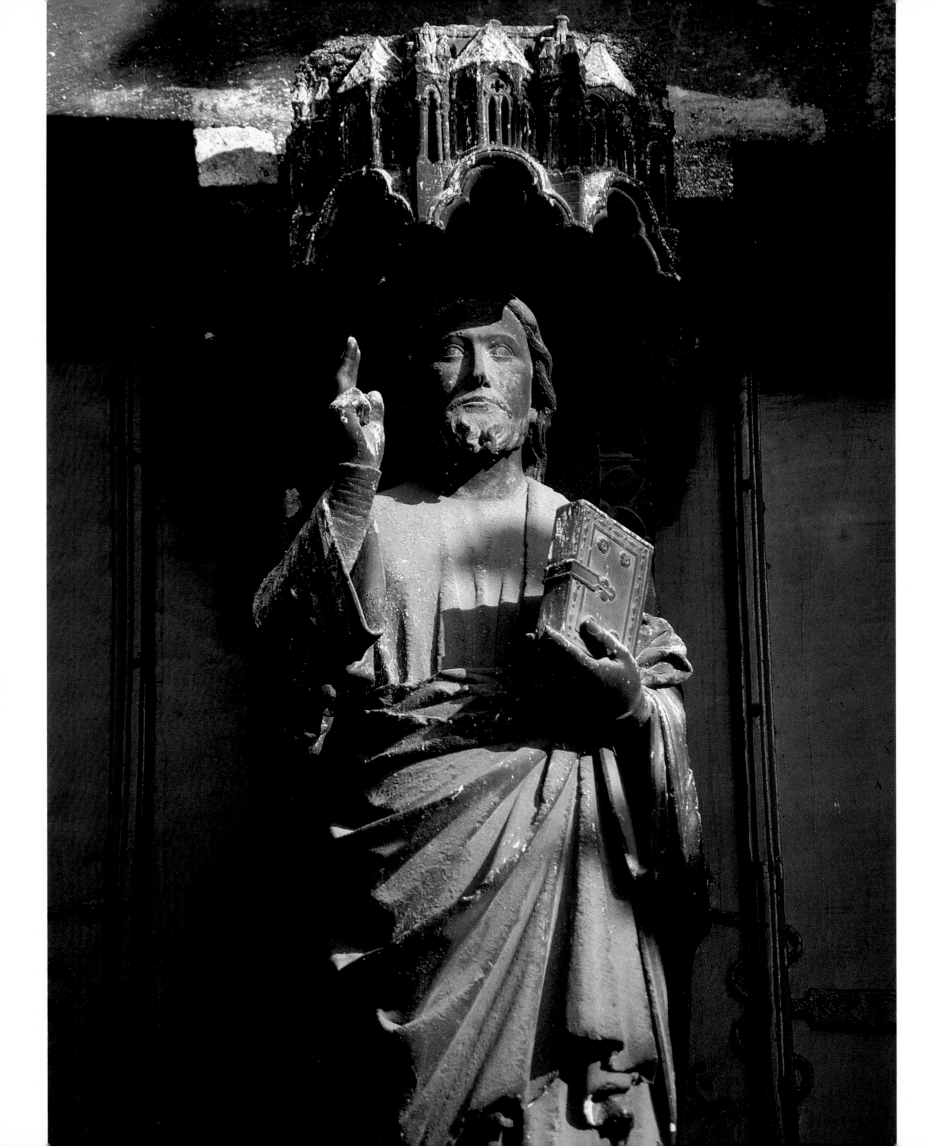

The depiction of prophesies themselves proved challenging, as it concerned illustrating texts of an abstract, literary, and poetic nature. Nonetheless, the sculptors succeeded, often in a comical manner. To evoke the prophesy of Zephaniah announcing the complete ruin of Nineveh, the sculptor placed a porcupine, a crow, and a caged bird in a simulacrum of a house. Two very realistic quatrefoils, in which one can make out the bellows, hearth, and blacksmith's anvil, illustrate Micah's pacifist prophesy.

THE NEW EVE

The portal to the right honors the Virgin and the Incarnation of Christ. The statue of Mary occupies the trumeau, and six small bas-reliefs decorating the base recall the opening of the Book of Genesis. God creates Adam (or, in Hebrew, man); then, from the sleeping Adam's rib, he creates Eve (in Hebrew, woman), and we see her emerge from her companion's side. They disobey God's injunction and taste the forbidden fruit, breaking their alliance with God, and are banished from earthly paradise. They must clothe themselves and work; Adam digs the earth and Eve spins.

Mary represents the new Eve who redeems the sins of the first one. The portal as a whole celebrates her magnificently and very completely. The large statues of the embrasures evoke the Annunciation, the Visitation, the Adoration of the Magi, and the Presentation at the Temple. But what are King Solomon and the Queen of Sheba doing here? As queen of Arabia, according to the Bible, the latter came to pay homage to the king whose reputation for glory and wisdom had reached her ears; it is to indicate deference that at Amiens she carries her crown in her hand. In the Middle Ages many thought that the Old Testament announced the coming of Christ in clear and prophetic words, but also that each event, each character, and each act in the New Testament had an allegorical correspondence "prefiguring" it in the Old Testament. In this way of reading the Bible, the Adoration of the Magi was "prefigured" by the voyage of the queen of Sheba. In the search for such correspondences between the Old and New Testaments, medieval scholars clearly became a bit carried away in their bent for symbols and allegories. The quatrefoils decorating this portal describe the life of the Virgin and the early childhood of Christ. The

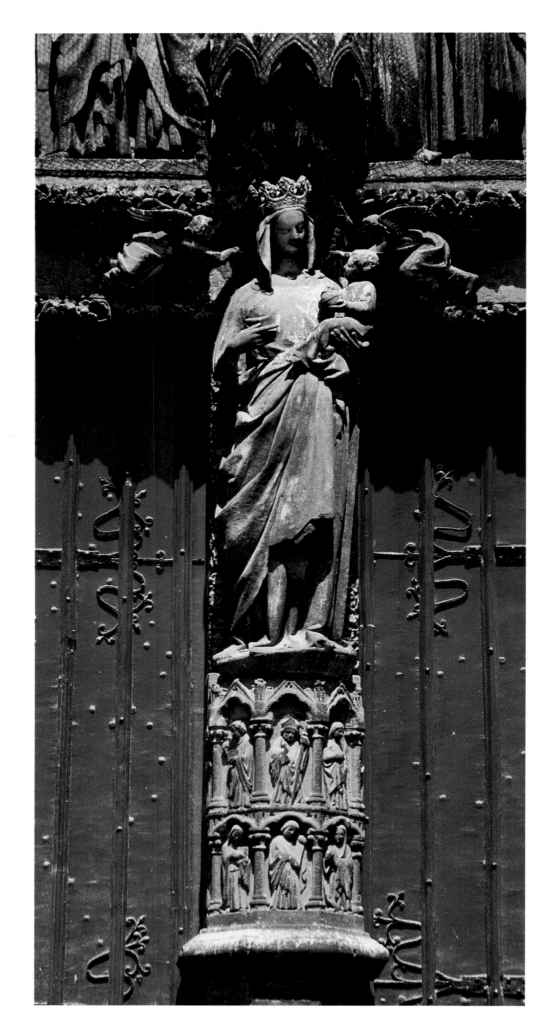

Opposite
AMIENS, CATHEDRAL, TRUMEAU OF THE PORTAL OF THE SOUTH FACADE, C. 1260–70
This sculpture, known as the "Gilded Virgin," pays homage to the Virgin, posed on a base whose bas-reliefs recall the beginning of the Book of Genesis. The sculpture conveys much movement; Mary sways slightly as she looks at the Child tenderly. The sculptor interpreted the biblical theme while humanizing it through Mary's maternal gesture.

AMIENS, CATHEDRAL, PORTAL OF THE SOUTH TOWER, EARLY 13TH CENTURY
Between the stained-glass windows are many sculptures in wood and stone. The artist's gift for animation blossoms in this small group, of a devil with a quasi-reptilian head striking down an imaginary animal, which serves to support a statue of one of the Magi.

tympanum depicts the death, assumption, and coronation of Mary.

THE HISTORY OF THE WORLD ON THREE PORTALS

The small scenes depicting Genesis narrate the first stage of human history, before the rupture with God. The evocation of the prophets recalls the Old Covenant, completed with the Incarnation of Christ, celebrated in the portal to the right. The "Handsome God" with his Apostles confirms the advent of the New Covenant on the central portal. The tympanum of this portal foretells the tale of the end of time, when on Judgment Day the elect are united with God in Heaven. Thus, the entire history of the world is told on these portals, including the present moment, the time spent since the coming of Christ, which will end on Judgment Day, and the time of the New Covenant, evoked by the portal to the left. Its large statues represent local saints, such as Firmin the bishop, Ulphe the hermit, Domice, Fuscien, Warlus, and Luxor. Logically, the quatrefoils of this portal describe everyday life; those of the upper level depict the signs of the zodiac, while those below the corresponding labors of the months. The month of May is placed beneath the sign of Gemini, two lovers holding hands; after the hard winter, against which medieval people were so ill-equipped to protect themselves, May was considered the most beautiful month of the year; it was the month of poets, the month of Love, with the figure in the quatrefoil stretched out on the new grass, once again listening to the songs of the birds. June, shown beneath the sign of Cancer, represented by a fine crab rendered very realistically, is the month of harvest: the scythe is not any different today. In July, the month of the lion, a man harvests with a sickle. Behind him lie

the sheaves of grain already bound, before him the work still to be done.

FROM THE SUBLIME TO THE FAMILIAR

The natives of Picardy in the Middle Ages were famous for their exuberant good humor, and we can sense a smile behind each of these small scenes, which the sculptors took pleasure in bringing to life with realistic and amusing details. This smile becomes loud laughter with the "grotesques," small figures contorted into various postures to hold up the bases of the large statues: a drunkard caresses his jug, two people fight, a third feels sick, another sleeps, still another plays the hurdy-gurdy. Such verve likewise animates the transitional works pointing toward the Renaissance, the reliefs in painted stone on the choir screen, recounting the life of Saint Firmin (about 1490), and especially the sculpted choir stalls (1509–19), made by Jehan Turpin, Arnould Boulin, Antoine Avernier, and Alexandre Huel. They contain about 3,650 figures from the Old and New Testaments, focusing on those with the most novelistic lives, like Jacob, model of patient love—although he loved Rachel, before he married her he had to serve Laban, her father, for seven years, and to marry her older sister Leah. We also see all the figures of daily life of the period, such as the water bearer, the market gardener (the Amiens market gardens were watered by a network of canals) delivering her vegetables, the baker, a domestic quarrel, the fruit seller, fools, and madwomen. The sculptors of Amiens excelled in all genres, from familiar subjects to sublime ones, such as the "Handsome God" or the "Gilded Virgin," which was known as such because at the time she was entirely gilded. Sculpted about 1260–70, she occupies the trumeau of the southern, or Saint-Honoré, portal. Crowned and surrounded by flying cherubs, she looks at the infant Jesus in her arms with a tender and sweet smile.

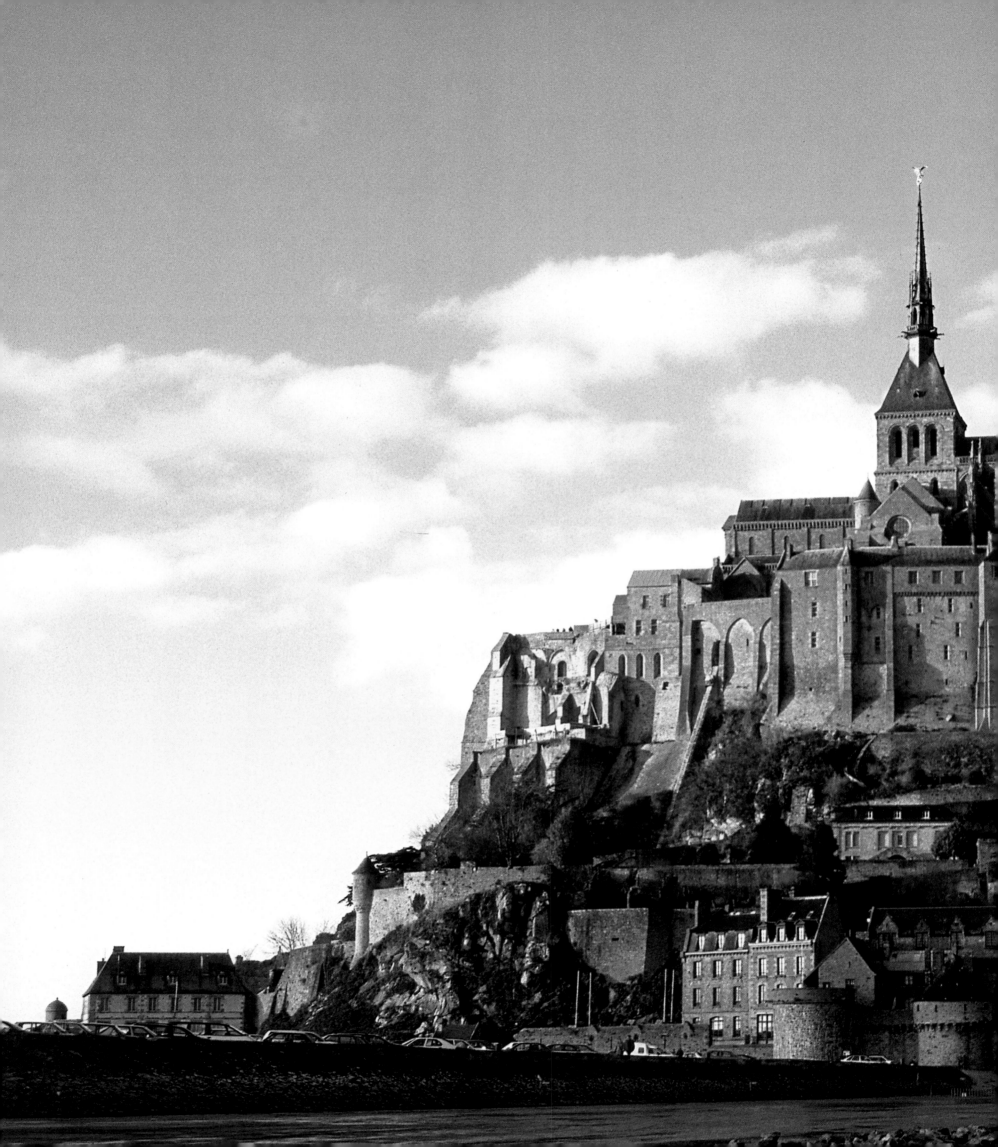

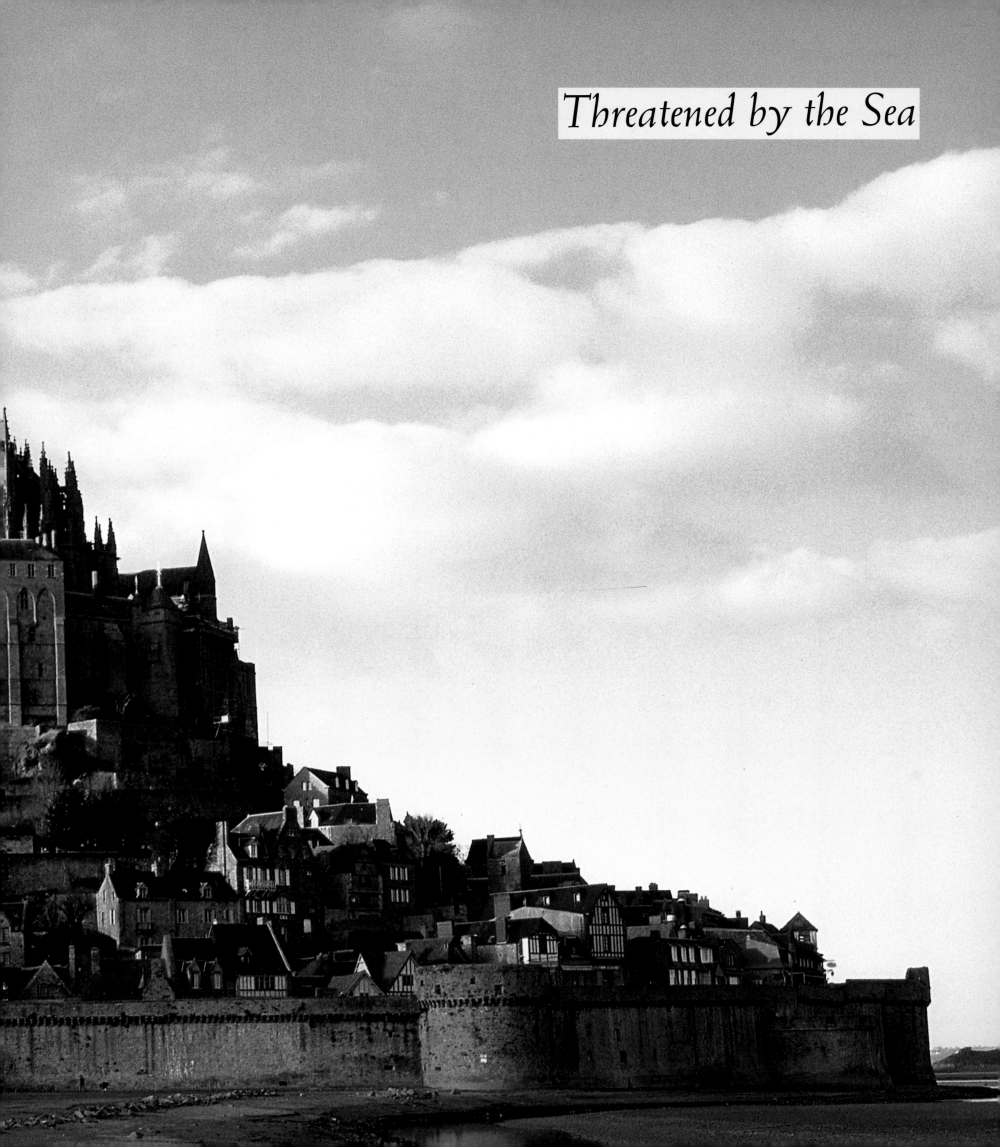

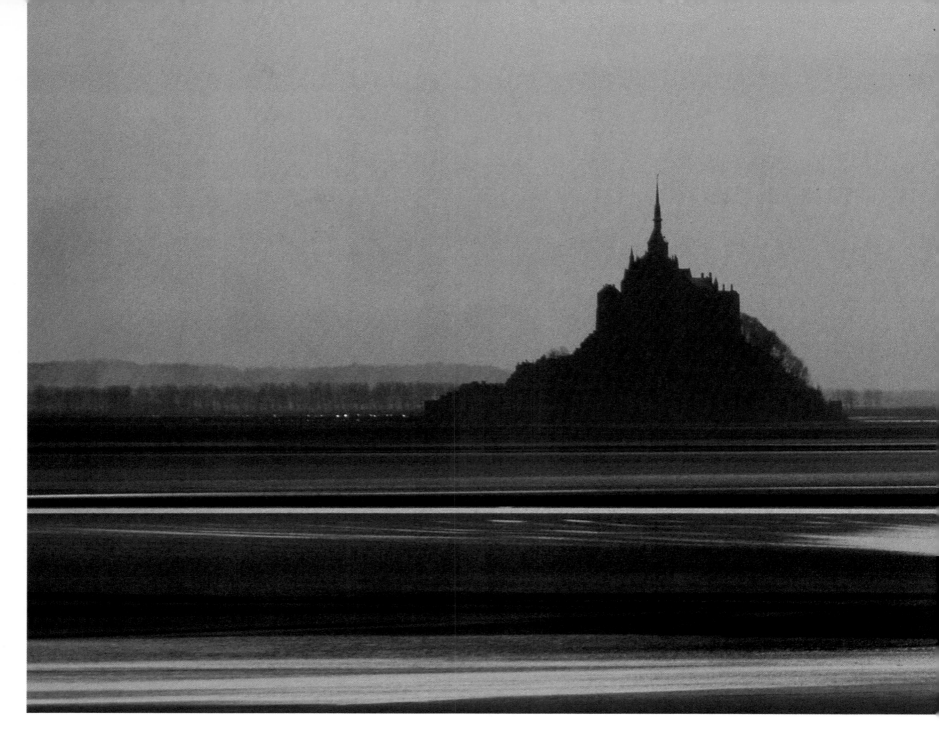

BY THE END of the twelfth century Mont Saint-Michel had been a Christian sanctuary for five or six hundred years; hermits first settled there during the seventh century. In 708 Aubert, the bishop of Avranches, began the construction of an oratory devoted to Saint Michael, following the wishes of the archangel, who appeared to him. A Carolingian church later replaced it. The Benedictine abbey was founded in 966, when Richard I, duke of Normandy and grandson of Rollon, the Scandinavian who founded the duchy of Normandy, brought monks from Fontenelle (Saint-Wandrille) to replace the canons tending the sanctuary, and he endowed the abbey very generously.

The abbey church, begun in the eleventh century, remains the principal tour de force of the rocky island site. The rock forms a fairly regular cone, crowned by a platform. This small, flat surface, symbolic top of the holy mountain, supports the transept crossing and part of the nave. All the rest of the church is precariously balanced, resting on crypts that serve as its foundation: to the west, Notre-Dame-sous-Terre (Our Lady Underground), the former Carolingian church; to the north Notre-Dame-des-Trente-Cierges (Our Lady of Thirty Candles); to the south, the Saint-Martin chapel; to the east, the thick-pillared crypt. The latter, and the choir over it, were redone in the fifteenth century after the accidental collapse of the Romanesque choir. To avoid a repetition of this disaster, the pillars of the crypt and those of the choir, as well as the abutments and the flying buttresses of the chevet rival one another in strength,

Mont-Saint-Michel represents an impressive technical feat: at the peak of the rock, a small, flat surface supports only part of the church. The construction exacted a patient and colossal labor. This monument exemplifies the Christian vision of the world, according to which architecture is not a triumph over nature but a completion.

MONT-SAINT-MICHEL,
GENERAL VIEW
*Mont-Saint-Michel, set
amid the beautiful and
perilous seas of the bay,
has always been a magi-
cal place that defies its
hostile natural environ-
ment, always in move-
ment. In the Middle
Ages, it had the strongest
tides in the known
world, and a tenacious
terror drove the inhabi-
tants in the face of the
immense ocean.*

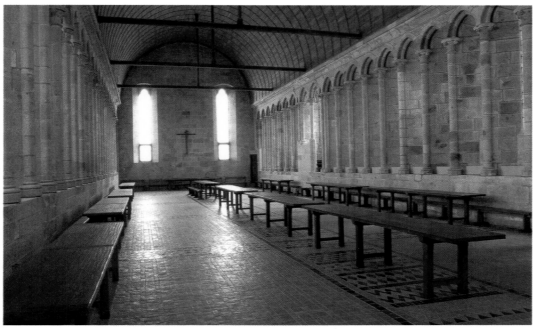

MONT-SAINT-MICHEL,
BUILDING OF
THE MERVEILLE
(THE MARVEL), THE
MONK'S REFECTORY,
13TH CENTURY
*The technical feat of this
room lies especially in
the treatment of light;
although it is channeled
by the building, it
nonetheless remains
constant and pleasantly
diffuse.*

but the fineness and variety of the flamboyant working of the stone dispel any sense of weight.

A "Marvel" of Strength and Lightness

In 1203, during the war between Philip Augustus, king of France, and John Lackland, king of England and duke of Normandy, the Breton Guy de Thouars, an ally of the king of France, lay siege to Mont-Saint-Michel, which he finally took after setting fire to it. Once peace was reestablished the abbey, like the rest of Normandy, became a possession of the French crown. Wanting to make amends for the harm he had done to the monks, the king had their buildings, which had been seriously damaged in the fire, magnificently rebuilt. The "Merveille" ("Marvel") has two parts. The eastern part comprises the almshouse on the first floor, the guests' hall on the second, the refectory on the last. The western part includes the pantry on the first level, the "Knights' Hall" (Salle des Chevaliers) on the second, and the cloister on the third. Another building, never constructed, was planned to extend the Merveille to the west.

The classical plan of the abbey of Royaumont is symbolic as well as practical: the holiest places, the church and the cloister, sit at the center of the monastery, just as the best part of human beings is within, at the silent and sincere heart of their souls, where Pascal's "hidden God" lives. Mont-Saint-Michel's plan evinces the same symbolism, but in another way: by grouping together the holiest parts on the heights.

During the Romanesque period the entrance to the abbey was at the west. In Gothic times it was moved to the east. Once past a large gate defended by a small castle, visitors were separated into different categories in the guardroom. Simple pilgrims climbed a staircase to the west that took them to the church, where they could visit only the nave. Those who had business with the abbey tribunal were directed to the left, toward the abbey buildings on the south side of the island. They ended up in the hearing room, known as the Belle Chaise ("handsome chair"), light streaming in through its tall narrow windows. Finally, guests were sent to the right, to the Merveille, which stood on the north side of the island. The almshouse, located on the first level, received the poor; the guest hall, on the level above, welcomed important guests.

The Merveille's almshouse and pantry, filling first and foremost a functional role, are equipped with mighty pillars in order to support the two upper levels. On the second level, the columns that support the rib vaults of the guests' hall and the Knights' Hall are more slender. It should be noted that the latter received a misleading name in the last century. In reality reserved for monks, it served as simultaneously their calefactory (the only heated hall in the monastery) and their scriptorium (the place where the monks studied and copied manuscripts). Finally, on the third level, the monks' refectory has no pillars; its wooden barrel-vaulted ceiling rested directly on the walls. Similarly, the cloister is covered not with rib vaults, which would have been too heavy, but with wood. For this reason, the columns that supported it could be light. In addition, the architect arranged

MONT-SAINT-MICHEL, THE MERVEILLE, THE "KNIGHTS' HALL," 13TH CENTURY
This was the calefactory, the room in which the monks studied and recopied manuscripts, activities that formed the third component of a life consisting of prayer, work, and study.

A Vertical Labyrinth

————●————

The greatest challenge facing the designers of Mont-Saint-Michel was lack of space. An abbey's buildings have a variety of functions to serve: space for liturgy and prayer; intellectual work and study; housing for the monks, lay brothers, and guests; the performance of domestic needs (farm, forge, kitchen, and so on). In addition, the rule of Saint Benedict had to be followed, a rule that had regulated most of the monastic orders since it was established in the fifth century. The rule prescribed that "monks must at all times try to enforce silence," as silence is essential to prayer. To this end, they were protected by the enclosure, a group of spaces to which only monks had access (and, exceptionally, great individuals like Saint Louis), including the church choir, the cloister, and the refectory. The rather classical plan of the abbey of Royaumont reconciled all these imperatives by means of a large-scale extension on the horizontal axis. Such a plan was out of the question on Mont-Saint-Michel. Its Gothic architects, like their Romanesque predecessors (on a more restricted scale), overcame the difficulty by layering a complex network of passageways, corridors, and stairways on the vertical axis, making the abbey a vertical labyrinth.

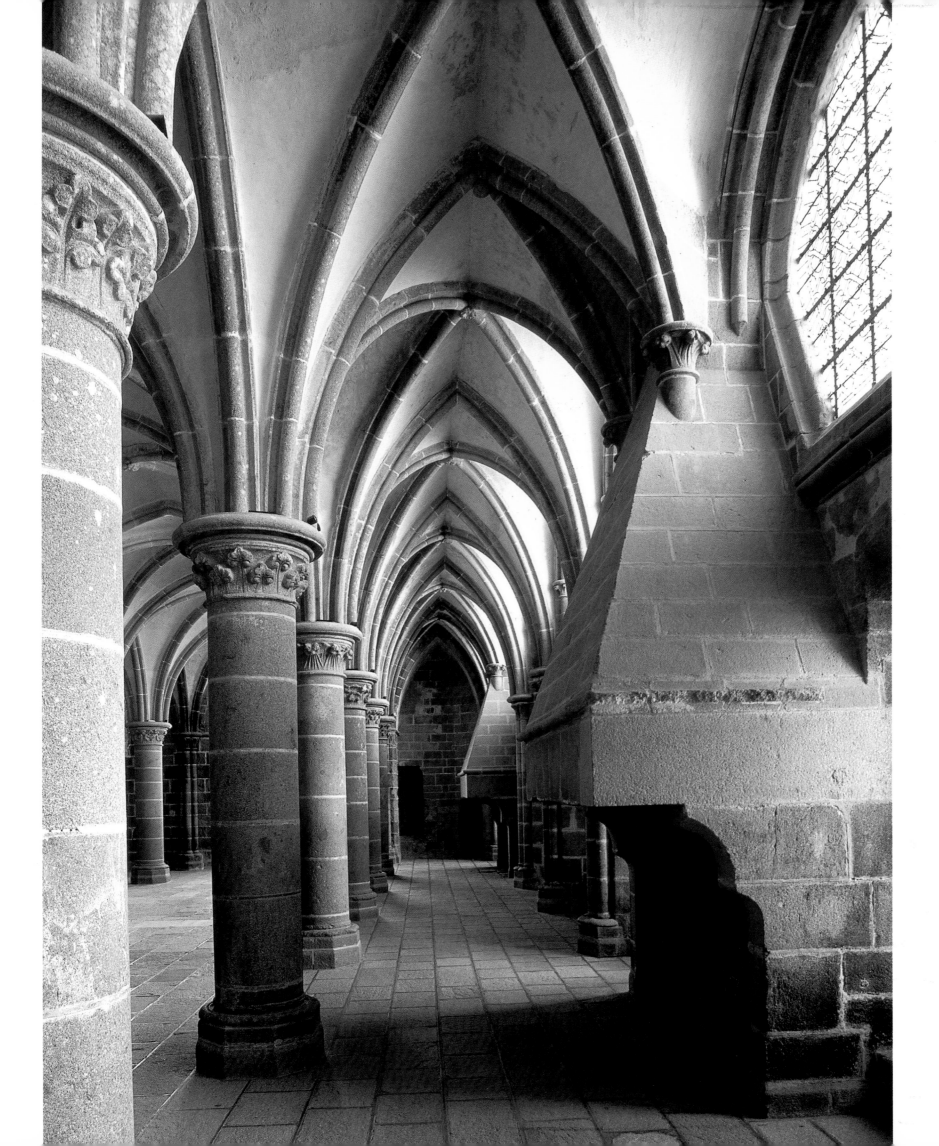

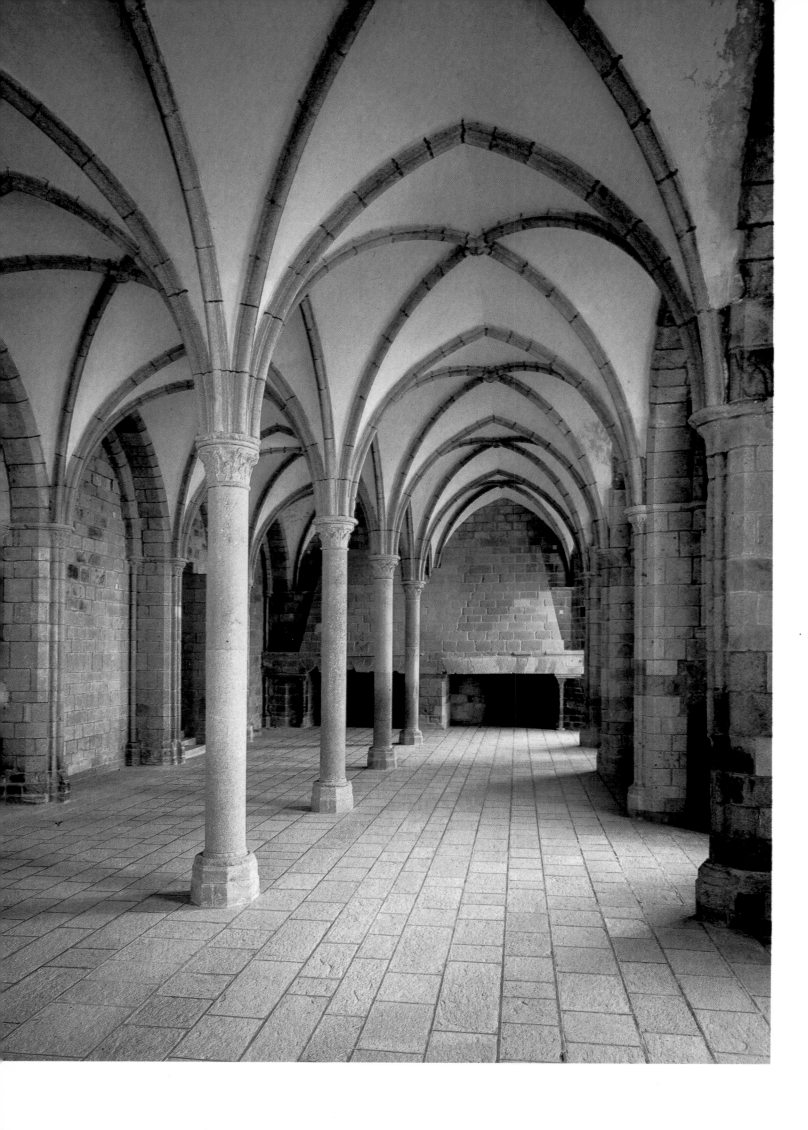

MONT-SAINT-MICHEL,
THE MERVEILLE,
GUESTS' HALL,
13TH CENTURY
*The architects of the
Merveille faced a double
challenge: to build on a
partly sloping site while
stacking three levels one
atop the other. Only the
pillars are load-bearing,
whence the importance
of an exact alignment of
their vertical axes. On
the second level, in this
hall destined to receive
important visitors, the
pillars are much slighter
than those on the first
level.*

them in a quincunx to make them both stronger and more aesthetic.

The structure at Mont-Saint-Michel known as the "Marvel" well deserves its nickname. While it is supported by impressive walls and abutments, these formidable masses do not impinge on the interior, where all is grace and lightness. It has not a single unnecessary element. How does the guests' hall manage with only one row of very thin columns, while the "Knights' Hall" deploys three rows of more massive pillars? Because the former merely supports the refectory floor, while the latter supports the cloister floor and colonnade.

Stacking large Gothic halls—later done in the Papal Palace in Avignon—constituted an architectural tour de force. Since the pillars and columns were weight-bearing, it was necessary for their loads to be aligned from one floor to the next, a task that required a great mastery of geometric adjustment.

It has always been difficult for an architect to create a very large hall that is both beautiful and harmonious. An immense ceiling surface, unless it is very high, can evoke the sensation of being crushed. The guests' hall of Mont-Saint-Michel, on the other hand, like the refectory at Royaumont, delights the eyes: its volume is divided into so many subvolumes—each defined by a rib vault—whose height is much greater than the two other dimensions, giving rise to the overall impression of an upward thrust and lightness. The refectory at Mont-Saint-Michel also delights the eyes instead of overwhelming them, although inside it forms but a single volume; its proportions are elongated, since its height is greater than its width, which the aesthetic contrast produced by the rounded shape of its vaulting further reinforces.

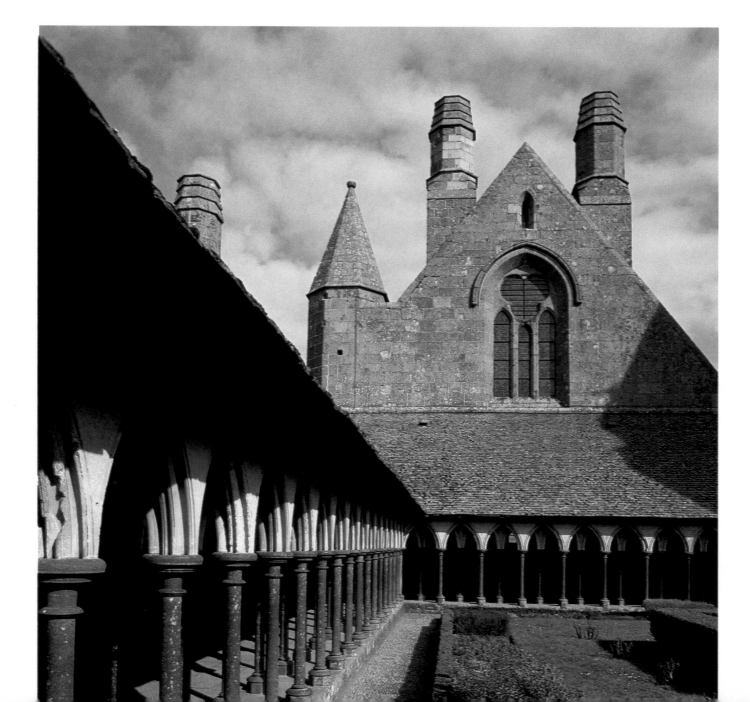

MONT-SAINT-MICHEL, THE MERVEILLE, CLOISTER, 13TH CENTURY
This is a calm place of meditation, an atmosphere promoted by the sound of the waves, the cries of the gulls, and the movement of the marine sky. To relieve the strain on the pillars of the two lower levels, the cloister is surrounded with narrow colonnettes arranged in a quincunx, and it carries relatively little decoration, consisting of sculpted rinceaux, foliage, and a variety of small figures.

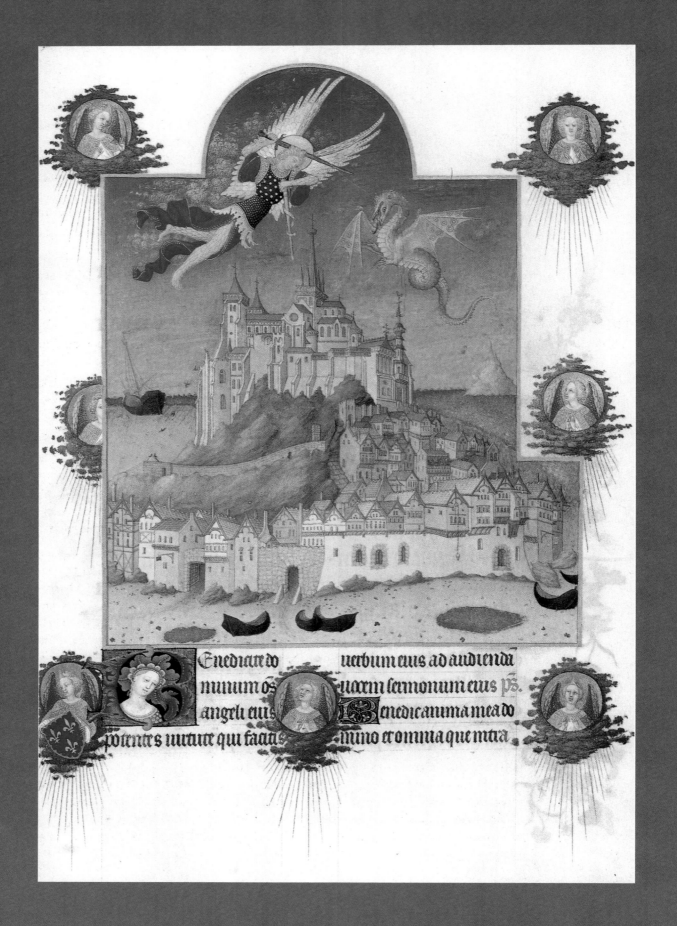

PAUL, HERMAN, AND
JEAN LIMBOURG,
ILLUMINATION FROM
THE TRÈS RICHES
HEURES DU DUC DE
BERRY, C. 1413–16.
MUSÉE CONDÉ,
CHANTILLY
*The archangel strikes
down the dragon, the
symbol of the forces of
evil, above Mont-Saint-
Michel, which is little
changed since the time
of this illumination.*

THE PILGRIMAGE: SAINT MICHAEL, SWORD OF GOD

In the Middle Ages, the pilgrimage gave those who were not professional travelers—such as merchants, knights, or itinerant workers—their only opportunity to travel. While always difficult and sometimes dangerous, travel offered a break from day-to-day social life, with its restrictions and constraints. Pilgrims placed themselves on the margins of society for a good cause, although their pious voyage could unleash a usually repressed exuberance and lead to joyous excesses, not always of a moral nature. Even children left in sizable groups, escapades that smacked strongly of juvenile revolt.

To take up the staff and the begging bag was to abandon everything for Christ: pilgrimage was a symbol of the conversion of the soul demanded by the Gospels. Concentration on pious acts was difficult to achieve and to maintain, which is why monks pray for many hours in a day. During a pilgrimage, however, the slow rate of travel and the regularity of the pace favored this state of concentration through an effect of gradual inculcation. The pilgrim's movement symbolically reproduced that of the Exodus, the long march undertaken by the Jews, led by Moses away from the slavery into which the Egyptian pharaoh had bound them and toward first Sinai—Mont-Saint-Michel is also the symbol of this holy mountain—and then on to Israel, the promised land. The place toward which all converged, regardless of language, country of origin, and social position, was also, symbolically, an anti-Babel, in which for a time the lost unity of humanity was restored. The pilgrims usually had a self-interested goal as well—to heal an illness, expiate a mortal sin, or thank the heavens. All these factors were mixed together in the pilgrimages undertaken to Mont-Saint-Michel or Chartres, Rocamadour, Saint-Martin-de-Tours, Saint-Benoît-sur-Loire, or Santiago de Compostela, among other destinations.

How can we explain this cult of Saint Michael? According to legend, the archangel, on the site of Mont-Saint-Michel, was supposed to have struck down the devil, who had assumed the shape of a dragon. The legend became symbolic; the archangel, one of the "voices" invoked by the dying Joan of Arc, became synonymous with the force of God. Medieval people saw manifestations of the archangel in the violence of rainstorms, lightning, and thunder. On Judgment Day he would sound the trumpet to wake the dead, he would weigh the souls and lead the elect to paradise. He therefore also became a symbol of the spiritual force that triumphs over death.

In 1469 Louis XI, seeking to ally himself with a powerful name, founded the order of Saint Michael. Hanging from the chain of the order is a medallion that carries, below the image of the archangel striking down the dragon, the Latin inscription, "Immensi tremor oceani" (the terror of the immense ocean). By the end of the nineteenth century great strides in steam navigation had allayed our ancestral fear of the sea. But in the Middle Ages, as in Greco-Roman antiquity, the sea was feared as a realm inhabited with prodigious beings and dangerous monsters; navigation was carried out cautiously, almost never losing sight of the coastlines. The site of the bay of Mont-Saint-Michel thus had great significance at the time. It was where the maleficent aspects of the sea were clearest, since it had the highest tide in all Europe, which comprised almost the entire known world at the time. Medieval people considered the tide a mysterious phenomenon. Although they associated it with the phases of the moon, this relationship simply heightened their perplexity. Moreover, everything on these strands was dangerous, especially their beauty. In his novel *Sous les pieds de l'Archange* (Beneath the Archangel's Feet), Roger Vercel has evoked the fascination of Mont-Saint-Michel, the product of a particular relation of light reflected by the infinitely varied waves of the waters flowing between the sands. This fascination, however, carries with it a treacherous undercurrent; the shifting terrains and quicksands are dangerous, but less so than the tide itself, insidiously isolating unwise travelers on sandbars, and less so than the fog that rises in a few seconds and causes travelers to lose their way.

Saint Michael striking down the dragon thus represents an image of the human desire to triumph over nature. In the Middle Ages agricultural technique had made great progress; with wilderness extensively cleared, the earth had almost been beaten in this struggle. But the sea, the sky, and the changing weather remained almost as terrifying and inexplicable as in the early days of humanity. Mont-Saint-Michel and its abbey church express the desire to vanquish them in turn, an act of faith in divine might.

IN THE TWELFTH century the county of Toulouse included Upper Languedoc, Armagnac, Agenais, Quercy, Rouergue, Gévaudin, Comtat Venaissin, Vivarais, and Provence. The principal vassals of the count were the viscounts of Narbonne and especially the viscounts of Carcassonne, the Trencavels, whose lands included Carcassès, Albigeois, Minervois, and Béziers.

Few wars came to trouble its history. Peace and prosperity allowed the development of a refined and profound culture, for which courtliness was not simply a veneer but an essential way of being, an attitude marked by grace, tolerance, and liberalism. Lyric poetry reflected the Occitan soul in this period. It was, in fact, in the county of Toulouse that the first French lyric poetry was born, created by the troubadours who also composed the accompanying music.

CATHARS AND THE COUNTS OF TOULOUSE

The counts of Toulouse, who treated their subjects with liberalism and tolerance, were not much concerned about the development of the Cathar heresy; they even tolerated it. Nonetheless—the enemy often appears from whence least expected—the proliferation of this sect and the crusade organized to eliminate it suddenly brought war to Languedoc and, finally, the destruction of the house of Toulouse. The Cathar heresy came from northern Italy, where it had been brought by the Bogomils. This sect, founded in Bulgaria by a man named Bogomil—"the friend of God"—was rooted in a dualistic Eastern trend of great antiquity. The beliefs of the Cathars were summarized by one of their members, Jean de Lugio, in his *Livre des deux principes* (Book of Two Principles): "It is absolutely impossible to believe that the true Lord God would have directly and in principle created darkness and evil. . . . Another principle exists, that of Evil, which is powerful in iniquity, and from whose power Sathanas, the Shades, and all the other dominations that oppose the true God follow singularly and in principle. It is from him that come all the evils that have been, that are, and that will be." Since matter is flawed, as if dominated by the principle of Evil, detachment from it through an absolute asceticism is necessary in order to be able to rejoin the kingdom of the spirit. Only some, however, are capable of this asceticism, the "perfects"; the other members of

the community are "believers." Worship was very simple, consisting of gatherings for singing, prayers, and listening to sermons expounding the doctrine. A believer became a perfect after having accomplished the rite of the *Consolamentum,* itself very simple. Essentially it consisted of the laying on of hands by the perfects, while the candidate swore an oath to renounce all food (especially meat, eggs, and cheese) except for fish and vegetables cooked in oil; not to lie; not to swear; to abstain from all sexual activity; and to remain faithful to the Cathar community.

Pope Innocent III was worried by the spread of the heresy in Toulouse, known in the Church as the Albigensian heresy, from the city of Albi, one of its centers. He sent his legate Pierre de Castelnau to lead Count Raymond VI on a crusade against the Cathars. The latter refused, as his father Raymond V had refused the entreaties of Pope Alexander III. The legate excommunicated him and left for Avignon, but while he was preparing to cross the Rhone at Saint-Gilles on January 15, 1208, he was murdered. The pope then ordered the crusade.

In July 1209 a ragtag army, very large for the period (perhaps 300,000 strong), crossed into Languedoc. Philip Augustus abstained, but Raymond VI was forced by the authority of the pope to join the

Preceding pages
TOULOUSE, CHURCH OF THE JACOBINS, PILLAR, COMPLETED 1385
The two naves, equal in dimensions, of the church lead to this single pillar on the choir side, which bears twenty-two arches. The plantlike "sprouting" of the ribs is still accentuated by the polychrome stone.

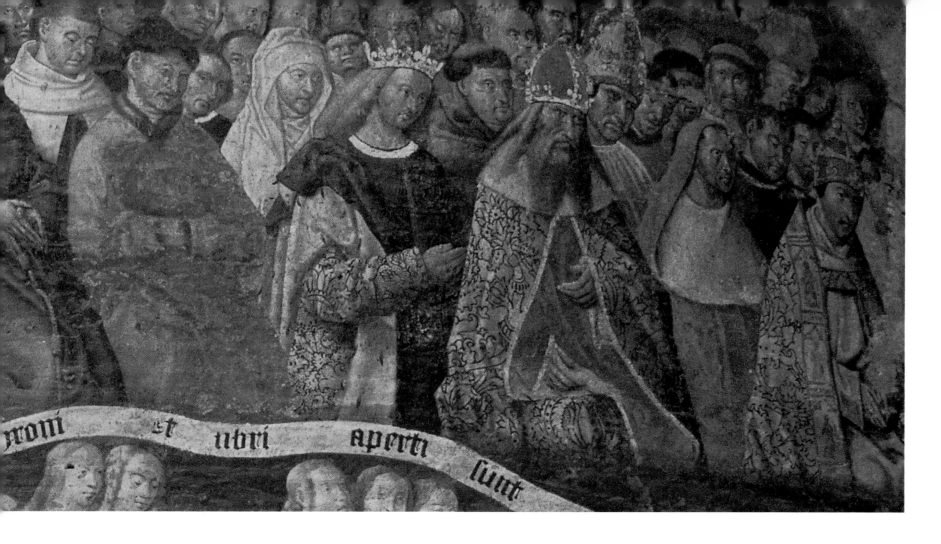

roní ... et ... ubri ... aperti ... sunt

ALBI, CATHEDRAL,
FRESCO OF THE LAST
JUDGMENT, DETAIL
DEPICTING THE ELECT,
COMPLETED C. 1480
*The elect, bound for
Heaven, are portrayed
with their hands clasped
in prayer, carefully lined
up, the social hierarchy
(emperors and kings at
the head) respected.
In such paintings of the
Last Judgment, Hell,
with its devils and its
vices, is rendered with
more energy and color.
The underlying idea is
that life would be
incomplete if it consisted
only of wisdom and
virtue, for life encom-
passes also agitation and
diversion.*

crusade. Béziers was taken and set on fire; it burned for two days, while the population was massacred. Next the crusaders besieged the young viscount Raymond-Roger Trencavel, twenty-five years old, in Carcassonne. It was the month of August. The fortress held fast but water ran short. Having gone out to parley, Raymond-Roger was taken prisoner, in defi-ance of justice. Carcassonne was taken and he died shortly thereafter of "illness" in a tower in his city, where he had been imprisoned. The viscounty of Carcassonne passed to a knight who had distin-guished himself in the battle, Simon de Montfort, lord of Montfort-l'Amaury near Paris. He thereafter acted as leader of the crusade. He besieged and took the châteaux of Minerve, Termes, and Lavaur. Then Raymond VI decided to go over to the opposition. He allied himself with King Pedro II of Aragon, who until then had remained neutral in the conflict, but they were defeated in 1213 in the Battle of Muret, in which Pedro II was killed. Two years later Simon de Montfort took Toulouse. Raymond VI and his son Raymond VII were forced to take refuge at the court of England.

But Raymond VI did not give up. He landed at Marseilles and marched victoriously toward Toulouse, which he entered in September 1217. Simon de Montfort laid siege. There he was killed by a stone from a mangonel, according to legend, fired by a woman. King Louis VIII of France entered into the conflict and in May 1226 began a new crusade. Raymond VII capitulated and signed the treaty of Meaux (1229). He accepted a considerable reduction in territory, agreed to rid it of heresy and to marry his only daughter, Jeanne, to the brother of Saint Louis, Alphonse de Poitiers, to demolish Toulouse and thirty of his strongholds, and to relinquish most of the others to the king of France.

Repression of the heresy was organized. The tribunal of the Inquisition judged the heretics. Languedoc was broken: two attempts at revenge failed, first by Raymond Trencavel, son of the viscount vanquished by Simon de Montfort, then by Raymond VII, who in 1243 was forced to sign a definitive peace treaty. On his death in 1248 his daughter inherited the county, which thus joined the house of France. It was attached to the crown in 1271, Alphonse de Poitiers and his wife, Jeanne, having died childless. In the meantime the last Cathar fortresses fell, including the château of Montségur in 1244, where 210 Cathars who had been condemned to the stake threw them-selves into the flames, singing.

THE JACOBIN MONASTERY

───────●───────

The Jacobin Monastery was the motherhouse of the order of Friar-Preachers, or Dominicans, also called the Jacobins after their first establishment in Paris, located near the Saint-Jacques Gate. Finished in 1385, the church, which rises in an unbroken sweep above the roofs of the town, is made of bricks and has no flying buttresses. The vaults of the double nave are directly buttressed by powerful abutments; between them stand chapels with low vaulting. The double nave responded to the order's custom of allowing the faithful and the monks to follow services at the same time, as long as they were physically separated. The last pillar, which supports twenty-two arches, has been compared to a palm tree. Aesthetic choice dictated the building's proportions, 66 feet (20 meters) wide and 92 feet (28 meters) high, which carry the relationship, so beloved by Gothic architects, of the sides of a square and its diagonal.

In the tradition of Languedoc, the church bears, like the Saint-Sernin basilica, an octagonal bell tower pierced with mitred, or triangular, bays under a gable framing an oculus, or small window, shaped like a diamond. The church, the cloister, the magnificent chapter hall with six vaults bearing simply on two slender columns make a magnificent impression. The order's spirit of poverty—if not poverty itself—is manifested in the simplicity of the decor. While the polychrome decoration creates a cheerful effect, none of it is figurative, so as not to distract attention. The arcades of the cloister are simple pointed arches bearing on double columns whose capitals carry little embellishment.

JEWELS OF GOTHIC LANGUEDOC: TOULOUSE AND ALBI

A very important center of art and religious life, as the basilica of Saint-Sernin, the largest Romanesque church still standing in France, splendidly testifies, Toulouse contains so many churches and religious establishments that it was called "Holy Toulouse."

In 1211 Count Raymond VI undertook the construction of the first nave of the cathedral of Saint-Étienne. The architect had assimilated the innovations of the Île-de-France, including the rib vault, but he nonetheless created an original style whose essential characteristics are the use of brick and construction of single naves of modest height (here, 66 feet, or 20 meters, high and 62 feet, or 19 meters, wide). Later on, architects who came from the north tried to introduce the Gothic style of the Île-de-France by raising buildings of stone with lofty proportions containing naves flanked with aisles and transepts, like the choir of Saint-Étienne, Saint-Nazaire in Carcassonne, or the cathedral of Narbonne, but Languedoc would never renounce its style.

A MUSEUM OF SCULPTURE

Built shortly after the convent of the Jacobins, the convent of the Augustins has a larger and more ornate cloister. Its church, with a single nave, is built in the purest Gothic style of Languedoc, as is its octagonal bell tower. The convent today houses the remarkable Musée des Augustins, whose three halls of Gothic sculpture present works that demonstrate the originality of the school of Languedoc. The saints and apostles in polychrome stone that decorate the "Rieux Chapel"—the chapel that Jean Tissendier, bishop of Rieux, gave to the convent of the Cordeliers—were sculpted about 1330 to 1350. The artist rendered various materials—for example, the leather strap that held the sword of Saint Paul, who was a soldier before his conversion—as well as anatomical details with an extreme realism; we seem to see the blood vessels and the bones beneath the skin in the faces and hands he carved. It is apparent that the sculptor was convinced of the loftiness of his task and the characters his work celebrated. He gives different features to each, following their nature and activity. All have an expression full of mystical force, but with variations; Saint John the Baptist expresses the torments and the hopes of the ascetic, while Saint Paul has a palpable presence, persuasive and warm.

About 1425–50 the famous "Notre-Dame de Grâce" (Our Lady of Grace) was sculpted. Very young, as she was at the time of Christ's birth, her face still childlike, Mary holds Jesus on her knees. She wears a long blue dress, slightly open at the collar, and masses of her blond hair escape from under her veil, which is

ALBI, CATHEDRAL, FRESCO OF THE LAST JUDGMENT, COMPLETED C. 1480
This is a large-scale painting, taking up the entire back wall of the cathedral, facing the choir. It depicts humankind and its society subjected to the scrutiny of God, who observes the mixed instincts of the struggle for life (the damned in Hell) and the aspiration to tranquillity, harmony, and beauty (the elect in Heaven).

held in place by her crown. Many early sculptures of the Virgin and Child, from the Romanesque period or the beginning of the Gothic style, are hieratic and monolithic. The mother and child sit at the center of the piece, her head directly over his. In contrast, the anonymous sculptor of Notre Dame de Grâce rendered the same subject unconventionally and with a great deal of movement. The Virgin is turned slightly to her right, while the Child strains diagonally to the left. The folds of Mary's mantle, ruffled and disturbed, seem to have been blown by the wind, adding more animation to the composition.

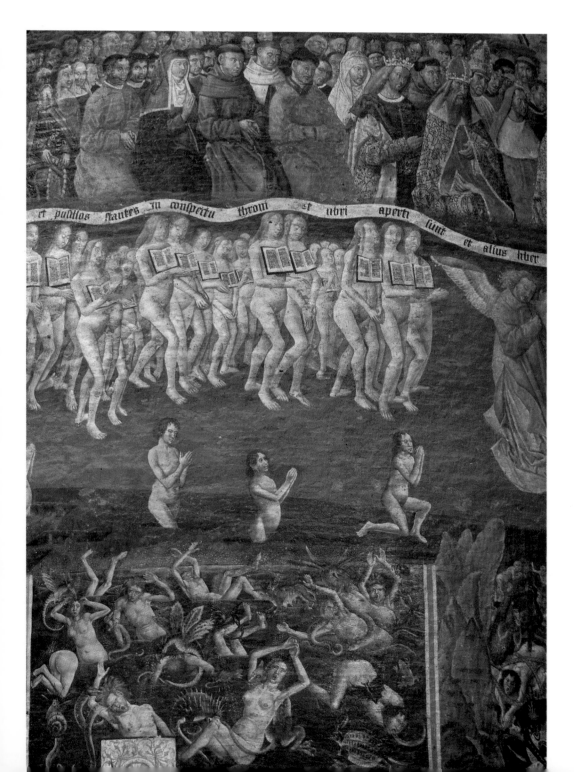

ALBI, STRONGHOLD OF THE FAITH

Albi, like Carcassonne, belonged to the lands of the Trencavels, who took up arms against the anti-Cathar crusade from the beginning. It was one of the principal centers of resistance. In 1265, when Bishop Bertrand de Combret undertook the construction of the episcopal palace of Berbie, and still when his successor Bertrand de Castanet began the cathedral of Sainte-Cécile in 1282, the country was not very safe. These buildings, fortresses to which one could eventually withdraw, forcefully affirm the victory of orthodox faith and order.

The cathedral, mostly finished by 1383, in its initial state was a very austere building. Its single nave is 63 feet (19.2 meters) wide and 98 feet (30 meters) high. All of the space contained within its abutments is given to the interior of the building, which has twenty-nine chapels, their vaults soaring as high as those of the nave in an unbroken sweep, interrupted in the fifteenth century by the construction of an intermediate level. On the exterior, the bell tower runs up to the level of the roof along the wall, becoming visible only above the windows. In the last century, when the walls were raised by 23 feet (7 meters), it became hard to make out.

The only "embellishment" of the cathedral, if we may call it that, are the semicylindrical volumes flanking the buttresses that match the volume of the bell tower, as well as those of the La Berbie Palace and its fortifications. These great masses of plain brick still fascinate contemporary architects with their originality.

By the fifteenth century heresy, conquest, and repression, the resistance they caused, and the subsequent escalation of violence and intolerance were all finally forgotten. To celebrate the joy of the return of better days the bishops undertook large-scale decorative works for the cathedral. The fresco of the Last Judgment was finished about 1480, the rood screen and the choir screen about 1500. At the same time the height of the tower was increased by three stories. This work was continued in the following century; Italian artists covered the whole interior of the building with paintings, while the principal portal was decorated with a porch in the Flamboyant style (discussed below) in the form of a baldachin.

The fresco of the Last Judgment is 46 feet (14 meters) high and 66 feet (20 meters) long. The central portion, depicting Christ and the archangel Michael,

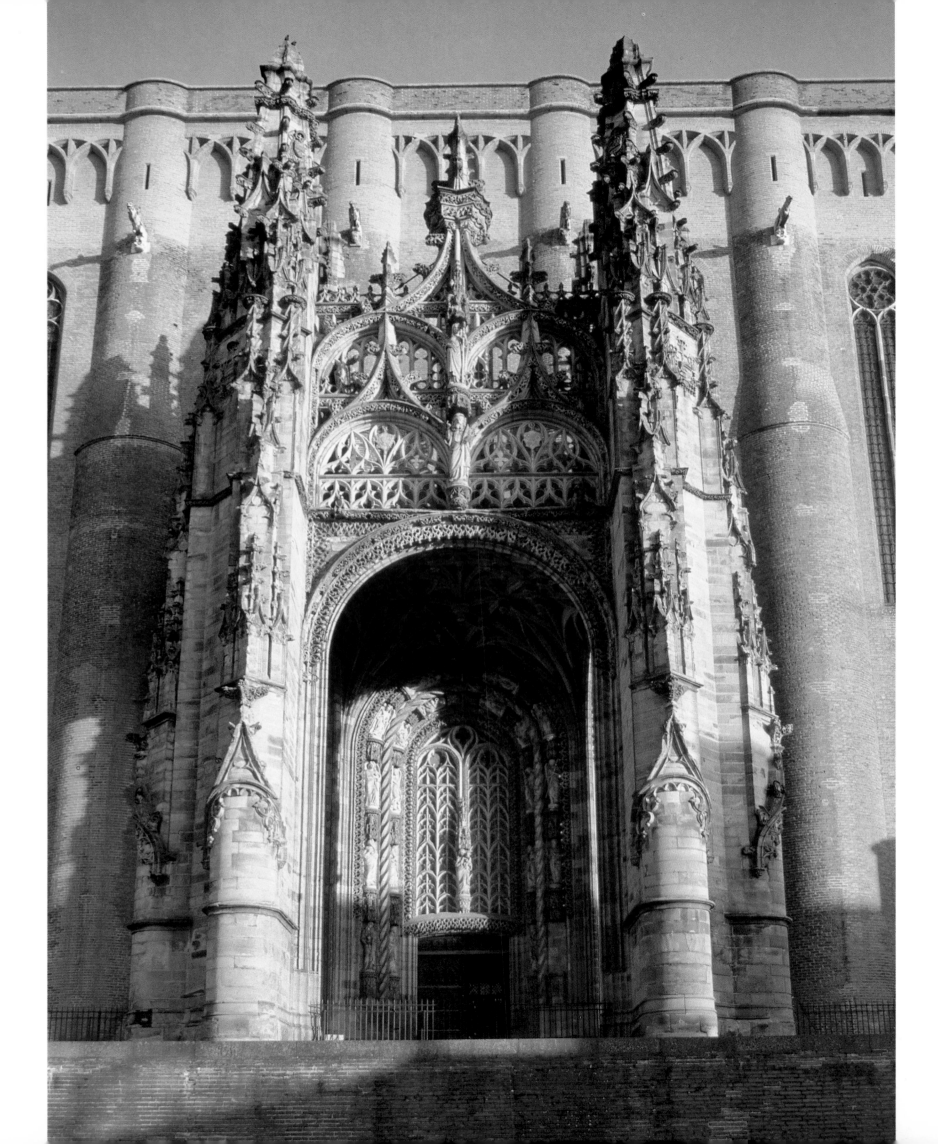

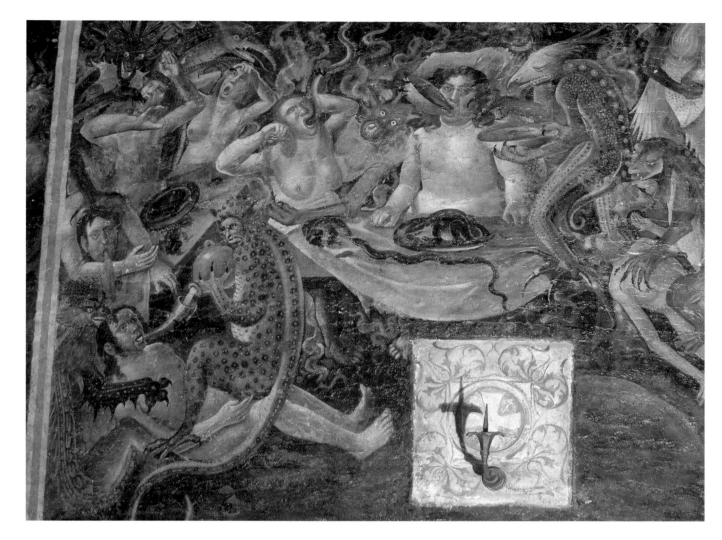

was unfortunately eliminated in the seventeenth cen-
tury when the large bay opening onto the chapel of
Saint-Clair was installed. Like the Last Judgment in
Bourges, the scene is divided into three levels. In the
middle, the dead return to life, bearing the open book
of their lives on their breasts; to the right of Christ
stand the elect, their hands clasped; on the other side
the damned open their arms or wave them convul-
sively in a sign of despair, seeming to say, "If only I
had known!" Below are depictions of the sufferings of
Hell linked with each of the seven deadly sins: the
proud burn, bound to wheels, in a predominantly red
composition, while the envious are plunged into a
frozen river where they are assailed by animals; green
is the predominant hue. Gluttons are condemned
endlessly to swallow filthy flesh and fluids, while the
lustful roast in a sort of well filled with fire, sulfur, and
smoke, in a torture that recalls their favorite places to
rendezvous in the Middle Ages, the *étuves*, or public
baths. Hell is depicted with a wealth of imagination
that makes these paintings masterpieces of fantastic
art. The painter, like Hieronymus Bosch, fabricated
demons from the body parts of different animals. This

Hell, which could be described as full of the pic-
turesque, hides another: on the upper level, opposite
the inhabitants of Heaven standing to the right of
Christ, is a space void of people, filled only by sinister
black clouds; perhaps for the painter this is the real
Hell.

The rood screen and the choir screen, sculpted
from soft, easily worked stone that subsequently hard-
ened in the air, form an exceptional group of sculp-
tures in polychrome stone. The interior part of the
screen, on the choir side, is devoted to characters
from the New Testament, the Virgin and the Apostles.
The exterior displays the great figures of the Old
Testament, among them two women, Esther and
Judith, both seductresses. Esther, a young and pretty
orphan, offered to sell herself on the advice of her
uncle and tutor Mordecai; she joined the harem of
Ahasuerus and thus obtained from the Persian
king favors for her people. Judith went out from the
town of Bethulia, besieged by the Assyrian general
Holofernes, found him in his tent, aroused his desire,
and cut off his head, thus freeing her people. With the
richness of her red robe, from which her fringed

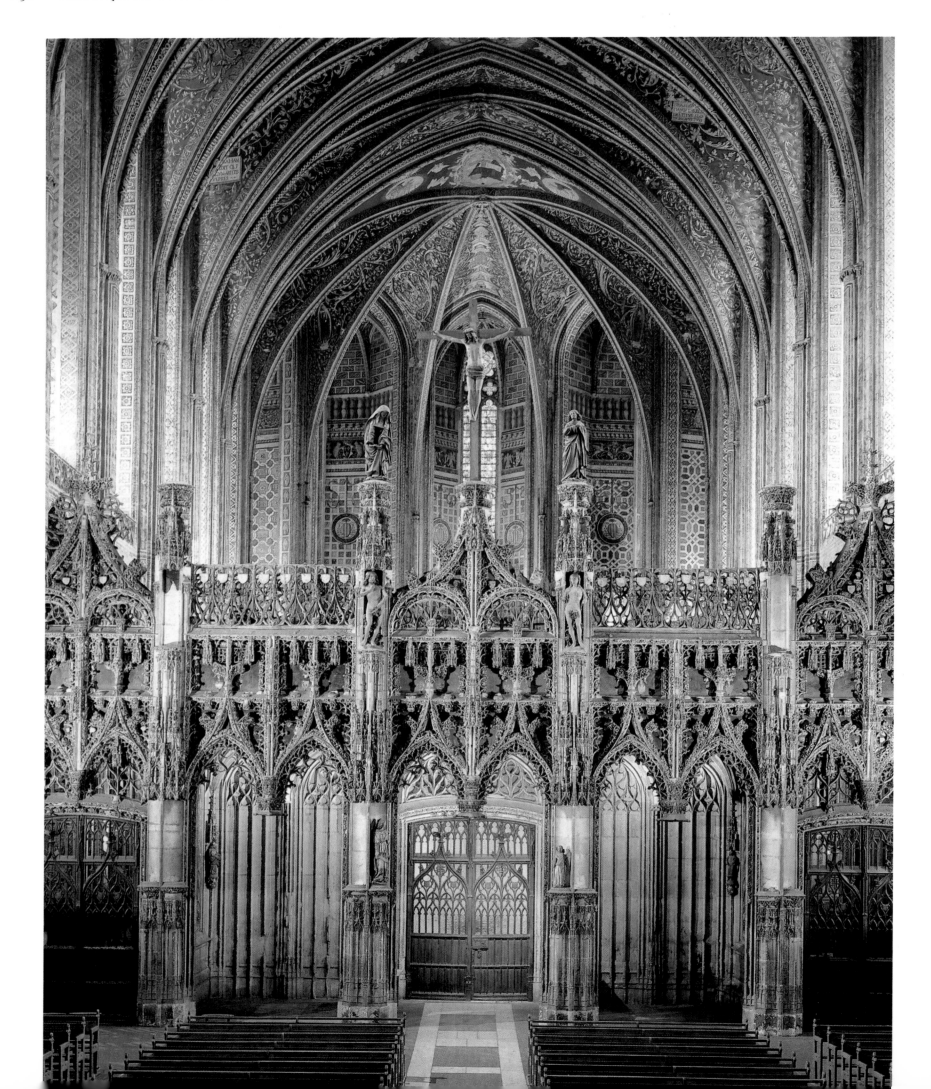

Opposite
ALBI, CATHEDRAL,
NAVE, 13TH–15TH
CENTURIES
The interior of the cathedral underwent a complete metamorphosis at the end of the fifteenth century, transformed into an immense piece of jewelry with sparkling colors with the addition of wall paintings, gilding, and the choir screen.

ALBI, CATHEDRAL,
CHOIR SCREEN, 1500
The choir screen displays a group of polychrome stone sculptures of great beauty, such as the prophet Jeremiah, whose face seems to reflect both horror and hope as he looks into the future.

sleeves peep out and which is decorated, like her hair, with lace and jewels, with her glowing forms and her half-closed eyes, Judith magically brings to life this colorful episode from the Bible.

All the prophets in the Old Testament are represented. Jeremiah has a piercing look, that of the seer confronted with a future at once marvelous and terrifying, which he alone can see. Biblical analysis distinguishes three trends in the Old Testament: an aristocratic tendency—that of the kings, the priests, and the officers—expressed in the first books, which are above all historical, poetic, and legislative. In the "books of wisdom" we become aware of the scribes, men from the middle classes, shaped by scholarship, prudence, the friends of divine wisdom. Finally, the prophetic books echo the popular faith; these are more exuberant in nature, loving the direct, even discordant, poetry of the outcry, also more exacting and easily alarmed by events—this is what we read in the look on the craggy old face of Jeremiah of Albi.

CARCASSONNE, MAGIC FORTRESS

The site of Carcassonne long held an exceptional strategic value. The fortress controls the passage cut

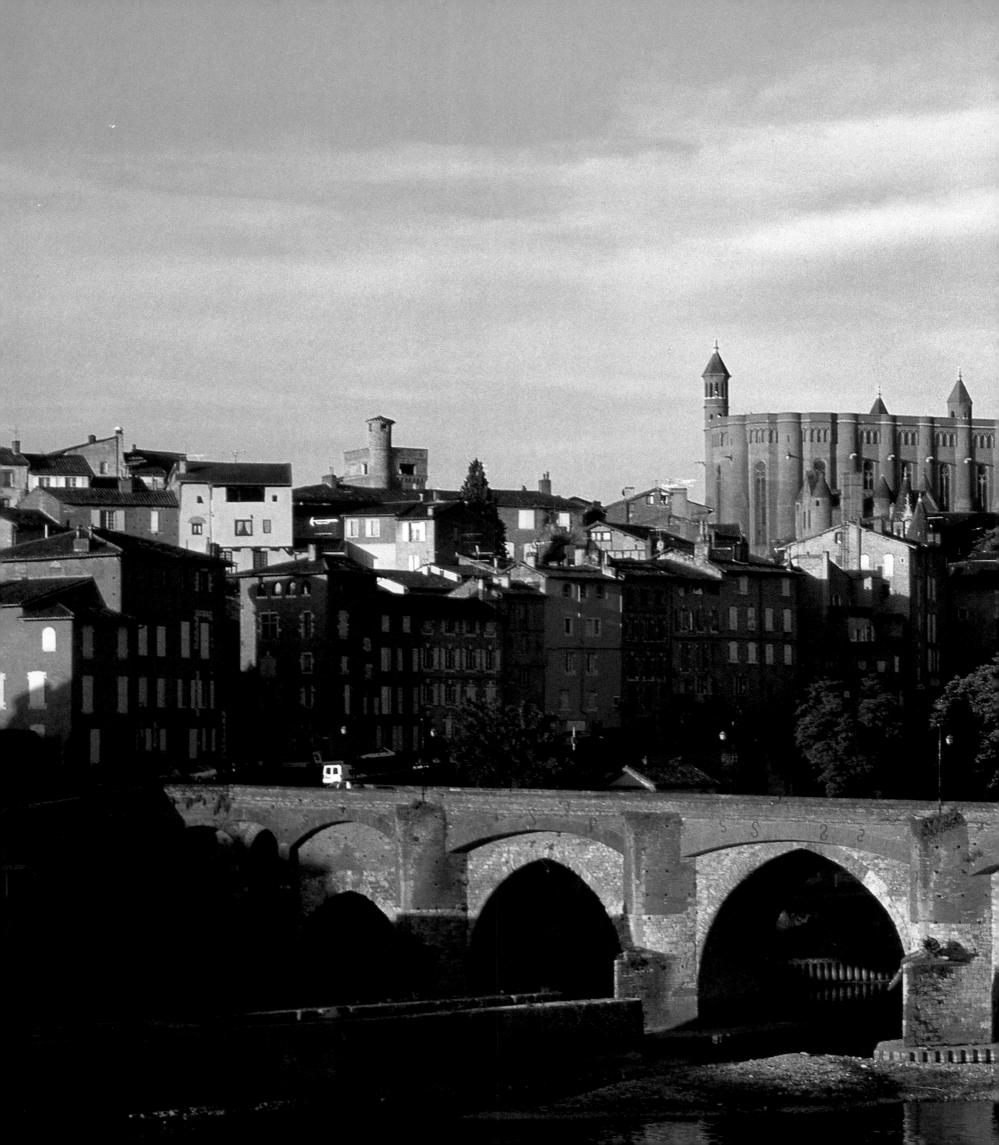

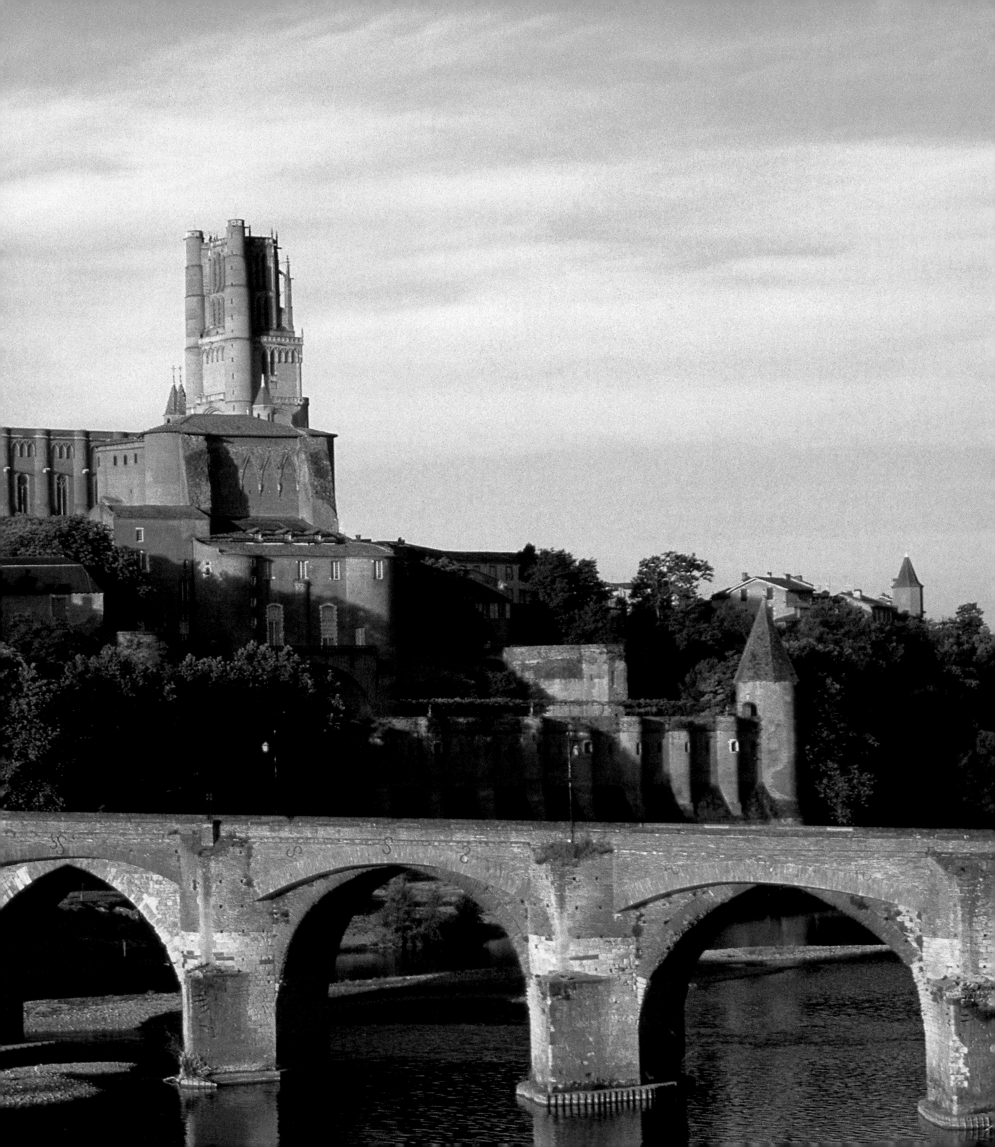

by the Aude River between the Massif Central to the north and the Pyrenees to the south. The Gauls, the Romans, then, from the fifth to the eighth centuries, the Visigoths held the site in succession. Curtains (the outer masonry wall with a parapet) and towers from the Visigothic citadel still remain, recognizable through their masonry of small cubic stones interspersed with narrow horizontal layers of bricks. In Carolingian times the city lost its strategic role, since it was situated far within the borders of the Holy Roman Empire, whose southern frontier was in Spain. In feudal times, however, it regained its importance as the principal defense of the county of Toulouse against potential raids originating from the shores of the Mediterranean.

First vassals of the counts of Toulouse, the viscounts of Carcassonne carved themselves a sizable fief thanks to the fortress. The majesty of the "château of the counts," with its nine towers, a veritable fortress within that of Carcassonne, built after 1130, bears witness to their power. There the viscounts held their own court, surrounded by their own vassals, whom they summoned to audiences, to sumptuous feasts, to tourneys, and to poetic contests of the troubadours.

After the conquest of the county of Toulouse, Saint Louis undertook important works at Carcassonne. He had the transept and choir of the cathedral of Saint-Nazaire built in the Gothic style of the north; decorated with magnificent stained-glass windows, the cathedral is a true "Sainte-Chapelle of the South." Above all, he saw to the improvement of the cities' defenses, a project pursued by his son Philip the Bold. The buildings of Saint Louis, like those of the viscounts, employ gray, rectangular-shaped, medium-size stone blocks in a regular construction, while those of Philip the Bold are recognizable by the modest bossage of the stonework (projecting pieces on the stone blocks). To the first we owe especially the outer fortress wall, parallel to the original wall, and the leveling of the space that separates the two walls; the latter is responsible for magnificent works like the towers of the Narbonne and Trésau Gates at the main entry to the city.

The city thus attained dimensions never before reached; with 1.8 miles, or 3 kilometers, of protective walls and fifty towers, several thousand people participated in its defense. The fortress, nonetheless, was only defensive. The city was the principal stronghold of royal power in Languedoc, upholding the suzerainty

of the Capetian kings and symbolizing the victory of the north and its culture over the south. Perhaps the relative "uselessness" of the fortress in its latter state contributes to its charm, imbued with romanticism.

"Above the abyss, built of the philosopher's stone, unfolds the glittering château," wrote André Breton. The city presents this appearance from all sides. Even if we know that each element in it is functional, that nothing was left to chance by the military architects, Carcassonne remains the citadel of dreams, where long walks within and around its walls bring back to us a complete past life.

Preceding pages
ALBI, GENERAL VIEW
The cathedral and the bishop's palace, built in the same style, dominate the city and the Tarn River. These are well-fortified citadels of the faith, made for still-dangerous times; the crusade against the Cathar heresy and the gradual annexation of the county of Toulouse by the French crown were recent events.

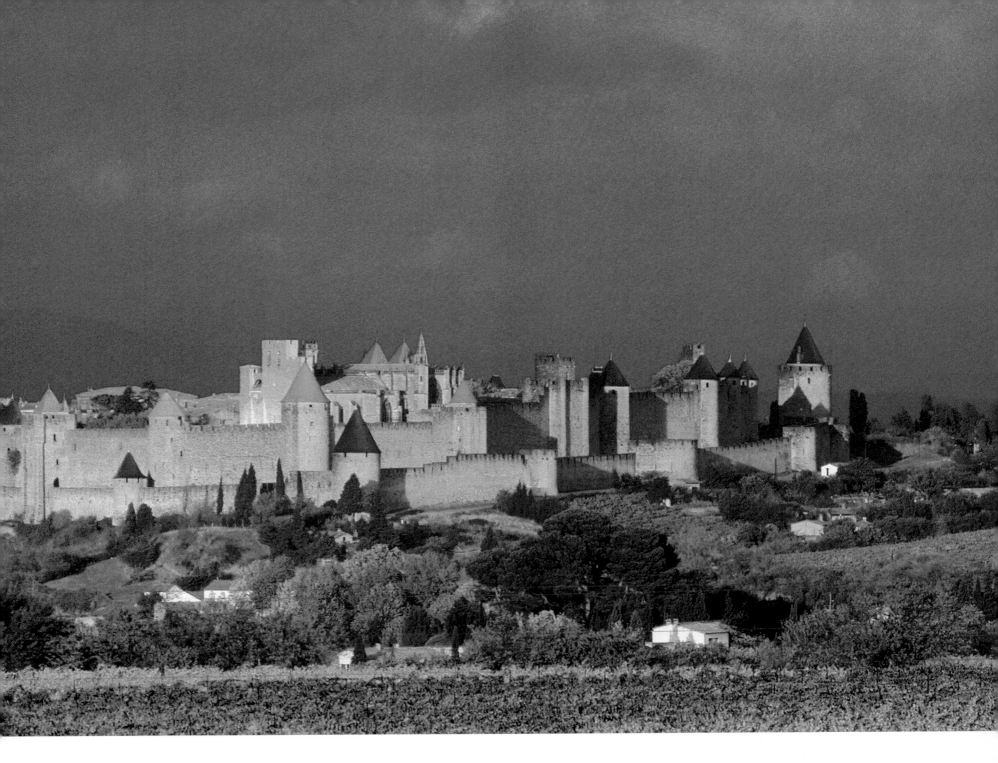

CARCASSONNE, LOWER
CITY, GENERAL VIEW,
5TH AND 14TH
CENTURIES
*The Visigoths, the
Trencavel viscounts,
Saint Louis, and Phillip
the Bold contributed to
the building of the old,
or lower, city, a fortress
of romantic charm that
inspires fantasies.*

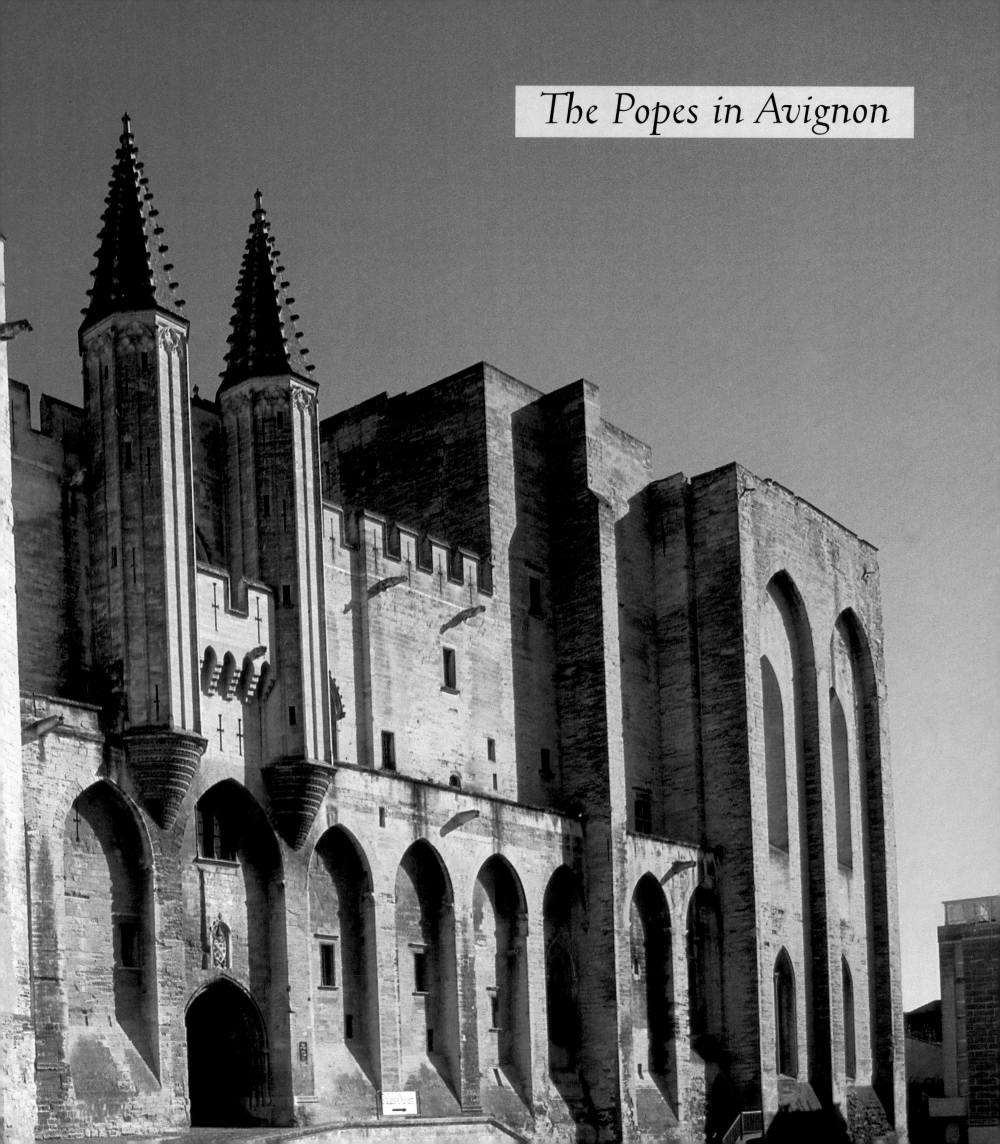

AFTER THE FALL of the Roman Empire, throughout the turmoil of the early Middle Ages, the Catholic Church and the papacy were supported by the emperors of Byzantium and then by the Carolingians, who gave the pope sovereignty over Rome and the central part of Italy. During this period of the feudal fragmentation of power, the Church, too, fell victim to anarchy, and all ecclesiastical functions fell into the hands of the sovereigns, large or small, who gave them to whomever they wanted, even sold them to the highest bidder: simony, the buying or selling of church offices, became the rule. In the Romanesque period popes Nicholas II and Gregory VII, the author of the "Gregorian reform," restored the authority of the Church and its right to name its own functionaries. The pope was elected by the "College of Cardinals" (Roman parish priests and the bishops of nearby dioceses), bishops by canons, and these in turn named the priests. The Church then became so strong that it emerged victorious in its struggles against the emperors of Germany. Subsequently, the Church took advantage of its power to raid sovereign territory; from the beginning of the Gothic period the popes, including Innocent III (r. 1198–1216) and Boniface VIII (r. 1294–1303), claimed the right to exercise supreme power over the rulers of Europe and imposed their will in all affairs of state.

In France the papacy found its support in the piety of King Louis IX. But his grandson Philip the Fair came into conflict with Boniface VIII, leading to the assault on Boniface in his palace at Anagni: on September 7, 1303, the king's envoy, Guillaume de Nogaret, carried off the pope, to be judged by a council of French bishops. Shattered by the violence of this insult, in which his enemies the Colonnas had joined, the pope died shortly afterward. The king obtained the nomination of a Frenchman, Clement V (Bertrand de Got), who in 1309 moved to Avignon to escape the civil war afflicting Italy. Avignon belonged to the king of Naples but was located at the gates to Comtat Venaissin, a possession of the Holy See.

IN THE PAPAL PALACE: SPLENDOR OR AUSTERITY?

The Papal Palace was built in under thirty years, principally by Benedict XII and his successor, Clement VI.

Benedict XII (Jacques Fournier, pope from 1334 to 1342) had built the "Old Palace," whose principal wing overlooks the town to the east. The largest spaces are the council room on the ground floor and, above, the Grand Tinel, 157 feet (48 meters) long, 33½ feet (10.25 meters) wide.

The building, majestic yet austere, conforms to the ideas of the simple Cistercian monk that the pope once was, and remained at heart. From a modest family—his father, it was said, was a baker—Benedict entered the abbey of Fontfroide at a young age and became its abbot. After he became pope he continued to wear the simple white habit of the order of Cîteaux.

Clement VI (Pierre Roger, pope from 1342 to 1352) had the "New Palace" built, which is composed of two wings. The Champeaux Gate, the main gate of the palace, opens on one wing; the other wing, perpendicular to it, contains the hall of the Great Audience, 171 feet (52 meters) long, 51⅔ feet (15.8 meters) wide, on its ground floor; above it, with the same dimensions, is the Clementine Chapel. Of more refined construction than the "Old Palace," the "New Palace" reflects Clement VI's love of splendor. He had the entire palace decorated with rich wall paintings (which, unfortunately, have for the most part disappeared). He was the son of a poor gentleman who gave his entire inheritance to the eldest of his five sons and had the others take orders. The brilliant talent that Pierre Roger showed for theology allowed him to overcome all obstacles.

The palace, with its 160,000 square feet, or 15,000 square meters, of space, fills a complicated group of functions. First of all it was the residence of the pope, whose apartment, for the most part located in the Angels' Tower and the Wardrobe Tower, includes a formal antechamber, the *chambre de parement*, or dressing room, then his bedroom, his study, whose wall paintings have been preserved, his library, and his personal kitchens and dining room, now destroyed. The Angels' Tower, the best-protected part of the palace, also housed the treasury. The Church was very wealthy, for it held a great fortune in lands; it collected various taxes, both in its own states as well as in the rest of Christendom; it received gifts and inheritances; it worked, produced, sold, saved. Behind the palace were spread the pope's gardens, in terraces overlooking the town. Urban V even installed a zoo there, and stags that ran free.

The pope is first of all priest and spiritual leader, so the palace includes several chapels, among them the great Clementine Chapel and, above it, the chapels

Preceding pages
AVIGNON, PAPAL PALACE, PRINCIPAL FACADE, 1334–43
Pope Benedict XII had the "Old Palace" erected between 1334 and 1342 (center). It was a building of many uses—spiritual and intellectual, political and jurisdictional, residential and defensive—hence the existence of chapels and studies. More space was needed, however, so Clement VI added on the "New Palace" (right) in 1342–43.

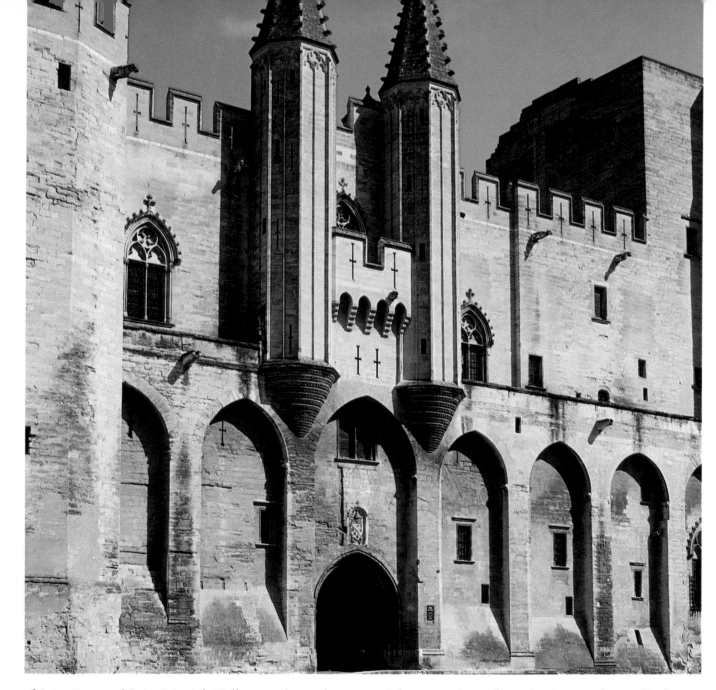

of Saint-Jean and Saint-Martial. Halls were devoted to the study of the "divine science" of theology, and to working out responses to questions of doctrine or tracts condemning heretical positions. The Albigensian heresy was then almost extinct, but the Waldenses, who foreshadowed the Reformation, were still active in the southeast of France. Their founder, the Lyonnais merchant Waldo, having resolved to live the ideal of evangelical poverty fully, about 1170 had sold all his goods and given the proceeds to the poor. He then took to the roads, preaching refusal of the mediation of the Church and arguing for a direct dialogue with Christ.

The pope was also head of the Church as an organization and a head of state, functions that he generally fulfilled in the council room. In this august space, he received foreign sovereigns and diplomats; he summoned his council, composed of cardinals, to reach important decisions; and he presided over offi-

cial ceremonies and nominations to the cardinalate or the curia (administration of the pope). Sessions of the papal courts were held there as well.

The Church made use of an organization of tribunals, the "officialities," headed by that of the pope, the supreme authority. These officialities had jurisdiction over clerics, who had the privilege of being judged not by the countries in which they resided but by the Church. If they were found guilty they were handed over to the "secular arm," that is, the country of residence, for execution of the sentence, for the Church could not shed blood. The officialities also had jurisdiction over certain actions having to do with religion, no matter who was involved: affairs concerning simony, blasphemy, sacrilege, heresy, the marriage of priests, religious vows, and marriage, for example. In those countries in which the pope was sovereign, his tribunals naturally had jurisdiction over all civil and criminal affairs.

This jurisdictional activity was so important that Clement VI devoted the large and small audience rooms to it. The former has six bays with rib vaults supported by a central row of five pillars. The papal judges, the "auditors of the holy apostolic college," sat there in a circle marked off by the stonework, from which the tribunal got its name, the *rote* (from the Latin *rota*, or "wheel"), a name it retains today.

When the time came for the election of a new pope, a part of the "Old Palace" was at the service of the Conclave. The cardinals were literally "under key"—the meaning of the word *conclave*—left with no contact with the outside world, the doors and windows being blocked to the height of twenty-six feet (eight meters). Staff, provisions, books—everything they needed to survive had to be shut up with them.

A wing of the palace was devoted to the lodging of some of the numerous servants and staff, the "regulars," and the Grand Tinel, the state dining room, which was used for receptions and feasts.

A Fortified Palace

A building of this size, with huge stacked halls, had to be supported by ponderous masses of masonry. What is more, the palace had to be able to defend itself. For both of these reasons, its walls are extremely thick, crowned with crenellations, and flanked with very high towers, like the Campane Tower. From afar can be made out the magnificent arcades with pointed arches superimposed on the facades to reinforce them and support walkways and machicolations. By hurling stones, boiling pitch, and anything else that came to hand, defenders could prevent access to the windows, placed high. As Prosper Mérimée described it, "To see the château of the popes, the most extensive of all the buildings, one would think it the citadel of an Asian despot rather than the abode of the vicar of the God of peace." The second line of fortifications was formed by the town's ramparts, built entirely at the initiative of the popes; three miles (five kilometers) long, they still stand today.

These defenses were mostly passive and dissuasive, the principal weapon of the pope being religious sanctions. The excommunication of a sovereign not only shook his faith in salvation but also affected the respectful attitude of his subjects toward him. This

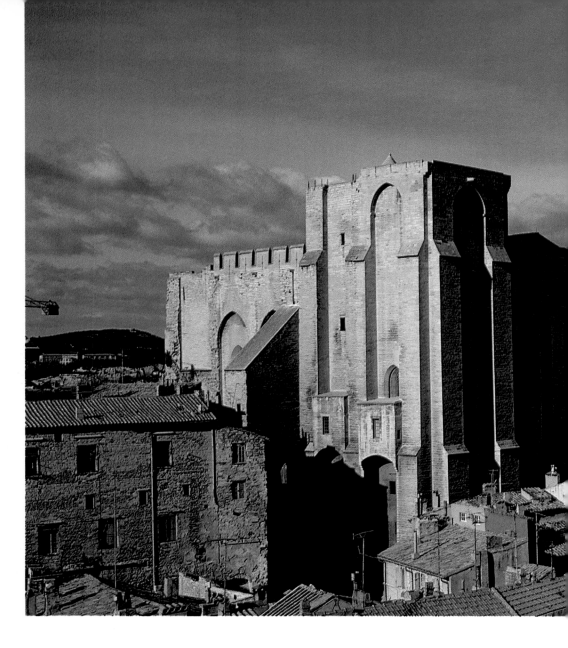

AVIGNON, PAPAL PALACE, REAR FACADE, 1334–43
Except for the left tower, the rear facade shows the "Old Palace." The immense building, enclosing 160,000 square feet (15,000 square meters), is severe and massive, even with the towers and the reinforcing walls, with their vertical lines, to break up the monotony.

sanction, however, proved ineffective against the *routiers,* bands of mercenary soldiers who often turned to brigandage once fighting was over, threatening Avignon. Rather than run the risks of a siege, the popes preferred to pay them to go away.

Avignon is also the city where, on April 6, 1327, the poet Petrarch for the first time saw his beloved Laura, during services at the church of Sainte-Claire. For the rest of his life he turned his passion into poetry without revealing the name of his love. An opponent of what he called "the Babylonian captivity" and, as a good Italian, a propagandist for the return of the papacy to Rome, he reviled the court of Avignon in his verse.

It is certain that Petrarch was biased and that his dislike was excessive, for popes like Benedict XII and Urban V lived at Avignon very austerely. They avoided nepotism or favoritism, unlike the first pope, Clement V, who had six members of his own family named cardinals, or Clement VI, who was very generous with church money toward his sister Guillemette

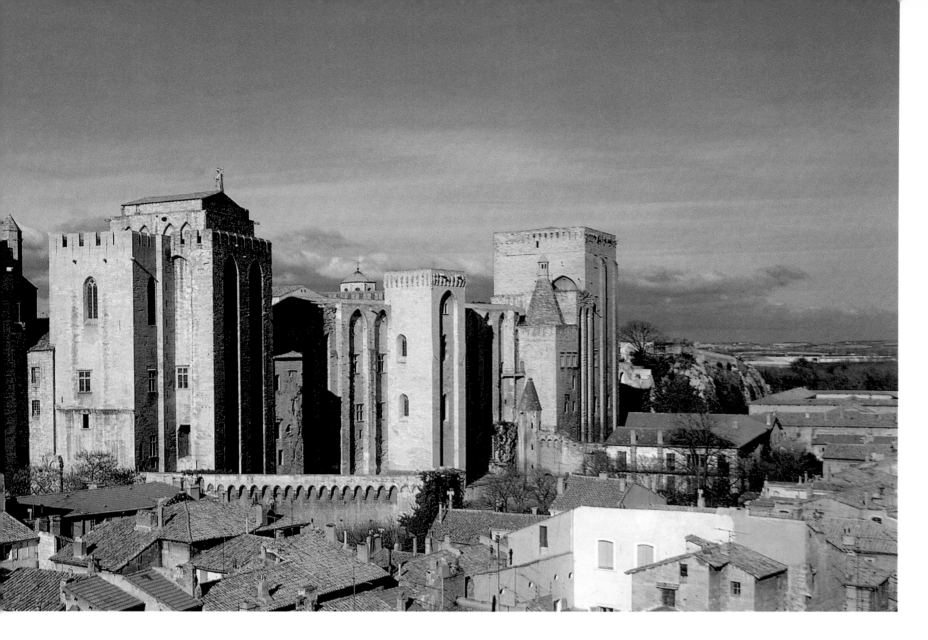

de la Jugie and his nieces, Élise de Valentinois, Delphine de la Roche, and Aliénor de Turenne. The methodical accountants of the pope opened an account entitled "ladies of the pope's family." He was also extremely generous to the poor, to whom he gave 32,000 loaves of bread every day, and during the plague he took the Jews under his protection, saving them from the people who had begun to massacre them, holding them responsible for the epidemic. He is criticized for having emphasized the political aspect of his charge to the detriment of its spiritual side, setting himself up as a sumptuous sovereign, the friend of artists rather than of theologians. He is even supposed to have said, "Our predecessors did not know how to be pope."

There was no dancing in the palace but the food, at least on great occasions, was similar to that provided by other heads of state. For example, for the enthronement of Innocent VI in 1352, ten thousand people—as many as for the coronation of Philip VI, king of France—were invited to a feast for which 324 plovers, 1,432 partridges, 1,560 rabbits, 11 peacocks, 100 river birds, and 1,400 pâtés were ordered. The cardinals reciprocated in their *livrées* (palaces) in the city or in those they had built "in the fields," on the other side of the Saint-Bénézet Bridge, in the French territory of Villeneuve-lès-Avignon, under the protection of the fort of Saint-André and the tower built by Philip the Fair. On the site of his *livrée* Innocent VI constructed the Carthusian monastery of Villeneuve.

Those who favored returning the papacy to Rome finally won the day, but the Church experienced another papal crisis. In protest against the election of an Italian as pope in 1378, installed in Rome, the French elected their own, who took his seat in Avignon. In 1417 the Council of Constance put an end to the "Great Schism" by electing Martin V. Avignon, which Clement VI had bought from the queen of Naples, remained a possession of the Holy See. Governed by a legate, it was a land of asylum, in particular for the Jews. Avignon and the Comtat Venaissin were not annexed by France until 1791.

A FLOWERING OF GREAT PAINTERS

By attracting artists—not only architects but also painters—the popes made Avignon one of the principal artistic centers of the fourteenth century. The Sienese Simone Martini was summoned by Benedict XII to decorate the cathedral of Notre-Dame-des-Doms with frescoes. Then Clement VI gave Matteo Giovanetti of Viterbo and his workshop the task of decorating the entire palace. He is the creator of the frescoes of the chapels of Saint-Jean and Saint-Martial. The wall paintings in the pope's study are attributed to a Frenchman, Robin de Romans. Painted in 1343, they depict characters pursuing various forms of hunting and fishing: a man climbs a tree to steal birds from the nest, another tries to attract them by imitating their songs, a third holds a falcon on his fist, ready to seize the birds that flee. A stag, hunted to exhaustion, is bitten in the haunch by a dog

Left
SIMONE MARTINI,
*THE VIRGIN AND
CHILD*, 1341. PAPAL
PALACE, AVIGNON
*Benedict XII summoned
Italian painters, including the Sienese Simone
Martini, to Avignon,
which led to the development of a flourishing
school of painting with a
distinctive style.*

AVIGNON, PAPAL
PALACE, WALL
PAINTING ATTRIBUTED
TO ROBIN DE ROMANS,
1343
*Clement VI, who served
as pope from 1342 to
1352, had a taste for
luxury and magnificence.
He had his study in the
Avignon palace deco-
rated with wall paint-
ings by a local artist,
who expressed his love
of life and nature exu-
berantly in his represen-
tations of different kinds
of fishing and hunting.
In this painting, a man
takes birds from the nest;
another depicts fishing
in a pond.*

Opposite below
ENGUERRAND
QUARTON,
*CORONATION OF THE
VIRGIN*, 1453–54.
CARTHUSIAN
MONASTERY OF
VILLENEUVE- LÈS-
AVIGNON, AVIGNON
*This masterpiece of the
school of Avignon
includes a very complete
iconographic program,
taking into account the
most recent develop-
ments in theology, for
example, the affirmation
of the identity of the
Father and Son.*

ATTRIBUTED TO
ENGUERRAND
QUARTON, *Pietà*,
C. 1454–56. MUSÉE
DU LOUVRE, PARIS
*Quarton was a painter
with many aspects. He
did not restrict himself
to glorious and pleasant
subjects but also tackled
the most tragic, such as
his* Pietà. *The arched
position of Christ here
emphasizes the rigidity
of the cadaver. From this
work emerges a reflec-
tion on the human
condition: we must all
undergo the tribulations
of suffering, through
which our essence
becomes greater, aban-
doning the excessive
attachment to the self.*

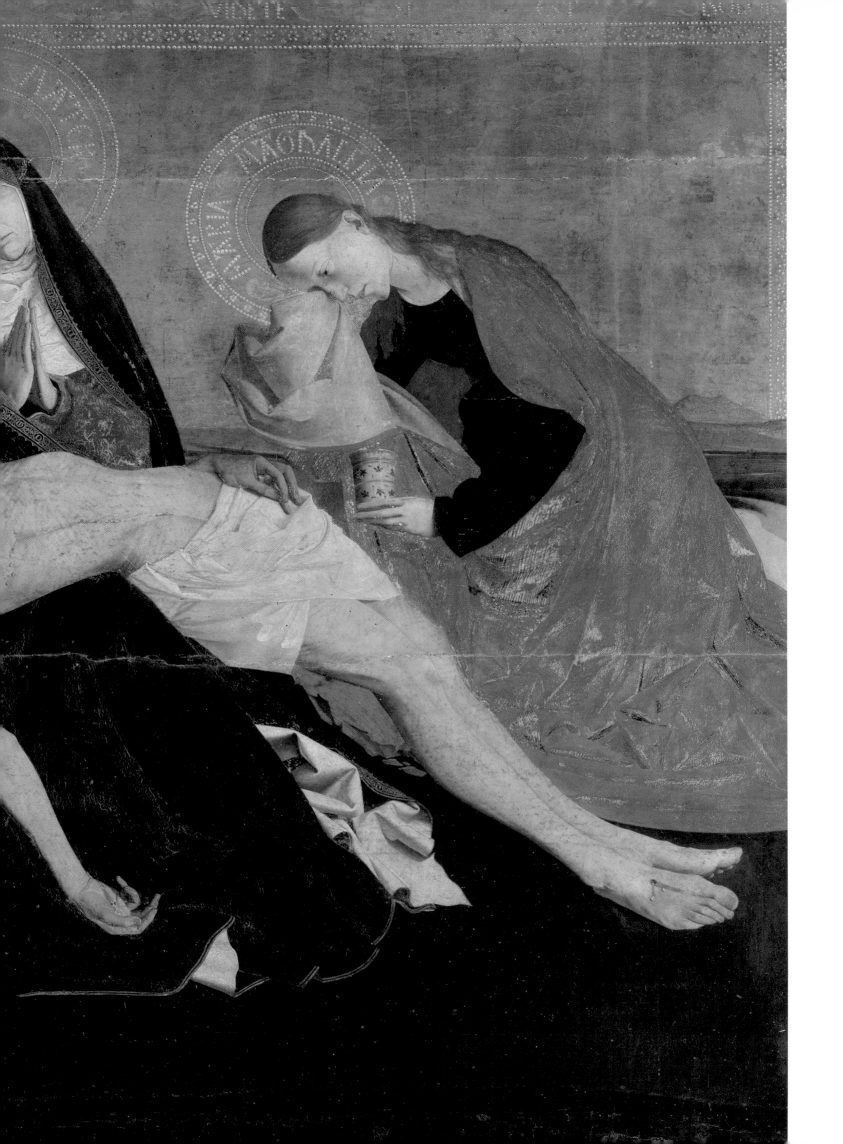

and killed with a pike. Fishermen stand around a fish pond in which ducks and fish swim: to the right a fisherman holds a basin between his legs and casts the bait while his neighbors prepare to throw a net; a third, dressed in red, looks at the fish he has just taken with his scoop net; and the last, crouching, seems to hold a fishing pole. All the scenes are full of life and gaiety. The vegetation is depicted in exuberant and disordered abundance, the reflection of a nature with which the artists seems to have been in intimate communion.

When civil war broke out during the time of the Great Schism, artists abandoned Avignon, which had become dangerous. With the return of peace, especially after 1420, the city grew prosperous once more, thanks to its location on a great commercial crossroads. Merchants, who came from all over to set up shop, promoted artistic creation, to which the patronage of King René, duke of Anjou, also contributed. Provence thus became one of the most important artistic centers of fifteenth-century France. Among the painters of the Provençal school, or the school of Avignon, the greatest were Nicolas Froment, responsible for the *Burning Bush* altarpiece, Enguerrand Quarton, and, to a lesser degree, Josse Liéférinxe.

Born about 1415 in Picardy, Enguerrand Quarton lived in Aix-en-Provence from 1444 to 1446, then moved the following year to Avignon, where he remained until his death. In his own day, he enjoyed great renown. Between 1453 and 1454 he painted the altarpiece of the *Coronation of the Virgin* for the chapel of the Sainte-Trinité in the church of the Carthusian monastery of Villeneuve-lès-Avignon (today, in that city's museum). Although it is not signed, the painting may be attributed to him with certainty, thanks to the discovery at the end of the last century of the "*prix-fait*," or contract, in which Jean de Montagnac, chaplain of the monastery, ordered it from the painter. The price was 120 florins, a large sum for the time. The contract, which even specifies the penalties for late delivery, describes point by point everything required to go in the painting. Are we to conclude that the artist in the Middle Ages had very little creative freedom? In fact, the painter departed from the agreement in many instances. Above all, we must remember that this document is the conclusion of a long negotiation; Jean de Montagnac would have indicated the theological program that he hoped to see depicted, while the painter would have made many sketches, in this process the ideas of both gradually becoming clearer.

The rather large painting, measuring 72 inches (1.83 meters) high by 87 inches (2.2 meters) wide, is worthy of the vast program it develops. Article 2 of the *prix-fait* reads as follows: "First there must be the form of Heaven, and in this Heaven must be the Holy Trinity, and between Father and Son there must be no dissimilarity, and the Holy Ghost in the form of a dove, and Our Lady in front, as it may seem best to the above-named Master Enguerrand; and the Holy Trinity will place the crown upon Our Lady's head." The greatest portion of the painting represents Heaven. The two figures of Christ and God the Father, who crown the Virgin, aided by the Holy Ghost, are indeed similar, illustrating the dogma of the identity of the Father and Son, which the Council of Ferrara had just affirmed in 1439.

Heaven contains, first of all, the beings that were part of it before the creation of the world: the angels who, on both sides above, accompany the Archangel Saint Michael and the Angel Gabriel, their wings spread; the seraphim, in an orange-red color, who stand behind the central group; and, finally, the cherubim, with their blue heads peeking out from the clouds on which the group is posed. Heaven is also populated by those humans who, after their death, are worthy of admittance: to the left, from top to bottom, Saint John the Baptist and the prophets; the martyrs, like Saint Étienne and Saint Laurent; the founders of orders, like Saint Francis of Assisi and Saint Bernard; and the representatives of the top of the social hierarchy—pope, emperor, king, cardinal. To the right, from top to bottom, are pictured the Apostles, like Saint Peter and Saint Paul; popes, like Saint Gregory the Great; bishops and cardinals; saints, like Saint Catherine; and then the notables from the middle and low end of the social hierarchy.

At the very bottom, Quarton painted Purgatory (to our left, that is, to the right of Christ) and Hell (to his left). The painter delighted in a highly imaginative depiction of the torments of hell; a devil tears the tongue from a blasphemer, and a suicide, his sword turned on himself, is condemned to repeat his action forever. An angel helps a pope to leave Purgatory and rejoin the cross of Christ and, through it, salvation. Jean de Montagnac insisted that members of the high clergy be portrayed even in Purgatory and Hell. Later, in a more hypocritical time, an effort was made to

efface the pope's tiara, the cardinal's biretta, and the bishop's miter from those three placed in Hell.

Between Heaven on the one hand and Hell and Purgatory on the other is the Earth, symbolized by Rome to our left and Jerusalem to our right, and by eight landscapes that form a summary of the world: a sea at the bottom, a river in the middle, plains and mountains, among which the highest is Mont Sainte-Victoire (dear to Paul Cézanne as well, much later).

The whole of the composition communicates a message of optimism. It expresses wonderment before the transcendence of Heaven and displays the variety of merits that allow access to it. The Virgin's coronation symbolizes that she was the first human being to be redeemed by the death of Christ.

The composition compels us to linger over every detail and admire the extreme richness of the work. For example, whereas Rogier van der Weyden and Giotto both created an original and very beautiful representation of angels, they tended to reproduce them subsequently. Enguerrand Quarton varied their faces, as well as their postures and their clothing. All the elements of the work are organized into a monumental composition. Not only the forms but also the colors were carefully chosen to harmonize with the vision of the whole. The artist made equal use of "strong" (dark red or brown, for example) and "weak" bright colors, alternating between them without calling attention to the technique, to avoid monotony. He employed a varied palette and made use of tones that were rare at the time, like mauve, ash grays, sea greens, and beige.

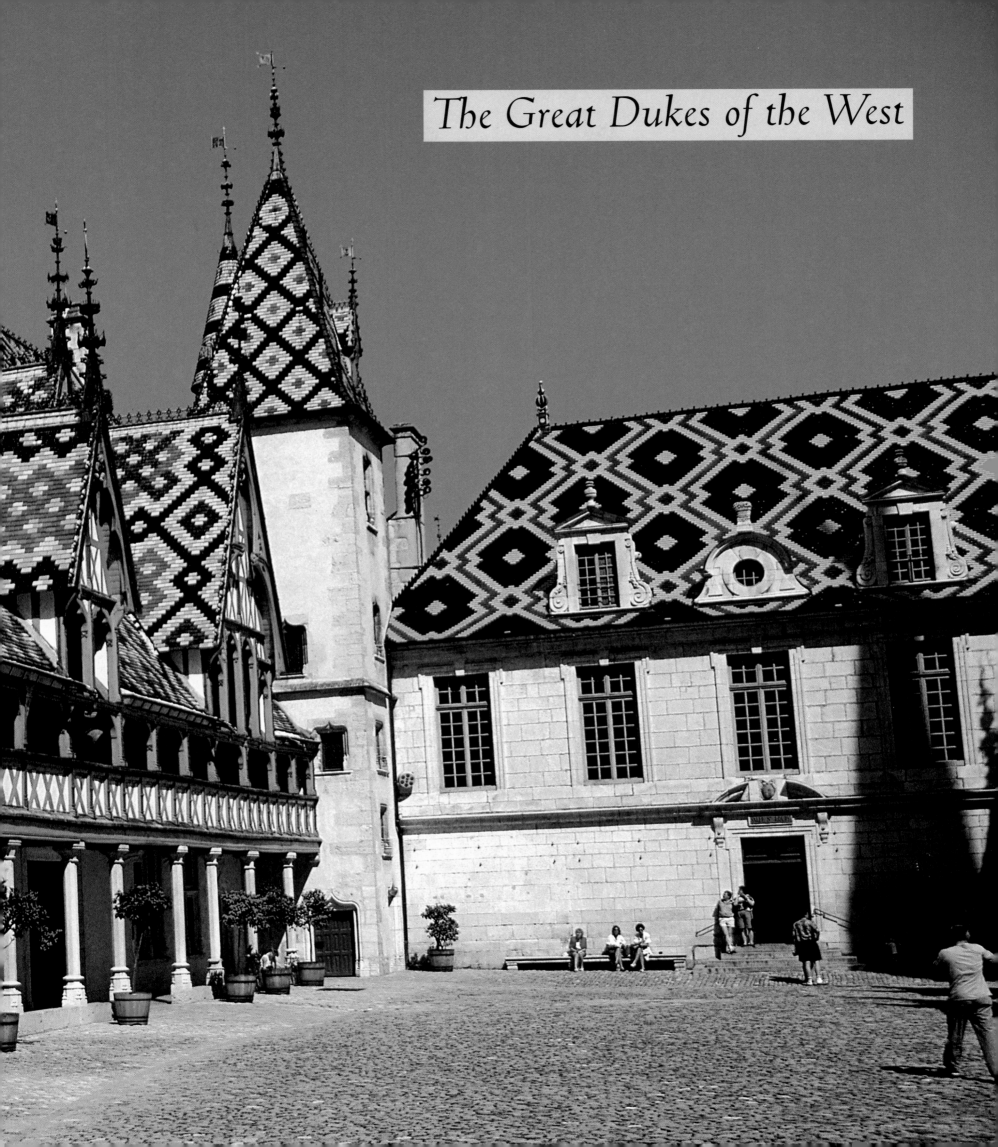

KING ROBERT the Pious conquered Burgundy in 1016 and gave it as an appanage (a fief that would revert to the crown if there were no male descendants) to his eldest son Henry. When he became king of France the latter gave it to his brother Robert. After him eleven dukes of the "first house of Burgundy" followed each other until the death of Duke Philippe de Rourves in 1361. During these three and a half centuries the fief grew slowly and prospered under the able leadership of the dukes.

THE "GREAT DUKES OF THE WEST"

Burgundy reverted to the crown, but not for long. In 1363 King John the Good gave it as an appanage to his fourth son, Philip the Bold, who was then twenty-two years old, who ruled as duke for forty-one years until his death in 1404. He owed his surname to the courage he displayed in the Battle of Poitiers in 1356; just fourteen years and eight months old, he fought by the side of his father, warning him with these words, since become famous: "Father, look out . . . to the right . . . to the left." In 1369 he married Marguerite de Maele, daughter and heir of the count of Flanders, destined to inherit all of present-day Benelux, with its ports and industrial activity one of the most prosperous regions in Europe. The "second house of Burgundy" that they founded was, from its beginnings, surrounded by extreme riches and glory.

The duke's sculptural portrait created by Claus Sluter for the portal of the Carthusian monastery of Champmol reveals his character: a solid and pragmatic man, sure of his authority, the founder of a dynasty, a man who accomplished much. As the head of Burgundy, he showed great zeal and solid good sense in everything except controlling the budget, for he spent lavishly. For his marriage he gave a banquet in Ghent so sumptuous that he could not pay for it; he was forced to borrow from the burghers of the town. On his death the treasury was empty, and the family silver had to be pawned to pay for his funeral. The Carthusians loaned one of their simple robes for him to wear on his funeral bed. Duchess Marguerite was forced to renounce her rights to their joint property, in accordance with the customs of Burgundy, by placing on her husband's coffin her purse, her bunch of keys, and her girdle. All his life Philip the Bold was a great patron; in 1401 he founded a "court of love" in his Paris residence, the Hôtel d'Artois, dedicated "to the honor, praise, and commendation and service of high ladies and damsels." This was a pleasant tribunal where debates were gravely held on the art of love.

Charles V, Philip the Bold's brother, died in 1380, leaving his crown to his twelve-year-old son Charles VI, whose madness became apparent in 1392. Resisting any temptation he might have experienced to seize the throne of France, the duke endeavored to have as much influence as possible over the sovereign and over the council of the regency, never going any further.

Such was not the case with the son who succeeded him, John the Fearless (duke from 1404 to 1419), a very complicated person, crafty, physically a little misshapen. In the council of the regency he clashed constantly with Louis d'Orléans, the king's brother. Here the history of France takes on the murky colors of Shakespearean drama: to eliminate his rival, John the Fearless had him murdered one night in Paris in 1407, on the rue Barbette in the Marais. This misdeed sparked the civil war that divided the French "Armagnacs," partisans of the young king, who gathered around the count of Armagnac, and "Burgundians." In an unjustifiable act of treason John the Fearless aligned himself with the enemy English. One of the great victims of these troubled times was Charles d'Orléans, son of the murdered duke; taken prisoner by the English at the Battle of Agincourt in 1415, he was imprisoned for twenty-five years. He became famous for his poetry, which relates his regret for a youth lost with discreet and elegant melancholy.

Another drama was brewing. In 1419 an interview took place on the Montereau Bridge between the dauphin—the future Charles VII—and John the Fearless, in an attempt to achieve peace. Suddenly— was it planned or the effect of their heated exchange?— a fight broke out in which John the Fearless in turn was killed.

His son Philip the Good thus suddenly inherited the duchy at the age of twenty-three. He kept it for forty-eight years, until his death in 1467. Good, but not weak, according to the words of a contemporary, he was "a prince of immense and touchy pride, of violent anger," but he was able to control himself, and his generosity won out. A portrait of him by the Flemish master Rogier van der Weyden can be seen in the Dijon museum, in what had been the great hall of his own palace.

In the beginning Philip III continued his father's policy by aligning himself with the English. In 1420 he

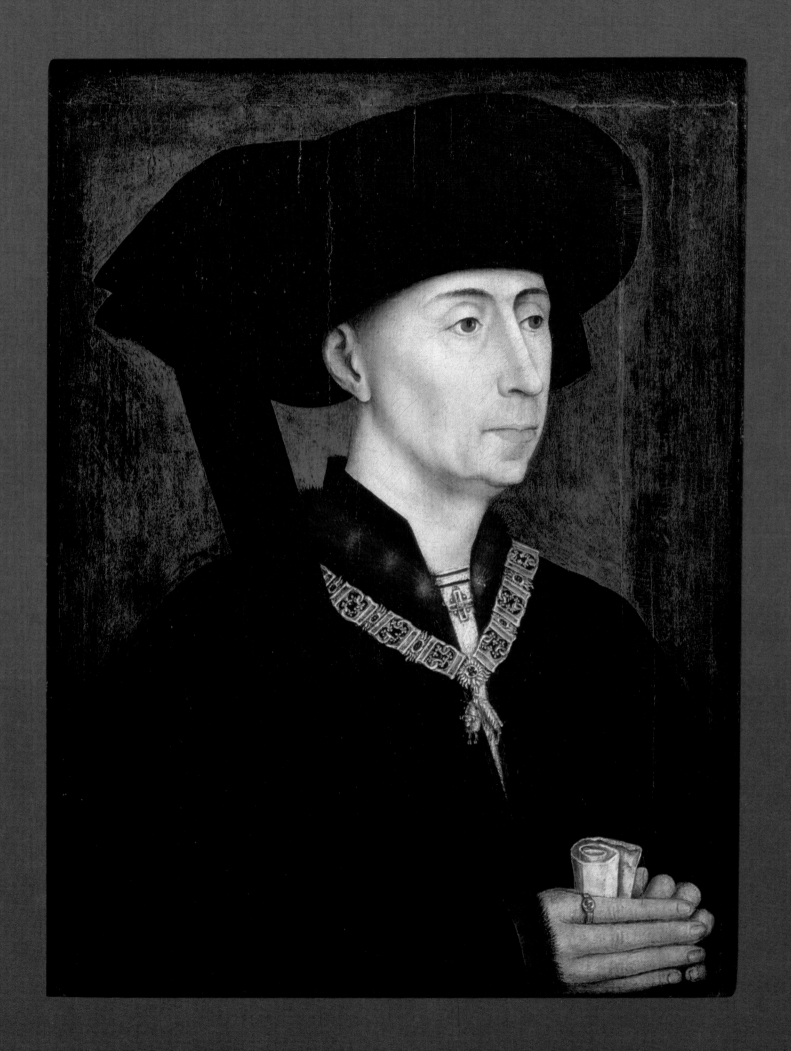

participated, with the king of England and Queen Isabel of Bavaria, wife of the mad French king Charles VI, in the shameful treaty of Troyes, which disinherited the dauphin, the future Charles VII. It was planned that the king of England would become regent, then king of France on the death of Charles VI. After long years of struggle, Philip the Good was reconciled with Charles VII in 1435 by the Treaty of Arras. This treaty marks not the end of the Hundred Years' War but the beginning of the defeat of the English, who could no longer profit from the lack of French unity.

Because of his father's long life Charles the Bold (duke from 1467 to 1477) had to wait until he reached the age of thirty-four to come to power. He was born late in his father's life, the child of his third wife, Isabel of Portugal. Impulsive, ambitious, proud, he did not

have his father's geniality. He lived isolated in the middle of his court, with neither friends nor confidants, as chaste as his father was sensual, animated by a sort of interior storm, turning over dreams of greatness in his soul. He dreamed of rebuilding Lotharingia, the kingdom of Lothair, grandson of Charlemagne. He even expressed this desire in public, in a speech given in 1474 at Dijon, in which he evoked "the former Kingdom of Burgundy, which that of France has long usurped and made of it a duchy, which all its subjects must well regret." Facing him was Louis XI, the "universal Spider," as the chroniclers of Burgundy named him. The king at first opposed the duke directly, but

ANTOINE LE MOITURIER, TOMB OF PHILIPPE POT, C. 1480. MUSÉE DES BEAUX-ARTS, DIJON
This was an innovative work in its day; for the first time, the deceased is shown being carried. The mourners are life-size.

CLAUS SLUTER,
BUST OF CHRIST,
1395–1405. MUSÉE
DES BEAUX-ARTS,
DIJON
*Claus Sluter, an artist of
genius, conveyed in this
head of Christ the pain
of the Savior's execution
and the greatness of
his victory over death.
The face reveals traces
of torment with a tragic
realism, but it also
expresses the promise
of the Resurrection in
its radiance.*

this did not turn out well; at their meeting in Péronne Charles the Bold took him prisoner, in defiance of international law, and gave him his freedom only after extracting concessions. Thereafter Louis XI did not confront him head-on; on the contrary, he signed a pact of nonaggression to lull his opponent's distrust, while the king worked tirelessly behind the scenes to turn all the leaders of Europe against him. Charles unwisely attempted to conquer Lorraine, whose duke he besieged when the latter took refuge in Nancy. It is there that death found Charles in a skirmish, near Saint-Jean Pond, in 1477. His body was not found until two days after the battle, disfigured and naked, for looters had despoiled it; he was identified with difficulty by his broken teeth and the scars of old wounds.

Thus, the house of Burgundy collapsed suddenly, the ambition of Louis XI, prudent and discreet but no less strong, having won out over that of Charles the Bold. With the latter gone, Louis XI quickly invaded Burgundy to impose his right for the return of the appanage to the crown, for Charles the Bold only had a single inheritor, the young Mary. But

the population resisted, and the king was forced to repress the rebellion harshly. This violence incited the young duchess to ask for the protection of the house of Austria to which, by marrying Maximilian of Hapsburg, she brought Flanders as a dowry, since it was not included in the appanage. She was the great-grandmother of Charles V, the Holy Roman emperor, who, by simultaneously obtaining Flanders, Austria, and Spain, threatened the France of François I. Even the wise policies of Louis XI would not have been able to predict this danger!

THE SPLENDORS OF THE COURT OF DIJON

The dukes made an effort to emphasize the quasi-royal grandeur of the house of Burgundy by the splendors of their court. In the great hall, 75 feet (23 meters) long, on the second story of their palace in Dijon, feast followed feast. Burgundy had already become the paradise of gastronomy. Its wines were famous in Roman times. We may imagine the Gargantuan character of these feasts by visiting the famous kitchens in the palace, vaulted in pointed arches, equipped with two enormous chimneys on three sides. Meals at the duke's table were a long ceremony, a ritual where, helped by the wines, guests were carried away in a sort of waking dream. The service of multiple courses was broken up with *entremets* (side dishes) for which the court of Burgundy was well known. Songs, recitations of poetry, pantomimes, exhibitions of acrobats, and rare animals, as well as tableaux vivants of quasi-surrealist fantasy amused the guests. Thus, a horse walked around the hall backward, mounted by two trumpeters seated back-to-back. A white stag with gilded antlers carried a young singer. A strange animal, worthy of the Apocalypse—simultaneously griffin, boar, and man—carried a tumbler who walked on his hands. A dwarf fought with a giant. A pâté was opened to reveal an orchestra with twelve musicians.

The dukes of Burgundy promoted the arts. Among their most notable constructions were their palace in Dijon and the Carthusian monastery of Champmol, also known as the Charterhouse of Champmol—their Saint-Denis. In Flanders, they fostered workshops of tapestry and painting; Jan van Eyck, Rogier van der Weyden, and Hans Memling were Burgundian subjects. At Dijon they supported a

A Bold Sculptor: Claus Sluter

THE BURGUNDIAN SCHOOL of sculpture gave rise to a genius, Claus Sluter, born in Haarlem in the Netherlands. All that remains of his work are pieces made to ornament the Carthusian monastery of Champmol. From 1389 to 1394 he worked on the sculptures of the chapel portal, which shows Philip the Bold and his wife, Marguerite of Flanders, praying on opposite sides of the portal, turned toward the Virgin and Child that occupies the trumeau.

From 1395 to 1405 Sluter undertook a vast project, a Calvary intended to ornament the center of the great cloister. Surrounded by a pool fed by a spring, it was mounted on a hexagonal base bearing on each of its faces a life-size statue of the Old Testament prophets who foretold the death of Christ: Moses, David, Jeremiah, Zachariah, Daniel, and Isaiah. The symbolic theme of the work was the prophecy of the death of Christ and its effect, salvation, symbolized by water—the water of life and baptism, the redemptive water that washes away sins. Today in the monastery only the base remains, called Moses' Well, as well as the bust of Christ preserved in the archaeological museum. Moses has an impressive presence; Sluter did not gloss over the signs of physical decrepitude in the old man but, on the contrary, reproduced them with a tragic realism. At the summit of his career, the artist already was thinking about the approach of old age. And yet this face, slightly raised to the heavens, is of great beauty. This is the face of the one whom the Bible tells us had the courage to climb alone to God, to encounter him in the form of a burning bush, then return to the human world bearing the tablets of a good and simple law, understandable to all. Christ of the Calvary is indeed Christ dead, bearing the traces, reproduced in minute detail, of the suffering he bore. Yet in death he retains his grandeur; this is the divine Christ, already resurrected. Through these two sculptures in particular,

Claus Sluter reveals the temperament of a northern artist, displaying a profound realism that proceeded from the dynamic and sensual perception of life, which, as a sculptor, he faced courageously, and a religious sentiment that mingled with this robust life philosophy.

At the same time, Sluter worked on the tomb of Philip the Bold and his wife, today located in the great hall of the Palais de Dijon. Having taken over from a sculptor named Jean de Marville, who died, he himself could not finish the work, which was completed by his nephew, Claus de Werve. The polychrome recumbent figures lie on a base of black granite surrounded by small figures in white marble, the "mourners." The face of the duke, with a strongly hooked nose, is rendered with an almost savage power. The tombs of John the Fearless and of Marguerite of Bavaria by Claus de Werve, Jean de la Huerta, and Antoine Le Moiturier, all three of whom carried on Sluter's work, are exhibited in the same hall.

Opposite
CLAUS SLUTER, *MOSES' WELL*, C. 1395–1405. CARTHUSIAN MONASTERY OF CHAMPMOL, DIJON
Sluter's genius has given us a Moses who unblinkingly presents himself with all the signs of the hardships he endured and the physical results of age, thus intensifying the grandiose, mystic effect of the work: ugliness itself is transfigured by the power of an interior spiritual light.

CLAUS SLUTER, *MOSES' WELL*, DETAIL, C. 1395–1405. CARTHUSIAN MONASTERY OF CHAMPMOL, DIJON
The great patron Philip the Bold, duke of Burgundy, summoned the Dutch sculptor Claus Sluter to provide sculpture for the Carthusian monastery of Champmol. Sluter's masterpiece is Moses' Well, *the central element in the cloister.*

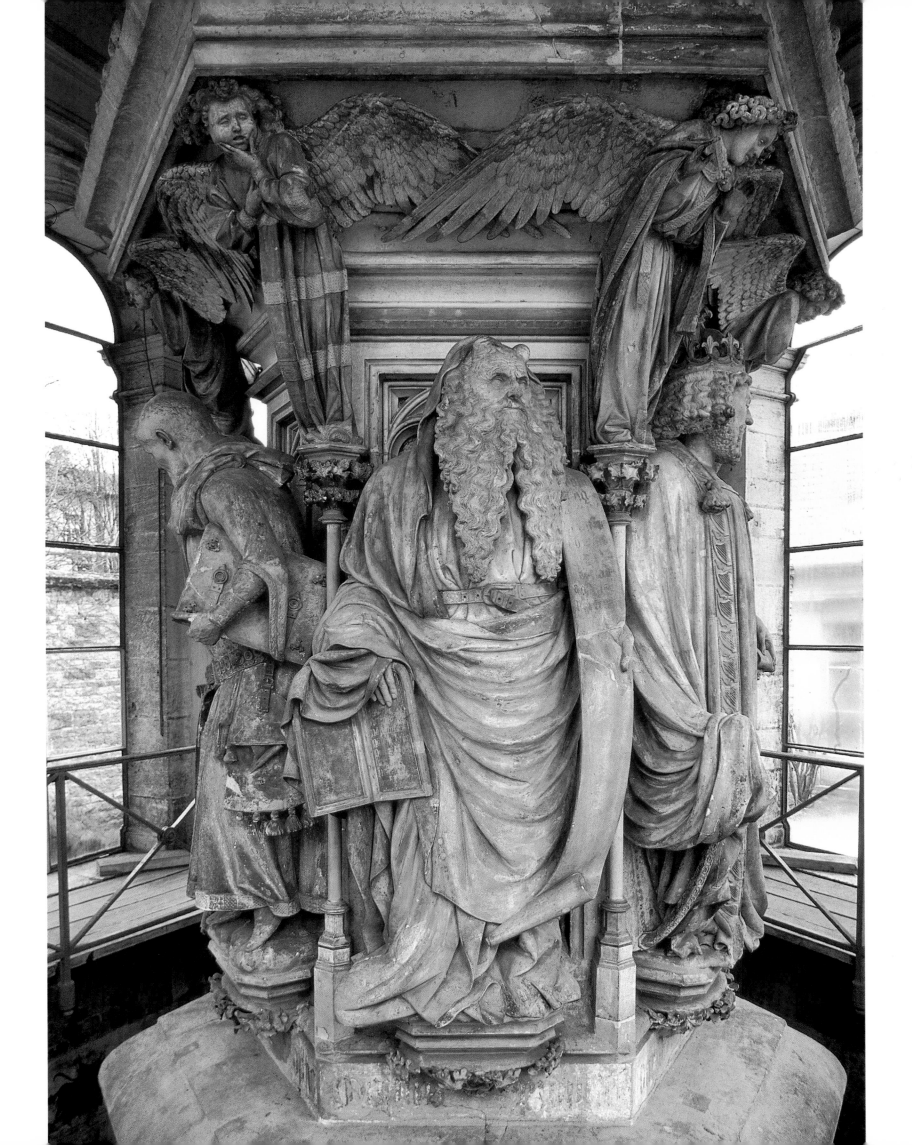

BEAUNE, HÔTEL-DIEU,
ROOFS, 1443
*The buildings are
crowned by immense
roofs of an unusual type.
With their glazed tiles
in bright colors, turrets,
skylights, and weather
vanes, the overall
impression is varied
and highly aesthetic.*

sculpture studio that nurtured a real Burgundian school, which, refusing to continue the imitation of thirteenth-century masterpieces, created a new style.

THE CHARITY OF THE GREAT CHANCELLOR AT BEAUNE

Nicolas Rolin, born at Autun about 1380 in a bourgeois family, had studied law. A lawyer in Paris, he defended the duke of Burgundy, then became an assistant of Jean de Thoisy, chancellor of John the Fearless. He won appreciation for his efficiency in taking care of first legal, then administrative, political, and economic affairs, performing so well that on the death of Jean de Thoisy he succeeded him. In 1422 Philip the Good named him chancellor, a position he filled for forty years, until 1462. To be chancellor was to be at once the duke's lawyer, his minister of justice, and head of his chancellery researches, services that engaged all of his correspondence. But with his genius, Rolin acted not only as chancellor but also as the duke's prime minister; he replaced the duke completely when the latter was in Flanders. Rolin had a feeling for good economic management; along with the duke's prosperity, he guaranteed his own.

A work of charity, an expression of love for others, a testimony to faith, a demonstration of power: the foundation of the Hôtel-Dieu of Beaune by Nicolas Rolin in 1443 was all these at the same time. The chancellor wanted everything to be of the very highest quality. We must admire the great court, the size of the buildings, their immense roofs with multicolored glazed tiles, adorned with turrets and dormers, weather

vanes and ornaments of lead, the wood-framed galleries supported by thin columns. The Hôtel-Dieu was a vast lordly mansion, "more the abode of princes than a hospital for the poor," according to a contemporary. The architect, like those of the cathedrals, attempted to avoid monotony, to break up symmetries and repetitions; for example, the pillars that support the gallery of the second story are deliberately not aligned with the elements of the structure on the other levels.

In the Middle Ages, and until the end of the ancien régime, all works of public assistance and education were administered by religious institutions. Schools, orphanages, hospitals, care for all the unlucky . . . there was so much to do that many specialized orders were created to provide for them. The Hôtel-Dieu was a hospital but also a kind of monastery, a place where people prayed, for the great courtyard was a cloister and the halls for the sick, like the great hall called the "chambre des povres" (room of the poor), were churches. Measuring 236 feet (72 meters) long and 46 feet (14 meters) wide—more than 10,000 square feet (1,000 square meters)—and 66 feet (20 meters) high under the vaulting, the hall contained twenty-eight two-patient beds arranged along the long sides. At the far end was the altar, so that the patients could follow the offices from their beds. Above the altar was found the altarpiece of the *Last Judgment* by Rogier van der Weyden, a masterpiece of Flemish art, which was opened on the days of high feasts and funerals. On the outside face of two of its wings are painted the portraits of the donators, Nicolas Rolin and Guigone de Salins.

The Hôtel-Dieu is also the expression of the gallantry of its founder. The former tiled floor, where the word "Alone" is written in gold letters on a red background, everywhere testified to the love that the chancellor had for his wife.

The town of Beaune contains another noteworthy masterpiece: the series of tapestries on the life of the Virgin, which is displayed on the perimeter of the choir of the collegiate church of Notre-Dame. It had been ordered by Cardinal Rolin, the son of the great chancellor, from the Burgundian painter Pierre Spicre, who drew the cartoons at the end of the fifteenth century. In seventeen scenes, which form a sort of high-quality comic book, the artist recalls the principal episodes of this holy life. Most of the scenes speak for themselves: the Marriage of the Virgin, the Nativity, the Adoration of the Magi, the Massacre of the Innocents, the Flight into Egypt, the death of the Virgin. Others must be explained, since they come from the legends that grew up around Mary, like the scene of the suitors. According to the latter, when Mary was fourteen years old a voice came from the Temple of Jerusalem saying that all of the unmarried men of marriageable age of the house of David should go to the altar with a stick in hand, and the one whose stick grew leaves would have the right to her hand. Joseph, believing himself to be too old to marry such a young girl, did not think he should participate. The voice bade that he be summoned and, when his stick immediately produced leaves, the Virgin was betrothed to him. Spicre fortunately did not attempt a historical reconstruction of the time in which Mary lived. All of the characters are dressed as contemporaries of the painter and shown among the architecture of the period, although, clearly, the richness of the clothing and the buildings would not have been within the reach of a carpenter from Nazareth. Some scenes reveal an easygoing realism, like that in which the Virgin and Joseph bring the naked baby Jesus to a roaring fireplace, or the Visitation, where the Virgin is shown in an advanced state of pregnancy. This last image demonstrates a great deal of charm, its colors still very bright despite the passage of time.

PIERRE SPICRE, TAPESTRY OF THE LIFE OF THE VIRGIN, LATE 15TH CENTURY. COLLEGIATE CHURCH OF NOTRE-DAME, BEAUNE
The painter Pierre Spicre designed the cartoons for a series of tapestries illustrating the life of the Virgin, a work full of charming and picturesque details, as in this scene of the Visitation, in which Mary is shown pregnant.

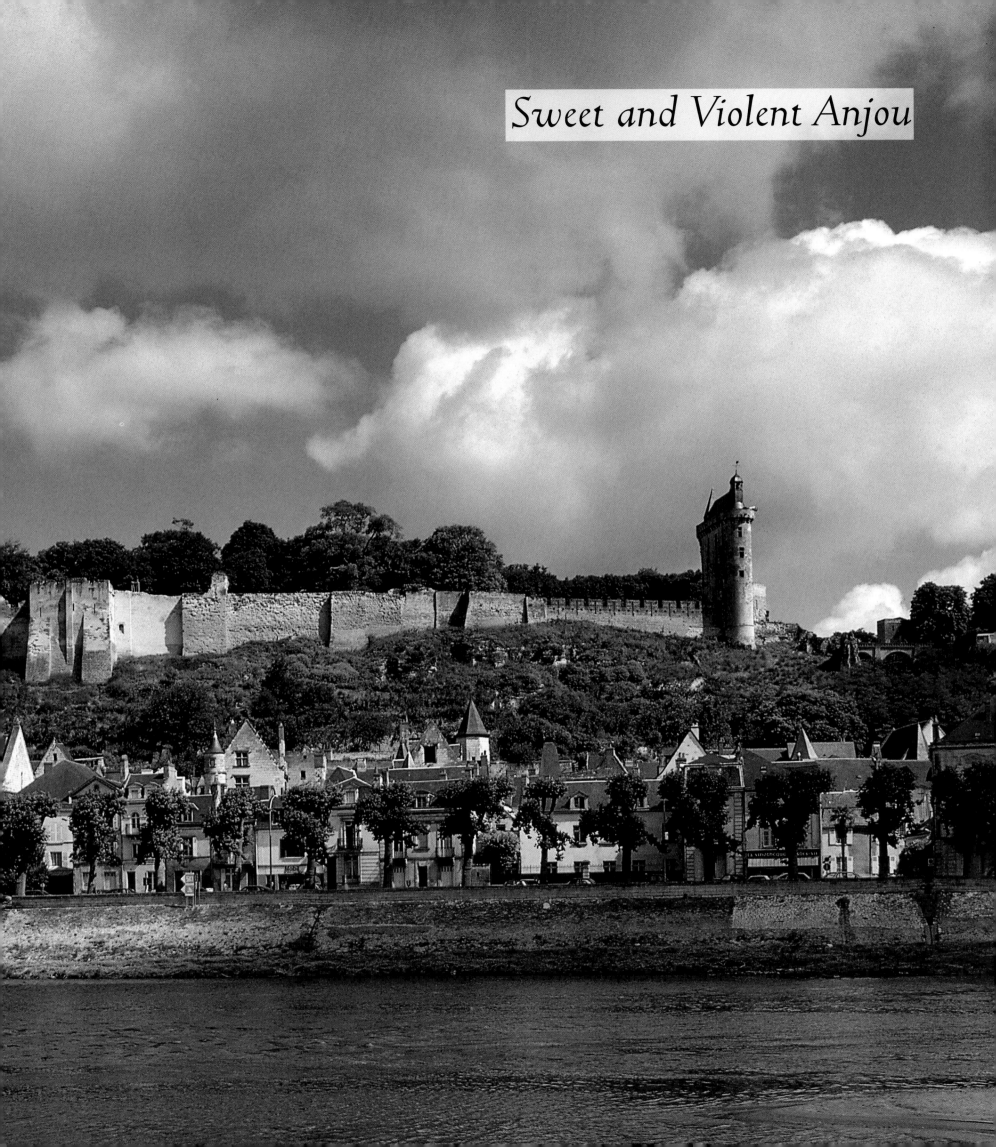

Sweet and Violent Anjou

IN THE LOIRE VALLEY, especially around Anjou, the luminosity of the sky, the gentleness and evenness of the climate, the width and the beauty of the river contained between its levees, the varied design of its sands, and, on the banks and the islands in the distance, the trembling of its great poplars, the *leards*, or the sparkling of its silver willows, the *luisettes*—all inspire a profound joy and peacefulness.

For all this, in the Middle Ages the Loire and its tributaries, which were navigable, were strategic lines and commercial thoroughfares of the first importance: a jealously sought prize, a place of bloody confrontation.

The founder of the first house of Anjou was a certain Ingelger or Enjeuger who distinguished himself in the struggle against the Normans in the ninth century. His descendants fought constantly. The famous Fulk "Nerra" (the Black), count of Anjou from 987 to 1040, prepared one of the most important victories of his house, that of his son Geoffroy "Martel" (Hammer) in 1044 over Thibault III, count of Blois, who was forced to cede Touraine to him, including, in particular, the strongholds of Chinon, Tours, and Langeais.

A shrewd policy of marriage may complete the work of weapons. In 1129 Geoffroy le Bel, duke of Anjou, married Mathilde, daughter of Henry I Beauclerc, the king of England. He was fourteen years old, she was twenty-nine. Their son Henry II Plantagenet succeeded his father at his death in 1151 and, the following year, married Eleanor of Aquitaine, whom King Louis VII had just repudiated. She brought all of southwestern France as a dowry to her new husband, twelve years younger than she. Henry asserted his rights to the crown of England, which he inherited from his maternal grandfather, and was crowned at Westminster on December 19, 1154. He was the head of a real empire.

His son John the Landless lost most of his French possessions to Philip Augustus, among them Anjou in 1204. In 1246 Saint Louis gave it as an appanage to his brother Charles, who thus became the first count of the second house of Anjou. The highly ambitious Charles I, or Charles of Anjou, acquired Provence through marriage and, as a reward for championing the papal cause against Manfred of Naples and Sicily, was crowned king of Naples and Sicily by the pope. At the death of his grandson Robert I, his daughter, "Queen Jeanne," kept Naples

and Provence, while the appanage of Anjou returned to the crown of France.

In 1360 King John the Good of France gave Anjou as an appanage to his second son, Louis, and raised it to the status of a duchy. Louis I was thus the first to found the third house of Anjou. In 1382, on the death of "Queen Jeanne," who had adopted him, he inherited Provence and Naples. His grandson René, "good King René" (1409–1480), was the last duke of Anjou. The scattered nature of his territories undid King René; he failed to assert his rights to the duchy of Bar, a possession of his first wife's family, as well as his distant kingdom in Italy, which he finally lost for good in 1442. At his death in 1480, Anjou, as well as Maine, to which it was attached from the time of the first house of Anjou, returned to the crown of France. Shortly thereafter, the crown also regained Provence.

CHINON, THE STRENGTH OF THE KINGDOM

When Charles VII, from whom the English had wrested the northern half of France and Paris, took shelter at Chinon in 1427, his choice was well reasoned: Chinon enjoyed one of the best strategic positions in the region. On a clear day, someone standing on its rocky heights can see to the east as far as Sainte-Maure in Touraine, 18 miles (30 kilometers) away, and to the west as far as Saumur, 16.2 miles (27 kilometers) away. Above all, it controls the best crossing over the Vienne River.

This is why its position has been fortified since time immemorial. After the Gauls, the Romans and then the counts of Blois made use of it. Beginning in 1044 the château belonged to the counts of Anjou, who enlarged it considerably. A rectangle, it was naturally protected by the sheer cliffs that served as foundations on three of its sides, but its weak point was the east, easy to attack by climbing down from the plateau. In order to remedy this situation, the counts had the so-called Saint-Georges Fort built as an outpost to the east, separated from the main building by a deeply dug moat. With its 1,300 feet (400 meters) of total length and its 230 feet (70 meters) of average width, the château of the Plantagenets strongly asserted their power and pride.

The most refined portion of the building was then the keep at the western end, the so-called Windmill Tower, probably constructed by Henry II Plantagenet

CHÂTEAU DE CHINON, EXAMPLE OF THE VAULTING, 13TH CENTURY
Rib vaults did not grace religious buildings alone. They were also used in civil, even utilitarian, architecture, as this octopartite vault (with eight curved vault surfaces) from a room in the château shows.

Preceding pages
CHÂTEAU DE CHINON, 10TH–15TH CENTURIES
This château has had an eventful history. The military position has been fortified since time immemorial because of its exceptional strategic importance. It served the Plantagenets, rivals of the kings of France, as their most important fortress, an essential symbol of their power. In the great hall of the central building the first meeting between Joan of Arc and the future Charles VII took place.

out there. It is he who had the main fortress split in two: the Coudray Fort to the west, the Middle Château to the east. A deep moat separated them and a new keep, which was called the Coudray Tower, watched over them. Cylindrical in form, it enclosed four floors, of which only the first three remain; here too, each floor was occupied by a great hall, two of them vaulted with rib vaults.

The successors to Philip Augustus brought many improvements to the château. In the second half of the fourteenth century the entry to the Middle Château was rebuilt and set off by what was known as the Clock Tower. With its 72 feet (22 meters) of height, it asserted its majesty, while its slender form—16 feet (5 meters) wide—made it a masterpiece of elegance. In the center of the Middle Château the "royal dwellings" were constructed, two long, parallel buildings linked by a third, at right angles. The present-day remains (of the building that faces the Vienne) gives an idea of the size of the whole. Its beautiful and spacious rooms opened out through large mullioned windows, even to the exterior of the fortress, for above a certain height, projectiles did not present any danger. Moreover, the presence of the royal court behind the ramparts of Chinon, called the Fortress-City, attracted many important people, who built handsome mansions there.

Famous ghosts haunted Chinon: first of all, that of Henry II Plantagenet, who came to a tragic end there in 1189. If we believe the anonymous author of the *Life of Guillaume le Maréchal*, he died as much from the shock caused by learning of the treason of his favorite son, John the Landless, as from his illness. Abandoned by all except for those who stayed to despoil him, left almost naked to face eternity—thus ended the life of a man who had been the most powerful in Europe. In the Coudray Tower in 1308 Jacques de Molay and other high dignitaries of the Knights Templar were imprisoned and interrogated; they left behind strange inscriptions.

It was in the "Great Hall" of the royal abode that on February 25, 1429, Joan of Arc— daughter of well-to-do peasants from Lorraine, then called Jeannette— had her first interview with the future Charles VII. On that day, surrounded with three hundred gentlemen, Charles was wearing simple attire; nonetheless, she went straight to him. She inspired the dauphin's confidence, and he gave her command of an army. There followed a string of victories—at Orléans, which

in the second half of the twelfth century. It demonstrates the passion for pure geometry that inspired Gothic architects. Square at the base, by means of triangular escarpments it becomes octagonal, then circular. The construction is no less subtle inside; on each of the three floors is a great hall; the lowest, covered by a false ribbed dome, and the one on the intermediate level are hexagonal, while the uppermost is circular.

Beginning in 1204 Chinon became a royal fortress. Philip Augustus had large-scale work carried

she liberated, Jargeau, Meung, Beaugency, Patay, among others—until her capture at Compiègne on March 23, 1430, the prelude to her trial and execution on May 30, 1431, at Rouen.

THE ANGEVIN STYLE

Henry II Plantagenet furnished Angers, the capital of his ancestors, with many buildings constructed in a variant of the Gothic style called the Angevin style or the Plantagenet style. Its masterpieces in Angers are the cathedral, the great hall of the Hospital of Saint-Jean, and the church of Saint-Serge. The Angevin style was a synthesis of the architectural forms of the new style and those favored by the Romanesque tradition of the southwest, where churches composed of a series of domes were much appreciated.

The single nave of the cathedral of Saint-Maurice, at 54¾ feet (16.38 meters), is the widest of all the Gothic naves in France. Built between 1149 and 1153, it includes three rib vaults. While the Gothic style of Île-de-France placed the keystone of the ribbed vaults (diagonal arches) at the same level as that of the pointed arches, here it is set higher. The ribs are no longer semicircles but pointed arches, and the vault is highly domed.

With the transept and the choir of the cathedral, the Angevin style reached a new stage in its evolution. The arches, or ribbing, no longer support the cells (the walls between the arches of the vault following a curved plane), for the latter support themselves through the domed form of the vault. Engaged in the masonry of the cells, the ribs simply serve as stiffening, their essential role being aesthetic. They thus could be very thin—revealing only a cylindrical torus (molding)—and more numerous.

To protect himself from the Bretons, Saint Louis had the city surrounded by a new wall, which ran on both sides of the Maine River for 2.4 miles, or 4 kilometers, at the location of the circular boulevards today. At the same time, he had the enceinte, or protective outer wall, of the château rebuilt, which ended up 2,165 feet (660 meters) long and furnished with seventeen towers. Formidable-looking even in its present state, it becomes more impressive when we remember that these towers, which have been cut down, were originally one or two stories higher. The alternating layers of white stone and dark blue slate-

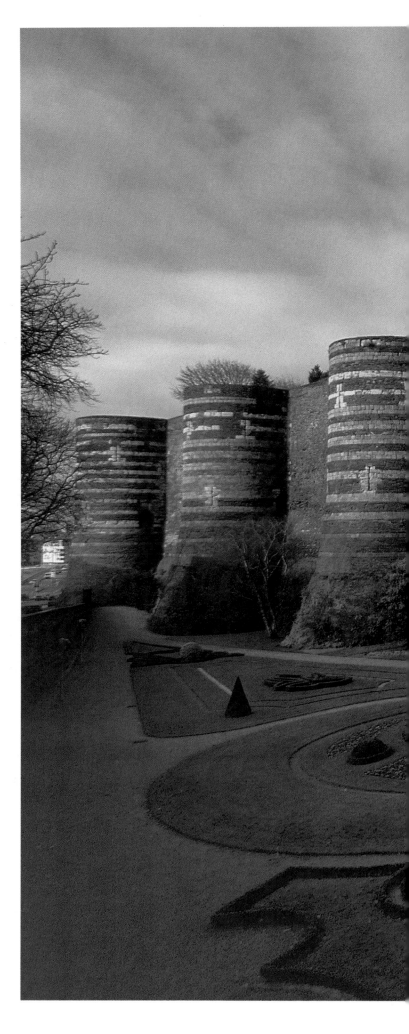

CHÂTEAU D'ANGERS, ENCEINTE, 1228–38
This château controlled the Maine region and protected France from Breton incursions. The fortified wall around this powerful fortress had a length of 2,165 feet (660 meters) and linked seventeen towers like this one, which at the time was two stories higher and crowned with roofs.

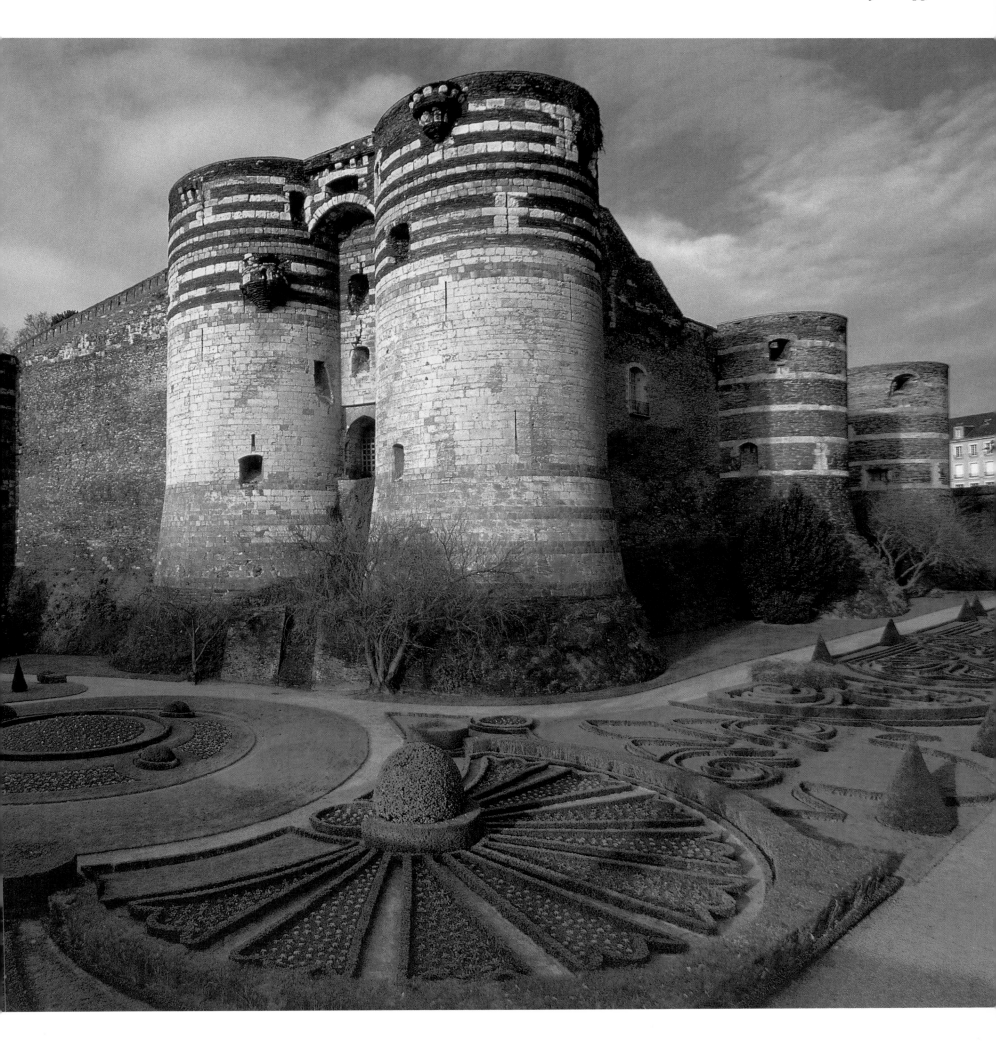

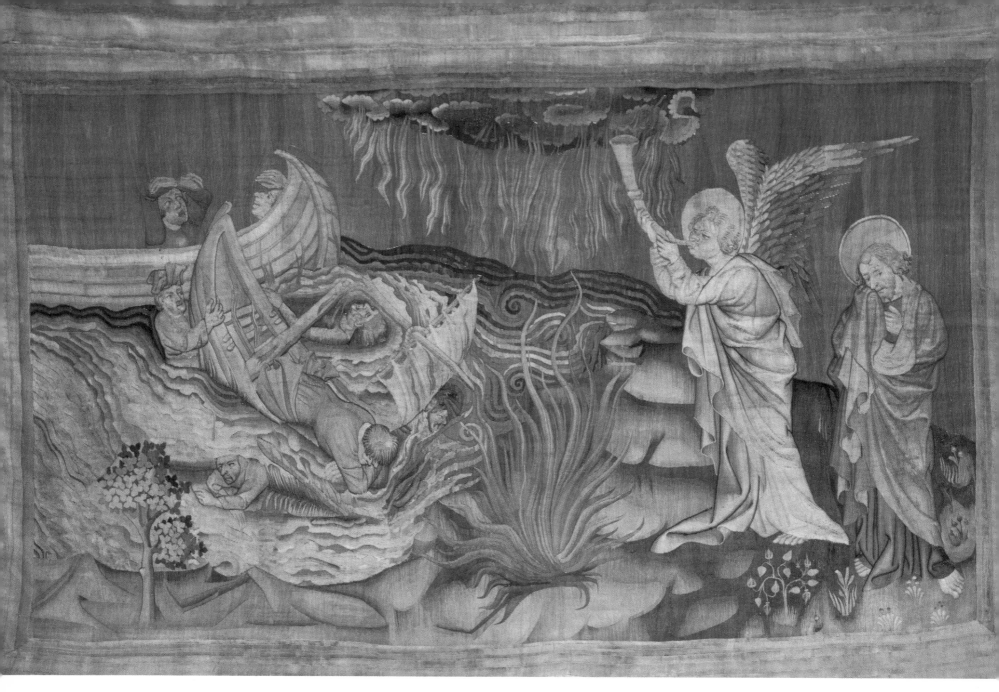

like schist that compose the walls create a pleasing effect. This forbidding fortress contained many spacious buildings, some of which, from the fifteenth century, remain. The great hall, today destroyed, looked out over the Maine and the Doultre, the neighborhood across the river.

FROM THE "APOCALYPSE" TO THE "SONG OF THE WORLD"

The series of tapestries on the Apocalypse displayed in the château of Angers had been ordered by Louis I of Anjou from Nicolas Bataille, a businessman who had them woven by the Parisian weaver Nicolas Poisson and his aides. Jean de Bondol, called Hennequin de Bruges, painter to King Charles V, apparently painted the cartoons on a small scale only. The weavers completed the work at full scale, which helps to explain

the work's lively character, for a great deal of initiative was given to the artisans.

Eighteen feet (5.5 meters) high, the tapestry presumably reached a length of over 551 feet (168 meters) and included 98 (or 84) scenes divided up into seven (or six) large pieces. Today, 73 scenes remain in a length of 354 feet (108 meters). Each piece begins with the representation of a large-scale character, a lay reader seated in a cathedral. The scenes, on alternating red and blue backgrounds, unfold on two levels and should be read from left to right beginning with the upper level. At the very top, a frieze symbolizes the heavens, with its angelic musicians emerging from the clouds; at the very bottom a meadow sprinkled with plants and leaves represents the ground.

No dwelling, no matter how vast, could have sheltered such a hanging; it was designed to be hung outside, along the battlements and the enceinte of the

THE ART OF TAPESTRY

———•———

Although some tapestries decorated churches, most of them went to private residences, where they added ornamentation while dividing great halls into more intimate spaces.

When the elite moved from one residence to another, the tapestries preceded them; quickly hung, they soon animated the most severe walls. Gothic tapestries carry a variety of themes. Some recalled the heroes of distant times (such as the victories of Julius Caesar), of recent history (the life of Bertrand du Guesclin), or of chivalric romances; others depicted the lives of the common people (harvests, reaping) or of lords (the hunt, chivalry, music, balls). Even those that ornamented a private residence could have a religious subject or develop a moral theme: the seven liberal arts, the passage of time, or the five senses, the theme of the series called The Lady and the Unicorn *in the Musée de Cluny.*

In the Middle Ages it took a month to weave ten square feet, or one square meter. This costly technique has changed little through time. The threads of the warp are stretched on a loom. The weaver, facing the warp, weaves the threads of the weft in and out of the warp threads with his shuttle. In a woven work the warp is visible, while in a tapestry it is entirely covered, since the weaver makes two passes in opposite directions, stopping at the edges of each area of color.

The tapestry is called "high loom" when the loom is perpendicular to the ground (vertical), "low loom" when it is parallel (horizontal). In the first case the cartoon is placed behind the weaver, in the second it is under the work. In both cases the work is done from the back of the piece. In the Angers tapestry only fifteen or so colors were used. In the seventeenth century, the color tones increased to as many as thirty thousand. In an excessive desire to imitate painting, the art of tapestry degenerated. In reaction, the number of colors was once again reduced in the twentieth century, and tapestry won respect as an art in its own right, with masterpieces produced by Henri Matisse, Le Corbusier, Brassaï, Picart le Doux, and Lurçat, among others.

CHÂTEAU D'ANGERS, SCENE FROM A SERIES OF TAPESTRIES OF THE APOCALYPSE, COMPLETED 1373–80 *Like the Apocalypse of Saint John, which inspired the scene, this tapestry is a work of extreme tension, showing the bitterness of the struggle between good and evil. An angel sounds a trumpet under the eyes of the weeping Saint John, and a burning mass falls into the sea, itself transformed into blood.*

château. It came out for important occasions: when tourneys or large receptions took place, or for the most important religious feasts, like Ascension Day, Pentecost, or the Feast of Saint Maurice, patron saint of Angers.

The tapestry attempts to be a faithful illustration of the Apocalypse of Saint John. Written during a period of persecution at the end of the first century A.D., under Emperor Nero or Domitian, this last canonical book of the Bible was intended to give courage and hope to the persecuted Christians. It symbolically describes the evils that the devil's interference unleashes on the world: war, famine, poverty, death, lust for power, destruction of cities, corruption of nature (natural catastrophes, pestilence), idolatry. At the same time it foretells that these evils will come to an end, for the devil will be vanquished by Christ and the forces of good.

The Apocalypse of Saint John had a particularly powerful influence in difficult times, such as the end of the fourteenth century, reflected in the harshness, violence, and tragedy of the tapestry. It is one of the masterpieces of fantastic art, but its fantasy is not gratuitous, for every element carries symbolic significance. The tapestry of Angers is exceptional, not merely in its size but especially in the profundity of its themes, which are still highly relevant. The discovery of this work in 1937 was so important to the painter Jean Lurçat that he decided to devote himself to the art of tapestry. His series entitled *Song of the World*, displayed at Angers in the great hall of the Hospital of Saint-Jean, expresses—in lay terms—the same impulse: horror at evil, at its manifestations, at its contagion, and hope in a better life.

The Angers tapestry is also the first masterpiece of this medium in France. Tapestry is a very ancient art; it was already known in Egypt in 3000 or 2000 B.C. It was widely practiced in Greco-Roman antiquity, and pre-Columbian America discovered it as well. Nonetheless, the Romanesque and Gothic Middle Ages of the eleventh to thirteenth centuries did not much cultivate it. In the fourteenth century it suddenly experienced a resurgence and remained popular in the following century.

"Good King René," Poet and Patron

The dukes of Anjou carried on the tradition of splendor and love for the arts, culminating with King René. Unlucky in war, he was more fortunate in the search for happiness and the quest for the rewards of culture. King René was an epicure; he loved beautiful books, feasts, tournaments, jewelry, and tapestry, as well as simple things, the plants of his garden, good wine, the light of Anjou and Provence.

A great patron, the king ordered the altarpiece of the *Burning Bush* from Nicolas Froment, which is today found in the cathedral of Aix-en-Provence. It represents the Virgin and Child in a burning bush, symbolizing Mary's virginity, appearing to Moses, dressed as a shepherd. The wings portray the king and his second wife, Jeanne de Laval, whom he married in 1451 when he was forty-five years old and she was twenty-one.

A writer and poet, the king was the author of *Traité de la forme et devis d'un tournoi* (Treatise on the Form and Design of a Tourney). As in the martial arts today, the art of tournaments, with its philosophy and aesthetics of combat, expressed man's desire to go beyond violence while accepting it. The *Livre du cuer d'amours espris* (Book of the Heart Seized by Love), which the king had illustrated with splendid illuminations, is simultaneously an allegorical love story—following the example of the *Roman de la Rose*—and a book of chivalry. During the narrator's sleep, Love comes to carry off his heart, which he gives to Desire, dressed in white. This heart then goes on to live an independent and liberated existence, traveling through countries of dream and adventure, always active and moved by love.

Le Plessis-Bourré, Château of Pleasure

The area of the Val de Loire, where Charles VII found refuge from the English invasion and began his reconquest of France, remained his favorite dwelling place. It also brought back memories of his love for Agnès Sorel, tragically interrupted by the death of the "Lady of Beauty" in 1450. The kings of France lavished a similar love on the region until almost the end of the sixteenth century, the great century of the "châteaux of the Loire." Many of these would be built as pure pleasure residences, unlike the fortress-

CHÂTEAU DU PLESSIS-BOURRÉ, 1468–73
Jean Bourré, minister to Louis XI, had this château built in the Anjou countryside for his own pleasure. It brought together all the elements of medieval military architecture, but for decorative rather than defensive purposes.

château of the Middle Ages, whose severity could only be mitigated.

A precursor was the château of Plessis-Bourré, built between 1468 and 1473 by Jean Bourré, minister of Louis XI and later of Charles VIII. This building still looks something like a fortress, with its four main towers, among them a keep 144 feet (44 meters) high, a fortified postern with two drawbridges, enceintes, moats, and a vast interior courtyard. These elements afforded protection against the bands of brigands who, from time to time, threatened the countryside. In addition, such architectural forms of feudal residences remained pleasing to the taste of the time. The château, with the mystery of its ceilings painted with alchemical symbols, the white brilliance of its stone, which still looks new, its great unified volumes, almost free of sculptured decoration, its beautiful reflections in the moats, still transports us into a dreamworld today.

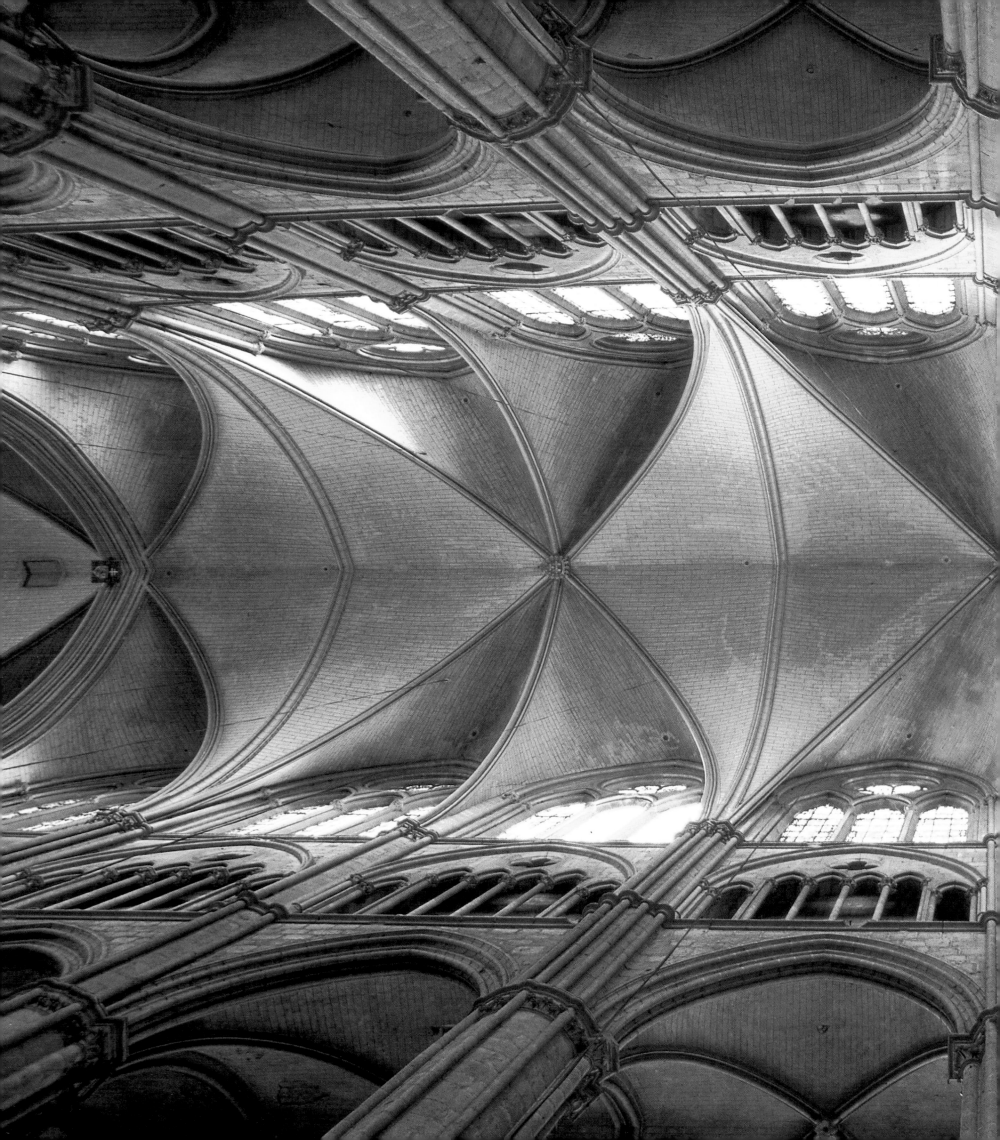

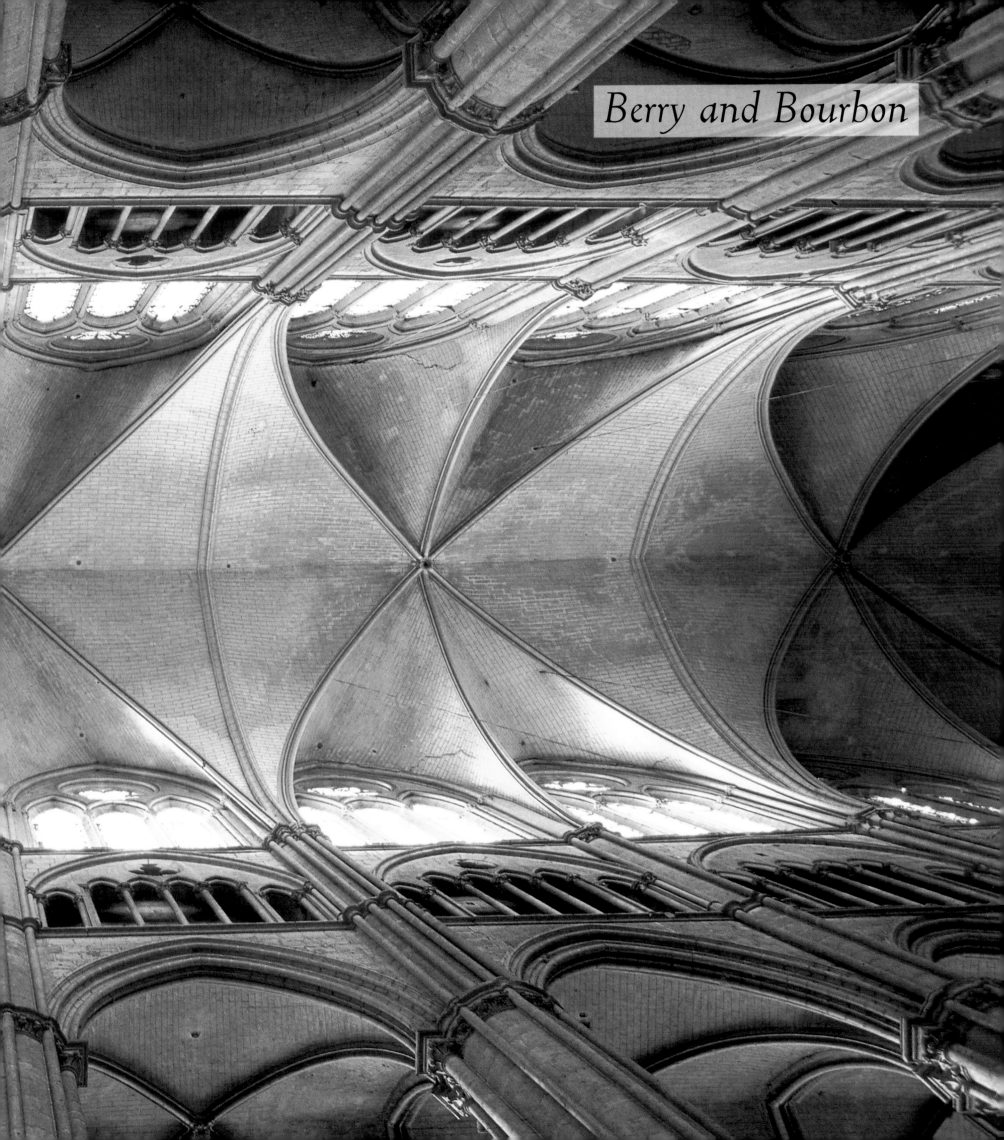

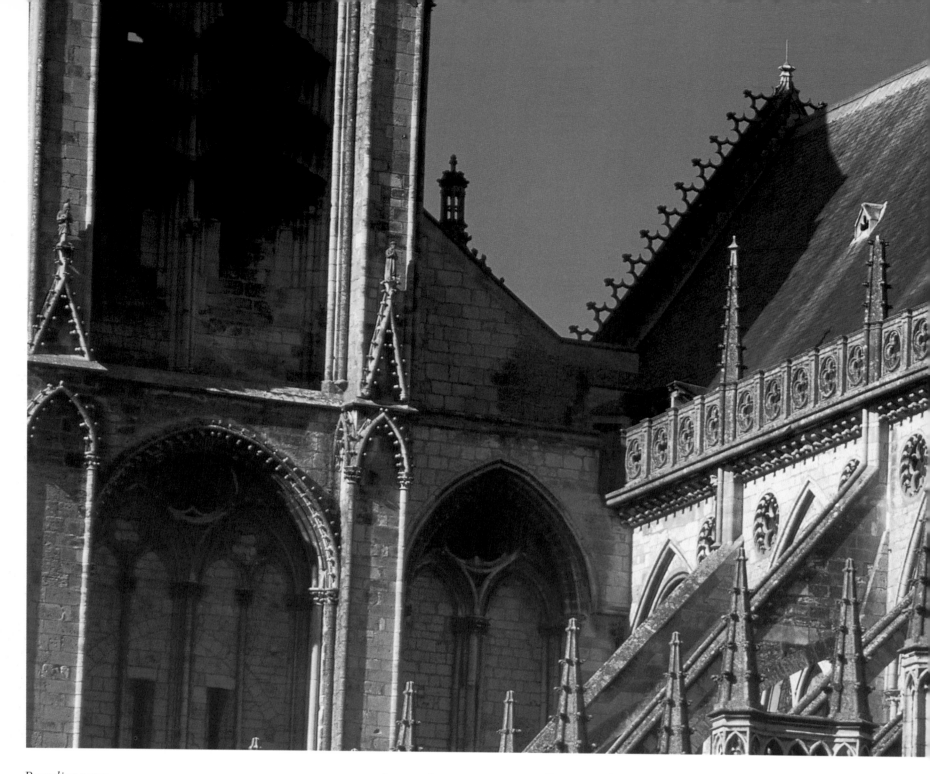

THE VISCOUNTY OF Bourges, the main part of
Berry, very early formed part of the "royal
domain," as King Philip I had purchased it
from Viscount Eudes Harpin in 1101. Bourges has
long been one of the most beautiful cities in France.
It was originally named Avaric, which the Romans
turned into Avaricum; its present name is derived from
that of the Bituriges, a Gaulish people who inhabited
Berry. The kings took a keen interest in their new
domain, and Philip Augustus conquered the vis-
county of Déols, the second half of Berry.

An outpost of the royal domain to the south and
the seat of an important bishopric, Bourges built itself
a magnificent cathedral constructed in the new
Gothic style invented in the Île-de-France.

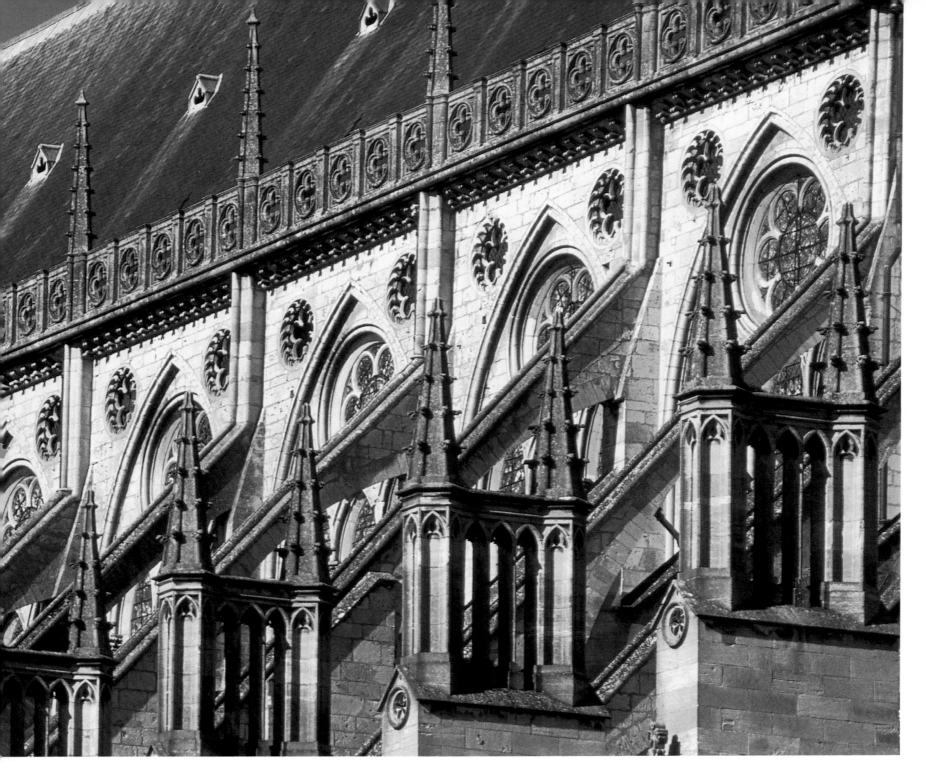

The Cathedral, in an Unbroken Sweep

The choir and nave of the cathedral of Saint-Étienne in Bourges were built between 1200 and 1260 by an unknown architect. Each Gothic architect knew the work of others, completed or in construction, and tried to distinguish himself by an original and distinctive design. And this is indeed true of the cathedral of Bourges, which has neither transepts nor chapels, except in the apse of the choir. It is provided with a nave flanked by double aisles. The nave, 121 feet (37 meters) high under the vaulting, is supported by a first aisle 69 feet (21 meters) high, then by a second 30 feet (9 meters) high. The architect opted for immense size to signify unity without interruption, and this is how

the cathedral appears from a position deep in the southern side. The architect of Bourges reveals himself as a lover of the straight line, of direct and straightforward expression. A lover, too, of the pyramid, the distant dream of all Gothic architecture, for this is the shape formed by the nave and aisles with their stepped heights. A lover of synthesis, he did not lose himself in the detail but concentrated on discovering the most beautiful proportions between the three heights of the central space. A lover of the straight line for the structure, but also for decoration; inside, almost nothing interferes to distract our eyes as they follow the ascending lines.

The sexpartite vault used at Bourges theoretically requires alternation between strong and weak

BOURGES, CATHEDRAL, ABUTMENTS OF THE FLYING BUTTRESSES, 1200–1260
For the Gothic architect, beauty and functionality coincided. The openwork pinnacles above the abutments simultaneously decorate the cathedral and add to the thrust, reinforcing the effect of counterbalance.

piers. The architect of Notre-Dame-de-Paris resolved the problem by bringing this alternation back to the level of the central pillars of the aisles. The solution found by the architect of Bourges is even better: given the transfer of thrust from the larger bay to the lateral aisles, this alternation is no longer necessary.

The five divisions of the main space into nave and four aisles logically lead to five portals in the principal facade. The tympanum of the central portal, sculpted between 1270 and 1280, is justly famous: it is the most beautiful Last Judgment in all of Gothic sculpture. The scene is divided into three levels. Above, Christ opens his arms in a sign of welcome, surrounded by angels. Below is the resurrection of the dead, who arise from the tomb as naked as when they laid down, naked also as souls reduced to their profound truth, stripped of pretense and props. The sculptors seized the chance to compose the bodies with skill and sensuality, varying their postures and their anatomy. In the center, souls are weighed by the archangel Saint Michael in a scale of forged iron; to Christ's right are the good, among them a queen, a king, and a Franciscan, turning to the heavens where Abraham stands; to Christ's left, the damned are carried away to Hell by demons. There are more figures in Hell than in Heaven, yet the balance is tipped toward good. The sculptor thus presents a message of optimism: even if evil seems to win in terms of numbers, good wins in terms of quality. The scene in Hell in which, notably, the cauldron of the damned cooks in the mouth of the devil today seems dreamlike and picturesque, but it certainly was terrifying to the medieval mind, the more so since bright colors emphasized the sculptures.

In contrast, the historiated stained-glass windows, in the purest style of Chartres, display a certain informality, like the one that retells the legend of Saint Thomas, one of the most popular of the day. The Apostle—the one who could not believe in the resurrection of Christ until he had touched his pierced side—gave himself the task of converting the inhabitants of Malabar, in present-day India. When King Abbanes gave him a large sum to build a palace he instead used the money to help the poor and build churches. He was then condemned to be burned alive, but the king's brother, who had just died, came back to life and persuaded the sovereign to repeal his sentence.

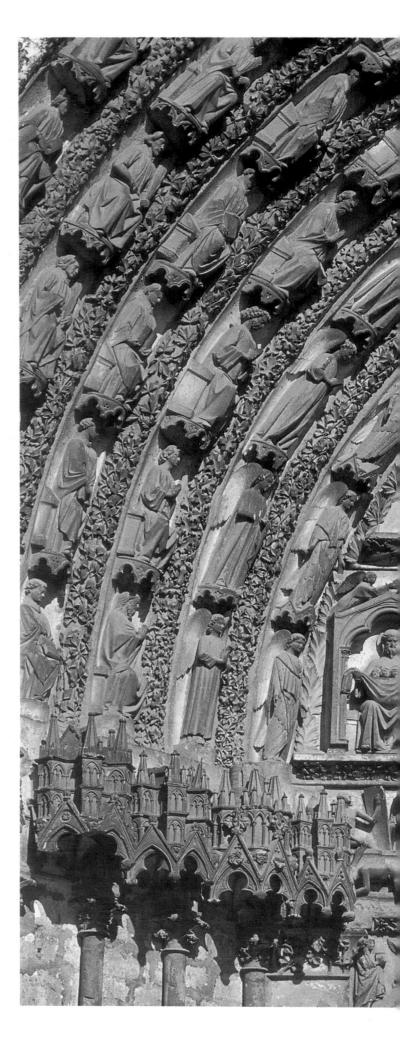

BOURGES, CATHEDRAL, WEST FACADE, TYMPANUM OF THE CENTRAL PORTAL DEPICTING THE LAST JUDGMENT, 1270–80
The dead are revived and the scale of good and evil, held by Saint Michael, weighs their merits and decides if they will be saved or damned. The message is nonetheless optimistic, for even though the damned are more numerous, the balance tips toward the good.

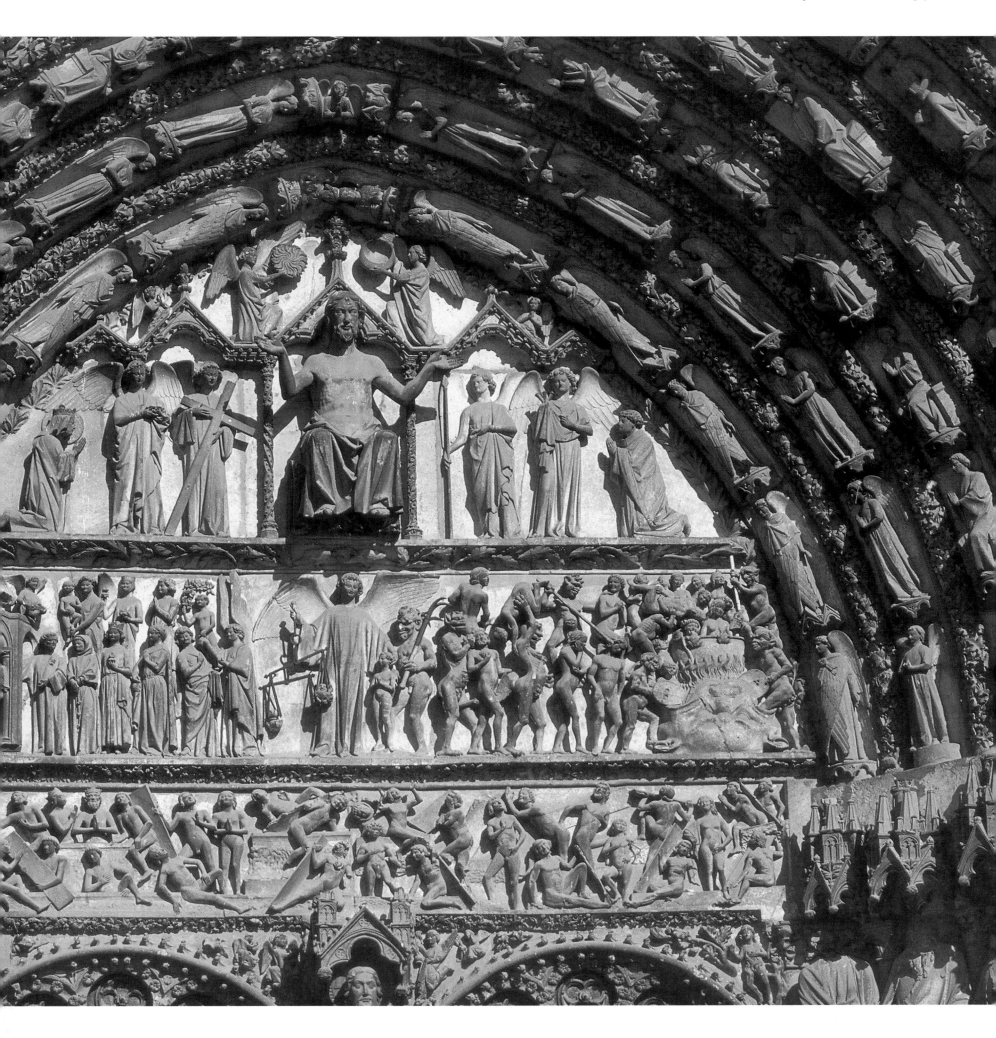

THE VERY RICH FEASTS OF JEAN DE FRANCE, DUKE OF BERRY

In 1360 King John the Good (Jean le Bon) of France gave Berry, Auvergne, and Limousin as an appanage to his third son. Jean of France, duke of Berry, was a magnificent *grand seigneur*, friend of all the arts, who surrounded himself with the best artists of his day, like André Beauneveu, Jacquemart de Hesdin, and the Limbourg brothers. He had the brothers, and then Jean Colombe, illustrate the manuscript of his Très Riches Heures (Very Rich Hours), one of the most incontestable successes of what some call the international Gothic style and others call the courtly style. By the end of the fourteenth and the beginning of the fifteenth century, in fact, painters, who worked for a small number of royal courts, all cultivated a single style, each adding his own personal "touch." Highly colored and pleasant, this style strove for naturalism and realism while remaining elegant and without losing the level of symbolic expression. Among the illuminations of the Très Riches Heures, the most famous are those that represent the months of the year. The illustration recalling the pleasures of January shows the duke during a feast that he is giving for the new year. We can clearly make out the features of his face; it is certainly not the face of an ascetic, but rather that of a pleasure seeker, an epicure. He wears a fur hat on his head and is dressed in a sumptuous blue robe sprinkled with designs embroidered in gold. The puritanical nineteenth century thought bright colors and furs were feminine, but until then men as well as women had worn them. Characters in the illumination also wear hose (stockings) of different colors. Skins of sable, squirrel, ermine, and otter line or trim clothing.

The illumination also shows how meals were eaten. At that time there were neither dining rooms nor permanent tables; a table was set up on trestles in the great hall. People were seated only on one side, leaving the other free for service. Knives and spoons had already been developed, but not the fork; fingers were much used for eating. Meats were cut up and brought on pieces of bread, or "trenchers." Food for the nobility consisted almost entirely of meat, much of it the fruits of the hunt. As a result, gout was the illness of the nobility. In this illumination, wine is served in ewers and containers of gold, but it was more commonly presented in round glass bottles. The bottle did not assume its present-day elongated shape until the seventeenth century, although the Burgundy bottle remained somewhat behind in this evolution.

Jean de Berry loved to build, as is demonstrated by his château at Mehun-sur-Yèvre and the ducal palace of Bourges—where Louis XI was born—since destroyed by a fire. His recumbent statue of white marble had been placed in the Sainte-Chapelle of the palace; it is now in the crypt of the cathedral.

The duke, who was passionately interested in animals, built a real zoo—with wolves, monkeys, falcons, peacocks, bears, ostriches, and camels—from which he could not bear to be separated, and which

PAUL, HERMAN, AND JEAN LIMBOURG, ILLUMINATION OF THE MONTH OF JANUARY, FROM THE TRÈS RICHES HEURES DU DUC DE BERRY, C. 1413–16. MUSÉE CONDÉ, CHANTILLY
An extravagant prince, a great connoisseur, and patron of the arts, the duke is here shown on the right, wearing a fur hat. The war is represented in the background.

Thus, the custom of the *huée* was born; when the end of the day arrived, the vineyard workers who were closest to the town—those who could hear the hour rung in the belfry—let the others know by their cries, and gradually a joyous clamor, the *huée*, spread through the countryside.

Although he was immensely wealthy, Jean de Berry spent too much. In 1416, at the age of seventy-six, he died insolvent in his Hôtel de Nesle in Paris. Since he had no son, his appanage returned to the crown.

JACQUES COEUR: THE AUDACITY OF THE BOURGEOISIE

Bourges was also the city of Jacques Coeur, whose birthplace is still standing, as is his mansion, the symbol of his success. What a contrast between the simple half-timbered house and the "shining palace"! His rise was the rise of an entire social class, the bourgeoisie.

At first there was the "communal movement," which began about the year 1100. The "bourgeois" (or merchants) of many cities, who acquired a fair bit of money through economic expansion and the development of cities, obtained, often after a stubborn struggle, "communal franchises" from their lords, that is, the right to administer themselves under their own authority.

The most notable among them were elected to serve in some capacity, especially as mayor or deputy mayor, and ran the town's affairs. By 1179 Bourges had a communal charter accepted by King Louis VII.

Later on—and this is where Jacques Coeur broke new ground—the bourgeoisie felt restricted within the limits of the town. It wanted to conquer the world, to participate in international markets, money—no longer small savings, but big capital—and large-scale political power.

Jacques Coeur was born in 1400. He learned on the job next to his father, a modest furrier. At the age of twenty he inherited his father's business and married a young neighbor, Macée de Léodepard. In 1430 he founded a small import-export business with friends. Then, after a voyage to the Near East (Egypt, Syria, Lebanon), he took a leap into the unknown. He founded alone and without associates (although he borrowed a great deal) the first French company for

BOURGES, HÔTEL DE JACQUES COEUR, 1443–51

A sign of the times, one of the most beautiful buildings in the fifteenth century is a private town residence. The Hôtel de Jacques Coeur in Bourges is a temple to the audacity and commercial success of the king's "treasurer."

followed him in his travels. He had a large number of dogs, and he had them bathed in the sea to keep them from getting rabies.

Jean de Berry remains a controversial character. During the Hundred Years' War he took sides against the king, his brother. The excessive taxes with which he overwhelmed his subjects provoked peasant revolts, like that of the Truchins in 1384. Nonetheless, he is characterized by a certain simplicity. Talking with the workers in the vineyards, he learned how they suffered workdays lasting from four o'clock in the morning to sunset. He ordered that they be reduced by two hours, and by four hours in winter.

THE HÔTEL DE JACQUES COEUR

●

Built between 1443 and 1451, the Hôtel de Jacques Coeur was both a comfortable dwelling—furnished, notably, with steam baths—and a commercial office. On the ground floor, where arcades open onto the court on three sides, he presented samples of his merchandise. Above, in galleries covered with wooden roofs shaped like the upside-down hulls of ships, important deals were struck, ships were chartered to the East, financial transactions took place.

Jacques Coeur's residence is a masterpiece of art. He summoned the best artists of his day, including Jean Fouquet, to decorate the vaults of his chapel. On a background of sky blue scattered with stars, twenty blond angels, each different from the others in form and face, unroll ribbons and streamers bearing written extracts from the Gloria and the Song of Songs. The artist made wonderful use of the space available to him, creating the illusion of three dimensionality and movement.

The hôtel *is filled with symbols. Its mass is an affirmation of power; built on a part of the Gallo-Roman wall that initially protected Bourges, it is wider than the slightly later* hôtels *of the abbots of Cluny and the archbishops of Sens at Paris. On its rear facade the three upper levels of the keep represent the ascent to power: the uppermost is a crenellated terrace; below it is the hall of the treasury; below that are the archives, containing contracts and precious documents. The whole forms a crown in the sky and asserts, "I am the king of money!"*

Here and there works of art recall his business, like the stained-glass windows representing his galleys or the sculptures that illustrate his industries. Through the mock tournament between peasants sculpted on his mantelpiece, Jacques Coeur expressed his contempt for the world of nobility and feudalism. Finally, the scallop shell of Saint Jacques (Saint James or Santiago) and hearts everywhere recall his first and last name, accompanied with his two mottoes: "À vaillans Coeurs, rien impossible" (to a valiant heart, nothing is impossible) and "Entendre dire–Faire–Taire" (hear what is said–do–keep quiet).

JEAN FOUQUET, CEILING OF THE CHAPEL, 1443–51. HÔTEL DE JACQUES COEUR, BOURGES *The dark blue of the sky, the gold, the fresh faces of the angels, the variety in the drawing, and its movement combine to make this a lively and refined work.*

maritime trade with the Levant. How could he do this from Bourges, which certainly was a mercantile town, but certainly was not a seaport? Jacques Coeur came to an agreement with the notables of Montpellier to create a port, Montpellier-Lattès, which would serve as a point of departure for his operations. His success was astonishing, and allowed him to get involved in industry: cloth and armor in Bourges, dyeing in Languedoc, silk and gold cloth in Florence. It allowed him above all to make loans to the great powers of the kingdom and to become their banker, first and foremost to King Charles VII.

Here again he is the representative of a period of change. In the time of knights in armor and castles, the lords, who were the "artisans" of war, financed it themselves. The Hundred Years' War began with important defeats of French knights, who were courageous but undisciplined and revealed their vulnerability when faced with English armies composed largely of a disciplined infantry, archers, and a new invention, artillery. Crécy, Poitiers, Agincourt—these three defeats sounded a wake-up call: a new style of warfare had arrived. Charles VII defeated the English by imitating them. His artillery, with the improvements

developed by Jean Bureau, terrified his adversaries and turned the tide, leading to victory. Warfare, no longer a craft, had become an industry. To finance it kings needed more and more capital and, thus, the services of financiers like Jacques Coeur.

In 1438 the king named Coeur treasurer, which meant not minister of finances but steward of spending; as such he was a member of the king's council. Later on he participated in political and diplomatic missions. The career of Jacques Coeur led him from small trade to international maritime trade, then to industry and banking, and finally to a prominent role close to the king. The outline of his story is the story of cities like London, Brussels, Antwerp, Amsterdam—and, more generally, of the budding capitalist economy, where maritime trade preceded and gave rise, through its profits, to banking and industrial activity. His political success increased his business successes, since through it he obtained economic privileges: the concession to mint money, the concession to the mines around Lyons and Beaujolais, the right to impress sailors for his ships.

He worked ceaselessly. Always traveling by land or sea, he was aided by his nephew, Jean de Village,

while Guillaume de Varye, more sedentary in nature, remained at Bourges, where he acted as administrative director and accountant. Jacques Coeur's organization included about two hundred agents and thousands of employees: sailors, longshoremen, warehousemen, mule drivers, scribes. He bought great estates and residences like the immense château of Saint-Fargeau, in the Yonne.

But this political and economic empire earned him many enemies, who gained the king's ear. On July 31, 1451, Jacques Coeur was arrested and imprisoned. He was tried, convicted, banished from the kingdom, and condemned to pay two enormous fines. Since he could not pay them he remained in prison, for imprisonment was the fate of the bankrupt. Although well guarded, he escaped to Rome and applied to Pope Calixtus III for sanctuary. The pope named him to head a naval expedition against the Turks in the Eastern Mediterranean. Coeur took ill and died on the island of Chios in 1453.

FROM THE GOD BORVO TO THE THRONE OF FRANCE

Around 950 the simple *viguier* (administrator) of the domain of Bourbon gained his autonomy from his employer and became lord of Bourbon (today, Bourbon-l'Archambault). The area took its name from Borvo, the Gaulish Apollo, god of beauty and the sun. The lords of Bourbon did not excite much comment. Through the centuries they increased their territory—by marriage, by inheritance, sometimes by conquest—assembling a part of Marche, Auvergne, Berry, Burgundy, and the land around Nevers. In 1249 Archambault VII died during a crusade. His two daughters Mathilde and Agnès succeeded him one after the other, since Bourbon was a "female fief." Béatrice, Agnès's daughter, married Robert de Clermont, sixth son of Saint Louis, and their descendants took back the name of Bourbon. It was from the second of their grandsons that the line of the Bourbon-Vendôme is descended; beginning with Henry IV and his successors and until the last kings of France, this line held the throne of France after the Valois line disappeared.

The Bourbon family located its most important seats in Bourbon-l'Archambault, Souvigny, and Moulins. The present château of Bourbon-l'Archam-

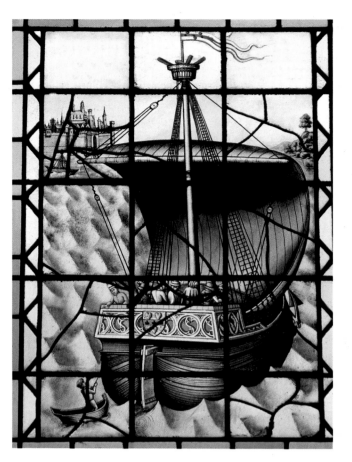

BOURGES, HÔTEL DE JACQUES COEUR, STAINED-GLASS WINDOW OF A GALLEY, 1443–51
Some elements of the decoration of the hôtel *recall the foundations of its owner's fortune. This stained-glass window depicts a galley, a merchant ship of large capacity that plied the seas during the Middle Ages.*

bault, of which only a few towers remain, is a reconstruction of the original château, begun in 1321. With its twenty-four towers and two chapels, it was magnificent. Bourbon-l'Archambault was then the capital of Bourbon; it was not transferred to Moulins until the end of the fifteenth century. The family sanctuary was in Souvigny, where Cluniac monks prayed for their dead. The tombs of Duke Louis II the Good (1356–1410) and his wife Anne d'Auvergne are particularly noteworthy. The duke earned his sobriquet because he dedicated half of his very great revenue to current expenses, a quarter to the upkeep of buildings and new construction, and the last quarter to alms. On his death a crowd of the poor, some of whom had come from very far away, followed the funeral procession, mourning their benefactor. Souvigny, then a great commercial center, is today a small town full of calm and beauty.

According to tradition, a lord who fell in love with a miller's daughter founded Moulins (mills) in order to be close to her. Moulins was one of the favorite residences of the dukes, who had a magnificent château built there in 1340, well before it was chosen as capital. There the duke Pierre II and his wife Anne de Beaujeu held court, and its fame spread to all of Europe. Jean Hey, who has been positively identified as the Master of Moulins, captured them for eternity on the panels of his triptych.

Jean Hey was born in Flanders about 1450. For a

chapel of the Hôtel de Jacques Coeur. The beauty of their faces reveals the painter's particular ability: a great talent for painting children. On the reverse he has painted the scene of the *Annunciation* in grisaille.

The portraits of the triptych's donors are remarkable. Discreetly, so as not to trouble the models, the artist nonetheless manages to reveal their souls, their faults. Duke Pierre II, a good fellow, is a reasonable man, who endeavors to keep half the power. Little Suzanne seems sickly, while Anne de Beaujeu is beautiful but tense, as the austere woman she is, whose only passion was the love of power, a taste for dominating others. In the opinion of her contemporaries she had the character of her father, King Louis XI, to whose diplomatic ability she owed her title of head of the duchy of Bourbon, the last of the great fiefs.

It has long been maintained that the French painters of the fifteenth century, like Enguerrand Quarton, Nicolas Froment, Jean Fouquet, and Jean Hey, had studied the works of Flemish and Italian painters and attempted to synthesize their respective qualities. It is true that they emulated the superb realism of the Flemish, relishing the exacting and sensual reproduction of various subjects; it is also true that like the Italians, they made use of sharply outlined and sculptural forms, abstract constructions, and logic. But their art above all follows a particularly French tradition of long standing—especially of the "schools of Paris"—characterized by the ever-present goal of uniting elegance and the natural. The art historian Charles Sterling emphasized this point: "Is the French work thus the mixture of two influences, does it represent a wisely measured balance of two conceptions? Very much to the contrary, such a median characteristic reveals a third spiritual conception, perfectly original. . . . Between the cerebral Latin rigor and the frank northern sensuality, this conception reposes on the instinctive feeling for a balance between sensuality and mind. . . . This profound feeling for life, but for a life that has been shaped, controlled by man, has always determined the form and the backdrop of the arts and letters in France" (*La Peinture française–Les Primitifs* [Paris, 1938]). And the French painter of the fifteenth century also was influenced by other arts, especially sculpture. Filled with wonder by the great compositions on the facades of the cathedrals, he wanted to include their powerful monumentality and their symbolic richness in his work.

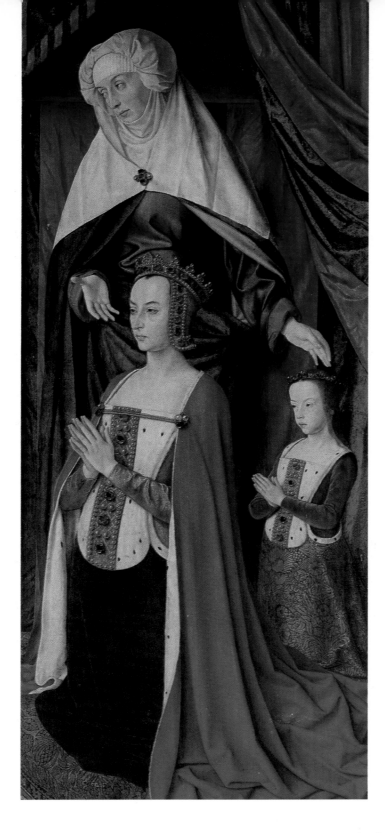

JEAN HEY, WING OF A TRIPTYCH, C. 1500. CATHEDRAL OF NOTRE-DAME, MOULINS
Jean Hey, the "Master of Moulins," painted the donors of the work, Anne de Beaujeu and her husband Pierre II, the duke of Bourbon, on the wings of the altarpiece. The artist realistically suggests in his portrait of this daughter of Louis XI a character shaped by the love of power.

long time he was one of the many artists attached to the Bourbon court. His masterpieces include the *Nativity* in the Musée d'Autun, the portraits of dauphin Charles-Orlant and of a *Child in Prayer,* which are in the Musée du Louvre, and the triptych in the cathedral of Moulins, painted about 1500. Its central portion contains the *Virgin of the Apocalypse.* The Virgin, her face radiating sweetness, is seated on her heavenly throne in a halo of several concentric colors, holding the baby Jesus on her knees. She is surrounded by flying angels; clearly, Jean Hey wanted to outdo the angels painted by Jean Fouquet in the

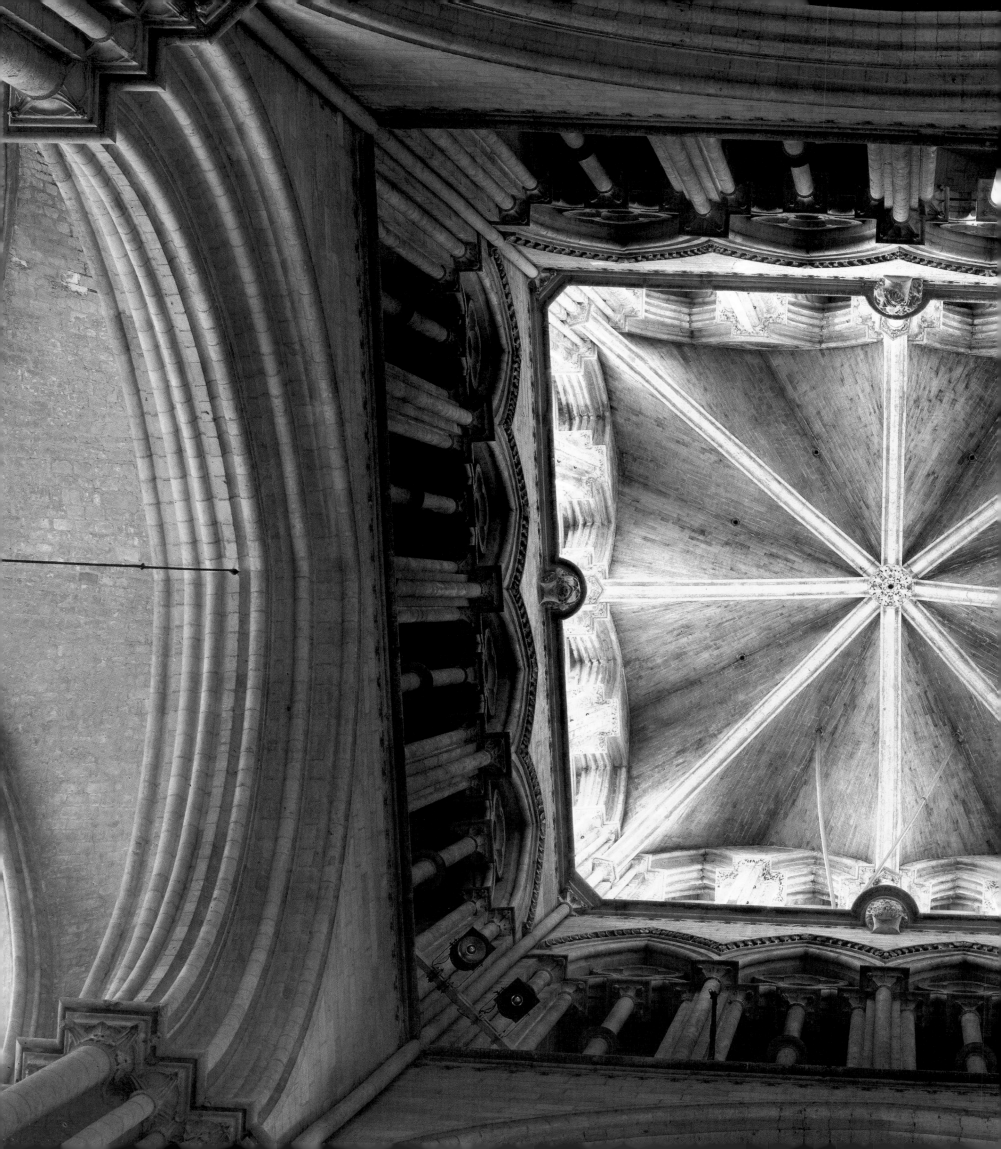

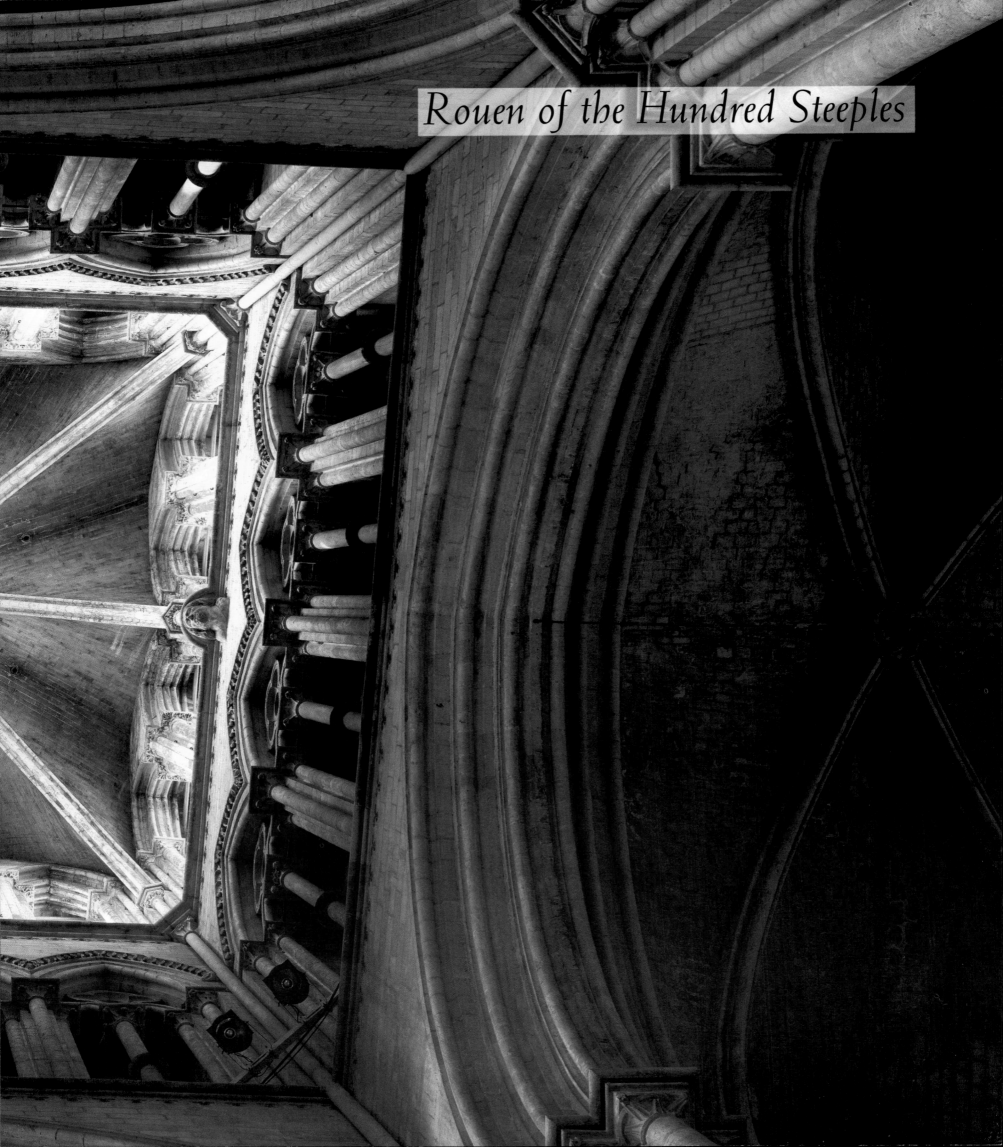

THE VIKINGS, also known as bay pirates, and the Normans (north men) came from Scandinavia. It has been postulated that the practice of polygamy by the Scandinavian peoples led to a permanent overpopulation, the surplus men being forced to emigrate to find new lands. In any case, the growing riches of Flanders, England, and northern France, from the expansion of their trade, attracted these raiders, who were remarkable navigators. Their *drakkars*, or long ships, about 66 feet (20 meters) long, could carry forty men. They established themselves at several points along the coasts, preferring river mouths, and from there they set out on expeditions in which they pillaged the towns and villages of the interior. They even laid siege to Paris in 885. In 911 the king of France, Charles the Simple, recognized the Viking chief Rollon as lord of Normandy by the treaty of Saint-Clair-sur-Epte.

FRANCE'S SECOND CITY

The new duke tried to organize his territory rationally, while assimilating local culture. He took Rouen as his capital, a commercial locale of great importance since Roman times. The city was also a great religious center, where Saint Melon had begun the conversion of the region about 260 A.D.

Nature had blessed the site of Rouen. The city is located within a loop of the Seine, a vast area formed by the alluvial deposits of two rivers, the Cailly and the Robec. At Rouen the river, sprinkled with islands, could be crossed easily. A stone bridge built about 1144–45 to replace a previous wooden bridge was, until the recent building of the Tancarville Bridge, the first bridge over the Seine from the point where it flowed into the English Channel. The effects of the tide are felt as far as Rouen; as it rises, it helps the boats that travel toward the port, and as it falls, it helps those that depart. Rouen was thus destined to become a great river port and seaport.

In 1066 the duke of Normandy, William the Conqueror, landed in England. Because of this conquest, the most famous exploit of the eleventh century (rivaled by the taking of Jerusalem by the Crusaders in 1099), trade from Rouen to the British Isles, London in particular, increased. As in the other great ports of Europe, maritime trade at Rouen gave rise to banking and industry, the first industry being cloth. Cloth

manufacturers set up shop on the banks of the Robec, along with fullers and dyers, who painted the quarter with brilliant colors by hanging out their cloth to dry. Rouen was very active in the Middle Ages; it was France's second city, and would remain so until the eighteenth century.

In 1204, conquered by Philip Augustus, the city became French. In 1382 a revolt broke out among the poorest of its residents, the "Harelle." During the Hundred Years' War, Rouen fell to the English, who occupied the city from 1419 to 1449. In 1431 the trial of Joan of Arc took place there. In spite of these events, the prosperity of the city, and of Normandy as a whole, never flagged; in 1449 the province furnished a quarter of the taxes collected in the kingdom.

The number of its ancient half-timbered houses and monuments, among the most important of which are the cathedral, the churches of Saint-Ouen and Saint-Maclou, and the Palais de Justice, testify to the richness of Rouen and its inhabitants during the Middle Ages.

Claude Monet spent the years 1892 and 1893 painting thirty or so canvases representing the facade of the cathedral at different times of the day and under different weather conditions. In the morning its upper portions, with their open design—the Saint-Romain tower to the left, the Beurre (Butter) tower to the right, and, further away, the lantern tower that sits atop the transept crossing—appear magnified against the background of the sky and the morning light, while the afternoon sun allows us to admire the details of its prodigious profusion of architectural forms and sculpture.

This facade combines the styles of the very early and very late Gothic period, the last phase known as the Flamboyant style. The bishop of Rouen, Hugues d'Amiens, who was a friend of Abbot Suger, had been very impressed by the abbot's work on Saint-Denis. The bishop soon undertook the reconstruction of his cathedral in the newest style, beginning in 1145 with the Saint-Romain tower and the facade. An important remnant from this period is the tympanum of the left portal. Its lower register narrates the story of Salomé and the beheading of John the Baptist. To the left we see the feast of Herod and Herodias, his wife, whom he had taken from his brother Philip. Her daughter Salomé performs before the guests, not a lascivious dance, as the biblical text suggests, but a balancing act similar to those presented by the *jongleurs* of the

ROUEN, CATHEDRAL, NAVE, 12TH–13TH CENTURIES
Begun in the twelfth century, like the cathedral of Laon, in the "first-generation" Gothic style with an elevation of four levels, after a fire in 1200 the cathedral was rebuilt in the "second-generation" style.

Preceding pages
ROUEN, CATHEDRAL, TRANSEPT CROSSING, 13TH CENTURY
Gothic architects in Normandy furnished their buildings with lantern towers over the transept crossing. These constituted feats of engineering, since the four main pillars support the weight of not quadripartite vaults but, as here, of a colonnade with an impressive octopartite vault, as well as the roof.

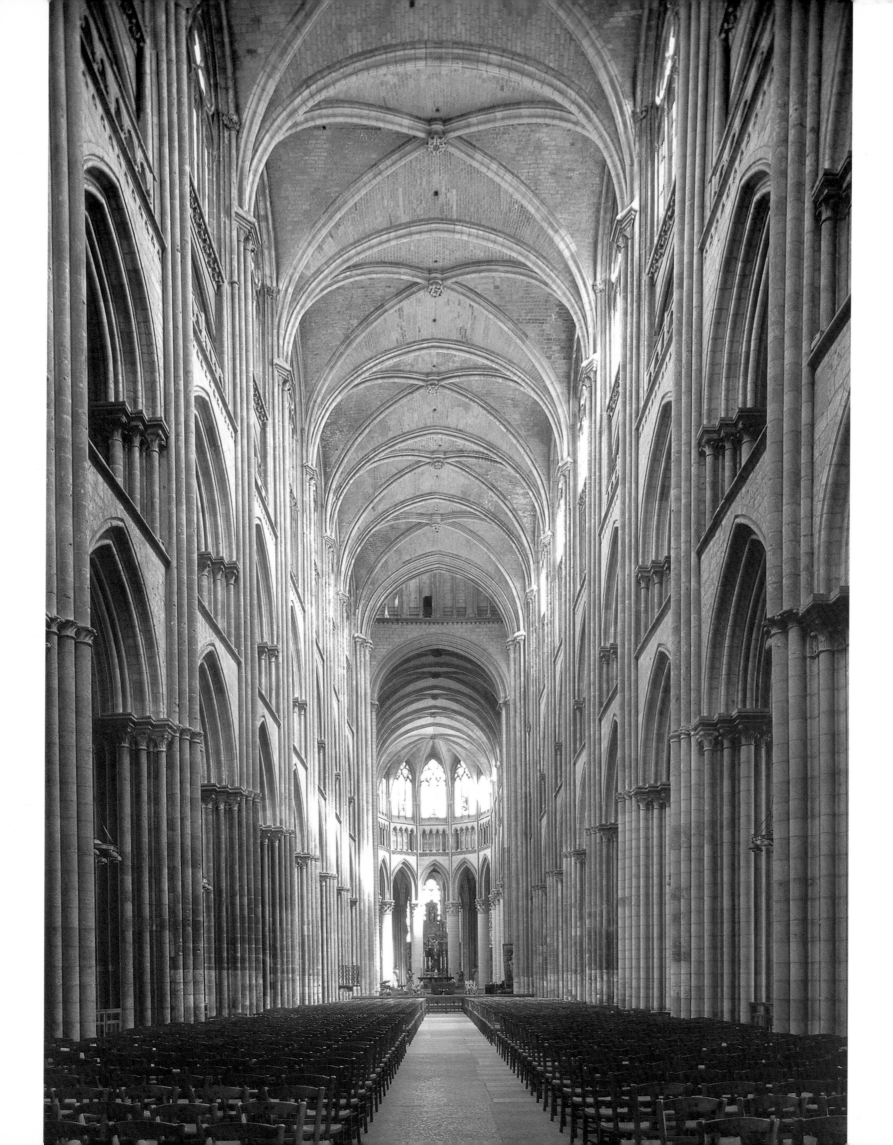

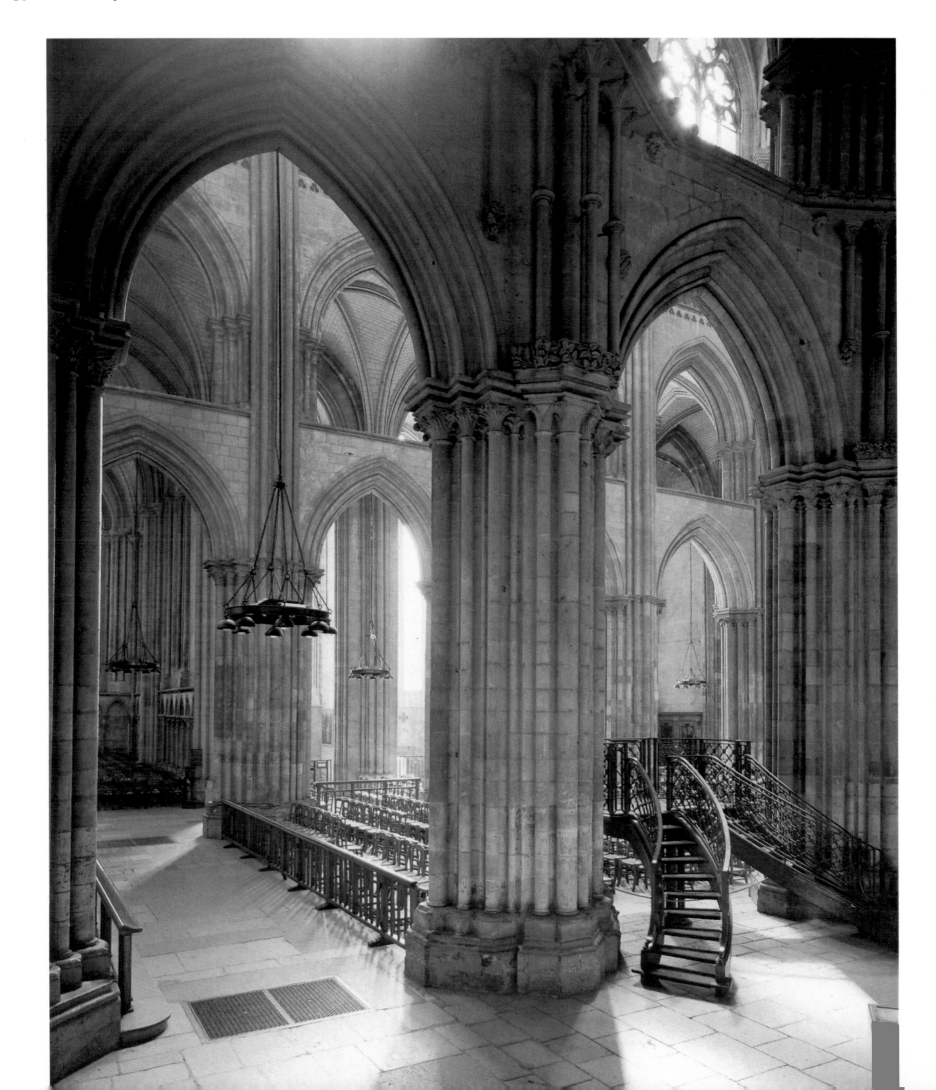

ROUEN, ABBEY CHURCH
OF SAINT-OUEN,
EXAMPLE OF THE
VAULTING
*In the fourteenth
century a transitional
style that preceded
Flamboyant Gothic
appeared. It was charac-
terized by highly refined
proportions, very
pointed arches, and a
great luminosity by way
of the stained-glass win-
dows, which alternated
colored scenes with clear
parts in grisaille. The
crowning achievement
of this style is the abbey
church of Saint-Ouen; a
sample of its vaulting is
shown here.*

Opposite
ROUEN, CATHEDRAL,
THE FALSE TRIBUNE OF
THE AISLE, 12TH–13TH
CENTURIES
*After the fire the eleva-
tion of the side of the
nave was kept as it was,
with four levels. This
included the tribune—
but it had no back, since
higher aisles were built.
The cathedral is unusual
in having a false tribune.*

period, who were simultaneously poets, singers, and acrobats. In the next scene, the princess receives the head of John the Baptist on a platter; his execution appears at right.

The upper register illustrates a legend surrounding the death of John the Baptist: at the moment of his interment, he is supposed to have been swept into the heavens in ecstasy. The whole is treated with humor, with a sense of the picturesque, and with naturalism, but without any concern for historical reality; the characters are represented as the sculptor's contemporaries, his goal apparently to make the public relate to them.

In the fifteenth century the inhabitants of Rouen, feeling that their cathedral was too austere, commissioned first Guillaume de Pontis and then Rouland le Roux to rebuild the upper portions of the Saint-Romain tower, transform the facade, and build another tower, the Buerre tower. This has a square base and an octagonal crown. Built as an offset, it is very open and is supported by buttresses and flying buttresses, themselves very open. The lantern towers over the transept crossings of Saint-Ouen and Saint-Maclou are conceived according to the same principles.

The nave of the cathedral was built in the twelfth century, shortly after the facade. It recalls the cathedral of Laon, its contemporary: the same four-story elevation, the same restrained height, here 92 feet (28 meters) under the vaulting, the same eclectic taste in architectural elements, expressed particularly in the colonnettes that surround the piers, making them seem thicker and focusing attention downward rather than above. The architect of Amiens almost seems to make us forget the nave; the architect of Rouen, on

the contrary, emphasizes it. Norman architecture of the Gothic period, however, often emphasizes the contrast between dark and light, as here with the multiplication of the colonnettes, thus making the space richer in discoveries.

In 1200 the cathedral burned. Since the elevation of the nave escaped the disaster it was preserved; the edifice was finished in the second-generation Gothic style, with raised aisles without tribunes, which explains why the nave has a "false tribune."

DECORATIVE EXUBERANCE, LEGENDS OF STONE AND GLASS

The cathedral preserves examples of each of the periods of stained-glass art from the Middle Ages to the Renaissance. The style of the beginning of the thirteenth century, that of Chartres, Bourges, and Reims, is in particular represented by the stained glass of the ambulatory. There we find the only stained glass of the period that is signed; it tells the story of Joseph and is inscribed, "Clemens vitrearius carnotensis me fecit" (Clement, glassworker at Chartres, made me).

Another stained-glass window in the ambulatory recounts the legend of Saint Julian the Hospitaller. Julian, a young noble, loved to hunt. One day a stag spoke to him and foretold that he would kill his father and his mother. To avoid the prophecy he went to a distant country; but no one may escape destiny. One day while he was away, his parents came to visit and fell asleep in his bed. On his return Julian boiled with anger on seeing them, for in the darkness he thought his wife was sleeping with a lover, and he killed them with his sword. Shortly thereafter, when he saw his wife alive, he learned of his mistake. In shame and remorse he renounced the world and moved with her to the banks of a great river. There he served as a ferryman to travelers. Later they together founded a hospital. One night a poor sick man sent by Christ came to ask for the help of the saint and told him that he was pardoned.

The stained-glass window of Saint Julian the Hospitaller is the fellow of the most beautiful masterpieces of Chartres. Here we recognize the technique from Chartres of breaking the colored space insofar as possible into a flickering mosaic—recalling the work of the jeweler and the illuminator—and of a solemn, hieratic representation, as well as a bent for comic

details. The artists' fantasy is also expressed in the sculptures of the choir stalls and in those of the tetrafoils that ornament the "Booksellers' Portal" to the north and the "Calends Portal" to the south. In the former, the medieval imagination gave itself free rein, creating fantastic animals with an unceasing verve.

In the second we see illustrated the most beloved stories of medieval man: those of Jacob, Joseph, Judith—and also that of Aristotle, whom we see being ridden by a young woman, Phyllis. Aristotle, who was Alexander the Great's teacher, asked his student to send away the young Persian captive he loved, so that he might better concentrate on his studies and on his search for virtue. Phyllis, to take revenge on the philosopher, seduced him and asked him to put a saddle on his back and let her ride him for a little while. Alexander, arriving on the scene, mocked him; no wisdom is proof against desire.

SAINT-OUEN AND SAINT-MACLOU: THE ELEGANCE OF LATE GOTHIC

To the northeast of the city stands the former Benedictine abbey of Saint-Ouen, founded in the sixth century. The dukes of Normandy endowed it generously, as they did those of Fécamp, Jumièges, Saint-Wandrille, Le Bec-Hellouin, and Caen, thus making their duchy a paradise for abbeys.

When the old abbey church collapsed, Abbot Jean Roussel, nicknamed "Mark Money" (which shows how rich monastic foundations were), had it rebuilt beginning in 1318. It was not finished until 1537. The plans of the original architect were nonetheless respected; Saint-Ouen is one of the rare churches built—although over the course of two centuries—entirely in the style of the fourteenth century. While the nave, with quadripartite vaults and a three-story elevation, follows the principles of thirteenth-century naves, the effect it gives is entirely different. This impression arises especially from the very sharp pointed arches, a characteristic of the Norman style, and the elongated proportions, with a height of 108 feet (33 meters) under the great vaults.

The church of Saint-Maclou, begun in 1436 and finished in 1521, is also a masterpiece. For all the richness of its exterior details, they are organized following a clear composition of the whole. The very finely worked gables that surmount the five fan-shaped sec-

ROUEN, CHURCH OF SAINT-OUEN, CHEVET, BEGUN 1318
In the fourteenth century a transitional style, which preceded Flamboyant Gothic, appeared. The church of the abbey of Saint-Ouen is its masterpiece and most characteristic example. Following the Norman tradition the transept crossing is crowned with a lantern tower, square at its base, then octagonal, with a great profusion of architectural forms.

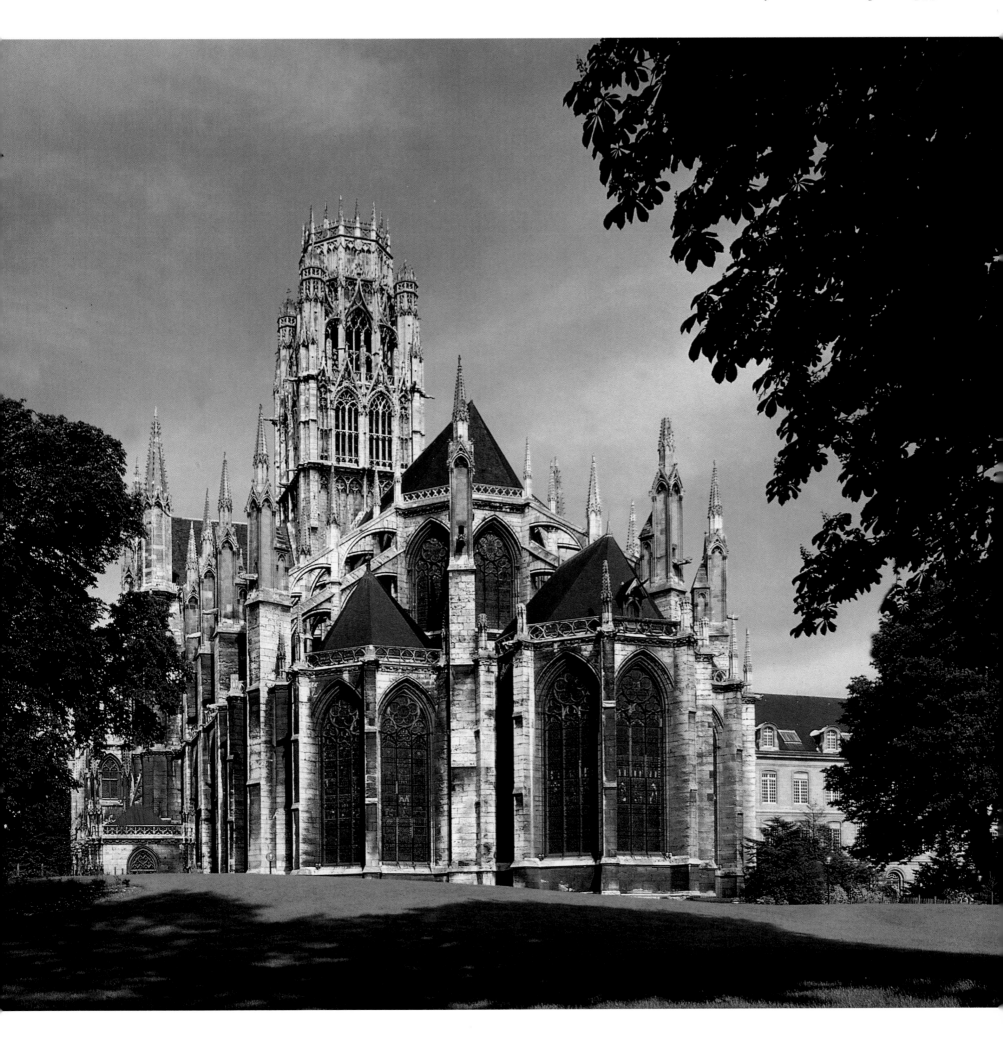

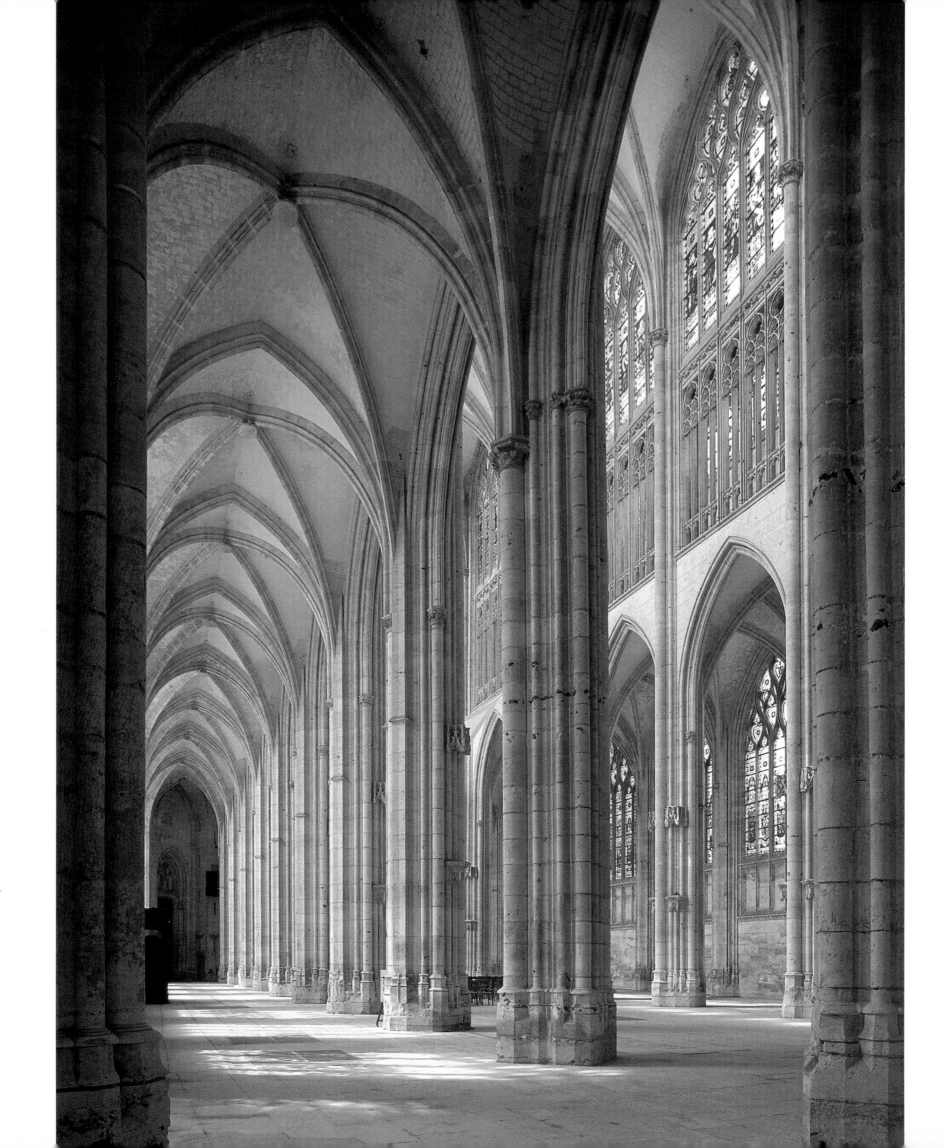

tions of its porch announce, by the oblique play of their lines, the shapes of the flying buttresses and roofs, and then of the lantern tower. By contrast, the interior is sober. Flamboyant construction, as expressed here, at Saint-Ouen, and in the late parts of the cathedral, breaks with the Gothic tradition on many points.

The arches rise in a single movement from the ground to the keystones of the vaults, which protrude. No capital serves as a relay to the thrust, as it would break the visual line of the upward movement. The unbroken upward sweep was achieved through having the ribs based imperceptibly in the piers; surrounding the bases of the latter with colonnettes with a prismatic profile that more sharply breaks the light than did the rounded forms of the bases of the thirteenth century; and visually fusing the second and third levels of the elevation. The stonework demonstrates an extreme fantasy and great virtuosity; especially in its upper reaches, the building is ornamented with a profusion of pinnacles, openwork gables, balustrades, gargoyles, and sculpted figures. The stone tracery of the windows and the roses no longer forms the orderly geometric pattern of the first-generation Gothic, creating new outlines composed of daggers and mouchettes. Their appearance, like flames, is at the origin of the name Flamboyant given to the last form that this Gothic style took in France.

A CENTER OF SPONTANEOUS POETRY

The verve and the exuberant fantasy of Rouen's art accurately expresses the nature of its inhabitants of the period, epicurean, loving to gather together in joyous associations like the Cornards. These latter organized the Feast of Fools, held on Saint Barnabas's day, when a false abbot was elected and carried in procession through the city. They acted farces such as *Master Minim* or *The Washtub*. The student Minim is so absorbed by his studies that he speaks only Latin, and his poor parents are heartbroken; happily, his young fiancée works her charm on him and cures him of his dangerous revery. In the beginning of the farce of *The Washtub*, Jacquinot tells us how unhappy he is, since his wife makes him do all the housework. Then she falls into the washtub in which the linen is boiling. He pretends that before getting her out he must finish all the chores on his list, and he thus manages to win some concessions from her.

The Cornards often gathered together for joyous feasts. During one of them they solemnly elected the city's bourgeois who had made the biggest fool of himself that year. Often, at the end of their feasts, they pronounced "joyous sermons," parodic homilies that celebrate imaginary saints, like *Saint Jambon* (Saint Ham), *Sainte Andouille* (Saint Sausage), or *Saint Velu* (Saint Hairy), the savior of women. These works reveal the concerns of Rouen's citizens during this period: the war waged by the "mighty," the avarice and lechery of some men of the church, the dishonesty of this or that shopkeeper, health, births. A certain anticlericalism speaks freely in it, but we must not mistake this; as the great Dutch historian Johan Huizinga writes in *The Waning of the Middle Ages* (Haarlem, 1919), "In all these profanations of faith by the indecent mixture with life, there is more naive familiarity than real impiety. Only a society permeated with religious sentiment and which accepts faith as something that is self-evident experiences these excesses and this degeneration."

The soul of the Middle Ages survives as much in these minor works, the farces and parodic sermons, as in the great works of art. Even the street names display a certain spontaneous poetry, authored by everyone and no one in particular. In Rouen, as elsewhere in the Middle Ages, streets took on the names of local convents (rue des Augustins, place des Carmes, or Carmelite Square, rue des Ursalines), of schools and hospitals (rue des Bons-Enfants), even of inns (rue du Petit-Mouton, or Little Sheep, rue Croix-de-Fer, or Iron Cross). The name may note a particularity of the place (rue Mal-Palu, or Bad Marsh, rue Tous-Vents, or All Winds) or its bad reputation (rue du Petit-Musc, where "la pute muse"—the whore dawdles—rue Coupe-Gorge, or Cutthroat, rue Merdret, or Shitty Street). Sometimes the trade practiced there gives its name to the street: rue du Change (Exchange Street), rue de la Savonnerie (Soap Makers' Street), rue de l'Épicerie (Grocers' Street), rue de la Ganterie (Glovers' Street), Sainte-Croix-des-Pelletiers (Holy Cross of the Furriers), Saint-Étienne-des-Tonneliers (Saint Stephen of the Coopers).

These and more picturesque names can be picked up on a walk through this city, which has its own mystery; "the city of the Gothic," according to Jean de La Varende, "of pinnacles, of flèches without number, of glorious portals, of intricate and flowered palaces."

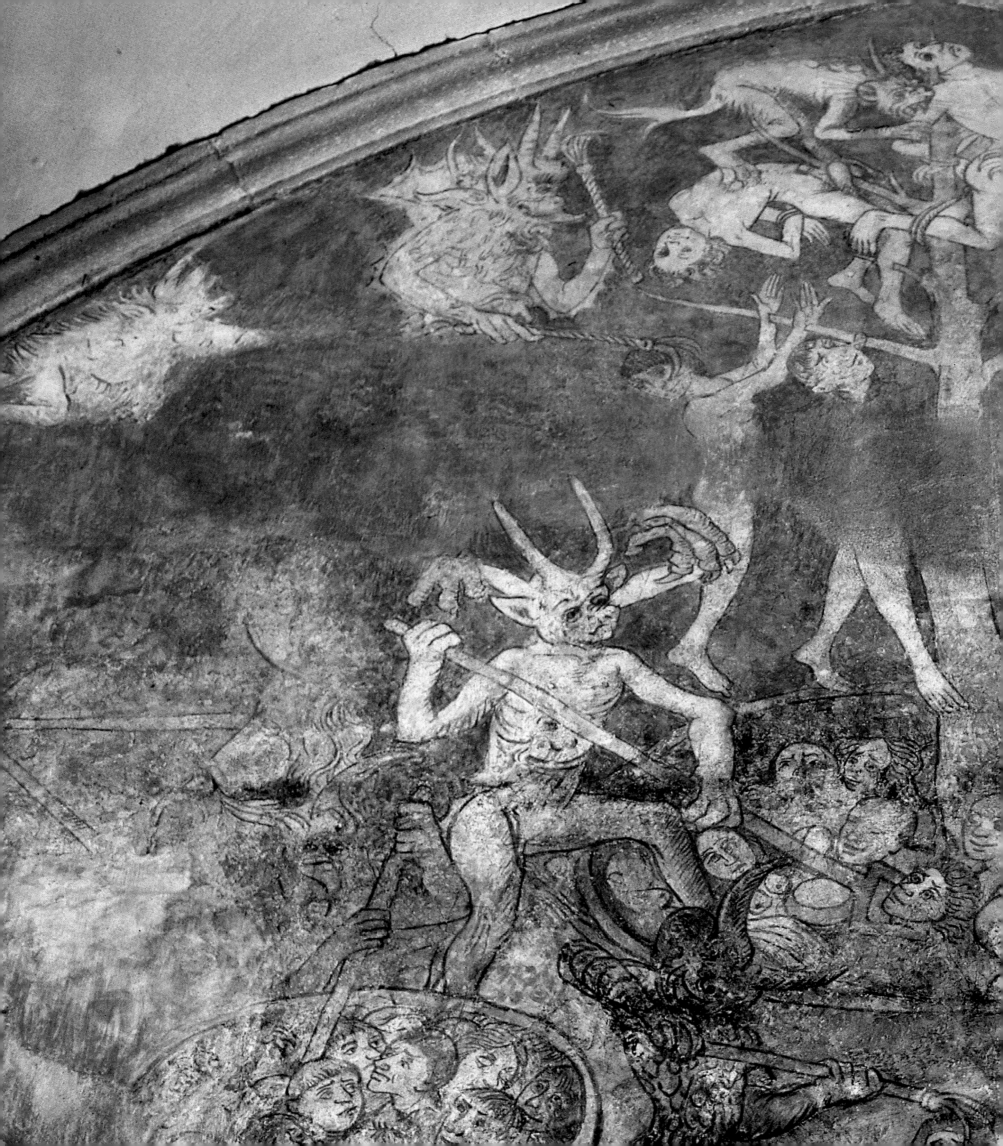

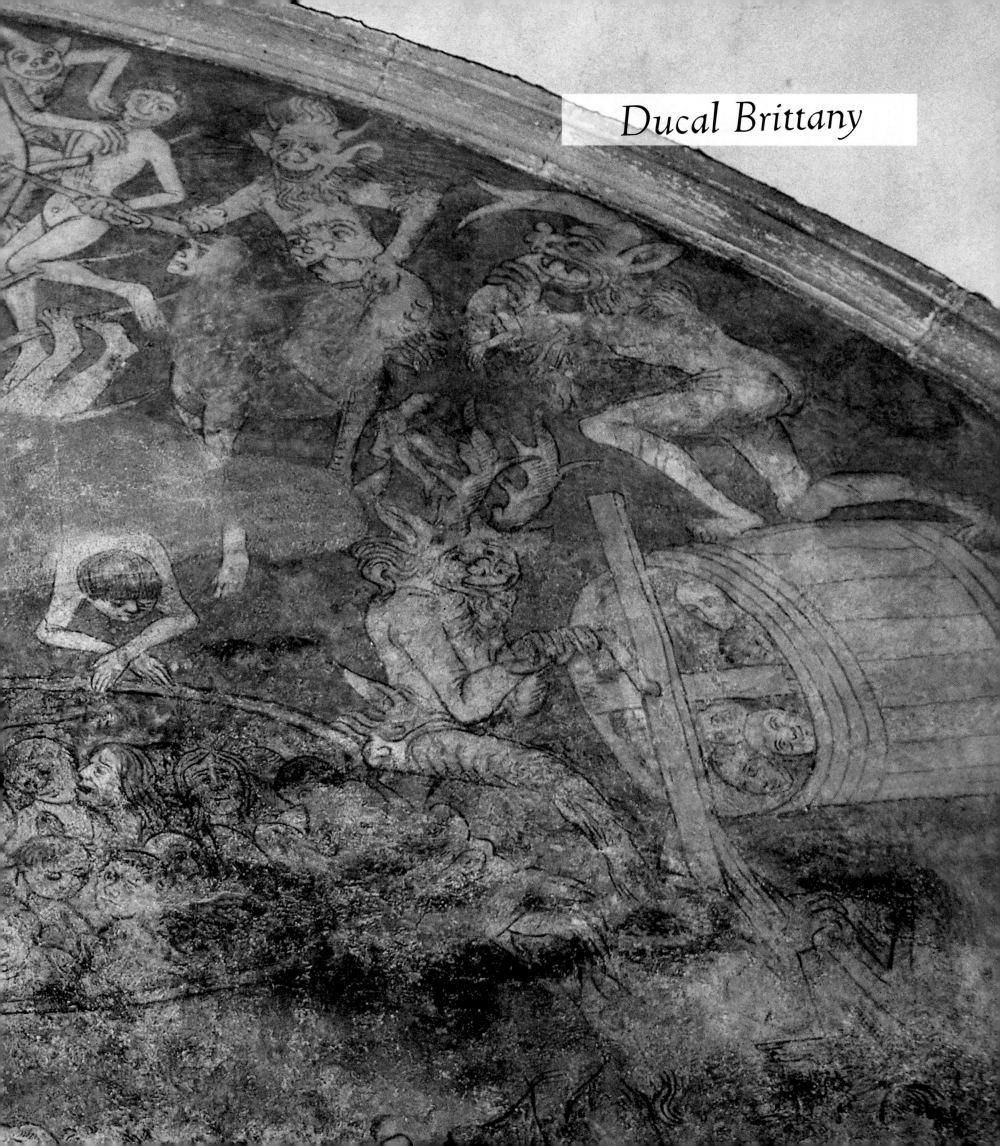

FOR A LONG time Brittany remained sparsely populated. Its earliest populations—the first inhabitants, who built the standing dolmens, rows of stones like those at Carnac, menhirs, and covered alleys; the Celts who invaded it beginning in 700 B.C.; and the Romans—did not venture beyond the coastal area. The center of Brittany was almost uninhabited, covered by a vast wild and impenetrable forest, the legendary Broceliande, and by moors. The region did not begin to fill in until the end of the fifth century A.D. (perhaps even earlier), with immigrations from the British Isles.

As they became more numerous, the human communities began to organize, and at the end of the sixth century Brittany was divided into three kingdoms, then into four. In the eighth century, faced with the threat of Emperor Louis the Pious, one of Charlemagne's three sons, it unified under a single king, Morvan. When Morvan died, Louis the Pious imposed his law on the Bretons by naming a local chief, Nevenoé (Nominoé), as duke, who was supposed to be Louis's representative in Brittany. But the opposite happened: Nominoé organized the Bretons against Louis's son, Charles the Bald. Nominoé was succeeded by Erispoé, then, after he was murdered, by Salaün (Solomon), murdered in his turn. A new dynasty was born when the Bretons chose as duke the brother of one of Solomon's murderers, Alain Barbetorte, who became famous in the struggle against the Normans.

GAUTIER MAP, *THE KNIGHTS OF THE ROUND TABLE*, FROM THE *LIVRE DE MESSIRE LANCELOT DU LAC*, 15TH CENTURY

Left
KERNASCLEDEN, ABBEY, FRESCO, 15TH CENTURY

A DUCHY IN DISPUTE

In the twelfth century Brittany was still very poor. Nonetheless, Henry II Plantagenet had designs on it. He forced the last duke to accept a marriage between the duke's daughter and inheritor, Constance, and Henry's son, Geoffroy Plantagenet, and administered the duchy while waiting for Geoffroy to reach his majority. To taste power in Brittany is certainly to taste the spirit of independence; when Geoffroy came into possession of the ducal crown, he escaped his father's influence. His son and heir Arthur, who had been raised in the court of France, was more favorable to the French than to the English. On the death of Richard the Lionhearted in 1199, Arthur's claim to the English throne was denied in favor of that of his uncle John the Landless. The latter captured Arthur in battle and imprisoned him in Rouen. John presumably killed Arthur with his own hands on April 3, 1203, in a small boat on the Seine in front of Rouen. King Philip Augustus of France then had an assembly of bishops and barons name Alix de Thouars, daughter of a second marriage of Constance, as duchess of Brittany. Her marriage to the count of Dreux, Pierre Mauclerc, a nephew of Philip Augustus who was popular in Brittany, confirmed the transition of Brittany from the Plantagenets to the Capetians.

The dukes of this line, who reigned for more than a century, remained on good terms with the kings of France. Nonetheless, on the death of Duke Jean III in 1341, a dynastic problem arose: Would the ducal crown go to his niece, Jeanne de Penthièvre, wife of Charles de Blois, cousin of the king of France, or to his brother Jean de Montfort? De Montfort initiated hostilities and allied himself with the English, while the French took the side of Charles de Blois. The kings of France who, by virtue of the Salic Law, had until then always maintained that their crown could not pass to a woman or to her male descendants, here maintained the opposite position. Brittany thus became one of the "fronts" of the Hundred Years' War, and the war of succession deeply divided the Bretons in a fratricidal war.

Charles V threw the celebrated soldier Bertrand du Guesclin into this war, but he was still beaten at Auray in 1364, where Charles de Blois was killed. The king was forced to compromise; in the Treaty of Guérande he recognized Jean de Montfort as duke. His descendants would be the last dukes of Brittany.

Hostilities broke out once again in 1369 between Duke Jean IV, ally of the English, and Charles V. In 1378 the king attempted to confiscate the duchy but was repulsed, and after his death in 1381 the second Treaty of Guérande was signed. Thus began the golden age of Brittany: after its victories against the kings of France the duchy was semi-independent and henceforth prosperous, thanks to the rise of maritime trade and fishing, as well as the clearing of lands in the interior and their increase in value. It was again a dynastic problem—the bane of Brittany's history—that finally put an end to the duchy's independence.

THE SLOW DISCOVERY OF THE GOTHIC IN BRITTANY

On the eve of the year 1000 Romanesque Brittany, stripped of all its possessions, slowly rebuilt itself with the help of its church, whose clergy struggled to maintain its moral autonomy and its liturgical rites. Most of the buildings that the invasions swept away had been made of wood. Stone begins to appear in new construction, opening the way for the creation of a Breton style, whose sobriety may too facilely be qualified as naive or rustic. Its essential quality, in fact, can be linked to the varied nature of materials available, sometimes hard (granite), sometimes brittle (schist) or friable (sandstone).

The ornamentation of Breton churches hardly bears comparison with the great sculpted creations of Burgundy or of the west. Nonetheless, a refined modeling appears in the twelfth century, influenced by the Loire region and Poitou. It can be seen in the design of the three western portals of the basilica of Dinan, in the historiated capitals in the collegiate church of Guérande, and in the admirable sculptures in the round grouped on the southern wall of the church of Malestroit.

In the thirteenth century Brittany adopted the new style, a period that saw the construction of a great many cathedrals—at Dol, Saint-Malo, Saint-Brieuc, Tréguier, Saint-Pol-de-Léon, Quimper, Vannes, and Nantes, among others. These display three distinct influences: the Angevin style, the Gothic style of the Île-de-France, and, especially, the Norman style. The most visible sign of this last influence is the construction of high bell towers—for example, those that grace the cathedral and the chapel of Kreisker at Saint-Pol-de-Léon—that feature, rising from a square base, a thin, octagonal spire surrounded by four small turrets. But—as art critics like to emphasize—if Brittany, beginning in the first years of the fifteenth century, invented a new variation of the Gothic style, its expression emerged less in the great cathedrals than in buildings of more modest dimensions: the Notre-Dame chapel in Kernascleden, the Saint-Fiacre chapel in Faouët, the church of Locronan, the collegiate church of Folgoët.

The Notre-Dame chapel in Kernascleden is the most perfect and most harmonious example of the Gothic Breton chapel. Its chevet is flat and opens in a vast bay, the only source of light except for the bays of

the lateral walls, since the walls that loom over the great arches of the nave have no windows. Even at the choir end, which has two aisles, the roof falls straight to the very thick exterior walls. These, along with the powerful abutments, serve to stabilize the building, which is not provided with flying buttresses.

On the facade a handsome tower bears a narrow spire, and two porches flank the southern side; the porch plays a very important role in Breton religious architecture. Making use of the vast surfaces of the walls, the chapel contains an important group of wall paintings whose subjects are the Resurrection of Christ, the life of the Virgin, angelic musicians, a Danse Macabre, and Hell.

Another little masterpiece of the Breton Gothic style is the chapel of Saint-Fiacre in Faouët. Its princi-

KERNASCLEDEN, CHAPEL, SOUTH PORCH, STATUES OF APOSTLES, 15TH CENTURY
The Apostles, as positive role models, were set on the lower part of the porch, depicted as rather squat figures in polychrome stone. Each holds his symbol, making identification easy, especially for those unable to read the names engraved on the banderole. Saint Peter carries his keys, John his chalice, and Simon his saw.

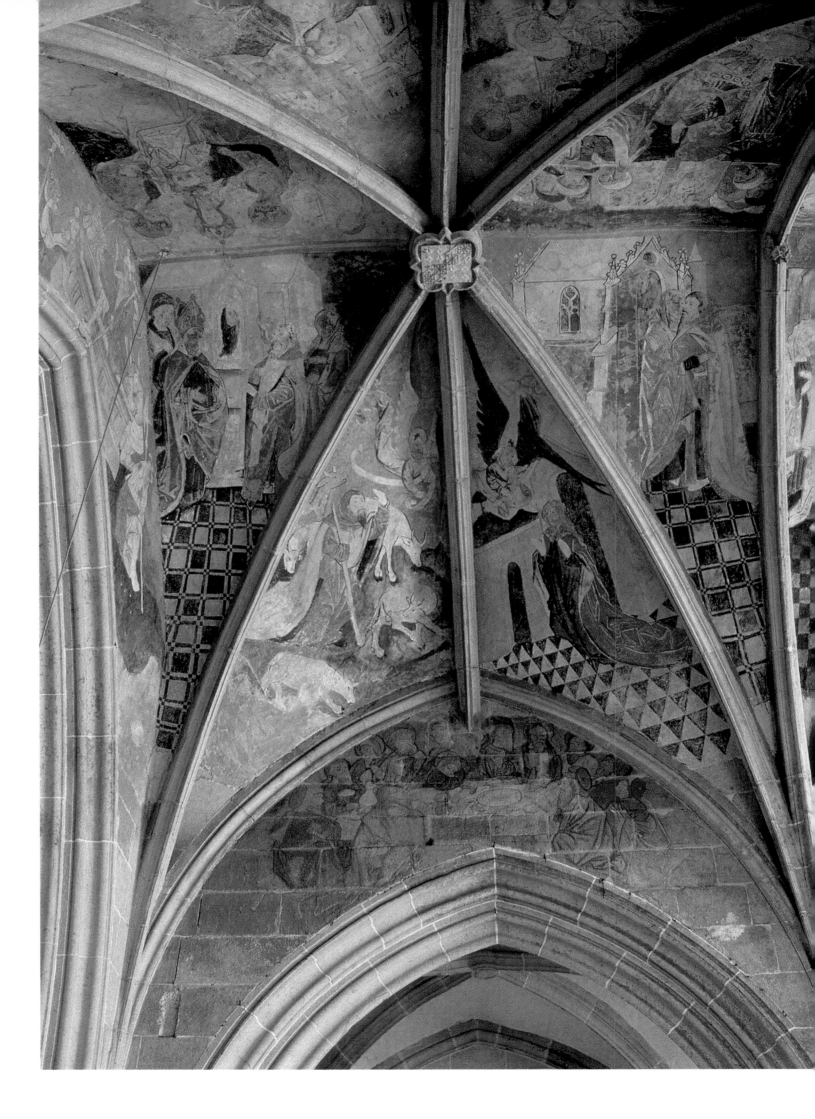

FAOUËT, CHAPEL OF
SAINT-FIACRE, DETAILS
OF THE CHOIR SCREEN,
15TH CENTURY
*The choir screen is
sculpted with boundless
verve and imagination.
This angel with folded
wings* (left) *seems to be
dropping from Heaven
at great speed. The sub-
ject of Adam and Eve*
(opposite below) *gave
the artist an opportunity
to sculpt the only nudes
allowed to be represented
realistically and with
sensual freshness. On
the main beam* (above)
*a man of the period is
left dumbfounded by
what he sees.*

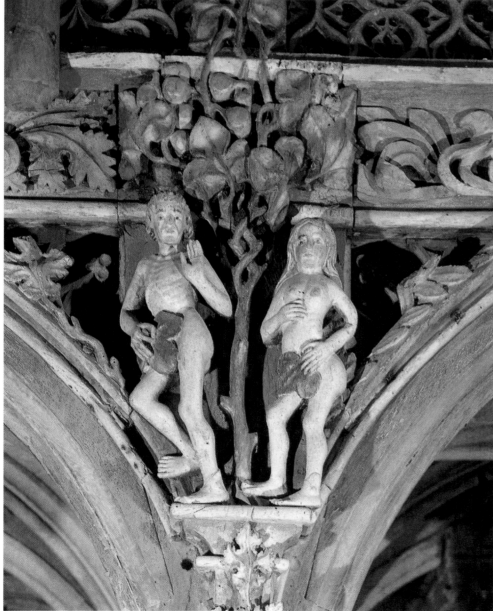

pal facade is topped with a very harmonious bell tower with balconies and turrets, whose clear-cut forms harmonize perfectly with their noble material, granite.

Breton civil architecture of the early Gothic period is severe. The great fortresses of Fougères, Vitré, and Nantes turned an impressive line of defense to the French enemy. In the interior of Brittany stand strongholds like Tonquédec, Suscinio, and La Hunaudaye.

In the golden age of Brittany, a century of peace and prosperity following the victory over the French between the end of the fourteenth century and the end of the fifteenth century, civil architecture underwent a remarkable development. At this time first François II, then Anne of Brittany had their residences built inside the fortress of Nantes, the Grand Logis and the Grand Gouvernement, agreeable buildings furnished with elaborate windows and highly decorated skylights. Together, they flanked the so-called Tower of the Golden Crown. Reached by two spiral staircases, the tower is ornamented on its two uppermost floors with loggias with vast rounded bays, above which is a delicate sculpted decoration in the Flamboyant style. The well, located in front of these buildings, has gilded wrought iron in the form of a ducal crown.

In 1370 Olivier de Clisson, twenty-seventh constable of the king of France, the successor to du Guesclin, took ownership of the château of Josselin and rebuilt it. The enceinte was furnished with nine towers, of which five would be destroyed in the seventeenth century on the orders of Cardinal Richelieu, first minister of Louis XIII. The main body of the dwelling, begun by Clisson, was furnished with a magnificent facade by one of his descendants, Jean II de Rohan, between 1490 and 1510, in a transitional style between Gothic and Renaissance. The grace of its sculpted decor defies the hardness of the granite that composes it. Sculpture adorns every element—the windows and their gables and the openwork gallery, on which symbolic representations alternate, including the fleur-de-lis of the arms of France, the stoats of Brittany, and the words "A Plus" (To More), the motto of the Rohans.

The beauty of this facade derives as much from its proportions as from its decoration. The architect emphasized its vertical lines; to keep the long structure from looking flat, he crowned the building with a very tall roof and broke its horizontal lines with ten two-story dormer windows.

THE CHOIR SCREEN OF THE CHAPEL OF SAINT-FIACRE

———————— • ————————

The chapel of Saint-Fiacre is famous for its choir screen, cut as finely as lace and executed in a picturesque style accentuated with brilliant polychrome. Besides the two thieves flanking Christ on the cross, it depicts Saint John and the Virgin Mary, Adam and Eve, the Annunciation, angels in flight, and Saint Gregory's Mass, as well as colorful scenes from daily life: an apple picker climbing a tree, a richly clad pair of lovers, a seated glutton who holds a barrel on his knees and vomits up a skinned fox. These three scenes may symbolize theft, lust, and drunkenness—and what better antidote to these vices than to see them painted in detail (even if they are depicted with a certain indulgence).

 But the sculptor illustrated the fable of the fox and the chickens simply for the pure joy of telling a story. The fox, disguised as a monk, preaches to the chickens, then starts eating them, before he himself is attacked, and then buried, by the victorious fowl. The choir screen of the chapel of Saint-Fiacre reveals an entire world to us.

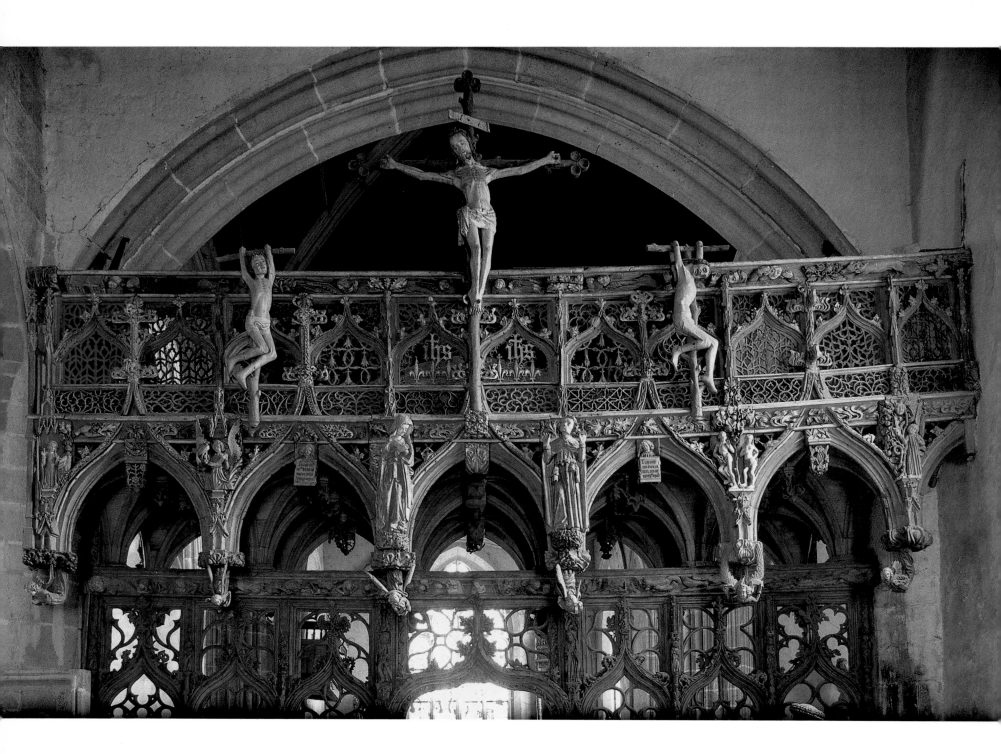

Opposite
FAOUËT, CHAPEL OF
SAINT-FIACRE, CHOIR
SCREEN, 15TH CENTURY
The choir screen contains a highly symbolic iconographic program, with the essential theme of the Crucifixion, Christ flanked by his two companions in torment, uppermost. The groups of Adam and Eve and the Annunciation carry particular significance: the new Eve redeems the sins of the first.

FAOUËT, CHAPEL OF
SAINT-FIACRE, DETAIL
OF THE CHOIR SCREEN,
15TH CENTURY
The monk fully conveys its maker's spirit. Although the passage of time has stripped this figure of its paint and part of its material, it has only gained in expressive power.

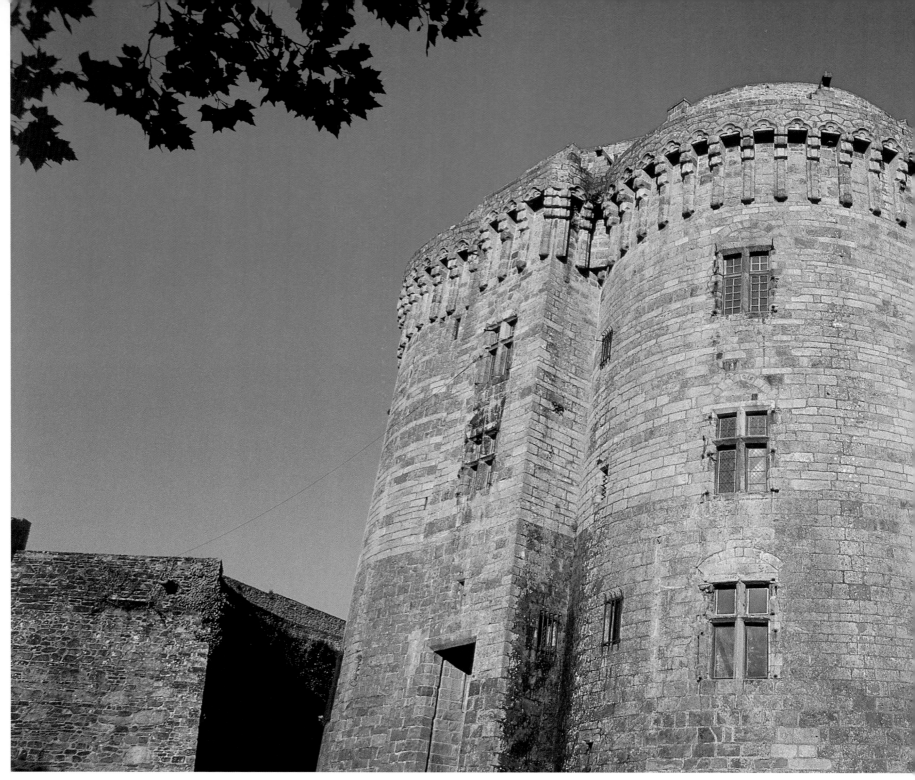

DINAN, DUCAL
CHÂTEAU, KEEP,
COMPLETED IN THE
14TH CENTURY
*The keep, which has an
unusual oval shape, is
the centerpiece of the
fortress of Dinan, whose
walls are 1½ miles (2.5
kilometers) long and are
furnished with twenty-
four towers. Duchess
Anne called Dinan, an
extremely wealthy com-
mercial town, "the
strings to her purse."*

DINAN, THE CITY OF BERTRAND DU GUESCLIN

Like Provins and Carcassonne, Dinan boasts a remarkable wealth of Gothic architecture. A strategic fortress not far from the frontiers of the duchy, Dinan was also an important commercial area. It had a large market, which served the whole surrounding area, and a port on the Rance River where seagoing ships could dock. In the mid-twelfth century the Arabic traveler and geographer al-Idrisi described Dinan as "a city surrounded with stone walls, a trade city, and a port from whence merchandise is sent all around." This richness grew slowly through the ages, and it brought in so many taxes that Duchess Anne considered the

city "the strings to her purse." In the thirteenth and fourteenth centuries, it was surrounded with a wall that extended 1½ miles (2.5 kilometers), almost all of it still standing, as are fifteen or so of the original twenty-four towers and three of its four gates: the Saint-Louis and Saint-Malo Gates and, on the side along the river, the Jerzual Gate that so inspired the painter Camille Corot in the nineteenth century.

In the fourteenth century the château of Duchess Anne was completed. The oval keep is crowned with machicolations decorated with (very rare) pointed three-lobed arches and a roof with a double slope above it. Remarkably, it does not contain any round rooms. An elegant building and the symbol of the power of the ducal house, it dominates the Champ Clos (Closed Field) Square, where the market was—and still is—held.

Dinan still has its two large churches, Saint-Sauveur and Saint-Malo, with magnificent Flamboyant chevets, a bell tower, a belfry, and the remains of its numerous convents, including the Jacobins and the Cordeliers. The convent of the Cordeliers has retained its majestic portal and part of its cloister, precious witnesses of Brittany's "golden age."

The city streets largely retain their medieval names—rue de Grâce (Grace Street), rue de la Ferronnerie (Ironsmith's Street), rue des Rouairies (Wheelwright's Street), rue de la Lainerie (Woolmarket Street), rue de la Poissonnerie (Fishmarket Street), place des Merciers (Mercers' Square), rue de la Larderie (Larders' Street). They are lined with a good number of ancient houses with half-timbered and corbeled construction, some furnished with porticoes. On one of these are the sculpted figures of Democritus and Heraclitus, one laughing, the other weeping, as if to contrast, in rather simplistic fashion, the optimism of the first with the pessimism of the philosopher of the eternal becoming.

Dinan is the city of du Guesclin. He was born in 1320 in the Château de la Mothe at Broons, near Dinan. In 1357 fighting took place around the city. During the battle the Englishman Thomas of Canterbury took du Guesclin's brother Olivier prisoner, and du Guesclin challenged Thomas to single combat. This took place at Dinan, on the Champ Clos Square, with the English leader, the duke of Lancaster, as judge. Du Guesclin emerged triumphant, and his victory led to a further one: the beautiful Typhaine Raguenel of Dinan, knowing of du Guesclin simply by his fame in combat, fell in love with him. They were married in 1363.

WHEN CHARLES V was born in 1338, the Hundred Years' War was a year old. When he died, in 1380, the situation stood in favor of the French, but the conflict continued. The war thus became a major element of the king's entire life. He fought at the side of his father, John the Good, and his brothers at Poitiers, but he had a weak constitution and suffered from a lesion on his left arm and weakness of the right. Later on, these infirmities kept him from fighting in the front lines of battle like all the other kings from Charlemagne to Saint Louis and John the Good. The war he fought, however, was no less harsh; shut up behind the walls and far from the companionship of combat, he pursued a bitter and solitary struggle.

THE "WISE" KING OF DESOLATE TIMES

The nickname "the Wise" given to Charles V carries connotations of both prudence and learning, for—and this was new—the king could read. Certainly kings, lords, and knights loved poetry, literature, and music, but they were primarily soldiers, and culture remained the province of clerics. Thus, John the Good had only ten books in his library. According to an inventory taken in 1373 Charles V, on the other hand, owned 973 manuscripts. His library was especially well furnished in religious works, including psalters, breviaries, saint's lives, and writings of the Church Fathers. A very pious man, the king read through the entire Bible each year. What is more, his library included works of the greatest philosophers and writers of antiquity, such as Aristotle, Seneca, and Livy, encyclopedias like the *Miroir historial* of Vincent de Beauvais, works of poetry, law, history, astronomy, even astrology, natural sciences, and tales of travel, like those of Marco Polo, written in 1298. The king was passionately interested in all branches of knowledge, and as a scholar and a man of reflection, he studied the art of ruling in his books and through his literate councillors, seeking to remedy the catastrophic situation left by his predecessors.

Charles V was eight years old when the French were defeated at Crécy in 1346. He was nine when the Black Plague broke out and, as the fourteenth-century historian Jean Froissart wrote, "a good third part of the world died." With the plague came famine, economic crisis, and perverse behaviors; Jews were perse-cuted as the alleged cause of the plague while a number of people, called the flagellants, punished themselves in public to beg God's forgiveness for the sins that supposedly precipitated the misfortune.

REVOLT IN PARIS AND PEASANTS' REVOLT

In 1356 King John the Good was taken prisoner at the Battle of Poitiers, and Charles V assumed his functions in the interim, first as "lieutenant," then as "regent" of the kingdom, before he inherited it at the death of his father in 1364.

In 1355 King John had summoned the États Généraux, or States-General (an assembly in which the major estates of the nation, usually the clergy, nobles, and cities, were represented) of Languedoïl and Languedoc to obtain the right to raise exceptional taxes. The States-General agreed, but on condition that the taxes be collected under their control and by their agents. In 1357 the regent summoned them once again, to raise funds in order to pay the English the enormous ransom they had demanded for the return of the captured King John. One of the most influential men in Languedoïl's States-General was Étienne Marcel. Born into a rich family of drapers and provost of the merchants of Paris (which had no mayor), he was that city's leading figure. Seeking a reform of the political regime that would put the king under the control of the States-General, he persuaded the States-General of Languedoïl to vote for the Grande Ordonnance (Great Decree) of March 1357, which stipulated that the delegates of the States-General would henceforth be a part of the King's Council. The regent was forced to accept it, but John the Good repudiated the measure from prison. Discontent grew, and Étienne Marcel became spokesman and leader of the dissidents. On February 22, 1358, he attempted a demonstration of force, leading three thousand people to attack the Palais de la Cité. Demonstrators managed to reach the king and before his eyes murdered two of his marshals, Robert de Clermont and Jean de Conflans, their blood soiling the dauphin's robe. Faced with a revolt in the capital, the dauphin secretly left Paris by small boat on March 25 in search of support in the provinces, which were more faithful to the crown.

In May a peasant revolt known as the Jacquerie, from the nobles' nickname for the peasants as the

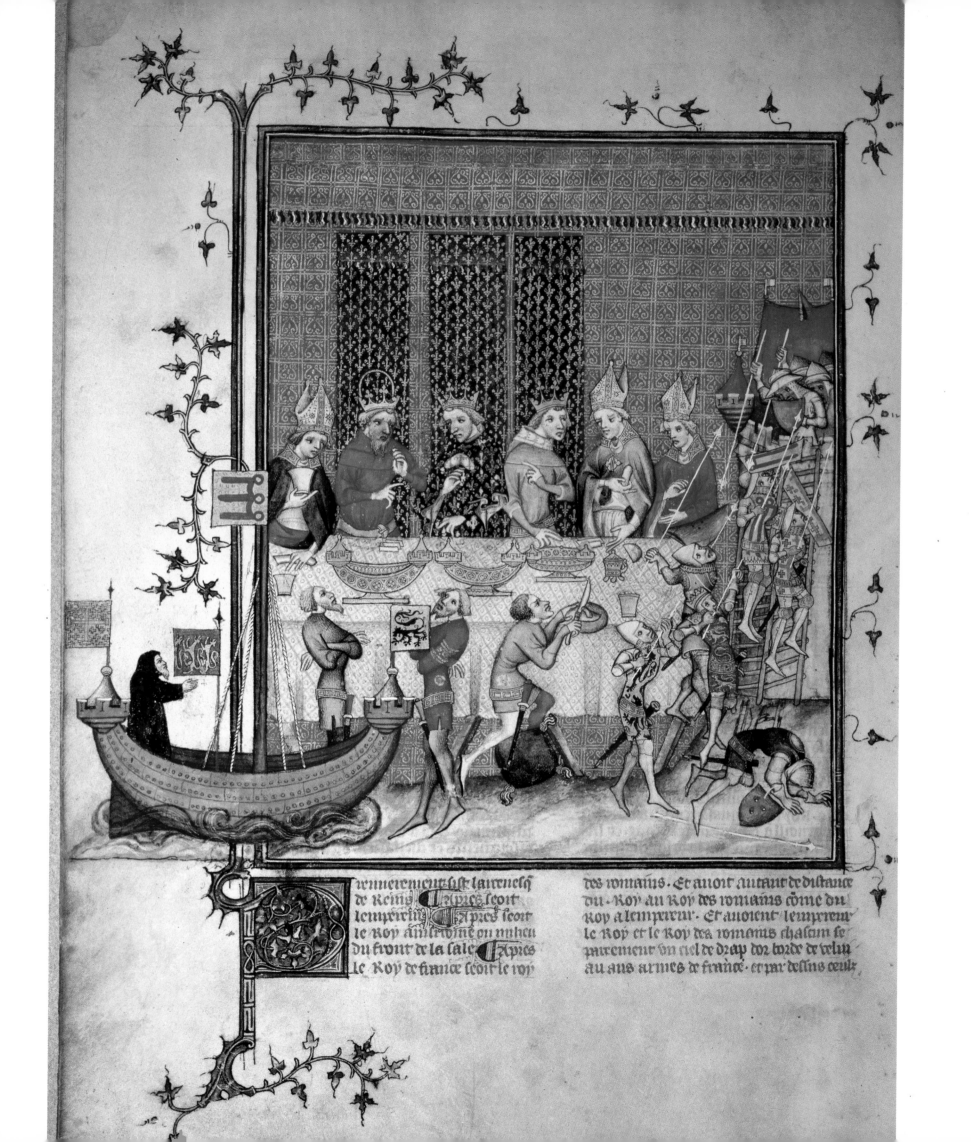

wureinement sift lawrench des romains · Et auoit autant de distance
de Reims · ¶Apres seoit du · Roy au Roy des romains come du
lempereur · ¶Apres seoit Roy a lempereur · Et auoient lempereur le
le Roy auisie ou milieu le Roy et le Roy des romains chascun se
du fwnt de la sale · ¶Apres pairement vn ciel de drap dor borde de velu
le Roy de france seoit le roy au aus armes de france · et par dessus ceulx

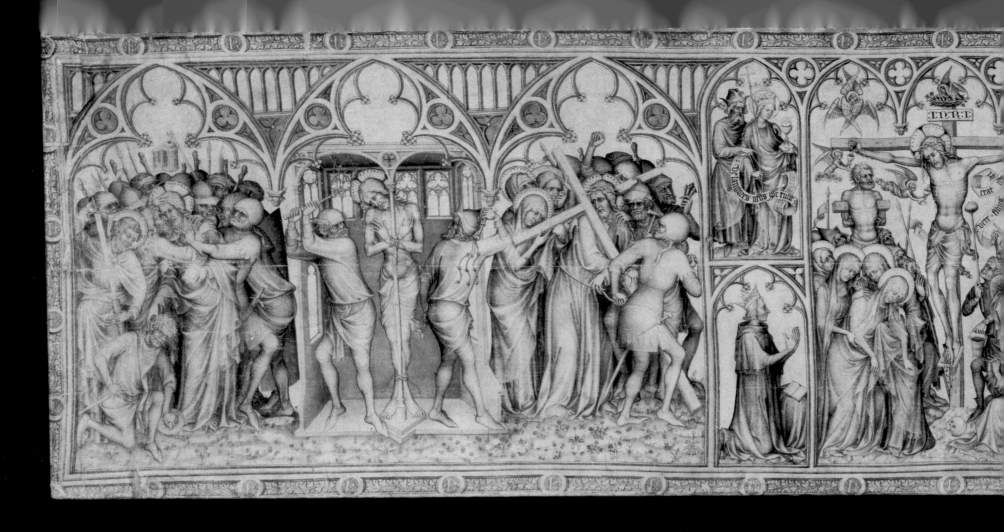

Jacques, broke out in Beauvais, Picardy, then to the north of the Île-de-France. It was directed especially against the nobility. Defeat at Crécy and Poitiers had shaken the peasantry's confidence in them, and from this fact discontent grew rapidly.

The violence of this revolt, as well as the excesses of Étienne Marcel, wrought a change of mind among the bourgeois reformists in Paris. At the same time, the Jacquerie was brutally repressed. Étienne Marcel formed an alliance with the king of Navarre, Charles the Bad, another pretender to the throne of France. This error proved fatal to him; he was assassinated by the Parisians on July 31, 1358, at the very moment he was attempting to open the gates of Paris to the forces of Navarre. The dauphin regained the city on August 4, and the Parisian revolution was, for the moment, over.

In 1360 the French signed a treaty with the English in Brétigny, a village in Normandy, that recognized English sovereignty over Calais, a part of the coast of Picardy, and the southwestern third of the country—roughly all the land stretching between the Loire River and the Pyrenees, on the one hand, and

between the Massif Central and the Atlantic Ocean on the other. The truce lasted until 1369. Charles V reestablished order, justice, and financial equilibrium. He restored monetary stability and created the franc on July 27, 1364. But the treaty proved too heavy a burden; when the Gascon barons came to complain of oppression by the English, Charles V decided to reopen the war in 1369.

At the beginning of the Hundred Years' War France had 16 million inhabitants and an army of 20,000 to 25,000 combatants. England only had 5 million inhabitants, but an army of 25,000. France thus could not blame its defeats at Crécy and Poitiers on an inferior force. Unlike England, it had remained blind to the changes that had taken place in the art of war, until then restricted to the individual exploits of knights. At Crécy, as at Poitiers, it was the horse, more than the knights, that turned out to be point of vulnerability. English archers took particular aim at the animals, which were poorly protected, while the smoke and noise from a few firearms drove them mad with fear.

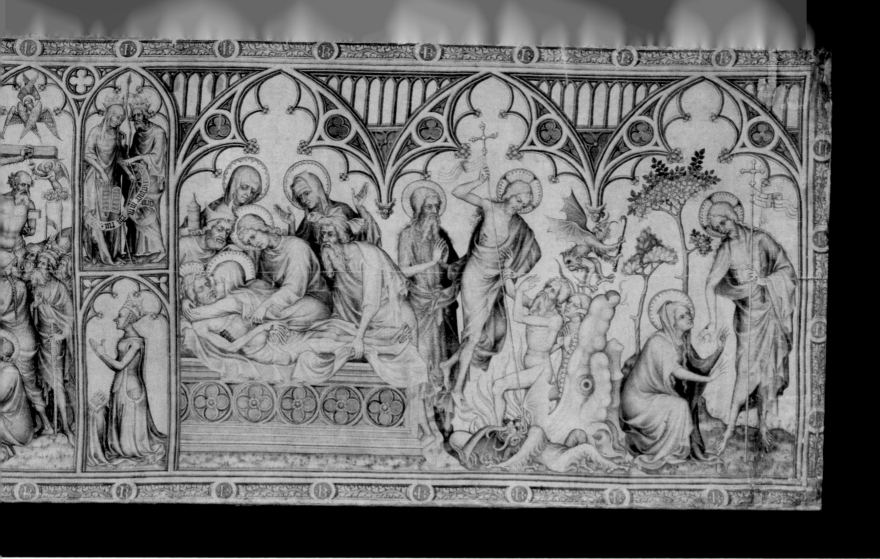

French school,
Narbonne Altar
Frontal, second
half of the 14th
century, black ink
on silk. Musée du
Louvre, Paris

A Sorrowful Work: The Narbonne Altar Frontal

———●———

The Narbonne Altar Frontal is a drawing in grisaille on silk, designed to be hung from the table of the altar during Lent. Divided into three panels, it features the scene of the Crucifixion in the center: to the left of Christ the Virgin, overcome with sorrow, is supported by the holy women; to her right Saint John the Evangelist kneels in prayer, his eyes fixed on the crucifix, overcome by the mystery of this sacrifice.

The left-hand panel depicts the kiss of Judas and the arrest of Christ, then the flagellation and the bearing of the cross. The artist was not sparing of tragic and even cruel details, such as the story of Saint Malchus. Saint Peter cut off the latter's ear while defending Christ, who healed the wound; we see Saint Malchus with his hand on the ear that has been restored to its place and the Apostle putting his long sword back into its scabbard. In a second scene we see the flagellation, with knotted whips; in a third, characters with terrifying faces brandish the hammer and nails with which Christ will be crucified.

The right-hand panel shows the entombment, the descent of Jesus into Limbo, and his appearance to Mary Magdalen. The first scene, in which the Virgin embraces Jesus as if to keep him among the living, is particularly poignant.

Charles V did not completely understand the magnitude of this change. Nonetheless, he managed to adapt to it. He did his best to make use of permanent paid armies in addition to the feudal army. Realizing that the English would retain their superiority in large battles, he turned the difficulty to his own advantage by avoiding them and practicing a war of attrition and skirmishes, at which the Breton Bertrand du Guesclin (who had come to the king's notice as a daredevil who prevailed over Charles the Bad at the Battle of Cocherel in 1364) excelled—no glamorous battles, but the gradual retaking of land and strongholds. In 1380, when the king died at the age of only forty-two, the English had been beaten. Almost entirely driven from France, they held only Calais, Brest, Bordeaux, Bayonne, and some fortifications.

THE ROYAL RESIDENCES: FROM THE LOUVRE TO VINCENNES

King Charles V had a taste for the good life. A peaceful man, he loved family life—he and his wife had nine children—and good company. While small, his court assembled respectable people who were level-headed, literate, worthy, and who loved beautiful things. But this ruler could find happiness only behind walls—walls of the city of Paris, widened on the Right Bank and reinforced on the Left Bank, and walls of the

Louvre. This fortified château, one of the strongest in France, had been built by Philip Augustus to guard the Seine River, which could be blocked by chains stretched between the Coin tower and the Nesle tower on the other side of the river. A square fortress, the Louvre was surrounded by moats filled with water and flanked with engaged towers and two gates opening to the east and south. The keep, 105 feet (32 meters) high to the base of the roof, was built in the center, itself surrounded by a ditch. Under Charles V the Louvre was placed inside the city walls. As it lost its defensive function, it could be brightened up. The king's architect, Raymond du Temple, built two new wings along the curtain walls to the north and the east, crowning the buildings and their towers with roofs of varied forms decorated with turrets, weather vanes, finials, and flags. The Louvre then took on the cheerful aspect shown in the illumination of the Très Riches Heures du duc de Berry. One of these towers housed his library, divided between three large rooms, one on top of the other, lined with Iceland wood on the perimeter and cypress on the ceiling.

But the preferred residence of the king in Paris was the Hôtel Saint-Pol, or the "Grands Esbatements du Roi" of which, unfortunately—like the Louvre of Charles V—nothing remains. It was located between the Seine and the rue Saint-Antoine. Sheltered by a wall, the group of buildings—the principal ones being the mansions of the king, the queen, and the royal children—was joined by galleries and cloisters and surrounded with gardens. Charles V even had a small zoo, which included lions, the symbols of royal power. But, as the riots had left bad memories, the Hôtel Saint-Pol seemed unsafe to him. For this reason he had the fortified castle (bastille) Saint-Antoine built nearby, which came to be known as La Bastille, a mighty fortress that guarded the entrance to Paris by the rue Saint-Antoine.

Vincennes, whose woods were rich in game, had given great pleasure to Saint Louis, who had a manor house built there. Philippe VI and John the Good put in a keep; around its square central section, which included a great hall on every level, four round towers were arranged containing octagonal halls, and a spur to the north for latrines. Charles V had the keep finished and lived there. On the lowest level were the kitchens and the stores of food; on the second floor was the reception hall; on the third the bedchamber of the king and on the fourth that of the children of France;

on the fifth and sixth were dormitories for the officers.

In addition, the king created a vast fortified space enclosing the manor of Saint Louis and the keep, where he invited all of those close to him, as well as important people in the kingdom, to build palaces surrounding his, keeping him company. But the time had not yet come in which, as under Louis XVI at Versailles, the important people of the kingdom would agree to gather around the king, who could then keep them under his control. Feudal individualism and the spirit of independence prevailed: the nobles rejected the royal plans.

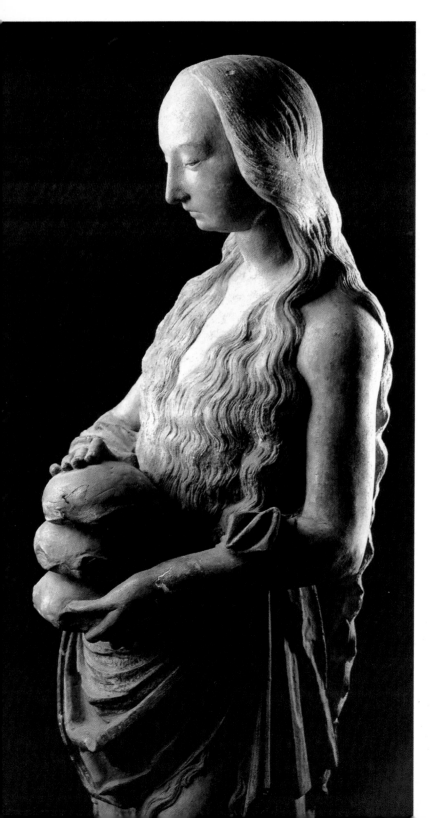

The enclosure, built nonetheless, measures 1,096 feet (334 meters) by 574 feet (175 meters), almost 15 acres (6 hectares) of space. In that period it was flanked by nine towers, of which the best preserved is the Village tower, 138 feet (42 meters) high, the entry to the château. The power and the beauty of its abutments are especially noteworthy. The construction of the chapel was begun in 1379, its vaults finished in the Gothic style in the mid-sixteenth century, by the architect of Henry II, Philippe de l'Orme.

At Vincennes it is possible to imagine what the king's life was like. Winter kept him confined to a small room in the southwest turret. From his window he looked out over the trees of the forest. The small size of this room reminds us that the king was a man alone, since authority, which must attempt to reconcile so many forces and so many diverse interests, isolates. His death, detailed by such authors of the period as Christine de Pisan, reveals the two fundamental traits of his character: piety and political obsession. He asked that Christ's crown of thorns be removed from its shrine in the Sainte-Chapelle and placed by his head, and the royal crown at his feet. He praised the former, and explained that the second was contemptible. Was it not, for him, a poisoned gift?

After his beneficial reign Paris experienced dark days until the end of the Hundred Years' War. While it had 200,000 inhabitants in the fourteenth century, war and civil unrest—for example, the movements of the Maillotins in 1382 and the Caboche in 1413—famines, and epidemics claimed many victims and drove many Parisians to leave the city, which lost half its population. It began to increase once again in 1440. As far as we can tell, by 1450 Paris had again reached the population of the preceding century.

SAINT-GERMAIN-L'AUXERROIS AND SAINT-SÉVERIN: FLAMBOYANT PARIS

Paris in the fifteenth century was still the city of Philip Augustus, Saint Louis, and Charles V. While many of the houses left abandoned during the dark years had deteriorated and had to be destroyed, the essential part of the city was preserved. Its heart remained the Île-de-la-Cité. In an illumination from the Book of Hours of Estienne Chevalier, one of the most beautiful works of the Gothic period, Jean Fouquet painted it about 1450, seen from the Left Bank. He depicted

SAINT MARY OF EGYPT, 15TH CENTURY. CHURCH OF SAINT-GERMAIN-L'AUXERROIS, PARIS *The saint was depicted nude, clothed only in her hair, bearing the three loaves of bread with which she fed herself during the forty-seven years she lived in the desert. Realism and symbolism are united in this work, full of freshness and expressive power.*

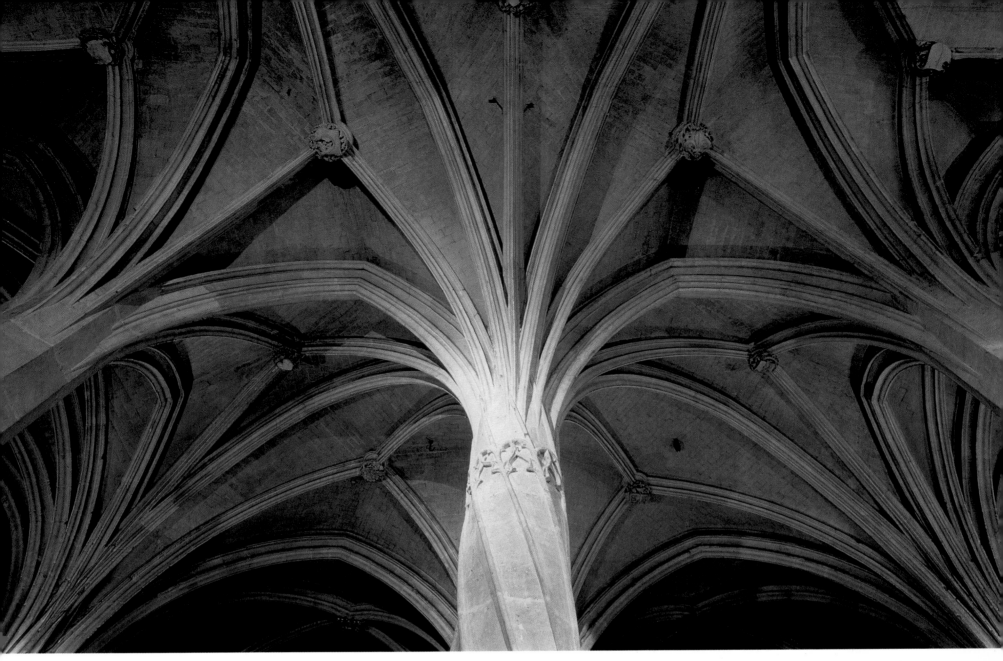

covered bridges that, like the Ponte Vecchio in Florence, sheltered the most luxurious boutiques, the goldsmiths, and the mercers (who specialized in expensive clothing), for these were the liveliest parts of the city. The mills were also located there, and their wheels turned under most of the arches.

Even before the final return of peace, modifications to the church of Saint-Germain-l'Auxerrois were begun in 1435. First it was fitted with a porch, then the nave, transept, and aisles were rebuilt. Of the thirteenth-century church only the portal and the choir remain. The building is almost entirely in the Flamboyant style: the elevation is reduced to two levels, with large arcades and high windows, and the network of ribbing is very complex, especially in the vaults of the porch and those of the south arm of the transept, divided into twenty compartments.

The church contains one of the most interesting sculptures of the fifteenth century, of Saint Mary of Egypt, supposedly a prostitute in Alexandria and

Jerusalem of the third or fourth century who withdrew to the desert of Jordan. The sculpture represents her carrying the few loaves of bread she ate for forty-seven years, each loaf miraculously being replaced as soon it was eaten.

Saint-Séverin, an even greater masterpiece of Flamboyant religious architecture in Paris, is the largest parish church on the Left Bank. Faced with a flood of the faithful, it had to be enlarged, which could only be done in its wide dimension, by creating a second aisle. Its pillars, from which the ribs emerge imperceptibly, like the branches of a tree from its trunk, are exceptional, especially the central pillar, where the ribs continue to run down the shaft in spirals.

The cloister of Saint-Séverin was a cemetery or charnel house. In the Middle Ages, people wanted to be buried in the house of God itself, but since there was not sufficient room for all, they hoped at least to lie near the church, in the "holy land" that surrounded it. For this reason the cloister of Saint-

Séverin is scattered with individual and mass graves. After a certain amount of time, some of them were emptied by the grave diggers, who carried the bones to storehouses over the galleries. The latter were destroyed in the last century and replaced by the new gables and roofs now visible.

The cemetery of the Innocents, in the neighborhood of the Halles, was much larger. On the end wall of its galleries a famous *danse macabre,* or "dance of death," was painted. This was a favorite place for taking a stroll, and even for assignations.

THE SHADOW OF FRANÇOIS VILLON

François Villon, born in 1431, came from the Saint-Séverin district. His mother, who was a widow and too poor to raise him, gave him as a child to Guillaume de Villon, the chaplain of Saint-Benoît-le-Bétourné, a small church that stood near the rue Saint-Jacques. Guillaume, whom François called "more than a father" and whose name he took, gave him a good education. He was accepted as master of arts in 1452. But his tastes lay elsewhere; his works reflect his many amorous adventures with coquettes, such as Catherine de Vausselles and Marthe, whose fickle hearts disappointed him; with young girls called "fillettes amoureuses," or little girls of love, like "Marion l'Idole," "Grant Jehanne de Bretagne," or "Grosse Margot," in whose clutches he even admitted having lived for a time; with the amiable "chamberières," young servants who liked, once their masters were asleep, to carouse in the cellars. "All to the taverns and to the girls": Villon frequented a joyous company of revelers, drinkers, players, cheats, and rowdies—which describes many students and some clerics in those days.

In 1455, during a quarrel over a woman, he killed a priest named Philippe Sermoise with a dagger and was forced to flee. Returning to Paris, he obtained "letters of remission" for this murder, but shortly thereafter, in 1456, with four companions, including his friend Colin de Cayeux, whose father was a locksmith and who furnished copies of keys, he took part in the theft of a large sum of money from the coffers of the Collège of Navarre.

After this "big haul," it was too dangerous to stay in Paris. He left for Angers after having written the *Lais,* also called the *Petit Testament,* a poem composed of forty-eight stanzas of eight lines each in which he describes in a comic style the fictitious bequests he intends to leave to various people. His first work, it sparkles with youth and liveliness, as well as biting ironic satire, as when he criticizes the gluttony and lasciviousness of some religious figures.

From 1456 to 1461 he skulked along the banks of the Loire. A vagabond and destitute, trying his hand at all the trades and certainly still engaging in crime, he tried, with no lasting success, to obtain the protection of a patron like King René of Angers or Charles d'Orléans, the poet, at Blois. There he was imprisoned on the orders of Bishop Thibaud d'Auxigny. Would he be hanged, like Colin de Cayeux? He won amnesty, in honor of passage through the city by the new king, Louis XI.

No doubt he again tried his luck, this time in Moulins, with the duke of Bourbon, then returned to Paris. There in 1461 he wrote his major work, the *Testament,* a poem of 186 stanzas of eight lines each, interspersed with ballads. In this, another burlesque testament, he marvelously imitates legalistic language, inspired by the taste for parody so characteristic of the Middle Ages. The tone has nonetheless changed: underneath the irony, the humor, the satire, we see the tears and a profound tragedy. How could his destiny henceforth change? Still young, he has already lost all his chances. Death obsessed him; it is everywhere in his poem, the image of a very near demise:

> *La mort le fait fremir, pallir,*
> *Le nez courber, les vaines tendre,*
>
> *Corps femenin, qui tant est tendre,*
> *Poly, souef [douce], si precieux,*
> *Te faudra il ces maux attendre? . . .*
>
> (Death makes him shudder, blanch,
> Bends the nose, stretches the veins,
>
> Woman's body, which is so tender,
> Smooth, soft, so precious,
> Must these ills await you?)

In Paris he was imprisoned for theft. Then, after a brawl, he was condemned to be hanged. It is believed that he wrote his *Ballade des pendus* (Ballad of the Hanged Men) at this time. However, he appealed the sentence and saved his neck; the sentence was

WOODCUT FROM FRANÇOIS VILLON, *LA BALLADE DES PENDUS,* LEVET, 1489 *The few black lines in this incunabulum, one of the first books printed, are as poignant as the words of Villon's poem* La Ballade des Pendus (The Ballad of the Hanged Men); *both simultaneously express religious sentiment and a penchant for the picturesque and the macabre, a mixture characteristic of the medieval soul.*

Epitaphe dudit Villon
Freres humains qui apres no⁹ viues
Nayez les cueurs contre no⁹ endurcis

commuted to banishment from Paris for ten years. He left in 1463; there is no further trace of him.

In his work, Villon brought to life an entire society with realism, verve, and color, a medieval style used by François Rabelais not long after. Through his verses we witness the crowded streets of the Paris of his time. The torments of his soul were shared by many of his contemporaries who, shaken in their certainties by the torment of the Hundred Years' War, sought their way through paths strewn with doubt.

BETWEEN COURTYARD AND GARDENS: THE *HÔTELS* OF SENS AND CLUNY

The end of the fifteenth century saw affluence return to Paris once and for all. Great lords and prelates, as well as financiers, "royal officers" (high functionaries), judges, and lawyers had splendid dwellings built for themselves.

The Hôtel de Sens was begun in 1475 to replace the former residence of the archbishop of Sens. Paris was only the seat of a bishop, a dependent of Sens, whose archbishop had to stay there regularly.

The *hôtel* was still a dwelling of the Middle Ages in its structure and its residual defensive function. Like a feudal fortress, it turned in on itself, toward a closed triangular court that was as large as possible. From its large tower, which housed the staircase, as well as from its three corner turrets, watch could easily be kept. This is because the city was not safe, stalked at night by criminals, and from time to time shaken by riots.

It was also medieval in the arrangement of its sculpted decor on the building's exterior, for ornamentation becomes more abundant on its upper reaches. The *hôtel*, in fact, was conceived along the same lines as the fortified châteaux of the end of the Middle Ages, whose lower parts, which could be attacked or scaled, were left bare, while the upper levels, like the dormer windows here, were richly ornamented.

The Hôtel de Sens fell into disrepair in the nineteenth century, and restoration on it began in 1911. The least dilapidated portion, and thus the least restored, is its narrow principal facade, which provides an admirable example of the medieval taste for asymmetry. It is flanked by two corner turrets, but

these are slightly different in their dimensions and their look; the turret to the left is surmounted by a triangular gable, the one to the right by a sculpted dormer, and none of the windows matches the others in either their horizontal or their vertical aspect.

The construction between 1485 and 1510 of the *hôtel* of the abbots of Cluny marks a very important stage in the evolution of Parisian dwellings. It retained its defensive aspect; the wall on the street is crenellated, the sculpted balustrade at the edge of the roof hides a walkway, and the top of the tower may, like a feudal keep, be used as a guard post. But the emphasis is on habitability and comfort; the *hôtel* is the very prototype of what was later called "the *hôtel* between courtyard and gardens."

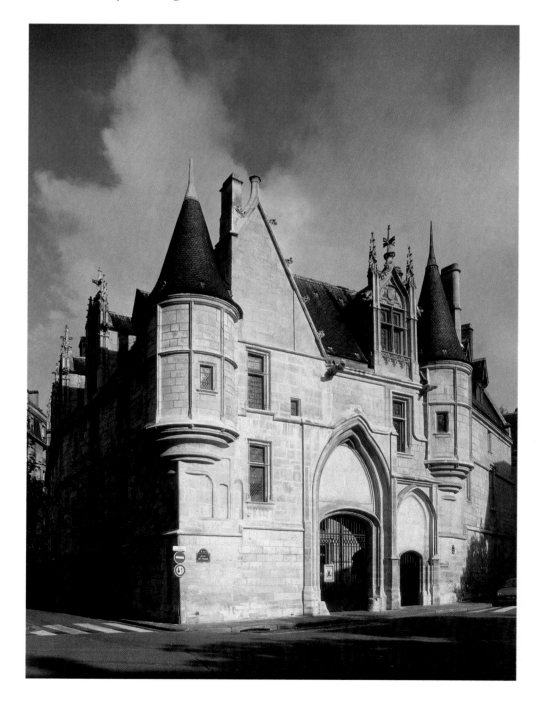

PARIS, *HÔTEL* OF THE
ABBOTS OF CLUNY,
CHAPEL, 1485–1510
*Abbots, such as the head
of the powerful abbey of
Cluny, kept residences
in the city of Paris. The
chapel of their Parisian
hôtel is one of the mas-
terpieces of Flamboyant
architecture: a single
central pillar receives
an entire network of
ribbing.*

Opposite
PARIS, *HÔTEL* OF THE
ARCHBISHOPS OF SENS,
EAST FACADE, BEGUN
1475
*As the cities were not
safe places in the fif-
teenth century, the
residences of the elite,
like the archbishops of
Sens, were built like the
fortresses of the period:
austere walls with few
openings. But such aus-
terity was compensated
for in the upper levels by
abundant architectural
elements, such as the
dormer windows, that
were beyond the reach
of ladders and arrows.*

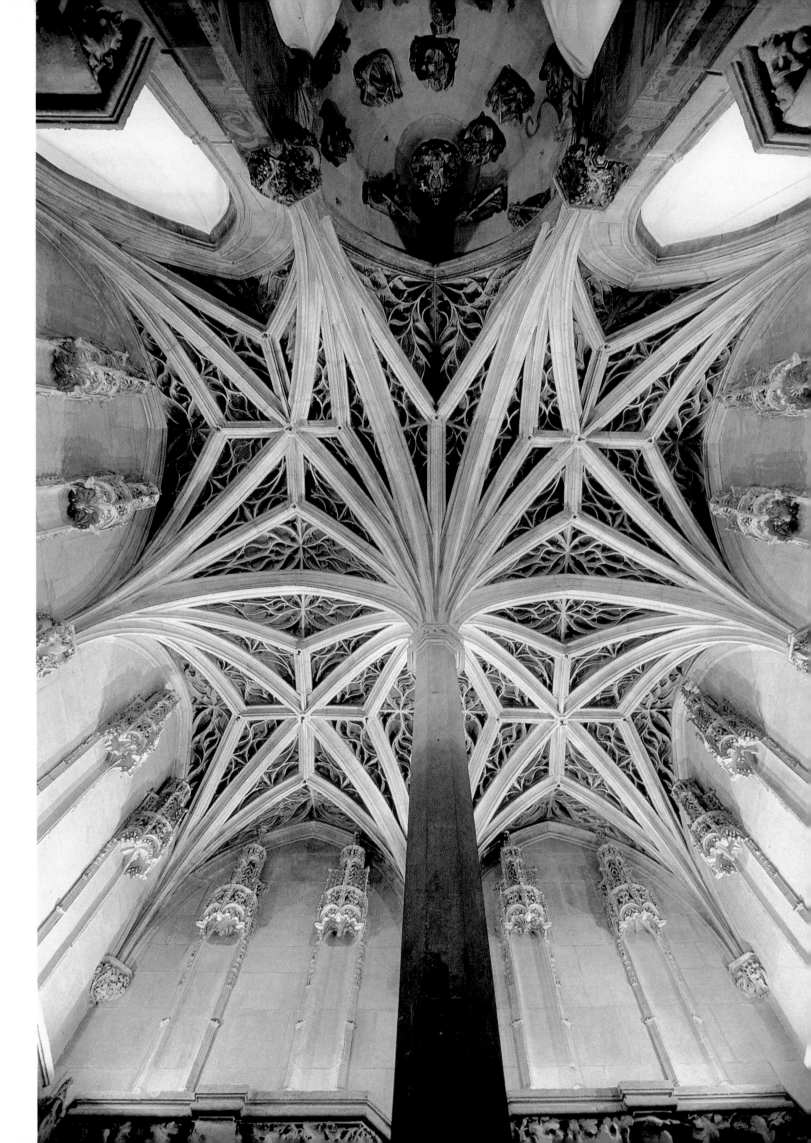

In the courtyard, the arcades of pointed arches of the left-hand building, the frames and mullions of the windows, the downspouts, the low-relief sculptures that ornament the tower compose a very elaborate whole. This side of the structure was given more ornamentation since it "presented" the building. The decoration of the facade overlooking the garden is simpler; its dormers, in particular, are narrower. Nonetheless, the chapel, which faces the garden, is an architectural triumph; located on the second floor, it is organized around the central pillar, from which springs a complicated network of ribbing; it is supported on the ground floor by a single colonnette with a magnificent capital.

The decor of the Hôtel de Cluny is a masterpiece of the art of its time, but this time represents the end of the Middle Ages, an art infatuated with the fantastic, which sought new forms by tormenting the ancient—like the thinking of the time, which also became contorted. This was the period of the Middle Ages that first fascinated the Romantics, as if the last medieval dead were the first to be reborn.

THE UNICORN'S CASKET

Confiscated during the Revolution, the Hôtel de Cluny housed Alexandre du Sommerard in the nineteenth century, who there gathered together all the medieval objects he could find. This was the beginning of the collection now preserved in the Musée de Cluny.

The most beautiful treasure in the museum is the series of tapestries called *The Lady and the Unicorn*. These were woven at the end of the fifteenth century for a member of the Le Viste family, a rich family of magistrates from Lyons. Millefleur-style tapestries, they do not tell a story but instead present genre scenes on a background depicting a meadow sprinkled with flowers, plants, trees (here, pine, holly, orange, and oak) and animals (here, rabbits, foxes, sheep, monkeys, goats, pheasants). The millefleurs usually have a green background, but in this tapestry— a great rarity—it was originally red; the passage of time has now softened the color to rose. A young woman and her servant, wearing rich clothes, stand on a mound, originally blue and now green, accompanied by a lion and a unicorn.

A masculine symbol, the lion allegorically represents the faithful love of the man, who in the courtly

PARIS, *HÔTEL* OF THE ABBOTS OF CLUNY, COURTYARD FACADE, 1485–1510
This hôtel, *built not long after that of the archbishops of Sens, is an innovative building, a prototype of the* hôtel *"between courtyard and gardens," designed to make the interior as comfortable and bright as possible. Since it was set back from the street and protected by high walls, the dwelling could be furnished with large windows.*

The dwelling lies at the end of the courtyard, somewhat withdrawn from the street and its noises. The courtyard, unlike the street, presents clean paving stones on which one could alight from carriage or horse. Wings that frame and focus attention on the main building close off the courtyard on the other two sides. Five circular stairways located in the central tower and the turrets lead to the upper floors. The principal rooms are on the second floor, the "best floor," since the moisture from the ground could not reach it. Since the corridor had not yet been invented, they open into each other.

The sculpted decoration of the Hôtel de Cluny is very rich. The lintels of the two entry doors bear the forms of the Flamboyant style; one is shaped like a basket handle (its outline formed by uprights ending in a half circle), the other an ogee arch. The larger of these doors is surrounded with friezes displaying angels, fantastic animals, foliage, grapes, and snails.

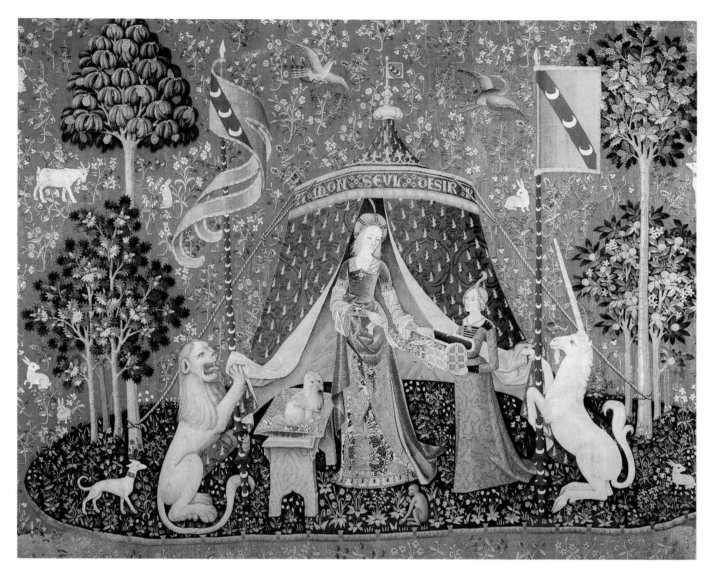

tradition respects and swears allegiance to his Lady. The unicorn is a legendary animal dear to the medieval imagination. No one doubted its existence. The white unicorn had a marvelous quality: no one could catch it, but when it saw a virgin it came to her without fear and rested its head on her knees. Thus made vulnerable, only then could it be captured.

Through the idea of virginity, symbolized by the presence of this legendary animal, it is the woman's youth, and, through her, all youth, to which the series in the Cluny museum pays homage. These feminine figures seem to have been frozen for an eternity at the peak of their beauty. In the panel called "À mon seul désir" (to my sole desire) the young woman selects jewelry from a casket that has been sent to her, no doubt by the man who is in love with her. The theme of the other pieces is the allegorical evocation of the five senses: in "Sight," she holds up a mirror to the unicorn reflected in it; in "Hearing," she plays the organ while her servant, standing behind the instrument, works the bellows; in "Scent," she weaves a chaplet of flowers that she has chosen from a basin; in "Taste," she makes a selection from a box of sweets, with climbing roses on a fence in the background; in "Touch," she strokes the horn of the mythical beast.

Why is the moment of youth so brief and so beautiful? Thus asks these two masterworks from the fifteenth century, the poetry of François Villon and the tapestries of the *Lady and the Unicorn*. Each expresses the sentiment with a great deal of poetry, but with different emotions, cheerful for one, tragic for the other.

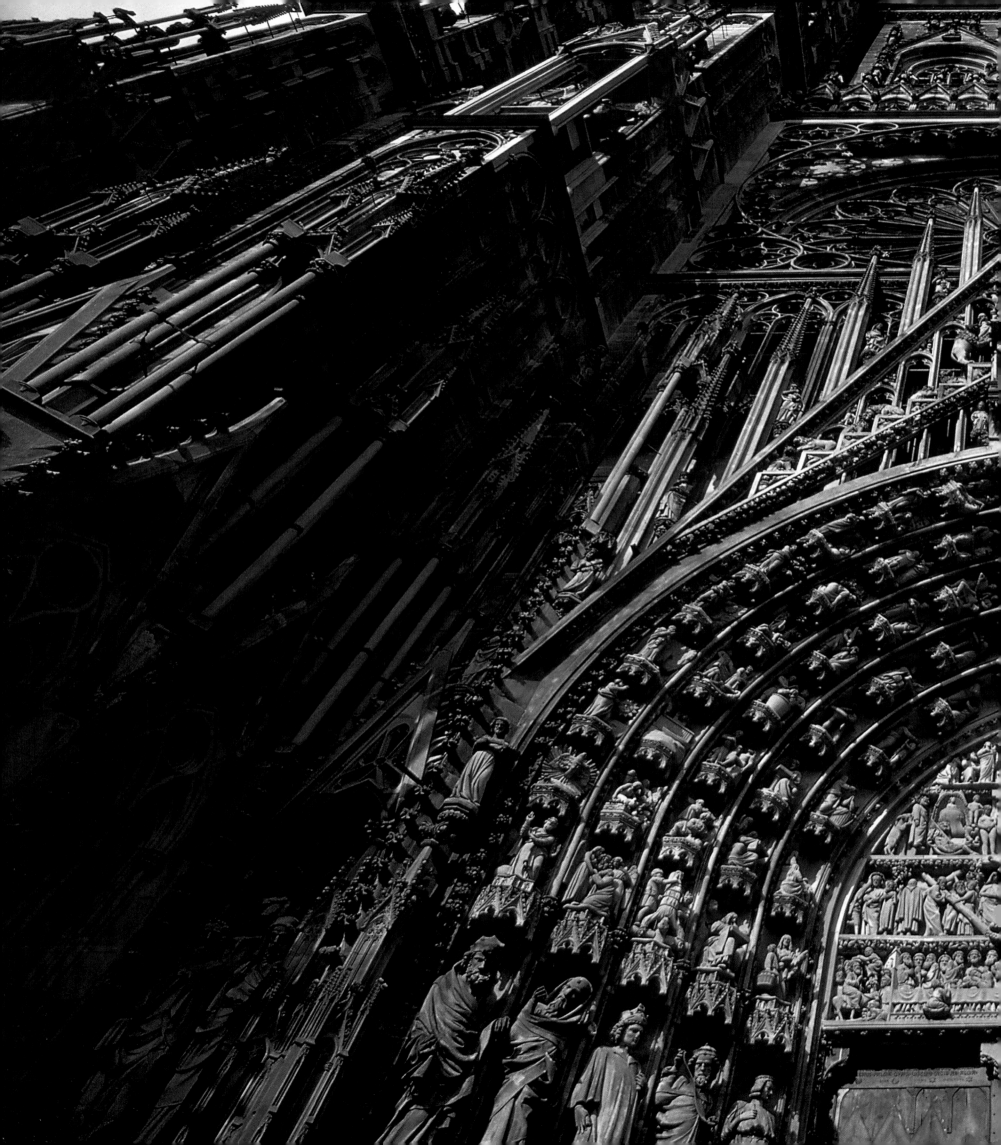

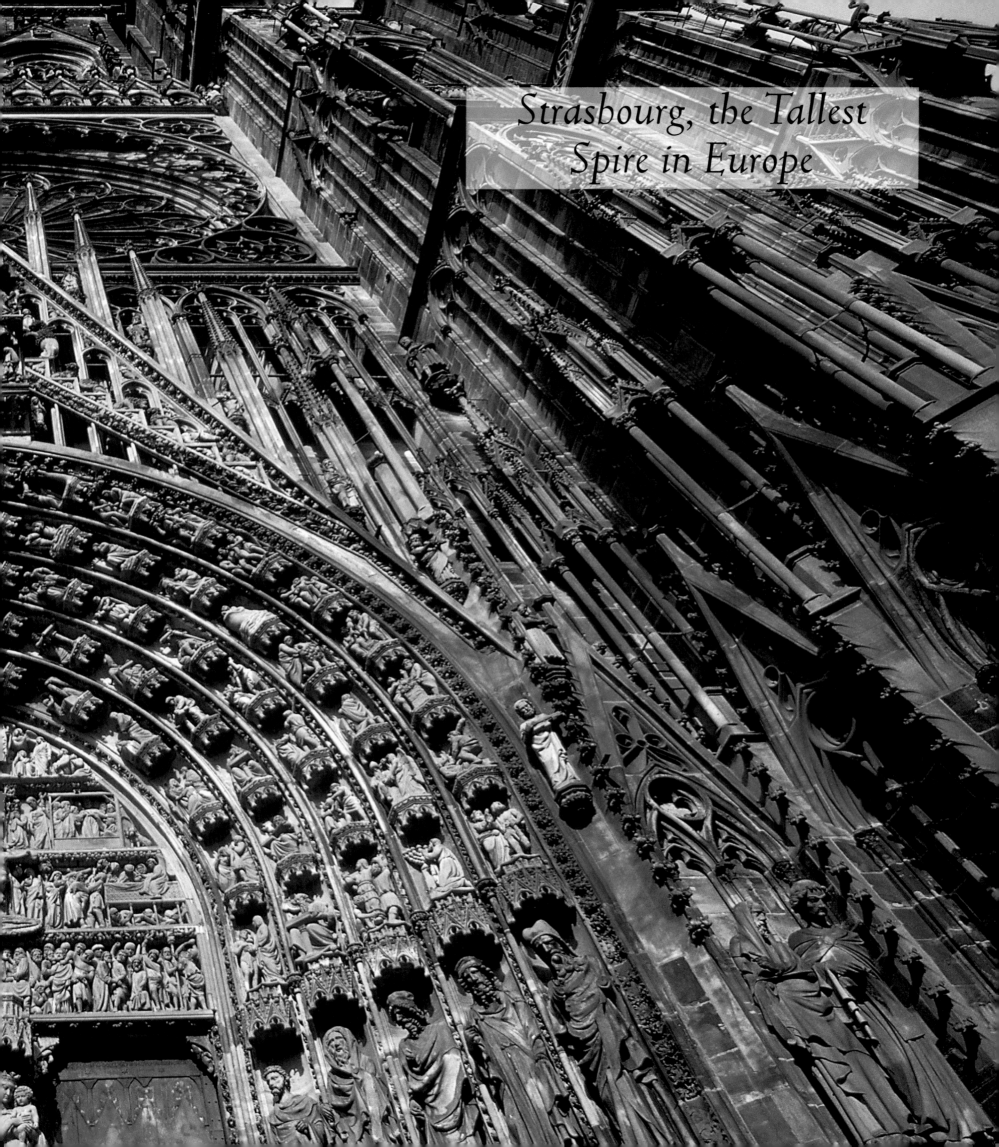
Strasbourg, the Tallest Spire in Europe

L IKE VENICE, Strasbourg was established on an island, formed by the two arms of the Ill River, itself a tributary of the Rhine. The city is bathed by the waters: at the mills, they boil like mountain tor-rents; elsewhere, more peaceful, they sparkle with a thousand reflections. When Johannes Tauler of Stras-bourg (d. 1361), one of the greatest mystics of the Middle Ages, wanted to express the joys of contem-plation in an understandable way, he did so by com-paring them with the even more beautiful light of the waters: "it is a light that no created intelligence may grasp or understand naturally; it is untamed because it cannot be gotten at; in this the mind is led above itself, above everything we are capable of conceiving or understanding. So we drink the bright water at its very source, at its true and central upwelling. Oh! It is delicious and cool and pure: all fresh waters are deli-cious, pure and cool at their springs, but warm and bitter in rivers. Oh! What fresh, pure, and exquisite water is given to us here at its source! Here the soul plunges itself entirely into all that it is, everything of which it is capable: it would like to drink great gulps, but it is impossible here on earth."

The waters also contributed to the city's unique commercial situation. Located at the crossroads of many river and land routes, the city became known as Strate-Burg, "the city of roads," which brought its citi-zens great wealth. This enabled the people of Stras-bourg to gain their autonomy in the heart of the vast Holy Roman Empire. The city was first ruled by its bish-ops, but its burghers, allying themselves with Rodolphe de Hapsbourg, seized power after their victory over Bishop Walther de Geroldseck at Hausburger in 1262.

After many struggles between rival factions, the final constitution of the city was proclaimed in 1482, which made it a small republic. Twenty corporations elected three hundred deputy mayors from which were chosen the members of the executive council. The city's real head was the Ammeister ("head of the trades"), as well as the members of the council and the commissions. Louis XIV respected these institutions, which survived until the Revolution.

ROMANESQUE, HIGH GOTHIC, FLAMBOYANT

Bishop Wernher began construction of a magnificent Romanesque basilica in 1015, sister of those in Mainz,

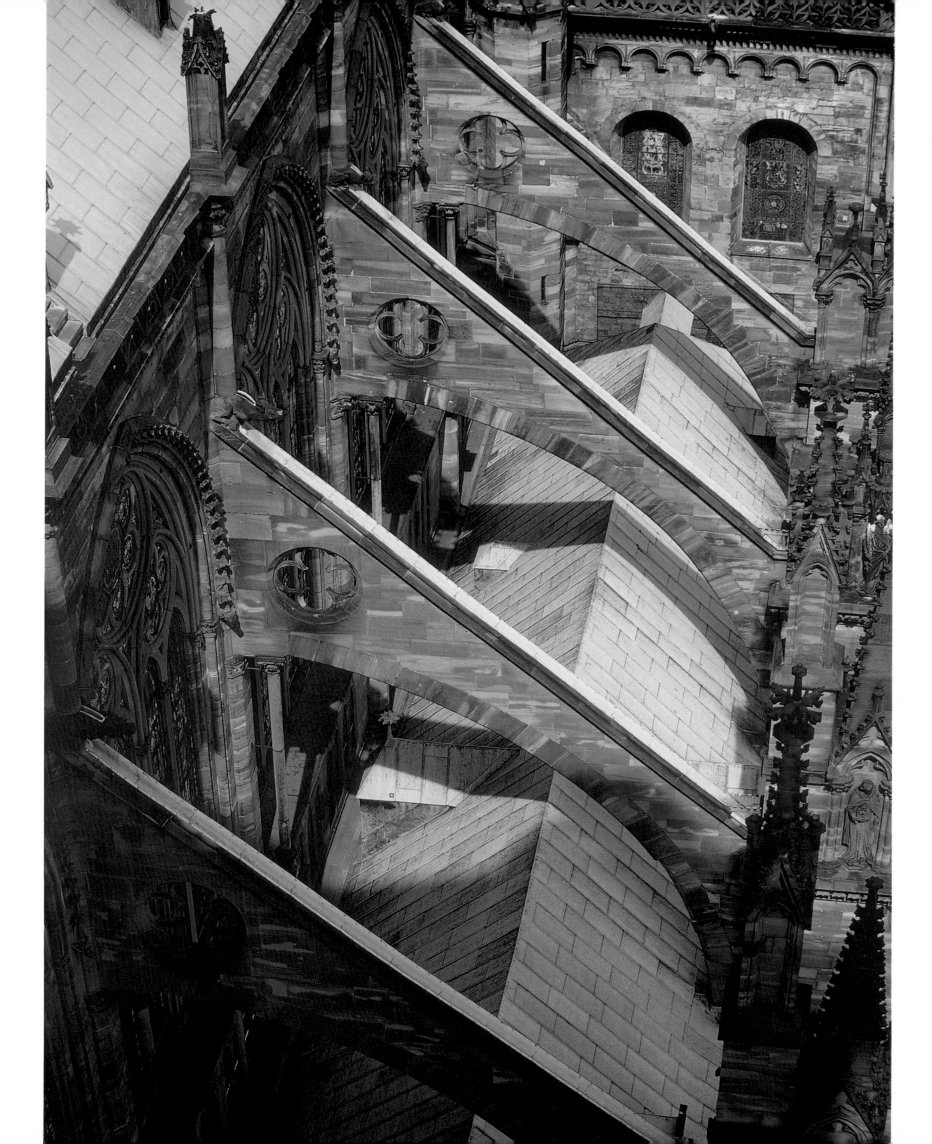

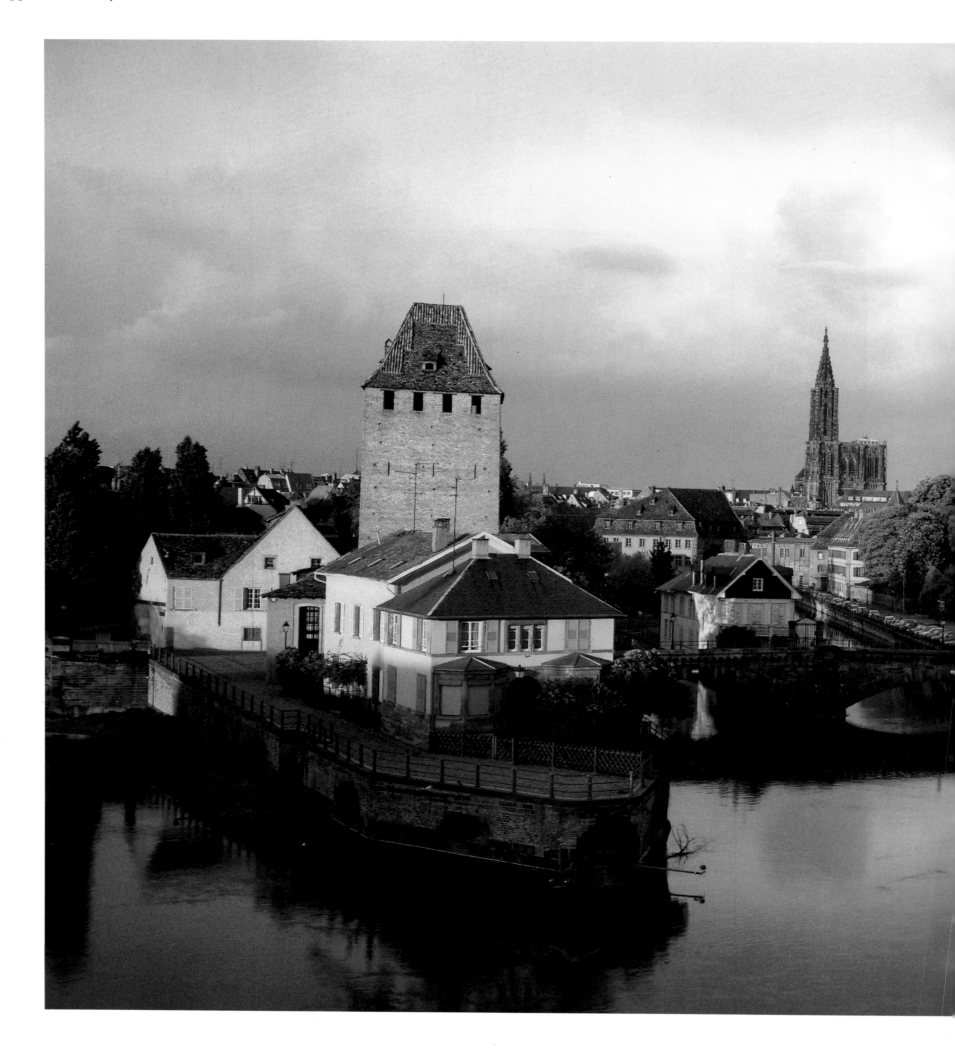

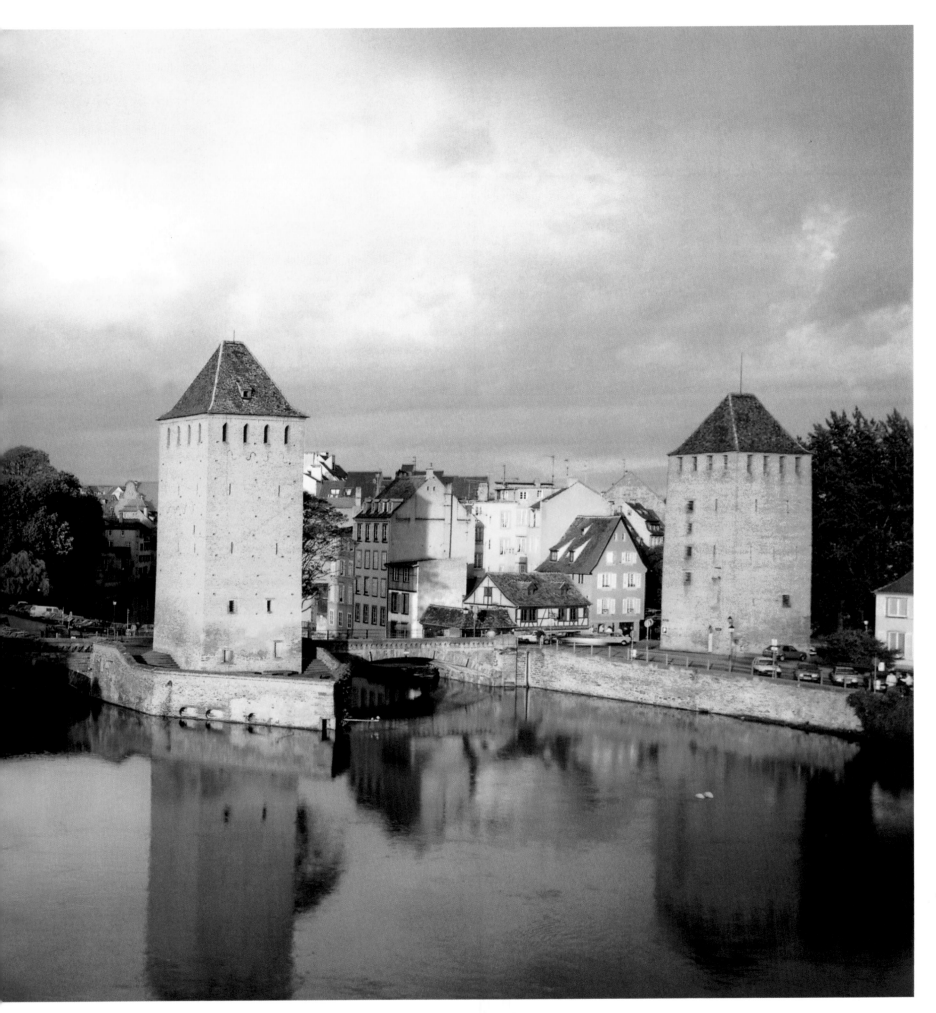

Speyer, and Worms, in Germany. When a fire destroyed it in 1176 it was decided to rebuild the church, beginning with the choir and the apse, in the Romanesque style.

In the meantime the wind of the architectural revolution from the Île-de-France arrived in Strasbourg, and the south transept and the nave were built in the new Gothic style from 1225 to 1275. With its three-story elevation, high, wide windows, and fairly low vaults for a second-generation cathedral (105 feet, or 32 meters), the nave has a strong relationship with that of the cathedral of Troyes or the basilica of Saint-Denis in its final state. It is furnished with a single aisle, rather wide, flanking the nave. Inside the cathedral, the viewer is immediately struck by its distinct light; it has preserved its highly original stained-glass windows from the thirteenth and fourteenth centuries, in which—even in the oldest—white and bright colors dominate, yellow and green.

The construction of the building culminated in a westwork, the site of the principal facade and tower. After the first master builder worked there, from 1277 to 1284, came an architectural genius, Erwin von Steinbach, from 1284 to 1318, and then his son, who followed his father's plans. The Steinbachs brought the facade up to the gallery of the second story, which runs below the large rose window. Erwin von Steinbach, like his predecessor, intended to build two immense towers crowned with spires beginning from this level. To support them, the walls and abutments form powerful masses of masonry, which the architect makes us forget with a foreground composed of a tracery of very thin stone of elongated proportion—a veritable stone harp. In order to prevent the rose window between these walls from appearing to be recessed, he wanted to continue the tracery in front of the rose, repeating its forms in stone alone.

The masters charged with carrying out the work did not follow the initial plan. They instead created another level above the rose. Even though the first design remained unfulfilled, the building nonetheless gained in power and force: this wall, 217 feet (66 meters) high to the "platform" at the base of the tower, is impressive.

In 1399 Ulrich von Ensingen began the octagonal tower. From 1419 to 1439, Johannes Hültz built the pyramid-shaped spire that rises above the tower and crowns the cathedral 466 feet (142 meters) above the ground. Until it was surpassed in the nineteenth century by the new cast-iron spire of the cathedral of Rouen, Strasbourg had the tallest spire in Europe, proclaiming, high in the sky over Alsace, the greatness of God and man.

The Oeuvre (building fund) de Notre-Dame is an institution that, like the cathedral, lasted through the centuries. It was founded to gather and administer the funds destined for the construction, and then the upkeep, of the building. The large house of the Oeuvre de Notre-Dame, part of which dates to 1347, also contains a museum devoted to Alsatian art of the Middle Ages and Renaissance. Some sculptures from the cathedral that suffered too much from the weather, notably Synagogue and the Tempter, are stored there, while good copies replaced them. It also displays the drawings of the architects who worked on the cathedral. The lines of the building and each of the designs decorating it are traced in ink, and every detail recorded. The sculptures are noted in a few lines touched up with gouache. It is moving to see the care and patience that went into these drawings; each of them is a work of art in itself.

PILLAR OF THE ANGELS

The building of the cathedral gave rise to the development of an original school of sculpture of expressive grace and vivid fantasy. A single master is perhaps the creator of the Pillar of the Angels and two statues symbolizing Church and Synagogue, about 1230–40. The Pillar of the Angels, which rises in the center of the south arm of the transept, takes as its theme the Last Judgment. The four Evangelists, whose emblems are sculpted on the consoles to allow easy identification, grace the first level; on the second, four angels sound the trumpet announcing the hour of judgment. Christ, on the third, looks out over the souls who awake from Limbo. He is surrounded by three angels bearing the instruments of the Passion: one holds the lance that pierced Christ's side, a second holds the crown of thorns, the third, the cross and the nails. In order to avoid monotony, the artist endeavored to animate the bodies of the angels who sound the trumpet and those of the Evangelists. His work was emphasized with bright colors, of which traces remain; Christ was entirely gilded.

The south transept opens to the exterior by means of two small portals framed by the statues representing Church and Synagogue. The first, crowned and holding the cross and the chalice, looks in perplexity at the second, who turns away and looks at the

STRASBOURG, CATHEDRAL, WEST FACADE, 13TH–14TH CENTURIES
Successive master builders, among them Erwin von Steinbach from 1284 to 1318, worked on this facade to a massive westwork. To support the tallest spire in Europe (466 feet, or 142 meters), its walls and buttresses are very imposing, yet the architectural decoration added to it makes it seem light and transparent.

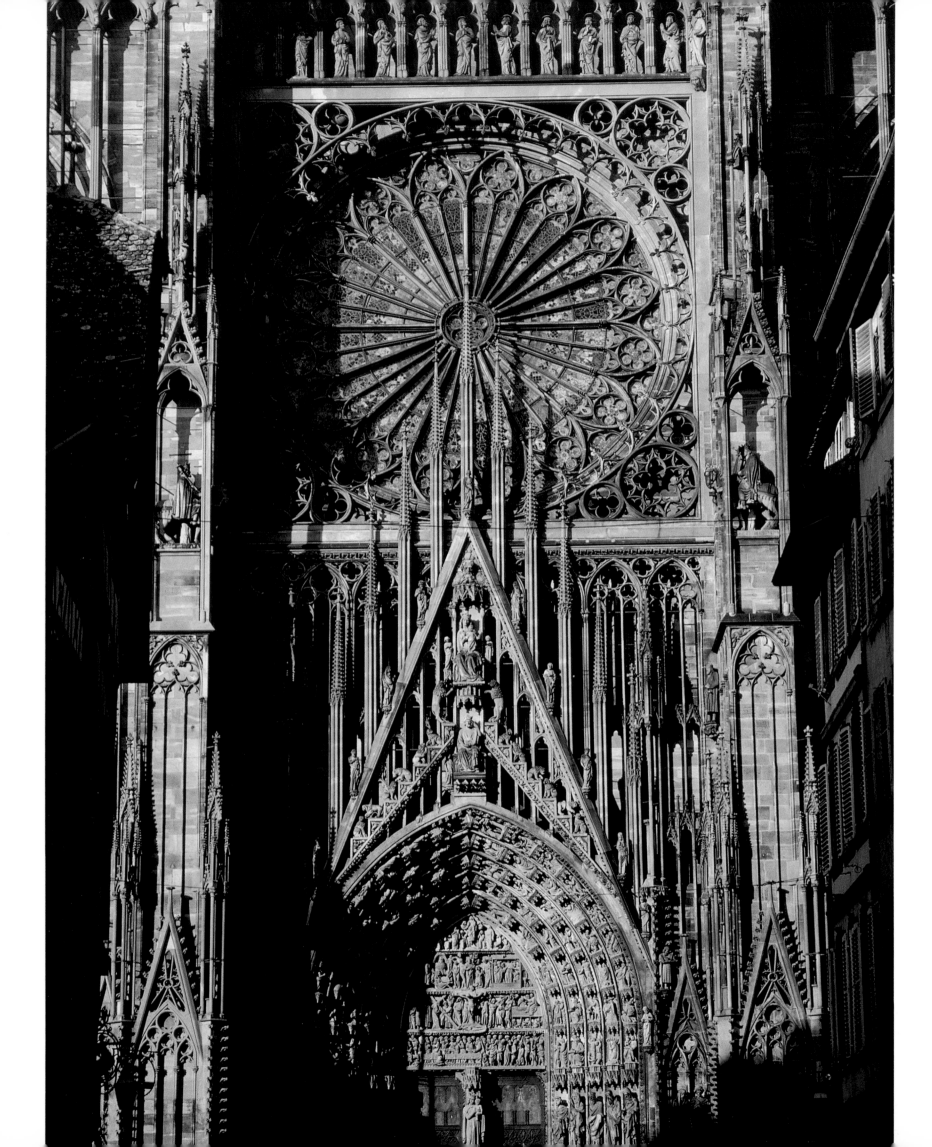

ground, her eyes covered with a blindfold: thus is represented the fact that the Jewish people never recognized in Jesus the Messiah foretold by the Old Testament. The more the first triumphs, the more the second seems discouraged and beaten; her crown is already on the ground, her lance is broken, and she is on the point of dropping the Tablets of the Law. In spite of the affliction that she symbolizes, Synagogue is a young woman with a nostalgic and delicate charm and a grace that seems almost Mannerist. The sculptor carved her with tenderness, suggesting and emphasizing her slender form by the swaying movement of her body and the precise and varied organization of the folds of her drapery.

The later sculptures of the portals of the principal facade, which date from about 1300, suffered much during the Revolution. Louis-Antoine-Léon de Saint-Just and Le Bas gave the order to destroy all the sculptures, which was carried out on the west facade, most notably on the tympanums of the two lateral portals. But Professor Jean Herman saved the statues of the embrasures, placing them safely in the house of the Oeuvre de Notre-Dame.

As at Amiens, the sculptures of the main facade are organized according to a general program. The central portal celebrates the Passion of Christ on the tympanum, foretold by the prophets whose statues stand in the embrasures. The tympanum presents simultaneously the main scenes of the Passion and the Resurrection, on four levels that read from left to right, beginning on the bottom. After Jesus' glorious entry to Jerusalem, the Last Supper is depicted; in the center we even see Saint John dozing against Christ. Then Jesus is arrested on the Mount of Olives; Judas gives him the kiss of treason and a soldier in a coat of mail seizes him. At his feet Saint Malchus, his ear cut off by Saint Peter, still holds the sword. Jesus is brought in judgment before Pontius Pilate, then is scourged. On the second level he is crowned with thorns and carries his cross to Calvary, where he is crucified between the Church Triumphant, which gathers his blood in a chalice, and Synagogue with blindfolded eyes. At the foot of the cross lies the skeleton of Adam, symbolically expressing that Christ, the new Adam, by dying has triumphed over death and promises eternal life to humankind. Jesus is then taken down from the cross. Sleeping soldiers guard his empty tomb; he has already come back to life. On the third level we first see Judas, who has hanged himself in despair. Then the souls exit

the maw of Leviathan, or Hell: Christ saves Adam and Eve, a double symbol of all humanity. He appears to Mary Magdalen, then to the Apostles; he has Doubting Thomas touch his wounds to prove that the Savior's body is not an illusion. The last level, which is a copy, depicts the Ascension.

A veritable book of stone, and of prayer, the prodigious statuary that ornaments this tympanum with its four registers is astonishing in the multiplicity of its characters and its attention to picturesque detail. These two elements were designed to make the thirteenth-century faithful aware of the story of the Passion, which they could not read in any other way.

The side portals deliver a moral education. On the left portal two young women with slender bodies and full cheeks strike down grotesque characters with their lances and tread on them: in them we recognize virtue triumphant over vice. On the right portal we see the parable of the wise and foolish virgins, as reported in the gospel of Saint Matthew 25:1–12: "Then shall the kingdom of Heaven be likened unto ten virgins, which took their lamps, and went forth to meet the bridegroom. And five of them were wise, and five were foolish. They that were foolish took their lamps, and took no oil with them: but the wise took oil in their vessels with their lamps. . . . " All of them fall asleep; when they awake, the "foolish" virgins realize that they have no oil. They go to buy some . . . and are not there when their future spouses arrive, whom they

Opposite
STRASBOURG, CATHEDRAL, SOUTH PORTAL DEPICTING SYNAGOGUE, C. 1230–40
Synagogue, vanquished, holds a broken lance and the tablets of the law. In her defeat she remains noble and beautiful. Blindfolded, she turns away from the cross and looks to the ground; she symbolizes the blindness of the Jewish people, who did not recognize Jesus as the Messiah.

STRASBOURG, CATHEDRAL, PRINCIPAL FACADE, DETAIL OF THE SCULPTURE, C. 1300
In general, scenes of "minor subjects," genre scenes, and sculptures of details, were rendered realistically, while the "major subjects," the standing figures, entrusted to accomplished masters, were sculpted with more idealism.

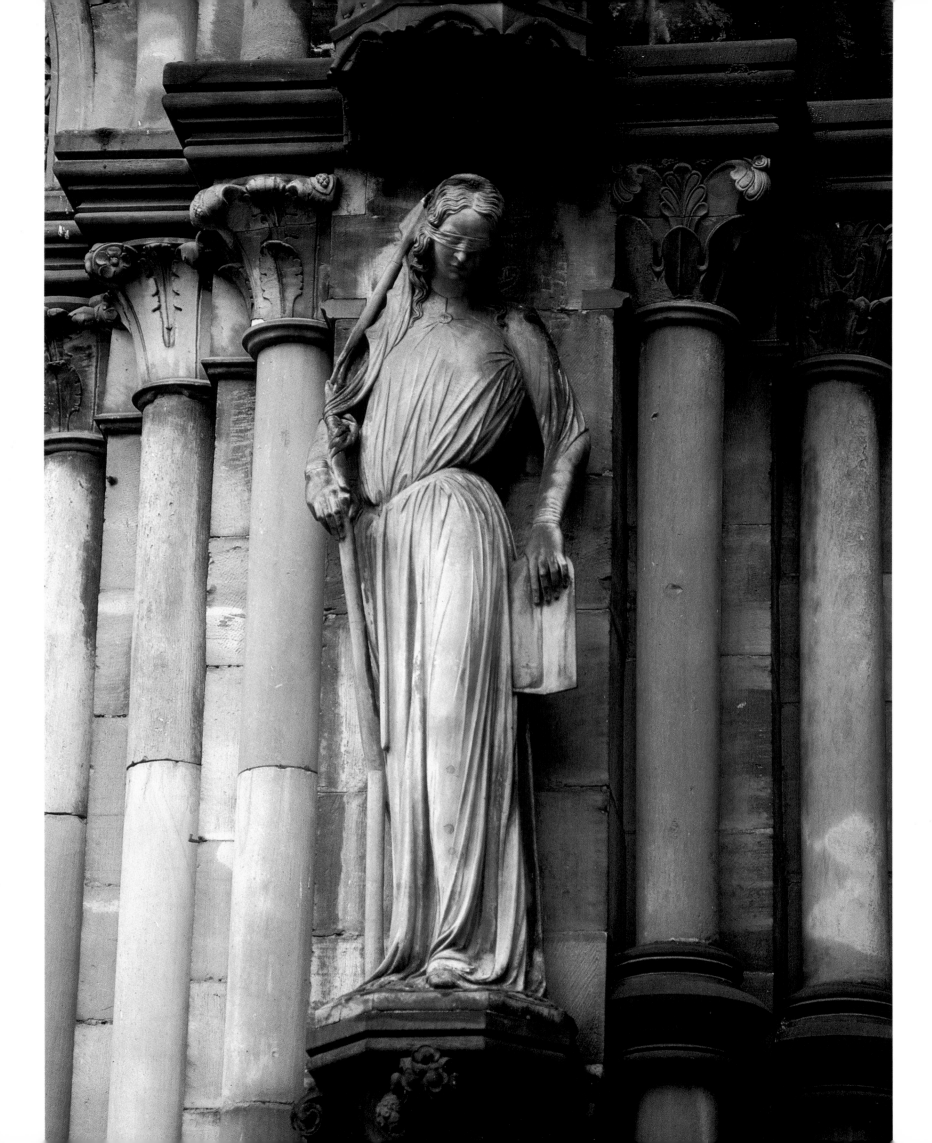

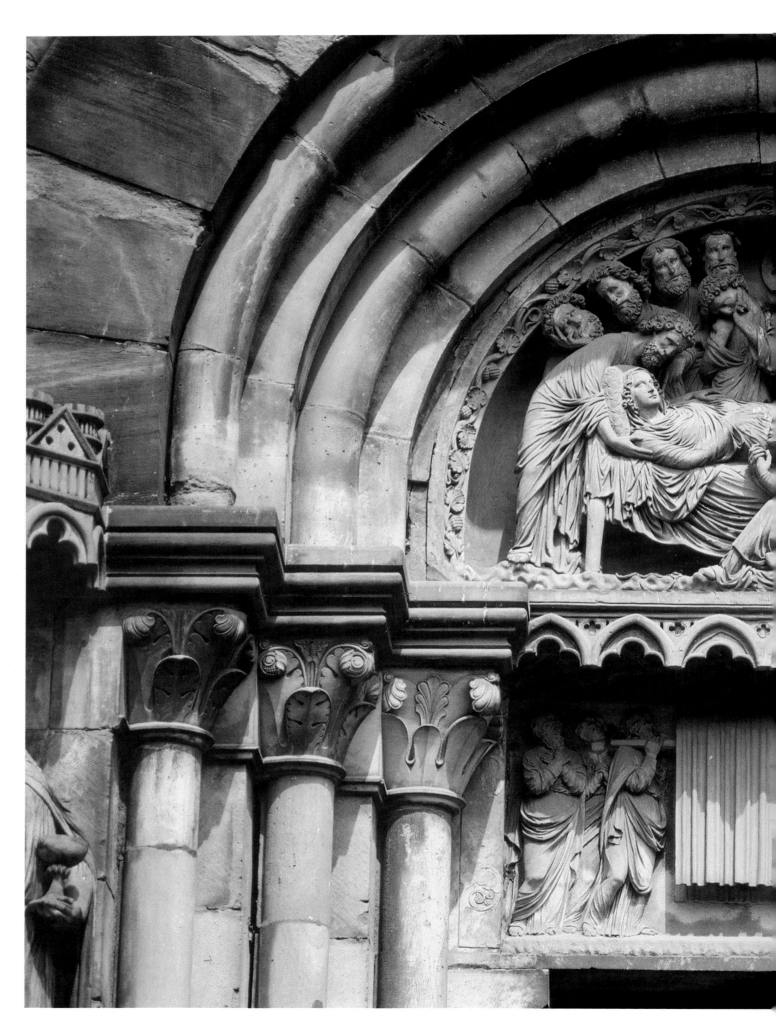

STRASBOURG, CATHEDRAL, SOUTH PORTAL DEPICTING THE DORMITION OF THE VIRGIN, C. 1230
The theme of the death of Mary, one of the most highly valued in Gothic iconography, is here treated with particular grandeur, her body appearing to be borne to Heaven. Symbolically, this representation shows that the soul, by returning to God, once again finds unity, purity, and the innocence of childhood.

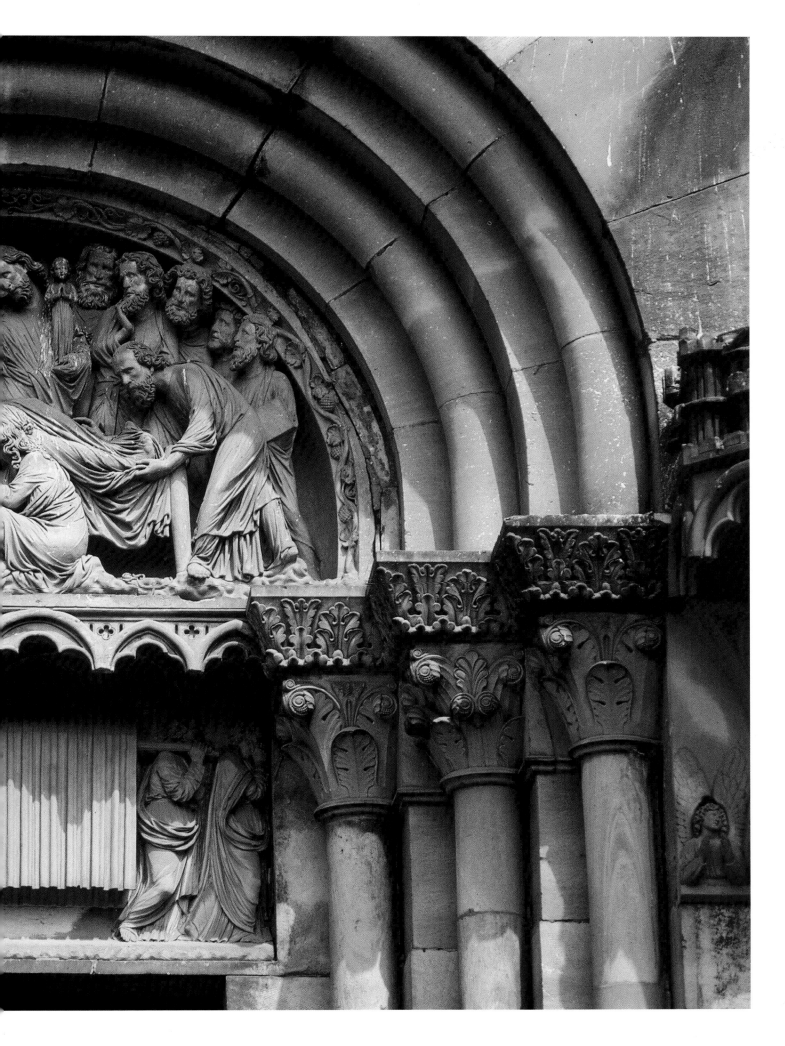

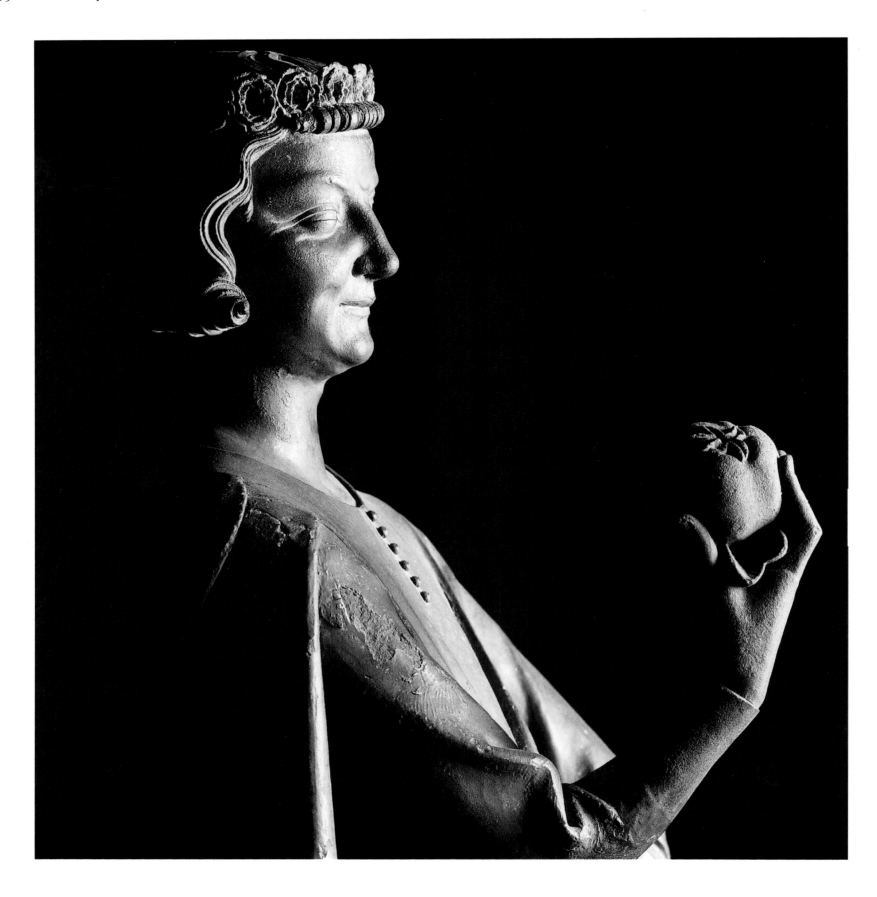

THE HOWLER MONKEYS

———•———

While the sculptures of Chartres are characterized by a mystical tension, those of Reims by a classical equilibrium, and those of Amiens by sweetness and playfulness, the sculptures of Strasbourg stand out for their sense of poignancy and drama.

Nonetheless, in this city, whose streets have names like Mésange (Titmouse), Pucelles (Virgins), Agneau (Lamb), Arc-en-ciel (Rainbow), and Hannetons (Cockchafers), imagination and humor are not absent from the cathedral. The frieze that runs along the north and south facades of the westwork presents a procession of surprising scenes: dice players, indecent assault, an initiation into fortune-telling, a man abandoning himself to his passions, the Lady and the Unicorn, Jonah and the whale, Daniel in the lions' den. Inside, the spandrels of the arcades that decorate the walls of the aisles bear representations of the stork pitted against the wolf and the fox in the fables, then a devil riding on a man, a scene from a hunt, and a crouching monkey eating cherries, among others. The Rohraffen, *or howler monkeys, of Strasbourg are two famous sculptures carved in 1385 attached to the north wall of the nave, on either side of the organ. One represents a herald in doublet and tight hose, the other a pretzel seller. During the services, and even during the sermons, a man hidden in the organ made them move, speak, and sing (they were jointed like puppets), improvising a comic, highly satirical, and even licentious dialogue between them.*

With wisdom and indulgence, the clergy of Strasbourg acknowledged that even those faithful sincere in their desire to pray were subject to the rush of the most profane thoughts in the moments of mental relaxation that comprise religious acts, and they left room for distraction. Thanks to the Rohraffen, *all this was expressed, shared, and, as it were, made sacred. For everything may become a prayer.*

THE TEMPTER, C. 1300. MUSÉE DE L'OEUVRE NOTRE-DAME, STRASBOURG
This depiction of the prince of evil marvelously renders the ambiguity of his character. The Tempter stands in the posture of the initiated, with feet and right arm at right angles. But his soul is already dead, as symbolized by the toads and intertwined snakes on his back.

had come to marry. The gospel concludes this lesson of spiritual vigilance, "Watch therefore; for ye know neither the date nor the hour wherein the Son of man cometh." On the right-hand embrasure is represented Jesus and four wise virgins; on the left is Satan, "the Tempter," and four foolish virgins. The former hold their lamps high and have the serene expression of happiness. The latter, to the contrary, have spilled their lamps on the ground and wear strongly contrasting expressions: one is hysterically happy, with a false happiness like that of a drunk, and the three others show pain, affliction, despair. The authors of these sculptures wanted to teach an optimistic moral: doing good leads to true happiness, while evil initially seduces, then fills the heart with bitterness.

The Devil is a masterpiece of symbolic expression. The very image of a seductive man, he stands straight and even arched backward a bit, for, proud by nature, he "blows his own trumpet." He wears stylish clothing, ornamented with many buttons, and his well-shod feet are small. The apple he holds reminds us of his identity: the Tempter, who seduced Adam and Eve in the first garden. His face seems to be jovial, but a closer examination of his profile—where the personality is revealed—tells a different story; his smile is fixed in a rictus, and a few small wrinkles at the cor-

ners of his eyes show that he is a "counterfeit young man." The Devil is old, aged without remedy, for his soul is dead, gnawed by the snakes, toads, and lizards that he carries on his back, symbols of evil and death.

Jesus is there, nonetheless, to protect mankind. Jesus is placed on a different level from the Devil (who is not a divine being) and across from him, as close as possible to the entry to the sanctuary, where he welcomes all who enter.

Glossary

1. Vestibule or narthex
2. Central space, or vessel, of the nave
3. Aisles
4. Transept, north and south arms
5. Crossing
6. Ambulatory
7. Axial chapel
8. Radiating chapels
9. Absidioles
10. Choir
11. Apse
12. Oblong or rectangular bay
13. Square bay
14. Porch

0 30 ft.

REPRESENTATIVE CHURCH PLAN

Cathedral of Santiago de Compostela, Spain (1075)

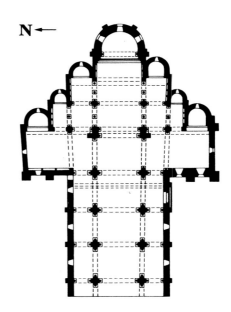

STEPPED CHAPELS

abacus The topmost element of a capital. *See capital diagram*

absidiole A chapel in the transept arms. *See church diagram*

aisles The spaces between the nave of a church and the outer walls. *See church diagram*

ambulatory The passage around the choir and the apse, which is sometimes double. *See church diagram*

apse The sanctuary end of a church, generally oriented to the east, semicircular or semipolygonal in plan. It may or may not project, and it may have different interior and exterior profiles. *See church diagram*

arch A curved supporting structure that spans an opening. It can take many different shapes. *See arch diagram*

archivolt The group of moldings that frame an arch or a bay. *See portal diagram*

avant-corps The part of a building projecting out from the main structure.

barrel vault *See* **vault**

bay The space included between two supports or corresponding to a portion of vaulting. *See church diagram*

billet molding A molding with three staggered rows of projections alternating with voids.

capital The topmost part of a column that receives the load from an arch. It is often decorated. *See capital diagram*

central plan A ground plan symmetrical in all directions. Forms include the circle, Greek cross, Latin cross, and trefoil. *See central plan diagram*

chevet The eastern end of a church as seen from the exterior, including the apse, ambulatory, and radiating chapels. Its name, from the Latin *caput* (head), comes from the presence of the high altar in the choir.

Christ in Majesty A representation of the enthroned Christ, usually surrounded by the symbols of the four Evangelists (the tetramorph).

clerestory In a church, the range of windows in a wall raised above an adjoining roof, usually the wall of the nave when it is taller than the aisles.

confessio The section of a crypt comprising access corridors and a series of rooms.

corbeling Masonry construction jutting out from a wall; also, an overhang carried by a series of supports, including the corbel, bracket, console, and caryatid.

crossing The bay formed by the intersection of the central space of the nave and the transept. It is called *regular* when its four openings are identical. *See church diagram*

diaphragm wall or **arch** A section of freestanding wall across the nave of a church and under a vault or a ceiling supported by transverse ribs.

drum A vertical cylinder that serves as the support for a dome.

elevation The internal or external vertical organization of a building. In ecclesiastical architecture, the term is more specifically used for the nave.

embrasure The outward-splayed wings surrounding a door jamb. *See portal diagram*

enceinte A fortified walled enclosure around a castle or town.

galilee The name given in the Middle Ages to the vestibule or porch of some churches, replacing the narthex of the first basilicas. It often takes the form of a multistoried sanctuary. The name comes from the Easter procession that ended at this location, in memory of the return of the arisen Christ to Galilee.

groin, groin vault The line formed by the intersection of two vaults is a *groin;* the *groin rib* is a projecting stone rib placed along the groin to add strength. The *groin vault* results from the intersection

ARCHES

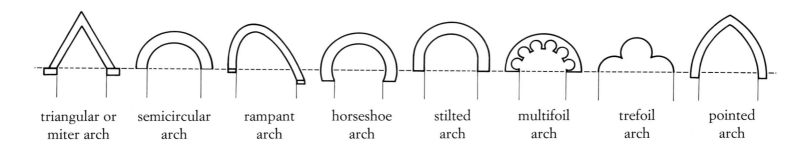

triangular or miter arch semicircular arch rampant arch horseshoe arch stilted arch multifoil arch trefoil arch pointed arch

of two vaults and has reinforcing groin ribs. A typical groin vault is formed by two semicircular barrel vaults crossing at right angles covering a square space. *See* **vault**

gutter wall An exterior wall carrying gutters, in churches, most often the walls of the nave.

hall church A church whose aisles are the same height as the central space of the nave.

historiated capitals Capitals bearing figural scenes, usually referring to a narrative iconography illustrating characters and episodes from the Old and New Testaments, as well as scenes from the saints' lives.

lantern tower A tower at the crossing of the transept whose dome, rising above the bays of the transept, allows direct illumination of the interior space.

lintel A horizontal structural beam or stone that spans an opening. *See portal diagram*

Lombard bands or **lesenes** Projecting vertical strips punctuating a wall, often joined at the top by small blind arcades.

mandorla An almond-shaped nimbus around the figure of Christ in Glory.

modillion A scroll-shaped ornamental bracket beneath the corona (projecting molding) of a cornice. Unlike the corbel, which has a similar shape, the modillion, most often sculpted, has no structural function.

Mozarabic art Art created by the Christians of Spain living under Arab domination; the Christians adopted some artistic forms from the Arabic culture.

nave The large central space of a church accessible to the faithful, encompassing the area between the entrance to the choir or the transept crossing. The term in principle includes the aisles but more commonly designates the central space or vessel. *See church diagram*

oculus A small, round window, especially the opening at the top of a dome, used in Roman and Romanesque architecture. It is the origin of the Gothic rose window.

pendentive A triangular vaulted shell set in the angles of a tower to support a round dome, creating a transition from the square or polygonal plan of the tower to the circle of the dome.

pier A vertical and rectangular support with neither base nor capital, in which a column or a pilaster may be engaged.

rib *See* **vault**

COLUMN WITH A CUSHION CAPITAL

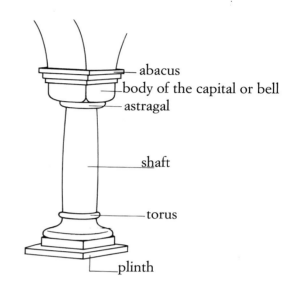

abacus
body of the capital or bell
astragal
shaft
torus
plinth

rubble masonry Broken stone and various materials set in mortar between two walls of cut stone.

squinches Small shell-shaped diagonal vaults that support an octagonal dome and provide a transition to a square plan.

stringcourse A projecting horizontal molding running across an exterior wall.

theophany A visible manifestation of God.

torus A carved ring of stone at the base of a column or around a window. *See column diagram*

transept In a church, the space that crosses the nave at a right angle. *See church diagram*

transverse rib or **arch** Masonry in the form of an arch that separates two vaults or sections a barrel vault, thereby reinforcing these structural elements.

tribune The arcaded gallery above the aisles and open to the nave in a church.

triforium A narrow passageway below the clerestory windows that opens onto the nave by means of a series of bays located above large arcades or tribunes. It is incorrectly called a *blind triforium* when passage through it is not possible.

CENTRAL PLANS

circular

polygonal

quatrefoil

polylobed

trefoil

LONGITUDINAL
PLANS

trumeau A pillar or pier between two adjacent openings, such as a double door. *See portal diagram*

tympanum In a portal, the space enclosed by the lintel and its surrounding arch. *See portal diagram*

vault An arched masonry ceiling or roof, comprising two parallel supports and the surface between them, to which they transfer lateral forces. Among the simple vaults is the **barrel vault,** a series of arches aligned along an axis. Of these, the type most commonly used in the Romanesque period is the continuous **semicircular barrel vault,** which basically consists of an extended arch. Its variants are the **half-barrel vault** (a quarter circle), the **pointed arch,** the **rampant vault,** with one side higher than the other, used to support inclines, and the **annular vault,** in which the center axis takes the shape of a segment of a circle. Transverse barrel vaults are perpendicular to the axis of the nave. *See arch diagram*

The Romanesque dome is sometimes hemispherical, supported on pendentives, and sometimes octagonal, supported on squinches. The **half-dome,** or semidome, vault found in apses, also known as the cul-de-four, is formed of a dome cut in half vertically.

Among the compound vaults, formed by the intersection of two or more vaults, is the **rib vault,** supported by a framework of ribs or arches, usually semicircular or pointed, and the **groin vault,** which adds a **groin rib** at the point of intersection. *See* **groin vault**

voussoir One of the individual masonry units of an arch or vault.

westwork The elaborated west end of a church, typically with an entrance hall or a porch at its base, a room above that opens onto the nave, and a tower.

aisleless nave
without transept

Latin Cross

double transept

double-ender
(with west-facing apse)

PORTAL

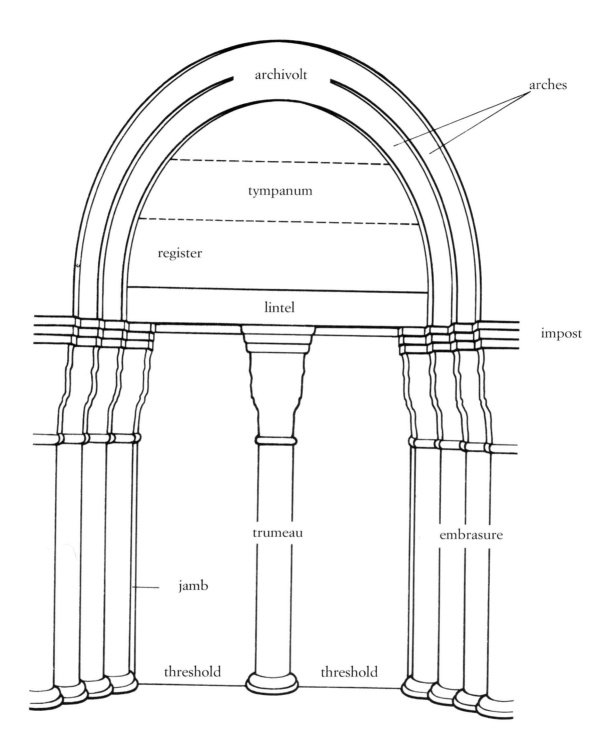

Index

Note: Page numbers in *italics* refer to illustrations. Captions are indexed as text.

A

Abadie, Paul 82, 93
Abbaye-aux-Dames, Saintes 78, 91
Abbaye-aux-Dames/Hommes, Caen 195, 198, *199*
Adeloch, Bishop, tomb of 162
Albi 41, *300–301*, 302; Cathedral 248, *292–93*, 293, 295–99, *296*, *297*, *298*
Alet, abbey 27, 28
Alsace 148–63
Ambialet, priory church, censer 41, *41*, 44
Ambulacrum, development of 110
Amiens: Cathedral *270–74*, *272–79*, *276*, 399; "Handsome God" 238, 275, *277*
Angers, Château d' 330, *330–31*, 332–33
Angevin style 330, 332, 362
Angoulème Cathedral 75, 78, 82, *82*, 91, 93
Anjou, dukes of 328, 334
Anzy-le-Duc 63, 66, 67
Apse, polygonal 173–74, 182
Aquitaine, dukes of 74, 102
Arches: Gothic 226, 227; horseshoe 19, 20
Arles-sur-Tech 19, 23, 28
Auvergne: feudalism 102; influence of 93, 117; Limagne Plain churches 105, 108, 109–10, 115, 117; pagan rituals 119; Upper 113, 115
Auzon, crucifix 122, *122*
Avenas, altar 183, *183*
Avernier, Antoine 279
Avignon: bridge 166, 167, *167*; Papal Palace 248, 287, *304–5*, *306–10*, *307*, *308–9*, *311*, 314–15, *315*

B

Basel Cathedral 163
Basse-Oeuvre, Beauvais 205, 272
Bayeux Cathedral *186–87*, 188
Bayeux Tapestry *196–97*
Beaulieu, Virgin of *118*, 119
Beaune, Hôtel-Dieu *317–18*, 318, 324–25, *324*

Benedictine order 50–51, 75, 127, 142, 143, 154, 216, 219
Benedict of Nursia, Saint 50, 75, 284
Bernard, Saint, abbot of Clairevaux 55, 219
Bernay: church 194–95; school of sculpture 198
Berry: frescoes 94, *94–95*; illuminated manuscript 75, *288*, 289, *342*, 342–43, 376
Bestiaries 82, 86–87, *86–87*, 145, 159, 160
Bianya, Raymond de 28
Blesle: abbey church 110, 113; crucifix 122
Boësse, church 206, *207*
Boulin, Arnould 279
Bourbon-l'Archambault 346–47
Bourgeoisie, rise of 343–44, 346
Bourges, Hôtel de Jacques Coeur 248, 343–47, *343*, *345*, *346*
Brittany 360–62, 365
Brivadois 110, 113
Burgundy: capitals 64–65; crypts 110; dukes of 318, 320–21, 324; end of kingdom of 180; influence of 162–63; mannerism of 67; portals 63, 66–67; two territories of 50; vaults 63
Byzantine art, influence of 18, 28, 31, 51, 92–93, 110, 111, 162, 163, 174

C

Cabestany 29, *29*
Capetian Gothic 76
Capitals: Alsatian 150, 159, 160; bestiaries 145; Burgundian 64–65, 67
Carcassonne 299, *299*, 302, *302–3*
Carolingian Empire 12–14, 148; antechurch 110; crypts 23; double-ended churches 55; influence of 18, 20, 59, 78, 93, 157, 162, 194, 195, 205, 207, 210; renaissance of 50, 150, 154; twin towers 59; vaults 19
Catalonia 12–14, 18, 19, 27, 28, 31
Cathar heresy 292–93
Censer, Ambialet 41, *41*, 44

Cerisy-la-Fôret 195, 198
Chamalières 110, 183
Champagne 263–64; influence of 71, 163; Romanesque 182, 206–7
Champagnolles, sculpture 74, *74*
Champmol, Carthusian monastery 321, 322
Charente, Lesterps 75, 78, 88
Charlemagne, scepter 376, *376*
Charlieu, portals 66, 67
Chartres Cathedral 40, 63, 205, 210–11, *211*, *212*, *213*, 224, *228–39*, 230–39, 261, 272, 276, 399
Château de Vincennes *370–71*, 372, 376, 377, 378
Château du Plessis-Bourré 334, *334–35*, 335
Château-Gaillard, Les Andelys *200–201*, 202
Châteauneuf-de-Contes 171, 172
Châtel-Montagne, Veauce 115, 116, *116*, 117
Chinon, Château *326–27*, 328–30, *329*
Christ in Majesty, theophany of 66, 82
Cistercian movement 55, 63, 71, 127, 177, 219
Cîteaux, abbey 50, 55
Civray 78, 82, 85
Clermont, diocese 102, 105
Cluniac style 18, 28
Cluny: abbey of 50–52, *53*, 54, *54*, 71, 182; capitals 64, *64*, 67; influence of 50, 54, 63, 118, 127, 143, 157, 162, 163, 182; order of 102, 219; portals 63
Coeur, Jacques 343–44, 346
Colors: in materials 171; in stained glass 235; in wall painting 94, *94–95*, 98, 163
Compostela, pilgrimages to 127, 133, 180
Conant, Kenneth J. 54
Conques, pilgrimages to 137–40
Corinthian style 46, 64
Cornard association 357
Corneilla-de-Conflent 20, *21*, 23
Coronation of the Virgin 243, *244–45*
Coronation of the Virgin (Quarton) *310*, 311, 314–15
Corsica 184

Crucifixes 119, 122, *123*
Crypts 23, 78, 88, 109–10

D

Débrédinoire 117
Digne Cathedral 171, 173
Dijon 321, 324
Dinan, château 368, *368–69*
Domes, Périgord 78, 91–93
Dominican order 246, 294
Dorat, collegiate church 88, *88*

E

Ébreuil, monastery 115–17
Eleanor of Aquitaine 74, 91, 102, 142
Elne: cloister 28; paintings 31; vaults 23
Enamels 89, *90*
Eschau, basilica 151, 159, 162
Étampes, Guinette tower 203, *203*, 204
Étienne de Bagé, Bishop 66

F

Feudalism 14, 102, 180, 188, 192, 242
Flamboyant style 350, 353, 357, 379, 383, 384
Flavigny-sur-Ozerain, crypts, 110; influence of 55
Fontenay: bell tower 177; former abbey 63
Fontevrault, abbey church 75, 91
Fontgombault, abbey church 92–93, *92–93*
Fouquet, Jean 262, 263, 347, 378–79
Foy, Saint 138, *140*, 141
Franche-Comté 50, 71
Franciscan order 246
Frescoes 94, 98; Albi *292–93*, *295*, *297*; Avignon *310*, *311*; Kernascleden *358–59*, *360*; *see also* Painted decoration
Froidefontaine, Rhenish style in 71
Froment, Nicolas 314, 334, 347
Fulk Nerra, Count 75, 328

Funerary art 91, 150, 151, 162, 167, 171, 320, 322

G

Galilee antechurch 59
Ganagobie, priory church 166, *166*, 173, *173*
Gensac-la-Pallue 82, 91
Geoffrey Plantagenet, duke of Anjou, tomb of 91
Geoffrey V of Anjou, tomb of 91
Gilabertus 47
Gilduin, Bernard 44, 47
Giovanetti, Matteo 310
Girauldus 93
Gislebertus 66, 67
Gothic period: aesthetic of 227; painted decoration 248, 361; secrets of 226–27, 272; tapestries *325*, *332–33*; transition to 91, 163, 205, 210, 211, 216–27, 238
Guesclin, Bertrand du 369, 376

H

Hall church 19, 78
Henry II Plantagenet 74, 91, 102, 142, 328–29, 330, 361
Hey, Jean 346–47
Hilarion, Saint 140
Hospitallers, orders of 35, 127
Huel, Alexandre 279
Hugues Capet 102, 202, 222
Humanism 47
Hundred Years' War 344, 361, 372, 374, 378, 382

I

Île-de-France: "French style" of 216; influence of 163, 362, 392; religious art 205, 210
Images, cult of 118–21
Innocent III, Pope 253, 292
Islam, influence of 18, 20

J

Jacobin Monastery 294
James the Greater, Saint 127, 133
Javarazay, tombs of 91
Jean de Chelles 224
Jean de France, duke of Berry 342–43
Jean d'Orbais 259
Jean Le Bouteiller 225

Holy Sepulcher in 20, 93; pilgrimages to 127
Joan of Arc 329–30, 350
Jourdain, Alphonse 36
Julian, Saint, tomb of 110
Junien, Saint, monument to 91

K

Kernascleden, chapel, 362; paintings, *358–59*, 360, *360*, 361, 363, *363*; sculpture 362, *362*
Knights of the Round Table 360, *360–61*

L

La Chaise-Dieu 110, 127
La Charité-sur-Loire 66, 259
La Daurade, workshop of 47
Lady and the Unicorn 384–85, *385*
Laleu, stone tomb of 91
Languedoc 292–94; Gothic art 294–303; Romanesque art 18–19, 23, 27, 28, 41, 88
Laon Cathedral 217, 219–23, *219*, *220*, *221*, *222–23*, 224, 259, 272, 353
Larresingle, Romanesque bridge 142
La Trinité, Lessay 192, *192*
Lavaudieu (Vallis Dei) cloister 110, *111*
L'Écluse 28, 31
Le Liget: narrative cycle 75; wall paintings 98
Le Moiturier, Antoine 320
Leo IX, Pope 71, 148
Le Thoronet, abbey 174, 176, *176*, 177, *178–79*, 180
Limbourg brothers 289, 342
Limousin, churches of 85, 88, 89, 93
Loire, recovery of 74–75
Lombardy, influence of 18, 19, 20, 21, 27, 162, 171, 183
Lorraine 148, 150–51; influence of 71; sculpture 162–63
Louis VII, king of France 74, 102, 302
Louis IX, king of France (Saint Louis) 242, 246, 330, 376, 378

M

Manuscript illumination 30, 50, 75; Berry 75, *288*, 289, 342–43, *342*, 376; School of Paris 246,

247, 248, 347, 372, *373*; Souvigny Bible 50, *51*; and stained glass 163
Map, Gautier 360
Marble, use of 23, 145
Marmoutier, abbey church 154, *156*, 157
Martel, Geoffroy 75
Martini, Simone 310
Mary: cult of 105, 120, 128, 134, 142, 172, 230; statues in the round 120–21, *120*, *121*
Mazères, fortified church 144–45
Mendicants, order of 246
Menulphus, Saint 117
Merimée, Prosper 71, 131
Merovingian basilicas 20
Michael, Saint 110, 128, 282, 289
Military architecture 202–4
Moissac, abbey: cloister of Saint-Pierre 46, *46*, 47, *47*; influence of 41, 44, 47; pilgrimages 140, 142, 143; portals 40, 261
Moissac, Master of 88, 115, 143
Molesmes, Robert de 55
Monasteries 50–71, 75; accommodations in 133; Benedictine 20; life in 50–52; of Provence 166; roles of 14
Monet, Claude 350
Mont-devant-Sassey 157, 163
Monte Cassini, monastery 50
Montmajour, abbey 166, 167, 171, 173–74, 177
Mont-Saint-Michel 280–83, 282–87, *285–88*
Mosaic 173, *173*
Moses' Well (Sluter) 322, *322*, *323*
Mozarabic influence 28, 31
Murbach, abbey church *146–47*, 148, 154, 157

N

Narbonne Altar Frontal *374–75*, 375
Naturalism 47
Neuwiller-lès-Saverne 154, 157
Normandy 188–98, 205, 362
Notre-Dame, Jumièges *194*, 195
Notre-Dame, Le Puy-en-Velay *130*, 131, *131*, 134, *135*, 137, 182
Notre-Dame, Moulins 347, *347*
Notre-Dame, Orcival 102, *103*, 121
Notre-Dame, Val-des-Nymphes 167, *172*
Notre-Dame-d'Aubune 167, 177
Notre-Dame-de-Galilée, Saint-Dié 157, 163
"Notre-Dame-de-Grâce" 294–95

Notre-Dame-de-la-Mer 180, *180*
Notre-Dame-de-Paris 206, *214–15*, 216, 217, 219, 224–25, *225*, 227, 230, 237, 259, 261, 272, 275, 340
Notre-Dame-des-Doms, Avignon 173, 177, 310
Notre-Dame-des-Miracles, Mauriac 113, 115
Notre-Dame-du-Port, Clermont-Ferrand 55, 102, *102*, 105, *105*, *106–7*, 108–9, 110
Notre-Dame-la-Grande, Poitiers 82, *84*, 85, 98
Noyon Cathedral 219, 222, 224

O

Orcival, church 105, 108, 109
Ottomarsheim, church 150, 151, *152–53*, 154
Ottonian churches: double-ended 55; exterior vs. interior of 150
Ottonian influence 71, 148, 150–51, 154, 183, 207

P

Painted decoration: Byzantine influence 110, *111*; colors in 94, *94–95*, 98, 163; Gothic 248, *272*, 347, *358–59*, 361; Mozarabic influence 28, 31; profane scenes 116–17; Romanesque *28–29*, *30–31*; *see also* Frescoes; Manuscript illumination
Palatine Chapel, Aix (Aachen) 19, 93, 151
Paray-le-Monial 59, *59*, 63
Paris 206, 372–85; as capital 246; Hôtel de Sens 382, *382*, 383; Hôtel of abbots of Cluny 382, *383*, 384; Hôtel Saint-Pol 376; Île-de-la-Cité 378; illuminated manuscripts 246, *247*, 248; as intellectual capital 253–55, 347; La Bastille 376; Louvre 376; Montmartre 82, 216; peasant revolt 372, 374; *see also* Notre-Dame-de-Paris
Peace of God movement 14, 35
Périgord: domes 78, 91–93; influence of 142; screen-facade 82
Perrecy-les-Forges, Charolais church of 59, 66
Pfaffenheim, sandstone church 157
Philippe Auguste (Philip

Augustus, Philip II, king of
France) 102, 202, 253, 329, 376
Philip the Good (Weyden) 318,
319
Pierre de Chelles 225
Pierre de Montreuil 217, 224,
226
Pietà (Quarton) *312–13*
Pilgrimages 126–45; Alsatian
routes 160; architecture *32–33*,
35; Auvergne route 102; to
Compostela 127, 133, 180; to
Conques 137–40; infrastruc-
ture 132–33; Limousin route
89; miraculous fountains 144;
to Moissac 140, 142, 143;
printed guides to 133–34, 137;
to Provence 171, 174; purposes
of 131–32; relics and 127,
128–31; to Roncevaux 142–45;
to Virgin of Puy 134, 137
Pisan influence 184
Plantagenet style 330, 332
Poitou 78, 82, 98
Pompierre, sculpture 159, *159*,
162–63
Popes: at Avignon 308–9;
election of 308; functions of
306–8
Portals 63, 66, 210–11, 239, 261;
bestiaries on 82, 86–87, *86–87*,
159, 160
Pot, Philippe, tomb of 320, *320*
Provence 166–77; civil works
167, 170; classical heritage
171–74; feudalism in 180;
influence of 41, 314; mosaics
173, *173*; pilgrimages to
171, 174
Provins 264–65, 268; "César"
tower 204, 265, *265*; chapel of
the palace 207; ramparts 265,
266–67
Prudentius 85
Psychomachia 85

Q

Quarton, Enguerrand 311, 312,
314–15, 347
Quitterie, Sainte 144

R

Ravy, Jean 225
Raymond du Temple 376
Relics 127, 128–31, 154
Relief, art of 27–28, 78
René, King (duke of Anjou) 334
Richard the Lionhearted, King
91, 202, 361

Rioux 82, *83*
Ripoll, abbey 20, 28
Robert de Luzarches 272, 275
Robin de Romans 310, 311
Rolin, Nicolas 318, 324–25
Roman antiquity, heritage of
172–74
Romanesque art: monumental
sculpture 26, 27–28;
monuments of 20, 23, 27;
mosaic floors 173; origins of
10–31; painted decoration 28,
30–31, 248; periods of 170–74;
Provençal style 170–71;
Rhenish style 151; simplicity,
rounded forms, and light 78;
stained glass 163
Rouen Cathedral *348–49*, 350,
351, *352*, 353
Roussillon: origins of
Romanesque in 13, 18–20, 23,
26, 28; sculpted lintels 63
Royaumont, abbey 248, *249*, 250,
250, 251, 284

S

Sacré-Coeur, Montmartre 82
Saine-Fontaine, Pierre de,
sarcophagus of 91
Saint-Aignan, Brinay *98*, 99
Saint-Andoche, Saulieu 64, *64*
Saint-André-de-Sorède *10–11*,
12, 13, 19, 28
Saint-Antonin-Noble-Val 36, *36*,
37, *37*
Saint-Aubin: crypts 55; Second
Romanesque style 75
Saint-Austremoine, Issoire 104,
105, 108, *109*, 110
Saint-Bénigne of Dijon 20,
50–51, *50*, 55, *56–57*, 110
Saint-Benoît-sur-Loire, Fleury
75–76, *76*, 77, 78, 116
Saint-Denis: abbey church
202, *202*, 210, 216–17, *216*,
217, 219, 261; portals 40,
47, 63
Saint-Donat chapel, Montfort
170, 171
Sainte-Chapelle, Paris 207, 237,
240–41, 242, 248, 250–51, 252,
252, *253*, 275
Sainte-Croix, Montmajour 145,
171
Sainte-Foy, Conques 40, *42*, 75,
91, *124–25*, 126, 127, 128,
128, 137, *137*, 138, *139*, 140,
141, *141*
Sainte-Foy, Sélestat 154, *155*,
157, 159, 163
Sainte-Madeleine, Vézelay 40,

59, *62*, 63, 64, *64*, 67, *68–69*,
71, 127, 261
Sainte-Marie-Principale,
Clermont 105, 109–10
Saint-Engrâce, capital 145, *145*
Saint-Étienne, Bourges 219,
336–37, 338, 339–40, *339*,
340–41
Saint-Étienne, Caen 192, *193*,
194, 195, 198
Saint-Étienne, Nevers 55, 59, 127
Saint-Étienne, Paris 206, 210
Saint-Étienne, Toulouse 47, 294
Saint-Étienne, Vignory 204, 205,
205, 207
Saint-Eutrope, Saintes 78, 98, 127
Saint-Fiacre, Faouët 362, 364–67,
364–67
Saint-Front, Périgueux 93, 127
Saint-Gabriel chapel 171, *171*,
172
Saint-Geniez-du-Dromon
170–71
Saint-Genis-des-Fontaines *26*,
27, 28, 63
Saint-Georges, Ydes 113, 114,
114, *115*
Saint-Georges-de-Boscherville
188, *189*, *190–91*, 192, 195
Saint-Gérard, Aurillac 113, 115
Saint-Germain-des-Prés 205, 206
Saint-Germain-l'Auxerrois, Paris
378, 379
Saint-Gilles-du-Gard 127, 167,
170, 172, 174, *174–75*, 175
Saint-Guilhem-le-Désert 23,
24–25, 27
Saint-Hilaire, Poitiers 78, 85, 91,
98, 127
Saint-Jean-de-Jérusalem 35–36
Saint-Jean-Saverne 157, 162
Saint-Julien, Brioude 102, 104,
110, *111*, 112, 113
Saint-Julien-de-Jonzy 66, 67
Saint-Junien, collegiate church
88, 89, *89*
Saint-Just-de-Val-Cabrère *22*,
23, 27
Saint-Lazare d'Autun *48–49*,
50, 63, 65, *65*, 66–67, *66–67*,
126, *126*
Saint-Léonard-de-Noblat 88, 127
Saint-Lizier 27, 31
Saint-Loup-de-Naud 210, *210*,
211
Saint-Maclou, Rouen 354, 357
Saint Mark, Venice 92–93
Saint-Martin, Nohant-Vic *72–73*,
75, 94, *94–95*
Saint-Martin-d'Ainay, Lyons
137, 182
Saint-Martin-de-Fenollar 19, 28,
30–31, *30–31*

Saint-Martin-du-Canigou 13, *13*,
18, *18*, 19, *19*, 20, 23
Saint Mary of Egypt 378, *378*,
379
Saint-Maurice, Vienne 182, *182*
Saint-Médard, Saugues 137–38
Saint-Menoux 110, 117
Saint-Michel, Lescure 40, *40*
Saint-Michel d'Aiguilhe, Le
Puy-en-Velay 122, 136, *136*
Saint-Michel-de-Cuxa 14, *16–17*,
18, 19, 20, 23, 28
Saint-Nazaire, Carcassonne 27,
302
Saint-Nectaire, abbey church
100–101, 102, 104, 105,
108, *109*
Saint-Ouen, Rouen 353, *353–56*,
354, 357
Saint-Pardoux, Gimel-les-
Cascades 88, *88*
Saint-Paul-Trois-Châteaux 167,
171, 173
Saint-Philibert, Tournus, abbey
church 52, *52*, 55, 58, 59,
60–61, 63
Saint-Pierre, Aulnay-de-
Saintonge 75, 78, 82, 85,
86–87, *86*
Saint-Pierre, Beaulieu-sur-
Dordogne 88, 133, *133*, 142
Saint-Pierre, Chauvigny 78, *78*,
80–81, 85, *85*
Saint-Pierre, Jumièges 194, 207
Saint-Pierre, Larnas 181, *181*
Saint-Pierre, Moissac 46, *46*, 47,
47, 132, *132*, 142, 143, *143*,
144, *144*
Saint-Pierre, Mozac 104, *104*
Saint-Pierre, Souvigny 110,
117–18
Saint-Pierre-des-Cuisines,
Toulouse 35, *35*, 36, 41, 44,
45
Saint-Pierre-et-Paul, Andlau 157,
160, *160–61*, 162
Saint-Pierre-Saint-Paul, Rosheim
148, *149*, 150, *150*, 151, *151*,
154, 157, *158*, 159
Saint-Pierre-Saint-Paul, Troyes
268, 269
Saint-Polycarpe, church 27, 29
Saint-Raphaël, church 172
Saint-Remi, Reims 127–28,
207, *208–9*, *256–57*, *258–59*,
260, 261–62, *261*, *262*, 272,
276, 399
Saint-Restitut, stonework 167,
170, *170*, 172
Saint-Samson, Ouistreham 198,
198
Saint-Saturnin, Toulouse 105,
108, 127

Saint-Sauveur, Saint-Honorat 174, 177, 180
Saint-Savin-sur-Gartempe 78, *79*, *96–97*, 98, 99, *99*
Saint-Sernin, Toulouse *32–33*, *34*, 35, 38, *38*, *39*, 40, 41, *43*, 44, 46, 47, 75, 145, 294
Saint-Sever 30, 140
Saint-Séverin, Paris 379–80, *379*
Saint-Thomas, Eschau 159, 162
Saint-Trophime, Arles *164–65*, 166, 167, 172–73, *172*, 174, *174*
Saint-Victor, Marseilles 41, 167, 171, *171*
Salers, Romanesque church 113, 116, *116*
Salles-Lavauguyon 88, 98
San Michele, Murato 184, *185*
San Sadurní de Tabérnoles 19–20
Santiago de Compostela, cathedral 35, 44
Sculpture: Alsatian 159, 160, 162–63; Amiens 238, 275–76, *276*, 277, *278*, *279*; Bernay school of 198; bestiaries 82, 86–87, *86–87*, 145, 159, 160; Brittany *362*, *364–67*; bust of Christ (Sluter) 321, *321*; capitals 64–65, 145, 150, 159, 160; Chartres *236*, *237*, 238, *239*; crucifixes 119, 122, *123*; cult of images 118–19; decorative 157, 159; drawing

method for 272; Gothic methods 263; Gothic transition 238; hierarchical order of 272; narrative cycles 159, 160, 162, 163; portals 63, 66, 126, 160; profane *74*; Reims 261–62, *261*, *262*; relief 27–28, 78; role of 64; Romanesque 26, 27–28, 63, 66, 210–11, 261, 279; stonecutters and 262–63; Strasbourg 392, *393–98*, 394, 399; Toulousan 47; Virgins *118*, 119, 120–21, *120*, *121*; wood 119
Sénanque, abbey 167, *168–69*, 170, 174, 177, *177*
Senlis Cathedral 219, 222, 224
Sens Cathedral 219, 224, 259
Sisteron, church 172, 173
Sluter, Claus 318, 321, 322
Soler, F. du, tomb of 28
Souvigny Bible 50–51, *51*
Speyer Cathedral 151, 154
Spicre, Pierre 325
Stained glass: Amiens *274*, 275; Bourges 340, *346*; Chartres 212, *212*, *213*, 230, 231, 232, 233–35, *234*, 237–38; Notre-Dame-de-Paris 217; Rouen 353–54; Saint-Denis 216, *216*, 217, 219, *219*; Sainte-Chapelle *240–41*, 242, 250–51, *252*, *253*; Strasbourg 162, *162*, 163;

Wissembourg Head 163
Steinbach, Erwin von 392
Stephen, Saint, reliquary 88, *88*
Stone keeps *203*, 204
Strasbourg 163, 388, *390–91*; Cathedral, *386–89*; sculpture 157, 159, 276, 392, *393–98*, 394, 399
Suger, Abbot 202, 216–17, 219
Sylvester II, Pope 115

T

Tapestries *325*, 332–33, *332–33*, 384–85, *385*
Tavant 75, 85, 98
Toulouse 34–47, 292–93; Church of the Jacobins *290–91*, 292
Tour-en-Bessin 188, *188*
Très Riches Heures du duc de Berry *288*, 289, 342, *342*, 376
Trinité d'Aregno 184, *184*
Troyes 268–69
Turpin, Jean 279

U

Urban II, Pope 102
Usatges de Barcelona, legal code 14

V

Vals, naves, 23; paintings 31
Vaults: Burgundian 63; Gothic 226–27; Ottonian 157; rediscovery of 19; rib 195, 205, 211, 222
Verdun Cathedral 157, 163
Vestibulum (Galilee) antechurch 59, 63
Vézelay, *70*; see also Sainte-Madeleine
Vicq: high gables 117; wall paintings 85, 98
Villon, François 380–82, 385
Viollet-le-Duc, Eugène 59, 71
Virgin and Child 120, *121*, 255, *278*, *310*
Virgin of Puy 134, 137
Visigoths, influence of 18, 28
Vitruvius 88
Vosges region 157

W

Weyden, Rogier van der 315, 318, 321
Wiligelmo 162
William of Volpiano, Abbot 20, 55
Windows, *see* Stained glass

Photograph Credits

All the photographs in this book were taken by Serge Chirol, with the following exceptions: